PENGUIN () CLASSICS

MONT SAINT MICHEL AND CHARTRES

Born in 1838 into one of the oldest and most distinguished families in Boston, a family which had produced two American presidents, Henry Adams had the opportunity to pursue a wide-ranging variety of intellectual interests during the course of his life. Functioning both in the world of practical men and affairs (as a journalist and an assistant to his father, who was an American diplomat in Washington and London), and in the world of ideas (as a prolific writer, the editor of the prestigious North American Review, and a professor of medieval, European, and American history at Harvard), Adams was one of the few men of his era who attempted to understand art, thought, culture, and history as one complex force field of interacting energies. His two masterworks in this dazzling effort are Mont Saint Michel and Chartres and The Education of Henry Adams, published one after the other in 1904 and 1907. Taken together they may be read as Adams' spiritual autobiography—two monumental volumes in which he attempts to bring together into a vast synthesis all of his knowledge of politics, economics, psychology, science, philosophy, art, and literature in order to attempt to understand the individual's place in history and society. They constitute one of the greatest historical and philosophical meditations on the human condition in all of literature.

Raymond Carney is well known for his writing on the relationships between American art, thought, and culture. He has been a Fellow of the National Endowment for the Humanities, served as an artistic consultant to the Whitney Museum of American Art, and written extensively on American and British poetry, fiction, drama, dance, painting, and film. His two most recent books are American Dreaming (University of California Press) and Figures of Desire (Cambridge University Press). He teaches at Middlebury College in Vermont.

CATTLAL DOMA BIND METHOR THO

Posses the last company of the contract of the

apple of the course country on the mappy live a certain following and a course of the country of

Adams, Henry, 1838-1918. Mont Saint Michel and Chartres / 1986. 33305238955474 mi 08/15/17

MONT SAINT MICHEL AND CHARTRES

HENRY ADAMS

Introduction and Notes by
Raymond Carney

PENGUIN BOOKS

Published by the Penguin Group

Penguin Group (USA) Inc., 375 Hudson Street, New York, New York 10014, U.S.A. Penguin Group (Canada), 90 Eglinton Avenue East, Suite 700, Toronto, Ontario, Canada M4P 2Y3 (a division of Pearson Penguin Canada Inc.)

Penguin Books Ltd, 80 Strand, London WC2R 0RL, England Penguin Ireland, 25 St Stephen's Green, Dublin 2, Ireland (a division of Penguin Books Ltd)

Penguin Group (Australia), 250 Camberwell Road, Camberwell, Victoria 3124, Australia (a division of Pearson Australia Group Pty Ltd) Penguin Books India Pvt Ltd, 11 Community Centre, Panchsheel Park, New Delhi – 110 017, India

Penguin Group (NZ), 67 Apollo Drive, Rosedale, North Shore 0632, New Zealand
(a division of Pearson New Zealand Ltd)
Penguin Books (South Africa) (Pty) Ltd, 24 Sturdee Avenue,
Rosebank, Johannesburg 2196, South Africa

Penguin Books Ltd, Registered Offices: 80 Strand, London WC2R 0RL, England

First published in the United States of America 1904
This edition with an introduction by Raymond Carney
First published in Penguin Books 1986
Published simultaneously in Canada

20 19 18 17 16

Introduction copyright © Viking Penguin Inc., 1986 All rights reserved

ISBN 978-0-14-039054-4

Photographs of Chartres and of the Nave of Mont Saint Michel by Whitney Stoddard, and Sandak, Inc., of Stamford, Connecticut

> Printed in the United States of America Set in Galliard

Except in the United States of America, this book is sold subject to the condition that it shall not, by way of trade or otherwise, be lent, resold, hired out, or otherwise circulated without the publisher's prior consent in any form of binding or cover other than that in which it is published and without a similar condition including this condition being imposed on the subsequent purchaser.

The scanning, uploading and distribution of this book via the Internet or via any other means without the permission of the publisher is illegal and punishable by law. Please purchase only authorized electronic editions, and do not participate in or encourage electronic piracy of copyrighted materials. Your support of the author's rights is appreciated.

Acknowledgments

Anyone working in the area of Henry Adams scholarship must, first and foremost, acknowledge his indebtedness to the pioneering work of Ernest Samuels as Adams' long-standing biographer, editor, and annotator. Mont Saint Michel and Chartres is encyclopedic in its range of references, and I am personally grateful to the following people for assistance in preparing this particular edition. Diane Legomsky and William Harris of the Department of Classics at Middlebury College collaborated with me on the translations from medieval and classical Latin; Nancy O'Connor of the Department of French at Middlebury College provided translations from medieval French and answered many questions about modern French passages; Giuseppe Faustini of the Department of Italian at Skidmore College translated the three passages of Italian in the text. Christopher Wilson of the Department of Art at Middlebury College spent several hours discussing architecture and possible illustrations for the volume with me, and I embrace the opportunity to thank him publicly for his time and extreme kindness. Whitney Stoddard, Professor of Art emeritus of Williams College, generously assisted me in locating suitable illustrations, which were provided by Sandak, Inc., of Stamford, Connecticut.

painting of the right controlled to the painting of the painti

Contents

Acknowledgments	v
Introduction by Raymond Carney	ix
A Brief Chronology of Adams' Life	xxxix
A Note on the Text	xli
MONT SAINT MICHEL AND CHARTRES	-1
Notes	361
Glossary of Architectural Terms	
Suggestions for Further Reading	380
Index	381

instant)

		100	Actoriorist my
	-0.5	Anymous Lesi	Therepulation for
			A Brist Cheers
ily			
	authright u	A JELONA!	PATAK TVOM
100			
ALC:		mist bhutshi	451, Paszoló,
988		uluka Agambilia di	Suggestory for
			stal

Introduction

If you please to plant yourself on the side of Fate, and say, Fate is all; then we say, a part of Fate is the freedom of man. Forever wells up the impulse of choosing and acting in the soul. Intellect annuls Fate. So far as a man thinks, he is free. And though nothing is more disgusting than the crowing about liberty by slaves, as most men are, [yet our] sound relation to these facts is to use and command, not to cringe to them. . . . Every solid in the universe is ready to become fluid on the approach of the mind, and the power to flux it is the measure of the mind. If the wall remain adamant, it accuses the want of thought. To a subtle force it will stream into new forms, expressive of the character of the mind.

-Ralph Waldo Emerson

Preceding the title page of the first edition of Mont Saint Michel and Chartres, Henry Adams placed the heading "TRAVELS-FRANCE." The reader coming to the book for the first time was thus led to expect some sort of tour guide or travelogue, perhaps the narration of an actual trek across northern France that began at the Romanesque monastery of Mont Saint Michel on the Norman coast and moved inland to the Gothic cathedral of Chartres. There were hundreds upon hundreds of such travel books published in England and America during the late nineteenth and early twentieth centuries. Almost without exception, their styles and contents were as wearying and pedestrian as their ambulatory approaches to art and architecture. But it would be hard to imagine a more misleading description of Adams' book than to call it a tour guide. If Mont Saint Michel and Chartres is a tour guide, it is one only in the sense in which Thoreau's Walden, Melville's Typee, Hawthorne's "The Custom-House," or Whitman's "Crossing Brooklyn Ferry" might be said to be. Mont Saint Michel and Chartres is the record, not of a literal journey across the Atlantic Ocean and France, but of a meditative one across strange seas of thought and feeling. It is the narration of a voyage of the imagination across interior landscapes. Like Thoreau, Melville, Hawthorne, and Whitman, Adams is interested in testing the conditions in which certain free movements, not of the body, but of the individual imagination are still possible in what, in his final chapter, he ends up calling the "prison" of space and time and actual human

society.

In short, the movements that matter in the pages of Mont Saint Michel and Chartres are less physical, geographical, and social than movements of mind and consciousness. That is why even to accompany Adams on this meditative journey, the reader is asked to disencumber himself of his ordinary physical and social identity. He must allow himself to be disembodied, and to be remade and rechristened imaginatively by Adams. On the first page of his Preface, Adams twists the verse "Who reads me, when I am ashes, / Is my son in wishes" (which he says he is appropriating from an old Elizabethan play or poem, but which, as far as I can tell, he is simply making up) in order to baptize us, his readers, as his new "nieces in wish." The point is that, in order to go on this journey at all, our selves must become fluid and mobile. We must make ourselves available to imaginative deformation and transformation. We must enter into a specially responsive relationship both to Adams and to the persons and events we will subsequently encounter, with a responsiveness and intimacy that cannot occur in the ordinary social world, the world outside of literature or our consciousnesses.

In the realm of the imagination, movements are possible that would be inconceivable in the actual physical world. On the second page of the Preface we, as "uncle" and "niece," are already crossing the Atlantic to spend the summer in France. But abrupt as that movement is, it is nothing compared to the dizzying rapidity of the subsequent movements in the book, in which, for example, by the fourth or fifth page of the first chapter, we and our new "uncle" have already dropped, together, body and soul, into the eleventh century. Adams fairly revels in the fact that, as we are his "nieces in wish," his prose can "wish" us and himself anywhere he pleases, with greater speed and mobility than the fleetest Atlantic steamer, first propelling us back into an eleventh-century granite quarry, and then even more rapidly whirling us back into our own century in the space between the paragraphs:

For the moment, we are helping to quarry granite for the Abbey Church, and to haul it to the Mount, or load it on our boat. We never fail to make our annual pilgrimage to the Mount on the Archangel's day, October 16. We expect to be called out for a new campaign which Duke William threatens against Brittany, and we hear stories that Harold the Saxon, the powerful Earl of Wessex in England, is a guest, or, as some say a prisoner or a hostage, at the Duke's Court, and will go with us on the campaign. The year is 1058.

All this time we have been standing on the *parris*, looking out over the sea and sands which are as good eleventh-century land-scape as they ever were; or turning at times towards the church door which is the *pons seclorum*, the bridge of ages, between us and our ancestors. Now that we have made an attempt, such as it is, to get our minds into a condition to cross the bridge without breaking down in the effort, we enter the church and stand face

to face with eleventh-century architecture.

If the church door is a pons sectorum, or bridge over which we may travel back and forth across ages and through systems of belief, it is Adams' playfully daring imaginative bridge-building that makes it one, and that allows both it and our minds, in his Thoreauvian pun, not to "break down in the effort." To be able to do this as a writer, to be able to move this freely and audaciously back and forth in space and time, is to be a supreme imaginative bridge-builder and someone undaunted by the absence of actual worldly bridges and connections. The wry slyness of Adams' bridge-building in such a passage is the opposite of "pontification" in the other sense of the word. To be able to do what Adams is doing here is what it means to be something "in wish."

Wishing, in this sense, as a form of wondering, dreaming, imagining, or meditatively speculating, is as important in Adams' work as it is in that of Wordsworth or Keats. Thus it is entirely appropriate that Wordsworth, even more than the Virgin, should be the patron saint of most of *Mont Saint Michel and Chartres*. Wordsworth's "Ode: Intimations of Immortality from Recollections of Early Childhood," which Adams quotes, paraphrases, and alludes to repeatedly, is an exploration of both the pains and the consolations of just such capacities of im-

aginative travel and return. But where Adams, as an American post-Romantic, differs from his illustrious English Romantic predecessors is in his determination to bring the Keatsian surmise or the Wordsworthian meditation into the real world of ordinary persons, places, and events. For Wordsworth and Keats, moments of heightened imagination and of meditative movement were necessarily characterized by a turn away from the practical world, by a willed withdrawal from society and its concerns. But, as every student of Emerson realizes, the American artist's audacious and distinctive effort was to explore the possibility of living the dream of Romantic poetry in the prose

of everyday life.

The first generation of American Romantics, specifically Hawthorne, Melville, and Thoreau, never quite saw their way clear to attempt this wholeheartedly. They were still engaged in acts of partial imaginative withdrawal and retreat from society even as they attempted to domesticate and naturalize the visions of the English Romantics. But the second generation, most notably Henry James and Henry Adams (who were coincidentally the best of friends), attempted to inject the transcendental imagination—the imagination of the human spirit in all of its potentially disencumbered, free, visionary mobility-into the real world of space, time, and social interaction. The man on the street (in America or in medieval France in the case of this book) is imagined to be potentially as capable of Wordsworthian exaltations, sublimities, and epiphanies as the average reader of Adams' book or Adams himself is, and he is thought to be capable of experiencing such visionary possibilities in his ordinary life. In the particular metaphors of the middle chapters of Mont Saint Michel and Chartres, in the contemplation of the Virgin and in absorption into the female principle, all of thirteenth-century society is potentially transformed into an extended and united visionary community. For Adams and James, writing in the wake of Whitman, the poetry of life is no longer the property of poets only, and it is no longer confined to the narrow precincts of a poetic stanza, or to the time of a poetic meditation in verse.

But as daringly as James and Adams entertained in their work the possibility that the structures of actual society could perhaps be made answerable to the most exalted and exalting

claims of the personal imagination (so that one would not have to remove oneself to Walden Pond, retreat to the second floor of the Custom-House or to the woods outside Salem, or embark on a whaling voyage to find or make a true and imaginatively satisfying community within which to express oneself), they were, nevertheless, profoundly torn by contradictory feelings as well. In short, much as they wanted to believe in it, they were ambivalent about the actual, practical attainability of such a visionary community. James and Adams, in effect, made their literary careers out of their ambivalences. James is truly unable to decide whether Isabel Archer's imaginative aspirations to express her dream of freedom within the actual structures of marriage and social intercourse are excessive and unrealistic. He is truly undecided whether Maggie Verver's attempt to transform an imaginative community of her own construction into an actual one by institutionalizing it in the real-world form of a double-ring ceremony involving herself and her three closest friends and relatives is commendably idealistic or culpably and horrifyingly naïve.

In a similar way, Adams is unable to make up his mind about the practical attainability of the "thirteenth-century unity" which he is often thought to be writing simply in praise of and with nostalgia for. The following passage (from the extraordinary conclusion to Chapter X) epitomizes his ambivalence. On the one hand, it is obvious that he would have given almost anything to have lived in an age as "very beautiful and very true" as the thirteenth century, and yet, on the other, his characterization of it as "very childlike [and] very foolish" reveals his doubts about whether it would indeed have satisfied him or

any other supremely intelligent participant:

Saints and prophets and martyrs are all very well, and Christ is very sublime and just, but Mary knows! It was very childlike, very foolish, very beautiful and very true,—as art, at least:—so true that everything else shades off into vulgarity . . . as though the heaven that lies about us in our infancy too quickly takes colors that are not so much sober as sordid. . . . We have done with Chartres. For seven hundred years Chartres has seen pilgrims, coming and going more or less like us; and will perhaps see them for another seven hundred years, but we shall see it no more,

and can safely leave the Virgin in her Majesty, with her three great prophets on either hand, as calm and confident in their own strength and in God's providence as they were when Saint Louis was born, but looking down from a deserted heaven, into an empty church, on a dead faith.

This passage points up both the similarities and the differences between Adams' views and those of Wallace Stevens. Like Stevens, Adams is a connoisseur of supreme fictions, but he is much more socially hard-headed and practical-minded than Stevens. The Virgin was what Stevens would have called a "supreme fiction" for her era, and Adams has a decidedly Stevensian nostalgia and fondness for the fiction of motherliness, femininity, and unconditional love and mercy that she embodies. As the Wordsworthian echoes in this particular passage suggest, and as Stevens would have agreed, what we cannot have socially, institutionally, or politically in the forms and structures of the world we can still cherish and keep alive in our consciousnesses.

But, with all due respect for this eminently Stevensian sentiment, Adams tonally patronizes it and puts it in its place. The fiction is merely a fiction. The cult of the Virgin is only interesting and true and beautiful "as art." Stevens could never regard art as such a limiting condition. Adams' strategy of referring to the mystique of the Virgin as merely a "feeling"the word he uses throughout Mont Saint Michel and Chartres to describe thirteenth-century consciousness—is only another way of hinting at its potential irrelevance to the world of thirteenth- or twentieth-century public affairs. For Adams, as never for Stevens, there is a world outside the world of literary traditions, artistic arrangements, and gorgeous, supreme, poetic fictions. There is a social, political, intellectual world with its own set of powerful, alternative fictions and rival myths. The placid surfaces of Stevens' poetry are never ruffled by having to come to grips with the fictions of Darwinism or Marxism. but these fictions have equal claims on Adams' attention, though he is as healthily able to remain as unseduced by the reigning fictions of late nineteenth-century Victorian England and America as he is unseduced by the thirteenth-century sexual cult of the Virgin of Chartres. The Education of Henry Adams, the autobiography Adams began immediately after finishing Mont Saint Michel and Chartres, is a virtual handbook on the dangers of being taking in by fictions, however apparently "true," "beau-

tiful," and artfully enticing.

Few writers are more salutarily and rigorously skeptical of the fictions all writing and thought (including their own) inevitably generate and depend upon. Adams had a radically modernist appreciation of the fictionality of all discourse, and of the inescapability of that predicament. There is no refuge from fiction in his work, no intelligible human "truth" or "reality" that exempts itself from its own fictionality. We cannot lever ourselves outside of our own systems of knowledge and understanding, and there is no alternative to such systems that is not another equally arbitrary and tentative fictional system. All of our insights and observations, all of our theories and understandings are only momentary stays against what is, without them, an always encroaching confusion. The relentlessness with which Adams applies this insight is what makes The Education such an exhilarating and continuously bracing piece of writing. He exempts nothing and no one from his critical scrutiny, least of all himself and his own writing. That is why, in his discussion of the provisionality of all of our scientific "laws" and "truths." Adams can, without even trying to do so, brilliantly and completely resist the pernicious tendencies of late-nineteenthcentury positivism, which took for granted the inexorable and triumphant progress of science toward some final absolute understanding of "reality":

He found himself in a land where no one had ever penetrated before; where order was an accidental relation obnoxious to nature; artificial compulsion imposed on motion; against which every free energy of the universe revolted; and which, being merely occasional, resolved itself back into anarchy at last. . . . the staggering problem was the outlook ahead into a despotism of artificial order which nature abhorred. The physicists had a phrase for it, unintelligible to the vulgar:—"All that we win is a battle,—lost in advance,—with the irreversible phenomena in the background of nature."

The only absolutes are the absolute insufficiency and absolute tentativeness of all of our fictions, each doomed ultimately to break down, or prove inadequate, or give way to another. But if this were the only point to notice (and it is indeed the point at which many appreciators of modernism have stopped), Adams would be the representative of an infinitely sad perception. Being denied all of the fictions of the past, and skeptical of all of the fictions of the present and future, the modernist would be left without anything positive to affirm or aspire after. That is why it is important to emphasize that there is a crucial countermovement within Adams' work (and within American modernism more generally). On the one hand, on the basis of the passage I quoted from the end of Chapter X and from many others within Mont Saint Michel and Chartres. it is undeniable that Adams does feel a nostalgia for an era before the modernist insight, for a time before truths were discredited as "truths" and rendered relative. On the other hand, however-and this is what is sometimes overlookedthere is a feeling of joy and potential liberation in the new situation as well. The modernist insight is not necessarily a sad and nostalgic one. It can also be excitingly liberating. Freed from enslavement to (or the support of) any one fiction, the self is freed to become an aesthetic eclectic, a connoisseur of an infinite variety of possible experiences.

Both sides of Adams' modernist doubleness of attitudethe nostalgic sadness and the euphoric feeling of possible liberation—are succinctly communicated in his relation to Darwinism in The Education. Darwinian notions of evolutionary descent, struggle, continuity, gradualism, and progress defined an absolutely supreme and increasingly unquestioned fiction in late-nineteenth- and early-twentieth-century England and America. (It is a fiction our culture is still under the spell of.) But what is interesting is Adams' double attitude toward it. He was not only one of the few contemporaries of Darwin to recognize Darwinism as a mere metaphor and fiction, not as a law of nature or fact of life, but having done that, he (in a Stevensian vein) went on not to argue against it or to reject it, but to embrace it (as a fiction) anyway, so that by the conclusion of the following passage he has even incorporated a set of evolutionary metaphors and concepts into his own argument. "Theory," "truth," "science," "fact" is, in the course of the

passage itself, gleefully transformed into (or revealed to be) metaphor, figure of speech, language, fiction:

Ponder over it as he might, Adams could see nothing in the theory of Sir Charles but pure inference, precisely like the inference of Paley, that, if one found a watch, one inferred a maker. He could detect no more evolution in life since Pteraspis than he could detect in architecture since the Abbey. . . . All this seemed trivial to the true Darwinian, and to Sir Charles it was mere defect in the geological record. Sir Charles labored only to heap up the evidences of evolution; to cumulate them till the mass became irresistible. With that purpose, Adams gladly studied and tried to help Sir Charles but, behind the lesson of the day, he was conscious that, in geology, as in theology, he could prove only Evolution that did not evolve; Uniformity that was not uniform; and Selection that did not select. To other Darwinians-except Darwin-Natural Selection seemed a dogma to be put in the place of the Athanasian creed; it was a form of religious hope; a promise of ultimate perfection. Adams wished no better; he warmly sympathised in the object; but when he came to ask himself what he truly thought, he felt that he had no Faith; that whenever the next new hobby should be brought out, he should surely drop off from Darwinism like a monkey from a perch; that the idea of one Form, Law, Order or Sequence, had no more value for him than the idea of none; that what he valued most was Motion, and that what attracted his mind was Change.

Never, since the days of his *Limulus* ancestry, had any of his ascendents thought thus. Their modes of thought might be many, but their thought was one. Out of his millions of millions of ancestors, back to the Cambrian mollusks, every one had probably lived and died in the illusion of Truths which did not amuse him, and which had never changed. Henry Adams was the first in an infinite series to discover and admit to himself that he really did not care whether truth was, or was not, true. He did not even care that it should be proved true, unless the process were

new and amusing. He was a Darwinian for fun.

If there is no nature or reality to get to, as it is assumed by the traditions of nineteenth-century positivism against which Adams is playfully but nonetheless firmly reacting in this passage, it does, for this descendent of *Pteraspis*, come down to "your and my fun" (in Henry James's phrase). And what it

means to be any- and everything for "fun" (in the most complex sense of the word) is, in the largest sense, the subject of both Mont Saint Michel and Chartres and The Education. Modernist alienation from "truth," "reality," and the social and institutional underpinnings of such things is not necessarily sad. Alienation can be a state of freedom, eclecticism, and connoisseurship. Alienation makes play and games possible, and games (like the metaphoric, stylistic, and intellectual games Adams plays throughout the above passage) can be great "fun." Against the sadness and nostalgia he feels in his belated, modern condition, Adams juxtaposes what Nietzsche would have called the sheer "gaiety" of this newly liberated sense of "science." It was in recognition of precisely this aspect of Adams' writing that William James saluted him upon receipt of his copy of the book by saving that "from beginning to end, Mont Saint Michel and Chartres reads as from a man in the fresh morning of life, with a frolic power unusual to historic literature." (It would be hard to find a better judge of "frolic power" insofar as that is exactly the quality James's writing itself most possesseswhich perhaps further suggests the deep similarity between his own and Adams' attitudes and responses.

I realize that I am making Adams sound quite sophisticated philosophically, but we should not be surprised that a nineteenth-century American historian like Adams should anticipate the attitudes and methods of twentieth-century continental, postmodernist critics, anthropologists, and philosophers. It was, after all, the American artist who from the beginning was put in a unique position to recognize the arbitrary and fictional quality of all of the received European cultural traditions and styles. His geographical and ideological position off to the side of such structures granted him a crucial margin of distance that is the sine qua non of critical awareness. America was, in its essence, the culture founded on a belief in man's personal power to escape the reigning European structures and forms of understanding and to replace them with new ones of his own creation, as substitutes for the discredited orders being

left behind.

As Gertrude Stein asserted, America was the first culture to enter the twentieth century, and the American native tradition has, in many respects, always already been a postmodernist one. That is why D. H. Lawrence can argue in his Studies in Classic American Literature:

The furthest frenzies of French modernism or futurism have not yet reached the pitch of extreme consciousness that Poe, Melville, Hawthorne, Whitman reached. The European moderns are all trying to be extreme. The great Americans I mention just were it.

And that is also why it would be entirely appropriate to link Adams' work with that of Stanley Elkin, Sam Shephard, and Thomas Pynchon today. For all of these writers, however critically naïve or unsophisticated they may appear to be in comparison with continental models, American alienation has stimulated a mode of imaginative mobility and performative freedom. Their wariness of, and distance from, the reigning social, fictional, and critical understandings of reality have liberated them to the same comic-parodic play with forms and structures of meaning that one finds in Adams' work, as part of a native American tradition of expression that is entirely independent of and in almost every respect more complex than the theorizing of the "deconstructionists" of the last twenty years. The American author (especially the author functioning, as Adams was, in the wake of the multiple disillusionments of the Civil War) was a native-born "deconstructionist" long before the term was coined on the other side of the Atlantic.

But what are the concrete consequences of this insight into Adams' modernism on our understanding of *Mont Saint Michel and Chartres*? If Adams is a historian under no illusions about getting down to some bedrock of unimpeachable "fact" or "reality," what replaces historical positivism in his work is an examination of the codes and rules by which all historical and social interpretation is organized. The texts of historical events become indistinguishable in form from those of art and literature, and the historian himself becomes indistinguishable in his job from the literary critic or the cultural anthropologist. Only his subject matter is different. That is to say, like Lévi-Strauss, Adams is less a searcher after "truth" or a reconstructor of some factual narrative of the past (ignoring the difference between facts and narratives as most other historians conve-

niently do) than an interpretor of a culture's and his own processes of interpretation. Like a literary critic, he is a reader of and a writer about his own and others' processes of reading and writing the "texts" of experience. This, I think, helps us to understand some of the strangest and apparently most perverse passages in *Mont Saint Michel and Chartres*, as when in an utterly typical passage, after giving a deadpan recital of two contradictory versions of the life of Eleanor of Aquitaine, Adams turns to the reader puckishly and says:

For us, both legends are true. They reflected, not perhaps the character of Eleanor, but what the society liked to see acted on its theatre of life. Eleanor's real nature in no way concerns us.

It would be an odd statement for a historian to make, if it were not for the fact that for this historian the interest of history is all in its interest, or what in the other passage he called his and our "fun." That is what Adams is suggesting by referring to the "theatre of life." For Adams, with his awareness of the pervasiveness of the conventions, traditions, and fictions that always and everywhere define our behavior and our understanding of it, the study of history is the study of a kind of theater, and the interest of the theater resides not in its truth or falsity (whatever that would mean) but in its use of conventions and traditions, its aesthetic beauty and complexity. As he says at one point in his argument, punning on the word "stage," the very reason he picked Chartres as his subject is because "for us the world is not a schoolroom or a pulpit, but a stage, and the stage [of Gothic art] is the highest yet seen on earth." But he is not making an exception for the conventionality of the Middle Ages when he treats life as theater. For example, in the following passage, discussing the code of courtly love and the love of Thibaut and Blanche as a form of conventionalized theater, he ends by including significant experience in the modern world as well under the rubric of fictional convention or drama:

For us the poetry is history, and the facts are false. French art starts not from facts, but from certain assumptions as conventional as a legendary window, and the commonest convention is the Woman. The fact, then as now, was Power, or its equivalent in exchange, but Frenchmen, while struggling for the Power, expressed it in terms of art. They looked on life as a drama,—and on drama as a phase of life,—in which the by-standers were bound to assume and accept the regular stage-plot. That the plot might be altogether untrue to real life affected in no way its interest. To them Thibaut and Blanche were bound to act Tristan and Isolde. Whatever they were when off the stage, they were lovers on it. Their loves were as real and as reasonable as the worship of the Virgin. Courteous love was avowedly a form of drama, but not the less a force of society. Illusion for illusion, courteous love, in Thibaut's hands, or in the hands of Dante and Petrarch, was as substantial as any other convention:—the balance of trade, the rights of man, or the Athanasian Creed. In that sense the illusions alone were real.

Alongside Adams' sense of "fun" and "gaiety," however, there is a darker and more ominous strain in his thought, connected with his conception of life as an elaborately coded form of theater. If life is a kind of theater in the way Adams imagines it to be, then the corollary is that individual actors are not really in control of or responsible for their roles or lines. Eleanor of Aquitaine is pointedly not in control of the interpretations she is subjected to. No more than Tristan and Isolde can Blanche and Thibaut escape the codes of courtly love that define the meaning of their acts. If history is viewed as a form of theater and the actors in it as "actors" in the other sense, then individuals have been dethroned as the originators and creators of value and meaning and replaced by a field of forces, a network of discursive, social, and intellectual systems beyond the mere individual's control or perhaps even knowledge. And this is the state of affairs which Adams believed to ordain, and which one can induce on the basis of all of his historical writing, here and elsewhere.

It is this aspect of his thought that finally distinguishes Adams' writing from that of Henry and William James, both of whom believed much more confidently in the ultimate imaginative autonomy and power of the single, independent individual. While William James (along with later writers, such as Wallace Stevens and Vladimir Nabokov, working in the same tradition) felt an almost giddy sense of liberation as a result of the rec-

ognition of the fictionality of the forms and understandings of experience and his consequent ability to substitute his own forms of meaning and fictional orders in their stead, Adams feels himself to be in a much less powerful and dominant position. He is much closer to Melville's Ahab (and to Melville himself—or to Hawthorne or Poe) in feeling "heaped" or overwhelmed by the fictional and historical forms and structures already in place around him. They are structures of meaning, like the dramatic structures of meaning in a play, that are in place before the individual actor comes on the scene, and that everywhere contextualize his meanings and inescapably limit

his deployment of new personal fictions.

The individual, in Adams' conception of his situation, is born into a network of impersonal systems of meaning and social relations that make mere individual motives and intentions almost irrelevant and always marginal in their effects. It is a conception of an individual's ultimate personal powerlessness and inability to escape systems of understanding and relationship in place around him that firmly distinguishes Adams' work from the altogether happier surmises of William James, with his belief in the individual's ability to continuously create his own new structures of experience. (Adams is closer to Henry James in his sense of the potential oppressiveness of the forms and forces that everywhere hedge an individual around.) Adams daringly imagines a universe in which man has been demoted as a unique, personal author and controller of meaning. This is the nightmare significance of Adams' cranky, frequently confusing, and invariably tiresome invocation of the vague and undefined concepts of "fields of force" and "energy" in his work. (I call Adams' use of those terms cranky only because they are paraded out at odd moments by him to explain seemingly any- and everything that will not yield itself to a more specific causal analysis, but what makes Adams finally more than a crank with a pet explanatory theory is the rigor and relentlessness of his application of these concepts, even to his own function as an author. This great system-builder, like most of the other American system-builders before and after him, from Whitman to Eliot and Pound, was as healthily skeptical of the repressiveness of his own intellectual systems and structures as he was of the ones he inherited from others. One can note further that this implicit devaluation of the imaginative power and autonomy of the individual is perhaps the reason Adams functions so much more adequately and engagingly as an intellectual historian than as a novelist. Although he wrote two novels—*Democracy* and *Esther*—they are paradoxically most interesting for the ways that they abrogate the traditional novelistic emphasis on individual motivation and emotion, and instead treat the characters as being representative of and responsive to larger political, social, and ideological force fields of energy.)

In Mont Saint Michel and Chartres, the scripting of the individual's lines and role extends even to the artist or architect who might, in another sort of history, be said to have planned, controlled, and supervised the building of the structures Adams is interpreting. In the extended conceit that runs through Chapter VII, he, too, is only a courtier patiently and facelessly serving in the Court of Notre Dame, obeying the every glance and

whim of the Virgin:

At Chartres the church services are Mary's own tastes; the church is Mary; and the chapels are her private rooms. She was not pleased with the arrangements made for her in her palace at Paris; they were too architectural; too regular and mathematical: too popular; too impersonal; and she rather abruptly ordered her architect at Chartres to go back to the old arrangement.... The Virgin herself saw to the lighting of her own boudoir. According to Viollet-le-Duc, Chartres differs from all the other great Cathedrals by being built not for its nave or even for its choir, but for its apse; it was planned not for the people or the court, but for the Queen; not a church but a shrine, and the shrine is the apse where the Queen arranged her light to please herself and not her architect, who had already been sacrificed at the western portal and who had a free hand only in the nave and transepts where the Queen never went, and which, from her own apartment, she did not even see. . . . The Church at Chartres belonged not to the people, not to the priesthood, and not even to Rome; it belonged to the Virgin.

In the next paragraph, as if anticipating the objection that we should not take a mere metaphoric extravagance too literally, Adams acknowledges how odd and merely poetic this conception of Mary as the hard-hat supervisor of construction must sound to ears untrained to his conceptions, but refuses to retract it. If anything, he insists on it all the more firmly. "The Imperial Queen," Mary, "the dictator of taste," made it all:

The Chartres apse shows the same genius that is shown in the Chartres rose; the same large mind that over-rules,—the same strong will that defies difficulties. The Chartres apse is as entertaining as all the other Gothic apses together, because it overrides the architect. You may, if you really have no imagination whatever, reject the idea that the Virgin herself made the plan; the feebleness of our fancy is now congenital, organic, beyond stimulant or strychnine, and we shrink like sensitive plants from the touch of a vision or spirit, but at least one can still sometimes feel a woman's taste, and in the apse of Chartres one feels nothing else. . . . You had better stop here, once for all, unless you are willing to feel that Chartres was made what it is, not by the artist but by the Virgin.

And only a few pages later, so as to be sure not to leave the stained-glass windows out of the account, he adds them to the list of things Mary has personally created: "All are marked by the hand of the Chartres Virgin. They are executed not merely for her, but by her." He could not be more emphatic. This is an age in which individuals—clerics, parishioners, artisans, and architects alike—do not exist (or matter). They have all been absorbed into the particular force field or system of signification that Adams denotes by means of the Virgin of Chartres.

To say that Adams' feelings about this situation are ambivalent is to put it mildly. If he can feel that there is something slightly enviable in this merging (or absorbing) of the individual into the force field of his time in *Mont Saint Michel and Chartres*, in *The Education* a virtually identical perception of the erasing of the individual as the personal author of value and the controller of meaning leads Adams to a nightmare vision of human powerlessness and irrelevance in the universe. This question of the power and role of the individual in an apparently "de-authored" universe becomes the central issue to be explored and wrestled with in Adams' two great master works. It is a problem any intellectual historian must implicitly

confront—what room is left for individual genius and creativity in a world everywhere defined by abstract structures of meaning? But it is one which most (right down to Foucault in our own era) have conveniently chosen to skirt. It is the problem that Adams, however, makes the central issue in both Mont Saint Michel and Chartres and The Education. To what extent is the individual erased by the structures of signification within which he is relentlessly inscribed? To what extent, and in what ways, is there room for a free and creative personal performance in the world described by Adams? (It is a question of more than academic or theoretical interest insofar as the world described by Adams is to some degree the world we all live in. Anyone who works for a large corporation or within an academic bureaucracy or who is a member of a contemporary political or social group has to feel a similar doubt about the degree to which individual intention or personal performance matters in his world. What Adams recognizes is that our lives are not like the lives of heroes or heroines in nineteenth-century novels. We do not personally create and generate our meanings out of nothing and the interpretations to which we are subjected are usually beyond both our knowledge and our control.)

The first clue to the fact that Adams ultimately refuses to accede to the nightmare erasure of the individual into the semiotic systems around him-however he theorizes about itis provided by his own authorial style and tone, if we can learn to hear them as being distinguishable from the very different meaning communicated by his abstract, theoretical analyses. His text, for all of its theorizing about the erasure of the individual, proclaims in every phrase and cadence the unabsorbable residue of the vocal presence of an eccentric, individual, passionate personal author. The exuberance of Adams' tone, the daring extravagance of his outlandish and inventive conceits, the puckish wit, the sly metaphorical games and puns (in English, French, and Latin) that run all the way through Mont Saint Michel and Chartres are signs of an idiosyncratic, personal, authorial presence that will not be absorbed into an abstract system of signification, an ego utterly unsubdued by the reigning historical systems of analysis, an energy of personal imagination and feeling ascendant and ultimately, one may judge, supremely triumphant over all systems of understanding.

Consider the great set pieces of dramatic creation that run throughout the book. They are conscious and calculated tours de force, exultant displays of Adams' unquenchable desire to "work up" a stunningly eccentric dramatic "scene" out of the most unpromising materials. To give six or seven almost random examples, I have in mind the passage near the beginning of Chapter VI in which Mary is imagined first as a Queen Mother presiding over her court in all of her imperious majesty, and then, without a transition, as a toy, as a "favorite blond doll" for whom a little girl sets up the "doll house" of Chartres; the description near the beginning of the next chapter of the Virgin as "the dictator of taste" setting the styles of haute couture in high-society fashion shows and engaged in clotheshorse competitions with Virgins at neighboring cathedrals; the outrageously sexually suggestive description of the choir of Chartres as the Virgin's rose-lighted "boudoir" in the middle of Chapter X; the description in the same chapter of the "War of the Roses" taking place between the two stained-glass windows, the Rose of Dreux and the Rose of France; near the end of the same chapter, the charmingly zany vision of the ragamuffin Saint Joseph standing with sawdust in his cuffs, sheepish, silent, and shuffling near the door of Mary's court, out of place and embarrassed to find himself there; the witty and playful colloquy that is imagined to take place between William and Abélard in Chapter XIV; and, finally, most astonishing and striking of all, the stunning transformation of Aquinas' doctrines into Adams' pet metaphors and terms that concludes the book.

The outrageousness, the extravagance, the outright nuttiness (at times) of these passages is the point. Adams is flaunting his ability to dramatically deploy his historical materials eccentrically, idiosyncratically, and personally. This is the American imagination in playful, confident ascendance—ventriloquizing and pulling all of the strings on puppets of its own creation, spinning fictions, telling tall tales with a straight face—breathing life into otherwise dead scenes, making interest and "fun" and drama where they would otherwise not exist. If, according to Adams, the Virgin Mary functions as a "dictator" in *Mont Saint Michel and Chartres*, defining the terms by which she will be appreciated and controlling interpretations, costumes, and

stage settings for her appearances, Adams outmaneuvers her with his own outrageous fictional and stylistic performance.

Adams is demonstrating the possibility of substituting stylistic free movements of consciousness within the text in compensation for social or historical blockages of movement in the world outside of the text. The writer becomes a stylistic performer or dramatic improviser, working up comic, parodic, and tonal routines that compensate for his powerlessness in more worldly or institutional expressions of himself. To become a stylistic performer in this way is to gain a quite marginal and tentative authority, but it is to gain an authority nonetheless that implicitly gives the lie to the loss of personality that Adams otherwise explicitly theorizes about in his text.

If it is understood this way, Mont Saint Michel and Chartres can be read as the record of the struggle between two tendencies in Adams' intellect. Its style is the record of Adams' ambivalences and uncertainties about the role of an author in the modern world. It documents a psychic struggle between two opposed and irreconcilable tendencies in Adams' thought—on the one hand, his rage for order and his interest in (and belief in the existence of) impersonal systems of analysis and understanding that dominate the individual actor and inescapably control his meaning; and on the other hand, Adams' countervailing allegiance to the indomitability of the individual imagination as it is expressed in the eccentric, idiosyncratic, and personal sounds of a unique authorial voice and presence in his work. The personal wars against the impersonal. The sounds of a distinctive voice emerge against the background of an awesomely abstract cultural analysis. The eccentricity of a powerful and idiosyncratic authorial presence struggles against the depersonalizing generality of the grand intellectual tapestry Adams unrolls for our inspection. That is why this great partisan of systematic understandings and analyses is also the writer who, in both Mont Saint Michel and Chartres and The Education, has crafted for himself one of the most distinctively eccentric and remarkably personal voices in all of American literature.

A reader moves through this book about systematic powerlessness and personal erasure with a growing appreciation of the power of one particular person and voice, the author's own.

One reads through this history of the rigidities and immobilities of institutional structures with continuous reminders of the eccentric, unpredictable, and free movements of Adams' imagination. In this sense, the central drama of Mont Saint Michel and Chartres is less the drama of the relationship of a thirteenth-century churchgoer to the Virgin or the drama of an architect's relation to his creation, than it is the drama of Adams' writing, the spectacle of his imagination asserting its simultaneous openness to and mastery over all of these inherited forms and potentially daunting structures of knowledge. It is in the nuttiness of his worked-up metaphors, the zaniness of his comparisons, and the idiosyncrasy of his voice—in brief, by demonstrating his overwhelming, eccentric mastery of all of the disparate linguistic, cultural, and historical materials he is immersed in-that he asserts his own personal authorial superiority to the depersonalizing systems and structures of experience that he is analyzing. In an extended, continuing pun on his name that runs throughout both Mont Saint Michel and Chartres and The Education, Adams compares himself with each of the other Adams he mentions in his texts (Adam de Saint Victor, Adam de la Halle, Charles Francis Adams, John Quincy Adams, and all of the others he mentions) and compares all of them with the first Adam in the Garden of Eden. He explicitly conceives of himself as an American Adam and, as if he could become a second Adam, he attempts to establish a free and independent relationship to the intimidating, daunting forms and structures of knowledge he has inherited.

For a variety of cultural and intellectual reasons the American artistic ego has always felt the historical, cultural, stylistic, and intellectual pressures impinging on it as potentially compromising forces. From Hawthorne and Poe to Elkin and Shepard, it has declared its repeated desire to break free of such pressures and influences even as it has inevitably felt itself relentlessly oppressed and potentially robbed of its unique identity because of them. Adams is an artist at the center of this tradition and all of his work is, in effect, an exploration of the free margin of movement available to the self that feels itself almost overwhelmed by such inherited cultural influences and traditions (or what he would call "force fields" and "energies").

That is what makes it particularly appropriate that Adams

ends this book with the figure of Thomas Aquinas. In Aquinas' wrestling with the problem of defining a possible margin of freedom available to man in a universe in which God has always already established a "force field" of predetermined tendencies and outcomes, Adams finds an exemplary image of his own wrestling with the problem of modern man's intellectually and stylistically embattled position. It is not that there are not other escapes from the relentless impersonality in the "law" imagined in Mont Saint Michel and Chartres, but none of them is as personally appealing to Adams as that offered by Aquinas. The Virgin's code of unconditioned feminine love and mercy, the lyrical, visionary poetry of Adam de Saint Victor, the mysticism of Saint Francis's teachings, the "broken arch" of the Gothic cathedral itself, each in its different way, represents a realm of pure feeling, idealism, or aspiration within which man is exempted from the rigors of history, society, and God's absolute laws of justice. To abase oneself in front of Our Lady at Chartres or to become a child again in the belief in the infinite mercy of the Divine Mother is to find a way of removing oneself from God's, man's, nature's, and culture's inhibiting, confining systems. And yet, although the heart of Mont Saint Michel and Chartres is given over to the description of the escape into such ideals and atavisms that is represented by the figure of the Virgin and the architecture of Chartres, it is obvious that none of these imaginative stances is really imaginatively available to Adams himself. He is extremely sympathetic to them, but he cannot worship the Virgin as a thirteenth-century mother could. He cannot love the fire or the sun as Saint Francis could. These solutions to his predicament are too childlike and simple. That is why Aquinas is such a crucial figure in the book. He is a figure who is much closer to Adams than the figure of the mother kneeling in front of the Virgin at Chartres, and he becomes an alter ego for Henry Adams in Adams' book.

Aquinas is given special treatment by Adams precisely because of the sophisticated similarity of his views to Adams' own. Aquinas was a close thirteenth-century relative of Adams in that he, too, believed in systems of energy and force larger than any individual could control or comprehend. He was a believer in the utter and inescapable relentlessness and inclusiveness of the "law" (which he called divine, and which Adams

calls social and scientific). Aquinas clearly saw the potential insignificance and powerlessness of the mere individual in such an all-encompassing scheme of things. And yet, as Adams dramatizes it, Aquinas' distinctive achievement was to find some small margin for human independence and freedom within the overruling coerciveness and rigor of the law. The freedom Aquinas defined was admittedly a very narrow and marginal freedom, but it is one that so closely accords with Adams' own views of the possibilities available to man that the names of Aquinas and Adams may be freely exchanged for each other at almost every point in Adams' final chapter without falsifying the meaning. Consider, for example, the following piece of black comedy. What is attributed to Aquinas is, as is suggested by the gleeful grimness of the tone (the literal gallows humor of the passage), precisely what Adams himself believes:

No one ever seriously affirmed the literal freedom of the will. Absolute liberty is absence of restraint; responsibility is restraint; therefore the ideally free individual is responsible only to himself. This principle is the philosophical foundation of anarchism. . . . [Therefore] the theory of absolute free-will never entered [Aquinas'] mind, more than the theory of material free-will would ever enter the mind of an architect. The Church gave him no warrant for discussing the subject in such a sense. In fact, the Church never admitted free-will, or used the word when it could be avoided. In Latin, the term used was liberum arbitrium, free choice,—and in French to this day it remains in strictness libre arbitre still. From Saint Augustine downwards the Church was never so unscientific as to admit of liberty beyond the faculty of choosing between paths, some leading through the Church and some not, but all leading to the next world; as a criminal might be allowed the liberty of choosing between the guillotine and the gallows, without infringing on the supremacy of the judge.

Which is to say, Aquinas (that is, Adams) suggests that we are both free and not-free, or that our freedom is intricately related to our condition of being unfree. Where Adams' argument becomes most interesting, obviously, is in his (or Aquinas') definition of exactly how we can be free in this unfree state of affairs. The following passage attempts an answer. One

notes in the first place how Adams implicitly admits the identity of his views and those of Aquinas by conflating them and recasting Aquinas' argument into his own pet terminology involving force fields, energies, motors, and principles of mechanics. Then one notices how, even more daringly, he bends and twists Aquinas' argument in quite un-Aquinan directions by making him over into a kind of American Romantic (descended, as the American Romantics were, from the double tradition of seventeenth-century meditative prose and poetry and nineteenth-century Wordsworthian Romanticism):

By the term God, is meant a Prime Motor which supplies all energy to the universe, and acts directly on man as well as on all other creatures, moving him as a mechanical motor might do; but man, being specially provided with an organism more complex than the organisms of other creatures, enjoys an exceptional capacity for reflex action, -a power of reflexion, -which enables him within certain limits to choose between paths, and this singular capacity is called free choice or free-will. . . . However abstruse these ideas may once have sounded, they are far from seeming difficult in comparison with modern theories of energy. Indeed, measured by that standard, the only striking feature of Saint Thomas's motor is its simplicity. Thomas's Prime Motor was very powerful, and its lines of energy were infinite. Among these infinite lines, a certain group ran to the human race, and, as long as the conduction was perfect, each man acted mechanically. In cases where the current, for any reason, was for a moment checked,-that is to say, produced the effect of hesitation or reflexion in the mind,—the current accumulated until it acquired power to leap the obstacle. . . . The only difference between Man and a Vegetable was the Reflex Action of the complicated mirror which was called Mind, and the mark of Mind was reflective absorption or choice.

I take this passage to be the crux of Adams' response to the implicit determinism and de-authoring of the universe wrestled with in the rest of his argument. One can call this a state of freedom or one of unfreedom, and Adams treats it as both a state of absolute determinism and a state of marginal autonomy in the next sections of his argument. The formulation leaves man thoroughly betwixt and between, neither entirely auton-

omous nor entirely determined in his action. The concept of "Reflex Action" or "reflective absorption" is the key to understanding this passage. The freedom and independence Adams grants to the individual is of the most marginal sort possible, but it is indeniably freedom and independence nonetheless. To be free only to "reflect" on one's unfreedom is certainly not to be very much less unfree, but it does represent a certain crucial kind of marginal freedom, or what one might call a freedom not in the text, but in the margins of experience.

It is precisely the celebration of man's meditative (or reflective) capacities-what Aquinas or Adams calls "Mind" in the above passage and what Emerson calls "intellect" in the quotation from "Fate" that I have used as the epigraph to this essay—that Adams' style embodies. In meditation or reflection is a kind of freedom, a margin for imaginative movement, room for vision and re-vision. Through Aguinas, Adams explicitly defines what one might call a prototypically American imaginative stance: a potentially liberating reflective (or reflexive) distance of the individual from his own otherwise unfree actions and beliefs. He defines the possibility of a state of imaginative alienation from one's own experience that is not destructive or desperate but potentially creative and invigorating and liberating. Adams locates in Aquinas' theory of mental reflection or reflexivity exactly the possibility he is committed to practicing in his own writing (though I emphasize that this is an Aquinas which Adams has invented, not found).

To be able to meditate or reflect in this admittedly extremely marginal and powerless way on the fixed structures one inherits, or lives within, is in itself a form of freedom. To be a meditator (in this sense) is not to have the large public power to exempt oneself from the force field in which one is situated but to have the small private power to gain some distance from it. One is emphatically not able to alter the force field or to abrogate its laws, but one is able to see it for what it is and meditatively to move around within it to some small extent. One is not able to escape from the pervasive styles and fictions within which one is inscribed, and there is no alternative to them that is not equally fictional, but one can meditatively move and imaginatively circulate through them, and, in a sense, gain a freedom and mastery over all of them by demonstrating one's freedom

from enslavement to any one of them (though it is only an imaginative freedom and mastery and not a worldly or social one). This is all the freedom Adams allows in his work. Nevertheless it is a powerful form of freedom.

In this respect, the significant contrast would be between the views of Adams and those of William James. The reflexive freedom, or freedom of reflection, imagined by Adams is much smaller, much weaker, and more marginal in its effects than the freedom to re-create the universe in our imaginations imagined by James in his pragmatic philosophy, but it is, perhaps to that extent, a description of man's situation that seems much less naïve, and more "tough-minded" (to turn one of James's phrases against him), than the philosophy of James. Adams sees that meditative or reflexive power may well be our only power. In our condition of creative alienation, as Adams sees it, we cannot change the structures of knowledge we are born into, but we can lever ourselves free of them, not in the world, but with acts of meditative consciousness and reflection. While William James offers the individual grand, powerful, imaginative reformulations of his relation to history and experience, Adams only offers him a slyer, more devious, more oblique and glancing meditative and parodic power. But it is not nothing. And most of all it is not resigned or despairing. It is jubilantly playful and ecstatically indomitable.

It is a capacity of consciousness that is testified to on every page of *Mont Saint Michel and Chartres* in its play of images, shifts of tones, and mastery of comparisons. It is an extremely marginal sort of freedom—a freedom stylistically to play with or mock or meditate on or reflect on fields of force that we cannot escape—but, as Adams argues in the following passage, which continues his discussion of Aquinas' doctrines, it is an imaginative freedom in some respects denied even to God, precisely because God is denied the possibility of being even momentarily creatively alienated from—or put into a meditative or reflective relationship to—his own acts and awarenesses:

Strange as it sounds, although Man thought himself hardly treated in respect to freedom, yet, if freedom meant superiority, Man was in action much the superior of God, whose freedom suffered, from Saint Thomas, under restraints that Man never would have tolerated. Saint Thomas did not allow God even an undetermined will; he was pure Act, and as such he could not change. Man alone was allowed, in act, to change direction. What was more curious still, Man might absolutely prove his freedom by refusing to move at all; if he did not like his life he could stop it, and habitually did so, or acquiesced in its being done for him; while God could not commit suicide or even cease for a single instant his continuous action. If Man had the singular fancy of making himself absurd,—a taste confined to himself but attested by evidence exceedingly strong,—he could be as absurd as he liked: but God could not be absurd. Saint Thomas did not allow the Deity the right to contradict himself, which is one of Man's chief pleasures. While Man enjoyed what was, for his purposes, an unlimited freedom to be wicked, -a privilege which, as both Church and State bitterly complained and still complain, he has outrageously abused, -God was Goodness and could be nothing else. While Man moved about his relatively spacious prison with a certain degree of ease, God, being everywhere, could not move. In one respect, at least, Man's freedom seemed to be not relative but absolute, for his thought was an energy paying no regard to space or time or order or object or sense; but God's thought was his act and will at once; speaking correctly, God could not think; he is.

Man may move about in what is only, after all, a "relatively spacious prison," but his capacities of meditative movement as they are reflected in his capacities of stylistic movement (what Adams calls his energy of Mind in the earlier passage and his energy of thought in the one just above) are "absolute" and uncontainable, unconfined by "space or time or order or object or sense." And that, I believe, is a clue to how, in the largest sense, one should understand Adams' mercurial, slipping, sliding, meditative, parodic, comic, reflective performance in Mont Saint Michel and Chartres. It is a book that is not only about the inexorability of "law" and attempted imaginative escapes from it in the thirteenth century, but one which in its very capacities of stylistic performance enacts the imaginative escape from oppression it is investigating and describing in the Middle Ages. To be able to perform as a writer in such a way is, in itself, a celebration of our free imaginative powers, and a demonstration of how we are not reducible to "laws" of understanding and behavior. This is a kind of power that does not

make itself felt in worldly action and that may indeed have no practical social consequences, but in the great tradition of American literature (as it comes down to Adams out of seventeenth-century poetry and prose, and nineteenth-century Wordsworthian Romanticism, and the subsequent work of Hawthorne, Emerson, Thoreau, and Whitman within and upon that tradition) it is still a cause of joy and celebration. That joy in our capacities of unprogrammatic, unpredictable reflexive movement (in spite of all of the abstract systems of social organization and structures of knowledge that hem us round) is communicated on every page of *Mont Saint Michel and Chartres*.

That aspiration to break free of "law," imperiled and uncertain of success as it always is, in Adams' elaborate metaphors on the final pages, is "the spire [that] justifies the church." The style of Mont Saint Michel and Chartres is, like the spire, the trace left behind by the unconquerable "soul vanishing into the skies." It is a style that, as a result, everywhere testifies to the strain of the effort—just as the spires, the nervures, and the flying buttresses of the great Gothic cathedrals testify to the strain of "the visible effort to throw off a visible strain." That strained and straining style, aspiring always upward vet ever anchored downward, is what situates this masterpiece in the great American literary tradition, which it would be difficult to find a better description of than by calling it the record of such an effort to rise above and throw off such a strain—the effort to beat the system and throw off the strain of tradition and received values and styles, even while realizing that such things can never be transcended or thrown off, only redistributed along new lines or held in an unstable equilibrium counterpoised against the aspirations of an author attempting to break free of their pressures. Adams' style is the verbal equivalent of the visual effect of the "captive slave" sculptures of Michelangelo, which he describes so eloquently on the closing pages of his book. Man is, in Adams' conception of his predicament, in exactly the situation of Michelangelo's figures. He is a captive slave tied down by the unyielding chains of historical law and social convention and the bonds of the material world, and yet, futilely and idealistically, aspiring relentlessly upward in a quest for personal freedom and imaginative power. It is that contrapuntal dynamism that Adams' style itself embodies.

The last paragraph of Mont Saint Michel and Chartres pretends to be a summary description of Adams' final understanding of Gothic architecture. But it can equally well stand as a description of the braced strains and aspirations of the style of the book we have just read. Adams' style is a demonstration of energy in motion, distributing the weight of the various strains pulling it down, while remaining undaunted and unsubdued by them. It is an uncertain attempt to throw off these downward pulling strains, to restlessly aspire upward to a condition of freedom and imaginative exaltation against the pull of gravity (in the tonal as well as the terrestrial sense) and the weight and inertia of the complex systems of history and the institutional traditions it recognizes and chooses to grapple with. And, most touchingly, it can never conceal its own deep doubts about the possibilities of success in such an effort. It cannot hide its self-distrust and anguish about its own audacious stylistic and imaginative attempt. And if, as Adams says of the Gothic architectural style, "the best proof is its instability," the same might be said of his own vexed, ambivalent and uncertain, yet still idealistic and upwardly aspiring verbal style. (In the metaphor of "reading" that he works into the final sentence, and in the pun on the concept of the nervure that precedes it-a pun which links the architectural nervous system of Chartres with the human nervous systems of figures like the captive slaves and the nervous systems of the artists who create such figures—Adams emphatically authorizes our use of this passage as a description of the stylistic nervous system of his own text.)

Perhaps the best proof of [the style of the great cathedrals is its] apparent instability. Of all the elaborate symbolism which has been suggested for the gothic Cathedral, the most vital and most perfect may be that the slender *nervure*, the springing motion of the broken arch, the leap downwards of the flying buttress,—the visible effort to throw off a visible strain,—never lets us forget that Faith alone supports it, and that, if Faith fails, Heaven is lost. The equilibrium is visibly delicate beyond the line of safety; danger lurks in every stone. The peril of the heavy tower, of the restless vault, of the vagrant buttress; the uncertainty of logic, the inequalities of the syllogism, the irregularities of the

mental mirror,—all these haunting nightmares of the Church are expressed as strongly by the gothic Cathedral as though it had been the cry of human suffering, and as no emotion had ever been expressed before or is likely to find expression again. The delight of its aspirations is flung up to the sky. The pathos of its self-distrust and anguish of doubt, is buried in the earth as its last secret. You can read out of it whatever else pleases your youth and confidence; to me, this is all.

Raymond Carney
 Middlebury College

integrals of a seminate equipment of the property of the prope

rimach broom dankara charach

A Brief Chronology of Adams' Life

1838 Born in Boston, Massachusetts.

1858 Graduates Harvard College.

1860–1961 Private secretary to his father, Charles Francis Adams, in Washington.

1861–1868 Private secretary to his father, who is head of the American legation in England; writes miscellaneous journalistic and review pieces.

1870–1877 Teaches medieval, European, and American history at Harvard; begins editorship of North American Review, in which he will publish many pieces between 1870 and 1880.

will publish many pieces between 1870 and 1880.

1872 Marries Marian Hooper.

1879 Publishes The Life of Albert Gallatin.

1880 Anonymously publishes Democracy: An American Novel.

1882 Publishes John Randolph.

1884 Pseudononymously publishes Esther: A Novel.

1884-1888 Privately prints and distributes to friends a small number of copies of his History of the United States During the Administrations of Thomas Jefferson and James Madison.

1885 His wife commits suicide.

1889-1891 Publication of the trade edition of his History.

1895 Begins the study of Gothic architecture that will lead to *Mont Saint Michel and Chartres*.

1904 Mont Saint Michel and Chartres privately printed.

1907 Publishes a private edition of his autobiography, The Education of Henry Adams.

1909–1910 Writes "The Rule of Phase Applied to History" and A Letter to American Teachers of History.

1912 Is partially paralyzed by a stroke.

1918 Dies in Washington, D.C., at the age of eighty.

A. Breef C. Sindam of Agency Life

The More and to the lear and their

and Conducted the wild Oakle

isotropic Ferra government as hat lather Child Administration. We always

republish to type ratio di della intra victoria successi della collina. Se para masamina intervalla anno comi di collina minoria della collina.

Toyle Per W. Dee et Jery E. Kinggere, and Amich architects as italical common closure of heart "mergan Ragar insulation of sufficient common procedures as a real state."

And the first of the second

and the reserve to this or the talkers are

1883 (2005) House, published Jacques S. Shi Xiannigos, Nordal 1883 (Shinished 1986) Karli Onjohan (2015)

Lott in a father than the second second

The state of the s

W. Tergosa, Telephone documents and Areasans.

erous autooralisment gist

the user I apacament in materials with an of a character.

(60) Ellino and critics of Landic architecture that the well broduced out of Some classes of the contract.

thems to visite the law as a fine as a talk that I have been

1907 Pelling to a several of his uthoughten by two teams of the second o

1909 On Street Brown of Charles Andred Living Linds and St.

saleus yd psynthe, alisimig it zwe

radge in aga shirar OVC stoppedas World stiCultur

A Note on the Text

The first edition of Mont Saint Michel and Chartres was an edition of one hundred quarto copies privately printed by Adams himself in 1904 for distribution to a select group of friends and acquaintances only. Copyright was filed for on January 7, 1905. Persuaded by the favorable reception of the book in the course of the following years, Adams decided to reprint it with a few slight revisions, amounting to less than fifteen pages of additional material and less than one page of changes and deletions. Five hundred copies of this volume were issued early in 1912. Late that same year Adams authorized the American Institute of Architects to publish a trade edition of the volume, which was edited by and prefaced with a brief introduction by Ralph Adams Cram, an architect avidly interested in the subject of the book and one of the leading figures in the American Gothic Revival movement. This was published by Houghton-Mifflin in 1913. Since the second of these three editions (the 1912 edition) was the last whose publication was supervised directly by Adams himself, it is the basis for the present text, which has been set from the plates of the Library of America printing of Henry Adams' works, edited by Ernest and Jayne Samuels.

tra'l old no stoy. A

The first current of advant inner the set as a fewer many and a function of the medical current measures measured the measures and a function of the measures and a function of the measures and a function of the measures of

MONT SAINT MICHEL AND CHARTRES

MONI SAINTAMOHEUS AND CHARTES

Contents

Preface		•	٠	•	٠				•		•	5
I. Saint Michiel de la Mer de	l Per	il		•	٠	٠					٠	7
II. La Chanson de Roland .												18
III. The Merveille										•		35
IV. Normandy and the Ile de	Fra	nce				•	٠	•		•	•	48
V. Towers and Portals				٠				•		٠	٠	62
VI. The Virgin of Chartres .		٠										87
VII. Roses and Apses												103
VIII. The Twelfth Century (Glass	•										123
IX. The Legendary Windows				•			٠					142
X. The Court of the Queen of	f Hea	ven	ι.				•	•				170
XI. The Three Queens												187
XII. Nicolette and Marion .												217
XIII. Les Miracles de Notre L	ame											237
XIV. Abélard									٠			269
XV. The Mystics							٠					301
XVI. Saint Thomas Aquinas												326

Conflicted a

9 1 - 1 - 1					ionla	dis.
		West S	in islami	is to the f	S. Albert	
			Solution.		***	B
				distray		III
(leji		aranti.	ia sili cosi i		esiV.	VQ.
50					· (83)	
				ye, Kaji Ti		īv.
				17, ben s		
\$43 -		1.544	(MART		
					147	71
		aca E.	e energy			
(T)			1.13	ur _{al} golde		
415			may a se		68K. I	
				MONEY.		
. X				e New Year		γX
			soup for		esa Y	

Preface

[December, 1904.]

Some old Elizabethan play or poem contains the lines:-

. . . . Who reads me, when I am ashes, Is my son in wishes

The relationship, between reader and writer, of son and father, may have existed in Queen Elizabeth's time, but is much too close to be true for ours. The utmost that any writer could hope of his readers now is that they should consent to regard themselves as nephews, and even then he would expect only a more or less civil refusal from most of them. Indeed, if he had reached a certain age, he would have observed that nephews, as a social class, no longer read at all, and that there is only one familiar instance recorded of a nephew who read his uncle. The exception tends rather to support the rule, since it needed a Macaulay to produce, and two volumes to record it. Finally, the metre does not permit it. One may not say:—"Who reads me when I am ashes is my nephew in wishes."

The same objections do not apply to the word "niece." The change restores the verse, and, to a very great degree, the fact. Nieces have been known to read in early youth, and in some cases may have read their uncles. The relationship, too, is convenient and easy, capable of being anything or nothing, at the will of either party, like a Mahommedan or Polynesian or American marriage. No valid objection can be offered to this

change in the verse. Niece let it be!

The following pages, then, are written for nieces, or for those who are willing, for the time, to be nieces in wish. For convenience of travel in France, where hotels, in out-of-the-way places, are sometimes wanting in space as well as luxury, the nieces shall count as one only. As many more may come as like, but one niece is enough for the uncle to talk to, and one niece is much more likely than two to listen. One niece is also more likely than two to carry a kodak and take interest in it, since she has nothing else, except her uncle, to interest her, and instances occur when she takes interest neither in the

uncle nor in the journey. One cannot assume, even in a niece, too emotional a nature, but one may assume a kodak.

The party, then, with such variations of detail as may suit its tastes, has sailed from New York, let us say, early in June for an entire summer in France. One pleasant June morning it has landed at Cherbourg or Havre and takes the train across Normandy to Pontorson, where, with the evening light, the tourists drive along the *chaussée*, over the sands or through the tide, till they stop at Madame Poulard's famous hotel within the Gate of the Mount.

near his one world reduce the transfer and it was all the remaining

The uncle talks: -

I

Saint Michiel de la Mer del Peril

THE ARCHANGEL loved heights. Standing on the summit of the tower that crowned his church, wings upspread, sword uplifted, the devil crawling beneath, and the cock, symbol of eternal vigilance, perched on his mailed foot, Saint Michael held a place of his own in heaven and on earth which seems, in the eleventh century, to leave hardly room for the Virgin of the Crypt at Chartres, still less for the Beau Christ of the thirteenth century at Amiens. The Archangel stands for Church and State, and both militant. He is the conqueror of Satan, the mightiest of all created spirits, the nearest to God. His place was where the danger was greatest; therefore you find him here. For the same reason he was, while the pagan danger lasted, the patron Saint of France. So the Normans, when they were converted to Christianity, put themselves under his powerful protection. So he stood for centuries on his Mount in Peril of the Sea, watching across the tremor of the immense ocean, - immensi tremor oceani, - as Louis XI., inspired for once to poetry, inscribed on the collar of the Order of Saint Michael which he created. So soldiers, nobles and monarchs went on pilgrimage to his shrine; so the common people followed, and still follow, like ourselves.

The church stands high on the summit of this granite rock, and on its west front is the platform, to which the tourist ought first to climb. From the edge of this platform, the eye plunges down, two hundred and thirty-five feet, to the wide sands or the wider ocean, as the tides recede or advance, under an infinite sky, over a restless sea, which even we tourists can understand and feel without books or guides; but when we turn from the western view, and look at the church door, thirty or forty yards from the parapet where we stand, one needs to be eight centuries old to know what this mass of encrusted architecture meant to its builders, and even then one must still learn to feel it. The man who wanders into the twelfth century is lost, unless he can grow prematurely young. One can do it, as one can play with children. Wordsworth,

whose practical sense equalled his intuitive genius, carefully limited us to "a season of calm weather," which is certainly best; but granting a fair frame of mind, one can still "have sight of that immortal sea" which brought us hither from the twelfth century; one can even travel thither and see the children sporting on the shore. Our sense is partially atrophied from disuse, but it is still alive, at least in old people, who

alone, as a class, have the time to be young.

One needs only to be old enough in order to be as young as one will. From the top of this Abbey Church one looks across the bay to Avranches, and towards Coutances and the Cotentin,—the Constantinus pagus—whose shore, facing us, recalls the coast of New England. The relation between the granite of one coast and that of the other may be fanciful, but the relation between the people who live on each is as hard and practical a fact as the granite itself. When one enters the church, one notes first the four great triumphal piers or columns, at the intersection of the nave and transepts, and on looking into M. Corroyer's architectural study which is the chief source of all one's acquaintance with the Mount, one learns that these piers were constructed in 1058. Four out of five American tourists will instantly recall the only date of mediæval history they ever knew, the date of the Norman Conquest. Eight years after these piers were built, in 1066, Duke William of Normandy raised an army of forty thousand men in these parts, and in northern France, whom he took to England where they mostly stayed. For a hundred and fifty years, until 1204, Normandy and England were united; the Norman peasant went freely to England with his lord, spiritual or temporal; the Norman woman, a very capable person, followed her husband or her parents; Normans held nearly all the English fiefs; filled the English church; crowded the English Court; created the English law; and we know that French was still currently spoken in England as late as 1400, or thereabouts, "After the scole of Stratford atte bowe." The aristocratic Norman names still survive in part, and if we look up their origin here we shall generally find them in villages so remote and insignificant that their place can hardly be found on any ordinary map; but the common people had no surnames, and cannot be traced, although for every noble whose

name or blood survived in England or in Normandy, we must reckon hundreds of peasants. Since the generation which followed William to England in 1066, we can reckon twentyeight or thirty from father to son, and, if you care to figure up the sum, you will find that you had about two hundred and fifty million arithmetical ancestors living in the middle of the eleventh century. The whole population of England and northern France may then have numbered five million, but if it were fifty it would not much affect the certainty that, if you have any English blood at all, you have also Norman. If we could go back and live again in all our two hundred and fifty million arithmetical ancestors of the eleventh century, we should find ourselves doing many surprising things, but among the rest we should pretty certainly be ploughing most of the fields of the Cotentin and Calvados; going to mass in every parish church in Normandy; rendering military service to every lord, spiritual or temporal, in all this region; and helping to build the Abbey Church at Mont Saint Michel. From the roof of the cathedral of Coutances over vonder, one may look away over the hills and woods, the farms and fields of Normandy, and so familiar, so homelike are they, one can almost take oath that in this, or the other, or in all, one knew life once and has never so fully known it since.

Never so fully known it since! for we of the eleventh century, hard-headed, close-fisted, grasping, shrewd, as we were, and as Normans are still said to be, stood more fully in the centre of the world's movement than our English descendants ever did. We were a part, and a great part, of the Church, of France and of Europe. The Leos and Gregories of the tenth and eleventh centuries leaned on us in their great struggle for reform. Our Duke Richard-Sans-Peur, in 966, turned the old canons out of the Mount in order to bring here the highest influence of the time, the Benedictine monks of Monte Cassino. Richard the Second, grandfather of William the Conqueror, began this Abbey Church in 1020, and helped Abbot Hildebert to build it. When William the Conqueror in 1066 set out to conquer England, Pope Alexander Second stood behind him and blessed his banner. From that moment our Norman Dukes cast the Kings of France into the shade. Our activity was not limited to Northern Europe, or even confined

by Anjou and Gascony. When we stop at Coutances, we will drive out to Hauteville to see where Tancred came from, whose sons Robert and Roger were conquering Naples and Sicily at the time when the Abbey Church was building on the Mount. Normans were everywhere in 1066, and everywhere in the lead of their age. We were a serious race. If you want other proof of it, besides our record in war and in politics, you have only to look at our art. Religious art is the measure of human depth and sincerity; any triviality, any weakness, cries aloud. If this church on the Mount is not proof enough of Norman character, we will stop at Coutances for a wider view. Then we will go to Caen and Bayeux. From there, it would almost be worth our while to leap at once to Palermo. It was in the year 1131 or thereabouts that Roger began the Cathedral at Cefalu and the Chapel Royal at Palermo; it was about the year 1174 that his grandson William began the Cathedral of Monreale. No art-neither Greek nor Byzantine, Italian or Arab-has ever created two religious types so beautiful, so serious, so impressive, and yet so different, as Mont Saint Michel watching over its northern ocean, and Monreale, looking down over its forests of orange and lemon, on Palermo and the Sicilian seas.

Down nearly to the end of the twelfth century the Norman was fairly master of the world in architecture as in arms, although the thirteenth century belonged to France, and we must look for its glories on the Seine and Marne and Loire; but for the present we are in the eleventh century,-tenants of the Duke or of the Church or of small feudal lords who take their names from the neighborhood, -Beaumont, Carteret, Greville, Percy, Pierpont,-who at the duke's bidding, will each call out his tenants, perhaps ten men-at-arms with their attendants, to fight in Brittany, or in the Vexin towards Paris, or on the great campaign for the conquest of England which is to come within ten years, -the greatest military effort that has been made in western Europe since Charlemagne and Roland were defeated at Roncesvalles three hundred years ago. For the moment, we are helping to quarry granite for the Abbey Church, and to haul it to the Mount, or load it on our boat. We never fail to make our annual pilgrimage to the Mount on the Archangel's day, October 16. We expect to be called out for a new campaign which Duke William threatens against Brittany, and we hear stories that Harold the Saxon, the powerful Earl of Wessex in England, is a guest, or, as some say a prisoner or a hostage, at the Duke's Court, and will go with us on the campaign. The year is 1058.

All this time we have been standing on the parvis, looking out over the sea and sands which are as good eleventh-century landscape as they ever were; or turning at times towards the church door which is the pons sectorum, the bridge of ages, between us and our ancestors. Now that we have made an attempt, such as it is, to get our minds into a condition to cross the bridge without breaking down in the effort, we enter the church and stand face to face with eleventh-century architecture; a ground-plan which dates from 1020; a central tower, or its piers, dating from 1058; and a church completed in 1135. France can offer few buildings of this importance equally old, with dates so exact. Perhaps the closest parallel to Mont Saint Michel is Saint Benoit-sur-Loire, above Orleans, which seems to have been a shrine almost as popular as the Mount, at the same time. Chartres was also a famous shrine, but of the Virgin, and the west porch of Chartres, which is to be our peculiar pilgrimage, was a hundred years later than the ground-plan of Mont Saint Michel, although Chartres porch is the usual starting-point of northern French art. Queen Matilda's Abbaye-aux-Dames, now the Church of the Trinity, at Caen, dates from 1066. Saint Sernin at Toulouse, the porch of the Abbey Church at Moissac, Notre-Dame-du-Port at Clermont, the Abbey Church at Vezelay, are all said to be twelfth century. Even San Marco at Venice was new in 1020.

Yet in 1020 Norman art was already too ambitious. Certainly nine hundred years leave their traces on granite as well as on other material, but the granite of Abbot Hildebert would have stood securely enough, if the Abbot had not asked too much from it. Perhaps he asked too much from the Archangel, for the thought of the Archangel's superiority was clearly the inspiration of his plan. The apex of the granite rock rose like a sugar-loaf two hundred and forty feet (73.60 metres) above mean sea-level. Instead of cutting the summit away to give his church a secure rock-foundation, which

would have sacrificed about thirty feet of height, the Abbot took the apex of the rock for his level, and on all sides built out foundations of masonry to support the walls of his church. The apex of the rock is the floor of the croisée the intersection of nave and transept. On this solid foundation the Abbot rested the chief weight of the church, which was the central tower, supported by the four great piers which still stand; but, from the croisée in the centre westward to the parapet of the platform, the Abbot filled the whole space with masonry, and his successors built out still further, until some two hundred feet of stone-work ends now in a perpendicular wall of eighty feet or more. In this space are several ranges of chambers, but the structure might perhaps have proved strong enough to support the light romanesque front which was usual in the eleventh century, had not fashions in architecture changed in the great epoch of building, a hundred and fifty years later, when Abbot Robert de Torigny thought proper to reconstruct the west front, and build out two towers on its flanks. The towers were no doubt beautiful, if one may judge from the towers of Bayeux and Coutances, but their weight broke down the vaulting beneath, and one of them fell in 1300. In 1618 the whole façade began to give way, and in 1776 not only the façade but also three of the seven spans of the nave were pulled down. Of Abbot Hildebert's nave, only four arches remain.

Still, the overmastering strength of the eleventh century is stamped on a great scale here, not only in the four spans of the nave, and in the transepts, but chiefly in the triumphal columns of the *croisée*. No one is likely to forget what Norman architecture was, who takes the trouble to pass once through this fragment of its earliest bloom. The dimensions are not great, though greater than safe construction warranted. Abbot Hildebert's whole church did not exceed two hundred and thirty feet in length in the interior, and the span of the triumphal arch was only about twenty-three feet, if the books can be trusted. The nave of the Abbaye-aux-Dames appears to have about the same width, and probably neither of them was meant to be vaulted. The roof was of timber, and about sixty-three feet high at its apex. Compared with the great churches of the thirteenth century, this building is mod-

est, but its size is not what matters to us. Its style is the starting-point of all our future travels. Here is your first eleventhcentury church! how does it affect you?

Serious and simple to excess! is it not? Young people rarely enjoy it. They prefer the gothic, even as you see it here, looking at us from the choir, through the great Norman arch. No doubt, they are right, since they are young: but men and women who have lived long and are tired, -who want rest,—who have done with aspirations and ambition, whose life has been a broken arch—feel this repose and selfrestraint as they feel nothing else. The quiet strength of these curved lines, the solid support of these heavy columns, the moderate proportions, even the modified lights, the absence of display, of effort, of self-consciousness, satisfy them as no other art does. They come back to it to rest, after a long circle of pilgrimage, - the cradle of rest from which their ancestors

started. Even here they find the repose none too deep.

Indeed, when you look longer at it, you begin to doubt whether there is any repose in it at all, -whether it is not the most unreposeful thought ever put into architectural form. Perched on the extreme point of this abrupt rock, the Church militant with its aspirant Archangel stands high above the world, and seems to threaten heaven itself. The idea is the stronger and more restless because the Church of Saint Michael is surrounded and protected by the world and the society over which it rises, as Duke William rested on his barons and their men. Neither the Saint nor the Duke was troubled by doubts about his mission. Church and State, Soul and Body, God and Man, are all one at Mont Saint Michel, and the business of all is to fight, each in his own way, or to stand guard for each other. Neither Church nor State is intellectual, or learned, or even strict in dogma. Here we do not feel the Trinity at all; the Virgin but little; Christ hardly more; we feel only the Archangel and the Unity of God. We have little logic here, and simple faith, but we have energy. We cannot do many things which are done in the centre of civilization, at Byzantium, but we can fight, and we can build a church. No doubt we think first of the church, and next of our temporal lord; only in the last instance do we think of our private affairs, and our private affairs sometimes suffer for it; but we reckon the affairs of Church and State to be ours too, and we carry this idea very far. Our church on the Mount is ambitious, restless, striving for effect; our conquest of England, with which the Duke is infatuated, is more ambitious still; but all this is a trifle to the outburst which is coming in the next generation; and Saint Michael on his Mount expresses it all.

Taking architecture as an expression of energy we can some day compare Mont Saint Michel with Beauvais, and draw from the comparison whatever moral suits our frame of mind, but you should first note that here, in the eleventh century, the church, however simple-minded or unschooled, was not cheap. Its self-respect is worth noticing, because it was shortlived in its art. Mont Saint Michel, throughout, even up to the delicate and intricate stonework of its cloisters, is built of granite. The crypts and substructures are as well constructed as the surfaces most exposed to view. When we get to Chartres, which is largely a twelfth-century work, you will see that the Cathedral there too is superbly built, of the hardest and heaviest stone within reach, which has nowhere settled or given way; while, beneath, you will find a crypt that rivals the church above. The thirteenth century did not build so. The great cathedrals after 1200 show economy, and sometimes worse. The world grew cheap, as worlds must.

You may like it all the better for being less serious, less heroic, less militant, and more what the French call bourgeois, just as you may like the style of Louis XV better than that of Louis XIV,-Madame du Barry better than Madame de Montespan,-for taste is free, and all styles are good which amuse; but since we are now beginning with the earliest, in order to step down gracefully to the stage, whatever it is, where you prefer to stop, we must try to understand a little of the kind of energy which Norman art expressed, or would have expressed if it had thought in our modes. The only word which describes the Norman style is the French word naif. Littré says that naif comes from natif, as vulgar comes from vulgus, as though native traits must be simple, and commonness must be vulgar. Both these derivative meanings were strange to the eleventh century. Naïveté was simply natural, and vulgarity was merely coarse. Norman naïveté was not dif-

ferent in kind from the naïveté of Burgundy or Gascony or Lombardy, but it was slightly different in expression, as you will see when you travel south. Here at Mont Saint Michel we have only a mutilated trunk of an eleventh-century church to judge by. We have not even a façade, and shall have to stop at some Norman village—at Thaon or Ouistreham—to find a west front which might suit the Abbey here, but wherever we find it we shall find something a little more serious, more military, and more practical than you will meet in other romanesque work, further south. So, too, the central tower or lantern—the most striking feature of Norman churches has fallen here at Mont Saint Michel, and we shall have to replace it from Cérisy-la-Forêt, and Lessay, and Falaise. We shall find much to say about the value of the lantern on a Norman church, and the singular power it expresses. We shall have still more to say of the towers which flank the west front of Norman churches, but these are mostly twelfth-century, and will lead us far beyond Coutances and Bayeux, from flèche to flèche, till we come to the flèche of all flèches, at Chartres.

We shall have a whole chapter of study, too, over the eleventh-century apse, but here at Mont Saint Michel, Abbot Hildebert's choir went the way of his nave and tower. He built out even more boldly to the east than to the west, and although the choir stood for some four hundred years, which is a sufficient life for most architecture, the foundations gave way at last, and it fell in 1421, in the midst of the English wars, and remained a ruin until 1450. Then it was rebuilt, a monument of the last days of the gothic, so that now, standing at the western door, you can look down the church, and see the two limits of mediæval architecture married together; the earliest Norman and the latest French. Through the romanesque arches of 1058, you look into the exuberant choir of latest gothic, finished in 1521. Although the two structures are some five hundred years apart, they live pleasantly together. The gothic died gracefully in France. The choir is charming,-far more charming than the nave, as the beautiful woman is more charming than the elderly man. One need not quarrel about styles of beauty, as long as the man and woman are evidently satisfied and love and admire each other still, with all the solidity of faith to hold them up, but, at least,

one cannot help seeing, as one looks from the older to the younger style, that whatever the woman's sixteenth-century charm may be, it is not the man's eleventh-century trait of naïveté;—far from it! The simple, serious, silent dignity and energy of the eleventh century have gone. Something more complicated stands in their place; graceful, self-conscious, rhetorical, and beautiful as perfect rhetoric, with its clearness, light and line, and the wealth of tracery that verges on the florid.

The crypt of the same period, beneath, is almost finer still, and even in seriousness stands up boldly by the side of the romanesque, but we have no time to run off into the sixteenth century: we have still to learn the alphabet of art in France. One must live deep into the eleventh century in order to understand the twelfth, and even after passing years in the twelfth, we shall find the thirteenth in many ways a world of its own, with a beauty not always inherited, and sometimes not bequeathed. At the Mount we can go no further into the eleventh as far as concerns architecture. We shall have to follow the romanesque to Caen and so up the Seine to the Ile de France, and across to the Loire and the Rhone, far to the South where its home lay. All the other eleventh-century work has been destroyed here or built over, except at one point, on the level of the splendid crypt we just turned from, called the Gros Piliers, beneath the choir.

There, according to M. Corroyer, in a corner between great constructions of the twelfth century and the vast Merveille of the thirteenth, the old Refectory of the eleventh was left as a passage from one group of buildings to the other. Below it is the kitchen of Hildebert. Above, on the level of the church, was the Dormitory. These eleventh-century abbatial buildings faced north and west, and are close to the present parvis, opposite the last arch of the nave. The lower levels of Hildebert's plan served as supports or buttresses to the church above, and must therefore be older than the nave; probably older than the triumphal piers of 1058.

Hildebert planned them in 1020, and died after carrying his plans out so far that they could be completed by Abbot Ralph de Beaumont, who was especially selected by Duke William in 1048, "more for his high birth than for his merits." Ralph

de Beaumont died in 1060, and was succeeded by Abbot Ranulph, an especial favorite of Duchess Matilda, and held in high esteem by Duke William. The list of names shows how much social importance was attributed to the place. The Abbot's duties included that of entertainment on a great scale. The Mount was one of the most famous shrines of northern Europe. We are free to take for granted that all the great people of Normandy slept at the Mount and, supposing M. Corroyer to be right, that they dined in this room, between 1050, when the building must have been in use, down to 1122 when the new Abbatial quarters were built.

How far the monastic rules restricted social habits is a matter for antiquaries to settle if they can, and how far those rules were observed in the case of great secular princes, but the eleventh century was not very strict, and the rule of the Benedictines was always mild, until the Cistercians and Saint Bernard stiffened its discipline towards 1120. Even then the Church showed strong leanings toward secular poetry and popular tastes. The drama belonged to it almost exclusively, and the Mysteries and Miracle plays which were acted under its patronage often contained nothing of religion except the miracle. The greatest poem of the eleventh century was the Chanson de Roland, and of that the Church took a sort of possession. At Chartres we shall find Charlemagne and Roland dear to the Virgin, and at about the same time, as far away as at Assisi in the Perugian country, Saint Francis himself-the nearest approach the western world ever made to an oriental incarnation of the divine essence, -loved the French Romans, and typified himself in the Chanson de Roland. With Mont Saint Michel, the Chanson de Roland is almost one. The Chanson is in poetry what the Mount is in architecture. Without the Chanson, one cannot approach the feeling which the eleventh century built into the Archangel's church. Probably there was never a day, certainly never a week, during several centuries, when portions of the Chanson were not sung, or recited, at the Mount, and if there was one room where it was most at home, this one, supposing it to be the old Refectory, claims to be the place.

TT

La Chanson de Roland

Molz pelerins qui vunt al Munt Enquierent molt e grant dreit unt Comment l'igliese fut fundee Premierement et estorce. Cil oui lor dient de l'estoire Oue cil demandent en memoire Ne l'unt pas bien ainz vunt faillant En plusors leus e mespernant. Por faire la apertement Entendre a cels qui escient N'unt de clerzie l'a tornee De latin tote et ordenee Par veirs romieus novelement Molt en segrei por son convent Uns jovencels moine est del Munt Deus en son reigne part li dunt. Guillaume a non de Saint Paier Cen vei escrit en cest quaier. El tens Robeirt de Torignie Fut cil romanz fait e trove.

Most pilgrims who come to the Mount Enquire much and are quite right, How the church was founded At first, and established. Those who tell them the story That they ask, in memory Have it not well, but fall in error In many places, and misapprehension. In order to make it clearly Intelligible to those who have No knowledge of letters, it has been turned From the Latin, and wholly rendered In romanesque verses, newly, Much in secret, for his convent, By a youth; a monk he is of the Mount. God in his kingdom grant him part! William is his name, of St. Pair As is seen written in this book. In the time of Robert of Torigny Was this Roman made and invented.

HESE VERSES begin the Roman du Mont Saint Michel, and if the spelling is corrected, they read still almost as easily as Voltaire; more easily than Verlaine; and much like a nursery rhyme; but as tourists cannot stop to clear their path, or smooth away the pebbles, they must be lifted over the rough spots, even when roughness is beauty. Translation is an evil, chiefly because everyone who cares for mediæval architecture cares for mediæval French, and ought to care still more for mediæval English. The language of this Roman was the literary language of England. William of Saint Pair was a subject of Henry II, king of England and Normandy; his verses, like those of Richard Cœur-de-Lion, are monuments of English literature. To this day their ballad measure is better suited to English than to French; even the words and idioms are more English than French. Anyone who attacks them boldly will find that the "vers romieus" run along like a ballad, singing their own meaning, and troubling themselves very little whether the meaning is exact or not. One's translation is sure to be full of gross blunders, but the supreme blunder is that of translating at all when one is trying to catch not a fact but a feeling. If translate one must, we had best begin by trying to be literal, under protest that it matters not a straw whether we succeed. Twelfth-century art was not precise; still less "précieuse" like Molière's famous seventeenthcentury prudes.

The verses of the young monk, William, who came from the little Norman village of Saint Pair, near Granville, within sight of the Mount, were verses not meant to be brilliant. Simple human beings like rhyme better than prose, though both may say the same thing, as they like a curved line better than a straight one, or a blue better than a gray; but, apart from the sensual appetite, they chose rhyme in creating their literature for the practical reason that they remembered it better than prose. Men had to carry their libraries in their heads.

These lines of William, beginning his story, are valuable because for once they give a name and a date. Abbot Robert of Torigny ruled at the Mount from 1154 to 1186. We have got to travel again and again between Mont Saint Michel and Chartres during these years, but for the moment we must hurry to get back to William the Conqueror and the Chanson de Roland. William of Saint Pair comes in here, out of place, only on account of a pretty description he gave of the annual pilgrimage to the Mount, which is commonly taken to be more or less like what he saw every year on the Archangel's Day, and what had existed ever since the Normans became Christian in 912:—

Li jorz iert clers e sanz grant vent.
Les meschines e les vallez
Chascuns d'els dist verz ou sonnez.
Neis li viellart revunt chantant
De leece funt tuit semblant.
Qui plus ne seit si chante outree
E Dex aie u Asusee,
Cil jugleor la u il vunt
Tuit lor vieles traites unt
Laiz et sonnez vunt vielant.

Li tens est beals la joie est grant. Cil palefrei e cil destrier E cil roncin e cil sommier The day was clear, without much wind. The maidens and the varlets
Each of them said verse or song;
Even the old people go singing;
All have a look of joy.
Who knows no more sings Hurrah,
Or God help, or Up and On!
The minstrels there where they go
Have all brought their viols;
Lays and songs playing as they go.

The weather is fine; the joy is great; The palfreys and the chargers, And the hackneys and the packhorses Qui errouent par le chemin Que menouent cil pelerin De totes parz henissant vunt Por la grant joie que il unt. Neis par les bois chantouent tuit Li oiselet grant et petit.

Li buef les vaches vunt muant Par les forez e repaissant. Cors e boisines e fresteals E fleutes e chalemeals Sonnoent si que les montaignes En retintoent et les pleignes. Que esteit dont les plaiseiz E des forez e des larriz. En cels par a tel sonneiz Com si ce fust cers acolliz.

Entor le mont el bois follu
Cil travetier unt tres tendu
Rues unt fait par les chemins.
Plentei i out de divers vins
Pain e pastez fruit e poissons
Oisels obleies veneisons
De totes parz aveit a vendre
Assez en out qui ad que tendre.

Which wander along the road That the pilgrims follow, On all sides neighing go, For the great joy they feel. Even in the woods sing all The little birds, big and small.

The oxen and the cows go lowing
Through the forests as they feed.
Horns and trumpets and shepherd's pipes
And flutes and pipes of reed
Sound so that the mountains
Echo to them, and the plains.
How was it then with the glades
And with the forests and the pastures?
In these there was such sound
As though it were a stag at bay.

About the Mount, in the leafy wood,
The workmen have tents set up;
Streets have made along the roads.
Plenty there was of divers wines,
Bread and pasties, fruit and fish,
Birds, cakes, venison,
Everywhere there was for sale.
Enough he had who has the means to pay.

If you are not satisfied with this translation, any scholar of French will easily help to make a better, for we are not studying grammar or archæology, and would rather be inaccurate in such matters than not, if, at that price, a freer feeling of the art could be caught. Better still, you can turn to Chaucer, who wrote his Canterbury Pilgrimage two hundred years afterwards:

Whanne that April with his shoures sote
The droughte of March hath perced to the rote . . .
Than longen folk to gon on pilgrimages
And palmeres for to seken strange strondes . . .
And especially, from every shires ende
Of Englelonde, to Canterbury they wende
The holy blisful martyr for to seke,
That hem hath holpen whan that they were seke.

The passion for pilgrimages was universal among our ancestors as far back as we can trace them. For at least a thousand years it was their chief delight, and is not yet extinct. To feel the art of Mont Saint Michel and Chartres we have got to

become pilgrims again; but, just now, the point of most interest is not the pilgrim so much as the minstrel who sang to amuse him,—the jugleor or jongleur,—who was at home in every abbey, castle or cottage, as well as at every shrine. The jugleor became a jongleur and degenerated into the street-juggler; the minstrel, or menestrier, became very early a word of abuse, equivalent to blackguard; and from the beginning, the profession seems to have been socially decried, like that of a music-hall singer or dancer in later times; but in the eleventh century, or perhaps earlier still, the jongleur seems to have been a poet, and to have composed the songs he sang. The immense mass of poetry known as the Chansons de Geste seems to have been composed as well as sung by the unnamed Homers of France, and of all spots in the many provinces where the French language in its many dialects prevailed, Mont Saint Michel should have been the favorite with the jongleur, not only because the swarms of pilgrims assured him food and an occasional small piece of silver, but also because Saint Michael was the saint militant of all the warriors whose exploits in war were the subject of the Chansons de Geste. William of Saint Pair was a priest-poet; he was not a minstrel, and his Roman was not a Chanson; it was made to read, not to recite; but the Chanson de Roland was a different affair.

So it was too with William's contemporaries and rivals or predecessors, the monumental poets of Norman-English literature. Wace, whose rhymed history of the Norman dukes which he called the Roman de Rou, or Rollo, is an English classic of the first rank, was a canon of Bayeux when William of Saint Pair was writing at Mont Saint Michel. His rival Benoist, who wrote another famous chronicle on the same subject, was also a historian, and not a singer. In that day literature meant verse; elegance in French prose did not yet exist; but the elegancies of poetry in the twelfth century were as different, in kind, from the grand style of the eleventh, as Virgil was different from Homer.

William of Saint Pair introduces us to the Pilgrimage and to the *jongleur*, as they had existed at least two hundred years before his time, and were to exist two hundred years after him. Of all our two hundred and fifty million arithmetical ancestors who were going on pilgrimages in the middle of

the eleventh century, the two who would probably most interest everyone, after eight hundred years have passed, would be William the Norman and Harold the Saxon. Through William of Saint Pair and Wace and Benoist, and the most charming literary monument of all, the Bayeux tapestry of Queen Matilda, we can build up the story of such a pilgrimage which shall be as historically exact as the battle of Has-

tings, and as artistically true as the Abbey Church.

According to Wace's Roman de Rou, when Harold's father, Earl Godwin, died, April 15, 1053, Harold wished to obtain the release of certain hostages, a brother and a cousin, whom Godwin had given to Edward the Confessor as security for his good behavior, and whom Edward had sent to Duke William for safe-keeping. Wace took the story from other and older sources, and its accuracy is much disputed, but the fact that Harold went to Normandy seems to be certain, and you will see at Bayeux the picture of Harold asking permission of King Edward to make the journey, and departing on horseback, with his hawk and hounds and followers, to take ship at Bosham, near Chichester and Portsmouth. The date alone is doubtful. Common sense seems to suggest that the earliest possible date could not be too early to explain the rash youth of the aspirant to a throne who put himself in the power of a rival in the eleventh century. When that rival chanced to be William the Bastard, not even boyhood could excuse the folly, but Mr. Freeman, the chief authority on this delicate subject, inclined to think that Harold was forty years old when he committed his blunder, and that the year was about 1064. Between 1054 and 1064 the historian is free to choose what year he likes, and the tourist is still freer. To save trouble for the memory, the year 1058 will serve, since this is the date of the triumphal arches of the Abbey Church on the Mount. Harold, in sailing from the neighborhood of Portsmouth, must have been bound for Caen or Rouen, but the usual west winds drove him eastward till he was thrown ashore on the coast of Ponthieu, between Abbeville and Boulogne, where he fell into the hands of the Count of Ponthieu, from whom he was rescued or ransomed by Duke William of Normandy and taken to Rouen. According to Wace and the Roman de Rou:-

Guillaume tint Heraut maint jour Si com il dut a grant enor. A maint riche torneiement Le fist aller mult noblement. Chevals e armes li dona Et en Bretaigne le mena Ne sai de veir treiz faiz ou quatre Quant as Bretons se dut combattre.

William kept Harold many a day,
As was his due in great honor.
To many a rich tournament
Made him go very nobly.
Horses and arms gave him
And into Brittany led him
I know not truly whether three or four times
When he had to make war on the Bretons.

Perhaps the allusion to rich tournaments belongs to the time of Wace rather than to that of Harold a century earlier, before the first crusade, but certainly Harold did go with William on at least one raid into Brittany, and the charming tapestry of Bayeux, which tradition calls by the name of Queen Matilda, shows William's men-at-arms crossing the sands beneath Mont Saint Michel, with the Latin legend: - "Et venerunt ad Montem Michaelis. Hic Harold dux trahebat eos de arena. Venerunt ad flumen Cononis." They came to Mont Saint Michel, and Harold dragged them out of the quicksands. They came to the river Couesnon. Harold must have got great fame by saving life on the sands, to be remembered and recorded by the Normans themselves after they had killed him; but this is the affair of historians. Tourists note only that Harold and William came to the Mount:-Venerunt ad Montem. They would never have dared to pass it, on such an errand, without stopping to ask the help of Saint Michael.

If William and Harold came to the Mount, they certainly dined or supped in the old Refectory, which is where we have lain in wait for them. Where Duke William was, his jongleur—jugleor—was not far, and Wace knew, as everyone in Normandy seemed to know, who this favorite was,—his name, his character, and his song. To him Wace owed one of the most famous passages in his story of the assault at Hastings, where Duke William and his battle began their advance against the English lines:—

Taillefer qui mult bien chantout Sor un cheval qui tost alout Devant le duc alout chantant De Karlemaigne e de Rollant E d'Oliver e des vassals Qui morurent en Rencevals.

Taillefer who was famed for song, Mounted on a charger strong, Rode on before the Duke, and sang Of Roland and of Charlemagne, Oliver and the vassals all Who fell in fight at Roncesvals. Quant il orent chevalchie tant Qu'as Engleis vindrent apreismant: 'Sire,' dist Taillefer, 'merci! 'To vos ai longuement servi. 'Tot mon servise me devez. 'Hui se vos plaist le me rendez. 'Por tot guerredon vos requier 'E si vos voil forment preier 'Otreiez mei que io ni faille 'Le premier colp de la bataille.' Li dus respondi: 'Io l'otrei.' When they had ridden till they saw The English battle close before: 'Sire,' said Taillefer, 'a grace! 'I have served you long and well; 'All reward you owe me still; 'Today repay me if you please. 'For all guerdon I require, 'And ask of you in formal prayer, 'Grant to me as mine of right 'The first blow struck in the fight.' The Duke answered him:—'I grant.'

Of course critics doubt the story as they very properly doubt everything. They maintain that the Chanson de Roland was not as old as the battle of Hastings, and certainly Wace gave no sufficient proof of it. Poetry was not usually written to prove facts. Wace wrote a hundred years after the battle of Hastings. One is not morally required to be pedantic to the point of knowing more than Wace knew, but the feeling of scepticism, before so serious a monument as Mont Saint Michel, is annoying. The Chanson de Roland ought not to be trifled with, at least by tourists in search of art. One is shocked at the possibility of being deceived about the starting-point of American genealogy. Taillefer and the song rest on the same evidence that Duke William and Harold and the battle itself rest upon, and to doubt the Chanson is to call the very roll of Battle Abbey in question. The whole fabric of society totters; the British peerage turns pale.

Wace did not invent all his facts. William of Malmesbury is supposed to have written his prose chronicle about 1120 when many of the men who fought at Hastings must have been alive, and William expressly said:—"Tunc cantilena Rollandi inchoata ut martium viri exemplum pugnaturos accenderet, inclamatoque dei auxilio, praelium consertum." Starting the Chanson de Roland to inflame the fighting temper of the men, battle was joined. This seems enough proof to satisfy any sceptic, yet critics still suggest that the "cantilena Rollandi" must have been a Norman Chanson de Rou, or Rollo, or at best an earlier version of the Chanson de Roland; but no Norman Chanson would have inflamed the martial spirit of William's army, which was largely French; and as for the age of the version, it is quite immaterial for Mont Saint

Michel; the actual version is old enough.

Taillefer himself is more vital to the interest of the dinner in the Refectory, and his name was not mentioned by William of Malmesbury. If the song was started by the Duke's order, it was certainly started by the Duke's jongleur, and the name of this jongleur happens to be known on still better authority than that of William of Malmesbury. Guy of Amiens went to England in 1068 as almoner of Queen Matilda, and there wrote a Latin poem on the battle of Hastings which must have been complete within ten years after the battle was fought, for Guy died in 1076. Taillefer, he said, led the Duke's battle:—

Incisor-ferri mimus cognomine dictus.

"Taillefer, a jongleur known by that name." A mime was a singer, but Taillefer was also an actor:—

Histrio, cor audax nimium quem nobilitabat.

"A jongleur whom a very brave heart ennobled." The jongleur was not noble by birth, but was ennobled by his bravery.

Hortatur Gallos verbis et territat Anglos Alte projiciens ludit et ense suo.

Like a drum-major with his staff, he threw his sword high in the air and caught it, while he chanted his song to the French, and terrified the English. The rhymed chronicle of Geoffroy Gaimer who wrote about 1150, and that of Benoist who was Wace's rival, added the story that Taillefer died in the mêlée.

The most unlikely part of the tale was, after all, not the singing of the Chanson, but the prayer of Taillefer to the Duke:—

"Otreiez mei que io ni faille Le premier colp de la bataille."

Legally translated, Taillefer asked to be ennobled, and offered to pay for it with his life. The request of a *jongleur* to lead the Duke's battle seems incredible. In early French "bataille" meant battalion,—the column of attack. The Duke's grant: "Io l'otrei!" seems still more fanciful. Yet Guy of Amiens distinctly confirmed the story:—"Histrio cor audax nimium quem nobilitabat;" a stage-player,—a juggler—the Duke's singer—whose bravery ennobled him. The Duke granted him—octroya—his patent of nobility on the field.

All this preamble leads only to unite the Chanson with the architecture of the Mount, by means of Duke William and his Breton campaign of 1058. The Poem and the Church are akin; they go together, and explain each other. Their common trait is their military character, peculiar to the eleventh century. The round arch is masculine. The Chanson is so masculine that, in all its four thousand lines, the only Christian woman so much as mentioned was Alda, the sister of Oliver and the betrothed of Roland, to whom one stanza, exceedingly like a later insertion, was given, towards the end. Never after the first crusade did any great poem rise to such heroism as to sustain itself without a heroine. Even Dante attempted no such feat.

Duke William's party, then, is to be considered as assembled at supper in the old Refectory, in the year 1058, while the triumphal piers of the Church above are rising. The Abbot, Ralph of Beaumont, is host; Duke William sits with him on a daïs; Harold is by his side "a grant enor;" the Duke's brother, Odo bishop of Bayeux, with the other chief vassals, are present; and the Duke's *jongleur* Taillefer is at his elbow. The room is crowded with soldiers and monks, but all are equally anxious to hear Taillefer sing. As soon as dinner is over, at a nod from the Duke, Taillefer begins:—

Carles li reis nostre emperere magnes Set anz tuz pleins ad estet en Espaigne Cunquist la tere tresque en la mer altaigne Ni ad castel ki devant lui remaigne Murs ne citez ni est remes a fraindre. Charles the king, our emperor, the great, Seven years complete has been in Spain, Conquered the land as far as the high seas, Nor is there castle that holds against him, Nor wall or city left to capture.

The Chanson opened with these lines which had such a direct and personal bearing on everyone who heard them as to sound like prophecy. Within ten years William was to stand in England where Charlemagne stood in Spain. His mind was full of it, and of the means to attain it; and Harold was even more absorbed than he by the anxiety of the position. Harold had been obliged to take oath that he would support William's claim to the English throne, but he was still undecided, and William knew men too well to feel much confidence in an oath. As Taillefer sang on, he reached the part of Ganelon, the typical traitor, the invariable figure of Mediæval society. No feudal lord was without a Ganelon.

Duke William saw them all about him. He might have felt that Harold would play the part, but if Harold should choose rather to be Roland, Duke William could have foretold that his own brother, Bishop Odo, after gorging himself on the plunder of half England, would turn into a Ganelon so dangerous as to require a prison for life. When Taillefer reached the battle-scenes, there was no further need of imagination to realize them. They were scenes of yesterday and to-morrow. For that matter, Charlemagne or his successor was still at Aix, and the Moors were still in Spain. Archbishop Turpin of Reims had fought with sword and mace in Spain, while Bishop Odo of Bayeux was to marshal his men at Hastings, like a modern general, with a staff, but both were equally at home on the field of battle. Verse by verse, the song was a literal mirror of the Mount. The battle of Hastings was to be fought on the Archangel's day. What happened to Roland at Roncesvalles was to happen to Harold at Hastings, and Harold, as he was dying like Roland, was to see his brother Gyrth die like Oliver. Even Taillefer was to be a part, and a distinguished part, of his Chanson. Sooner or later, all were to die in the large and simple way of the eleventh century. Duke William himself, twenty years later, was to meet a violent death at Mantes in the same spirit, and if Bishop Odo did not die in battle, he died at least, like an eleventh-century hero, on the first crusade. First or last, the whole company died in fight, or in prison, or on crusade, while the monks shrived them and prayed.

Then Taillefer certainly sang the great death-scenes. Even to this day every French school-boy, if he knows no other poetry, knows these verses by heart. In the eleventh century they wrung the heart of every man-at-arms in Europe, whose school was the field of battle and the hand-to-hand fight. No modern singer ever enjoys such power over an audience as Taillefer exercised over these men who were actors as well as listeners. In the *mêlée* at Roncesvalles, overborne by innumer-

able Saracens, Oliver at last calls for help:-

Munjoie escriet e haltement e cler. Rollant apelet sun ami e sun per; 'Sire compainz a mei kar vus justez. 'A grant dulur ermes hoi deseveret.' Aoi. 'Montjoie!' he cries, loud and clear. Roland he calls, his friend and peer: 'Sir Friend! ride now to help me here! 'Parted today, great pity were.'

Of course the full value of the verse cannot be regained. One knows neither how it was sung nor even how it was pronounced. The assonances are beyond recovering; the "laisse" or leash of verses or assonances with the concluding cry: "Aoi", has long ago vanished from verse or song. The sense is as simple as the ballad of Chevy Chase, but one must imagine the voice and acting. Doubtless Taillefer acted each motive; when Oliver called loud and clear, Taillefer's voice rose; when Roland spoke doulcement et suef, the singer must have sung gently and soft; and when the two friends, with the singular courtesy of knighthood and dignity of soldiers, bowed to each other in parting and turned to face their deaths, Taillefer may have indicated the movement as he sang. The verses gave room for great acting. Hearing Oliver's cry for help, Roland rode up, and at sight of the desperate field, lost for a moment his consciousness:-

As vus Rollant sur sun cheval pasmet E Olivier ki est a mort nafrez! Tant ad sainiet li oil li sunt trublet Ne luinz ne pres ne poet veeir si cler Que reconuisset nisun hume mortel. Sun cumpaignun cum il l'ad encuntret Sil fiert amunt sur l'elme a or gemmet Tut li detrenchet d'ici que al nasel Mais en la teste ne l'ad mie adeset. A icel colp l'ad Rollanz reguardet Si li demandet dulcement et suef 'Sire cumpainz, faites le vus de gred? Ja est co Rollanz ki tant vus soelt amer. 'Par nule guise ne m'aviez desfiet,' Dist Oliviers: 'Or vus oi jo parler To ne vus vei. Veied vus damnedeus! 'Ferut vus ai. Kar le me pardunez!' Rollanz respunt: 'Jo n'ai nient de mel. Jol vus parduins ici e devant deu.' A icel mot l'uns al altre ad clinet. Par tel amur as les vus desevrez!

There Roland sits unconscious on his horse, And Oliver who wounded is to death, So much has bled, his eyes grow dark to him, Nor far nor near can see so clear As to recognize any mortal man. His friend, when he has encountred him, He strikes upon the helmet of gemmed gold, Splits it from the crown to the nose-piece, But to the head he has not reached at all. At this blow Roland looks at him, Asks him gently and softly: 'Sir Friend, do you it in earnest? 'You know 'tis Roland who has so loved you. 'In no way have you sent to me defiance.' Says Oliver: 'Indeed I hear you speak, 'I do not see you. May God see and save you! 'Strike you I did. I pray you pardon me.' Roland replies: 'I have no harm at all. 'I pardon you here and before God!' At this word, one to the other bends himself. With such affection, there they separate.

No one should try to render this into English,—or indeed into modern French,—verse, but anyone who will take the trouble to catch the metre and will remember that each verse in the "leash" ends in the same sound—aimer, parler, cler, mortel, damnedé, mel, deu, suef, nasel—however the terminal syllables may be spelled, can follow the feeling of the poetry

as well as though it were Greek hexameter. He will feel the simple force of the words and action, as he feels Homer. It is the grand style,—the eleventh century:—

Ferut vus ai! Kar le me pardunez!

Not a syllable is lost, and always the strongest syllable is chosen. Even the sentiment is monosyllabic and curt:—

Ja est ço Rollanz ki tant vus soelt amer!

Taillefer had, in such a libretto, the means of producing dramatic effects that the French Comedy or the Grand Opera never approached, and such as made Baireuth seem thin and feeble. Duke William's barons must have clung to his voice and action as though they were in the very mêlée, striking at the helmets of gemmed gold. They had all been there, and were to be there again. As the climax approached, they saw the scene itself; probably they had seen it every year, more or less, since they could swing a sword. Taillefer chanted the death of Oliver and of Archbishop Turpin and all the other barons of the rear-guard, except Roland, who was left for dead by the Saracens when they fled on hearing the horns of Charlemagne's returning host. Roland came back to consciousness on feeling a Saracen marauder tugging at his sword Durendal. With a blow of his ivory horn-oliphant,-he killed the pagan; then feeling death near, he prepared for it. His first thought was for Durendal, his sword, which he could not leave to infidels. In the singular triple repetition which gives more of the same solidity and architectural weight to the verse, he made three attempts to break the sword, with a lament—a plaint—for each. Three times he struck with all his force against the rock; each time the sword rebounded without breaking. The third time-

Rollanz ferit en une pierre bise Plus en abat que jo ne vus sai dire. L'espee cruist ne fruisset ne ne briset

Cuntre le ciel amunt est resortie. Quant veit li quens que ne la fraindrat mie

Mult dulcement la plainst a sei meisme. E! Durendal cum ies bele e saintisme! 'En l'oret punt asez i ad reliques. Roland strikes on a grey stone, More of it cuts off than I can tell you. The sword grinds, but shatters not nor breaks,

Upward against the sky it rebounds. When the Count sees that he can never break it,

Very gently he mourns it to himself:
'Ah, Durendal, how fair you are and sacred!'
In your golden guard are many relics,

'E des chevels mun seignur seint Denisie 'Del vestment i ad seinte Marie. 'Il nen est dreiz que paien te baillisent. 'De chrestiens devez estre servie. 'Ne vus ait hum ki facet cuardie!

'Mult larges terres de vus averai cunquises 'Que Carles tient ki la barbe ad flurie.

'E li emperere en est e ber e riches.'

'La dent saint Pierre e del sanc seint Basilie 'The tooth of St. Peter and blood of St. Basil, 'And hair of my seigneur Saint Denis, 'Of the garment too of Saint Mary. It is not right that pagans should own you. 'By Christians you should be served, 'Nor should man have you who does cowardice.

> 'Many wide lands by you I have conquered 'That Charles holds, who has the white

'And emperor of them is noble and rich.'

This laisse is even more eleventh-century than the other, but it appealed no longer to the warriors; it spoke rather to the monks. To the warriors, the sword itself was the religion, and the relics were details of ornament or strength. To the priest, the list of relics was more eloquent than the Regent diamond on the hilt and the Kohinoor on the scabbard. Even to us it is interesting if it is understood. Roland had gone on pilgrimage to the Holy Land. He had stopped at Rome and won the friendship of Saint Peter, as the tooth proved; he had passed through Constantinople and secured the help of Saint Basil; he had reached Jerusalem and gained the affection of the Virgin; he had come home to France and secured the support of his "seigneur" Saint Denis; for Roland, like Hugh Capet, was a liege-man of Saint Denis and French to the heart. France, to him, was Saint Denis and at most the Ile de France, but not Anjou or even Maine. These were countries he had conquered with Durendal:

> Jo l'en cunquis e Anjou e Bretaigne Si l'en cunquis e Peitou e le Maine Jo l'en cunquis Normendie la franche Si l'en cunquis Provence e Equitaigne.

He had conquered these for his emperor Charlemagne with the help of his immediate spiritual lord or seigneur Saint Denis, but the monks knew that he could never have done these feats without the help of Saint Peter, Saint Basil, and Saint Mary the Blessed Virgin whose relics, in the hilt of his sword, were worth more than any King's ransom. To this day a tunic of the Virgin is the most precious property of the Cathedral at Chartres. Either one of Roland's relics would have made the glory of any shrine in Europe, and every monk knew their enormous value and power better than they knew the value of Roland's conquests.

Yet even the religion is martial, as though it were meant for the fighting Archangel and Odo of Bayeux. The relics serve the sword; the sword is not in service of the relics. As the death-scene approaches, the song becomes even more military:

Ço sent Rollanz que la mort le tresprent Devers la teste sur le quer li descent. Desuz un pin i est alez curanz Sur l'erbe verte si est culchiez adenz Desuz lui met s'espee e l'olifant Turnat sa teste vers la paiene gent. Pur ço l'ad fait que il voelt veirement Que Carles diet et trestute sa gent Li gentils quens quil fut morz cunqueranz.

Then Roland feels that death is taking him; Down from the head upon the heart it falls. Beneath a pine he hastens running; On the green grass he throws himself down; Beneath him puts his sword and oliphant, Turns his face towards the pagan army. For this he does it, that he wishes greatly That Charles should say and all his men, The gentle Count has died a conqueror.

Thus far, not a thought or a word strays from the field of war. With a childlike intensity, every syllable bends towards the single idea—

Li gentils quens quil fut morz cunqueranz.

Only then the singer allowed the Church to assert some of its rights:—

Ço sent Rollanz de sun tens ni ad plus Devers Espaigne gist en un pui agut A l'une main si ad sun piz batut. 'Deus meie culpe vers les tues vertuz 'De mes pecchiez des granz e des menuz 'Que jo ai fait des l'ure que nez fui 'Tresqu'a cest jur que ci sui consouz.' Sun destre guant en ad vers deu tendut Angle del ciel i descendent a lui. Aoi.

Then Roland feels that his last hour has come Facing towards Spain he lies on a steep hill, While with one hand he beats upon his breast: 'Mea culpa, God! through force of thy miracles 'Pardon my sins, the great as well as small, 'That I have done from the hour I was born 'Down to this day that I have now attained.' His right glove towards God he lifted up. Angels from heaven descend on him. Aoi.

Li quens Rollanz se jut desuz un pin Envers Espaigne en ad turnet sun vis De plusurs choses a remembrer li prist De tantes terres cume li bers cunquist

De dulce France des humes de sun lign De Carlemagne sun seignur kil nurrit Ne poet muer nen plurt e ne suspirt Count Roland throws himself beneath a pine And towards Spain has turned his face away. Of many things he called the memory back, Of many lands that he, the brave, had conquered,

Of gentle France, the men of his lineage, Of Charlemagne his lord, who nurtured him; He cannot help but weep and sigh for these, Mais lui meisme ne voelt metre en ubli Claimet sa culpe si priet deu mercit. Veire paterne ki unkes ne mentis 'Seint Lazarun de mort resurrexis 'E Daniel des liuns guaresis 'Guaris de mei l'anme de tuz perils 'Pur les pecchiez que en ma vie fis.'

Sun destre guant a deu en puroffrit E de sa main seinz Gabriel lad pris Desur sun braz teneit le chief enclin Juintes ses mains est alez a sa fin. Deus li tramist sun angle cherubin E Seint Michiel de la mer del peril Ensemble od els Seinz Gabriels i vint L'anme del cunte portent en pareis.

But for himself will not forget to care;
He cries his Culpe, he prays to God for grace.
'Oh God the Father who hast never lied,
'Who raised up Saint Lazarus from death,
'And Daniel from the lions saved,
'Save my soul from all the perils
'For the sins that in my life I did!'

His right-hand glove to God he proffered; Saint Gabriel from his hand took it; Upon his arm he held his head inclined, Folding his hands he passed to his end. God sent to him his angel cherubim And Saint Michael of the Sea in Peril, Together with them came Saint Gabriel. The soul of the Count they bear to Paradise.

Our age has lost much of its ear for poetry, as it has its eve for color and line, and its taste for war and worship, wine and women. Not one man in a hundred thousand could now feel what the eleventh century felt in these verses of the Chanson, and there is no reason for trying to do so, but there is a certain use in trying for once to understand not so much the feeling as the meaning. The naïveté of the poetry is that of the society. God the Father, was the feudal seigneur, who raised Lazarus—his baron or vassal—from the grave, and freed Daniel, as an evidence of his power and loyalty; a seigneur who never lied, or was false to his word. God the Father, as feudal seigneur, absorbs the Trinity, and, what is more significant, absorbs or excludes also the Virgin, who is not mentioned in the prayer. To this Seigneur, Roland in dying, proffered (puroffrit) his right-hand gauntlet. Death was an act of homage. God sent down his Archangel Gabriel as his representative to accept the homage and receive the glove. To Duke William and his barons, nothing could seem more natural and correct. God was not further away than Charlemagne.

Correct as the law may have been, the religion even at that time must have seemed to the monks to need professional advice. Roland's life was not exemplary. The Chanson had taken pains to show that the disaster at Roncesvalles was due to Roland's head-strong folly and temper. In dying, Roland had not once thought of these faults, or repented of his worldly ambitions, or mentioned the name of Alda, his be-

trothed. He had clung to the memory of his wars and conquests, his lineage, his earthly *seigneur* Charlemagne, and of 'douce France.' He had forgotten to give so much as an allusion to Christ. The poet regarded all these matters as the affair of the Church; all the warrior cared for was courage, loyalty and prowess.

The interest of these details lies not in the scholarship or the historical truth or even the local color, so much as in the art. The naïveté of the thought is repeated by the simplicity of the verse. Words and thought are equally monosyllabic. Nothing ever matched it. The words bubble like a stream in

the woods: Ço sent Rollanz de sun tens ni ad plus.

Try and put them into modern French, and see what will happen:

Que jo ai fait des l'ure que nez fui.

The words may remain exactly the same, but the poetry will have gone out of them. Five hundred years later, even the English critics had so far lost their sense for military poetry that they professed to be shocked by Milton's monosyllables:

Whereat he inly raged, and, as they talked, Smote him into the midriff with a stone That beat out life.

Milton's language was indeed more or less archaic and biblical; it was a puritan affectation; but the Chanson in the Refectory actually reflected, repeated, echoed, the piers and arches of the Abbey Church just rising above. The verse is built up. The qualities of the architecture reproduce themselves in the song: the same directness, simplicity, absence of self-consciousness; the same intensity of purpose; even the same material; the prayer is granite:—

Guaris de mei l'anme de tuz perils Pur les pecchiez que en ma vie fis!

The action of dying is felt, like the dropping of a key-stone into the vault, and if the romanesque arches in the Church, which are within hearing, could speak, they would describe what they are doing in the precise words of the poem:—

Desur sun braz teneit le chief enclin Juintes ses mains est alez a sa fin. Upon their shoulders have their heads inclined, Folded their hands, and sunken to their rest.

Many thousands of times these verses must have been sung at the Mount and echoed in every castle and on every battlefield from the Welsh Marches to the shores of the Dead Sea. No modern opera or play ever approached the popularity of the Chanson. None has ever expressed with anything like the same completeness the society that produced it. Chanted by every minstrel-known by heart, from beginning to end, by every man and woman and child, lay or clerical,-translated into every tongue,-more intensely felt, if possible, in Italy and Spain than in Normandy and England, - perhaps most effective, as a work of art, when sung by the Templars in their great castles in the Holy Land, -it is now best felt at Mont Saint Michel, and from the first must have been there at home. The proof is the line evidently inserted for the sake of its local effect, which invoked Saint Michael in Peril of the Sea at the climax of Roland's death, and one needs no original documents or contemporary authorities to prove that, when Taillefer came to this invocation, not only Duke William and his barons, but still more Abbot Ranulf and his monks, broke into a frenzy of sympathy which expressed the masculine and military passions of the Archangel better than it accorded with the rules of Saint Benedict.

III

The Merveille

THE NINETEENTH CENTURY moved fast and furious, so that one who moved in it felt sometimes giddy, watching it spin; but the eleventh moved faster and more furiously still. The Norman conquest of England was an immense effort, and its consequences were far-reaching, but the first crusade was altogether the most interesting event in European history. Never has the western world shown anything like the energy and unity with which she then flung herself on the East, and for the moment made the East recoil. Barring her family quarrels, Europe was a unity then, in thought, will and object. Christianity was the unit. Mont Saint Michel and Byzantium were near each other. The Emperor Constantine and the Emperor Charlemagne were figured as allies and friends in the popular legend. The East was the common enemy, always superior in wealth and numbers, frequently in energy, and sometimes in thought and art. The outburst of the first crusade was splendid even in a military sense, but it was great beyond comparison in its reflexion in architecture, ornament, poetry, color, religion and philosophy. Its men were astonishing, and its women were worth all the rest.

Mont Saint Michel, better than any other spot in the world keeps the architectural record of that ferment, much as the Sicilian temples keep the record of the similar outburst of Greek energy, art, poetry and thought, fifteen hundred years before. Of the eleventh century, it is true, nothing but the Church remains at the Mount and, if studied further, the century has got to be sought elsewhere, which is not difficult since it is preserved in any number of churches in every path of tourist travel. Normandy is full of it; Bayeux and Caen contain little else. At the Mount, the eleventh-century work was antiquated before it was finished. In the year 1112 Abbot Roger II was obliged to plan and construct a new group in such haste that it is said to have been finished in 1122. It extends from what we have supposed to be the old Refectory to the *Parvis*, and abuts on the three lost spans of the Church.

covering about one hundred and twenty feet. As usual there were three levels; a crypt or gallery beneath, known as the Aquilon; a cloister or Promenoir above; and on the level of the Church a Dormitory, now lost. The group is one of the most interesting in France, another *pons seclorum*, an antechamber to the west portal of Chartres, which bears the same date (IIIO—II25). It is the famous period of Transition, the glory of the twelfth century, the object of our pilgrimage.

Art is a fairly large field where no one need jostle his neighbor, and no one need shut himself up in a corner; but, if one insists on taking a corner of preference, one might offer some excuse for choosing the Gothic Transition. The quiet, restrained strength of the romanesque married to the graceful curves and vaulting imagination of the gothic makes a union nearer the ideal than is often allowed in marriage. The French, in their best days, loved it with a constancy that has thrown a sort of aureole over their fickleness since. They never tired of its possibilities. Sometimes they put the pointed arch within the round, or above it; sometimes they put the round within the pointed. Sometimes a roman arch covered a cluster of pointed windows, as though protecting and caressing its children; sometimes a huge pointed arch covered a great rose-window spreading across the whole front of an enormous cathedral, with an arcade of romanesque windows beneath. The French architects felt no discord, and there was none. Even the pure gothic was put side by side with the pure roman. You will see no later gothic than the choir of the Abbey Church above (1450-1521), unless it is the north flèche of Chartres cathedral (1507-1513); and if you will look down the nave, through the triumphal arches, into the pointed choir four hundred years more modern, you can judge whether there is any real discord. For those who feel the art, there is none; the strength and the grace join hands; the man and woman love each other still.

The difference of sex is not imaginary. In 1058 when the triumphal columns were building, and Taillefer sang to William the Bastard and Harold the Saxon, Roland still prayed his mea culpa to God the Father and gave not a thought to Alda his betrothed. In the twelfth century Saint Bernard recited "Ave Stella Maris" in an ecstacy of miracle before the

image of the Virgin, and the armies of France in battle cried Notre-Dame-Saint-Denis-Montjoie. What the roman could not express flowered into the gothic; what the masculine mind could not idealize in the warrior, it idealized in the woman; no architecture that ever grew on earth except the gothic, gave this effect of flinging its passion against the sky.

When men no longer felt the passion, they fell back on themselves, or lower. The architects returned to the round arch, and even further to the flatness of the Greek colonnade; but this was not the fault of the twelfth or thirteenth centuries. What they had to say they said; what they felt they expressed; and if the seventeenth century forgot it, the twentieth in turn has forgotten the seventeenth. History is only a catalogue of the forgotten. The eleventh century is no worse off than its neighbors. The twelfth is, in architecture, rather better off than the nineteenth. These two rooms, the Aquilon and Promenoir, which mark the beginning of the Transition, are on the whole, more modern than Saint Sulpice, or Il Gesu at Rome. In the same situation, for the same purposes, any architect would be proud to repeat them today.

The Aquilon, though a hall or gallery of importance in its day, seems to be classed among crypts. M. Camille Enlart, in his Manual of French Archaeology (p. 252) gives a list of Romanesque and Transition crypts, about one hundred and twenty, to serve as examples for the study. The Aquilon is not one of them, but the crypt of Saint Denis and that of Chartres cathedral would serve to teach any over-curious tourist all that he should want to know about such matters. Photographs such as those of the Monuments Historiques answer all the just purposes of underground travel. The Aquilon is one's first lesson in Transition architecture because it is dated, (III2); and the crypt of Saint Denis serves almost equally well because the Abbé Suger must have begun his plans for it about 1122. Both have the same arcs-doubleaux and arcsformerets, though in opposite arrangement. Both show the first heavy hint at the broken arch. There are no Nervuresno rib-vaulting, - and hardly a suggestion of the gothic as one sees it in the splendid crypt of the Gros Piliers close at hand, except the elaborately intersecting vaults and the heavy columns; but the Promenoir above is an astonishing leap in

time and art. The Promenoir has the same arrangement and columns as the Aquilon, but the vaults are beautifully arched and pointed, with ribs rising directly from the square capitals and intersecting the central spacings, in a spirit which neither you nor I know how to distinguish from the pure gothic of the thirteenth century, unless it is that the arches are hardly pointed enough; they seem to the eye almost round. The

height appears to be about fourteen feet.

The Promenoir of Abbot Roger II has an interest to pilgrims who are going on to the shrine of the Virgin, because the date of the Promenoir seems to be exactly the same as the date which the Abbé Bulteau assigns for the western Portal of Chartres. Ordinarily a date is no great matter, but when one has to run forward and back, with the agility of an electric tram, between two or three fixed points, it is convenient to fix them once for all. The Transition is complete here in the Promenoir which was planned as early as 1115. The subject of vaulting is far too ambitious for summer travel; it is none too easy for a graduate of the Beaux Arts, and few architectural fields have been so earnestly discussed and disputed. We must not touch it. The age of the Chanson de Roland itself is not so dangerous a topic. Our vital needs are met, more or less sufficiently, by taking the Promenoir at the Mount, the Crypt at Saint Denis, and the western Portal at Chartres, as the Trinity of our Transition, and roughly calling their date the years 1115-1120. To overload the memory with dates is the vice of every schoolmaster and the passion of every secondrate scholar. Tourists want as few dates as possible; what they want is poetry. Yet a singular coincidence, with which every class-room is only too familiar, has made of the years -'15 a curiously convenient group, and the year 1115 is as convenient as any for the beginning of the century of Transition. That was the year when Saint Bernard laid the foundations of his Abbey of Clairvaux. Perhaps 1115 or at latest 1117, was the year when Abélard sang love-songs to Héloïse in canon Fulbert's house in the Rue des Chantres, beside the cloister of Notre Dame in Paris. The Abbé Suger, the Abbé Bernard, and the Abbé Abélard are the three interesting men of the French Transition.

The Promenoir, then, shall pass for the year 1115, and, as

such, is an exceedingly beautiful hall, uniting the splendid calm and seriousness of the romanesque with the exquisite lines of the gothic. You will hardly see its equal in the twelfth century. At Angers the great hall of the Bishop's palace survives to give a point of comparison, but commonly the halls of that date were not vaulted; they had timber roofs, and have perished. The Promenoir is about sixty feet long, and divided into two aisles, ten feet wide, by a row of columns. If it were used on great occasions as a refectory, eighty or a hundred persons could have been seated at table, and perhaps this may have been about the scale of the Abbey's needs, at that time. Whatever effort of fancy was needed to place Duke William and Harold in the old refectory of 1058, none whatever is required in order to see his successors in the halls of Roger II. With one exception they were not interesting persons. The exception was Henry II of England and Anjou, and his wife Eleanor of Guienne who was for a while regent of Normandy. One of their children was born at Domfront just beyond Avranches, and the Abbot was asked to be Godfather. In 1158, just one hundred years after Duke William's visit, King Henry and his whole suite came to the Abbey, heard mass, and dined in the Refectory. "Rex venit ad Montem Sancti Michaelis, audita missa ad magis altare, comedit in Refectorio cum baronibus suis." Abbot Robert of Torigny was his host, and very possibly William of Saint Pair looked on. Perhaps he recited parts of his Roman before the King. One may be quite sure that when Queen Eleanor came to the Mount she asked the poet to recite his verses, for Eleanor gave law to poets.

One might linger over Abbot Robert of Torigny, who was a very great man in his day, and an especially great architect, but too ambitious. All his work, including the two towers, crumbled and fell for want of proper support. What would correspond to the Cathedrals of Noyon and Soissons and the old *clocher* and *flèche* of Chartres is lost. We have no choice but to step down into the next century at once, and into the full and perfect gothic of the great age when the new Chartres

was building.

In the year 1203 Philip Augustus expelled the English from Normandy and conquered the province; but, in the course of the war the Duke of Brittany, who was naturally a party to any war that took place under his eyes, happened to burn the town beneath the Abbey, and in doing so, set fire unintentionally to the Abbey itself. The sacrilege shocked Philip Augustus, and the wish to conciliate so powerful a vassal as Saint Michael, or his Abbot, led the King of France to give a large sum of money for repairing the buildings. The Abbot Jordan (1191–1212) at once undertook to outdo all his predecessors, and, with an immense ambition, planned the huge pile which covers the whole north face of the Mount, and which has

always borne the expressive name of the Merveille.

The general motive of abbatial building was common to them all. Abbeys were large households. The Church was the centre, and at Mont Saint Michel the summit, for the situation compelled the Abbots there to pile one building on another instead of arranging them on a level in squares or parallelograms. The Dormitory in any case had to be near a door of the church, because the Rules required constant services, day and night. The Cloister was also hard by the church door, and, at the Mount, had to be on the same level in order to be in open air. Naturally the Refectory must be immediately beneath one or the other of these two principal structures, and the Hall, or place of meeting for business with the outside world, or for internal administration, or for guests of importance, must be next the Refectory. The kitchen and offices would be placed on the lowest stage, if for no other reason, because the magazines were two hundred feet below at the landing-place, and all supplies, including water, had to be hauled up an inclined plane by windlass. To administer such a society required the most efficient management. An Abbot on this scale was a very great man indeed, who enjoyed an establishment of his own, close by, with officers in no small number; for the monks alone numbered sixty, and even these were not enough for the regular church services at seasons of pilgrimage. The Abbot was obliged to entertain scores and hundreds of guests and these too of the highest importance, with large suites. Every ounce of food must be brought from the mainland, or fished from the sea. All the tenants and their farms, their rents and contributions, must be looked after. No secular prince had a more serious task of administration, and none did it so well. Tenants always preferred an Abbot or Bishop for landlord. The Abbey was the highest administrative creation of the middle ages, and when one has made one's pilgrimage to Chartres, one might well devote another summer to visiting what is left of Clairvaux, Citeaux, Cluny, and the other famous monasteries, with Viollet-le-Duc to guide, in order to satisfy one's mind whether, on the whole, such a life may not have had activity as well as idleness.

This is a matter of economics, to be settled with the keepers of more modern hotels, but the art had to suit the conditions, and when Abbot Jordan decided to plaster this huge structure against the side of the Mount the architect had a relatively simple task to handle. The engineering difficulties alone were very serious. The architectural plan was plain enough. As the Abbot laid his requirements before the architect, he seems to have begun by fixing the scale for a Refectory capable of seating two hundred guests at table. Probably no king in Europe fed more persons at his table than this. According to M. Corroyer's plan, the length of the new Refectory is one hundred and twenty-three feet (37.5 metres). A row of columns down the centre divides it into two aisles, measuring twelve feet clear, from column to column, across the room. If tables were set the whole length of the two aisles, forty persons could have been easily seated, in four rows, or one hundred and sixty persons. Without crowding, the same space would give room for fifty guests, or two hundred in all.

Once the scale was fixed, the arrangement was easy. Beginning at the lowest possible level, one plain, very solidly built, vaulted room, served as foundation for another, loftier and more delicately vaulted; and this again bore another which stood on the level of the church, and opened directly into the north transept. This arrangement was then doubled; and the second set of rooms, at the west end, contained the cellar on the lower level, another great room or Hall above it, and the Cloister at the church door, also entering into the north transept. Door-ways, passages and stairs unite them all. The two heavy halls on the lowest level are now called the Almonry and the Cellar, which is a distinction between administrative arrangements that does not concern us. Architecturally the

rooms might, to our untrained eyes, be of the same age with the Aquilon. They are earliest Transition, as far as a tourist can see, or at least they belong to the class of crypts which has an architecture of its own. The rooms that concern us are those immediately above: the so-called Salle des Chevaliers at the west end; and the so-called Refectory at the east. Every writer gives these rooms different names, and assigns them different purposes, but whatever they were meant for, they are, as Halls, the finest in France; the purest in thirteenth-

century perfection.

The Salle des Chevaliers of the Order of Saint Michael created by Louis XI in 1469 was, or shall be for tourist purposes, the great Hall that every palace and castle contained, and in which the life of the chateau centred. Planned at about the same time with the Cathedral of Chartres (1195-1210), and before the Abbey church of Saint Denis this Hall and its neighbor the Refectory, studied together with the Cathedral and the Abbey, are an exceedingly liberal education for anybody, tourist or engineer or architect, and would make the fortune of an intelligent historian, if such should happen to exist; but the last thing we ask from them is education or instruction. We want only their poetry, and shall have to look for it elsewhere. Here is only the shell,—the dead art—and silence. The Hall is about ninety feet long, and sixty feet in its greatest width. It has three ranges of columns making four vaulted aisles which seem to rise about twenty-two feet in height. It is warmed by two huge and heavy cheminées or fireplaces in the outside wall, between the windows. It is lighted beautifully, but mostly from above through round windows in the arching of the vaults. The vaulting is a study for wiser men than we can ever be. More than twenty strong round columns, free or engaged, with romanesque capitals, support heavy ribs or nervures and while the two central aisles are eighteen feet wide, the outside aisle into which the windows open, measures only ten feet in width, and has consequently one of the most sharply pointed vaults we shall ever meet. The whole design is as beautiful a bit of early gothic as exists, but what would take most time to study, if time were to spare, would be the instinct of the Archangel's presence which has animated his architecture. The masculine, military energy of Saint Michael lives still in every stone. The genius that realised this warlike emotion has stamped his power everywhere, on every centimetre of his work; in every ray of light; on the mass of every shadow; wherever the eye falls; still more strongly on all that the eye divines, and in the shadows that are felt like the lights. The architect intended it all. Anyone who doubts has only to step through the doorway in the corner into the Refectory. There the architect has undertaken to express the thirteenth-century idea of the Archangel; he has left the twelfth-century behind him.

The Refectory, which has already served for a measure of the Abbot's scale, is, in feeling, as different as possible from the Hall. Six charming columns run down the centre, dividing the room into two vaulted aisles, apparently about twenty-seven feet in height. Wherever the Hall was heavy and serious, the Refectory was made light and graceful. Hardly a trace of the romanesque remains. Only the slight, round columns are not yet grooved or fluted, and their round capitals are still slightly severe. Every detail is lightened. The great fire-places are removed to each end of the room. The most interesting change is in the windows. When you reach Chartres, the great book of architecture will open on the word Fenestration, - Fenêtre, - a word as ugly as the thing was beautiful; and then, with pain and sorrow, you will have to toil till you see how the architects of 1200 subordinated every other problem to that of lighting their spaces. Without feeling their lights, you can never feel their shadows. These two Halls at Mont Saint Michel are ante-chambers to the nave of Chartres; their fenestration, inside and out, controls the whole design. The lighting of the Refectory is superb, but one feels its value in art only when it is taken in relation to the lighting of the Hall, and both serve as a simple preamble to the romance of the Chartres windows.

The Refectory shows what the architect did when, to lighten his effects, he wanted to use every possible square centimetre of light. He has made nine windows; six on the north, two on the east, and one on the south. They are nearly five feet wide, and about twenty feet high. They flood the room. Probably they were intended for glass, and M. Corroyer's volume contains wood-cuts of a few fragments of thirteenth-cen-

tury glass discovered in his various excavations; but one may take for granted that with so much light, color was the object intended. The floors would be tiled in color; the walls would be hung with color; probably the vaults were painted in color; one can see it all in scores of illuminated manuscripts. The thirteenth-century had a passion for color, and made a color-world of its own which we have got to explore.

The two halls remain almost the only monuments of what must be called secular architecture of the early and perfect period of gothic art (1200-1210). Churches enough remain, with Chartres at their head, but all the great Abbeys, Palaces and Chateaux of that day are ruins. Argues, Gaillard, Montargis, Coucy, the old Louvre, Chinon, Angers, as well as Cluny, Clairvaux, Citeaux, Jumièges, Vezelay, Saint Denis, Poissy, Fontevrault, and a score of other residences royal or semiroyal, have disappeared wholly, or have lost their residential buildings. When Viollet-le-Duc under the second empire, was allowed to restore one great chateau, he chose the latest, Pierrefonds, built by Louis d'Orleans in 1390. Vestiges of Saint Louis' palace remain at the Conciergerie, but the first great royal residence to be compared with the Merveille is Amboise dating from about 1500, three centuries later. Civilization made almost a clean sweep of art. Only here, at Mont Saint Michel, one may still sit at ease on the stone benches in the embrasures of the Refectory windows, looking over the thirteenth-century ocean and watching the architect as he worked out the details which were to produce or accent his contrasts or harmonies, heighten his effects, or hide his show of effort, and all by means so true, simple and apparently easy that one seems almost competent to follow him. One learns better in time. One gets to feel that these things were due in part to an instinct that the architect himself might not have been able to explain. The instinct vanishes as time creeps on. The Halls at Rouen or at Blois are more easily understood; the Salle des Caryatides of Pierre Lescot at the Louvre, charming as it is, is simpler still; and one feels entirely at home in the Salle des Glaces which filled the ambition of Louis XIV at Versailles.

If any lingering doubt remains in regard to the professional cleverness of the architect and the thoroughness of his study, we had best return to the great Hall, and pass through a low door in its extreme outer angle, up a few steps into a little room some thirteen feet square, beautifully vaulted, lighted, warmed by a large stone fire-place, and in the corner, a spiral staircase leading up to another square room above opening directly into the Cloister. It is a little Library or Charter House. The arrangement is almost too clever for gravity, as is the case with more than one arrangement in the Merveille. From the outside one can see that at this corner the architect had to provide a heavy buttress against a double strain, and he built up from the rock below a square corner tower as support, into which he worked a spiral staircase leading from the Cellar up to the Cloisters. Just above the level of the great Hall he managed to construct this little room, a gem. The place was near and far; it was quiet and central; William of Saint Pair, had he been still alive, might have written his Roman there; monks might have illuminated missals there. A few steps upward brought them to the Cloisters for meditation: a few more brought them to the church for prayer. A few steps downward brought them to the great Hall, for business, a few steps more led them into the Refectory, for dinner. To contemplate the goodness of God was a simple joy, when one had such a room to work in; such a spot as the great Hall to walk in, when the storms blew; or the Cloisters in which to meditate, when the sun shone; such a diningroom as the Refectory; and such a view from one's windows over the infinite ocean and the guiles of Satan's quicksands. From the battlements of Heaven, William of Saint Pair looked down on it with envy.

Of all parts of the Merveille, in summer, the most charming must always have been the Cloisters. Only the Abbey of the Mount was rich and splendid enough to build a cloister like this, all in granite, carved in forms as light as though it were wood; with columns arranged in a peculiar triangular order that excited the admiration of Viollet-le-Duc. "One of the most curious and complete cloisters that we have in France," he said; although in France there are many beautiful and curious cloisters. For another reason it has value. The architect meant it to reassert, with all the art and grace he could command, the mastery of love, of thought and poetry, in religion, over the masculine, military energy of the great Hall below.

The thirteenth century rarely let slip a chance to insist on this moral that love is law. Saint Francis was preaching to the birds in 1215 at Assisi, and the architect built this cloister in 1226 at Mont Saint Michel. Both sermons were saturated with the feeling of the time, and both are about equally worth not-

ing, if one aspires to feel the art.

A conscientious student has yet to climb down the many steps, on the outside, and look up at the Merveille from below. Few buildings in France are better worth the trouble. The horizontal line at the roof measures two hundred and thirty-five feet. The vertical line of the buttresses measures in round numbers one hundred feet. To make walls of that height and length stand up at all was no easy matter as Robert de Torigny had shown; and so the architect buttressed them from bottom to top with twelve long buttresses against the thrust of the interior arches, and three more, bearing against the interior walls. This gives, on the north front, fifteen strong vertical lines in a space of two hundred and thirtyfive feet. Between these lines the windows tell their story; the seven long windows of the Refectory on one side; the seven rounded windows of the Hall on the other. Even the corner tower with the Charter House becomes as simple as the rest. The sum of this impossible wall, and its exaggerated vertical lines, is strength and intelligence at rest.

The whole Mount still kept the grand style; it expressed the unity of Church and State, God and Man, Peace and War, Life and Death, Good and Bad; it solved the whole problem of the universe. The priest and the soldier were both at home here, in 1215 as in 1115 or in 1058; the politician was not outside of it; the sinner was welcome; the poet was made happy in his own spirit, with a sympathy, almost an affection, that suggests a habit of verse in the Abbot as well as in the architect. God reconciles all. The world is an evident, obvious, sacred harmony. Even the discord of war is a detail on which the Abbey refuses to insist. Not till two centuries afterwards did the Mount take on the modern expression of war as a discord in God's providence. Then, in the early years of the fifteenth century, Abbot Pierre le Roy plastered the gate of the Châtelet as you now see it, over the sunny thirteenth-century entrance called Belle Chaise which had treated mere military construction with a sort of quiet contempt. You will know what a Châtelet is when you meet another; it frowns in a spirit quite alien to the twelfth century; it jars on the religion of the place; it forebodes wars of religion; dissolution of society; loss of unity; the end of a world. Nothing is sadder than the catastrophe of gothic art, religion and hope.

One looks back on it all as a picture; a symbol of unity; an assertion of God and Man in a bolder, stronger, closer union than ever was expressed by other art; and when the idea is absorbed, accepted and perhaps partially understood, one

may move on.

IV

Normandy and the Ile de France

ROM MONT SAINT MICHEL, the architectural road leads across Normandy, up the Seine to Paris, and not directly through Chartres, which lies a little to the south. In the empire of architecture, Normandy was one kingdom, Brittany another; the Ile de France, with Paris was a third; Touraine and the valley of the Loire was a fourth; and in the centre, the fighting-ground between them all, lay the counties of Chartres and Dreux. Before going to Chartres one should go up the Seine and down the Loire, from Angers to Le Mans, and so enter Chartres from Brittany after a complete circle; but if we set out to do our pleasure on that scale, we must start from the Pyramid of Cheops. We have set out from Mont Saint Michel; we will go next to Paris.

The architectural highway lies through Coutances, Bayeux, Caen, Rouen and Mantes. Every great artistic kingdom solved its architectural problems in its own way, as it did its religious, political and social problems, and no two solutions were ever quite the same; but among them the Norman was commonly the most practical, and sometimes the most dignified. We can test this rule by the standard of the first town we stop at,—Coutances. We can test it equally well at Bayeux or Caen, but Coutances comes first after Mont Saint Michel; let us begin with it, and state the problems with their Norman solution, so that it may be ready at hand to compare with the French solution, before coming to the solution at

Chartres.

The Cathedral at Coutances is said to be about the age of the Merveille, (1200–1250), but the exact dates are unknown, and the work is so Norman as to stand by itself; yet the architect has grappled with more problems than one need hope to see solved in any single church in the Ile de France. Even at Chartres, although the two stone *flèches* are, by exception, completed, they are not of the same age, as they are here. Neither at Chartres nor at Paris, nor at Laon or Amiens or Reims or Bourges, will you see a central tower to compare

with the enormous pile at Coutances. Indeed the architects of France failed to solve this particular church-problem, and we shall leave it behind us in leaving Normandy, although it is the most effective feature of any possible church. "A clocher of that period (circa 1200), built over the croisée of a cathedral, following lines so happy, should be a monument of the greatest beauty; unfortunately we possess not a single one in France. Fire, and the hand of man more than time, have destroyed them all, and we find on our greatest religious edifices no more than bases and fragments of these beautiful constructions. The cathedral of Coutances alone has preserved its central clocher of the thirteenth century, and even there it is not complete; its stone flèche is wanting. As for its style it belongs to Norman architecture, and diverges widely from the character of French architecture." So says Viollet-le-Duc, but although the great churches for the most part never had central clochers which, on the scale of Amiens, Bourges or Beauvais, would have required an impossible mass, the smaller churches frequently carry them still, and they are, like the dome, the most effective features they can carry. They were made to dominate the whole.

No doubt the flèche is wanting at Coutances, but you can supply it in imagination from the two flèches of the western tower which are as simple and severe as the spear of a manat-arms. Supply the flèche, and the meaning of the tower cannot be mistaken; it is as military as the Chanson de Roland; it is the man-at-arms himself, mounted and ready for battle, spear in rest. The mere seat of the central tower astride of the church, so firm, so fixed, so serious, so defiant, is Norman, like the seat of the Abbey church on the Mount; and at Falaise where William the Bastard was born, we shall see a central tower on the church which is William himself, in armor, on horseback, ready to fight for the Church, and perhaps, in his bad moods, against it. Such militant churches were capable of forcing Heaven itself; all of them look as though they had fought at Hastings or stormed Jerusalem. Wherever the Norman central clocher stands, the Church Militant of the eleventh century survives; - not the Church of Mary Queen, but of Michael the Archangel; -not the Church of Christ, but of God the Father-who never lied!

Taken together with the flèches of the façade, this clocher of Coutances forms a group such as one very seldom sees. The two towers of the façade are something apart, quite by themselves among the innumerable church-towers of the gothic time. We have got a happy summer before us, merely in looking for these church-towers. There is no livelier amusement for fine weather than in hunting them as though they were mushrooms, and no study in architecture nearly so delightful. No work of man has life like the flèche. One sees it for a greater distance and feels it for a longer time than is possible with any other human structure, unless it be the dome. There is more play of light on the octagonal faces of the flèche as the sun moves around them than can be got out of the square or the cone or any other combination of surfaces. For some reason, the facets of the hexagon or octagon are more pleasing than the rounded surfaces of the cone, and Normandy is said to be peculiarly the home of this particularly gothic church ornament; yet clochers and flèches are scattered all over France until one gets to look for them on the horizon as though every church in every hamlet were an architectural monument. Hundreds of them literally are so,-Monuments Historiques,-protected by the government; but when you undertake to compare them, or to decide whether they are more beautiful in Normandy than in the Ile de France, or in Burgundy, or on the Loire or the Charente, you are lost. Even the superiority of the octagon is not evident to everyone. Over the little church at Fenioux on the Charente not very far from La Rochelle, is a conical steeple that an infidel might adore; and if you have to decide between provinces, you must reckon with the decision of architects and amateurs who seem to be agreed that the first of all flèches is at Chartres, the second at Vendome, not far from Blois in Touraine, and the third at Auxerre in Burgundy. The towers of Coutances are not in the list, nor are those at Bayeux nor those at Caen. France is rich in art. Yet the towers of Coutances are in some ways as interesting, if not as beautiful, as the best.

The two stone *flèches* here, with their octagon faces, do not descend, as in other churches, to their resting-place on a square tower, with the plan of junction more or less dis-

guised; they throw out nests of smaller flèches, and these cover buttressing corner-towers, with lines that go directly to the ground. Whether the artist consciously intended it or not, the effect is to broaden the façade and lift it into the air. The façade itself has a distinctly military look, as though a fortress had been altered into a church. A charming arcade at the top has the air of being thrown across in order to disguise the alteration, and perhaps owes much of its charm to the contrast it makes with the severity of military lines. Even the great west window looks like an afterthought; one's instinct asks for a blank wall. Yet, from the ground up to the cross on the spire, one feels the Norman nature throughout, animating the whole, uniting it all, and crowding into it an intelligent variety of original motives that would build a dozen churches of late gothic. Nothing about it is stereotyped or

conventional, - not even the conventionality.

If you have any doubts about this, you have only to compare the photograph of Coutances with the photograph of Chartres; and yet, surely, the façade of Chartres is severe enough to satisfy Saint Bernard himself. With the later fronts of Reims and Amiens, there is no field for comparison; they have next to nothing in common; yet Coutances is said to be of the same date with Reims or nearly so, and one can believe it when one enters the interior. The Normans, as they slowly reveal themselves, disclose most unexpected qualities; one seems to sound subterranean caverns of feeling hidden behind their iron nasals. No other cathedral in France or in Europe has an interior more refined, - one is tempted to use even the hard-worn adjective, more tender, -or more carefully studied. One test is crucial here and everywhere. The treatment of the apse and choir is the architect's severest standard. This is a subject not to be touched lightly; one to which we shall have to come back in a humble spirit, prepared for patient study, at Chartres; but the choir of Coutances is a cousin to that of Chartres, as the façades are cousins; Coutances like Chartres belongs to Notre Dame and is felt in the same spirit; the church is built for the choir and apse, rather than for the nave and transepts; for the Virgin rather than for the public. In one respect Coutances is even more delicate in the feminine charm of the Virgin's peculiar grace than Chartres, but

this was an afterthought of the fourteenth century. The system of chapels radiating about the apse was extended down the nave, in an arrangement "so beautiful and so rare," according to Viollet-le-Duc, that one shall seek far before finding its equal. Among the unexpected revelations of human nature that suddenly astonish historians, one of the least reasonable was the passionate outbreak of religious devotion to the ideal of feminine grace, charity and love that took place here in Normandy while it was still a part of the English kingdom, and flamed up into almost fanatical frenzy among the most hard-hearted and hard-headed race in Europe.

So in this church, in the centre of this arrangement of apse and chapels with their quite unusual—perhaps quite singular—grace, the four huge piers which support the enormous central tower, offer a tour de force almost as exceptional as the refinement of the chapels. At Mont Saint Michel, among the monks, the union of strength and grace was striking, but at Coutances it is exaggerated, like Tristan and Iseult,—a Roman of chivalry. The four "enormous" columns of the croisée, carry, as Viollet-le-Duc says, the "enormous octagonal tower,"—like Saint Christopher supporting the Christ-child, before the image of the Virgin, in her honor. Nothing like this can be seen at Chartres, or at any of the later palaces which France built for the pleasure of the Queen of Heaven.

We are slipping into the thirteenth century again; the temptation is terrible to feeble minds and tourist natures; but a great mass of twelfth and eleventh century work remains to be seen and felt. To go back is not so easy as to begin with it: the heavy round arch is like old cognac compared with the champagne of the pointed and fretted spire; one must not quit Coutances without making an excursion to Lessay on the road to Cherbourg, where is a church of the twelfth century, with a square tower and almost untouched Norman interior that closely repeats the Abbey Church at Mont Saint Michel. "One of the most complete models of romanesque architecture to be found in Normandy," says M. de Caumont. The central clocher will begin a photographic collection of square towers, to replace that which was lost on the Mount; and a second example is near Bayeux, at a small place called Cérisyla-Forêt, where the church matches that on the Mount, according to M. Corroyer; for Cérisy-la-Forêt was also an Abbey, and the church, built by Richard II, Duke of Normandy, at the beginning of the eleventh century was larger than that

on the Mount. It still keeps its central tower.

All this is intensely Norman, and is going to help very little in France; it would be more useful in England; but at Bayeux is a great Cathedral much more to the purpose, with two superb western towers crowned by stone flèches, cousins of those at Coutances, and distinctly related to the twelfthcentury flèche at Chartres. "The Normans," says Viollet-le-Duc. "had not that instinct of proportion which the architects of the Ile de France, Beauvais and Soissons possessed to a high degree; yet the boldness of their constructions, their perfect execution, the elevation of the flèches, had evident influence on the French school properly called, and that influence is felt in the old spire of Chartres." The Norman seemed to show distinction in another respect which the French were less quick to imitate. What they began, they completed. Not one of the great French churches has two stone spires complete, of the same age, while each of the little towns of Coutances, Baveux and Caen, contains its twin towers and flèches of stone, as solid and perfect now as they were seven hundred years ago. Still another Norman character is worth noting, because this is one part of the influence felt at Chartres. If you look carefully at the two western towers of the Bayeux Cathedral perhaps you will feel what is said to be the strength of the way they are built up. They rise from their foundation with a quiet confidence of line and support, which passes directly up to the weather-cock on the summit of the flèches. At the plane where the square tower is changed into the octagon spire, you will see the corner turrets and the long intermediate windows which effect the change without disguising it. One can hardly call it a device; it is so simple and evident a piece of construction that it does not need to be explained; yet you will have to carry a photograph of this flèche to Chartres, and from there to Vendome, for there is to be a great battle of flèches about this point of junction, and the Norman scheme is a sort of standing reproach to the French.

Coutances and Bayeux are interesting, but Caen is a romanesque Mecca. There William the Conqueror dealt with the same architectural problems, and put his solution in his Abbave-aux-Hommes, which bears the name of Saint Stephen. Queen Matilda put her solution into her Abbave-aux-Femmes, the church of the Trinity. One ought particularly to look at the beautiful central clocher of the church at Vaucelles in the suburbs: and one must drive out to Thaon to see its eleventh-century church with a charming romanesque blind arcade on the outside, and a little clocher "the more interesting to us." according to Viollet-le-Duc, "because it bears the stamp of the traditions of defense of the primitive towers which were built over the porches." Even "a sort of chemin de ronde" remains around the clocher, perhaps once provided with a parapet of defense. "C'est là, du reste, un charmant édifice." A tower with stone stèche which actually served for defense in a famous recorded instance, is that of the church at Secqueville, not far off; this beautiful tower, as charming as anything in Norman art, is known to have served as a fortress in 1105, which gives a valuable date. The pretty old romanesque front of the little church at Ouistreham, with its portal that seems to come fresh from Poitiers and Moissac, can be taken in, while driving past; but we must on no account fail to make a serious pilgrimage to Saint Pierre-sur-Dives, where the church-tower and flèche are not only classed among the best in Normandy, but have an exact date, 1145, and a very close relation with Chartres, as will appear. Finally, if for no other reason, at least for interest in Arlette, the tanner's daughter, one must go to Falaise, and look at the superb clocher of St. Gervais, which was finished and consecrated by 1135.

Some day, if you like, we can follow this romanesque style to the south, and on even to Italy where it may be supposed to have been born; but France had an architectural life fully a thousand years old when these twelfth-century churches were built, and was long since artistically, as she was politically independent. The Normans were new in France, but not the romanesque architecture; they only took the forms and stamped on them their own character. It is the stamp we want to distinguish, in order to trace up our lines of artistic ancestry. The Norman twelfth-century stamp was not easily effaced. If we have not seen enough of it at Mont St. Michel,

Coutances, Bayeux and Caen, we can go to Rouen, and drive out to Boscherville, and visit the ruined Abbey of Jumièges. Wherever there is a church-tower with a tall flèche as at Boscherville. Secqueville. St. Pierre-sur-Dives, Caen and Baveux. Viollet-le-Duc bids notice how the octagonal steeple is fitted on to the square tower. Always the passage from the octagon to the square seems to be quite simply made. The gothic or romanesque spire had the advantage that a wooden flèche was as reasonable a covering for it as a stone one, and the Normans might have indulged in freaks of form very easily, if they chose, but they seem never to have thought of it. The nearest approach to the freedom of wooden roofs is not in the lofty flèches, but in the covering of the great square central towers, like Falaise or Vaucelles, a huge four-sided roof which tries to be a flèche, and is as massive as the heavy structure it covers

The last of the Norman towers that Viollet-le-Duc insists upon is the so-called clocher de St. Romain, the northern tower on the west front of the Cathedral of Rouen. Unfortunately it has lost its primitive octagon flèche if it ever had one, but "the tower remains entire, and," according to Viollet-le-Duc, "is certainly one of the most beautiful in this part of France; it offers a mixture of the two styles of the Ile de France and of Normandy, in which the former element dominates"; it is of the same date as the old tower of Chartres, (1140-1160) and follows the same interior arrangement; "but here the petty, confused disposition of the Norman towers, with their division into stories of equal height, has been adopted by the French master builder, although in submitting to these local customs he has still thrown over his work the grace and finesse, the study of detail, the sobriety in projections, the perfect harmony between the profiles, sculpture and the general effect of the whole, which belong to the school he came from. He has managed his voids and solids with especial cleverness, giving the more importance to the voids, and enlarging the scale of his details, as the tower rose in height. These details have great beauty; the construction is executed in materials of small dimensions with the care that the twelfth-century architects put into their building; the profiles project little, and, in spite of their extreme finesse, produce much effect; the buttresses are skilfully planted and profiled. The staircase, which, on the east side, deranges the arrangement of the bays, is a chef-d'œuvre of architecture." This long panegyric, by Violletle-Duc, on French taste at the expense of Norman temper, ought to be read, book in hand, before the Cathedral of Rouen, with photographs of Bayeux to compare. Certain it is that the Normans and the French never talked quite the same language, but it is equally certain that the Norman language, to the English ear, expressed itself quite as clearly as the French, and sometimes seemed to have more to express.

The complaint of the French artist against the Norman, is the "mesquin" treatment of dividing his tower into stories of equal height. Even in the twelfth century and in religious architecture, artists already struggled over the best solution of this particularly American problem of the twentieth century, and when tourists return to New York, they may look at the twenty-story towers which decorate the city, to see whether the Norman or the French plan has won; but this, at least will be sure in advance:—the Norman will be the practical scheme which states the facts, and stops; while the French will be the graceful one, which states the beauties and more or less fits the facts to suit them. Both styles are great: both can sometimes be tiresome.

Here we must take leave of Normandy; a small place but one which, like Attica or Tuscany, has said a great deal to the world, and even goes on saying things—not often in the famous genre ennuyeux—to this day; for Gustave Flaubert's style is singularly like that of the Tour St. Romain and the Abbaye aux Hommes. Going up the Seine one might read a few pages of his letters, or of Madame de Bovary, to see how an old art transmutes itself into a new one, without changing its methods. Some critics have thought that at times Flaubert was mesquin like the Norman tower, but these are, as the French say, the defects of his qualities; we can pass over them, and let our eyes rest on the simplicity of the Norman flèche which pierces the line of our horizon.

The last of Norman art is seen at Mantes where there is a little church of Gassicourt that marks the furthest reach of the style. In arms as in architecture, Mantes barred the path of Norman conquest; William the Conqueror met his death here

in 1087. Geographically Mantes is in the Ile de France, less than forty miles from Paris. Architecturally, it is Paris itself; while, forty miles to the southward, is Chartres, an independent, or only feudally dependent country. No matter how hurried the architectural tourist may be, the boundary-line of the Ile de France is not to be crossed without stopping. If he came down from the north or east, he would have equally to stop—either at Beauvais, or at Laon, or Noyon, or Soissons,—because there is an architectural *Douane* to pass, and one's architectural baggage must be opened. Neither Notre Dame de Paris nor Notre Dame de Chartres is quite intelligible unless one has first seen Notre Dame de Mantes, and studied it in the sacred sources of M. Viollet-le-Duc.

Notre Dame de Mantes is a sister to the Cathedral of Paris. "built at the same time, perhaps by the same architect, and reproducing its general dispositions, its mode of structure, and some of its details"; but the Cathedral of Paris has been greatly altered, so that its original arrangement is quite changed, while the church at Mantes remains practically as it was, when both were new, about the year 1200. As nearly as the dates can be guessed, the Cathedral was finished up to its vaulting, in 1170, and was soon afterwards imitated on a smaller scale at Mantes. The scheme seems to have been unsatisfactory because of defects in the lighting, for the whole system of fenestration had been changed at Paris before 1230, naturally at great cost, since the alterations according to Viollet-le-Duc (Articles Cathedral and Rose, and allusions Triforium), left little except the ground-plan unchanged. To understand the Paris design of 1160-1170, which was a long advance from the older plans, one must come to Mantes; and, reflecting that the great triumph of Chartres was its fenestration, which must have been designed immediately after 1195, one can understand how, in this triangle of churches only forty or fifty miles apart, the architects, watching each other's experiments, were influenced, almost from day to day, by the failures or successes which they saw. The fenestration which the Paris architect planned in 1160-1170, and repeated at Mantes, 1190-1200, was wholly abandoned, and a new system introduced, immediately after the success of Chartres in 1210.

As they now stand, Mantes is the oldest. While conscien-

tiously trying to keep as far away as we can from technique, about which we know nothing and should care if possible still less if only ignorance would help us to feel what we do not understand, still the conscience is happier if it gains a little conviction, founded on what it thinks a fact. Even theologians-even the great theologians of the thirteenth century,—even Saint Thomas Aquinas himself—did not trust to faith alone, or assume the existence of God; and what Saint Thomas found necessary in philosophy, may also be a sure source of consolation in the difficulties of art. The church at Mantes is a very early fact in gothic art; indeed it is one of the earliest; for our purposes it will serve as the very earliest of pure gothic churches, after the Transition, and this we are

told to study in its windows.

Before one can get near enough fairly to mark the details of the facade, one sees the great rose window which fills a space nearly twenty-seven feet in width. Gothic fanatics commonly reckon the great rose windows of the thirteenth century as the most beautiful creation of their art, among the details of ornament; and this particular rose is the direct parent of that at Chartres, which is classic like the Parthenon, while both of them served as models or guides for that at Paris which dates from 1220, those in the north and south transepts at Reims, about 1230, and so on, from parent to child, till the rose faded forever. No doubt there were romanesque roses before 1200, and we shall see them, but this Rose of Mantes is the first gothic rose of great dimensions, and that from which the others grew; in its simplicity, its honesty, its large liberality of plan, it is also one of the best, if M. Violletle-Duc is a true guide; but you will see a hundred roses, first or last, and can choose as you would among the flowers.

More interesting than even the great Rose of the Portal is the remark that the same rose-motive is carried round the church throughout its entire system of fenestration. As one follows it, on the outside, one sees that all the windows are constructed on the same rose-scheme; but the most curious arrangement is in the choir inside the church. You look up to each of the windows through a sort of tunnel or telescope: an arch enlarging outwards, the roses at the end resembling "oeil-de-boeufs," "oculi." So curious is this arrangement that Viollet-le-Duc has shown it, under the head *Triforium*, in drawings and sections which anyone can study who likes; its interest to us is that this arrangement in the choir was probably the experiment which proved a failure in Notre Dame of Paris, and led to the tearing out the old windows and substituting those which still stand. Perhaps the rose did not give enough light, although the church at Mantes seems well-lighted, and even at Paris the rose-windows remain in the

transepts and in one bay of the nave.

All this is introduction to the windows of Chartres, but these three churches open another conundrum as one learns, bit by bit, a few of the questions to be asked of the forgotten middle-ages. The church-towers at Mantes are very interesting, inside and out; they are evidently studied with love and labor by their designer; yet they have no flèches. How happens it that Notre Dame at Paris also has no flèches, although the towers, according to Viollet-le-Duc, are finished in full preparation for them? This double omission on the part of the French architect seems exceedingly strange, because his rival at Chartres finished his flèche just when the architect of Paris and Mantes was finishing his towers (1175-1200). The Frenchman was certainly consumed by jealousy at the triumph never attained on anything like the same scale by any architect of the Ile de France; and he was actually engaged at the time on at least two flèches, close to Paris, one at Saint Denis, another of Saint Leu d'Esserent, which proved the active interest he took in the difficulties conquered at Chartres, and his perfect competence to deal with them.

Indeed one is tempted to say that these twin churches Paris and Mantes are the only French churches of the time (1200) which were left without a *flèche*. As we go from Mantes to Paris, we pass, about half way, at Poissy, under the towers of a very ancient and interesting church which has the additional merit of having witnessed the baptism of Saint Louis in 1215. Parts of the church at Poissy go back to the seventh and ninth centuries. The square base of the tower dates back before the time of Hugh Capet, to the Carolingian age, and belongs, like the square tower of Saint Germain-des-Prés at Paris, to the old defensive military architecture; but it has a later, stone *flèche* and it has too by exception a central octagonal *clocher*,

with a timber flèche which dates from near 1100. Paris itself has not much to show, but in the immediate neighborhood are a score of early churches with charming flèches, and at Etampes, about thirty-five miles to the south, is an extremely interesting church with an exquisite flèche, which may claim an afternoon to visit. That at Saint Leu d'Esserent is a still easier excursion, for one need only drive over from Chantilly a couple of miles. The fascinating old Abbey Church of Saint Leu looks down over the valley of the Oise, and is a sort of antechamber to Chartres, as far as concerns architecture. Its flèche, built towards 1160, - when that at Chartres was rising-is unlike any other, and shows how much the French architects valued their lovely French creation. On its octagonal faces, it carries upright batons, or lances, as a device for relieving the severity of the outlines; a device both intelligent and amusing, though it was never imitated. A little further from Paris, at Senlis, is another flèche which shows still more plainly the effort of the French architects to vary and elaborate the Chartres scheme. As for Laon, which is interesting throughout, and altogether the most delightful building in the Ile de France, the flèches are gone, but the towers are there, and you will have to study them, before studying those at Chartres, with all the intelligence you have to spare. They were the chef-d'œuvre of the mediæval architect, in his own opinion.

All this makes the absence of flèches at Paris and Mantes the more strange. Want of money was certainly not the cause, since the Parisians had money enough to pull their whole Cathedral to pieces at the very time when flèches were rising in half the towns within sight of them. Possibly they were too ambitious, and could find no design that seemed to satisfy their ambition. They took pride in their Cathedral, and they tried hard to make their shrine of Our Lady rival the great shrine at Chartres. Of course one must study their beautiful church, but this can be done at leisure, for, as it stands, it is later than Chartres and more conventional. Saint Germaindes-Prés leads more directly to Chartres; but perhaps the church most useful to know is no longer a church at all, but a part of the Museum of Arts et Métiers,—the desecrated Saint Martin-des-Champs, a name which shows that it dates

from a time when the present Porte Saint Martin was far out among fields. The choir of Saint Martin, which is all that needs noting, is said by M. Enlart to date from about 1150. Hidden in a remnant of old Paris near the Pont Notre Dame. where the student life of the middle ages was to be most turbulent and the Latin Quarter most renowned, is the little church of Saint Julien-le-Pauvre towards 1170. On the whole, further search in Paris would not greatly help us. If one is to pursue the early centuries, one must go further afield, for the schools of Normandy and the Ile de France were only two among half a dozen which flourished in the various provinces that were to be united in the kingdom of Saint Louis and his successors. We have not even looked to the south and east, whence the impulse came. The old Carolingian school, with its centre at Aix-la-Chapelle, is quite beyond our horizon. The Rhine had a great romanesque architecture of its own. One broad architectural tide swept up the Rhone and filled the Burgundian provinces as far as the water-shed of the Seine. Another lined the Mediterranean, with a centre at Arles. Another spread up the western rivers, the Charente and the Loire, reaching to Le Mans and touching Chartres. Two more lay in the centre of France, spreading from Perigord and Clermont in Auvergne. All these schools had individual character, and all have charm; but we have set out to go from Mont Saint Michel to Chartres in three centuries, the eleventh, twelfth and thirteenth, trying to get, on the way, not technical knowledge; not accurate information; not correct views either on history, art, or religion; not anything that can possibly be useful or instructive; but only a sense of what those centuries had to say, and a sympathy with their ways of saying it. Let us go straight to Chartres!

V

Towers and Portals

FOR A FIRST VISIT to Chartres, choose some pleasant morning when the lights are soft, for one wants to be welcome, and the Cathedral has moods, at times severe. At

best, the Beauce is a country none too gay.

The first glimpse that is caught, and the first that was meant to be caught, is that of the two spires. With all the education that Normandy and the Isle de France can give, one is still ignorant. The spire is the simplest part of the romanesque or gothic architecture, and needs least study in order to be felt. It is a bit of sentiment almost pure of practical purpose. It tells the whole of its story at a glance, and its story is the best that architecture had to tell, for it typified the aspirations of man at the moment when man's aspirations were highest. Yet nine persons out of ten, - perhaps ninety-nine in a hundred, - who come within sight of the two spires of Chartres will think it a jest if they are told that the smaller of the two, the simpler, the one that impresses them least, is the one which they are expected to recognise as the most perfect piece of architecture in the world. Perhaps the French critics might deny that they make any such absolute claim; in that case you can ask them what their exact claim is; it will always be high enough to astonish the tourist.

Astonished or not, we have got to take this southern spire of the Chartres Cathedral as the object of serious study, and before taking it as art, must take it as history. The foundations of this tower—always to be known as the old tower,—are supposed to have been laid in 1091, before the first crusade. The *flèche* was probably half a century later (1145–1170). The foundations of the new tower, opposite, were laid not before 1110, when also the Portal which stands between them, was begun with the three lancet windows above it, but not the Rose. For convenience, this old façade, including the Portal and the two towers, but not the *flèches*, and the three lancet windows, but not the Rose, may be dated as complete

about 1150.

Originally the whole Portal,—the three doors and the three lancets-stood nearly forty feet back, on the line of the interior foundation, or rear wall of the towers. This arrangement threw the towers forward, free on three sides, as at Poitiers, and gave room for a Parvis, before the Portal,—a Porch, roofed over, to protect the pilgrims who always stopped there to pray before entering the church. When the church was rebuilt after the great fire of 1194, and the architect was required to enlarge the interior, the old Portal and Lancets were moved bodily forward, to be flush with the front walls of the two towers, as you see the façade today; and the façade itself was heightened, to give room for the Rose, and to cover the loftier pignon and vaulting behind. Finally, the wooden roof, above the stone vault, was masked by the Arcade of Kings and its railing, completed in the taste of Philip the Hardy, who reigned from 1270 to 1285.

These changes have of course altered the values of all the parts. The Portal is injured by being thrown into a glare of light, when it was intended to stand in shadow, as you will see in the north and south Porches over the transept-portals. The towers are hurt by losing relief and shadow; but the old flèche is obliged to suffer the cruelest wrong of all by having its right shoulder hunched up by half of a huge Rose and the whole of a row of kings, when it was built to stand free, and to soar above the whole façade from the top of its second storey. One can easily figure it so, and replace the lost parts of the old façade, more or less at haphazard, from the front

of Noyon.

What an outrage it was, you can see by a single glance at the new *flèche* opposite. The architect of 1500 has flatly refused to submit to such conditions, and has insisted, with very proper self-respect, on starting from the balustrade of the arcade of kings, as his level. Not even content with that, he has carried up his square tower another lofty storey before he would consent to touch the heart of his problem, the conversion of the square tower into the octagon *flèche*. In doing this, he has sacrificed once more the old *flèche*; but his own tower stands free as it should.

At Vendome, when you go there, you will be in a way to appreciate still better what happened to the Chartres flèche;

for the clocher at Vendome, which is of the same date, - Viollet-le-Duc says earlier, and Enlart, "after 1130,"-stood, and still stands, free, like an Italian campanile, which gives it a vast advantage. The tower of St. Leu d'Esserent, also after 1130, stands free, above the second storey. Indeed, you will hardly find, in the long list of famous French spires, another which has been treated with so much indignity as this, the greatest and most famous of all; and perhaps the most annoying part of it is that you must be grateful to the architect of 1195 for doing no worse. He has on the contrary, done his best to show respect for the work of his predecessor, and has done so well that, handicapped as it is, the old tower still defies rivalry. Nearly three hundred and fifty feet high, or, to be exact, 106.50 metres from the church floor, it is built up with an amount of intelligence and refinement that leaves to unprofessional visitors no chance to think a criticism, - much less to express one. Perhaps—when we have seen more—and feel less-who knows? but certainly not now!

"The greatest, and surely the most beautiful monument of this kind that we possess in France," says Viollet-le-Duc; but although an ignorant spectator must accept the architect's decision on a point of relative merit, no one is compelled to accept his reasons, as final. "There is no need to dwell," he continues, "upon the beauty and the grandeur of composition in which the artist has given proof of rare sobriety where all the effects are obtained not by ornaments but by the just and skilful proportion of the different parts. The transition, so hard to adjust, between the square base and the octagon of the flèche, is managed and carried out with an address which

has not been surpassed in similar monuments."

One stumbles a little at the word "adresse." One never caught oneself using the word in Norman churches. Your photographs of Bayeux or Boscherville or Secqueville will show you at a glance whether the term "adresse" applies to them. Even Vendome would rather be praised for "droiture" than for "adresse." Whether the word address means cleverness, dexterity, adroitness, or simple technical skill, the thing itself is something which the French have always admired more than the Normans ever did. Viollet-le-Duc himself

seems to be a little uncertain whether to lay most stress on the one or the other quality:—

"If one tries to appreciate the conception of this tower," quotes the Abbé Bulteau (II, 84.), "one will see that it is as frank as the execution is simple and skilful. Starting from the bottom, one reaches the summit of the *flèche* without marked break; without anything to interrupt the general form of the building. This *clocher*, whose base is broad (*pleine*), massive and free from ornament, transforms itself, as it springs, into a sharp spire with eight faces, without its being possible to say where the massive construction ends and the light construction begins."

Granting, as one must, that this concealment of the transition is a beauty, one would still like to be quite sure that the Chartres scheme is the best. The Norman clochers being thrown out, and that at Vendome being admittedly simple, the clocher de Saint Jean on the church of Saint Germain at Auxerre seems to be thought among the next in importance, although it is only about one hundred and sixty feet in height (49 metres), and therefore hardly in the same class with Chartres. Any photograph shows that the Auxerre spire is also simple; and that at Etampes you have seen already to be of the Vendome rather than of the Chartres type. The clocher at Senlis is more "habile"; it shows an effort to be clever, and offers a standard of comparison; but the mediæval architects seem to have thought that none of them bore rivalry with Laon for technical skill. One of these professional experts, named Villard de Honnecourt, who lived between 1200 and 1250, left a note-book which you can see in the vitrines of the Bibliothèque Nationale in the Rue Richelieu, and which is the source of most that is known about the practical ideas of mediæval architects. He came to Chartres, and, standing here before the doors, where we are standing, he made a rough drawing, not of the tower but of the Rose, which was then probably new, since it must have been planned between 1195 and 1200. Apparently the tower did not impress him strongly, for he made no note of it; but on the other hand, when he went to Laon, he became vehement in praise of the cathedral tower there, which must have been then quite new: "I have

been in many countries, as you can find in this book. In no place have I ever such a tower seen as that of Laon. - I'ai esté en mult de tieres, si cum vus porés trover en cest livre. En aucun liu onques tel tor ne vi com est cele de Loon." The reason for this admiration is the same that Viollet-le-Duc gives for admiring the tower of Chartres, -the "adresse" with which the square is changed into the octagon. Not only is the tower itself changed into the flèche without visible junction. under cover of four corner tourelles, of open work, on slender columns, which start as squares; but the tourelles also convert themselves into octagons in the very act of rising, and end in octagon flèches that carry up-or once carried up-the lines of profile to the central flèches that soared above them. Clearly this device far surpassed in cleverness the scheme of Chartres. which was comparatively heavy and structural, the weights being adjusted for their intended work, while the transformation at Laon takes place in the air, and challenges discovery in defiance of one's keenest eyesight. "Regard . . . how the tourelles pass from one disposition to another, in rising! Meditate on it!"

The flèche of Laon is gone, but the tower and tourelles are still there to show what the architects of the thirteenth century thought their most brilliant achievement. One cannot compare Chartres directly with any of its contemporary rivals, but one can at least compare the old spire with the new one which stands opposite and rises above it. Perhaps you will like the new best. Built at a time which is commonly agreed to have had the highest standard of taste, it does not encourage tourist or artist to insist on setting up standards of their own against it. Begun in 1507, it was finished in 1517. The dome of St. Peter's at Rome, over which Bramante and Rafael and Michael Angelo toiled, was building at the same time; Leonardo da Vinci was working at Amboise; Jean Bullant, Pierre Lescot, and their patron Francis the First, were beginning their architectural careers. Four hundred years, or thereabouts, separated the old spire from the new one; and four hundred more separate the new one from us. If Viollet-le-Duc, who himself built Gothic spires, had cared to compare his flèches at Clermont-Ferrand with the new flèche at Chartres, he might perhaps have given us a rule where

"adresse" ceases to have charm, and where detail becomes tiresome; but in the want of a schoolmaster to lay down a law of taste, you can admire the new flèche as much as you please. Of course one sees that the lines of the new tower are not clean, like those of the old; the devices that cover the transition from the square to the octagon are rather too obvious; the proportion of the flèche to the tower quite alters the values of the parts; a rigid classical taste might even go so far as to hint that the new tower, in comparison with the old, showed signs of a certain tendency towards a dim and distant vulgarity. There can be no harm in admitting that the new tower is a little wanting in repose for a tower whose business is to counterpoise the very classic lines of the old one; but no law compels you to insist on absolute repose in any form of art; if such a law existed, it would have to deal with Michael Angelo before it dealt with us. The new tower has many faults, but it has great beauties, as you can prove by comparing it with other late Gothic spires including those of Violletle-Duc. Its chief fault is to be where it is. As a companion to the crusades and to Saint Bernard, it lacks austerity. As a companion to the Virgin of Chartres, it recalls Diane de Poitiers.

In fact, the new tower, which in years is four centuries younger than its neighbor, is in feeling fully four hundred years older. It is self-conscious if not vain; its coiffure is elaborately arranged to cover the effects of age, and its neck and shoulders are covered with lace and jewels to hide a certain sharpness of skeleton. Yet it may be beautiful, still; the poets derided the wrinkles of Diane de Poitiers at the very moment when King Henry II idealised her with the homage of a Don Quijote; an atmosphere of physical beauty and decay hangs about the whole renaissance.

One cannot push these resemblances too far, even for the twelfth century and the old tower. Exactly what date the old tower represents, as a social symbol, is a question that might be as much disputed as the beauty of Diane de Poitiers, and yet half the interest of architecture consists in the sincerity of its reflexion of the society that builds. In mere time, by actual date, the old tower represents the second crusade, and when, in 1150, Saint Bernard was elected chief of that crusade in this

very Cathedral, -or rather, in the Cathedral of 1120, which was burned,—the workmen were probably setting in mortar the stones of the flèche as we now see them; yet the flèche does not represent Saint Bernard in feeling, for Saint Bernard held the whole array of church towers in horror as signs merely of display, wealth and pride. The flèche rather represents Abbot Suger of Saint Denis, Abbot Peter the Venerable of Cluny, Abbot Abélard of Saint Gildas de Rhuys, and Oueen Eleanor of Guienne, who had married Louis le Jeune in 1137; who had taken the cross from Saint Bernard in 1147; who returned from the Holy Land in 1149; and who compelled Saint Bernard to approve her divorce in 1152. Eleanor and Saint Bernard were centuries apart, yet they lived at the same time and in the same church. Speaking exactly, the old tower represents neither of them; the new tower itself is hardly more florid than Eleanor was; perhaps less so, if one can judge from the fashions of the court-dress of her time. The old tower is almost Norman, while Eleanor was wholly Gascon, and Gascony was always florid without being always correct. The new tower, if it had been built in 1150, like the old one, would have expressed Eleanor perfectly, even in height and apparent effort to dwarf its mate, except that Eleanor dwarfed her husband without an effort, and both in art and in history the result lacked harmony.

Be the contrast what it may, it does not affect the fact that no other church in France has two spires that need be discussed in comparison with these. Indeed no other Cathedral of the same class has any spires at all, and this superiority of Chartres gave most of its point to a saying that "with the spires of Chartres, the choir of Beauvais, the nave of Amiens, and the façade of Reims," one could make a perfect church—

for us tourists.

The towers have taken much time, though they are the least religious and least complicated part of church architecture, and in no way essential to the church; indeed Saint Bernard thought them an excrescence due to pride and worldliness, and this is merely Saint Bernard's way of saying that they were an ornament created to gratify the artistic sense of beauty. Beautiful as they are, one's eyes must drop at last down to the church itself. If the spire symbolises aspiration,

the door symbolises the Way; and the Portal of Chartres is the type of French doors; it stands first in the history of gothic art; and, in the opinion of most gothic artists, first in the interest of all art, though this is no concern of ours. Here is the Way to Eternal Life as it was seen by the Church and the Art of the First Crusade!

The fortune of this monument has been the best attested Miracle de la Vierge in the long list of the Virgin's miracles, for it comes down, practically unharmed, through what may with literal accuracy be called the jaws of destruction and the flames of hell. Built sometime in the first half of the twelfth century, it passed, apparently unscathed, through the great fire of 1194 which burnt out the church behind, and even the timber-interior of the towers in front of it. Owing to the enormous mass of timber employed in the structure of the great churches, these recurrent fires were as destructive as fire can be made, yet not only the Portals with their statuary and carving, but also the lancet windows with their glass, escaped the flames; and, what is almost equally strange, escaped also the hand of the builder afterwards, who, if he had resembled other architects, would have made a new front of his own, but who, with piety unexampled, tenderly took the old stones down, one by one, and replaced them forty feet in advance of their old position. The English wars and the wars of religion brought new dangers, sieges and miseries; the revolution of 1792 brought actual rapine and waste; boys have flung stones at the saints; architects have wreaked their taste within and without; fire after fire has calcined the church vaults; the worst wrecker of all, the restaurer of the nineteenth century, has prowled about it; yet the Porch still stands, mutilated but not restored, burned but not consumed, as eloquent a witness to the power and perfections of Our Lady as it was seven hundred years ago, and perhaps more impressive.

You will see Portals and Porches more or less of the same period elsewhere in many different places,—at Paris, Le Mans, Sens, Autun, Vezelay, Clermont-Ferrand, Moissac, Arles,—a score of them; for the same piety has protected them more than once; but you will see no other so complete or so instructive, and you may search far before you will find another equally good in workmanship. Study of the Chartres

portal covers all the rest. The feeling and motive of all are nearly the same, or vary only to suit the character of the patron saint; and the point of all is that this feeling is the architectural child of the first crusade. At Chartres one can read the first crusade in the Portal, as at Mont Saint Michel in the

Aguilon and the Promenoir.

The Abbé Bulteau gives reason for assuming the year 1117 as the approximate date of the sculpture about the west Portal, and you saw at Mont Saint Michel, in the Promenoir of Abbot Roger II, an accurately dated work of the same decade; but whatever the date of the plan, the actual work and its spirit belong to 1145 or thereabouts. Some fifty years had passed since the crusaders streamed through Constantinople to Antioch and Jerusalem, and they were daily going and returning. You can see the ideas they brought back with the relics and missals and enamels they bought in Byzantium. Over the central door is the Christ, which might be sculptured after a Byzantine enamel, with its long nimbus or aureole or glory enclosing the whole figure. Over the left door is an Ascension, bearing the same stamp; and, over the right door, the seated Virgin, with her crown and her two attendant archangels, is an empress. Here is the Church, the Way, and the Life of the twelfth century that we have undertaken to feel, if not to understand!

First comes the central door-way, and above it is the glory of Christ, as the church at Chartres understood Christ in the year 1150; for the glories of Christ were many, and the Chartres Christ is one. Whatever Christ may have been in other churches, here, on this portal, he offers himself to his flock as the herald of salvation alone. Among all the imagery of these three door-ways, there is no hint of fear, punishment or damnation, and this is the note of the whole time. Before 1200, the Church seems not to have felt the need of appealing habitually to terror; the promise of hope and happiness was enough; even the Portal at Autun, which displays a Last Judgment, belonged to Saint Lazarus, the proof and symbol of Resurrection. A hundred years later, every church portal showed Christ not as Savior but as Judge, and he presided over a Last Judgment at Bourges and Amiens, and here on the south Portal, where the despair of the damned is the evident joy of the artist, if it is not even sometimes a little his jest, which is worse. At Chartres Christ is identified with his Mother, the spirit of love and grace, and his Church is the

Church Triumphant.

Not only is Fear absent; there is not even a suggestion of pain; there is not a martyr with the symbol of his martyrdom; and what is still more striking, in the sculptured life of Christ, from the Nativity to the Ascension, which adorns the capitals of the columns, the single scene that has been omitted is the Crucifixion. There, as everywhere in this Portal, the artists seem actually to have gone out of their way in order to avoid a suggestion of suffering. They have pictured Christ and his Mother in all the other events of their lives; they have represented Evangelists; Apostles; the twenty-four old men of the Apocalypse; saints, prophets, kings, queens and princes, by the score; the signs of the zodiac, and even the seven liberal arts: Grammar, Rhetoric, Dialectics, Arithmetic, Geometry, Astronomy and Music; everything is there except misery.

Perhaps Our Lady of Chartres was known to be peculiarly gracious and gentle, and this may partially account also for the extreme popularity of her shrine; but whatever the reason, her church was clearly intended to show only this side of her nature, and to impress it on her Son. You can see it in the grave and gracious face and attitude of the Christ, raising his hand to bless you as you enter his kingdom; in the array of long figures which line the entrance to greet you as you pass; in the expression of majesty and mercy of the Virgin herself on her throne above the southern doorway; never once are you regarded as a possible rebel, or traitor, or a stranger to be treated with suspicion, or as a child to be impressed by

fear.

Equally distinct, perhaps even more emphatic, is the sculptor's earnestness to make you feel, without direct insistence, that you are entering the Court of the Queen of Heaven who is one with her Son and his Church. The central door always bore the name of the Royal Door because it belonged to the celestial majesty of Christ, and naturally bears the stamp of royalty; but the south door belongs to the Virgin and to us. Stop a moment to see how she receives us, remembering, or trying to remember, that, to the priests and artists who de-

signed the Portal, and to the generations that went on the first and second crusades, the Virgin in her shrine was at least as living, as real, as personal an empress as the Basilissa at

Constantinople!

On the lintel immediately above the doorway is a succession of small groups:—first, the Annunciation; Mary stands to receive the Archangel Gabriel who comes to announce to her that she is chosen to be the mother of God. The second is the Visitation, and in this scene also Mary stands, but she already wears a crown;—at least, the Abbé Bulteau says so, although time has dealt harshly with it. Then, in the centre, follows the Nativity; Mary lies on a low bed, beneath, or before, a sort of table or cradle on which lies the infant, while Saint Joseph stands at the bed's head. Then the angel appears, directing three shepherds to the spot, filling the rest of the

space.

In correct theology, the Virgin ought not to be represented in bed, for she could not suffer like ordinary women, but her palace at Chartres is not much troubled by theology, and to her, as empress-mother, the pain of child-birth was a pleasure which she wanted her people to share. The Virgin of Chartres was the greatest of all Queens, but she was also the most womanly of women, as we shall see; and her double character is sustained throughout her palace. She was also intellectually gifted in the highest degree. In the upper zone you see her again, at the Presentation in the Temple, supporting the child Jesus on the altar, while Simeon aids. Other figures bring offerings. The voussures of the arch above contain six archangels, with curious wings, offering worship to the infant and his imperial mother. Below are the signs of the zodiac; the Fishes and the Twins. The rest of the arch is filled by the seven liberal arts, with Pythagoras, Aristotle, Cicero, Euclid, Nicomachus, Ptolemy and Priscian as their representatives, testifying to the Queen's intellectual superiority.

In the center sits Mary, with her crown on her head and her son in her lap, enthroned, receiving the homage of heaven and earth; of all time, ancient and modern; of all thought, Christian and Pagan; of all men, and all women; including, if you please, your homage and mine, which she receives without question, as her due; which she cannot be said to claim, because she is above making claims; she is empress. Her left hand bore a sceptre; her right supported the child, who looks directly forward, repeating the mother's attitude, and raises his right hand to bless, while his left rests on the orb of empire. She and her child are one.

All this was noble beyond the nobility of man, but its earthly form was inspired by the empire rather than by the petty royalty of Louis le Gros or his pious queen Alix of Savoy. One mark of the period is the long, oval nimbus; another is the imperial character of the Virgin; a third is her unity with the Christ which is the Church. To us, the mark that will distinguish the Virgin of Chartres, or, if you prefer, the Virgin of the Crusades, is her crown and robes and throne. According to M. Rohault de Fleury's "Iconographie de la Sainte Vierge," (ii, 62), the Virgin's head-dress and ornaments had been for long ages borrowed from the costume of the Empresses of the East in honor of the Queen of Heaven. No doubt the Virgin of Chartres was the Virgin recognised by the Empress Helena, mother of Constantine, and was at least as old as Helena's pilgrimage to Jerusalem in 326. She was not a western, feudal queen, nor was her son a feudal king; she typified an authority which the people wanted, and the fiefs feared; the Pax Romana; the omnipotence of God in government. In all Europe, at that time, there was no power able to enforce justice or to maintain order, and no symbol of such a power except Christ and his Mother and the imperial crown.

This idea is very different from that which was the object of our pilgrimage to Mont Saint Michel; but since all Chartres is to be one long comment upon it, you can lay the history of the matter on the shelf for study at your leisure, if you ever care to study into the weary details of human illusions and disappointments, while here we pray to the Virgin, and absorb ourselves in the art, which is your pleasure and which shall not teach either a moral or a useful lesson. The Empress Mary is receiving you at her portal, and whether you are an impertinent child, or a foolish old peasant-woman, or an insolent prince, or a more insolent tourist, she receives you with the same dignity; in fact, she probably sees very little difference between you. An empress of Russia today would

probably feel little difference in the relative rank of her subjects, and the Virgin was empress over emperors, patriarchs and popes. Anyone, however ignorant, can feel the sustained dignity of the sculptor's work, which is asserted with all the emphasis he could put into it. Not one of these long figures which line the three doorways but is an officer or official in attendance on the Empress or her Son, and bears the stamp of the imperial court. They are mutilated, but, if they have been treated with indignity, so were often their temporal rivals, torn to pieces, trampled on, to say nothing of being merely beheaded or poisoned, in the Sacred Palace and the Hippodrome, without losing that peculiar oriental dignity of style which seems to drape the least dignified attitudes. The grand air of the twelfth century is something like that of a Greek temple; you can, if you like, hammer every separate stone to pieces, but you cannot hammer out the Greek style. There were originally twenty-four of these statues, and nineteen remain. Beginning at the north end, and passing over the first figure, which carries a head that does not belong to it, notice the second, a king with a long sceptre of empire, a book of law, and robes of Byzantine official splendor. Beneath his feet is a curious woman's head with heavy braids of hair, and a crown. The third figure is a queen, charming as a woman, but particularly well-dressed, and with details of ornament and person elaborately wrought; worth drawing, if one could only draw; worth photographing with utmost care to include the strange support on which she stands; a monkey, two dragons, a dog, a basilisk with a dog's head. Two prophets follow-not so interesting; - prophets rarely interest. Then comes the central bay: two queens who claim particular attention, then a prophet, then a saint next the doorway; then on the southern jamb-shafts, another saint, a king, a queen, and another king. Last comes the southern bay, the Virgin's own, and there stands first a figure said to be a youthful king; then a strongly sculptured saint; next the door a figure called also a king, but so charmingly delicate in expression that the robes alone betray his sex; and who this exquisite young aureoled king may have been who stands so close to the Virgin, at her right hand, no one can now reveal. Opposite him is a saint who may be, or should be, the Prince

of the Apostles, then a bearded king with a broken sceptre, standing on two dragons; and, at last, a badly mutilated queen.

These statues are the Eginetan marbles of French art; from them all modern French sculpture dates, or ought to date. They are singularly interesting; as naif as the smile on the faces of the Greek warriors, but no more grotesque than they. You will see gothic grotesques in plenty, and you cannot mistake the two intentions; the twelfth century would sooner have tempted the tortures of every feudal dungeon in Europe than have put before the Virgin's eyes any figure that could be conceived as displeasing to her. These figures are full of feeling, and saturated with worship; but what is most to our purpose is the feminine side which they proclaim and insist upon. Not only the number of the female figures, and their beauty, but also the singularly youthful beauty of several of the males; the superb robes they wear; the expression of their faces and their figures; the details of hair, stuffs, ornaments, jewels; the refinement and feminine taste of the whole, are enough to startle our interest if we recognise what meaning they had to the twelfth-century.

These figures looked stiff and long and thin and ridiculous to enlightened citizens of the eighteenth century, but they were made to fit the architecture; if you want to know what an enthusiast thinks of them, listen to M. Huysmans' "Cathedral." "Beyond a doubt, the most beautiful sculpture in the world is in this place." He can hardly find words to express his admiration for the queens, and particularly for the one on the right of the central doorway. "Never in any period has a more expressive figure been thus wrought by the genius of man; it is the chef-d'œuvre of infantile grace and holy candor. . . . She is the elder sister of the Prodigal Son, the one, of whom Saint Luke does not speak, but who, if she existed, would have pleaded the cause of the absent, and insisted, with the father, that he should kill the fatted calf at his son's return." The idea is charming if you are the returning son, as many twelfth-century pilgrims must have thought themselves; but in truth, the figure is that of a queen; an Eleanor of Guienne; her position there is due to her majesty, which bears witness to the celestial majesty of the Court in which she is

only a lady-in-waiting: and she is hardly more humanly fascinating than her brother, the youthful king at the Virgin's right hand, who has nothing of the Prodigal son, but who certainly has much of Lohengrin, or even,—almost—Tristan.

The Abbé Bulteau has done his best to name these statues, but the names would be only in your way. That the sculptor meant them for a Queen of Sheba or a King of Israel has little to do with their meaning in the twelfth century, when the people were much more likely to have named them after the queens and kings they knew. The whole charm lies for us in the twelfth-century humanity of Mary and her Court; not in the scriptural names under which it was made orthodox. Here, in this western portal, it stands as the crusaders of 1100–1150 imagined it; but by walking round the church to the porch over the entrance to the north transept, you shall see it again as Blanche of Castile and Saint Louis imagined it, a hundred years later, so that you will know better whether

the earthly attributes are exaggerated or untrue.

Porches, like steeples, were rather a peculiarity of French churches, and were studied, varied, one might even say petted by French architects to an extent hardly attempted elsewhere; but among all the French porches, those of Chartres are the most famous. There are two; one on the north side, devoted to the Virgin; the other, on the south, devoted to the Son. "The mass of intelligence, knowledge, acquaintance with effects, practical experience, expended on these two porches of Chartres" says Viollet-le-Duc, "would be enough to establish the glory of a whole generation of artists." We begin with the north porch because it belonged to the Virgin; and it belonged to the Virgin because the north was cold, bleak, sunless, windy, and needed warmth, peace, affection and power to protect against the assaults of Satan and his swarming devils. There the all-suffering, but the all-powerful, Mother, received other mothers who suffered like her, but who, as a rule, were not powerful. Traditionally in the primitive church, the northern porch belonged to the women. When they needed help, they came here, because it was the only place in this world or in any other where they had much hope of finding even a reception. See how Mary received them!

The Porch extends the whole width of the transept, about

one hundred and twenty feet (37.65 metres), divided into three bays some twenty feet deep, and covered with a stone vaulted roof supported on piers outside. Begun towards 1215 under Philip Augustus, the architectural part was finished towards 1225 under Louis VIII; and after his death in 1226, the decorative work and statuary were carried on under the regency of his widow, Blanche of Castile, and through the reign of her son, Saint Louis (1235-1270), until about 1275, when the work was completed by Philip the Hardy. A gift of the royal family of France, all the members of the family seem to have had a share in building it, and several of their statues have been supposed to adorn it. The walls are lined,—the porch, in a religious sense, is inhabited—by more than seven hundred figures, great and small, all, in one way or another, devoted to the glory of the Queen of Heaven. You will see that a hundred years have converted the Byzantine Empress into a French Queen, as the same years had converted Alix of Savoy into Blanche of Castile; but the note of majesty is the same, and the assertion of power is, if possible, more emphatic.

The highest note is struck at once, in the central Bay, over the door, where you see the Coronation of Mary as Queen of Heaven, a favorite subject in art from very early times, and the dominant idea of Mary's church. You see Mary on the left, seated on her throne; on the right, seated on a precisely similar throne, is Christ, who holds up his right hand apparently to bless, since Mary already bears the crown. Mary bends forward, with her hands raised toward her Son, as though in gratitude or adoration or prayer, but certainly not in an attitude of feudal homage. On either side, an archangel

swings a censer.

On the lintel below, on the left, is represented the death of Mary; on the right, Christ carries, in the folds of his mantle, the soul of Mary in the form of a little child, and at the same time blesses the body which is carried away by angels,—the Resurrection of Mary.

Below the lintel, supporting it, and dividing the doorway in halves, is the *trumeau*,—the central pier—a new part of the portal which was unknown to the western door. Usually in the Virgin's churches, as at Reims or Amiens or Paris, the

Virgin herself with her Son in her arms, stands against this pier, trampling on the dragon with the woman's head. Here, not the Virgin with the Christ, but her mother Saint Anne stands, with the infant Virgin in her arms; while beneath, is, or was Saint Joachim, her husband, among his flocks, receiving from the Archangel Gabriel the Annunciation.

So at the entrance, the Virgin declares herself divinely Queen in her own right; divinely born; divinely resurrected from death, on the third day; seated by divine right on the throne of heaven, at the right hand of God, the Son, with

whom she is one.

Unless we feel this assertion of divine right in the Queen of Heaven, apart from the Trinity, yet one with it, Chartres is unintelligible. The extreme emphasis laid upon it at the church door shows what the church means within. Of course, the assertion was not strictly orthodox; perhaps, since we are not members of the Church, we might be unnoticed and unrebuked, if we start by suspecting that the worship of the Virgin never was strictly orthodox; but Chartres was hers before it ever belonged to the Church, and, like Lourdes in our own time, was a shrine peculiarly favored by her presence. The mere fact that it was a bishopric had little share in its sanctity. The bishop was much more afraid of Mary than he

was of any Church Council ever held.

Critics are doing their best to destroy the peculiar personal interest of this Porch, but tourists and pilgrims may be excused for insisting on their traditional rights here, since the Porch is singular, even in the thirteenth century, for belonging entirely to them and the royal family of France, subject only to the Virgin. True artists, turned critics, think also less of rules than of values, and no ignorant public can be trusted to join the critics in losing temper judiciously over the date or correctness of a portrait until they knew something of its motives and merits. The public has always felt certain that some of the statues which stand against the outer piers of this Porch are portraits, and they see no force in the objection that such decoration was not customary in the Church. Many things at Chartres were not customary in the Church, although the Church now prefers not to dwell on them. Therefore the student returns to Viollet-le-Duc with his usual

delight at finding at least one critic whose sense of values is stronger than his sense of rule:—"Each statue," he says in his Dictionary (iii, 166), "possesses its personal character which remains graven on the memory like the recollection of a living being whom one has known. . . A large part of the statues in the Porches of Notre Dame de Chartres, as well as of the Portals of the Cathedrals of Amiens and Reims, possess these individual qualities, and this it is which explains why these statues produce on the crowd so vivid an impression that it names them, knows them, and attaches to each of them an idea, often a legend."

Probably the crowd did so from the first moment they saw the statues, and with good reason. At all events they have attached to two of the most individual figures on the north Porch, two names, perhaps the best known in France in the year 1226, but which since the year 1300 can have conveyed only the most shadowy meaning to any but pure antiquarians. The group is so beautiful as to be given a plate to itself in the Monographie (No. 26), as representing Philip Hurepel and his wife Mahaut de Boulogne. So little could any crowd, or even any antiquarian, at any time within six hundred years, have been likely to pitch on just these persons to associate with Blanche of Castille in any kind of family unity, that the mere suggestion seems wild; yet Blanche outlived Pierre by nearly twenty years, and her power over this transept and Porch ended only with her death as regent in 1252.

Philippe nicknamed Hurepel—Boarskin—was a "fils de France," whose father, Philip Augustus, had serious, not to say fatal difficulties with the Church about the legality of his marriage, and was forced to abandon his wife, who died in 1201, after giving birth to Hurepel in 1200. The child was recognised as legitimate, and stood next to the throne, after his half-brother Louis, who was thirteen years older. Almost at his birth he was affianced to Mahaut, Countess of Boulogne, and the marriage was celebrated in 1216. Rich and strongly connected, Hurepel naturally thought himself,—and was,—head of the royal family next to the King, and when his half-brother, Louis VIII died in 1226, leaving only a son, afterwards St. Louis, a ten-year-old boy, to succeed, Hurepel very properly claimed the guardianship of his infant nephew, and

deeply resented being excluded by Queen Blanche from what he regarded,—perhaps with justice,—as his right. Nearly all the great lords and the members of the royal family sided with him, and entered into a civil war against Blanche, at the moment when these two Porches of Chartres were building, between 1228 and 1230. The two greatest leaders of the conspiracy were Hurepel, whom we are expected to recognise on the pier of this Porch, and Pierre Mauclerc of Brittany and Dreux whom we have no choice but to admit on the trumeau of the other. In those days every great feudal lord was more or less related by blood to the crown, and although Blanche of Castille was also a cousin as well as queen-mother, they hated her as a Spanish intruder with such hatred as men felt

in an age when passions were real.

That these two men should be found here, associated with Blanche in the same work, at the same time, under the same roof, is a fantastic idea, and students can feel in this political difficulty a much stronger objection to admitting Hurepel to Queen Blanche's Porch, than any supposed rule of church custom; yet the first privilege of tourist ignorance is the right to see, or try to see, their thirteenth century with thirteenth century eyes. Passing by the statues of Philip and Mahaut, and stepping inside the church door, almost the first figure that the visitor sees on lifting his eyes to the upper windows of the transept is another figure of Philippe Hurepel, in glass, on his knees, with clasped hands, before an altar; and to prevent possibility of mistake his blazoned coat bears the words: - "Phi: Conte de Bolone." Apparently he is the donor, for, in the rose above, he sits in arms on a white horse with a shield bearing the blason of France. Obliged to make his peace with the Queen in 1230, Hurepel died in 1233 or 1234, while Blanche was still regent, and instantly took his place as of right side by side with Blanche's castles of Castile among the great benefactors of the church.

Beneath the next rose is Mahaut herself, as donor, bearing her husband's arms of France, suggesting that the windows must have been given together, probably before Philip's death in 1233, since Mahaut was married again in 1238, this time to Alfonso of Portugal, who repudiated her in 1249, and left her to die in her own town of Boulogne in 1258. Lastly, in the third

window of the series, is her daughter Jeanne, - "Iehenne," -who was probably born before 1220, and who was married in 1236 to Gaucher de Chatillon, one of the greatest warriors of his time. Jeanne also, -according to the Abbé Bulteau (iii, 225)—bears the arms of her father and mother; which seems to suggest that she gave this window before her marriage. These three windows, therefore, have the air of dating at least as early as 1233 when Philip Hurepel died, while next them follow two more roses, and the great Rose of France, presumably of the same date, all scattered over with the Castles of Oueen Blanche. The motive of the Porch outside is repeated in the glass, as it should be, and as the Saint Anne of the Rose of France, within, repeats the Saint Anne on the trumeau of the Portal. The personal stamp of the royal family is intense, but the stamp of the Virgin's personality is intenser still. In the presence of Mary, not only did princes hide their quarrels, but they also put on their most courteous manners and the most refined and even austere address. The Byzantine display of luxury and adornment had vanished. All the figures suggest the sanctity of the King and his sister Isabel; the court has the air of a convent; but the idea of Mary's majesty is asserted through it all. The artists and donors and priests forgot nothing which, in their judgment could set off the authority, elegance and refinement of the Queen of Heaven; even the young ladies-in-waiting are there, figured by the twelve Virtues and the fourteen Beatitudes; and, indeed, though men are plenty and some of them are handsome, women give the tone, the charm, and mostly the intelligence. The court of Mary is feminine, and its charms are Grace and Love; perhaps even more grace than love, in a social sense, if you look at Beauty and Friendship among Beatitudes.

M. Huysmans insists that this sculpture is poor in comparison with his twelfth-century Prodigal Daughter, and I hope you can enter into the spirit of his enthusiasm; but other people prefer the thirteenth-century work, and think it equals the best Greek. Approaching, or surpassing this,—as you like—is the sculpture you will see at Reims, of the same period, and perhaps the same hands; but, for our purpose, the Queen of Sheba, here in the right-hand bay, is enough, because you can compare it on the spot with M. Huysmans' figure on the

western Portal, which may also be a Queen of Sheba, who, as spouse of Solomon, typified the Church, and therefore prefigured Mary herself. Both are types of court beauty and grace, one from the twelfth century, the other from the thirteenth, and you can prefer which you please; but you want to bear in mind that each, in her time, pleased the Virgin. You can even take for a settled fact, that these were the types of feminine beauty and grace which pleased the Virgin beyond all others.

The purity of taste, feeling and manners which stamps the art of these centuries, as it did the Court of Saint Louis and his mother, is something you will not wholly appreciate till you reach the depravity of the Valois; but still you can see how exquisite the Virgin's taste was, and how pure. You can also see how she shrank from the sight of pain. Here, in the central bay, next to King David who stands at her right hand, is the great figure of Abraham about to sacrifice Isaac. If there is one subject more revolting than another to a woman who typifies the Mother, it is this subject of Abraham and Isaac, with its compound horror of masculine stupidity and brutality. The sculptor has tried to make even this motive a pleasing one. He has placed Abraham against the column in the correct harshness of attitude, with his face turned aside and up, listening for his orders; but the little Isaac, with hands and feet tied, leans like a bundle of sticks against his father's knee with an expression of perfect faith and confidence, while Abraham's left hand quiets him and caresses the boy's face, with a movement that must have gone straight to Mary's heart, for Isaac always prefigured Christ.

The glory of Mary was not one of terror, and her Porch contains no appeal to any emotion but those of her perfect grace. If we were to stay here for weeks, we should find only this idea worked into every detail. The Virgin of the thirteenth century is no longer an Empress; she is Queen Mother,—an idealised Blanche of Castile;—too high to want, or suffer, or to revenge, or to aspire, but not too high to pity, to punish or to pardon. The women went to her Porch for help as naturally as babies to their mother; and the men, in her presence, fell on their knees because they feared

her intelligence and her anger.

Not that all the men showed equal docility! We must go next, round the church, to the south Porch, which was the gift of Pierre Mauclerc, Comte de Dreux, another member of the royal family, great-grandson of Louis VI, and therefore second cousin to Louis VIII and Philip Hurepel. Philip Augustus, his father's first cousin, married the young man, in 1212, to Alix, heiress of the Duchy of Brittany, and this marriage made him one of the most powerful vassals of the crown. He joined Philip Hurepel in resisting the regency of Queen Blanche in 1227, and Blanche, after a long struggle, caused him to be deposed in 1230. Pierre was obliged to submit, and was pardoned. Until 1236, he remained in control of the Duchy of Brittany, but then was obliged to surrender his power to his son, and turned his turbulent activity against the. infidels in Syria and Egypt, dying in 1250, on his return from Saint Louis' disastrous crusade. Pierre de Dreux was a masculine character, -a bad cleric, as his nickname Mauclerc testified, but a gentleman, a soldier, and a scholar, and, what is more to our purpose, a man of taste. He built the south Porch at Chartres, apparently as a memorial of his marriage with Alix in 1212, and the statuary is of the same date with that of the north Porch, but, like that, it was not finished when Pierre died in 1250.

One would like to know whether Pierre preferred to take the southern entrance, or whether he was driven there by the royal claim to the Virgin's favor. The southern Porch belongs to the Son, as the northern belongs to the Mother. Pierre never showed much deference to women, and probably felt more at his ease under the protection of the Son than of Mary; but in any case he showed as clearly as possible what he thought on this question of persons. To Pierre, Christ was first, and he asserted his opinion as emphatically as Blanche asserted hers.

Which Porch is the more beautiful is a question for artists to discuss and decide, if they can. Either is good enough for us, whose pose is ignorance, and whose pose is strictly correct; but apart from its beauty or its art, there is also the question of feeling, of motive, which puts the *Porche de Dreux* in contrast with the *Porche de France*, and this is wholly within our competence. At the outset, the central bay dis-

plays, above the doorway, Christ, on a throne, raising his hands to show the stigmata, the wounds which were the proof of man's salvation. At his right hand sits the Mother, without her crown; on his left, in equal rank with the mother, sits Saint John the Evangelist. Both are in the same attitude of supplication as intercessors; there is no distinction in rank or power between Mary and John, since neither has any power except what Christ gives them. Pierre did not, indeed, put the Mother on her knees before the Son, as you can see her at Amiens and in later churches.—certainly bad taste in Mary's own palace,—but he allowed her no distinction which is not her strict right. The angels above and around bear the symbols of the Passion; they are unconscious of Mary's presence; they are absorbed in the perfections of the Son. On the lintel just below is the Last Judgment, where Saint Michael reappears, weighing the souls of the dead which Mary and John above are trying to save from the strict justice of Christ. The whole melodrama of church terrors appears after the manner of the thirteenth century, on this church-door, without regard to Mary's feelings; and below, against the trumeau, stands the great figure of Christ—the whole Church,-trampling on the lion and dragon. On either side of the doorway stand six great figures of the Apostles asserting themselves as the columns of the Church, and looking down at us with an expression no longer calculated to calm our fears or encourage extravagant hopes. No figure on this Porch suggests a portrait or recalls a memory.

Very grand indeed is this doorway; dignified, impressive and masculine to a degree seldom if ever equalled in art; and the left bay rivals it. There, in the tympanum, Christ appears again; standing; bearing on his head the crown royal; alone, except for the two angels who adore, and surrounded only by the martyrs, his witnesses. The right bay is devoted to Saint Nicholas and the Saints Confessors who bear witness to the authority of Christ in faith. Of the twenty-eight great figures, the officers of the royal court, who make thus the strength of the Church beneath Christ, not one is a woman. The masculine orthodoxy of Pierre Mauclerc has spared neither sex nor youth; all are of a maturity which chills the blood, excepting two, whose youthful beauty is heightened by the severity of

their surroundings, so that the Abbé Bulteau makes bold even to say, that "the two statues of Saint George and of Saint Theodore may be regarded as the most beautiful of our Cathedral, perhaps even as the two master-pieces of statuary at the end of the thirteenth-century." On that point, let everyone follow his taste; but one reflexion at least seems to force itself on the mind in comparing these twenty-eight figures. Certainly the sword, however it may compare with the pen in other directions, is in art more powerful than all the pens, or volumes, or crosiers ever made. Your Golden Legend and Roman Breviary are here the only guide-books worth consulting, and the stories of young George and Theodore stand there recorded; as their miracle under the walls of Antioch during the first Crusade, is matter of history; but among these magnificent figures one detects at a glance that it is not the religion or sacred purity of the subject, or even the miracles or the sufferings, which inspire passion for Saint George and Saint Theodore, under the Abbé's robe; it is with him, as with the plain boy and girl, simply youth, with lance and sword and shield.

These two figures stand in the outer embrasures of the left bay, where they can be best admired, and perhaps this arrangement shows what Perron de Dreux, as he was commonly called, loved most, in his heart of hearts; but elsewhere, even in this porch, he relaxed his severity, and became at times almost gracious to women. Good judges have, indeed, preferred this Porch to the northern one; but, be that as you please, it contains seven hundred and eighty-three figures, large and small, to serve for comparison. Among these, the female element has its share, though not a conspicuous one; and even the Virgin gets her rights, though not beside her son. To see her, you must stand outside in the square, and with a glass, look at the central pignon, or gable, of the Porch. There, just above the point of the arch, you will see Mary on her throne, crowned, wearing her royal robes, and holding the child on her knees, with the two archangels on either side offering incense. Pierre de Dreux, or some one else, admitted at last that she was Queen Regent, although evidently not eager to do so; and if you turn your glass up to the gable of the transept itself, above the great rose and the

colonnade over it, you can see another and a colossal statue of the Virgin, but standing, with the child on her left arm. She seems to be crowned, and to hold the globe in her right hand; but the Abbé Bulteau says it is a flower. The two archangels are still there. This figure is thought to have been a part of the finishing decoration added by Philip the Fair in

1304.

In theology, Pierre de Dreux seems to show himself a more learned clerk than his cousins of France, and, as an expression of the meaning the Church of Mary should externally display, the Porche de Dreux, if not as personal, is as energetic as the Porche de France or the western Portal. As we pass into the Cathedral, under the great Christ on the trumeau you must stop to look at Pierre himself. A bridegroom, crowned with flowers on his wedding-day, he kneels in prayer, while two servants distribute bread to the poor. Below, you see him again, seated with his wife Alix before a table with one loaf, assisting at the meal they give to the poor. Pierre kneels to God; he and his wife bow before the Virgin and the poor;—but not to Oueen Blanche!

Now let us enter!—

VI

The Virgin of Chartres

WE MUST TAKE ten minutes to accustom our eyes to the light, and we had better use them to seek the reason why we come to Chartres rather than to Reims or Amiens or Bourges, for the cathedral that fills our ideal. The truth is, there are several reasons; there generally are, for doing the things we like; and after you have studied Chartres to the ground, and got your reasons settled, you will never find an antiquarian to agree with you; the architects will probably listen to you with contempt; and even these excellent priests, whose kindness is great, whose patience is heavenly, and whose good opinion you would so gladly gain, will turn from you with pain, if not with horror. The gothic is singular in this; one seems easily at home in the renaissance; one is not too strange in the Byzantine; as for the Roman, it is ourselves; and we could walk blindfolded through every chink and cranny of the Greek mind; all these styles seem modern when we come close to them; but the gothic gets away. No two men think alike about it, and no woman agrees with either man. The Church itself never agreed about it, and the architects agree even less than the priests. To most minds it casts too many shadows; it wraps itself in mystery; and when people talk of mystery, they commonly mean fear. To others, the gothic seems hoary with age and decrepitude, and its shadows mean death. What is curious to watch is the fanatical conviction of the gothic enthusiast, to whom the twelfth century means exuberant youth, the eternal child of Wordsworth, over whom its immortality broods like the day; it is so simple and yet so complicated; it sees so much and so little; it loves so many toys and cares for so few necessities; its youth is so young, its age so old, and its youthful yearning for old thought is so disconcerting, like the mysterious senility of the baby that:-

> Deaf and silent, reads the eternal deep, Haunted forever by the eternal mind.

One need not take it more seriously than one takes the baby itself. Our amusement is to play with it, and to catch its meaning in its smile; and whatever Chartres may be now, when young it was a smile. To the Church no doubt its cathedral here has a fixed and administrative meaning, which is the same as that of every other bishop's seat and with which we have nothing whatever to do. To us, it is a child's fancy; a toy-house to please the Queen of Heaven,—to please her so much that she would be happy in it,—to charm her till she smiled.

The Queen Mother was as majestic as you like; she was absolute; she could be stern; she was not above being angry; but she was still a woman, who loved grace, beauty, ornament, -her toilette, robes, jewels; -who considered the arrangements of her palace with attention, and liked both light and color; who kept a keen eye on her Court, and exacted prompt and willing obedience from King and Archbishops as well as from beggars and drunken priests. She protected her friends and punished her enemies. She required space, beyond what was known in the courts of Kings, because she was liable at all times to have ten thousand people begging her for favors,-mostly inconsistent with law-and deaf to refusal. She was extremely sensitive to neglect, to disagreeable impressions, to want of intelligence in her surroundings. She was the greatest artist, as she was the greatest philosopher and musician and theologist, that ever lived on earth, except her Son, who, at Chartres, is still an infant under her guardianship. Her taste was infallible; her sentence eternally final. This church was built for her in this spirit of simple-minded, practical, utilitarian faith, - in this singleness of thought, exactly as a little girl sets up a doll-house for her favorite blonde doll. Unless you can go back to your dolls, you are out of place here. If you can go back to them, and get rid for one small hour of the weight of custom, you shall see Chartres in glory.

The palaces of earthly Queens were hovels compared with these palaces of the Queen of Heaven at Chartres, Paris, Laon, Noyon, Reims, Amiens, Rouen, Bayeux, Coutances,—a list that might be stretched into a volume. The nearest approach we have made to a palace was the Merveille at Mont Saint Michel, but no Queen had a palace equal to that. The Mer-

veille was built, or designed, about the year 1200; towards the year 1500 Louis XI built a great castle at Loches in Touraine, and there Queen Anne de Bretagne had apartments which still exist, and which we will visit. At Blois you shall see the residence which served for Catherine de Medicis till her death in 1589. Anne de Bretagne was trebly Queen, and Catherine de Medicis took her standard of comfort from the luxury of Florence. At Versailles you can see the apartments which the Queens of the Bourbon line occupied through their century of magnificence. All put together, and then trebled in importance, could not rival the splendor of any single Cathedral dedicated to Queen Mary in the thirteenth century; and of them all, Chartres was built to be peculiarly and exceptionally her delight.

One has grown so used to this sort of loose comparison, this reckless waste of words, that one no longer adopts an idea, unless it is driven in with hammers of statistics and columns of figures. With the irritating demand for literal exactness and perfectly straight lines which lights up every truly American eve, you will certainly ask when this exaltation of Mary began, and unless you get the dates, you will doubt the facts. It is your own fault if they are tiresome; you might easily read them all in the "Iconographie de la Sainte Vierge" by M. Rohault de Fleury, published in 1878. You can start at Byzantium with the Empress Helena in 326, or with the Council of Ephesus in 431. You will find the Virgin acting as the patron saint of Constantinople and of the imperial residence, under as many names as Artemis or Aphrodite had borne. As God-mother (Θεομητηρ), Deipara (Θεοτοκος), Path-finder ('Οδηγητρια), she was the chief favorite of the eastern empire, and her picture was carried at the head of every procession and hung on the wall of every hut and hovel, as it is still wherever the Greek Church goes. In the year 610, when Heraclius sailed from Carthage to dethrone Phocas at Constantinople, his ships carried the image of the Virgin at their mast-heads. In 1143, just before the flèche on the Chartres clocher was begun, the Basileus John Comnenus died, and so devoted was he to the Virgin that, on a triumphal entry into Constantinople, he put the image of the Mother of God in his chariot, while he himself walked. In the western Church

the Virgin had always been highly honored, but it was not until the crusades that she began to overshadow the Trinity itself. Then her miracles became more frequent and her shrines more frequented, so that Chartres, soon after 1100, was rich enough to build its western Portal with Byzantine splendor. A proof of the new outburst can be read in the story of Citeaux. For us, Citeaux means Saint Bernard, who joined the Order in 1112, and in 1115 founded his Abbev of Clairvaux in the territory of Troyes. In him the religious emotion of the half-century between the first and second crusades (1095-1145) centred as in no one else. He was a French precursor of Saint Francis of Assisi who lived a century later. If we were to plunge into the story of Citeaux and Saint Bernard we should never escape, for Saint Bernard incarnates what we are trying to understand, and his mind is further from us than the architecture. You would lose hold of everything actual, if you could comprehend in its contradictions the strange mixture of passion and caution, the austerity, the self-abandonment, the vehemence, the restraint, the love, the hate, the miracles and the scepticism of Saint Bernard. The Cistercian Order, which was founded in 1098, from the first put all its churches under the special protection of the Virgin, and Saint Bernard in his time was regarded as the apple of the Virgin's eye. Tradition as old as the twelfth century, which long afterwards gave to Murillo the subject of a famous painting, told that once, when he was reciting before her statue the "Ave Maris Stella," and came to the words, "Monstra te esse Matrem," the image, pressing its breast, dropped on the lips of her servant three drops of the milk which had nourished the Savior. The same miracle, in various forms, was told of many other persons, both saints and sinners; but it made so much impression on the mind of the age, that, in the fourteenth century, Dante, seeking in Paradise for some official introduction to the foot of the throne, found no intercessor with the Queen of Heaven more potent than Saint Bernard. You can still read Bernard's hymns to the Virgin, and even his sermons, if you like. To him she was the great mediator. In the eyes of a culpable humanity, Christ was too sublime, too terrible, too just, but not even the weakest human frailty could fear to approach his Mother. Her attribute

was humility; her love and pity were infinite. "Let him deny your mercy who can say that he has ever asked it in vain."

Saint Bernard was emotional and to a certain degree mystical, like Adam de Saint Victor, whose hymns were equally famous, but the emotional saints and mystical poets were not by any means allowed to establish exclusive rights to the Virgin's favor. Abélard was as devoted as they were, and wrote hymns as well. Philosophy claimed her, and Albert the Great, the head of scholasticism, the teacher of Thomas Aquinas, decided in her favor the question: "Whether the Blessed Virgin possessed perfectly the seven liberal arts." The Church at Chartres had decided it a hundred years before by putting the seven liberal arts next her throne, with Aristotle himself to witness; but Albertus gave the reason: "I hold that she did, for it is written 'Wisdom has built herself a house, and has sculptured seven columns.' That house is the blessed Virgin; the seven columns are the seven liberal arts. Mary therefore had perfect mastery of science." Naturally she had also perfect mastery of economics, and most of her great churches were built in economic centres. The guilds were, if possible, more devoted to her than the monks; the bourgeoisie of Paris, Rouen, Amiens, Laon, spend money by millions to gain her favor. Most surprising of all, the great military class was perhaps the most vociferous. Of all inappropriate haunts for the gentle, courteous, pitying Mary, a field of battle seems to be the worst, if not distinctly blasphemous; yet the greatest French warriors insisted on her leading them into battle, and in the actual mêlée when men were killing each other, on every battle-field in Europe, for at least five hundred years, Mary was present, leading both sides. The battle-cry of the famous Constable du Guesclin was Notre Dame Guesclin; Notre Dame Coucy was the cry of the great Sires de Coucy; Notre Dame Auxerre; Notre Dame Sancerre; Notre Dame Hainault; Notre Dame Gueldres; Notre Dame Bourbon; Notre Dame Bearn; - all well-known battle-cries. The King's own battle at one time cried Notre Dame Saint Denis Montjoie; the Dukes of Burgundy cried Notre Dame Bourgogne; and even the soldiers of the Pope were said to cry Notre Dame Saint Pierre.

The measure of this devotion which proves to any religious

American mind, beyond possible cavil, its serious and practical reality, is the money it cost. According to statistics, in the single century between 1170 and 1270, the French built eighty cathedrals and nearly five hundred churches of the cathedral class, which would have cost, according to an estimate made in 1840, more than five milliards to replace. Five thousand million francs is a thousand million dollars, and this covered only the great churches of a single century. The same scale of expenditure had been going on since the year 1000, and almost every parish in France had rebuilt its church in stone; to this day France is strewed with the ruins of this architecture, and yet the still preserved churches of the eleventh and twelfth centuries alone, the churches that belong to the romanesque and transition periods, are numbered by hundreds until they reach well into the thousands. The share of this capital which was, - if one may use a commercial figure, invested in the Virgin, cannot be fixed, any more than the total sum given to religious objects between 1000 and 1300; but in a spiritual and artistic sense, it was almost the whole, and expressed an intensity of conviction never again reached by any passion, whether of religion, of lovalty, of patriotism, or of wealth; perhaps never even paralleled by any single economic effort, except in war. Nearly every great church of the twelfth and thirteenth centuries belonged to Mary, until in France one asks for the church of Notre Dame as though it meant Cathedral; but, not satisfied with this, she contracted the habit of requiring in all churches a chapel of her own. called in English the Lady Chapel, which was apt to be as large as the church but was always meant to be handsomer; and there, behind the High Altar, in her own private apartment, Mary sat, receiving her innumerable suppliants, and ready at any moment to step up upon the High Altar itself to support the tottering authority of the local saint.

Expenditure like this rests invariably on an economic idea. Just as the French of the nineteenth century invested their surplus capital in a railway-system in the belief that they would make money by it in this life, in the thirteenth they trusted their money to the Queen of Heaven because of their belief in her power to repay it with interest in the life to come. The investment was based on the power of Mary as

Queen rather than on any orthodox church-conception of the Virgin's legitimate station. Papal Rome never greatly loved Byzantine Empresses or French Queens. The Virgin of Chartres was never wholly sympathetic to the Roman Curia. To this day the church writers,—like the Abbé Bulteau or M. Rohault de Fleury—are singularly shy of the true Virgin of Majesty, whether at Chartres or at Byzantium or wherever she is seen. The Fathers Martin and Cahier at Bourges alone felt her true value. Had the Church controlled her, the Virgin would perhaps have remained prostrate at the foot of the Cross. Dragged by a Byzantine court, backed by popular insistence and impelled by overpowering self-interest, the Church accepted the Virgin throned and crowned, seated by Christ, the Judge throned and crowned; but even this did not wholly satisfy the French of the thirteenth century who seemed bent on absorbing Christ in his Mother, and making the Mother the Church, and Christ the Symbol. ·

The Church had crowned and enthroned her almost from the beginning, and could not have dethroned her if it would. In all Christian art,—sculpture or mosaic, painting or poetry,—the Virgin's rank was expressly asserted. Saint Bernard like John Comnenus, and probably at the same time (1120–1140) chanted hymns to the Virgin as Queen:

O salutaris Virgo Stella Maris Generans prolem, Aequitatis solem, Lucis auctorem, Retinens pudorem, Suscipe laudem!

Coeli Regina Per quam medicina Datur aegrotis, Gratia devotis, Gaudium moestis, Mundo lux cœlestis, Spesque salutis;

Aula regalis, Virgo specialis, Posce medelam Nobis et tutelam, Suscipe vota, Precibusque cuncta Pelle molesta! O savior Virgin, Star of Sea, Who bore for child the Sun of Justice, The source of Light, Virgin always Hear our praise!

Queen of Heaven who have given Medicine to the sick, Grace to the devout, Joy to the sad, heaven's light to the world And hope of salvation;

Court royal, Virgin typical, Grant us cure and guard, Accept our vows, and by prayers Drive all griefs away!

As the lyrical poet of the twelfth century, Adam de Saint Victor seems to have held rank higher, if possible than that of Saint Bernard, and his hymns on the Virgin are certainly quite as emphatic an assertion of her majesty:

Imperatrix supernorum!
Superatrix infernorum!
Eligenda via cœli,
Retinenda spe fideli,
Separatos a te longe
Revocatos ad te junge
Tuorum collegio!

Empress of the highest,
Mistress over the lowest,
Chosen path of heaven,
Held fast by faithful hope,
Those separated from you far,
Recalled to you, unite
In your fold!

To delight in the childish jingle of the mediæval Latin is a sign of a futile mind, no doubt, and I beg pardon of you and of the Church for wasting your precious summer day on poetry which was regarded as mystical in its age and which now sounds like a nursery rhyme; but a verse or two of Adam's hymn on the Assumption of the Virgin completes the record of her rank, and goes to complete also the documentary proof of her Majesty at Chartres:

Salve, Mater Salvatoris!
Vas electum! Vas honoris!
Vas cœlestis Gratiae!
Ab aeterno Vas provisum!
Vas insigne! Vas excisum
Manu sapientiae!

Salve, Mater pietatis, Et totius Trinitatis Nobile Triclinium! Verbi tamen incarnati Speciale majestati Praeparans hospitium!

O Maria! Stella maris!
Dignitate singularis,
Super omnes ordinaris
Ordines cœlestium!
In supremo sita poli
Nos commenda tuae proli,
Ne terrores sive doli
Nos supplantent hostium!

Mother of our Savior, hail!
Chosen vessel! Sacred Grail!
Font of celestial grace!
From eternity forethought!
By the hand of Wisdom wrought!
Precious, faultless Vase!

Hail, Mother of Divinity!
Hail, Temple of the Trinity!
Home of the Triune God!
In whom the incarnate word had birth,
The King! to whom you gave on earth
Imperial abode.

Oh, Maria! Constellation!
Inspiration! Elevation!
Rule and Law and Ordination
Of the angels' host!
Highest height of God's Creation,
Pray your Son's commiseration,
Lest, by fear or fraud, salvation
For our souls be lost!

Constantly—one might better say at once, officially, she was addressed in these terms of supreme majesty:—Imperatrix supernorum! Cœli Regina! Aula regalis! but the twelfth century seemed determined to carry the idea out to its logical conclusion in defiance of dogma. Not only was the Son absorbed in the Mother, or represented as under her guardian-

ship, but the Father fared no better, and the Holy Ghost followed. The poets regarded the Virgin as the "Templum Trinitatis;" "totius Trinitatis nobile Triclinium." She was the Refectory of the Trinity—the "Triclinium"—because the Refectory was the largest room and contained the whole of the members, and was divided in three parts by two rows of columns. She was the "Templum Trinitatis," the Church itself, with its triple aisle. The Trinity was absorbed in her.

This is a delicate subject in the Church, and you must feel it with delicacy, without brutally insisting on its necessary contradictions. All theology and all philosophy are full of contradictions quite as flagrant and far less sympathetic. This particular variety of religious faith is simply human, and has made its appearance in one form or another in nearly all religions; but though the twelfth century carried it to an extreme, and at Chartres you see it in its most charming expression, we have got always to make allowances for what was going on beneath the surface in men's minds, consciously or unconsciously, and for the latent scepticism which lurks behind all faith. The Church itself never quite accepted the full claims of what was called Mariolatry. One may be sure, too, that the bourgeois capitalist and the student of the schools, each from his own point of view, watched the Virgin with anxious interest. The bourgeois had put an enormous share of his capital into what was in fact an economical speculation, not unlike the South Sea Scheme, or the railway system of our own time; except that in one case the energy was devoted to shortening the road to Heaven; in the other, to shortening the road to Paris; but no serious schoolman could have felt entirely convinced that God would enter into a business partnership with man, to establish a sort of joint-stock society for altering the operation of divine and universal laws. The bourgeois cared little for the philosophical doubt, if the economical result proved to be good, but he watched this result with his usual practical sagacity, and required an experience of only about three generations (1200-1300) to satisfy himself that relics were not certain in their effects; that the Saints were not always able or willing to help; that Mary herself could not certainly be bought or bribed; that prayer without money seemed to be quite as efficacious as prayer with

money; and that neither the road to Heaven nor Heaven itself had been made surer or brought nearer by an investment of capital which amounted to the best part of the wealth of France. Economically speaking, he became satisfied that his enormous money-investment had proved to be an almost total loss, and the reaction on his mind was as violent as the emotion. For three hundred years it prostrated France. The efforts of the *hourgeoisie* and the peasantry to recover their property so far as it was recoverable, have lasted to the present day and we had best take care not to get mixed in those

passions.

If you are to get the full enjoyment of Chartres, you must, for the time, believe in Mary as Bernard and Adam did, and feel her presence as the architects did, in every stone they placed, and every touch they chiseled. You must try first to rid your mind of the traditional idea that the gothic is an intentional expression of religious gloom. The necessity for light was the motive of the gothic architects. They needed light and always more light, until they sacrificed safety and common-sense in trying to get it. They converted their walls into windows, raised their vaults, diminished their piers, until their churches could no longer stand. You will see the limit at Beauvais; at Chartres we have not got so far, but even here in places where the Virgin wanted it—as above the high altar—the architect has taken all the light there was to take. For the same reason, fenestration became the most important part of the gothic architect's work, and at Chartres was uncommonly interesting because the architect was obliged to design a new system, which should at the same time satisfy the laws of construction and the taste and imagination of Mary. No doubt the first command of the Queen of Heaven was for light, but the second, at least equally imperative, was for color. Any earthly Queen, even though she were not Byzantine in taste, loved color; and the truest of Queens,—the only true Queen of Queens, -had richer and finer taste in color, than the Queens of fifty earthly kingdoms, as you will see when we come to the immense effort to gratify her in the glass of her windows. Illusion for illusion, - granting for the moment that Mary was an illusion,—the Virgin Mother in this instance repaid to her worshippers a larger return for their money than the capitalist has ever been able to get, at least in this world, from any other illusion of wealth which he has tried to make a source of pleasure and profit.

The next point on which Mary evidently insisted was the arrangement of her private apartments, the apse, as distinguished from her throne-room, the choir; both being quite distinct from the hall, or reception room of the public, which was the nave with its enlargements in the transepts. This arrangement marks the distinction between churches built as shrines for the deity, and churches built as halls of worship for the public. The difference is chiefly in the apse, and the apse of Chartres is the most interesting of all apses from this point of view.

The Virgin required chiefly these three things, or, if you like, these four:—Space, Light, Convenience; and Colour Decoration to unite and harmonise the whole. This concerns the interior; on the exterior she required statuary, and the only complete system of decorative sculpture that existed seems to belong to her churches:—Paris, Reims, Amiens and Chartres. Mary required all this magnificence at Chartres for herself alone, not for the public. As far as one can see into the spirit of the builders, Chartres was exclusively intended for the Virgin, as the Temple at Abydos was intended for Osiris. The wants of man, beyond a mere roof-cover, and perhaps space to some degree, enter to no very great extent into the problem of Chartres. Man came to render homage or to ask favors. The Queen received him in her palace, where she alone was at home, and alone gave commands.

The artist's second thought was to exclude from his work everything that could displease Mary; and since Mary differed from living Queens only in infinitely greater majesty and refinement, the artist could admit only what pleased the actual taste of the great ladies who dictated taste at the Courts of France and England, which surrounded the little Court of the Counts of Chartres. What they were—these women of the twelfth and thirteenth centuries—we shall have to see or seek in other directions; but Chartres is perhaps the most magnificent and permanent monument they left of their taste, and we can begin here with learning certain things which they

were not.

In the first place, they were not in the least vague, dreamy or mystical in a modern sense; - far from it! They seemed anxious only to throw the mysteries into a blaze of light; not so much physical perhaps, - since they, like all women, liked moderate shadow for their toilets,—but luminous in the sense of faith. There is nothing about Chartres that you would think mystical, who know your Lohengrin, Siegfried and Parsifal. If you care to make a study of the whole literature of the subject, read M. Male's "Art Religieux du XIIIe Siècle en France," and use it for a guide-book. Here you need only note how symbolic and how simple the sculpture is, on the Portals and Porches. Even what seems a grotesque or an abstract idea is no more than the simplest child's personification. On the walls you may have noticed the Ane qui vielle,the Ass playing the Lyre; and on all the old churches you can see Bestiaries, as they were called, of fabulous animals, symbolic or not; but the symbolism is as simple as the realism of the oxen at Laon. It gave play to the artist in his effort for variety of decoration, and it amused the people,-probably the Virgin also was not above being amused; -now and then it seems about to suggest what you would call an esoteric meaning, that is to say, a meaning which each one of us can consider private property reserved for our own amusement, and from which the public is excluded; yet, in truth, in the Virgin's churches the public is never excluded, but invited. The Virgin even had the additional charm to the public that she was popularly supposed to have no very marked fancy for priests as such; she was a Queen, a Woman, and a Mother, functions, all, which priests could not perform. Accordingly, she seems to have had little taste for mysteries of any sort, and even the symbols that seem most mysterious were clear to every old peasant-woman in her church. The most pleasing and promising of them all is the woman's figure you saw on the front of the cathedral in Paris; her eyes bandaged; her head bent down; her crown falling; without cloak or royal robe; holding in her hand a guidon or banner with its staff broken in more than one place. On the opposite pier stands another woman, with royal mantle, erect and commanding. The symbol is so graceful that one is quite eager to know its meaning; but every child in the middle-ages would have instantly told you that the woman with the falling crown meant only the Jewish Synagogue, as the one with the royal robe meant the Church of Christ.

Another matter for which the female taste seemed not much to care was Theology in the metaphysical sense. Mary troubled herself little about Theology except when she retired into the south transept with Pierre de Dreux. Even there one finds little said about the Trinity, always the most metaphysical subtlety of the Church. Indeed, you might find much amusement here in searching the Cathedral for any distinct expression at all of the Trinity as a dogma recognised by Mary. One cannot take seriously the idea that the three doors, the three portals, and the three aisles express the Trinity, because, in the first place, there was no rule about it; churches might have what portals and aisles they pleased; Paris and Bourges both have five; the doors themselves are not allotted to the three members of the Trinity, nor are the portals; while another more serious objection is that the side doors and aisles are not of equal importance with the central, but mere adjuncts and dependencies, so that the architect who had misled the ignorant public into accepting so black a heresy would have deserved the stake, and would probably have gone to it. Even this suggestion of trinity is wanting in the transepts which have only one aisle, and in the choir which has five, as well as five or seven, chapels, and, as far as an ignorant mind can penetrate, no triplets whatever. Occasionally, no doubt, you will discover in some sculpture or window, a symbol of the Trinity, but this discovery itself amounts to an admission of its absence as a controlling idea, for the ordinary worshipper must have been at least as blind as we are, and to him, as to us, it would have seemed a wholly subordinate detail. Even if the Trinity, too, is anywhere expressed, you will hardly find here an attempt to explain its metaphysical meaning-not even a mystic triangle.

The church is wholly given up to the Mother and the Son. The Father seldom appears; the Holy Ghost still more rarely. At least, this is the impression made on an ordinary visitor who has no motive to be orthodox; and it must have been the same with the thirteenth-century worshipper who came here with his mind absorbed in the perfections of Mary.

Chartres represents, not the Trinity, but the identity of the Mother and Son. The Son represents the Trinity, which is thus absorbed in the Mother. The idea is not orthodox, but this is no affair of ours. The Church watches over its own.

The Virgin's wants and tastes, positive and negative, ought now to be clear enough to enable you to feel the artist's sincerity in trying to satisfy them; but first you have still to convince yourselves of the people's sincerity in employing the artists. This point is the easiest of all, for the evidence is express. In the year 1145 when the old flèche was begun,—the year before Saint Bernard preached the second crusade at Vezelay,-Abbot Haimon of Saint Pierre-sur-Dives in Normandy wrote to the monks of Tutbury Abbey in England a famous letter to tell of the great work which the Virgin was doing in France and which began at the Church of Chartres. "Hujus sacrae institutionis ritus apud Carnotensem ecclesiam est inchoatus." From Chartres it had spread through Normandy where it produced among other things the beautiful spire which we saw at Saint Pierre-sur-Dives. "Postremo per totam fere Normanniam longe lateque convaluit ac loca per singula Matri misericordiae dicata praecipue occupavit." The movement affected especially the places devoted to Mary, but, ran through all Normandy, far and wide. Of all Mary's Miracles, the best attested, next to the preservation of her church, is the building of it; not so much because it surprises us, as because it surprised even more the people of the time, and the men who were its instruments. Such deep popular movements are always surprising, and at Chartres the miracle seems to have occurred three times, coinciding more or less with the dates of the crusades, and taking the organisation of a crusade, as Archbishop Hugo of Rouen described it in a letter to Bishop Thierry of Amiens. The most interesting part of this letter is the evident astonishment of the writer, who might be talking to us to-day, so modern is he:-

"The inhabitants of Chartres have combined to aid in the construction of their church by transporting the materials; our Lord has rewarded their humble zeal by miracles which have roused the Normans to imitate the piety of their neighbors. . . . Since then the faithful of our diocese and of other neighboring regions have formed associations for the same

object; they admit no one into their company unless he has been to confession, has renounced enmities and revenges, and has reconciled himself with his enemies. That done, they elect a chief, under whose direction they conduct their wagons in silence and with humility."

The quarries at Berchères-l'Evêque are about five miles from Chartres. The stone is excessively hard, and was cut in blocks of considerable size, as you can see for yourselves; blocks which required great effort to transport and lay in place. The work was done with feverish rapidity, as it still shows, but it is the solidest building of the age, and without a sign of weakness yet. The Abbot told, with more surprise than pride, of the spirit which was built into the cathedral with the stone:—

"Who has ever seen!-Who has ever heard tell, in times past, that powerful princes of the world, that men brought up in honors and in wealth, that nobles, men and women, have bent their proud and haughty necks to the harness of carts, and that, like beasts of burden, they have dragged to the abode of Christ these wagons, loaded with wines, grains, oil, stone, wood, and all that is necessary for the wants of life, or for the construction of the church? But while they draw these burdens, there is one thing admirable to observe; it is that often when a thousand persons and more are attached to the chariots, -so great is the difficulty, -yet they march in such silence that not a murmur is heard, and truly if one did not see the thing with one's eyes, one might believe that among such a multitude there was hardly a person present. When they halt on the road, nothing is heard but the confession of sins, and pure and suppliant prayer to God to obtain pardon. At the voice of the priests who exhort their hearts to peace, they forget all hatred, discord is thrown far aside, debts are remitted, the unity of hearts is established. But if anyone is so far advanced in evil as to be unwilling to pardon an offender. or if he rejects the counsel of the priest who has piously advised him, his offering is instantly thrown from the wagon as impure, and he himself ignominiously and shamefully excluded from the society of the holy. There one sees the priests who preside over each chariot exhort everyone to penitence, to confession of faults, to the resolution of better life! there one sees old people, young people, little children, calling on the Lord with a suppliant voice, and uttering to him, from the depth of the heart, sobs and sighs with words of glory and praise! After the people, warned by the sound of trumpets and the sight of banners, have resumed their road, the march is made with such ease that no obstacle can retard it. . . . When they have reached the church they arrange the wagons about it like a spiritual camp, and during the whole night they celebrate the watch by hymns and canticles. On each wagon they light tapers and lamps; they place there the infirm and sick, and

bring them the precious relics of the Saints for their relief. Afterwards the priests and clerics close the ceremony by processions which the people follow with devout heart, imploring the clemency of the Lord and of his Blessed Mother for the recovery of the sick."

Of course the Virgin was actually and constantly present during all this labor, and gave her assistance to it, but you would get no light on the architecture from listening to an account of her miracles, nor do they heighten the effect of popular faith. Without the conviction of her personal presence, men would not have been inspired; but, to us, it is rather the inspiration of the art which proves the Virgin's presence, and we can better see the conviction of it in the work than in the words. Every day, as the work went on, the Virgin was present, directing the architects, and it is this direction that we are going to study, if you have now got a realising sense of what it meant. Without this sense, the church is dead. Most persons of a deeply religious nature would tell you emphatically that nine churches out of ten actually were dead-born, after the thirteenth century, and that church architecture became a pure matter of mechanism and mathematics: but that is a question for you to decide when you come to it; and the pleasure consists not in seeing the death, but in feeling the life.

Now let us look about!

VII

Roses and Apses

TIKE ALL GREAT CHURCHES, that are not mere store-houses of theology, Chartres expressed, besides whatever else it meant, an emotion, the deepest man ever felt,—the struggle of his own littleness to grasp the infinite. You may, if you like, figure in it a mathematic formula of infinity, -the broken arch, our finite idea of space; the spire, pointing, with its converging lines, to Unity beyond space; the sleepless, restless thrust of the vaults, telling the unsatisfied, incomplete, overstrained effort of man to rival the energy, intelligence and purpose of God. Thomas Aquinas and the schoolmen tried to put it in words, but their Church is another chapter. In act, all man's work ends there; - mathematics, physics, chemistry, dynamics, optics, every sort of machinery science may invent,-to this favor come at last, as religion and philosophy did before science was born. All that the centuries can do is to express the idea differently:—a miracle or a dynamo; a dome or a coal-pit; a cathedral or a world's fair; and sometimes to confuse the two expressions together. The world's fair tends more and more vigorously to express the thought of infinite energy; the great Cathedrals of the middle-ages always reflected the industries and interests of a world's fair. Chartres showed it less than Laon or Paris, for Chartres was never a manufacturing town but a shrine, such as Lourdes, where the Virgin was known to have done miracles, and had been seen in person; but still the shrine turned itself into a market and created valuable industries. Indeed this was the chief objection which Saint Paul made to Ephesus and Saint Bernard to the Cathedrals. They were in some ways more industrial than religious. The mere masonry and structure made a vast market for labor; the fixed metal-work and woodwork were another; but the decoration was by far the greatest. The wood-carving, the glass windows, the sculpture, inside and out, were done mostly in workshops on the spot, but besides these fixed objects, precious works of the highest perfection filled the church treasuries. Their money-value was great then;

it is greater now. No world's-fair is likely to do better today. After five hundred years of spoliation, these objects fill museums still, and are bought with avidity at every auction, at prices continually rising and quality steadily falling, until a bit of twelfth-century glass would be a trouvaille like an emerald; a tapestry earlier than 1600 is not for mere tourists to hope; an enamel, a missal, a crystal, a cup, an embroidery of the middle-ages, belongs only to our betters, and almost invariably, if not to the State, to the rich Jews, whose instinctive taste has seized the whole field of art which rested on their degradation. Royalty and feudality spent their money rather on arms and clothes. The Church alone was universal patron,

and the Virgin was the dictator of taste.

With the Virgin's taste, during her regency, critics never find fault. One cannot know its whole magnificence, but one can accept it as a matter of faith and trust, as one accepts all her other miracles without caviling over small details of fact. The period of eighteenth-century scepticism about such matters, and the bourgeois taste of Voltaire and Diderot have long since passed, with the advent of a scientific taste still more miraculous; the whole world of the Virgin's art, catalogued in the Dictionnaire du Mobilier Français in six volumes by Viollet-le-Duc; narrated as history by M. Labarte, M. Molinier, M. Paul Lacroix; catalogued in Museums by M. du Sommerard and a score of others, in works almost as costly as the subjects, - all the vast variety of bric-a-brac useful or ornamental, belonging to the church, increased enormously by the insatiable, universal, private demands for imagery, in ivory, wood, metal, stone, for every room in every house, or hung about every neck, or stuck on every hat, made a market such as artists never knew before or since, and such as instantly explains to the practical American not only the reason for the Church's tenacity of life, but also the inducements for its plunder. The Virgin especially required all the resources of art, and the highest. Notre Dame of Chartres would have laughed at Notre Dame of Paris if she had detected an economy in her robes; Notre Dame of Reims or Rouen would have derided Notre Dame of Amiens if she had shown a feminine, domestic, maternal turn towards cheapness. The Virgin was never cheap. Her great ceremonies were as splendid as

her rank of Queen in Heaven and on Earth required; and as her procession wound its way along the aisles, through the crowd of her subjects, up to the high altar, it was impossible then, and not altogether easy now, to resist the rapture of her radiant presence. Many a young person, and now and then one who is not in first youth, witnessing the sight in the religious atmosphere of such a church as this, without a suspicion of susceptibility, has suddenly seen what Paul saw on the road to Damascus, and has fallen on his face with the crowd, groveling at the foot of the Cross, which, for the first time in his life, he feels.

If you want to know what Churches were made for, come down here on some great festival of the Virgin, and give vourself up to it; but come alone! That kind of knowledge cannot be taught and can seldom be shared. We are not now seeking religion; indeed, true religion generally comes unsought. We are trying only to feel gothic art. For us, the world is not a schoolroom or a pulpit, but a stage, and the stage is the highest yet seen on earth. In this church the old romanesque leaps into the gothic under our eyes; of a sudden. between the portal and the shrine, the infinite rises into a new expression, always a rare and excellent miracle in thought. The two expressions are nowhere far apart; not further than the Mother from the Son. The new artist drops unwillingly the hand of his father or his grandfather; he looks back, from every corner of his own work, to see whether it goes with the old. He will not part with the western portal or the lancet windows; he holds close to the round columns of the choir; he would have kept the round arch if he could, but the round arch was unable to do the work; it could not rise; so he broke it, lifted the vaulting, threw out flying buttresses, and satisfied the Virgin's wish.

The matter of gothic vaulting, with its two weak points, the flying buttress and the false, wooden, shelter-roof, is the bête noire of the Beaux Arts. The duty of defence does not lie on tourists, who are at best hardly able to understand what it matters whether a wall is buttressed without or within, and whether a roof is single or double. No one objects to the dome of Saint Peter's. No one finds fault with the Pont Neuf. Yet it is true that the gothic architect showed contempt for

facts. Since he could not support a heavy stone vault on his light columns, he built the lightest possible stone vault and protected it with a wooden shelter-roof which constantly burned. The lightened vaults were still too heavy for the walls and columns, so the architect threw out buttress beyond buttress resting on separate foundations, exposed to extreme inequalities of weather, and liable to multiplied chances of accident. The results were certainly disastrous. The roofs

burned; the walls yielded.

Flying buttresses were not a necessity. The Merveille had none; the Angevin school rather affected to do without them; Albi had none; Assisi stands up independent; but they did give support wherever the architect wanted it and nowhere else; they were probably cheap; and they were graceful. Whatever expression they gave to a church, at least it was not that of a fortress. Amiens and Albi are different religions. The expression concerns us: the construction concerns the Beaux Arts. The problem of permanent equilibrium which distresses the builder of arches is a technical matter which does not worry, but only amuses, us who sit in the audience and look with delight at the theatrical stage-decoration of the gothic vault; the astonishing feat of building up a skeleton of stone ribs and vertebra, on which every pound of weight is adjusted, divided, and carried down from level to level till it touches ground at a distance as a bird would alight. If any stone in any part, from apex to foundation, weathers or gives way, the whole must yield, and the charge for repairs is probably great, but, on the best building the Ecole des Beaux Arts can build, the charge for repairs is not to be wholly ignored, and at least the Cathedral of Chartres, in spite of terribly hard usage, is as solid today as when it was built, and as plumb, without crack or crevice. Even the towering fragment at Beauvais, poorly built from the first, which has broken down oftener than most gothic structures, and seems ready to crumble again whenever the wind blows over its windy plains, has managed to survive, after a fashion, six or seven hundred years, which is all that our generation had a right to ask.

The vault of Beauvais is nearly one hundred and sixty feet high (48 metres), and was cheaply built. The vault of Saint Peter's at Rome is nearly one hundred and fifty feet (45 metres). That of Amiens is one hundred and forty-four feet (44 metres). Reims, Bourges and Chartres are nearly the same height, at the entrance; one hundred and twenty-two feet, Paris is one hundred and ten feet. The Abbé Bulteau is responsible for these measurements; but at Chartres, as in several very old churches the nave slopes down to the entrance. because—as is said,—pilgrims came in such swarms that they were obliged to sleep in the church, and the nave had to be sluiced with water to clean it. The true height of Chartres, at the croisée of nave and transept, is as near as possible one hundred and twenty feet (36.55 metres).

The measured height is the least interest of a church. The architect's business is to make a small building look large, and his failures are in large buildings which he makes to look small. One chief beauty of the gothic is to exaggerate height, and one of its most curious qualities is its success in imposing an illusion of size. Without leaving the heart of Paris anyone can study this illusion in the two great churches of Notre Dame and Saint Sulpice; for Saint Sulpice is as lofty as Notre Dame in vaulting, and larger in its other dimensions, besides being, in its style, a fine building; yet its Roman arches show, as if they were of the eleventh century, why the long, clean, unbroken, refined lines of the gothic, curving to points, and leading the eye with a sort of compulsion to the culminating point above, should have made an architectural triumph that carried all Europe off its feet with delight. The world had seen nothing to approach it except perhaps in the dome of Sancta Sofia in Constantinople; and the discovery came at a moment when Europe was making its most united and desperate struggle to attain the kingdom of Heaven.

According to Viollet-le-Duc, Chartres was the final triumph of the experiment on a very great scale, for Chartres has never been altered and never needed to be strengthened. The flying-buttresses of Chartres answered their purpose, and if it were not a matter of pure construction it would be worth while to read what Viollet-le-Duc says about them (Article; Arcs-boutants). The vaulting above is heavy, about fifteen inches thick; the buttressing had also to be heavy: and to lighten it, the architect devised an amusing sort of arcades, applied on his outside buttresses. Throughout the church,

everything was solid beyond all later custom, so that architects would have to begin by a study of the crypt which came down from the eleventh century so strongly built that it still carries the church without a crack in its walls; but if we went down into it, we should understand nothing; so we will be-

gin, as we did outside, at the front.

A single glance shows what trouble the architect had with the old façade and towers, and what temptation to pull them all down. One cannot quite say that he has spoiled his own church in trying to save what he could of the old, but if he did not quite spoil it he saved it only by the exercise of an amount of intelligence that we shall never learn enough to feel our incapacity to understand. True ignorance approaches the infinite more nearly than any amount of knowledge can do, and, in our case, ignorance is fortified by a certain element of nineteenth-century indifference which refuses to be interested in what it cannot understand; a violent reaction from the thirteenth century which cared little to comprehend anything except the incomprehensible. The architect at Chartres was required by the Virgin to provide more space for her worshippers within the church, without destroying the old Portal and Flèche which she loved. That this order came directly from the Virgin may be taken for granted. At Chartres, one sees everywhere the Virgin, and nowhere any rival authority; one sees her give orders, and architects obey them; but very rarely a hesitation as though the architect were deciding for himself. In his western front, the architect has obeyed orders so literally that he has not even taken the trouble to apologise for leaving unfinished the details which, if he had been responsible for them, would have been his anxious care. He has gone to the trouble of moving the heavy doorways forward, so that the chapels in the towers which were meant to open on a porch, now open into the nave, and the nave itself has in appearance, two more spans than in the old church; but the work shows blind obedience, as though he were doing his best to please the Virgin without trying to please himself. Probably he could in no case have done much to help the side-aisles in their abrupt collision with the solid walls of the two towers, but he might at least have brought the vaulting of his two new bays, in the nave, down to the ground, and finished it. The vaulting is awkward in these two bays, and yet he has taken great trouble to effect what seems at first a small matter. Whether the great rose window was an afterthought or not, can never be known, but anyone can see with a glass, and better on the architectural plan, that the vaulting of the main church was not high enough to admit the great rose, and that the architect has had to slope his two tower-spans upward. So great is the height that you cannot see this difference of level very plainly even with a glass, but on the plans it seems to amount to several feet; perhaps a metre. The architect has managed to deceive our eyes, in order to enlarge the Rose; but you can see as plainly as though he were here to tell you, that, like a great general, he has concentrated his whole energy on the Rose, because the Virgin has told him that the Rose symbolised herself, and that the light and splendor of her appearance in the west were to redeem all his awkwardnesses.

Of course this idea of the Virgin's interference sounds to you a mere bit of fancy, and that is an account which may be settled between the Virgin and you; but even twentieth-century eyes can see that the Rose redeems everything, dominates everything, and gives character to the whole church.

In view of the difficulties which faced the artist, the Rose is inspired genius,—the kind of genius which Shakespeare showed when he took some other man's play, and adapted it. Thus far, it shows its power chiefly by the way it comes forward and takes possession of the west front, but if you want a foot-rule to measure by, you may mark that the old, twelfthcentury lancet-windows below it, are not exactly in its axis. At the outset, in the original plan of 1090, or thereabouts, the old tower-the southern tower-was given greater width than the northern. Such inequalities were common in the early churches, and so is a great deal of dispute in modern books whether they were accidental or intentional, while no one denies that they are amusing. In these towers the difference is not great-perhaps fourteen or fifteen inches-but it caused the architect to correct it, in order to fit his front to the axis of the church, by throwing his entrance six or seven inches to the south, and narrowing to that extent the south door and south lancet. The effect was bad, even then, and

went far to ruin the south window; but when, after the fire of 1194, the architect inserted his great rose, filling every inch of possible space between the lancet and the arch of the vault, he made another correction which threw his rose six or seven inches out of axis with the lancets. Not one person in a hundred thousand would notice it, here in the interior, so completely are we under the control of the artist and the Vir-

gin; but it is a measure of the power of the Rose.

Looking further, one sees that the rose-motive, which so dominates the west front, is carried round the church, and comes to another outburst of splendor in the transepts. This leads back to fenestration on a great scale, which is a terribly ambitious flight for tourists; all the more because here the tourist gets little help from the architect, who in modern times, has seldom the opportunity to study the subject at all, and accepts as solved the problems of early gothic fenestration. One becomes pedantic and pretentious at the very sound of the word which is an intolerable piece of pedantry in itself; but Chartres is all windows, and its windows were as triumphant as its Virgin, and were one of her miracles. One can no more overlook the windows of Chartres than the glass which is in them. We have already looked at the windows of Mantes; we have seen what happened to the windows at Paris. Paris had at one leap risen twenty-five feet higher than Noyon, and even at Noyon, the architect about 1150, had been obliged to invent new fenestration. Paris and Mantes, twenty years later, made another effort, which proved a failure. Then the architect of Chartres, in 1195, added ten feet more to his vault, and undertook, once for all, to show how a great cathedral should be lighted. As an architectural problem, it passes far beyond our powers of understanding, even when solved; but we can always turn to see what the inevitable Viollet-le-Duc says about its solution at Chartres:-

Towards the beginning of the thirteenth century, the architect of the cathedral of Chartres sought out entirely new window-combinations to light the nave from above. Below, in the side-aisles he kept to the customs of the times; that is, he opened pointed windows which did not wholly fill the spaces between the piers; he wanted, or was willing to leave here below the effect of a wall. But in the upper part of his building we see that he changed the system; he throws a round arch directly across from one pier to the next;

then, in the enormous space which remains within each span, he inserts two large pointed windows surmounted by a great rose. . . . We recognise in this construction of Notre Dame de Chartres a boldness, a force, which contrast with the fumbling of the architects in the Ile de France and Champagne. For the first time one sees at Chartres the builder deal frankly with the clerestory, or upper-fenestration, occupying the whole width of the arches, and taking the arch of the vault as the arch of the window. Simplicity of construction, beauty in form, strong workmanship, structure true and solid, judicious choice of material, all the characteristics of good work, unite in this magnificent specimen of architecture at the beginning of the thirteenth century.

Viollet-le-Duc does not call attention to a score of other matters which the architect must have had in his mind, such as the distribution of light, and the relations of one arrangement with another; the nave with the aisles, and both with the transepts, and all with the choir. Following him, we must take the choir separately, and the aisles and chapels of the apse also. One cannot hope to understand all the experiments and refinements of the artist, either in their successes or their failures, but, with diffidence, one may ask oneself whether the beauty of the arrangement, as compared with the original arrangement in Paris, did not consist in retaining the rose-motive throughout, while throwing the whole upper-wall into window. Triumphant as the clerestory windows are, they owe their charm largely to their roses, as you see by looking at the same scheme applied on a larger scale on the transept fronts; and then, by taking stand under the croisée, and looking at all in succession as a whole.

The rose window was not gothic but romanesque, and needed a great deal of coaxing to feel at home within the pointed arch. At first, the architects felt the awkwardness so strongly that they avoided it wherever they could. In the beautiful façade of Laon, one of the chief beauties is the setting of the rose under a deep round arch. The western roses of Mantes and Paris are treated in the same way, although a captious critic might complain that their treatment is not so effective or so logical. Reims boldly imprisoned the roses within the pointed arch; but Amiens, towards 1240, took refuge in the same square exterior setting that was preferred, in 1200, here at Chartres; and in the interior of Amiens the round arch of the rose is the last vault of the nave, seen

through a vista of pointed vaults, as it is here. All these are supposed to be among the chief beauties of the gothic façade, although the gothic architect, if he had been a man of logic, would have clung to his lines, and put a pointed window in his front, as in fact he did at Coutances. He felt the value of the rose in art, and perhaps still more in religion, for the rose was Mary's emblem. One is fairly sure that the great Chartres rose of the west front was put there to please her, since it was to be always before her eyes, the most conspicuous object she would see from the high altar, and therefore the most carefully considered ornament in the whole church, outside the choir. The mere size proves the importance she gave it. The exterior diameter is nearly forty-four feet, (13.36 metres). The nave of Chartres is, next perhaps to the nave of Angers, the widest of all gothic naves; about fifty-three feet (16.30 metres); and the rose takes every inch it can get of this enormous span. The value of the rose, among architects of the time, was great, since it was the only part of the church that Villard de Honnecourt sketched; and since his time, it has been drawn and redrawn, described and commented by generations of architects till it has become as classic as the Parthenon.

Yet this Chartres rose is solid, serious, sedate, to a degree unusual in its own age; it is even more romanesque than the pure romanesque roses. At Beauvais you must stop a moment to look at a romanesque rose on the transept of the church of Saint Etienne; Viollet-le-Duc mentions it, with a drawing (Art. Pignon), as not earlier than the year 1100, therefore about a century earlier than the rose of Chartres; it is not properly a rose, but a wheel of fortune, with figures climbing up and falling over. Another supposed twelfth-century rose is at Etampes, which goes with that of Laon and Saint Leu d'Esserent and Mantes. The rose of Chartres is so much the most serious of them all, that Viollet-le-Duc has explained it by its material, -the heavy stone of Berchères; -but the material was not allowed to affect the great transept roses, and the architect made his material yield to his object wherever he thought it worth while. Standing under the central croisée, you can see all three roses by simply turning your head. That on the north, the Rose de France, was built, or planned, between 1200 and 1210, in the reign of Philip Augustus, since the Porch outside, which would be a later construction, was begun by 1212. The Rose de France is the same in diameter as the western rose, but lighter, and built of lighter stone. Opposite the Rose de France, stands, on the south front, Pierre Mauclerc's Rose de Dreux, of the same date, with the same motive, but even lighter; more like a rose and less like a wheel. All three roses must have been planned at about the same time, perhaps by the same architect, within the same workshop; yet the western rose stands quite apart, as though it had been especially designed to suit the twelfth-century facade and portal which it rules. Whether this was really the artist's idea is a question that needs the artist to answer; but that this is the effect, needs no expert to prove; it stares one in the face. Within and without, one feels that the twelfthcentury spirit is respected and preserved with the same religious feeling which obliged the architect to injure his own work by sparing that of his grandfathers.

Conspicuous, then, in the west front are two feelings:respect for the twelfth-century work, and passion for the rose fenestration; both subordinated to the demand for light. If it worries you to have to believe that these three things are in fact one; that the architect is listening, like the stone Abraham, for orders from the Virgin, while he caresses and sacrifices his child; that Mary and not her architects built this façade; if the divine intention seems to you a needless impertinence, you can soon get free from it by going to any of the later churches, where you will not be forced to see any work but that of the architect's compasses. According to Viollet-le-Duc, the inspiration ceased about 1250, or as the Virgin would have dated it, on the death of Blanche of Castile in 1252. The work of Chartres, where her own hand is plainly shown, belongs in feeling, if not in execution, to the last years of the twelfth century (1195-1200). The great western Rose which gives the motive for the whole decoration and is repeated in the great roses of the transepts, marks the Virgin's will,—the taste and knowledge of 'cele qui la rose est des roses,' or, if you prefer the Latin of Adam de Saint Victor, the hand of her who is 'Super rosam rosida.'

All this is easy; but if you really cannot see the hand of

Mary herself in these broad and public courts, which were intended not for her personal presence but for the use of her common people, you had better stop here, and not venture into the choir. Great halls seem to have been easy architecture. Naves and transepts were not often failures; façades and even towers and flèches are invariably more or less successful because they are more or less balanced, mathematical, calculable products of reason and thought. The most serious difficulties began only with the choir, and even then did not become desperate until the architect reached the curve of the apse, with its impossible vaultings, its complicated lines, its cross-thrusts, its double problems, internal and external, its defective roofing and unequal lighting. A perfect gothic apse was impossible; an apse that satisfied perfectly its principal objects was rare; the simplest and cheapest solution was to have no apse at all, and that was the English scheme, which was tried also at Laon; a square, flat wall and window. If the hunt for Norman towers offered a summer's amusement, a hunt for apses would offer an education, but it would lead far out of France. Indeed it would be simpler to begin at once with Sancta Sophia at Constantinople, San Vitale at Ravenna and Monreale at Palermo and the churches at Torcello and Murano, and San Marco at Venice; and admit that no device has ever equalled the startling and mystical majesty of the Byzantine half-dome, with its marvellous mosaic Madonna dominating the church, from the entrance, with her imperial and divine presence. Unfortunately, the northern churches needed light, and the northern architects turned their minds to a desperate effort for a new apse.

The scheme of the Cathedral at Laon seems to have been rejected unanimously; the bare, flat wall at the end of the choir was an eyesore; it was quite bad enough at the end of the nave, and became annoying at the end of the transepts, so that at Noyon and Soissons the architect, with a keen sense of interior form, had rounded the transept ends; but, though external needs might require a square transept, the unintelligence of the flat wall becomes insufferable at the east end. Neither did the square choir suit the church ceremonies and processions, or offer the same advantages of arrangement, as the French understood them. With one voice, the French

architects seem to have rejected the Laon experiment, and turned back to a solution taken directly from the romanesque.

Quite early—in the eleventh century—a whole group of churches had been built in Auvergne—at Clermont and Issoire, for example,—possibly by one architect, with a circu-

lar apse, breaking out into five apsidal chapels. Tourists who get down as far south as Toulouse, see another example of this romanesque apse in the famous church of Saint Sernin, of the twelfth century; and few critics take offence at one's liking it. Indeed, as far as concerns the exterior, one might even risk thinking it more charming than the exterior of

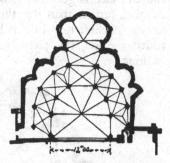

SAINT MARTIN-DES-CHAMPS

any gothic apse ever built. Many of these romanesque apses of the eleventh and twelfth centuries still remain in France, showing themselves in unsuspected parish churches, here and there, but always a surprise for their quiet, unobtrusive grace, making a harmony with the romanesque tower, if there is one, into which they rise, as at Saint Sernin; but all these churches had only one aisle, and, in the interior, there came invariable trouble when the vaults rose in height. The architect of Chartres, in 1200, could get no direct help from these, or even from Paris which was a beautifully perfect apse, but had no apsidal chapels. The earliest apse that could have served as a suggestion for Chartres, -or at least, as a point of observation for us,-was that of the Abbey church of Saint Martindes-Champs, which we went to see in Paris, and which is said to date from about 1150. Here is a circular choir, surrounded by two rows of columns, irregularly spaced, with circular chapels outside, which seems to have been more or less what the architect of Chartres, for the Virgin's purposes, had set his heart on obtaining. Closely following the scheme of Saint Martin-des-Champs came the scheme of the Abbey Church at Vezelay, built about 1160-1180. Here the vaulting sprang directly from the last arch of the choir, as is shown on the plan, and bearing first on the light columns of the choir, which

were evenly spaced, then fell on a row of heavier columns outside, which were also evenly spaced, and came to rest at last on massive piers, between which were five circular chapels. The plan shows at a glance that this arrangement stretched the second row of columns far apart, and that a church much larger than Vezelay would need to space them so much further apart that the arch uniting them would have to rise indefinitely; while, if beyond this, another aisle were added outside, the piers finally would require impossible vaulting.

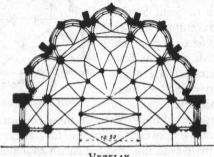

VEZELAY

The problem stood thus when the great Cathedrals were undertaken, and the architect of Paris boldly grappled with the double aisle on a scale requiring a new scheme. Here, in spite of the most virtuous resolutions not to be technical, we must attempt a technicality, because without it, one of the most interesting eccentricities of Chartres would be lost. Once more, Viollet-le-Duc:-

As the architect did not want to give the interior bays of the apse spaces between the columns (AA) less than that of the parallel bays (BB), it followed that the first radiating bay gave a first space (LMGH) which was difficult to vault, and a second space (HGEF) which was impossible; for how establish an arch from F to E? Even if round, its key would have risen much higher than the key of the pointed archivolt LM. As the second radiating bay opened out still wider, the difficulty was increased. The builder therefore inserted the two intermediate pillars O and P between the columns of the second aisle (H, G, and I); which he supported, in the outside wall of the church, by one corresponding pier (Q) in the first bay of the apse, and by two similar piers (R and S) in the second bay.

"There is no need to point out," continued Viollet-le-Duc,

as though he much suspected that there might be need of pointing out, "what skill this system showed and how much the art of architecture had already been developed in the Ile de France towards the end of the twelfth century; to what an extent the unity of arrangement and style preoccupied the artists of that province."

In fact the arrangement seems mathematically and technically perfect. At all events, we know too little to criticise it. Yet one would much like to be told why it

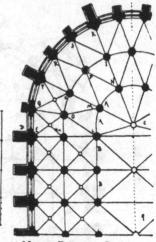

NOTRE DAME DE PARIS

was not repeated by any other architect or in any other church. Apparently the Parisians themselves were not quite satisfied with it, since they altered it a hundred years later, in 1296, in order to build out chapels between the piers. As the architects of each new cathedral had, in the interval, insisted on apsidal chapels, one may venture to guess that the Paris scheme hampered the services.

At Chartres the church services are Mary's own tastes; the church is Mary; and the chapels are her private rooms. She was not pleased with the arrangements made for her in her palace at Paris; they were too architectural; too regular and mathematical; too popular; too impersonal; and she rather abruptly ordered her architect at Chartres to go back to the old arrangement. The apse at Paris was hardly covered with its leading before the architect of Chartres adopted a totally new plan, which according to Viollet-le-Duc, does him little credit, but which was plainly imposed on him, like the twelfth-century Portal. Not only had it nothing of the mathematical correctness and precision of the Paris scheme, easy to understand and imitate, but it carried even a sort of violence—a wrench—in its system, as though the Virgin had said, with her grand Byzantine air:—I will it!

"At Chartres," says Viollet-le-Duc, "the choir of the

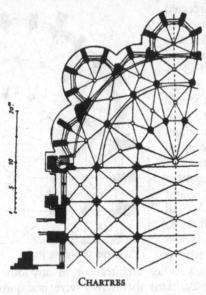

Cathedral presents a plan which does no great honor to its architect. There is want of accord between the circular apse and the parallel sides of the sanctuary: the spacings of the columns of the second collateral are (laches); the vaults quite poorly combined, and in spite of the great width of the spaces between the columns of the second aisle, the architect had still to narrow those between the interior columns."

The plan shows that, from the first, the architect must have deliberately rejected the Paris scheme; he must have begun by narrowing the spaces between his inner columns; then, with a sort of violence, he fitted on his second row of columns; and, finally, he showed his motive by constructing an outer wall of an original or unusual shape. Any woman would see at once the secret of all this ingenuity and effort. The Chartres apse, enormous in size and width, is exquisitely lighted. Here, as everywhere throughout the church, the windows give the law, but here they actually take place of law. The Virgin herself saw to the lighting of her own boudoir. According to Viollet-le-Duc, Chartres differs from all the other great Cathedrals by being built not for its nave or even for its choir, but for its apse; it was planned not for the people or the court, but for the Queen; not a church but a shrine, and the shrine is the apse where the Queen arranged her light to please herself and not her architect, who had already been sacrificed at the western portal and who had a free hand only in the nave and transepts where the Queen never went, and which, from her own apartment, she did not even see.

This is, in effect. what Viollet-le-Duc says in his professional language, which is perhaps or sounds—more reasonable to tourists. whose imaginations are hardly equal to the effort of fancying a real deity. Perhaps, indeed, one might get so high as to imagine a real bishop of Laon, who should have ordered his architect to build an enormous hall of religion, to rival the immense Abbeys of the day, and to attract the

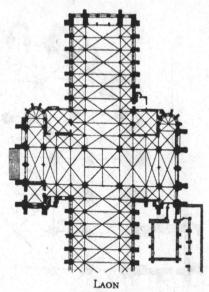

people, as though it were a club-room. There they were to see all the great sights; church ceremonies; theatricals; political functions; there they were to do business, and frequent society. They were to feel at home in their church because it was theirs, and did not belong to a priesthood or to Rome. Jealousy of Rome was a leading motive of gothic architecture, and Rome repaid it in full. The bishop of Laon conceded at least a transept to custom or tradition, but the Archbishop of Bourges abolished even the transept, and the great hall had no special religious expression except in the circular apse with its chapels which Laon had abandoned. One can hardly decide whether Laon or Bourges is the more popular, industrial, political, or in other words, the less religious; but the Parisians, as the plan of Viollet-le-Duc has shown, were quite as advanced as either, and only later altered their scheme into one that provided chapels for religious service.

Amiens and Beauvais have each seven chapels, but only one aisle so that they do not belong in the same class with the apses of Paris, Bourges and Chartres, though the plans are worth studying for comparison since they show how many-sided the problem was, and how far from satisfied the archi-

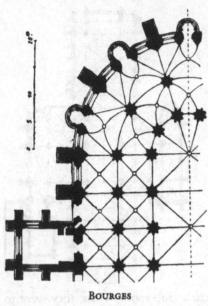

tects were with their own schemes. The most interesting of all, for comparison with Chartres, is Le Mans, where the apsidal chapels are carried to fanaticism, while the vaulting seems to be reasonable enough, and the double aisle successfully managed, if Viollet-le-Duc permits ignorant people to form an opinion on architectural dogma. For our purposes, the architectural dogma may stand, and the Paris scheme may be taken for granted, as

alone correct and orthodox; all that Viollet-le-Duc teaches is that the Chartres scheme is unorthodox, not to say heretical; and this is the point on which his words are most interesting.

The Church at Chartres belonged not to the people, not to the priesthood, and not even to Rome; it belonged to the Virgin. "Here the religious influence appears wholly; three large chapels in the apse; four others less pronounced;

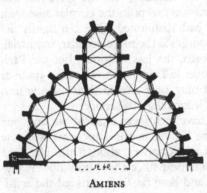

double aisles of great width round the choir; vast transepts! Here the church ceremonial could display all its pomp; the choir, more than at Paris, more than at Bourges, more than at Soissons, and especially more than at Laon, is the principal object; for it, the church is built."

One who is painfully conscious of ignorance. and who never would dream of suggesting a correction to anybody, may not venture to suggest an idea of any sort to an architect; but if it were allowed to paraphrase Viollet-le-Duc's words into a more or less emotional or twelfth-century form, one might say, after him, that, compared with Paris or Laon, the Chartres apse shows the same genius that is shown in the Chartres rose; the same large mind that overrules,—the same strong will that defies difficulties. The Chartres apse is as entertaining as all the other Gothic apses together, because it overrides the architect. You may, if you really have no imagination whatever, reject the idea that the Virgin herself made the plan; the feebleness of our fancy is now congenital, organic, beyond stimulant or strychnine, and we shrink like sensitiveplants from the touch of a vision or spirit;

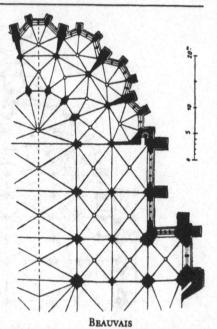

LE MANS

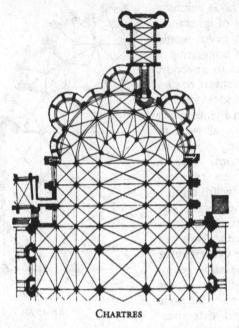

but at least one can still sometimes feel a woman's taste, and in the apse of Chartres one feels nothing else.

VIII

The Twelfth Century Glass

At Last we are face to face with the crowning glory of Chartres. Other churches have glass,—quantities of it, and very fine,—but we have been trying to catch a glimpse of the glory which stands behind the glass of Chartres, and gives it quality and feeling of its own. For once the architect is useless and his explanations are pitiable; the painter helps still less; and the decorator, unless he works in glass, is the poorest guide of all, while, if he works in glass, he is sure to lead wrong; and all of them may toil until Pierre Mauclerc's stone Christ comes to life, and condemns them among the unpardonable sinners on the southern Portal, but neither they nor any other artist will ever create another Chartres. You had better stop here, once for all, unless you are willing to feel that Chartres was made what it is, not by the artist but by the Virgin.

If this imperial presence is stamped on the architecture and the sculpture with an energy not to be mistaken, it radiates through the glass with a light and color that actually blind the true servant of Mary. One becomes, sometimes, a little incoherent in talking about it; one is ashamed to be as extravagant as one wants to be; one has no business to labor painfully to explain and prove to oneself what is as clear as the sun in the sky; one loses temper in reasoning about what can only be felt, and what ought to be felt instantly, as it was in the twelfth century, even by the *Truie qui file* and the *Ane qui vielle*. Anyone should feel it that wishes; any one who does not wish to feel it can let it alone. Still, it may be that not one tourist in a hundred,—perhaps not one in a thousand of the English-speaking race—does feel it, or can feel it even when explained to them, for we have lost many senses.

Therefore let us plod on, laboriously proving God, although, even to Saint Bernard and Pascal, God was incapable of proof; and using such material as the books furnish for help. It is not much. The French have been shockingly negligent of their greatest artistic glory. One knows not even

where to seek. One must go to the National Library and beg as a special favor permission to look at the monumental work of M. Lastevrie, if one wishes to make even a beginning of the study of French glass. Fortunately there exists a fragment of a great work which the government began, but never completed, upon Chartres; and another, quite indispensable, but not official, upon Bourges; while Viollet-le-Duc's article Vitrail serves as guide to the whole. Ottin's book "Le Vitrail" is convenient. Male's volume "L'Art Religieux" is essential. In English, Westlake's "History of Design" is helpful. Perhaps, after reading all that is readable, the best hope will be to provide the best glasses with the largest possible field; and, choosing an hour when the church is empty, take seat about half way up the nave, facing towards the western entrance with a morning light, so that the glass of the western windows shall not stand in direct sun.

The glass of the three lancets is the oldest in the Cathedral. If the Portal beneath it, with the sculpture, was built in the twenty or thirty years before 1150, the glass could not be much later. It goes with the Abbé Suger's glass at Saint Denis which was surely made as early as 1140-1150, since the Abbé was a long time at work on it, before he died in 1152. Their perfection proves, what his biographer asserted, that the Abbé Suger spent many years as well as much money on his windows at Saint Denis, and the specialists affirm that the three lancets at Chartres are quite as good as what remains of Suger's work. Viollet-le-Duc and M. Paul Durand, the government expert, are positive that this glass is the finest ever made, as far as record exists; and that the northern lancet representing the Tree of Jesse stands at the head of all glass-work whatever. The windows claim, therefore, to be the most splendid color-decoration the world ever saw, since no other material, neither silk nor gold, and no opaque color laid on with a brush, can compare with translucent glass, and even the Ravenna mosaics or Chinese porcelains are darkness beside them.

The claim may not be modest, but it is none of ours. Viollet-le-Duc must answer for his own sins, and he chose the lancet window of the Tree of Jesse for the subject of his lecture on glass in general, as the most complete and perfect example of this greatest decorative art. Once more, in following him, one is dragged, in spite of oneself, into technique, and, what is worse, into a color world whose technique was forgotten five hundred years ago. Viollet-le-Duc tried to recover it. "After studying our best French windows," he cautiously suggests that "one might maintain" as their secret of harmony, that "the first condition for an artist in glass is to know how to manage blue. The blue is the light in windows, and light has value only by opposition." The radiating power of blue is therefore the starting-point, and on this matter Viollet-le-Duc has much to say which a student would need to master; but a tourist never should study, or he ceases to be a tourist; and it is enough for us if we know that, to get the value they wanted, the artists hatched their blues with lines, covered their surface with figures as though with screens, and tied their blue within its own field with narrow circlets of white or yellow, which, in their turn, were beaded to fasten the blue still more firmly in its place. We have chiefly to remember the law that blue is light:-

"But also it is that luminous color which gives value to all others. If you compose a window in which there shall be no blue, you will get a dirty or dull (blafard) or crude surface which the eye will instantly avoid; but if you put a few touches of blue among all these tones you will immediately get striking effects if not a skilfully conceived harmony. So the composition of blue glass singularly preoccupied the glass-workers of the twelfth and thirteenth centuries. If there is only one red, two yellows, two or three purples, and two or three greens at the most, there are infinite shades of blue, . . . and these blues are placed with a very delicate observation of the effects they should produce on other tones, and other tones on them."

Viollet-le-Duc took the window of the Tree of Jesse as his first illustration of the rule, for the reason that its blue ground is one continuous strip from top to bottom, with the subordinate red on either side, and a border uniting the whole so plainly that no one can fail to see its object or its method.

"The blue tone of the principal subject," that is to say, the ground of the Tree of Jesse, "has commanded the tonality of all the rest. This medium was necessary to enable the lumi-

nous splendor to display its energy. This primary condition has dictated the red ground for the prophets, and the return to the blue on reaching the outside semicircular band. To give full value both to the vigor of the red, and to the radiating transparency of the blue, the ground of the corners is put in emerald green; but then, in the corners themselves, the blue is recalled and is given an additional solidity of value by the delicate ornamentation of the squares."

This translation is very free, but one who wants to know these windows must read the whole article, and read it here in the church, the Dictionary in one hand, and binocle in the other, for the binocle is more important than the Dictionary when it reaches the complicated border which repeats in de-

tail the color-scheme of the centre:-

"The border repeats all the tones allotted to the principal subjects, but by small fragments, so that this border, with an effect both solid and powerful, shall not enter into rivalry

with the large arrangements of the central parts."

One would think this simple enough; easily tested on any illuminated manuscript, Arab, Persian or Byzantine; verified by any oriental rug, old or new; freely illustrated by any Chinese pattern on a Ming jar, or cloisonné vase; and offering a kind of alphabet for the shop-window of a Paris modiste. A strong red; a strong and a weak yellow; a strong and a weak purple; a strong and a weak green, are all to be tied together, given their values, and held in their places by blue. The thing seems simpler still when it appears that perspective is forbidden, and that these glass windows of the twelfth and thirteenth centuries, like oriental rugs, imply a flat surface, a wall which must not be treated as open. The twelfth-century glassworker would sooner have worn a landscape on his back than have costumed his church with it; he would as soon have decorated his floors with painted holes as his walls. He wanted to keep the colored window flat, like a rug hung on the wall. "The radiation of translucent colors in windows cannot be modified by the artist; all his talent consists in profiting by it, according to a given harmonic scheme on a single plane, like a rug, but not according to an effect of aerial perspective. Do what you like, a glass window never does and never can represent anything but a plane surface; its real virtues even exist only on that condition. Every attempt to present several planes to the eye is fatal to the harmony of color, without producing any illusion in the spectator. . . . Translucid painting can propose as its object only a design supporting as energetically as possible a harmony of colors."

Whether this law is absolute you can tell best by looking at modern glass which is mostly perspective; but, whether you like it or not, the matter of perspective does not enter into a twelfth-century window more than into a Japanese picture, and may be ignored. The decoration of the twelfth century, as far as concerns us, was intended only for one plane, and a window was another form of rug or embroidery or mosaic. hung on the wall for color,—simple decoration to be seen as a whole. If the Tree of Jesse teaches anything at all, it is that the artist thought first of controlling his light, but he wanted to do it not in order to dim the colors; on the contrary, he toiled, like a jeweller setting diamonds and rubies, to increase their splendor. If his use of blue teaches this lesson, his use of green proves it. The outside border of the Tree of Jesse is a sort of sample which our schoolmaster Viollet-le-Duc sets, from which he requires us to study out the scheme, beginning with the treatment of light, and ending with the value of the emerald green ground in the corners.

Complicated as the border of the Tree of Jesse is, it has its mates in the borders of the two other twelfth century windows, and a few of the thirteenth-century in the side-aisles; but the southern of the three lancets shows how the artists dealt with a difficulty that upset their rule. The border of the southern window does not count as it should; something is wrong with it; and a little study shows that the builder, and not the glass-worker, was to blame. Owing to his miscalculation—if it was really a miscalculation,—in the width of the southern tower, the builder economised six or eight inches in the southern door and lancet, which was enough to destroy the balance between the color-values, as masses, of the south and north windows. The artist was obliged to choose whether he would sacrifice the centre or the border of his southern window, and decided that the windows could not be made to balance if he narrowed the centre, but that he must balance

them by enriching the centre, and sacrificing the border. He

has filled the centre with medallions as rich as he could make them, and these he has surrounded with borders, which are also enriched to the utmost; but these medallions with their borders spread across the whole window, and when you search with the binocle for the outside border, you see its pattern clearly only at the top and bottom. On the sides, at intervals of about two feet, the medallions cover and interrupt it; but this is partly corrected by making the border, where it is seen, so rich as to surpass any other in the cathedral, even that of the Tree of Jesse. Whether the artist has succeeded or not is a question for other artists—or for you, if you please to decide; but apparently he did succeed, since no one has ever noticed the difficulty or the device.

The southern lancet represents the Passion of Christ. Granting to Viollet-le-Duc that the unbroken vertical colorscheme of the Tree of Jesse made the more effective window. one might still ask whether the medallion-scheme is not the more interesting. Once past the work-shop, there can be no question about it; the Tree of Jesse has the least interest of all the three windows. A genealogical tree has little value, artistic or other, except to those who belong in its branches, and the Tree of Jesse was put there, not to please us, but to please the Virgin. The Passion window was also put there to please her, but it tells a story, and does it in a way that has more novelty than the subject. The draughtsman who chalked out the design on the whitened table that served for his sketch-board was either a Greek, or had before him a Byzantine missal, or enamel or ivory. The first medallion on these legendary windows is the lower left-hand one, which begins the story or legend; here it represents Christ after the manner of the Greek Church. In the next medallion is the Last Supper; the fish on the dish is Greek. In the middle of the window, with the help of the binocle, you will see a Crucifixion, or even two, for on the left is Christ on the Cross, and on the right a Descent from the Cross; in this is the figure of a man pulling out with pincers the nails which fasten Christ's feet; a figure unknown to western religious art. The Noli Me Tangere, on the right, near the top, has a sort of Greek character. All the critics, especially M. Paul Durand, have noticed this Byzantine look, which is even more marked in the Suger window

at Saint Denis, so as to suggest that both are by the same hand, and that, the hand of a Greek. If the artist was really a Greek, he has done work more beautiful than any left at Byzantium, and very far finer than anything in the beautiful work at Cairo, but although the figures and subjects are more or less Greek, like the sculptures on the Portal, the art seems to be French.

Look at the central window! Naturally, there sits the Virgin, with her genealogical tree on her left, and her Son's testimony on her right, to prove her double divinity. She is seated in the long halo; as, on the western Portal, directly beneath her, her Son is represented in stone. Her crown and head, as well as that of the child, are fourteenth-century restorations more or less like the original; but her cushioned throne and her robes of imperial state, as well as the flowered sceptre in either hand, are as old as the sculpture of the Portal, and redolent of the first crusade. On either side of her. the Sun and the Moon offer praise; her two Archangels, Michael and Gabriel, with resplendent wings offer not incense as in later times, but the two sceptres of spiritual and temporal power; while the child in her lap repeats his mother's action and even her features and expression. At first sight, one would take for granted that all this was pure Byzantium, and perhaps it is; but it has rather the look of Byzantium gallicised, and carried up to a poetic French ideal. At Saint Denis the little figure of the Abbé Suger at the feet of the Virgin has a very oriental look, and in the twin medallion the Virgin resembles greatly the Virgin of Chartres, yet, for us, until some specialist shows us the Byzantine original, the work is as thoroughly French as the flèches of the churches.

Byzantine art is altogether another chapter, and, if we could but take a season to study it in Byzantium, we might get great amusement; but the art of Chartres, even in 1100, was French and perfectly French, as the architecture shows, and the glass is even more French than the architecture, as you can detect in many other ways. Perhaps the surest evidence is the glass itself. The men who made it were not professional but amateurs, who may have had some knowledge of enamelling, but who worked like jewellers, unused to glass, and with the refinement that a reliquary or a crozier

required. The cost of these windows must have been extravagant: one is almost surprised that they are not set in gold rather than in lead. The Abbé Suger shirked neither trouble nor expense, and the only serious piece of evidence that his artist was a Greek is given by his biographer who unconsciously shows that the artist cheated him: "He sought carefully for makers of windows and workmen in glass of exquisite quality, especially in that made of sapphires in great abundance that were pulverised and melted up in the glass to give it the blue color which he delighted to admire." The "materia saphirorum" was evidently something precious, -as precious as crude sapphires would have been, - and the words imply beyond question that the artist asked for sapphires and that Suger paid for them; yet all specialists agree that the stone known as sapphire, if ground, could not produce translucent color at all. The blue which Suger loved and which is probably the same as that of these Chartres windows, cannot be made out of sapphires. Probably the "materia saphirorum" means cobalt only, but whatever it was, the glass-makers seem to agree that this glass of 1140-1150 is the best ever made. M. Paul Durand in his official report of 1881 said that these windows, both artistically and mechanically, were of the highest class: - "I will also call attention to the fact that the glass and the execution of the painting are, materially speaking, of a quality much superior to windows of the thirteenth and fourteenth centuries. Having passed several months in contact with these precious works when I copied them, I was able to convince myself of their superiority in every particular, especially in the upper parts of the three windows." He said that they were perfect and irreproachable. The true enthusiast in glass would in the depths of his heart like to say outright that these three windows are worth more than all that the French have since done in color, from that day to this; but the matter concerns us chiefly because it shows how French the experiment was, and how Suger's taste and wealth made it possible.

Certain it is, too, that the southern window—the Passion—was made on the spot, or near by, and fitted for the particular space with care proportionate to its cost. All are marked by the hand of the Chartres Virgin. They are executed

not merely for her, but by her. At Saint Denis the Abbé Suger appeared,—it is true that he was prostrate at her feet, but still he appeared. At Chartres no one—no suggestion of a human agency—was allowed to appear; the Virgin permitted no one to approach her, even to adore. She is enthroned above, as Queen and Empress and Mother, with the symbols of exclusive and universal power. Below her, she permitted the world to see the glories of her earthly life;—the Annunciation, Visitation and Nativity; the Magi; King Herod; the Journey to Egypt; and the single medallion which shows the Gods of Egypt falling from their pedestals at her coming, is more entertaining than a whole picture-gallery of oil-paintings.

In all France there exist barely a dozen good specimens of twelfth-century glass. Besides these windows at Chartres and the fragments at Saint Denis, there are windows at Le Mans and Angers and bits at Vendome, Chalons, Poitiers, Reims, and Bourges; here and there one happens on other pieces, but the earliest is the best, because the glass-makers were new at the work and spent on it an infinite amount of trouble and money which they found to be unnecessary as they gained experience. Even in 1200 the value of these windows was so well understood, relatively to new ones, that they were preserved with the greatest care. The effort to make such windows was never repeated. Their jewelled perfection did not suit the scale of the vast churches of the thirteenth century. By turning your head towards the windows of the side-aisles, you can see the criticism which the later artists passed on the old work. They found it too refined, too brilliant, too jewellike for the size of the new cathedral; the play of light and color allowed the eye too little repose; indeed the eye could not see their whole beauty, and half their value was thrown away in this huge stone setting. At best they must have seemed astray on the bleak, cold, windy plain of Beauce,homesick for Palestine or Cairo, - yearning for Monreale or Venice,—but this is not our affair, and, under the protection of the Empress Virgin, Saint Bernard himself could have afforded to sin even to drunkenness of color. With trifling expense of imagination one can still catch a glimpse of the crusades in the glory of the glass. The longer one looks into it, the more overpowering it becomes, until one begins almost to feel an echo of what our two hundred and fifty million arithmetical ancestors, drunk with the passion of youth and the splendor of the Virgin, have been calling to us from Mont Saint Michel and Chartres. No words and no wine could revive their emotions so vividly as they glow in the purity of the colors; the limpidity of the blues; the depth of the red; the intensity of the green; the complicated harmonies; the sparkle and splendor of the light; and the quiet and

certain strength of the mass.

With too strong direct sun the windows are said to suffer, and become a cluster of jewels—a delirium of colored light. The lines, too, have different degrees of merit. These criticisms seldom strike a chance traveler, but he invariably makes the discovery that the designs within the medallions are childish. He may easily correct them, if he likes, and see what would happen to the window; but, although this is the alphabet of art, and we are past spelling words of one syllable, the criticism teaches at least one lesson. Primitive man seems to have had a natural color-sense, instinctive like the scent of a dog. Society has no right to feel it as a moral reproach to be told that it has reached an age when it can no longer depend, as in childhood, on its taste, or smell, or sight, or hearing, or memory; the fact seems likely enough, and in no way sinful; yet society always denies it, and is invariably angry about it; and, therefore, one had better not say it. On the other hand, we can leave Delacroix and his school to fight out the battle they began against Ingres and his school, in French art, nearly a hundred years ago, which turned in substance on the same point. Ingres held that the first motive in color-decoration was line, and that a picture which was well drawn was well enough colored. Society seemed, on the whole, to agree with him. Society in the twelfth century agreed with Delacroix. The French held then that the first point in color-decoration was color, and they never hesitated to put their color where they wanted it, or cared whether a green camel or a pink lion looked like a dog or a donkey provided they got their harmony or value. Everything except color was sacrificed to line in the large sense, but details of drawing were conventional and subordinate. So we laugh to see a knight with a blue face, on a green horse, that looks as though drawn by a four-year

old child, and probably the artist laughed too; but he was a colorist, and never sacrificed his color for a laugh.

We tourists assume commonly that he knew no better. In our simple faith in ourselves, great hope abides, for it shows an earnestness hardly less than that of the crusaders; but in the matter of color one is perhaps less convinced, or more open to curiosity. No school of color exists in our world today, while the middle ages had a dozen; but it is certainly true that these twelfth-century windows break the French tradition. They had no antecedent, and no fit succession. All the authorities dwell on their exceptional character. One is sorely tempted to suspect that they were in some way an accident; that such an art could not have sprung, in such perfection, out of nothing, had it been really French; that it must have had its home elsewhere,—on the Rhine,—in Italy—in Byzantium—or in Bagdad.

The same controversy has raged for near two hundred years over the gothic arch, and everything else mediæval, down to the philosophy of the schools. The generation that lived during the first and second crusades tried a number of original experiments, besides capturing Jerusalem. Among other things, it produced the western Portal of Chartres, with its statuary, its glass and its flèche, as a by-play; as it produced Abélard, Saint Bernard and Christian of Troves, whose acquaintance we have still to make. It took ideas wherever it found them; - from Germany, Italy, Spain, Constantinople, Palestine, or from the source which has always attracted the French mind like a magnet-from ancient Greece. That it actually did take the ideas, no one disputes, except perhaps patriots who hold that even the ideas were original; but to most students the ideas need to be accounted for less than the taste with which they were handled, and the quickness with which they were developed. That the taste was French, you can see in the architecture, or you will see if ever you meet the Gothic elsewhere; that it seized and developed an idea quickly, you have seen in the arch, the flèche, the porch, and the windows, as well as in the glass; but what we do not comprehend, and never shall, is the appetite behind all this; the greed for novelty; the fun of life. Everyone who has lived since the sixteenth century has felt deep distrust of everyone who lived

before it, and of everyone who believed in the middle ages. True it is that the last thirteenth-century artist died a long time before our planet began its present rate of revolution; it had to come to rest, and begin again; but this does not prevent astonishment that the twelfth-century planet revolved so fast. The pointed arch not only came as an idea into France, but it was developed into a system of architecture and covered the country with buildings on a scale of height never before attempted except by the dome, with an expenditure of wealth that would make a railway system look cheap, all in a space of about fifty years; the glass came with it, and went with it, at least as far as concerns us; but, if you need other evidence, you can consult Renan, who is the highest authority: - "One of the most singular phenomena of the literary history of the middle ages," says Renan of Averroès, "is the activity of the intellectual commerce, and the rapidity with which books were spread from one end of Europe to the other. The philosophy of Abélard during his lifetime (1100-1142) had penetrated to the ends of Italy. The French poetry of the trouvères counted within less than a century, translations into German, Swedish, Norwegian, Icelandic, Flemish, Dutch, Bohemian, Italian, Spanish," and he might have added that England needed no translation, but helped to compose the poetry, not being at that time so insular as she afterwards became. "Such or such a work, composed in Morocco or in Cairo, was known at Paris and at Cologne in less time than it would need in our days for a German book of capital importance to pass the Rhine;" and Renan wrote this in 1852 when German books of capital importance were revolutionising the literary world.

One is apt to forget the smallness of Europe, and how quickly it could always be crossed. In summer weather, with fair winds, one can sail from Alexandria or from Syria, to Sicily, or even to Spain and France, in perfect safety and with ample room for freight, as easily now as one could do it then, without the aid of steam; but one does not now carry freight of philosophy, poetry or art. The world still struggles for unity, but by different methods, weapons and thought. The mercantile exchanges which surprised Renan, and which have puzzled historians, were in ideas. The twelfth century was as

greedy for them in one shape, as the nineteenth century in another. France paid for them dearly, and repented for centuries; but what creates surprise to the point of incredulity is her hunger for them, the youthful gluttony with which she devoured them, the infallible taste with which she dressed them out. The restless appetite that snatched at the pointed arch, the stone flèche, the colored glass, the illuminated missal, the Chanson and Roman and Pastorelle, the fragments of Aristotle, the glosses of Avicenne, was nothing compared with the genius which instantly gave form and flower to them all.

This episode merely means that the French twelfth-century artist may be supposed to have known his business, and if he produced a grotesque, or a green-faced Saint, or a blue castle, or a syllogism, or a song, that he did it with a notion of the effect he had in mind. The glass window was to him a whole, -a mass, -and its details were its amusement; for the twelfth-century Frenchman enjoyed his fun, though it was sometimes rather heavy for modern French taste, and less refined than the Church liked. These three twelfth-century windows, like their contemporary Portal outside, and the flèche that goes with them, are the ideals of enthusiasts of mediæval art: they are above the level of all known art, in religious form; they are inspired; they are divine! This is the claim of Chartres and its Virgin. Actually, the French artist, whether architect, sculptor, or painter in glass, did rise here above his usual level. He knew it when he did it, and probably he attributed it, as we do, to the Virgin; for these works of his were hardly fifty years old when the rest of the old church was burned; and already the artist felt the virtue gone out of him. He could not do so well in 1200 as he did in 1150; and the Virgin was not so near.

The proof of it—or, if you prefer to think so, the proof against it—is before our eyes on the wall above the lancet windows. When Villard de Honnecourt came to Chartres, he seized at once on the western Rose as his study, although the two other Roses were probably there, in all their beauty and lightness. He saw in the western Rose some quality of construction which interested him; and, in fact, the western Rose is one of the flowers of architecture which reveals its beauties slowly without end; but its chief beauty is the feeling which

unites it with the Portal, the lancets and the flèche. The glassworker, here in the interior had the same task to perform. The glass of the lancets was fifty years old when the glass for the Rose was planned; perhaps it was seventy, for the exact dates are unknown, but it does not matter, for the greater the interval, the more interesting is the treatment. Whatever the date, the glass of the western Rose cannot be much earlier or much later than that of the other roses, or that of the choir, and yet you see at a glance that it is quite differently treated. On such matters one must of course submit to the opinion of artists, which one does the more readily because they always disagree; but until the artists tell us better, we may please ourselves by fancying that the glass of the Rose was intended to harmonize with that of the lancets, and unite it with the thirteenth-century glass of the nave and transepts. Among all the thirteenth-century windows the Western Rose alone seems to affect a rivalry in brilliancy with the lancets, and carries it so far that the separate medallions and pictures are quite lost,—especially in direct sunshine,—blending in a confused effect of opals, in a delirium of color and light, with a result like a cluster of stones in jewelry. Assuming as one must, in want of the artist's instruction, that he knew what he wanted to do, and did it, one must take for granted that he treated the Rose as a whole, and aimed at giving it harmony with the three precious windows beneath. The effect is that of a single large ornament; a round breastpin, or what is now called a sun-burst, of jewels, with three large pendants beneath.

We are ignorant tourists, liable to much error in trying to seek motives in artists who worked seven hundred years ago for a society which thought and felt in forms quite unlike ours, but the mediæval pilgrim was more ignorant than we, and much simpler in mind; if the idea of an ornament occurs to us, it certainly occurred to him, and still more to the glassworker whose business was to excite his illusions. An artist, if good for anything, foresees what his public will see; and what his public will see is what he ought to have intended—the measure of his genius. If the public sees more than he himself did, this is his credit; if less, this is his fault. No matter how simple or ignorant we are, we ought to feel a discord or a

harmony where the artist meant us to feel it, and when we see a motive, we conclude that other people have seen it before us, and that it must therefore have been intended. Neither of the transept Roses is treated like this one; neither has the effect of a personal ornament; neither is treated as a jewel. No one knew so well as the artist that such treatment must give the effect of a jewel. The Roses of France and of Dreux bear indelibly and flagrantly the character of France and Dreux; on the western Rose is stamped with greater refinement but equal decision the character of a much greater power than either of them.

No artist would have ventured to put up, before the eyes of Mary in Majesty, above the windows so dear to her, any object that she had not herself commanded. Whether a miracle was necessary, or whether genius was enough, is a point of casuistry which you can settle with Albertus Magnus or Saint Bernard, and which you will understand as little when settled as before; but for us, beyond the futilities of unnecessary doubt, the Virgin designed this Rose; not perhaps in quite the same perfect spirit in which she designed the lancets, but still wholly for her own pleasure and as her own idea. She placed upon the breast of her Church—which symbolised herself—a jewel so gorgeous that no earthly majesty could bear comparison with it, and which no other heavenly majesty has rivalled. As one watches the light play on it, one is still overcome by the glories of the jeweled Rose and its three gemmed pendants; one feels a little of the effect she meant it to produce even on infidels, Moors and heretics, but infinitely more on the men who feared, and the women who adored her; - not to dwell too long upon it, one admits that hers is the only Church. One would admit anything that she should require. If you had only the soul of a shrimp, you would crawl, like the Abbé Suger, to kiss her feet.

Unfortunately she is gone, or comes here now so very rarely that we never shall see her; but her genius remains as individual here as the genius of Blanche of Castile and Pierre de Dreux in the transepts. That the three lancets were her own taste as distinctly as the Trianon was the taste of Louis XIV, is self-evident. They represent all that was dearest to her; her Son's glory on her right; her own beautiful life in

the middle; her royal ancestry on her left; the story of her divine right, thrice-told. The pictures are all personal, like family portraits. Above them the man who worked in 1200 to carry out the harmony, and to satisfy the Virgin's wishes, has filled his rose with a dozen or two little compositions in glass, which reveal their subjects only to the best powers of a binocle. Looking carefully, one discovers at last that this gorgeous combination of all the hues of Paradise contains or hides a Last Judgment,—the one subject carefully excluded from the old work, and probably not existing on the south portal for another twenty years. If the scheme of the western Rose dates from 1200, as is reasonable to suppose, this Last Judgment is the oldest in the church, and makes a link between the theology of the first crusade, beneath, and the theology of Pierre Mauclerc in the south Porch. The churchman is the only true and final judge on his own doctrine, and we neither know nor care to know the facts; but we are as good judges as he of the feeling, and we are at full liberty to feel that such a Last Judgment as this was never seen before or since by churchman or heretic, unless by virtue of the heresy which held that the true Christian must be happy in being damned since such is the will of God. That this blaze of heavenly light was intended, either by the Virgin or by her workmen, to convey ideas of terror or pain, is a notion which the Church might possibly preach, but which we sinners knew to be false in the thirteenth century as well as we know it now. Never in all these seven hundred years has one of us looked up at this Rose without feeling it to be Our Lady's promise of Paradise.

Here as everywhere else throughout the Church, one feels the Virgin's presence, with no other thought than her majesty and grace. To the Virgin and to her suppliants, as to us, who though outcasts in other churches can still hope in hers, the Last Judgment was not a symbol of God's justice or man's corruption but of her own infinite mercy. The Trinity judged, through Christ;—Christ loved and pardoned, through her. She wielded the last and highest power on earth and in hell. In the glow and beauty of her nature, the light of her Son's infinite love shone as the sunlight through the glass, turning the Last Judgment itself into the highest proof of her divine

and supreme authority. The rudest ruffian of the middle-ages, when he looked at this Last Judgment, laughed; for what was the Last Judgment to her! An ornament, a play-thing, a pleasure! a jeweled decoration which she wore on her breast! Her chief joy was to pardon; her eternal instinct was to love; her deepest passion was pity! On her imperial heart the flames of hell showed only the opaline colors of heaven. Christ the Trinity might judge as much as he pleased, but Christ the Mother would rescue; and her servants could look boldly into the flames.

If you, or even our friends the priests who still serve Mary's shrine, suspect that there is some exaggeration in this language, it will only oblige you to admit presently that there is none; but for the moment we are busy with glass rather than with faith, and there is a world of glass here still to study. Technically we are done with it. The technique of the thirteenth century comes naturally and only too easily out of that of the twelfth. Artistically, the motive remains the same, since it is always the Virgin; but although the Virgin of Chartres is always the Virgin of Majesty, there are degrees in the assertion of her majesty even here, which affect the art, and qualify its feeling. Before stepping down to the thirteenth century, one should look at these changes of the Virgin's royal presence.

First and most important as record is the stone Virgin on the south door of the western Portal, which we studied, with her Byzantine court; and the second, also in stone, is of the same period, on one of the carved capitals of the Portal, representing the Adoration of the Magi. The third is the glass Virgin at the top of the central lancet. All three are undoubted twelfth-century work; and you can see another at Paris, on the same door of Notre Dame, and still more on Abbé Suger's window at Saint Denis, and, later, within a beautiful grisaille at Auxerre; but all represent the same figure; a Queen, enthroned, crowned, with the symbols of royal power, holding in her lap the infant king whose guardian she is. Without pretending to know what special crown she bears, we can assume, till corrected, that it is the Carlovingian imperial, not the Byzantine. The Trinity nowhere appears except as implied in the Christ. At the utmost, a mystic hand may symbolise the Father. The Virgin as represented by the artists

of the twelfth century in the Ile de France and at Chartres seems to be wholly French in spite of the Greek atmosphere of her workmanship. One might almost insist that she is blonde, full in face, large in figure, dazzlingly beautiful, and not more than thirty years of age. The child never seems to be more than five.

You are equally free to see a southern or eastern type in her face, and perhaps the glass suggests a dark type, but the face of the Virgin on the central lancet is a fourteenth-century restoration which may or may not reproduce the original, while all the other Virgins represented in glass, except one, belong to the thirteenth century. The possible exception is a wellknown figure called Notre-Dame-de-la-Belle-Verrière in the choir next the south transept. A strange, almost uncanny feeling seems to haunt this window, heightened by the veneration in which it was long held as a shrine, though it is now deserted for Notre-Dame-du-Pilier on the opposite side of the choir. The charm is partly due to the beauty of the scheme of the angels, supporting, saluting and incensing the Virgin and Child with singular grace and exquisite feeling, but rather that of the thirteenth than of the twelfth century. Here, too, the face of the Virgin is not ancient. Apparently the original glass was injured by time or accident, and the colors were covered or renewed by a simple drawing in oil. Elsewhere the color is thought to be particularly good, and the window is a favorite mine of motives for artists to exploit, but to us its chief interest is its singular depth of feeling. The Empress Mother sits full-face, on a rich throne and dais, with the child on her lap, repeating her attitude except that her hands support his shoulders. She wears her crown; her feet rest on a stool, and both stool, rug, robe and throne are as rich as color and decoration can make them. At last a dove appears, with the rays of the Holy Ghost. Imperial as the Virgin is, it is no longer quite the unlimited empire of the western lancet. The aureole encircles her head only; she holds no sceptre; the Holy Ghost seems to give her support which she did not need before, while Saint Gabriel and Saint Michael, her archangels, with their symbols of power, have disappeared. Exquisite as the angels are who surround and bear up her throne, they assert no authority. The window itself is not a single composition; the panels below seem inserted later merely to fill up the space; six represent the Marriage of Cana, and the three at the bottom show a grotesque little demon tempting Christ in the Desert. The effect of the whole, in this angle which is almost always dark or filled with shadow, is deep and sad, as though the Empress felt her authority fail, and had come down from the western Portal to reproach us for neglect. The face is haunting. Perhaps its force may be due to nearness, for this is the only instance in glass of her descending so low that we can almost touch her, and see what the twelfth century instinctively felt in the features which, even in their beatitude, were serious and almost sad under the austere responsibilities

of infinite pity and power.

No doubt the window is very old, or perhaps an imitation or reproduction of one which was much older, but to the pilgrim its interest lies mostly in its personality, and there it stands alone. Although the Virgin reappears again and again in the lower windows, - as in those on either side of the Belle Verrière; in the remnant of window representing her Miracles at Chartres, in the south aisle next the transept; in the fifteenth-century window of the Chapel of Vendome which follows; and in the third window which follows that of Vendome and represents her Coronation,—she does not show herself again in all her Majesty till we look up to the high windows above. There we shall find her in her splendor on her throne, above the high altar, and still more conspicuously in the Rose of France in the north transept. Still again she is enthroned in the first window of the choir next the north transept. Elsewhere we can see her standing, but never does she come down to us in the full splendor of her presence. Yet wherever we find her at Chartres, and of whatever period, she is always queen. Her expression and attitude are always calm and commanding. She never calls for sympathy by hysterical appeals to our feelings; she does not even altogether command, but rather accepts the voluntary, unquestioning, unhesitating, instinctive faith, love and devotion of mankind. She will accept ours, and we have not the heart to refuse it; we have not even the right, for we are her guests.

IX

The Legendary Windows

NE'S FIRST VISIT to a great Cathedral is like one's first visit to the British Museum; the only intelligent idea is to follow the order of time, but the Museum is a chaos in time, and the Cathedral is generally all of one and the same time. At Chartres, after finishing with the twelfth century, everything is of the thirteenth. To catch even an order in time, one must first know what part of the thirteenth-century church was oldest. The books say it was the choir. After the fire of 1194, the pilgrims used the great crypt as a church where services were maintained; but the builders must have begun with the central piers and the choir, because the choir was the only essential part of the church. Nave and transepts might be suppressed, but without a choir the church was useless, and in a shrine, such as Chartres, the choir was the whole church. Towards the choir, then, the priest or artist looks first; and, since dates are useful, the choir must be dated. The same popular enthusiasm which had broken out in 1145, revived in 1195 to help the rebuilding; and the work was pressed forward with the same feverish haste, so that ten years should have been ample to provide for the choir, if for nothing more; and services may have been resumed there as early as the year 1206; certainly in 1210. Probably the windows were designed and put in hand as soon as the architect gave the measurements, and anyone who intended to give a window would have been apt to choose one of the spaces in the apse, in Mary's own presence, next the sanctuary.

The first of the choir windows to demand a date is the Belle Verrière, which is commonly classed as early thirteenth century, and may go with the two windows next it, one of which,—the so-called Zodiac window,—bears a singularly interesting inscription:—"COMES TEOBALDUS DAT AD PRECES COMITIS PTICENSIS." If Shakespeare could write the tragedy of King John, we cannot admit ourselves not to have read it, and this inscription might be a part of the play. The "pagus perticensis" lies a short drive to the west, some

fifteen or twenty miles on the road to Le Mans, and in history is known as the Comté du Perche, although its memory is now preserved chiefly by its famous breed of Percheron horses. Probably the horse also dates from the crusades, and may have carried Richard Cœur-de-Lion, but in any case the Count of that day was a vassal of Richard, and one of his most intimate friends, whose memory is preserved forever by a single line in Richard's prison-song:-

> Mes compaignons cui j'amoie et cui j'aim, Ces dou Caheu et ces dou Percherain.

In 1194, when Richard Coeur-de-Lion wrote these verses, the Comte du Perche was Geoffroy III, who had been a companion of Richard on his crusade in 1192, where, according to the Chronicle, "he shewed himself but a timid man"; which seems scarcely likely in a companion of Richard; but it is not of him that the Chartres window speaks, except as the son of Mahaut or Matilda of Champagne who was a sister of Alix of Champagne, Queen of France. The Table shows, therefore, that Geoffroi's son and successor as the Comte du Perche,-Thomas,-was second cousin of Louis the Lion, known as King Louis VIII of France. They were probably of much the same age.

If this were all, one might carry it in one's head for a while, but the relationship which dominates the history of this period was that of all these great ruling families with Richard Cœur-de-Lion and his brother John, nicknamed Lackland, both of whom in succession were the most powerful Frenchmen in France. The Table shows that their mother Eleanor of Guienne, the first Queen of Louis VII, bore him two daughters, one of whom, Alix, married, about 1164, the Count Thibaut of Chartres and Blois, while the other, Mary, married the great Count of Champagne. Both of them being half-sisters of Cœur-de-Lion and John, their children were nephews or half-nephews, indiscriminately, of all the reigning monarchs, and Cœur-de-Lion immortalised one of them by a line in his prison-song, as he immortalised Le Perche:-

> Je nel di pas de celi de Chartain, La mere Loeis.

FRANCE AND LE PERCHE

CHAMPAGNE AND CHARTRES

ENGLAND

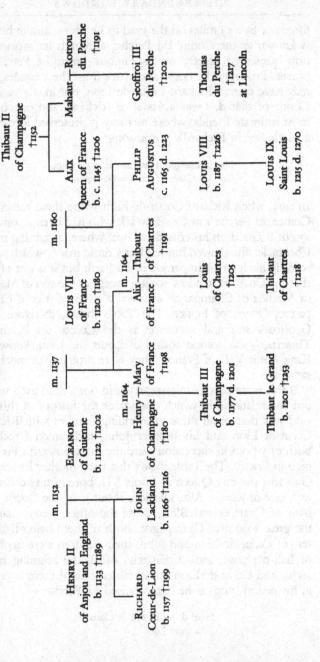

"Loeis," therefore, or Count Louis of Chartres was not only nephew of Cœur-de-Lion and John Lackland, but was also, like Count Thomas of Le Perche a second cousin of Louis VIII. Feudally and personally he was directly attached to

Cœur-de-Lion rather than to Philip Augustus.

If society in the twelfth century could follow the effects of these relationships, personal and feudal, it was cleverer than society in the twentieth; but so much is simple:—Louis of France, Thibaut of Chartres, and Thomas of Le Perche, were cousins and close friends in the year 1215, and all were devoted to the Virgin of Chartres. Judging from the character of Louis' future queen, Blanche of Castile, their wives were, if possible, more devoted still; and in that year Blanche gave birth to Saint Louis, who seems to have been the most devoted of all.

Meanwhile their favorite uncle, Cœur-de-Lion, had died in the year 1199. Thibaut's great-grandmother Eleanor of Guienne, died in 1202. King John, left to himself, rapidly accumulated enemies innumerable, abroad and at home. In 1203, Philip Augustus confiscated all the fiefs he held from the French crown, and in 1204 seized Normandy. John sank rapidly from worse to worst, until at last the English barons rose and forced him to grant their Magna Carta at Runnimede in 1215.

The year 1215 was, therefore, a year to be remembered at Chartres, as at Mont Saint Michel; one of the most convenient dates in history. Everyone is supposed, even now, to know what happened then, to give another violent wrench to society, like the Norman conquest in 1066. John turned on the barons and broke them down; they sent to France for help, and offered the crown of England to young Louis, whose father Philip Augustus called a council which pledged support to Louis. Naturally the Comte du Perche and the Comte de Chartres must have pledged their support, among the foremost, to go with Louis to England. He was then twenty-nine years old; they were probably somewhat younger.

The Zodiac window, with its inscription, was the immediate result. The usual authority that figures in the histories is Roger of Wendover, but much the more amusing for our purpose is a garrulous Frenchman known as the Ménestrel de

Reims who wrote some fifty years later. After telling in his delightful thirteenth-century French, how the English barons sent hostages to Louis, "et mes sires Loueys les fit bien gardeir et honourablement," the Ménestrel continued:—"Et assembla granz genz par amours, et par deniers, et par lignage. Et fu avec lui li cuens dou Perche, et li cuens de Montfort, et li cuens de Chartres, et li cuens de Monbleart, et mes sires Enjorrans de Couci, et mout d'autre grant seigneur dont je ne parole mie."

The Comte de Chartres, therefore, may be supposed to have gone with the Comte du Perche, and to have witnessed the disaster at Lincoln which took place May 20, 1217, after

King John's death: -

Et li cuens dou Perche faisait l'avantgarde, et courut tout leiz des portes; et la garnisons de laienz issi hors et leur coururent sus; et i ot asseiz trait et lancié; et chevaus morz et chevaliers abatuz, et gent à pié morz et navreiz. Et li cuens dou Perche i fu morz par un ribaut qui li leva le pan dou hauberc, et l'ocist d'un coutel; et fu desconfite l'avantgarde par la mort le conte. Et quant mes sires Loueys le sot, si ot graigneur duel qu'il eust onques, car il estoit ses prochains ami de char.

Such language would be spoiled by translation. For us it is enough to know that the "ribaut" who lifted the "pan," or skirt, of the Count's "hauberc" or coat-of-mail, as he sat on his horse refusing to surrender to English traitors, and stabbed him from below with a knife, may have been an invention of the Ménestrel; or the knight who pierced with his lance through the visor to the brain, may have been an invention of Roger of Wendover; but in either case, Count Thomas du Perche lost his life at Lincoln, May 20, 1217, to the deepest regret of his cousin Louis the Lion as well as of the Count Thibaut of Chartres, whom he charged to put up a window for him in honor of the Virgin.

The window must have been ordered at once, because Count Thibaut, "le Jeune ou le Lépreux," died himself within a year, April 22, 1218, thus giving an exact date for one of the choir windows. Probably it was one of the latest, because the earliest to be provided would have been certainly those of the central apsidal chapel. According to the rule laid down by Viollet-le-Duc, the windows in which blue strongly predom-

inates, like the Saint Sylvester, are likely to be earlier than those with a prevailing tone of red. We must take for granted that some of these great legendary windows were in place as early as 1210, because, in October of that year, Philip Augustus attended mass here. There are some two dozen of these windows in the choir alone, each of which may well have represented a year's work in the slow processes of that day, and we can hardly suppose that the workshops of 1200 were on a scale such as to allow of more than two to have been in hand at once. Thirty or forty years later, when the Sainte Chapelle was built, the workshops must have been vastly enlarged, but with the enlargement, the glass deteriorated. Therefore, if the architecture were so far advanced in the year 1200 as to allow of beginning work on the glass, in the apse, the year 1225 is none too late to allow for its completion in the choir.

Dates are stupidly annoying; - what we want is not dates but taste; - yet we are uncomfortable without them. Except the Perche window, none of the lower ones in the choir help at all; but the clerestory is more useful. There they run in pairs, each pair surmounted by a rose. The first pair (Nos. 27 and 28) next the north transept, show the Virgin of France, supported, according to the Abbés Bulteau and Clerval, by the arms of Bishop Reynault de Mouçon who was Bishop of Chartres at the time of the great fire in 1194 and died in 1217. The window No. 28 shows two groups of peasants on pilgrimage; below, on his knees, Robert of Berou, as donor:-ROBERTUS DE BEROU: CARN. CANCELLARIUS. The Cartulary of the Cathedral contains an entry (Bulteau, i, 123):-"The 26th February, 1216, died Robert de Berou, Chancellor, who has given us a window." The Cartulary mentions several previous gifts of windows by canons or other dignitaries of the Church in the year 1215.

Next follow, or once followed, a pair of windows (Nos. 29 and 30) which were removed by the sculptor Bridan, in 1788, in order to obtain light for his statuary below. The donor was DOMINA JOHANNES BAPTISTA, who, we are told, was Jeanne de Dammartin; and the window was given in memory, or in honor, of her marriage to Ferdinand of Castile in 1237. Jeanne was a very great lady, daughter of the Comte d'Aumale and

Marie de Ponthieu. Her father affianced her in 1235 to the King of England, Henry III, and even caused the marriage to be celebrated by proxy, but Queen Blanche broke it off, as she had forbidden, in 1231, that of Yolande of Brittany. She relented so far as to allow Jeanne in 1237 to marry Ferdinand of Castile, who still sits on horseback in the next rose:—Rex Castillae. He won the Crown of Castile in 1217 and died in 1252, when Queen Jeanne returned to Abbeville and then, at latest, put up this window at Chartres in memory of her husband.

The windows Nos. 31 and 32 are the subject of much dispute, but whether the donors were Jean de Chatillon or the three children of Thibaut le Grand of Champagne, they must equally belong to the later series of 1260–1270, rather than to the earlier of 1210–1220. The same thing is or was, true of the next pair, Nos. 33 and 34, which were removed in 1773, but the record says that at the bottom of 34 was the figure of Saint Louis' son, Louis of France, who died in 1260, before

his father, who still rides in the rose above.

Thus the north side of the choir shows a series of windows that precisely cover the life-time of Saint Louis (1215-1270) The south side begins, next the apse, with windows Nos. 35 and 36 which belong, according to the Comte d'Armancourt, to the family of Montfort, whose ruined castle crowns the hill of Montfort l'Amaury, on the road to Paris, some forty kilometres northeast of Chartres. Everyone is supposed to know the story of Simon de Montfort who was killed before Toulouse in 1218. Simon left two sons, Amaury and Simon. The sculptor Bridan put an end also to the window of Amaury, but in the rose, Amaury, according to the Abbés, still rides on a white horse. Amaury's history is well known. He was made Constable of France by Queen Blanche in 1231; went on crusade in 1239; was captured by the infidels, taken to Babylon, ransomed, and in returning to France, died at Otranto in 1241. For that age Amaury was but a commonplace person, totally overshadowed by his brother Simon, who went to England, married King John's daughter Eleanor, and became almost King himself as Earl of Leicester. At your leisure you can read Matthew Paris's dramatic account of him and of his death at the battle of Evesham, August 5, 1265. He was perhaps the last of the very great men of the thirteenth century,

excepting Saint Louis himself who lived a few years longer. M. d'Armancourt insists that it is the great Earl of Leicester who rides with his visor up, in full armor, on a brown horse, in the rose above the windows Nos. 37 and 38. In any case, the windows would be later than 1240.

The next pair of windows, Nos. 39 and 40, also removed in 1788, still offer, in their rose, the figure of a member of the Courtenay family. Gibbon was so much attracted by the romance of the Courtenavs as to make an amusing digression on the subject which does not concern us or the Cathedral except so far as it tells us that the Courtenays, like so many other benefactors of Chartres Cathedral, belonged to the roval blood. Louis-le-Gros, who died in 1137, besides his son Louis-le-Jeune who married Eleanor of Guienne in that year, had a youngest son, Pierre, whom he married to Isabel de Courtenay, and who, like Philip Hurepel, took the title of his wife. Pierre had a son, Pierre II, who was a cousin of Philip Augustus, and became the hero of the most lurid tragedy of the time. Chosen Emperor of Constantinople in 1216, to succeed his brothers-in-law Henry and Baldwin, he tried to march across Illyria and Macedonia, from Durazzo opposite Brindisi, with a little army of five thousand men, and instantly disappeared forever. The Epirotes captured him in the summer of 1217, and from that moment nothing is known of his fate.

On the whole, this catastrophe was perhaps the grimmest of all the Shakespearian tragedies of the thirteenth century; and one would like to think that the Chartres window was a memorial of this Pierre, who was a cousin of France and an Emperor without empire; but M. d'Armancourt insists that the window was given in memory not of this Pierre, but of his nephew, another Pierre de Courtenay, seigneur de Conches, who went on crusade with Saint Louis in 1249 to Egypt, and died shortly before the defeat and captivity of the King, on February 8, 1250. His brother Raoul, seigneur d'Illiers, who died in 1271, is said to be donor of the next window, No. 40. The date of the Courtenay windows should therefore be no earlier than the death of Saint Louis in 1270; yet one would like to know what has become of another Courtenay window left by the first Pierre's son-in-law, Gaucher or Gaultier of Bar-sur-Seine, who seems to have

been Vicomte de Chartres, and who, dying before Damietta in 1218, made a will leaving to Notre Dame de Chartres thirty silver marks, "de quibus fieri debet miles montatus super equum suum." Not only would this mounted knight on horseback supply an early date for these interesting figures, but would fix also the cost, for a mark contained eight ounces of silver, and was worth ten sous, or half a livre. We shall presently see that Aucassins gave twenty sous, or a livre, for a strong ox, so that the "miles montatus super equum suum" in glass was equivalent to fifteen oxen if it were money of Paris, which is far from certain.

This is an economical problem which belongs to experts, but the historical value of these early evidences is still something,-perhaps still as much as ten sous. All the windows tend to the same conclusion. Even the last pair, Nos. 41 and 42, offer three personal clues which lead to the same result:the arms of Bouchard de Marly who died in 1226, almost at the same time as Louis VIII; a certain Colinus or Colin, "de camera Regis," who was alive in 1225; and Robert of Beaumont in the rose, who seems to be a Beaumont of Le Perche, of whom little or nothing is as yet certainly known. As a general rule, there are two series of windows, one figuring the companions or followers of Louis VIII (1215-1226); the other, friends or companions of Saint Louis (1226-1270), Queen Blanche uniting both. What helps to hold the sequences in a certain order, is that the choir was complete, and services regularly resumed there, in 1210, while in 1220 the transept and nave were finished and vaulted. For the apside windows, therefore, we will assume, subject to correction, a date from 1200 to 1225 for their design and workmanship; for the transept, 1220 to 1236; and for the nave a general tendency to the actual reign of Saint Louis from 1236 to 1270. Since there is a deal of later glass scattered everywhere among the earlier, the margin of error is great; but by keeping the reign of Louis VIII and its personages, distinct from that of Louis IX and his generation, we can be fairly sure of our main facts. Meanwhile the Sainte Chapelle in Paris, wholly built and completed between 1240 and 1248, offers a standard of comparison for the legendary windows.

The choir of Chartres is as long as the nave, and much

broader, besides that the apse was planned with seven circular projections which greatly increased the window-space, so that the guide-book reckons thirty-seven windows. A number of these are grisailles, and the true amateur of glass considers the grisailles to be as well worth study as the legendary windows. They are a decoration which has no particular concern with churches, and no distinct religious meaning, but, it seems, a religious value, which Viollet-le-Duc is at some trouble to explain; and, since his explanation is not very technical, we can look at it, before looking at the legends:—

The coloration of the windows had the advantage of throwing on the opaque walls a veil, or colored glazing, of extreme delicacy, always assuming that the colored windows themselves were harmoniously toned. Whether their resources did not permit the artists to adopt a complete system of colored glass, or whether they wanted to get daylight in purer quality into their interiors, - whatever may have been their reasons - they resorted to this beautiful grisaille decoration which is also a coloring harmony obtained by the aid of a long experience in the effects of light on translucent surfaces. Many of our churches retain grisaille windows filling either all, or only a part of their bays. In the latter case, the grisailles are reserved for the side windows which are meant to be seen obliquely, and in that case the colored glass fills the bays of the fond, the apsidal openings which are meant to be seen in face from a distance. These lateral grisailles are still opaque enough to prevent the solar rays which pass through them from lighting the colored windows on the reverse side; yet, at certain hours of the day, these solar rays throw a pearly light on the colored windows which gives them indescribable transparence and refinement of tones. The lateral windows in the choir of the Auxerre Cathedral, half-grisaille, half-colored, throw on the wholly colored apsidal window, by this means, a glazing the softness of which one can hardly conceive. The opaline light which comes through these lateral bays, and makes a sort of veil, transparent in the extreme, under the lofty vaulting, is crossed by the brilliant tones of the windows behind, which give the play of precious stones. The solid outlines then seem to waver like objects seen through a sheet of clear water. Distances change their values, and take depths in which the eye gets lost. With every hour of the day these effects are altered, and always with new harmonies which one never tires of trying to understand; but the deeper one's study goes, the more astounded one becomes before the experience acquired by these artists, whose theories on the effects of color, assuming that they had any, are unknown to us and whom the most kindly-disposed among us treat as simple children.

You can read the rest for yourselves. Grisaille is a separate branch of color-decoration which belongs with the whole sys-

tem of lighting and *fenêtrage*, and will have to remain a closed book because the feeling and experience which explained it once are lost, and we cannot recover either. Such things must have been always felt rather than reasoned, like the irregularities in plan of the builders; the best work of the best times shows the same subtlety of sense as the dog shows in retrieving, or the bee in flying, but which tourists have lost. All we can do is to note that the *grisailles* were intended to have values. They were among the refinements of light and color with which the apse of Chartres is so crowded that one must be content to feel what one can, and let the rest go.

Understand, we cannot! nothing proves that the greatest artists who ever lived have, in a logical sense, understood! or that omnipotence has ever understood! or that the utmost power of expression has ever been capable of expressing more than the reaction of one energy on another, but not of two on two; and when one sits here, in the central axis of this complicated apse, one sees, in mere light alone, the reaction of hundreds of energies, although time has left only a wreck of what the artist put here. One of the best window-spaces is wholly filled up by the fourteenth-century door-way to the chapel of Saint Piat, and only by looking at the two windows which correspond on the north, does a curious inquirer get a notion of the probable loss. The same chapel more or less blocks the light of three other principal windows. The sun, the dust, the acids of dripping water, and the other works of time, have in seven hundred years corroded or worn away or altered the glass, especially on the south side. Windows have been darkened by time and mutilated by wilful injury. Scores of the panels are wholly restored, modern reproductions or imitations. Even after all this loss, the glass is probably the best-preserved, or perhaps the only preserved part of the decoration in color, for we never shall know the color-decoration of the vaults, the walls, the columns or the floors. Only one point is fairly sure; -that on festivals, if not at other times, every foot of space was covered in some way or another, throughout the apse, with color; either paint or tapestry or embroidery or Byzantine brocades and oriental stuffs or rugs, lining the walls, covering the altars, and hiding the floor. Occasionally you happen upon illuminated manuscripts showing

the interiors of chapels with their color decoration; but every-

thing has perished here except the glass.

If one may judge from the glass of later centuries, the first impression from the thirteenth-century windows ought to be disappointment. You should find them too effeminate, too soft, too small, and above all not particularly religious. Indeed, except for the nominal subjects of the legends, one sees nothing religious about them; the medallions, when studied with the binocle, turn out to be less religious than decorative. Saint Michael would not have felt at home here, and Saint Bernard would have turned from them with disapproval; but when they were put up, Saint Bernard was long dead, and Saint Michael had yielded his place to the Virgin. This apse is all for her. At its entrance she sat, on either side, in the Belle Verrière or as Our Lady of the Pillar, to receive the secrets and the prayers of suppliants who wished to address her directly in person; there she bent down to our level, resumed her humanity, and felt our griefs and passions. Within, where the cross-lights fell through the wide columned space behind the high altar, was her withdrawing room, where the decorator and builder thought only of pleasing her. The very faults of the architecture and effeminacy of taste witness the artists' object. If the glass-workers had thought of themselves or of the public or even of the priests, they would have strained for effects, strong masses of color, and striking subjects to impress the imagination. Nothing of the sort is even suggested. The great, awe-inspiring mosaic figure of the Byzantine halfdome was a splendid religious effect, but this artist had in his mind an altogether different thought. He was in the Virgin's employ; he was decorating her own chamber in her own palace; he wanted to please her; and he knew her tastes, even when she did not give him her personal orders. To him, a dream would have been an order. The salary of the twelfthcentury artist was out of all relation with the percentage of a twentieth-century decorator. The artist of 1200 was probably the last who cared little for the baron, not very much for the priest, and nothing for the public, unless he happened to be paid by the guild, and then he cared just to the extent of his hire, or, if he was himself a priest, not even for that. His pay was mostly of a different kind, and was the same as that of the peasants who were hauling the stone from the quarry at Berchères while he was firing his ovens. His reward was to come when he should be promoted to decorate the Queen of Heaven's palace in the New Jerusalem, and he served a mistress who knew better than he did what work was good and what was bad, and how to give him his right place. Mary's taste was infallible; her knowledge like her power had no limits; she knew men's thoughts as well as acts, and could not be deceived. Probably, even in our own time, an artist might find his imagination considerably stimulated and his work powerfully improved if he knew that anything short of his best would bring him to the gallows, with or without trial by jury; but in the twelfth century the gallows was a trifle; the Queen hardly considered it a punishment for an offence to her dignity. The artist was vividly aware that Mary disposed of Hell.

All this is written in full, on every stone and window of this apse, as legible as the legends to anyone who cares to read. The artists were doing their best not to please a swarm of flat-eared peasants or slow-witted barons, but to satisfy Mary, the Queen of Heaven, to whom the Kings and Queens of France were coming constantly for help, and whose absolute power was almost the only restraint recognised by Emperor, Pope and clown. The color-decoration is hers, and hers alone. For her the lights are subdued, the tones softened, the subjects selected, the feminine taste preserved. That other great ladies interested themselves in the matter, even down to its technical refinements, is more than likely; indeed, in the central apside chapel, suggesting the Auxerre grisaille that Viollet-le-Duc mentioned, is a grisaille which bears the arms of Castile and Queen Blanche; further on, three other grisailles bear also the famous Castles, but this is by no means the strongest proof of feminine taste. The difficulty would be rather to find a touch of certainly masculine taste in the whole apse.

Since the central apside chapel is the most important, we can begin with the windows there, bearing in mind that the subject of the central window was the Life of Christ, dictated by rule or custom. On Christ's left hand is the window of Saint Peter; next him is Saint Paul. All are much restored; thirty-three of the medallions are wholly new. Opposite Saint

Peter, at Christ's right hand, is the window of Saint Simon and Saint Jude; and next is the *grisaille* with the arms of Castile. If these windows were ordered between 1205 and 1210, Blanche, who was born in 1187, and married in 1200, would have been a young princess of twenty or twenty-five when she gave this window in *grisaille* to regulate and harmonise and soften the lighting of the Virgin's boudoir. The central chapel must be taken to be the most serious, the most studied, and the oldest of the chapels in the church, above the crypt. The windows here should rank in importance next to the lancets of the west front which are only about sixty years earlier. They show fully that difference.

Here one must see for oneself. Few artists know much about it, and still fewer care for an art which has been quite dead these four hundred years. The ruins of Nippur would hardly be more intelligible to the ordinary architect of English tradition than these twelfth-century efforts of the builders of Chartres. Even the learning of Viollet-le-Duc was at fault in dealing with a building so personal as this, the history of which is almost wholly lost. This central chapel must have been meant to give tone to the apse, and it shows with the color-decoration of a Queen's salon, a subject-decoration too serious for the amusement of heretics. One sees at a glance that the subject-decoration was inspired by church-custom. while color was an experiment, and the decorators of this enormous window-space were at liberty as colorists to please the Countess of Chartres and the Princess Blanche and the Duchess of Brittany, without much regarding the opinions of the late Bernard of Clairvaux or even Augustine of Hippo, since the great ladies of the Court knew better than the Saints what would suit the Virgin.

The subject of the central window was prescribed by tradition. Christ is the Church, and in this church he and his Mother are one; therefore the life of Christ is the subject of the central window, but the treatment is the Virgin's, as the colors show, and as the absence of every influence but hers, including the crucifixion, proves officially. Saint Peter and Saint Paul are in their proper place as the two great ministers of the throne who represent the two great parties in western religion, the Jewish and the Gentile. Opposite them, balanc-

ing by their family influence the weight of delegated power, are two of Mary's nephews, Simon and Jude; but this subject branches off again into matters so personal to Mary that Simon and Jude require closer acquaintance. One must study a new guide-book,—the Golden Legend, by the blessed James, bishop of Genoa and member of the order of Dominic, who was born at Varazze or Voragio in almost the same year that Thomas was born at Aquino, and whose Legenda Aurea, written about the middle of the thirteenth century, was more popular history than the Bible itself, and more generally consulted as authority. The decorators of the thirteenth century got their motives quite outside the Bible, in sources that James of Genoa compiled into a volume almost as fascinating as the Fioretti of Saint Francis.

According to the Golden Legend and the tradition accepted in Jerusalem by pilgrims and crusaders, Mary's family connection was large. It appears that her mother Anne was three times married, and by each husband had a daughter Mary, so that there were three Marys, half-sisters.

Simon and Jude were, therefore, nephews of Mary and cousins of Christ, whose lives were evidence of the truth not merely of scripture but specially of the private and family distinction of their aunt, the Virgin Mother of Christ. They were selected, rather than their brothers, or cousins James and John, for the conspicuous honor of standing opposite Peter and Paul, doubtless by reason of some merit of their own, but perhaps also because in art the two counted as one, and therefore the one window offered two witnesses, which allowed the artist to insert a *grisaille* in place of another legendary window to complete the chapel on their right. According

to Viollet-le-Duc, the grisaille in this position regulates the

light and so completes the effect.

If custom prescribed a general rule for the central chapel, it seems to have left great freedom in the windows near by. At Chartres the curved projection that contains the next two windows was not a chapel, but only a window-bay, for the sake of the windows, and, if the artists aimed at pleasing the Virgin, they would put their best work there. At Bourges in the same relative place are three of the best windows in the building: - the Prodigal Son, the New Alliance and the Good Samaritan; all of them full of life, story and color, with little reference to a worship or a saint. At Chartres the choice is still more striking, and the windows are also the best in the building, after the twelfth-century glass of the west front. The first, which comes next to Blanche's grisaille in the central chapel, is given to another nephew of Mary and apostle of Christ, Saint James the Major, whose life is recorded in the proper Bible Dictionaries, with a terminal remark as follows: -

For legends respecting his death and his connections with Spain, see the Roman Breviary, in which the healing of a paralytic and the conversion of Hermogenes are attributed to him, and where it is asserted that he preached the Gospel in Spain, and that his remains were translated to Compostella . . . As there is no shadow of foundation for any of the legends here referred to, we pass them by without further notice. Even Baronius shows himself ashamed of them.

If the learned Baronius thought himself required to show shame for all the legends that pass as history, he must have suffered cruelly during his laborious life, and his sufferings would not have been confined to the annals of the Church; but the historical accuracy of the glass windows is not our affair, nor are historians especially concerned in the events of the Virgin's life, whether recorded or legendary. Religion is, or ought to be, a feeling, and the thirteenth-century windows are original documents, much more historical than any recorded in the Bible, since their inspiration is a different thing from their authority. The true life of Saint James or Saint Jude or any other of the apostles, did not, in the opinion of the ladies in the Court of France, furnish subjects agreeable

enough to decorate the palace of the Queen of Heaven; and that they were right, anyone must feel, who compares these two windows with subjects of dogma. Saint James, better known as Santiago of Compostella, was a compliment to the young Dauphine—before Dauphines existed—the Princess Blanche of Castile, whose arms, or Castles, are on the *grisaille* window next to it. Perhaps she chose him to stand there. Certainly her hand is seen plainly enough throughout the church to warrant suspecting it here. As a nephew, Saint James was dear to the Virgin, but, as a friend to Spain, still more dear to Blanche, and it is not likely that pure accident caused three

adjacent windows to take a Spanish tone.

The Saint James in whom the thirteenth century delighted, and whose windows one sees at Bourges, Tours, and wherever the scallop-shell tells of the pilgrim, belongs not to the Bible but to the Golden Legend. This window was given by the Merchant Tailors whose signature appears at the bottom. in the corners, in two pictures that paint the tailor's shop of Chartres in the first quarter of the thirteenth century. The shop-boy takes cloth from chests for his master to show to customers, and to measure off by his ell. The story of Saint James begins in the lower panel, where he receives his mission from Christ. Above, on the right, he seems to be preaching. On the left appears a figure which tells the reason for the popularity of the story. It is Almogenes, or in the Latin, Hermogenes, a famous magician in great credit among the pharisees, who has the command of demons, as you see, for behind his shoulder, standing, a little demon is perched, while he orders his pupil Filetus to convert James. Next, James is shown in discussion with a group of listeners. Filetus gives him a volume of false doctrine. Almogenes then further instructs Filetus. James is led away by a rope, curing a paralytic as he goes. He sends his cloak to Filetus to drive away the demon. Filetus receives the cloak, and the droll little demon departs in tears. Almogenes, losing his temper, sends two demons with horns on their heads and clubs in their hands, to reason with James; who sends them back to remonstrate with Almogenes. The demons then bind Almogenes and bring him before James who discusses differences with him until Almogenes burns his books of magic and prostrates himself before

the Saint. Both are then brought before Herod, and Almogenes breaks a pretty heathen idol, while James goes to prison. A panel comes in here, out of place, showing Almogenes enchanting Filetus, and the demon entering into possession of him. Then Almogenes is seen being very roughly handled by a young Jew, while the bystanders seem to approve. James next makes Almogenes throw his books of magic into the sea; both are led away to execution, curing the infirm on their way; their heads are cut off; and, at the top, God blesses the orb of the world.

That this window was intended to amuse the Virgin seems quite as reasonable an idea as that it should have been made to instruct the people, or us. Its humor was as humorous then as now, for the French of the thirteenth century loved humor even in churches, as their grotesques proclaim. The Saint James window is a tale of magic, told with the vivacity of a Fabliau; but if its motive of amusement seems still a forced idea, we can pass on, at once, to the companion window which holds the best position in the church, where, in the usual Cathedral, one expects to find Saint John or some other Apostle; or Saint Joseph; or a doctrinal lesson such as that called the New Alliance where the Old and New Testaments are united. The window which the artists have set up here is regarded as the best of the thirteenth-century windows, and is the least religious.

The subject is nothing less than the Chanson de Roland in pictures of colored glass, set in a border worth comparing at leisure with the twelfth-century borders of the western lancets. Even at Chartres, the artists could not risk displeasing the Virgin and the Church by following a wholly profane work like the Chanson itself, and Roland had no place in religion. He could be introduced only through Charlemagne who had almost as little right there as he. The twelfth century had made persistent efforts to get Charlemagne into the Church, and the Church had made very little effort to keep him out; yet by the year 1200, Charlemagne had not been sainted except by the Anti-pope Pascal III in 1165, although there was a popular belief, supported in Spain by the necessary documents, that Pope Calixtus II in 1122 had declared the so-called Chronicle of Archbishop Turpin to be authentic.

The Bishop of Chartres in 1200 was very much too enlightened a prelate to accept the Chronicle or Turpin or Charlemagne himself, still less Roland and Thierry, as authentic in sanctity; but if the young and beautiful Dauphine of France, and her cousins of Chartres, and their artists, warmly believed that the Virgin would be pleased by the story of Charlemagne and Roland, the Bishop might have let them have their way in spite of the irregularity. That the window was an irregularity, is plain; that it has always been immensely admired, is certain; and that Bishop Renaud must have given his assent to it, is not to be denied.

The most elaborate account of this window can be found in Male's "Art Religieux" (pp. 444-450). Its feeling or motive is quite another matter, as it is with the statuary on the north porch. The Furriers or Fur-merchants paid for the Charlemagne window, and their signature stands at the bottom, where a merchant shows a fur-lined cloak to his customer. That Mary was personally interested in furs no authority seems to affirm, but that Blanche and Isabel and every lady of the Court, as well as every king and every count, in that day, took keen interest in the subject, is proved by the prices they paid, and the quantities they wore. Not even the Merchant-tailors had a better standing at Court than the Furriers, which may account for their standing so near the Virgin. Whatever the cause, the Furriers were allowed to put their signature here, side by side with the Tailors, and next to the princess Blanche. Their gift warranted it. Above the signature, in the first panel, the Emperor Constantine is seen, asleep, in Constantinople, on an elaborate bed, while an angel is giving him the order to seek aid from Charlemagne against the Saracens. Charlemagne appears, in full armor of the year 1200, on horseback. Then Charlemagne, sainted, wearing his halo, converses with two bishops on the subject of a crusade for the rescue of Constantine. In the next scene, he arrives at the gates of Constantinople where Constantine receives him. The fifth picture is most interesting; Charlemagne has advanced with his knights and attacks the Saracens; the Franks wear coats of mail, and carry long, pointed shields; the infidels carry round shields; Charlemagne, wearing a crown, strikes off with one blow of his sword the head of a Saracen

emir; but the battle is desperate; the chargers are at full gallop, and a Saracen is striking at Charlemagne with his battle-axe. After the victory has been won, the Emperor Constantine rewards Charlemagne by the priceless gift of three chasses or reliquaries, containing a piece of the true Cross; the Suaire or grave-cloth of the Savior; and a tunic of the Virgin. Charlemagne then returns to France, and in the next medallion presents the three chasses and the crown of the Saracen king to the church at Aix, which to a French audience meant the Abbey of Saint Denis. This scene closes the first volume of the story.

The second part opens on Charlemagne, seated between two persons, looking up to heaven at the Milky Way, called then the Way of Saint James, which directs him to the grave of Saint James in Spain. Saint James himself appears to Charlemagne in a dream, and orders him to redeem the tomb from the infidels. Then Charlemagne sets out, with Archbishop Turpin of Reims and knights. In presence of his army he dismounts and implores the aid of God. Then he arrives before Pampeluna and transfixes with his lance the Saracen chief as he flies into the city. Mounted he directs workmen to construct a church in honor of Saint James; a little cloud figures the hand of God. Next is shown the miracle of the lances; stuck in the ground at night, they are found in the morning to have burst into foliage, prefiguring martyrdom. Two thousand people perish in battle. Then begins the story of Roland which the artists and donors are so eager to tell, knowing as they do, that what has so deeply interested men and women on earth, must interest Mary who loves them. You see Archbishop Turpin celebrating mass when an angel appears, to warn him of Roland's fate. Then Roland himself, also wearing a halo, is introduced, in the act of killing the giant Ferragus. The combat of Roland and Ferragus is at the top, out of sequence, as often happens in the legendary windows. Charlemagne and his army are seen marching homeward through the Pyrenees, while Roland winds his horn and splits the rock without being able to break Durendal. Thierry, likewise sainted, brings water to Roland in a helmet. At last Thierry announces Roland's death. At the top, on either side of Roland and Ferragus, is an angel with incense.

The execution of this window is said to be superb. Of the color, and its relations with that of the Saint James, one needs time and long acquaintance to learn the value. In the feeling, compared with that of the twelfth century, one needs no time in order to see a change. These two windows are as French and as modern as a picture of Lancret; they are pure art, as simply decorative as the decorations of the Grand Opera. The thirteenth century knew more about religion and decoration than the twentieth century will ever learn. The windows were neither symbolic nor mystical nor more religious than they pretended to be. That they are more intelligent or more costly or more effective is nothing to the purpose, so long as one grants that the combat of Roland and Ferragus, or Roland winding his olifant, or Charlemagne cutting off heads and transfixing Moors, were subjects never intended to teach religion or instruct the ignorant, but to please the Queen of Heaven as they pleased the Queens of earth with a Roman, not in verse but in color, as near as possible to decorative perfection. Instinctively one looks to the corresponding bay, opposite, to see what the artists could have done to balance these two great efforts of their art; but the bay opposite is now occupied by the entrance to Saint Piat's chapel and one does not know what changes may have been made in the fourteenth century to re-arrange the glass; yet, even as it now stands, the Sylvester window which corresponds to the Charlemagne is, as glass, the strongest in the whole Cathedral. In the next chapel, on our left, come the martyrs, with Saint Stephen, the first martyr, in the middle window. Naturally the subject is more serious, but the color is not differently treated. A step further, and you see the artists returning to their lighter subjects. The stories of Saint Julian and Saint Thomas are more amusing than the plots of half the thirteenth-century romances, and not very much more religious. The subject of Saint Thomas is a pendant to that of Saint James, for Saint Thomas was a great traveller and an architect, who carried Mary's worship to India as Saint James carried it to Spain. Here is the amusement of many days in studying the stories, the color and the execution of these windows, with the help of the Monographs of Chartres and Bourges or the Golden Legend and occasional visits to Le Mans, Tours,

Clermont-Ferrand, and other cathedrals: but, in passing, one has to note that the window of Saint Thomas was given by France, and bears the royal arms, perhaps for Philip Augustus, the King; while the window of Saint Julian was given by the Carpenters and Coopers. One feels no need to explain how it happens that the taste of the royal family, and of their tailors, furriers, carpenters and coopers, should fit so marvelously, one with another, and with that of the Virgin; but one can compare with theirs the taste of the Stone-workers opposite, in the window of Saint Sylvester and Saint Melchiades whose blues almost kill the Charlemagne itself, and of the Tanners in that of Saint Thomas of Canterbury; or, in the last chapel on the south side, with that of the Shoemakers in the window to Saint Martin, attributed for some reason to a certain Clemens vitrearius Carnutensis whose name is on a window in the cathedral of Kouen. The name tells nothing, even if the identity could be proved. Clement the glass-maker may have worked on his own account, or for others; the glass differs only in refinements of taste or perhaps of cost. Nicolas Lescine, the canon, or Geoffroi Chardonnel, may have been less rich than the Bakers, and even the Furriers may have not had the revenues of the King; but some controlling hand has given more or less identical taste to all.

What one can least explain is the reason why some windows that should be here, are elsewhere. In most churches, one finds in the choir a window of doctrine, such as the socalled New Alliance, but here the New Alliance is banished to the nave. Besides the costly Charlemagne and Saint James windows in the apse, the Furriers and Drapers gave several others, and one of these seems particularly suited to serve as companion to Saint Thomas, Saint James and Saint Julian, so that it is best taken with these while comparing them. It is in the nave, the third window from the new tower, in the north aisle,—the window of Saint Eustace. The story and treatment and beauty of the work would have warranted making it a pendant to Almogenes, in the bay now serving as the door to Saint Piat's Chapel, which should have been the most effective of all the positions in the church for a legendary story. Saint Eustace, whose name was Placidas, commanded the guards of the Emperor Trajan. One day he went out hunting

with huntsmen and hounds, as the legend in the lower panel of the window begins; a pretty picture of a stag-hunt about the year 1200; followed by one still prettier, where the stag, after leaping upon a rock, has turned, and shows a crucifix between his horns, the stag on one side balancing the horse on the other, while Placidas on his knees yields to the miracle of Christ. Then Placidas is baptised as Eustace; and in the centre, you see him with his wife and two children-another charming composition—leaving the city. Four small panels in the corners are said to contain the signatures of the Drapers and Furriers. Above, the story of adventure goes on, showing Eustace bargaining with a shipmaster for his passage; his embarcation with wife and children, and their arrival at some shore, where the two children have landed, and the master drives Eustace after them while he detains the wife. Four small panels here have not been identified, but the legend was no doubt familiar to the middle-ages, and they knew how Eustace and the children came to a river, where you can see a pink lion carrying off one child, while a wolf, which has seized the other, is attacked by shepherds and dogs. The children are rescued, and the wife reappears, on her knees before her lord, telling of her escape from the shipmaster, while the children stand behind; and then the reunited family, restored to the emperor's favor, is seen feasting and happy. At last Eustace refuses to offer a sacrifice to a graceful antique idol, and is then shut up, with all his family, in a brazen bull; a fire is kindled beneath it; and, from above, a hand confers the crown of martyrdom.

Another subject which should have been placed in the apse, stands in a singular isolation which has struck many of the students in this branch of church learning. At Sens, Saint Eustace is in the choir, and by his side is the Prodigal Son. At Bourges also the Prodigal Son is in the choir. At Chartres, he is banished to the north transept where you will find him in the window next the nave, almost as though he were in disgrace; yet the glass is said to be very fine, among the best in the church, while the story is told with rather more vivacity than usual; and as far as color and execution go, the window has an air of age and quality higher than the average. At the bottom you see the signature of the corporation of Butchers.

The window at Bourges was given by the Tanners. The story begins with the picture showing the younger son asking the father for his share of the inheritance, which he receives in the next panel, and proceeds, on horseback, to spend, as one cannot help suspecting, at Paris, in the Latin Quarter, where he is seen arriving, welcomed by two ladies. No one has offered to explain why Chartres should consider two ladies theologically more correct than one; or why Sens should fix on three, or why Bourges should require six. Perhaps this was left to the artist's fancy; but, before quitting the twelfthcentury, we shall see that the usual young man who took his share of patrimony and went up to study in the Latin Ouarter, found two schools of scholastic teaching, one called Realism, the other Nominalism, each of which in turn the Church had been obliged to condemn. Meanwhile the Prodigal Son is seen feasting with them, and is crowned with flowers, like a new Abélard, singing his songs to Heloise, until his religious capital is exhausted, and he is dragged out of bed, to be driven naked from the house with sticks, in this, also resembling Abélard. At Bourges he is gently turned out; at Sens he is dragged away by three devils. Then he seeks service, and is seen knocking acorns from boughs, to feed his employer's swine; but, among the thousands of young men who must have come here directly from the Schools, nine in every ten said that he was teaching letters to his employer's children or lecturing to the students of the Latin Quarter. At last he decides to return to his father, -possibly the Archbishop of Paris or the Abbot of Saint Denis-who receives him with open arms, and gives him a new robe, which to the ribald student would mean a church living-an Abbey, perhaps Saint Gildas-de-Rhuys in Brittany, or elsewhere. The fatted calf is killed, the feast is begun, and the elder son, whom the malicious student would name Bernard, appears in order to make protest. Above, God, on his throne, blesses the globe of the world.

The original symbol of the Prodigal Son was a rather different form of prodigality. According to the church interpretation, the Father had two sons; the older was the people of the Jews; the younger, the Gentiles. The Father divided his substance between them, giving to the older the divine law, to the younger, the law of nature. The younger went off and dissipated his substance, as one must believe, on Aristotle; but repented and returned when the Father sacrificed the victim—Christ—as the symbol of reunion. That the Synagogue also accepts the sacrifice is not so clear; but the Church clung to the idea of converting the Synagogue as a necessary proof of Christ's divine character. Not until about the time when this window may have been made, did the new Church, under the influence of Saint Dominic, abandon the Jews and turn in despair to the Gentiles alone.

The old symbolism belonged to the fourth and fifth centuries, and, as told by the Jesuit fathers Martin and Cahier in their Monograph of Bourges, it should have pleased the Virgin who was particularly loved by the young, and habitually showed her attachment to them. At Bourges the window stands next the central chapel of the apse, where at Chartres is the entrance to Saint Piat's chapel; but Bourges did not belong to Notre Dame, nor did Sens. The story of the prodigal sons of these years from 1200 to 1230 lends the window a little personal interest that the Prodigal Son of Saint Luke's Gospel could hardly have had even to thirteenth century penitents. Neither the Church nor the Crown loved prodigal sons. So far from killing fatted calves for them, the bishops in 1200 burned no less than ten in Paris for too great intimacy with Arab and Jew disciples of Aristotle. The position of the Bishops of Chartres between the Schools had been always awkward. As for Blanche of Castile, her first son, afterwards Saint Louis, was born in 1215; and after that time no Prodigal Son was likely to be welcome in any society which she frequented. For her, above all other women on earth or in heaven, Prodigal Sons felt most antipathy, until, in 1229, the quarrel became so violent that she turned her police on them and beat a number to death in the streets. They retaliated without regard for loyalty or decency, being far from model youth and prone to relapses from virtue, even when forgiven and beneficed.

The Virgin Mary, Queen of Heaven, showed no prejudice against prodigal sons, or even prodigal daughters. She would hardly, of her own accord, have ordered such persons out of her apse, when Saint Stephen at Bourges and Sens showed no

such puritanism; yet the Chartres window is put away in the north transept. Even there it still stands opposite the Virgin of the Pillar, on the women's and Queen Blanche's side of the church, and in an excellent position, better seen from the choir than some of the windows in the choir itself, because the late summer sun shines full upon it, and carries its colors far into the apse. This may have been one of the many instances of tastes in the Virgin which were almost too imperial for her official court. Omniscient as Mary was, she knew no difference between the Blanches of Castile and the students of the Latin Quarter. She was rather fond of prodigals, and gentle towards the ladies who consumed the prodigal's substance. She admitted Mary Magdalen and Mary the Gypsey to her society. She fretted little about Aristotle so long as the prodigal adored her, and naturally the prodigal adored her almost to the exclusion of the Trinity. She always cared less for her dignity than was to be wished. Especially in the nave and on the porch, among the peasants, she liked to appear as one of themselves; she insisted on lying in bed, in a stable, with the cows and asses about her, and her baby in a cradle by the bed-side, as though she had suffered like other women, though the Church insisted she had not. Her husband, Saint Joseph, was notoriously uncomfortable in her Court, and always preferred to get as near to the door as he could. The choir at Chartres on the contrary was aristocratic; every window there had a court-quality, even down to the contemporary Thomas A'Becket, the fashionable martyr of goodsociety. Theology was put into the transepts or still further away in the nave where the window of the New Alliance elbows the Prodigal Son. Even to Blanche of Castile, Mary was neither a philanthropist nor theologist nor merely a mother, -she was an absolute Empress, and whatever she said was obeyed, but sometimes she seems to have willed an order that worried some of her most powerful servants.

Mary chose to put her Prodigal into the transept, and one would like to know the reason. Was it a concession to the Bishop or the Queen? or was it to please the common-people that these familiar picture-books, with their popular interest, like the Good Samaritan and the Prodigal Son, were put on the walls of the great public hall. This can hardly be, since the

people would surely have preferred the Charlemagne and Saint James to any other. We shall never know; but sitting here in the subdued afternoon light of the apse, one goes on for hours reading the open volumes of color, and listening to the steady discussion by the architects, artists, priests, princes and princesses of the thirteenth century about the arrangements of this apse. However strong-willed they might be, each in turn whether priest, or noble, or glass-worker, would have certainly appealed to the Virgin and one can imagine the architect still beside us, in the growing dusk of evening, mentally praying, as he looked at the work of a finished day:-"Lady Virgin, show me what you like best! The central chapel is correct, I know. The Lady Blanche's grisaille veils the rather strong blue tone nicely, and I am confident it will suit you. The Charlemagne window seems to me very successful, but the bishop feels not at all easy about it, and I should never have dared put it here if the Lady Blanche had not insisted on a Spanish bay. To balance at once both the subjects and the color, we have tried the Stephen window in the next chapel, with more red; but if Saint Stephen is not good enough to satisfy you, we have tried again with Saint Julian, whose story is really worth telling you as we tell it; and with him we have put Saint Thomas because you loved him and gave him your girdle. I do not myself care so very much for Saint Thomas of Canterbury opposite, though the Count is wild about it, and the Bishop wants it; but the Sylvester is stupendous in the morning sun. What troubles me most is the first right-hand bay. The princesses would not have let me put the Prodigal Son there, even if it were made for the place. I've nothing else good enough to balance the Charlemagne unless it be the Eustace. Gracious Lady, what ought I to do? Forgive me my blunders, my stupidity, my wretched want of taste and feeling! I love and adore you! All that I am, I am for you! If I cannot please you, I care not for Heaven! but without your help, I am lost!"

Upon my word, you may sit here forever imagining such appeals, and the endless discussions and criticisms that were heard every day, under these vaults, seven hundred years ago. That the Virgin answered the questions is my firm belief, just as it is my conviction that she did not answer them elsewhere.

One sees her personal presence on every side. Anyone can feel it who will only consent to feel like a child. Sitting here any Sunday afternoon, while the voices of the children of the mâitrise are chanting in the choir,—your mind held in the grasp of the strong lines and shadows of the architecture; your eyes flooded with the autumn tones of the glass; your ears drowned with the purity of the voices; one sense reacting upon another until sensation reaches the limit of its range; you or any other lost soul, could, if you cared to look and listen, feel a sense beyond the human ready to reveal a sense divine that would make that world once more intelligible, and would bring the Virgin to life again, in all the depth of feeling which she shows here, - in lines, vaults, chapels, colors, legends, chants,-more eloquent than the prayer-book, and more beautiful than the autumn sunlight; and anyone willing to try, could feel it like the child, reading new thought without end into the art he has studied a hundred times; but what is still more convincing, he could, at will, in an instant, shatter the whole art by calling into it a single motive of his own.

X

The Court of the Queen of Heaven

ALL ARTISTS love the sanctuary of the Christian church, and All tourists love the rest. The reason becomes clear as one leaves the choir, and goes back to the broad, open hall of the nave. The choir was made not for the pilgrim but for the deity, and is as old as Adam, or perhaps older; at all events old enough to have existed in complete artistic and theological form, with the whole mystery of the Trinity, the Mother and Child, and even the Cross, thousands of years before Christ was born; but the Christian church not only took the sanctuary in hand, and gave it a new form, more beautiful and much more refined than the Romans or Greeks or Egyptians had ever imagined, but it also added the idea of the nave and transepts, and developed it into imperial splendor. The pilgrim-tourist feels at home in the nave because it was built for him; the artist loves the sanctuary because he built it for God.

Chartres was intended to hold ten thousand people easily, or fifteen thousand when crowded, and the decoration of this great space, though not a wholly new problem, had to be treated in a new way. Sancta Sofia was built by the Emperor Justinian, with all the resources of the empire, in a single violent effort, in six years, and was decorated throughout with mosaics on a general scheme, with the unity that Empire and Church could give, when they acted together. The Norman Kings of Sicily, the richest princes of the twelfth century, were able to carry out a complete work of the most costly kind, in a single sustained effort from beginning to end, according to a given plan. Chartres was a local shrine, in an agricultural province, not even a part of the royal domain, and its Cathedral was the work of society, without much more tie than the Virgin gave it. Socially Chartres, as far as its stonework goes, seems to have been mostly rural; its decoration, in the Porches and transepts, is royal and feudal; in the nave and choir it is chiefly bourgeois. The want of unity is much less surprising than the unity, but it is still evident, especially in the glass. The mosaics of Monreale begin and end; they are a series; their connection is artistic and theological at once; they have unity. The windows of Chartres have no sequence, and their charm is in variety, in individuality, and sometimes even in downright hostility to each other, reflecting the picturesque society that gave them. They have, too, the charm that the world has made no attempt to popularise them for its modern uses, so that, except for the useful little Guide-book of the Abbé Clerval, one can see no clue to the legendary chaos; one has it to one's self, without much fear of being trampled upon by critics or Jew dealers in works of art; any Chartres beggar-woman can still pass a summer's day here, and never once be mortified by ignorance of things that every dealer in bric-a-brac is supposed to know.

Yet the artists seem to have begun even here with some idea of sequence, for the first window in the north aisle, next the new tower, tells the story of Noah; but the next plunges into the local history of Chartres, and is devoted to Saint Lubin, a bishop of this diocese who died in or about the year 556, and was, for some reason, selected by the wine-merchants to represent them, as their interesting medallions show. Then follow three amusing subjects, charmingly treated:—Saint Eustace, whose story has been told;—Joseph and his brethren;—and Saint Nicholas, the most popular saint of the thirteenth century, both in the Greek and in the Roman churches. The sixth and last window on the north aisle of the

Opposite these, in the south aisle, the series begins next the tower with John the Evangelist, followed by Saint Mary Magdalen, given by the Water Carriers. The third, the Good Samaritan, given by the Shoemakers, has a rival at Sens which critics think even better. The fourth is the Death, Assumption and Coronation of the Virgin. Then comes the fifteenth-century Chapel of Vendome, to compare the early and later glass. The sixth is, or was, devoted to the Virgin's Miracles at Chartres; but only one complete subject remains.

nave is the New Alliance.

These windows light the two aisles of the nave and decorate the lower walls of the church with a mass of color and variety of line still practically intact in spite of much injury; but the windows of the transepts on the same level have al-

most disappeared, except the Prodigal Son and a border to what was once a Saint Lawrence, on the north; and, on the south, part of a window to Saint Apollinaris of Ravenna, with an interesting hierarchy of Angels above:—Seraphim and Cherubim with six wings, red and blue; Dominations; Pow-

ers; Principalities; all, except Thrones.

All this seems to be simple enough, at least to the people for whom the nave was built, and to whom the windows were meant to speak. There is nothing esoteric here; nothing but what might have suited the great hall of a great palace. There is no difference in taste between the Virgin in the choir, and the Water Carriers by the doorway. Blanche, the young Queen, liked the same colors, legends, and lines that her Grocers and Bakers liked. All equally loved the Virgin. There was not even a social difference. In the choir, Thibaut. the Count of Chartres, immediate lord of the province, let himself be put in a dark corner next the Belle Verrière, and left the Bakers to display their wealth in the most serious spot in the church, the central window of the central chapel, while in the nave and transepts all the lower windows that bear signatures, were given by trades, as though that part of the church were abandoned to the commons. One might suppose that the feudal aristocracy would have fortified itself in the clerestory and upper windows, but even there the bourgeoisie invaded them, and you can see, with a glass, the Pastrycooks and Turners looking across at the Weavers and Curriers and Money-changers, and the "Men of Tours." Beneath the throne of the Mother of God, there was no distinction of gifts; and above it the distinction favored the commonalty. Of the seven immense windows above and around the high altar, which are designed as one composition, none was given by a prince or a noble. The Drapers, the Butchers, the Bakers, the Bankers, are charged with the highest duties attached to the Virgin's service. Apparently neither Saint Louis, nor his father Louis VIII, nor his mother Blanche, nor his uncle Philip Hurepel, nor his cousin Saint Ferdinand of Castile, nor his other cousin Pierre de Dreux, nor the Duchess Alix of Brittany, cared whether their portraits or armorial shields were thrust out of sight into corners by Pastrycooks and Teamsters, or took a whole wall of the church to themselves.

The only relation that connects them is their common relation to the Virgin, but that is emphatic, and dominates the whole.

It dominates us, too, if we reflect on it, even after seven hundred years that its meaning has faded. When one looks up to this display of splendor in the clerestory, and asks what was in the minds of the people who joined to produce, with such immense effort and at such self-sacrifice, this astonishing effect, the question seems to answer itself like an echo. With only half of an atrophied imagination, in a happy mood we could still see the nave and transepts filled with ten thousand people on their knees, and the Virgin, crowned and robed, seating herself on the embroidered cushion that covered her imperial throne; sparkling with gems; bearing in her right hand the sceptre, and in her lap the infant King; but, in the act of seating herself, we should see her pause a moment to look down with love and sympathy on us, -her peoplewho pack the enormous hall, and throng far out beyond the open portals; while, an instant later, she glances up to see that her great Lords, spiritual and temporal, the advisers of her judgment, the supports of her authority, the agents of her will, shall be in place; robed, mitred, armed; bearing the symbols of her authority and their office; on horseback, lance in hand; all of them ready at a sign to carry out a sentence of judgment or an errand of mercy; to touch with the sceptre or to strike with the sword; and never err.

There they still stand! unchanged, unfaded, as alive and complete as when they represented the real world, and the people below were the unreal and ephemeral pageant! Then the reality was the Queen of Heaven on her throne in the sanctuary, and her Court in the glass; not the Queens or Princes who were prostrating themselves, with the crowd, at her feet. These people knew the Virgin as well as they knew their own mothers; every jewel in her crown, every stitch of gold-embroidery in her many robes; every color; every fold; every expression on the perfectly familiar features of her grave, imperial face; every care that lurked in the silent sadness of her power; repeated over and over again, in stone, glass, ivory, enamel, wood; in every room, at the head of every bed, hanging on every neck, standing at every street corner, the Virgin was as familiar to every one of them as the

sun or the seasons; far more familiar than their own earthly Queen or Countess, although these were no strangers in their daily life; familiar from the earliest childhood to the last agony; in every joy and every sorrow and every danger; in every act and almost in every thought of life, the Virgin was present with a reality that never belonged to her Son or to the Trinity, and hardly to any earthly being, prelate, king or kaiser; her daily life was as real to them as their own loyalty which brought to her the best they had to offer as the return for her boundless sympathy; but while they knew the Virgin as though she were one of themselves, and because she had been one of themselves, they were not so familiar with all the officers of her court at Chartres; and pilgrims from abroad, like us, must always have looked with curious interest at the pageant.

Far down the nave, next the western towers, the rank began with Saints, Prophets and Martyrs of all ages and countries; local, like Saint Lubin; national, like Saint Martin of Tours and Saint Hilary of Poitiers; popular like Saint Nicholas; militant like Saint George; without order; symbols like Abraham and Isaac; the Virgin herself, holding on her lap the seven gifts of the Holy Ghost; Christ with the Alpha and Omega; Moses and Saint Augustine; Saint Peter; Saint Mary the Egyptian; Saint Jerome; a whole throne-room of heavenly powers, repeating, within, the pageant carved on the Porches and on the Portals without. From the croisée in the centre, where the crowd is most dense, one sees the whole almost better than Mary sees it from her High Altar, for there all the great rose windows flash in turn, and the three twelfthcentury lancets glow on the western sun. When the eyes of the throng are directed to the north, the Rose of France strikes them almost with a physical shock of color, and, from the south, the Rose of Dreux challenges the Rose of France.

Everyone knows that there is war between the two! The thirteenth century has few secrets. There are no outsiders. We are one family as we are one church. Every man and woman here, from Mary on her throne to the beggar on the porch, knows that Pierre de Dreux detests Blanche of Castile, and that their two windows carry on war across the very heart of the cathedral. Both unite only in asking help from Mary; but

Blanche is a woman, alone in the world with young children to protect, and most women incline strongly to suspect that Mary will never desert her. Pierre, with all his masculine strength, is no courtier. He wants to rule by force. He carries the assertion of his sex into the very presence of the Queen of Heaven.

The year happens to be 1230, when the roses may be supposed just finished and showing their whole splendor for the first time. Queen Blanche is forty-three years old, and her son Louis is fifteen. Blanche is a widow these four years, and Pierre a widower since 1221. Both are regents and guardians for their heirs. They have necessarily carried their disputes before Mary. Queen Blanche claims for her son, who is to be Saint Louis, the place of honor at Mary's right hand; she has taken possession of the north Porch outside, and of the north transept within, and has filled the windows with glass, as she is filling the Porch with statuary. Above is the huge Rose; below are five long windows; and all proclaim the homage that France renders to the Queen of Heaven.

The Rose of France shows in its centre the Virgin in her majesty, seated, crowned, holding the sceptre with her right hand, while her left supports the infant Christ-king on her knees; which shows that she too is acting as regent for her son. Round her, in a circle, are twelve medallions; four containing doves; four six-winged angels or Thrones; four angels of a lower order, but all symbolizing the gifts and endowments of the Queen of Heaven. Outside these are twelve more medallions with the Kings of Juda, and a third circle contains the twelve lesser prophets. So Mary sits, hedged in by all the divinity that graces earthly or heavenly kings; while, between the two outer circles are twelve quatrefoils bearing on a blue ground the golden lilies of France; and in each angle below the rose are four openings, showing alternately the Lilies of Louis and the Castles of Blanche. We who are below, the common people, understand that France claims to protect and defend the Virgin of Chartres, as her chief vassal, and that this ostentatious profusion of Lilies and Castles is intended not in honor of France but as a demonstration of loyalty to Notre Dame, and an assertion of her rights as Queen Regent of Heaven against all comers, but particularly against Pierre, the rebel, who has the audacity to assert rival

rights in the opposite transept.

Beneath the rose are five long windows, very unlike the twelfth-century pendants to the western rose. These five windows blaze with red, and their splendor throws the Virgin above quite into the background. The artists, who felt that the twelfth-century glass was too fine and too delicate for the new scale of the church, have not only enlarged their scale and coarsened their design, but have coarsened their colorscheme also, discarding blue in order to crush us under the earthly majesty of red. These windows, too, bear the stamp and seal of Blanche's Spanish temper as energetically as though they bore her portrait. The great central figure, the tallest and most commanding in the whole church, is not the Virgin but her mother Saint Anne, standing erect as on the trumeau of the door beneath, and holding the infant Mary on her left arm. She wears no royal crown, but bears a flowered scepter. The only other difference between Mary and her mother, that seems intended to strike attention, is that Mary sits, while her mother stands; but as though to proclaim still more distinctly that France supports the royal and divine pretensions of Saint Anne, Queen Blanche has put beneath the figure a great shield blazoned with the golden lilies on an azure ground.

With singular insistance on this motive, Saint Anne has at either hand a royal court of her own, marked as her own by containing only figures from the Old Testament. Standing next on her right is Solomon, her Prime Minister, bringing wisdom in worldly counsel, and trampling on human folly. Beyond Wisdom stands Law, figured by Aaron with the Book, trampling on the lawless Pharaoh. Opposite them, on Saint Anne's left, is David, the energy of State, trampling on a Saul suggesting suspicions of a Saul de Dreux; while last, Melchisedec who is Faith, tramples on a disobedient Nebu-

chadnezzar Mauclerc.

How can we, the common people, help seeing all this, and much more, when we know that Pierre de Dreux has been for years in constant strife with the Crown and the Church? He is very valiant and lion-hearted;—so say the chroniclers, priests though they are;—very skilful and experienced in war

whether by land or sea; very adroit, with more sense than any other great Lord in France; but restless, factious and regardless of his word. Brave and bold as the day; full of courtesy and "largesse;" but very hard on the clergy; a good Christian but a bad churchman! Certainly the first man of his time, says Michelet! "I have never found any that sought to do me more ill than he," says Blanche, and Joinville gives her very words; indeed, this year, 1230, she has summoned our own Bishop of Chartres among others to Paris in a court of peers, where Pierre has been found guilty of treason and deposed. War still continues, but Pierre must make submission. Blanche has beaten him in politics and in the field! Let us look round and see how he fares in theology and art!

There is his Rose,—so beautiful that Blanche may well think it seeks to do hers ill! As color, judge for yourselves whether it holds its own against the flaming self-assertion of the opposite wall! As subject, it asserts flat defiance of the monarchy of Queen Blanche. In the central circle, Christ as King is seated on a royal throne, both arms raised, one holding the golden cup of eternal priesthood, the other, blessing the world. Two great flambeaux burn beside him. The four Apocalyptic figures surround and worship him; and in the concentric circles round the central medallion are the Angels and the Kings in a blaze of color, symbolising the New Jerusalem.

All the force of the Apocalypse is there, and so is some of the weakness of theology, for, in the five great windows below, Pierre shows his training in the schools. Four of these windows represent what is called, for want of a better name, the New Alliance; the dependence of the New Testament on the Old; but Pierre's choice in symbols was as masculine as that of Blanche was feminine. In each of the four windows, a gigantic Evangelist strides the shoulders of a colossal Prophet. Saint John rides on Ezekiel; Saint Mark bestrides Daniel; Saint Matthew is on the shoulders of Isaiah; Saint Luke is carried by Jeremiah. The effect verges on the grotesque. The balance of Christ's Church seems uncertain. The Evangelists clutch the Prophets by the hair, and while the Synagogue stands firm, the Church looks small, feeble, and vacillating. The new dispensation has not the air of mastery either phys-

ical or intellectual; the old gives it all the support it has, and, in the absence of Saint Paul, both old and new seem little concerned with the sympathies of Frenchmen. The Synagogue is stronger than the Church, but even the Church is Jew.

That Pierre could ever have meant this is not to be dreamed; but when the true scholar gets thoroughly to work, his logic is remorseless, his art is implacable, and his sense of humor is blighted. In the Rose above, Pierre had asserted the exclusive authority of Christ in the New Jerusalem, and his scheme required him to show how the Church rested on the Evangelists below, who in their turn had no visible support except what the Prophets gave them. Yet the artist may have had a reason for weakening the Evangelists, because there remained the Virgin! One dares no more than hint at a motive so disrespectful to the Evangelists; but it is certainly true that, in the central window, immediately beneath the Christ, and his chief support, with the four staggering Evangelists and Prophets on either hand, the Virgin stands, and betrays no sign of weakness.

The compliment is singularly masculine; a kind of twelfth-century flattery that might have softened the anger of Blanche herself, if the Virgin had been her own; but the Virgin of Dreux is not the Virgin of France. No doubt she still wears her royal crown, and her head is circled with the halo; her right hand still holds the flowered sceptre, and her left the infant Christ, but she stands, and Christ is King. Note, too, that she stands directly opposite to her mother Saint Anne in the Rose of France, so as to place her one stage lower than the Virgin of France in the hierarchy. She is the Saint Anne of France, and shows it. "She is no longer," says the official Monograph, "that majestic queen who was seated on a throne, with her feet on a stool of honor; the personages have become less imposing and the heads show the decadence." She is the Virgin of Theology; she has her rights, and no

more; but she is not the Virgin of Chartres.

She, too, stands on an altar or pedestal, on which hangs a

shield bearing the ermines, an exact counterpart of the royal shield beneath Saint Anne. In this excessive display of armorial bearings—for the two Roses above are crowded with

them—one likes to think that these great princes had in their minds not so much the thought of their own importance which is a modern sort of religion, -as the thought of their devotion to Mary. The assertion of power and attachment by one is met by the assertion of equal devotion by the other. and while both loudly proclaim their homage to the Virgin, each glares defiance across the church. Pierre meant the Oueen of Heaven to know that, in case of need, her left hand was as good as her right, and truer; that the ermines were as well able to defend her as the lilies, and that Brittany would fight her battles as bravely as France. Whether his meaning carried with it more devotion to the Virgin or more defiance to France depends a little on the date of the windows, but, as a mere point of history, everyone must allow that Pierre's promise of allegiance was kept more faithfully by Brittany than that of Blanche and Saint Louis has been kept by France.

The date seems to be fixed by the windows themselves. Beneath the Prophets kneel Pierre and his wife Alix, while their two children, Yolande and Jean, stand. Alix died in 1221. Jean was born in 1217. Yolande was affianced in marriage in 1227, while a child, and given to Queen Blanche to be brought up as the future wife of her younger son John, then in his eighth year. When John died, Yolande was contracted to Thibaut of Champagne in 1231, and Blanche is said to have written to Thibaut in consequence: "Sire Thibauld of Champagne, I have heard that you have covenanted and promised to take to wife the daughter of Count Perron of Brittany. Wherefore I charge you, if you do not wish to lose whatever you possess in the kingdom of France, not to do it. If you hold dear or love aught in the said kingdom, do it not." Whether Blanche wrote in these words or not, she certainly prevented the marriage, and Yolande remained single until 1238 when she married the Comte de la Marche, who was, by the way, almost as bitter an enemy of Blanche as Pierre had been; but by that time, both Blanche and Pierre had ceased to be regents. Yolande's figure in the window is that of a girl, perhaps twelve or fourteen years old; Jean is younger, certainly not more than eight or ten years of age; and the appearance of the two children shows that the window itself should date between 1225 and 1230, the year when Pierre de Dreux was condemned

because he had renounced his homage to King Louis, declared war on him, and invited the King of England into France. As already told, Philippe Hurepel de Boulogne, the Comte de la Marche, Enguerrand de Couci,—nearly all the great nobles—had been leagued with Pierre de Dreux since

Blanche's regency began in 1226.

That these transept windows harmonise at all, is due to the Virgin, not to the donors. At the time they were designed, supposing it to be during Blanche's regency (1226-1236), the passions of these donors brought France to momentary ruin, and the Virgin in Blanche's Rose de France, as she looked across the church could not see a single friend of Blanche. What is more curious, she saw enemies in plenty, and in full readiness for battle. We have seen in the centre of the small Rose in the north transept, Philip Hurepel still waiting her orders; across the nave, in another small Rose of the south transept, sits Pierre de Dreux on his horse. The upper windows on the side walls of the choir are very interesting but impossible to see, even with the best glasses, from the floor of the church. Their sequence and dates have already been discussed; but their feeling is shown by the character of the Virgin, who in French territory, next the north transept, is still the Virgin of France, but in Pierre's territory, next the Rose de Dreux, becomes again the Virgin of Dreux, who is absorbed in the child, -not the child absorbed in her, -and accordingly the window shows the chequers and ermines.

The figures, like the stone figures outside, are the earliest of French art, before any school of painting fairly existed. Among them, one can see no friend of Blanche. Indeed, outside of her own immediate family and the Church, Blanche had no friend of much importance except the famous Thibaut of Champagne, the single member of the royal family who took her side and suffered for her sake, and who, as far as books tell, has no window or memorial here. One might suppose that Thibaut, who loved both Blanche and the Virgin, would have claimed a place, and perhaps he did; but one seeks him in vain. If Blanche had friends here, they are gone. Pierre de Dreux, lance in hand, openly defies her, and it was not on her brother-in-law Philip Hurepel that she could de-

pend for defense.

This is the court pageant of the Virgin that shows itself to the people who are kneeling at high mass. We, the public, whoever we are, - Chartrain, Breton, Norman, Angevin, Frenchman, Percherain, or what not-know our local politics as intimately as our lords do, or even better, for our imaginations are active, and we do not love Blanche of Castile. We know how to read the passions that fill the church. From the north transept Blanche flames out on us in splendid reds and flings her Spanish castles in our face. From the south transept Pierre retorts with a brutal energy which shows itself in the Prophets who serve as battle-chargers and in the Evangelists who serve as knights, --mounted warriors of faith, --whose great eves follow us across the church and defy Saint Anne and her French shield opposite. Pierre was not effeminate; Blanche was fairly masculine. Between them, as a matter of sex, we can see little to choose; and, in any case, it is a family quarrel; they are all cousins; they are all equals on earth, and none mean to submit to any superior except the Virgin and her Son in heaven. The Virgin is not afraid. She has seen many troubles worse than this; she knows how to manage perverse children, and if necessary she will shut them up in a darker room than ever their mothers kept open for them in this world. One has only to look at the Virgin to see!

There she is, of course, looking down on us from the great window above the high altar, where we never forget her presence! Is there a thought of disturbance there? Around the curve of the choir are seven great windows, without roses, filling the whole semi-circle and the whole vault, forty-seven feet high, and meant to dominate the nave as far as the western portal, so that we may never forget how Mary fills her church without being disturbed by quarrels, and may understand why Saint Ferdinand and Saint Louis creep out of our sight, close by the Virgin's side, far up above brawls; and why France and Brittany hide their ugly or their splendid passions at the ends of the transepts, out of sight of the high altar where Mary is to sit in state as Queen with the young king on her lap. In an instant she will come, but we have a moment still to look about at the last great decoration of her palace, and see how the artists have arranged it.

Since the building of Sancta Sofia, no artist has had such a

chance. No doubt, Rheims and Amiens and Bourges and Beauvais, which are now building, may be even finer, but none of them is yet finished, and all must take their ideas from here. One would like, before looking at it, to think over the problem, as though it were new, and so choose the scheme that would suit us best if the decoration were to be done for the first time. The architecture is fixed: we have to do only with the color of this mass of seven huge windows, forty-seven feet high, in the clerestory, round the curve of the choir, which close the vista of the church as viewed from the entrance. This vista is about three hundred and thirty feet long. The windows rise above a hundred feet. How ought this vast space to be filled? Should the perpendicular upward leap of the architecture be followed and accented by a perpendicular leap of color? The decorators of the fifteenth and sixteenth centuries seem to have thought so, and made perpendicular architectural drawings in yellow that simulated gold, and lines that ran with the general lines of the building. Many fifteenth century windows seem to be made up of florid Gothic details rising in stages to the vault. No doubt critics complained, and still complain, that the monotony of this scheme, and its cheapness of intelligence, were objections; but at least the effect was light, decorative, and safe. The artist could not go far wrong and was still at liberty to do beautiful work, as can be seen in any number of churches scattered broadcast over Europe and swarming in Paris and France. On the other hand, might not the artist disregard the architecture and fill the space with a climax of color? Could he not unite the Roses of France and Dreux above the high altar in an overpowering outburst of purples and reds? The seventeenth century might have preferred to mass clouds and colors, and Michael Angelo, in the sixteenth, might have known how to do it. What we want is not the feeling of the artist so much as the feeling of Chartres. What shall it be,-the jewelled brilliancy of the western windows, or the fierce self-assertion of Pierre Mauclerc, or the royal splendor of Queen Blanche, or the feminine grace and decorative refinement of the Charlemagne and Santiago windows in the apse?

Never again in art was so splendid a problem offered, either before or since, for the artist of Chartres solved it, as he did the whole matter of fenestration, and later artists could only offer variations on his work. You will see them at Bourges and Tours and in scores of thirteenth and fourteenth and fifteenth and sixteenth century churches and windows, and perhaps in some of the twentieth century,—all of them interesting and some of them beautiful,—and far be it from us, mean and ignorant pilgrims of art, to condemn any intelligent effort to vary or improve the effect; but we have set out to seek the feeling, and while we think of art in relation to ourselves, the sermon of Chartres, from beginning to end, teaches and preaches and insists and reiterates and hammers into our torpid minds the moral that the art of the Virgin was not that of her artists but her own. We inevitably think

of our tastes; they thought instinctively of hers.

In the transepts, Queen Blanche and Duke Perron, in legal possession of their territory, showed that they were thinking of each other as well as of the Virgin, and claimed loudly that they ought each to be first in the Virgin's favor; and they stand there in place, as the thirteenth century felt them. Subject to their fealty to Mary, the transepts belonged to them. and if Blanche did not, like Pierre, assert herself and her son on the Virgin's window, perhaps she thought the Virgin would resent Pierre's boldness the more by contrast with her own good taste. So far as is known, nowhere does Blanche appear in person at Chartres; she felt herself too near the Virgin to obtrude a useless image, or she was too deeply religious to ask anything for herself. A Queen who was to have two children sainted, to intercede for her at Mary's throne, stood in a solitude almost as unique as that of Mary, and might ignore the raw brutalities of a man-at-arms, but neither she nor Pierre has carried the quarrel into Mary's presence, nor has the Virgin condescended even to seem conscious of their temper. This is the theme of the artist,—the purity, the beauty, the grace, and the infinite loftiness of Mary's nature, among the things of earth, and above the clamor of kings.

Therefore, when we, and the crushed crowd of kneeling worshippers around us, lift our eyes at last after the miracle of the mass, we see, far above the high altar, high over all the agitation of prayer, the passion of politics, the anguish of suffering, the terrors of sin, only the figure of the Virgin in

Majesty, looking down on her people, crowned, throned, glorified, with the infant Christ on her knees. She does not assert herself; probably she intends to be felt rather than feared. Compared with the Greek Virgin, as you see her for example at Torcello, the Chartres Virgin is retiring and hardly important enough for the place. She is not exaggerated either in scale, drawing or color. She shows not a sign of self-consciousness, -not an effort for brilliancy-not a trace of stage effect-hardly even a thought of herself, except that she is at home, among her own people, where she is loved and known as well as she knows them. The seven great windows are one composition; and it is plain that the artist, had he been ordered to make an exhibition of power, could have overwhelmed us with a storm of purple, red, yellow, or given us a Virgin of Passion who would have torn the vault asunder: his ability is never in doubt, and if he has kept true to the spirit of the western Portal and the twelfth-century, it is because the Virgin of Chartres was the Virgin of Grace, and ordered him to paint her so. One shudders to think how a single false note,—a suggestion of meanness, in this climax of line and color-would bring the whole fabric down in ruins on the eighteenth-century meanness of the choir below: and one notes, almost bashfully, the expedients of the artists to quiet their effects. So the lines of the seven windows are built up, to avoid the horizontal, and yet not exaggerate the vertical. The architect counts here for more than the colorist: but the color, when you study it, suggests the same restraint. Three great windows on the Virgin's right, balanced by three more on her left, show the Prophets and precursors of her Son; all architecturally support and exalt the Virgin, in her celestial atmosphere of blue, shot with red, calm in the certainty of heaven. Anyone who is prematurely curious to see the difference in treatment between different centuries should go down to the church of Saint Pierre in the lower town, and study there the methods of the renaissance. Then we can come back to study again the ways of the thirteenth century. The Virgin will wait; she will not be angry; she knows her power; we all come back to her in the end.

Or the renaissance, if one prefers, can wait equally well, while one kneels with the thirteenth-century, and feels the

little one still can feel of what it felt. Technically these apsidal windows have not received much notice; the books rarely speak of them; travellers seldom look at them; and their height is such that even with the best glass, the quality of the work is beyond our power to judge. We see, and the artists meant that we should see, only the great lines, the color, and the Virgin. The mass of suppliants before the choir look up to the light, clear blues and reds of this great space, and feel there the celestial peace and beauty of Mary's nature and abode. There is heaven! and Mary looks down from it, into her church, where she sees us on our knees, and knows each one of us by name. There she actually is, -not in symbol or in fancy, but in person, descending on her errands of mercy and listening to each one of us, as her miracles prove, or satisfying our prayers merely by her presence which calms our excitement as that of a mother calms her child. She is there as Queen, not merely as intercessor, and her power is such that to her the difference between us earthly beings is nothing. Her quiet, masculine strength enchants us most. Pierre Mauclerc and Philip Hurepel and their men-at-arms are afraid of her, and the Bishop himself is never quite at his ease in her presence; but to peasants, and beggars, and people in trouble, this sense of her power and calm is better than active sympathy. People who suffer beyond the formulas of expression,who are crushed into silence, and beyond pain,-want no display of emotion, -no bleeding heart, -no weeping at the foot of the Cross, -no hysterics, -no phrases! They want to see God, and to know that he is watching over his own. How many women are there, in this mass of thirteenth-century suppliants, who have lost children? Probably nearly all, for the death-rate is very high in the conditions of mediæval life. There are thousands of such women here, for it is precisely this class who come most; and probably every one of them has looked up to Mary in her great window, and has felt actual certainty, as though she saw with her own eyes, -there, in heaven, while she looked,—her own lost baby playing with the Christ-child at the Virgin's knee, as much at home as the saints, and much more at home than the kings. Before rising from her knees, everyone of these women will have bent down and kissed the stone pavement in gratitude for

Mary's mercy. The earth, she says, is a sorry place, and the best of it is bad enough, no doubt, even for Queen Blanche and the Duchess Alix who has had to leave her children here alone; but there above is Mary in heaven who sees and hears me as I see her, and who keeps my little boy till I come; so I can wait with patience, more or less! Saints and prophets and martyrs are all very well, and Christ is very sublime and just,

but Mary knows!

It was very childlike, very foolish, very beautiful and very true, -as art, at least: -so true that everything else shades off into vulgarity, as you see the Persephone of a Syracusan coin shade off into the vulgarity of a Roman emperor; as though the heaven that lies about us in our infancy too quickly takes colors that are not so much sober as sordid, and would be welcome if no worse than that. Vulgarity, too, has feeling, and its expression in art has truth and even pathos, but we shall have time enough in our lives for that, and all the more because, when we rise from our knees now, we have finished our pilgrimage. We have done with Chartres. For seven hundred years Chartres has seen pilgrims, coming and going more or less like us; and will perhaps see them for another seven hundred years, but we shall see it no more, and can safely leave the Virgin in her Majesty, with her three great prophets on either hand, as calm and confident in their own strength and in God's providence as they were when Saint Louis was born, but looking down from a deserted heaven, into an empty church, on a dead faith.

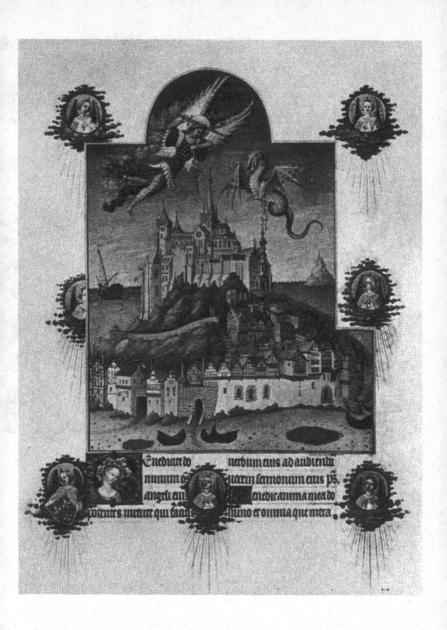

A painting of Mont Saint Michel appearing in the Très Riches Heures of Jean Duc de Berry, showing Michael guarding and protecting the Mount

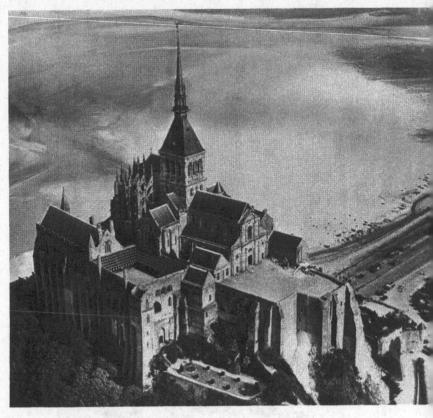

An aerial view of Mont Saint Michel

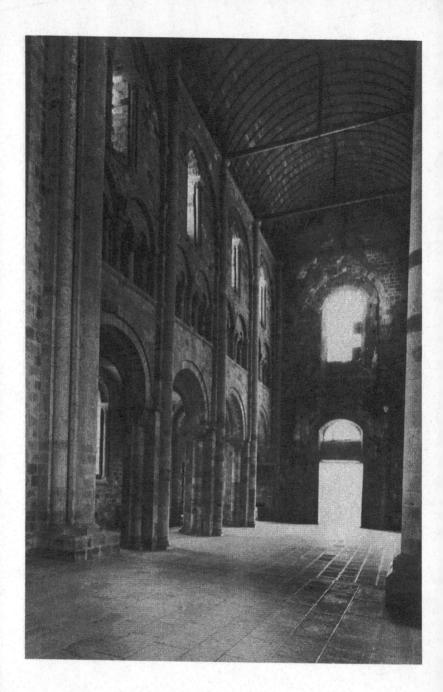

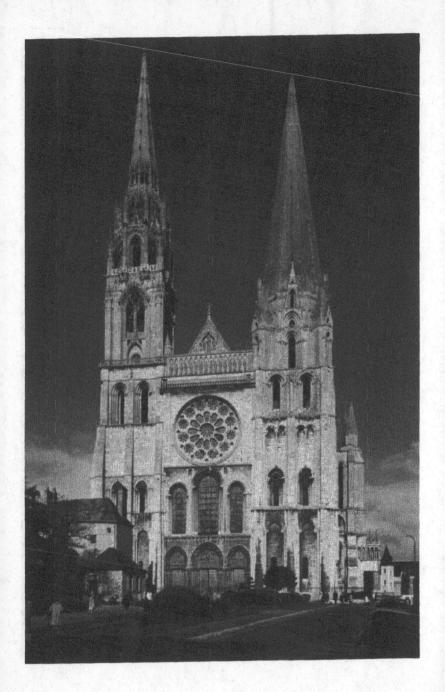

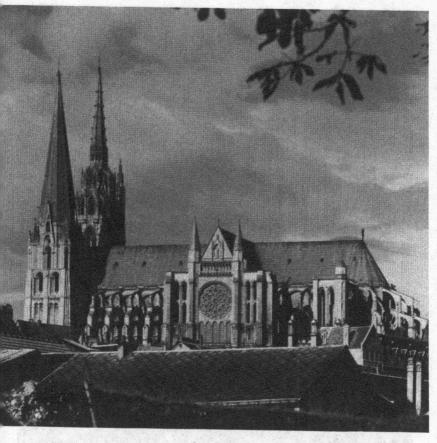

The South Flank of Chartres (photographed by Whitney Stoddard)

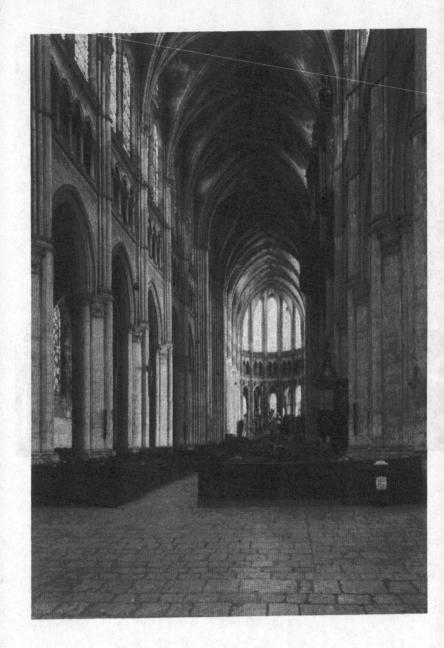

The Nave of Chartres (photographed by Whitney Stoddard)

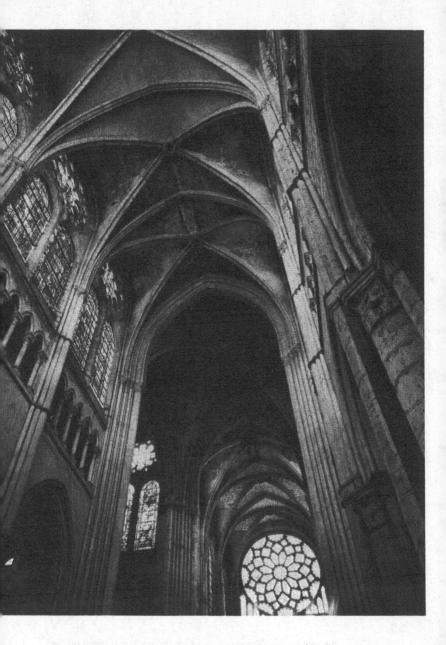

The Vaulting and Nervures of Chartres (photographed by Whitney Stoddard)

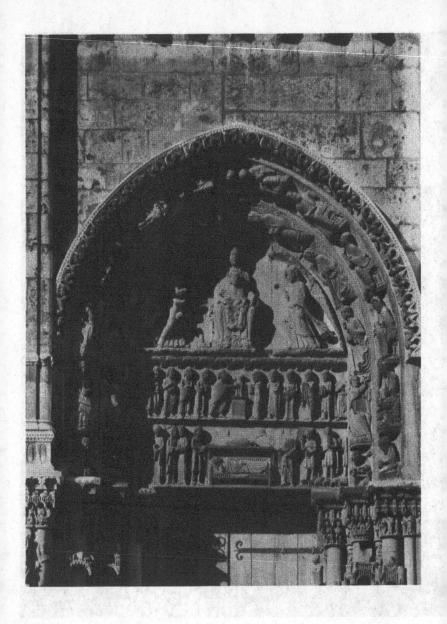

The Sculpture on the Tympanum and Lintel of the South Portal on the West Front of Chartres (photographed by Whitney Stoddard)

XI

The Three Queens

A FTER WORSHIPPING at the shrines of Saint Michael on his Mount and of the Virgin at Chartres, one may wander far and wide over France, and seldom feel lost; all later Gothic art comes naturally, and no new thought disturbs the perfected form. Yet tourists of English blood and American training are seldom or never quite at home there. Commonly they feel it only as a stage-decoration. The twelfth and thirteenth centuries, studied in the pure light of political economy, are insane. The scientific mind is atrophied, and suffers under inherited cerebral weakness, when it comes in contact with the eternal woman, -Astarte, Isis, Demeter, Aphrodite, and the last and greatest deity of all, the Virgin. Very rarely one lingers, with a mild sympathy, such as suits the patient student of human error, willing to be interested in what he cannot understand. Still more rarely, owing to some revival of archaic instincts, he rediscovers the woman. This is perhaps the mark of the artist alone, and his solitary privilege. The rest of us cannot feel; we can only study. The proper study of mankind is woman, and, by common agreement since the time of Adam, it is the most complex and arduous. The study of Our Lady, as shown by the art of Chartres, leads directly back to Eve, and lays bare the whole subject of sex.

If it were worth while to argue a paradox, one might maintain that nature regards the female as the essential, the male as the superfluity of her world. Perhaps the best starting-point for study of the Virgin would be a practical acquaintance with bees, and especially with queen bees. Precisely where the French man may come in, on the genealogical tree of Parthenogenesis, one hesitates to say; but certain it is that the French woman, from very early times, has shown qualities peculiar to herself, and that the French woman of the middle ages was a masculine character. Almost any book which deals with the social side of the twelfth century has something to say on this subject, like the following page from M. Garreau's

volume published in 1899, on the Social State of France during the Crusades:—

A trait peculiar to this epoch is the close resemblance between the manners of men and women. The rule that such and such feelings or acts are permitted to one sex and forbidden to the other was not fairly settled. Men had the right to dissolve in tears, and women that of talking without prudery. . . . If we look at their intellectual level, the women appear distinctly superior. They are more serious; more subtle. With them we do not seem dealing with the rude state of civilisation that their husbands belong to. . . . As a rule, the women seem to have the habit of weighing their acts; of not yielding to momentary impressions. While the sense of Christianity is more developed in them than in their husbands, on the other hand they show more perfidy and art in crime. . . . One might doubtless prove by a series of examples that the maternal influence when it predominated in the education of a son gave him a marked superiority over his contemporaries. Richard Cœur de Lion the crowned poet, artist, the king whose noble manners and refined mind in spite of his cruelty exercised so strong an impression on his age, was formed by that brilliant Eleanor of Guienne who, in her struggle with her husband, retained her sons as much as possible within her sphere of influence in order to make party chiefs of them. Our great Saint Louis, as all know, was brought up exclusively by Blanche of Castile; and Joinville, the charming writer so worthy of Saint Louis' friendship, and apparently so superior to his surroundings, was also the pupil of a widowed and regent mother.

The superiority of the woman was not a fancy but a fact. Man's business was to fight, or hunt, or feast or make love. The man was also the travelling partner in commerce, commonly absent from home for months together, while the woman carried on the business. The woman ruled the household and the workshop; cared for the economy; supplied the intelligence, and dictated the taste. Her ascendency was secured by her alliance with the Church, into which she sent her most intelligent children; and a priest or clerk, for the most part, counted socially as a woman. Both physically and mentally the woman was robust, as the men often complained, and she did not greatly resent being treated as a man. Sometimes the husband beat her, dragged her about by the hair, locked her up in the house; but he was quite conscious that she always got even with him in the end. As a matter of fact, probably she got more than even. On this point, history, legend, poetry, romance, and especially the popular Fabliaux,—invented to amuse the gross tastes of the coarser

class,—are all agreed, and one could give scores of volumes illustrating it. The greatest men illustrate it best, as one might show almost at hazard. The greatest men of the eleventh, twelfth and thirteenth centuries were William the Norman; his great grandson Henry II Plantagenet; Saint Louis of France; and, if a fourth be needed, Richard Coeur de Lion. Notoriously all these men had as much difficulty as Louis XIV himself, with the women of their family. Tradition exaggerates everything it touches, but shows, at the same time, what is passing in the mind of the society which tradites. In Normandy, the people of Caen have kept a tradition, told elsewhere in other forms, that one day, Duke William-the Conqueror—exasperated by having his bastardy constantly thrown in his face by the Duchess Matilda, dragged her by the hair, tied to his horse's tail, as far as the suburb of Vaucelles; and this legend accounts for the splendor of the Abbaye-aux-Dames, because William, the common people believed, afterwards regretted the impropriety, and atoned for it by giving her money to build the Abbey. The story betrays the man's weakness. The Abbaye-aux-Dames stands in the same relation to the Abbaye-aux-Hommes that Matilda took towards William. Inferiority there was none; on the contrary, the woman was socially the superior, and William was probably more afraid of her than she of him, if Mr. Freeman is right in insisting that he married her in spite of her having a husband living, and certainly two children. If William was the strongest man in the eleventh century, his great-grandson Henry II of England was the strongest man of the twelfth; but the history of the time resounds with the noise of his battles with Queen Eleanor whom he, at last, held in prison for fourteen years. Prisoner as she was, she broke him down in the end. One is tempted to suspect that, had her husbands and children been guided by her, and by her policy as peacemaker for the good of Guienne, most of the disasters of England and France might have been postponed for the time; but we can never know the truth, for monks and historians abhor emancipated women,—with good reason since such women are apt to abhor them, - and the quarrel can never be pacified. Historians have commonly shown fear of women without admitting it, but the man of the middle ages knew at

least why he feared the woman, and told it openly, not to say brutally. Long after Eleanor and Blanche were dead, Chaucer brought the Wife of Bath on his Shakespearian stage, to explain the woman, and as usual he touched masculine frailty with caustic, while seeming to laugh at woman and man alike:—

'My liege lady! generally,' quoth he, 'Women desiren to have soverainetee.'

The point was that the Wife of Bath, like Queen Blanche and Queen Eleanor, not only wanted sovereignty, but won and held it.

That Saint Louis, even when a grown man and king, stood in awe of his mother, Blanche of Castile, was not only notorious but seemed to be thought natural. Joinville recorded it not so much to mark the King's weakness, as the woman's strength; for his Queen, Margaret of Provence, showed the courage which the King had not. Blanche and Margaret were exceedingly jealous of each other. "One day," said Joinville, "Oueen Blanche went to the Queen's (Margaret) chamber where her son (Louis IX) had gone before to comfort her, for she was in great danger of death from a bad delivery; and he hid himself behind the Queen (Margaret) to avoid being seen; but his mother perceived him, and taking him by the hand said: 'Come along! you will do no good here!' and put him out of the chamber. Queen Margaret, observing this, and that she was to be separated from her husband, cried aloud: 'Alas! will you not allow me to see my lord either living or dving?" According to Joinville, King Louis always hid himself when, in his wife's chamber, he heard his mother coming.

The great period of gothic architecture begins with the coming of Eleanor (1137) and ends with the passing of Blanche (1252). Eleanor's long life was full of energy and passion of which next to nothing is known; the woman was al-

ways too slippery for monks or soldiers to grasp.

Eleanor came to Paris, a Queen of fifteen years old, in 1137, bringing Poitiers and Guienne as the greatest dowry ever offered to the French crown. She brought also the tastes and manners of the south, little in harmony with the tastes and

manners of Saint Bernard whose authority at court rivalled her own. The Abbé Suger supported her, but the King leaned towards the Abbé Bernard. What this puritan reaction meant is a matter to be studied by itself, if one can find a cloister to study in; but it bore the mark of most puritan reactions in its hostility to women. As long as the woman remained docile, she ruled, through the Church; but the man feared her and was jealous of her, and she of him. Bernard specially adored the Virgin because she was an example of docile obedience to the Trinity who atoned for the indocility of Eve, but Eve herself remained the instrument of Satan, and French society as a whole showed a taste for Eves.

THE THREE QUEENS

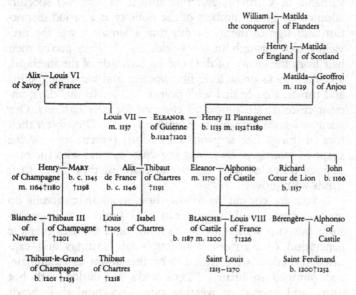

Eleanor could hardly be called docile. Whatever else she loved, she certainly loved rule. She shared this passion to the full with her only great successor and rival on the English throne, Queen Elizabeth, and she happened to become Queen of France at the moment when society was turning from worship of its military ideal, Saint Michael, to worship of its social ideal, the Virgin. According to the monk Orderic,

men had begun to throw aside their old military dress and manners even before the first crusade, in the days of William Rufus (1087–1100), and to affect feminine fashions. In all ages, priests and monks have denounced the growing vices of society, with more or less reason; but there seems to have been a real outbreak of display at about the time of the first crusade, which set a deep mark on every sort of social expression, even down to the shoes of the statues on the western

portal of Chartres:-

"A debauched fellow named Robert," said Orderic, "was the first, about the time of William Rufus, who introduced the practice of filling the long points of the shoes with tow, and of turning them up like a ram's horn. Hence he got the surname of Cornard; and this absurd fashion was speedily adopted by great numbers of the nobility as a proud distinction and sign of merit. At this time effeminacy was the prevailing vice throughout the world. They parted their hair from the crown of the head on each side of the forehead. and their locks grow long like women, and wore long shirts and tunics, closely tied with points. In our days, ancient customs are almost all changed for new fashions. Our wanton youths are sunk in effeminacy. . . . They insert their toes in things like serpents' tails which present to view the shape of scorpions. Sweeping the dusty ground with the prodigious trains of their robes and mantles, they cover their hands with gloves . . ."

If you are curious to follow these monkish criticisms on your ancestors' habits, you can read Orderic at your leisure; but you want only to carry in mind the fact that the generation of warriors who fought at Hastings and captured Jerusalem were regarded by themselves as effeminate, and plunged in luxury. "Their locks are curled with hot irons, and instead of wearing caps, they bind their heads with fillets. A knight seldom appears in public with his head uncovered and properly shaved according to the apostolic precept." The effeminacy of the first crusade took artistic shape in the west portal of Chartres and the glass of Saint Denis, and led instantly to the Puritan reaction of Saint Bernard, followed by the gentle asceticism of Queen Blanche and Saint Louis. Whether the pilgrimages to Jeru-

salem and contact with the east were the cause or only a consequence of this revolution, or whether it was all one,—a result of converting the northern pagans to peaceful habits and the consequent enrichment of northern Europe,—is indifferent; the fact and the date are enough. The art is French, but the ideas may have come from anywhere, like the game of chess which the pilgrims or crusaders brought home from Syria. In the oriental game, the King was followed step by step by a *Minister* whose functions were personal. The crusaders freed the piece from control; gave it liberty to move up or down or diagonally, forwards and backwards; made it the most arbitrary and formidable champion on the board, while the King and the Knight were the most restricted in movement; and this piece they named Queen, and called the Virgin:—

Li Baudrains traist sa *fierge* por son paon sauver, E cele son aufin qui cuida conquester La *firge* ou le paon, ou faire reculer.

The aufin or dauphin became the Fou of the French game, and the bishop of the English. Baldwin played his Virgin to save his pawn; his opponent played the bishop to threaten

either the Virgin or the pawn.

For a hundred and fifty years, the Virgin and Queens ruled French taste and thought so successfully that the French man has never yet quite decided whether to be more proud or ashamed of it. Life has ever since seemed a little flat to him, and art a little cheap. He saw that the woman, in elevating herself, had made him appear ridiculous, and he tried to retaliate with a wit not always sparkling, and too often at his own expense. Sometimes in museums or collections of bric-abrac, you will see in an illuminated manuscript, or carved on stone, or cast in bronze, the figure of a man on his hands and knees, bestridden by another figure holding a bridle and a whip; it is Aristotle, symbol of masculine wisdom, bridled and driven by woman. Six hundred years afterwards, Tennyson revived the same motive in Merlin, enslaved not for a time but forever. In both cases the satire justly punished the man. Another version of the same story, - perhaps the original,—was the Mystery of Adam, one of the earliest churchplays. Gaston Paris says "it was written in England in the twelfth century, and its author had real poetic talent; the scene of the seduction of Eve by the serpent is one of the best pieces of Christian dramaturgy. . . . This remarkable work seems to have been played no longer inside the Church, but under the Porch:"—

Devil. Adam I've seen, but he's too Diabolus. Jo vi Adam mais trop est fols. rough. Un poi est durs. Epe. A little hard! Eva. Devil. He'll soon be soft enough! Diaholus Il serra mols. Il est plus durs qui n'est enfers. Harder than hell he is till now. Eve. He's very frank! Il est mult francs. Eva. Devil. Say very low! Diaholus. Ainz est mult sers. To help himself he does not care; Cure ne volt prendre de sei The helping you shall be my share; Car la prenge sevals de tei. For you are tender, gentle, true, Tu es fieblette et tendre chose The rose is not so fresh as you; E es plus fresche que n'est rose. Whiter than crystal, or than snow Tu es plus blanche que cristal That falls from heaven on ice Que neif que chiet sor glace en below. A sorry mixture God has brewed, Mal cuple en fist li Criatur. You too tender, he too rude. Tu es trop tendre e il trop dur. But you have much the greater Mais neporquant tu es plus sage Your will is all intelligence. En grant sens as mis tun corrage Therefore it is I turn to you. Por co fait bon traire a tei. I want to tell you-Parler te voil. Do it now! Eva. Ore ja fai.

The woman's greater intelligence was to blame for Adam's fall. Eve was justly punished because she should have known better, while Adam, as the Devil truly said, was a dull animal, hardly worth the trouble of deceiving. Adam was disloyal too, untrue to his wife after being untrue to his Creator:

La femme que tu me donas Ele fist prime icest trespas Donat le mei e jo mangai. Or mest vis tornez est a gwai Mal acontai icest manger. Jo ai mesfait par ma moiller. The woman that you made me take First led me into this mistake. She gave the apple that I ate And brought me to this evil state. Badly for me it turned, I own, But all the fault is hers alone.

The audience accepted this as natural and proper. They recognized the man as of course stupid, cowardly and traitorous.

The men of the baser sort revenged themselves by boorishness that passed with them for wit in the taverns of Arras, but the poets of the higher class commonly took sides with the women. Even Chaucer, who lived after the glamor had faded, and who satirized women to satiety, told their tale in his "Legend of Good Women," with evident sympathy. To him, also, the ordinary man was inferior,—stupid, brutal, and untrue. "Full brittle is the truest," he said:—

For well I wote that Christ himself telleth That in Israel, as wide as is the lond, That so great faith in all the lond he ne fond As in a woman, and this is no lie; And as for men, look ye, such tyrannie They doen all day, assay hem who so list, The truest is full brotell for to trist.

Neither brutality nor wit helped the man much. Even Bluebeard in the end fell a victim to the superior qualities of his last wife, and Scheherazade's wit alone has preserved the memory of her royal husband. The tradition of thirteenth-century society still rules the French stage. The struggle between two strong-willed women to control one weak-willed man is the usual motive of the French drama in the nineteenth century, as it was the whole motive of Partenopeus of Blois, one of the best twelfth-century *Romans*; and Joinville described it, in the middle of the thirteenth, as the leading motive in the Court of Saint Louis, with Queen Blanche and Queen Margaret for players, and Saint Louis himself for pawn.

One has only to look at the common, so-called Elzevirian, volume of thirteenth-century Nouvelles to see the Frenchman as he saw himself. The story of La Comtesse de Ponthieu is the more Shakespearian, but La Belle Jehanne is the more natural and lifelike. The plot is the common masculine intrigue against the woman, which was used over and over again before Shakespeare appropriated it in Much Ado; but its French development is rather in the line of All's Well. The fair Jeanne, married to a penniless knight, not at all by her choice, but only because he was a favorite of her father's, was a woman of the true twelfth-century type. She broke the head of the traitor, and when he, with his masculine falseness,

caused her husband to desert her, she disguised herself as a squire and followed Sir Robert to Marseilles in search of service in war, for the poor knight could get no other means of livelihood. Robert was the husband, and the wife, in entering his service as squire without pay, called herself John:—

Molt fu mesire Robiers dolans cant il vint a Marselle de çou k'il n'oï parler de nulle chose ki fust ou païs; si dist a Jehan:

—Ke ferons nous? Vous m'aves preste de vos deniers la vostre mierchi; si les vos renderai car je venderai mon palefroi et m'acuiterai a vous.

—Sire, dist Jehans, crees moi se il vous plaist je vous dirai ke nous ferons; jou ai bien enchore .c. sous de tournois; s'il vous plaist je venderai nos .ii. chevaus et en ferai deniers; et je suis li miousdres boulengiers ke vous sacies; si ferai pain françois et je ne douc mie ke je ne gaagne bien et largement mon depens.

—Jehans, dist mesire Robiers, je m'otroi del tout a faire votre volente.

Et lendemain vendi Jehans ses .ii. chevaux .X. livres de tornois, et achata son ble et le fist muire, et achata des corbelles et coumencha a faire pain françois si bon et si bien fait k'il en vendoit plus ke li doi melleur boulengier de la ville; et fist tant dedens les .ii. ans k'il ot bien .c. livres de katel. Lors dist Jehans a son segnour:

—Je lo bien que nous louons une tres grant mason et jou akaterai del vin et hierbegerai la bonne gent.

—Jehan, dist mesire Robiers, faites a vo volente kar je l'otroi et si me loc molt de vous.

Jehans loua une mason grant et bielle, et si hierbrega la bonne gent et gaegnoit ases a plente, et viestoit son segnour biellement et richement; et avoit mesire Robiers son palefroi et aloit boire et mengier aveukes les plus vallans de la ville; et Jehans li envoioit vins et viandes ke tout cil ki o lui conpagnoient s'en esmervelloient. Si gaegna tant ke dedens .iiii. ans il gaegna plus de .ccc. livres de meuble sains son harnois qui valoit bien .L. livres.

Much was sir Robert grieved when he came to Marseilles and found that there was no talk of anything doing in the country; and he said to John:—"What shall we do? You have lent me your money; I thank you, and will repay you, for I will sell my palfrey and discharge the debt to you."

"Sir," said John, "Trust to me, if you please, I will tell you what we will do; I have still a hundred sous; if you please I will sell our two horses and turn them into money; and I am the best baker you ever knew; I will make French bread, and I've no doubt I shall pay my expenses well and make money."

"John," said sir Robert, "I agree wholly to do whatever you like."

And the next day John sold their two horses for ten pounds, and bought his wheat and had it ground, and bought baskets, and began to make French bread so good and so well made that he sold more of it than the two best bakers in the city; and made so much within two years that he had a good hundred pounds property. Then he said to his lord:—"I advise our hiring a very large house, and I will buy wine and will keep lodgings for good society."

"John," said Sir Robert, "do what you please, for I grant it, and am greatly pleased with you."

John hired a large and fine house and lodged the best people and gained a great plenty, and dressed his master handsomely and richly; and sir Robert kept his palfrey and went out to eat and drink with the best people of the city; and John sent them such wines and food that all his companions marveled at it. He made so much that within four years he gained more than three hundred pounds in money besides clothes, etc., well worth fifty.

The docile obedience of the man to the woman seemed as reasonable to the thirteenth century as the devotion of the woman to the man, not because she loved him, for there was no question of love, but because he was her man, and she owned him as though he were her child. The tale went on to develop her character always in the same sense. When she was ready, Jeanne broke up the establishment at Marseilles, brought her husband back to Hainault, and made him, without knowing her object, kill the traitor and redress her wrongs. Then, after seven years patient waiting, she revealed

herself and resumed her place.

If you care to see the same type developed to its highest capacity, go to the theatre the first time some ambitious actress attempts the part of Lady Macbeth. Shakespeare realised the thirteenth-century woman more vividly than the thirteenth-century poets ever did; but that is no new thing to say of Shakespeare. The author of La Comtesse de Ponthieu made no bad sketch of the character. These are fictions, but the Chronicles contain the names of women by scores who were the originals of the sketch. The society which Orderic described in Normandy,—the generation of the first crusade, produced a great variety of Lady Macbeths. In the country of Evreux, about 1100, Orderic says that "a worse than civil war was waged between two powerful brothers, and the mischief was fomented by the spiteful jealousy of their haughty wives. The countess Havise of Evreux took offense at some taunts uttered by Isabel de Conches, -wife of Ralph, the seigneur of Conches, some ten miles from Evreux, - and used all her influence with her husband, Count William, and his barons, to make trouble. . . . Both the ladies who stirred up these fierce enmities were great talkers and spirited as well as handsome; they ruled their husbands, oppressed their vassals, and inspired terror in various ways. But still their characters were very different. Havise had wit and eloquence, but she was cruel and avaricious. Isabel was generous, enterprising and gay, so that she was beloved and esteemed by those about her. She rode in knight's armor when her vassals were called to war, and showed as much daring among men-at-arms and mounted knights as Camilla. . . . "More than three hundred years afterwards, far off in the Vosges, from a village never

heard of, appeared a common peasant of seventeen years old, a girl without birth, education, wealth or claim of any sort to consideration, who made her way to Chinon and claimed from Charles VII a commission to lead his army against the English. Neither the King nor the Court had faith in her, and yet the commission was given, and the rank-and-file showed again that the true Frenchman had more confidence in the woman than in the man, no matter what the gossips might say. No one was surprised when Jeanne did what she promised, or when the men burned her for doing it. There were Jeannes in every village. Ridicule was powerless against them. Even Voltaire became what the French call frankly bête, in

trying it.

Eleanor of Guienne was the greatest of all French women. Her decision was law, whether in Bordeaux or Poitiers, in Paris or in Palestine, in London or in Normandy; in the Court of Louis VII, or in that of Henry II, or in her own Court of Love. For fifteen years she was Queen of France; for fifty she was Queen in England; for eighty or thereabouts she was equivalent to Queen over Guienne. No other Frenchwoman ever had such rule. Unfortunately, as Queen of France, she struck against an authority greater than her own, that of Saint Bernard, and after combatting it, with Suger's help, from 1137 until 1152, the monk at last gained such mastery that Eleanor quitted the country and Suger died. She was not a person to accept defeat. She royally divorced her husband and went back to her own kingdom of Guienne. Neither Louis nor Bernard dared to stop her, or to hold her territories from her, but they put the best face they could on their defeat by proclaiming her as a person of irregular conduct. The irregularity would not have stood in their way, if they had dared to stand in hers, but Louis was much the weaker, and made himself weaker still by allowing her to leave him for the sake of Henry of Anjou, a story of a sort that rarely raised the respect in which French kings were held by French society. Probably politics had more to do with the matter than personal attachments, for Eleanor was a great ruler, the equal of any ordinary king, and more powerful than most kings living in 1152. If she deserted France in order to join the enemies of France, she had serious reasons besides love for young Henry

of Anjou; but in any case she did, as usual, what pleased her, and forced Louis to pronounce the divorce at a Council held at Beaugency, March 18, 1152, on the usual pretext of relationship. The humors of the twelfth-century were Shakespearian. Eleanor, having obtained her divorce at Beaugency, to the deep regret of all Frenchmen, started at once for Poitiers, knowing how unsafe she was in any territory but her own. Beaugency is on the Loire, between Orleans and Blois, and Eleanor's first night was at Blois, or should have been; but she was told on arriving, that Count Thibaut of Blois, undeterred by King Louis' experience, was making plans to detain her, with perfectly honorable views of marriage; and, as she seems at least not to have been in love with Thibaut, she was obliged to depart at once, in the night, to Tours. A night journey on horseback from Blois to Tours in the middle of March can have been no pleasure-trip, even in 1152; but, on arriving at Tours in the morning, Eleanor found that her lovers were still so dangerously near that she set forward at once on the road to Poitiers. As she approached her own territory she learned that Geoffrey of Anjou, the younger brother of her intended husband, was waiting for her at the border, with views of marriage as strictly honorable as those of all the others. She was driven to take another road, and at last got safe to Poitiers.

About no figure in the middle-ages, man or woman, did so many legends grow, and with such freedom, as about Eleanor, whose strength appealed to French sympathies and whose adventures appealed to their imagination. They never forgave Louis for letting her go. They delighted to be told that in Palestine she had carried on relations of the most improper character, now with a Saracen slave of great beauty; now with Raymond of Poitiers, her uncle, the handsomest man of his time; now with Saladin himself; and, as all this occurred at Antioch in 1147 or 1148, they could not explain why her husband should have waited until 1152 in order to express his unwilling disapproval; but they quoted with evident sympathy a remark attributed to her that she thought she had married a king, and found she had married a monk. To the Frenchman, Eleanor remained always sympathetic, which is the more significant because, in English tradition,

her character suffered a violent and incredible change. Although English history has lavished on Eleanor somewhat more than her due share of conventional moral reproof, considering that, from the moment she married Henry of Anjou, May 18, 1152, she was never charged with a breath of scandal, it atoned for her want of wickedness by French standards, in the usual manner of historians, by inventing traits which reflected the moral standards of England. Tradition converted her into the fairy-book type of feminine jealousy and invented for her the legend of the Fair Rosamund and the poison of toads.

For us, both legends are true. They reflected, not perhaps the character of Eleanor, but what the society liked to see acted on its theatre of life. Eleanor's real nature in no way concerns us. The single fact worth remembering was that she had two daughters by Louis VII, as shown in the Table; who, in due time, married:-Mary, in 1164, married Henry, the great Count of Champagne: - Alix, at the same time, became Countess of Chartres by marriage with Thibaut who had driven her mother from Blois in 1152 by his marital intentions. Henry and Thibaut were brothers whose sister Alix had married Louis VII in 1160, eight years after the divorce. The relations thus created were fantastic, especially for Queen Eleanor, who, besides her two French daughters, had eight children as Queen of England. Her second son, Richard Cœur-de-Lion, born in 1157, was affianced in 1174 to a daughter of Louis VII and Alix; a child only six years old, who was sent to England to be brought up as future queen. This was certainly Eleanor's doing, and equally certain was it that the child came to no good in the English Court. The historians, by exception, have not charged this crime to Queen Eleanor; they charged it to Eleanor's husband, who passed most of his life in crossing his wife's political plans; but with politics we want as little as possible to do. We are concerned with the artistic and social side of life, and have only to notice the coincidence that while the Virgin was miraculously using the power of spiritual love to elevate and purify the people, Eleanor and her daughters were using the power of earthly love to discipline and refine the Courts. Side by side with the crude realities about them, they insisted on teaching and enforcing an ideal that contradicted the realities, and had no value for them or for us except in the contradiction.

The ideals of Eleanor and her daughter Mary of Champagne were a form of religion, and if you care to see its evangels, you had best go directly to Dante and Petrarch, or, if you like it better, to Don Quijote de la Mancha. The religion is dead as Demeter, and its art alone survives as, on the whole, the highest expression of man's thought or emotion, but in its day it was almost as practical as it now is fanciful. Eleanor and her daughter Mary and her granddaughter Blanche knew as well as Saint Bernard did, or Saint Francis, what a brute the emancipated man could be; and as though they foresaw the society of the sixteenth and eighteenth centuries, they used every terror they could invent as well as every tenderness they could invoke, to tame the beasts around them. Their charge was of manners, and, to teach manners, they made a school which they called their Court of Love. with a code of law to which they gave the name of "courteous love." The decisions of this Court were recorded, like the decisions of a modern Bench, under the names of the great ladies who made them, and were enforced by the ladies of good society for whose guidance they were made. They are worth reading, and anyone who likes may read them to this day, with considerable scepticism about their genuineness. The doubt is only ignorance. We do not, and never can, know the twelfth-century woman, or, for that matter, any other woman, but we do know the literature she created; we know the art she lived in, and the religion she professed. We can collect from them some idea why the Virgin Mary ruled, and what she was taken to be, by the world which worshipped her.

Mary of Champagne created the literature of courteous love. She must have been about twenty years old when she married Count Henry and went to live at Troyes, not actually a queen in title, but certainly a queen in social influence. In 1164, Champagne was a powerful country, and Troyes a centre of taste. In Normandy, at the same date, William of Saint Pair and Wace were writing the poetry we know. In Champagne the Court poet was Christian of Troyes, whose poems were new when the churches of Noyon and Senlis and Saint Leu

d'Esserent, and the flèche of Chartres, and the Leaning Tower of Pisa, were building, at the same time with the Abbey of Vezelay, and before the church at Mantes. Christian died not long after 1175, leaving a great mass of verse, much of which has survived, and which you can read more easily than you can read Dante or Petrarch, although both are almost modern compared with Christian. The quality of this verse is something like the quality of the glass windows, -conventional decoration: colors in conventional harmonies: refinement, restraint and feminine delicacy of taste. Christian has not the grand manner of the eleventh century, and never recalls the masculine strength of the Chanson de Roland or Raoul de Cambrai. Even his most charming story, Erec et Enide, carries chiefly a moral of courtesy. His is poetlaureate's work, says M. Gaston Paris: the flower of a twelfthcentury court and of twelfth-century French; the best example of an admirable language; but not lyric; neither strong, nor deep, nor deeply felt. What we call tragedy is unknown to it. Christian's world is sky-blue and rose, with only enough red to give it warmth, and so flooded with light that even its mysteries count only by the clearness with which they are shown.

Among other great works, before Mary of France came to Troves Christian had, towards 1160, written a Tristan, which is lost. Mary herself, he says, gave him the subject of Lancelot, with the request or order to make it a lesson of "courteous love," which he obeyed. Courtesy has lost its meaning as well as its charm, and you might find the "Chevalier de la Charette" even more unintelligible than tiresome; but its influence was great in its day, and the lesson of courteous love, under the authority of Mary of Champagne, lasted for centuries as the standard of taste. Lancelot was never finished, but later, not long after 1174, Christian wrote a Perceval, or Conte du Graal, which must also have been intended to please Mary, and which is interesting because, while the Lancelot gave the twelfth-century idea of courteous love, the Perceval gave the twelfth-century idea of religious mystery. Mary was certainly concerned with both. "It is for this same Mary," says Gaston Paris, "that Walter of Arras undertook his poem of Eracle; she was the object of the songs of the troubadours as well as of their French imitators; for her use also she caused the translations of books of piety like Genesis, or the paraphrase at

great length, in verse, of the psalm Eructarit."

With her theories of courteous love, everyone is more or less familiar if only from the ridicule of Cervantes and the follies of Quijote, who, though four hundred years younger, was Lancelot's child; but we never can know how far she took herself and her laws of love seriously, and to speculate on so deep a subject as her seriousness is worse than useless, since she would herself have been as uncertain as her lovers were. Visionary as the Courtesy was, the Holy Grail was as practical as any bric-a-brac that has survived of the time. The mystery of Perceval is like that of the gothic cathedral, illuminated by floods of light, and enlivened by rivers of color. Unfortunately Christian never told what he meant by the fragment, itself a mystery, in which he narrated the story of the knight who saw the Holy Grail, because the knight, who was warned, as usual, to ask no questions, for once, unlike most knights, obeyed the warning when he should have disregarded it. As knights-errant necessarily did the wrong thing in order to make their adventures possible, Perceval's error cannot be in itself mysterious, nor was the castle in any way mysterious where the miracle occurred. It appeared to him to be the usual castle, and he saw nothing unusual in the manner of his reception by the usual old lord, or in the fact that both seated themselves quite simply before the hall fire with the usual household. Then, as though it were an every-day habit, the Holy Grail was brought in. (Bartsch, Chrestomathie, 183-185, ed. 1895):-

Et leans avait luminaire
Si grant con l'an le porrait faire
De chandoiles a un ostel.
Que qu'il parloient d'un et d'el,
Uns vallez d'une chambre vint
Qui une blanche lance tint
Ampoigniee par le mi lieu.
Si passa par endroit le feu
Et cil qui al feu se seoient,
Et tuit cil de leans veoient
La lance blanche et le fer blanc.
S'issoit une gote de sang
Del fer de la lance au sommet,

And, within, the hall was bright
As any hall could be with light
Of candles in a house at night.
So, while of this and that they talked,
A squire from a chamber walked,
Bearing a white lance in his hand,
Grasped by the middle, like a wand;
And, as he passed the chimney wide,
Those seated by the fire-side,
And all the others, caught a glance
Of the white steel and the white lance.
As they looked, a drop of blood
Down the lance's handle flowed;

Et jusqu'a la main au vaslet Coroit cele gote vermoille. . A tant dui autre vaslet vindrent Oui chandeliers an lors mains tindrent De fin or ovrez a neel. Li vaslet estoient moult bel Qui les chandeliers aportoient. An chacun chandelier ardoient Dous chandoiles a tot le mains. Un graal antre ses dous mains Une demoiselle tenoit, Qui avec les vaslets venoit, Bele et gente et bien acesmee. Quant ele fu leans antree Atot le graal qu'ele tint Une si granz clartez i vint Qu'ausi perdirent les chandoiles Lor clarte come les estoiles Oant li solauz luist et la lune. Apres celi an revint une Qui tint un tailleor d'argent. Le graal qui aloit devant De fin or esmere estoit, Pierres precieuses avoit El graal de maintes menieres Des plus riches et des plus chieres Oui en mer ne en terre soient. Totes autres pierres passoient Celes del graal sanz dotance. Tot ainsi con passa la lance Par devant le lit trespasserent Et d'une chambre a l'autre alerent Et li vaslet les vit passer, Ni n'osa mie demander Del graal cui l'an an servoit.

Down to where the youth's hand stood. From the lance-head at the top They saw run that crimson drop. Presently came two more squires, In their hands two chandeliers, Of fine gold in enamel wrought. Each squire that the candle brought Was a handsome chevalier. There burned in every chandelier Two lighted candles at the least. A damsel, graceful and well dressed, Behind the squires followed fast Who carried in her hands a graal; And as she came within the hall With the graal there came a light So brilliant that the candles all Lost clearness, as the stars at night When moon shines, or in day the sun.

After her there followed one
Who a dish of silver bore.
The graal, which had gone before,
Of gold the finest had been made,
With precious stones had been inlaid,
Richest and rarest of each kind
That man in sea or earth could find.
All other jewels far surpassed
Those which the holy graal enchased.

Just as before had passed the lance They all before the bed advance, Passing straightway through the hall, And the knight who saw them pass Never ventured once to ask For the meaning of the graal.

The simplicity of this narration gives a certain dramatic effect to the mystery, like seeing a ghost in full daylight, but Christian carried simplicity further still. He seemed either to feel, or to want others to feel, the reality of the adventure and the miracle, and he followed up the appearance of the graal by a solid meal in the style of the twelfth-century, such as one expects to find in Ivanhoe or the Talisman. The knight sat down with his host to the best dinner that the County of Champagne afforded, and they eat their haunch of venison with the graal in full view. They drank their Champagne wine of various sorts, out of gold cups:

Vins clers ne raspez ne lor faut A copes dorees a boivre; they sat before the fire and talked till bedtime, when the squires made up the beds in the hall, and brought in supper,—dates, figs, nutmegs, spices, pomegranates, and at last lectuaries, suspiciously like what we call jams; and "alexandrine gingerbread"; after which they drank various drinks, with or without spice or honey or pepper; and old *moret*, which is thought to be mulberry wine, but which generally went with *clairet*, a colorless grape-juice, or *piment*. At least, here are the lines, and one may translate them to suit one-self:

Et li vaslet aparellierent
Les lis et le fruit au colchier
Que il en i ot de moult chier,
Dates, figues, et nois mugates,
Girofles et pomes de grenates,
Et leituaires an la fin,
Et gingenbret alixandrin.
Apres ce burent de maint boivre,
Piment ou n'ot ne miel ne poivre
Et viez more et cler sirop.

The twelfth century had the child's love of sweets and spices and preserved fruits, and drinks sweetened or spiced, whether they were taken for supper or for poetry; the true knight's palate was fresh and his appetite excellent either for sweets or verses or love; the world was young then; Robin Hoods lived in every forest, and Richard Cœur-de-Lion was not yet twenty years old. The pleasant adventures of Robin Hood were real, as you can read in the stories of a dozen outlaws, and men troubled themselves about pain and death much as healthy bear did, in the mountains. Life had miseries enough but few shadows deeper than those of the imaginative lover, or the terrors of ghosts at night. Men's imaginations ran riot, but did not keep them awake; at least, neither the preserved fruits nor the mulberry wine nor the clear syrup nor the gingerbread nor the Holy Graal kept Perceval awake, but he slept the sound and healthy sleep of youth, and when he woke the next morning, he felt only a mild surprise to find that his host and household had disappeared, leaving him to ride away without farewell, breakfast, or Graal.

Christian wrote about Perceval in 1174 in the same spirit in which the workmen in glass, thirty years later, told the story

of Charlemagne. One artist worked for Mary of Champagne; the others for Mary of Chartres, commonly known as the Virgin; but all did their work in good faith, with the first, fresh, easy instinct of color, light and line. Neither of the two Maries was mystical, in a modern sense; none of the artists was oppressed by the burden of doubt; their scepticism was as childlike as faith. If one has to make an exception, perhaps the passion of love was more serious than that of religion, and gave to religion the deepest emotion, and the most complicated one, which society knew. Love was certainly a passion; and even more certainly it was, as seen in poets like Dante and Petrarch—in Romans like Lancelot and Aucassins—in ideals like the Virgin,—complicated beyond modern conception. For this reason the loss of Christian's Tristan makes a terrible gap in art, for Christian's poem would have given the first and best idea of what led to courteous love. The Tristan was written before 1160, and belonged to the cycle of Queen Eleanor of England rather than to that of her daughter Mary of Troyes; but the subject was one neither of courtesy nor of France; it belonged to an age far behind the eleventh century, or even the tenth, or indeed any century within the range of French history; and it was as little fitted for Christian's way of treatment as to any avowed burlesque. The original Tristan-critics say-was not French, and neither Tristan nor Isolde had ever a drop of French blood in their veins. In their form as Christian received it, they were Celts or Scots; they came from Brittany, Wales, Ireland, the northern ocean, or further still. Behind the Welsh Tristan, which passed probably through England to Normandy and thence to France and Champagne, critics detect a far more ancient figure living in a form of society that France could not remember ever to have known. King Marc was a tribal chief of the stone age whose subjects loved the forest and lived on the sea or in caves; King Marc's royal hall was a common shelter on the banks of a stream, where everyone was at home, and king, queen, knights, attendants and dwarf, slept on the floor, on beds laid down where they pleased; Tristan's weapons were the bow and stone-knife; he never saw a horse or a spear; his ideas of loyalty, and Isolde's ideas of marriage, were as vague as Marc's royal authority; and all

were alike unconscious of law, chivalry or church. The note they sang was more unlike the note of Christian, if possible, than that of Richard Wagner; it was the simplest expression of rude and primitive love, as one could perhaps find it among North American Indians, though hardly so defiant even there, and certainly in the Icelandic Sagas hardly so lawless; but it was a note of real passion, and touched the deepest chords of sympathy in the artificial society of the twelfth century, as it did in that of the nineteenth. The task of the French poet was to tone it down and give it the fashionable dress, the pointed shoes and long sleeves, of the time. "The Frenchman," says Gaston Paris, "is specially interested in making his story entertaining for the society it is meant for; he is 'social'; that is, of the world; he smiles at the adventures he tells, and delicately lets you see that he is not their dupe; he exerts himself to give to his style a constant elegance, a uniform polish, in which a few neatly-turned, clever phrases, sparkle here and there; above all, he wants to please, and thinks of his audience more than of his subject."

In the twelfth century he wanted chiefly to please women, as Orderic complained; Isolde came out of Brittany to meet Eleanor coming up from Guienne, and the Virgin from the east; and all united in giving law to society. In each case it was the woman, not the man, who gave the law;—it was Mary, not the Trinity; Eleanor, not Louis VII; Isolde, not Tristan. No doubt, the original Tristan had given the law like Roland or Achilles, but the twelfth-century Tristan was a comparatively poor creature. He was in his way a secondary figure in the romance, as Louis VII was to Eleanor and Abélard to Héloïse. Everyone knows how, about twenty years before Eleanor came to Paris, the poet-professor Abélard, the hero of the Latin Quarter had sung to Héloïse those songs which—he tells us—resounded through Europe as widely as his scholastic fame, and probably to more effect for his renown. In popular notions Héloïse was Isolde, and would in a moment have done what Isolde did. (Bartsch, 107-8):

Quaint reis Marcs nus out conjeies E de sa curt nus out chascez, As mains ensemble nus preismes When king Marc had banned us both, And from his court had chased us forth, Hand in hand each clasping fast E hors de la sale en eissimes, A la forest puis en alasmes E un mult bel liu i trouvames E une roche, fu cavee, Devant ert estraite la entree, Dedans fu voesse ben faite, Tant bel cum se fust purtraite. Straight from out the hall we passed;
To the forest turned our face;
Found in it a perfect place,
Where the rock that made a cave
Hardly more than passage gave;
Spacious within and fit for use,
As though it had been planned for us.

At any time of her life, Héloïse would have defied society or church, and would—at least in the public's fancy—have taken Abélard by the hand and gone off to the forest much more readily than she went to the cloister; but Abélard would have made a poor figure as Tristan. Abélard and Christian of Troyes were as remote as we are from the legendary Tristan; but Isolde and Héloïse, Eleanor and Mary were the immortal and eternal woman. The legend of Isolde, both in the earlier and the later version, seems to have served as a sacred book to the women of the twelfth and thirteenth centuries, and Christian's Isolde surely helped Mary in giving law to the Court of Troyes, and decisions in the Court of Love.

Countess Mary's authority lasted from 1164 to 1198, thirty-four years, during which, at uncertain intervals, glimpses of her influence flash out in poetry rather than in prose. Christian began his Roman de la Charette by invoking her:—

Puisque ma dame de Chanpaigne Vialt que romans a faire anpraigne

Si deist et jel tesmoignasse Que ce est la dame qui passe Totes celes qui sont vivanz Si con li funs passe les vanz Qui vante en Mai ou en Avril

Dirai je: tant com une jame Vaut de pailes et de sardines Vaut la contesse de reïnes?

Christian chose curious similes. His dame surpassed all living rivals as smoke passes the winds that blow in May; or as much as a gem would buy of straws and sardines is the Countess worth in queens. Louis XIV would have thought that Christian might be laughing at him, but court styles

changed with their masters. Louis XIV would scarcely have written a prison-song to his sister such as Richard Cœur-de-Lion wrote to Mary of Champagne: -

Ja nus hons pris ne dirat sa raison Adroitement s'ansi com dolans non; Mais par confort puet il faire chanson. Moult ai d'amins, mais povre sont li don;

Honte en avront se por ma rëançon Suix ces deus yvers pris.

Ceu sevent bien mi home et mi baron, Englois, Normant, Poitevin et Gascon, Ke je n'avoie si povre compaingnon Cui je laissasse por avoir an prixon. Je nel di pas por nulle retraison, Mais ancor suix je pris.

Or sai ge bien de voir certainement Ke mors ne pris n'ait amin ne parent, Cant on me lait por or ne por argent. Moult m'est de moi, mais plus m'est de

C'apres ma mort avront reprochier grant Se longement suix pris.

N'est pas mervelle se j'ai lo cuer dolent Cant li miens sires tient ma terre en torment

S'or li menbroit de nostre sairement Ke nos feismes andui communament, Bien sai de voir ke ceans longement Ne seroie pas pris.

Ce sevent bien Angevin et Torain,

Cil bacheler ki or sont fort et sain, C'ancombreis suix long d'aus en autrui main.

Forment m'amoient, mais or ne m'aimment grain.

De belles armes sont ores veut cil plain, Por tant ke je suix pris.

Mes compaingnons cui j'amoie et cui j'aim, Companions whom I loved, and still do

Ces dou Caheu et ces dou Percherain, Me di, chanson, kil ne sont pas certain,

C'onques vers aus n'en oi cuer faus ne vain.

No prisoner can tell his honest thought Unless he speaks as one who suffers wrong; But for his comfort he may make a song. My friends are many, but their gifts are naught.

Shame will be theirs, if, for my ransom, here I lie another year.

They know this well, my barons and my men, Normandy, England, Gascony, Poitou, That I had never follower so low Whom I would leave in prison to my gain. I say it not for a reproach to them, But prisoner I am!

The ancient proverb now I know for sure: Death and a prison know nor kin nor tie, Since for mere lack of gold they let me lie. Much for myself I grieve; for them still

After my death they will have grievous wrong If I am prisoner long.

What marvel that my heart is sad and sore When my own lord torments my helpless lands!

Well do I know that, if he held his hands, Remembering the common oath we swore, I should not here imprisoned with my song, Remain a prisoner long.

They know this well who now are rich and

Young gentlemen of Anjou and Touraine, That far from them, on hostile bonds I strain

They loved me much, but have not loved me

Their plains will see no more fair lists arrayed, While I lie here betrayed.

love,

Geoffroi du Perche and Ansel de Caïeux, Tell them, my song, that they are friends untrue.

Never to them did I false-hearted prove;

S'il me guerroient, il font moult que vilain But they do villainy if they war on me, Tant com je serai pris. While I lie here, unfree.

Comtesse suer, vostre pris soverain
Vos saut et gart cil a cui je me claim
Et par cui je suix pris.
Je n'ou di pas de celi de Chartain
La meire Lowëis.

Countess sister! your sovereign fame May he preserve whose help I claim, Victim for whom am I! I say not this of Chartres' dame, Mother of Louis!

Richard's prison-song, one of the chief monuments of English literature, sounds to every ear, accustomed to twelfth-century verse, as charming as when it was household rhyme to

mi ome et mi baron Englois, Normant, Poitevin et Gascon.

Not only was Richard a far greater king than any Louis ever was, but he also composed better poetry than any other king who is known to tourists, and, when he spoke to his sister in this cry of the heart altogether singular among monarchs, he made law and style, above discussion. Whether he meant to reproach his other sister, Alix of Chartres, historians may tell, if they know. If he did, the reproach answered its purpose, for the song was written in 1193; Richard was ransomed and released in 1194; and in 1198 the young Count "Loweis" of Chartres and Blois leagued with the Counts of Flanders, Le Perche, Guines and Toulouse, against Philip Augustus, in favor of Cœur-de-Lion to whom they rendered homage. In any case, neither Mary nor Alix in 1193 was reigning Countess. Mary was a widow since 1181, and her son Henry was Count in Champagne, apparently a great favorite with his uncle Richard Cœur-de-Lion. The life of this Henry of Champagne was another twelfth-century romance, but can serve no purpose here except to recall the story that his mother, the great Countess Mary, died in 1198 of sorrow for the death of this son who was then king of Jerusalem and was killed, in 1197, by a fall from the window of his palace at Acre. Cœur-de-Lion died in 1199. In 1201, Mary's other son who succeeded Henry,-Count Thibaut III,-died, leaving a posthumous heir, famous in the thirteenth-century as Thibaut-le-Grand,the Thibaut of Queen Blanche.

They were all astonishing—men and women—and filled the world, for two hundred years, with their extraordinary energy and genius; but the greatest of all was old Queen Eleanor, who survived her son Cœur-de-Lion, as well as her two husbands, - Louis-le-Jeune and Henry II Plantagenet, and was left in 1200 still struggling to repair the evils and fend off the dangers they caused. "Queen by the wrath of God," she called herself, and she knew what just claim she had to the rank. Of her two husbands and ten children, little remained except her son John who, by the unanimous voice of his family, his friends, his enemies and even his admirers, achieved a reputation for excelling in every form of twelfthcentury crime. He was a liar and a traitor, as was not uncommon; but he was thought to be also a coward which, in that family, was singular. Some redeeming quality he must have had, but none is recorded. His mother saw him running, in his masculine, twelfth-century recklessness, to destruction, and she made a last and a characteristic effort to save him and Guienne by a treaty of amity with the French king, to be secured by the marriage of the heir of France, Louis, to Eleanor's granddaughter, John's niece, Blanche of Castile, then twelve or thirteen years old. Eleanor herself was eighty, and yet she made the journey to Spain, brought back the child to Bordeaux, affianced her to Louis VIII as she had herself been affianced in 1137 to Louis VII, and in May, 1200, saw her married. The French had then given up their conventional trick of attributing Eleanor's acts to her want of morals; and France gave her, -as to most women after sixty years old, the benefit of the convention which made women respectable after they had lost the opportunity to be vicious. In French eyes, Eleanor played out the drama according to the rules. She could not save John, but she died in 1202, before his ruin, and you can still see her lying with her husband and her son Richard at Fontevrault in her twelfth-century tomb.

In 1223, Blanche became Queen of France. She was thirtysix years old. Her husband, Louis VIII, was ambitious to rival his father, Philip Augustus, who had seized Normandy in 1203. Louis undertook to seize Toulouse and Avignon. In 1225 he set out with a large army in which, among the chief vassals, his cousin Thibaut of Champagne led a contingent. Thibaut was five-and-twenty-years old, and, like Pierre de Dreux, then Duke of Brittany, was one of the most brilliant and versatile men of his time, and one of the greatest rulers. As royal vassal Thibaut owed forty days' service in the field; but his interests were at variance with the king's, and at the end of the term he marched home with his men, leaving the king to fall ill and die in Auvergne, November 8, 1226, and a child of ten years old to carry on the government as Louis IX.

Chartres Cathedral has already told the story twice, in stone and glass; but Thibaut does not appear there, although he saved the Queen. Some member of the royal family must be regent. Queen Blanche took the place, and of course the princes of the blood, who thought it was their right, united against her. At first, Blanche turned violently on Thibaut and forbade him to appear at the coronation at Reims in his own territory, on November 29, as though she held him guilty of treason; but when the league of great vassals united to deprive her of the regency, she had no choice but to detach at any cost any member of the league, and Thibaut alone offered help. What price she paid him was best known to her; but what price she would be believed to have paid him was as well known to her as what had been said of her grandmother Eleanor when she changed her allegiance in 1152. If the scandal had concerned Thibaut alone, she might have been well content, but Blanche was obliged also to pay desperate court to the papal legate. Every member of her husband's family united against her and libelled her character with the freedom which enlivened and envenomed roval tongues.

> Maintes paroles en dit en Comme d'Iseult et de Tristan.

Had this been all, she would have cared no more than Eleanor or any other queen had cared, for in French drama, real or imaginary, such charges were not very serious and hardly uncomplimentary; but Iseult had never been accused, over and above her arbitrary views on the marriage-contract, of acting as an accomplice with Tristan in poisoning King Marc. French convention required that Thibaut should have poisoned Louis VIII for love of the Queen, and that this secret reciprocal love should control their lives. Fortunately for Blanche she was a devout ally of the Church, and the Church believed evil only of enemies. The legate and the prel-

ates rallied to her support and after eight years of desperate struggle they crushed Pierre Mauclerc and saved Thibaut and Blanche.

For us the poetry is history, and the facts are false. French art starts not from facts, but from certain assumptions as conventional as a legendary window, and the commonest convention is the Woman. The fact, then as now, was Power, or its equivalent in exchange, but Frenchmen, while struggling for the Power, expressed it in terms of art. They looked on life as a drama, - and on drama as a phase of life, - in which the by-standers were bound to assume and accept the regular stage-plot. That the plot might be altogether untrue to real life affected in no way its interest. To them Thibaut and Blanche were bound to act Tristan and Isolde. Whatever they were when off the stage, they were lovers on it. Their loves were as real and as reasonable as the worship of the Virgin. Courteous love was avowedly a form of drama, but not the less a force of society. Illusion for illusion, courteous love, in Thibaut's hands, or in the hands of Dante and Petrarch, was as substantial as any other convention;—the balance of trade, the rights of man, or the Athanasian Creed. In that sense the illusions alone were real; if the middle-ages had reflected only what was practical, nothing would have survived for us.

Thibaut was Tristan, and is said to have painted his verses on the walls of his chateau. If he did, he painted there, in the opinion of M. Gaston Paris, better poetry than any that was written on paper or parchment, for Thibaut was a great prince and great poet who did in both characters whatever he pleased. In modern equivalents, one would give much to see the chateau again with the poetry on its walls. Provins has lost the verses, but Troyes still keeps some churches and glass of Thibaut's time which hold their own with the best. Even of Thibaut himself, something survives, and though it were only the memories of his seneschal, the famous sire de Joinville, history and France would be poor without him. With Joinville in hand, you may still pass an hour in the company of these astonishing thirteenth-century men and women:crusaders who fight, hunt, make love, build churches, put up glass windows to the Virgin, buy missals, talk scholastic philosophy, compose poetry; Blanche, Thibaut, Perron, Joinville,

Saint Louis, Saint Thomas, Saint Dominic, Saint Francis, you may know them as intimately as you can ever know a world that is lost; and in the case of Thibaut you may know more, for he is still alive in his poems; he even vibrates with life. One might try a few verses, to see what he meant by courtesy. Perhaps he wrote them for Queen Blanche, but, to whomever he sent them, the French were right in thinking that she ought to have returned his love. (Edition of 1742):-

Nus hom ne puet ami reconforter Se cele non ou il a son cuer mis. Pour ce m'estuet sovent plaindre et plourer Therefore I can but murmur and complain Que nus confors ne me vient, ce m'est vis, De la ou j'ai tote ma remembrance. Pour bien amer ai sovent esmaiance A dire voir. Dame, merci! donez moi esperance De joie avoir.

Je ne puis pas sovent a li parler Ne remirer les biaus iex de son vis. Ce pois moi que je n'i puis aler Car ades est mes cuers ententis.

Ho! bele riens, douce sans conoissance, Car me mettez en millor attendance De bon espoir!

Dame, merci! donez moi esperance De joie avoir.

Aucuns si sont qui me vuelent blamer

Quant je ne di a qui je suis amis; Mais ja, dame, ne saura mon penser Nus qui soit nes fors vous cui je le dis Couardement a pavours a doutance Dont puestes vous lors bien a ma semblance

Mon cuer savoir. Dame, merci! donez moi esperance De joie avoir.

There is no comfort to be found for pain Save only where the heart has made its home. Because no comfort to my pain has come From where I garnered all my happiness. From true love have I only earned distress The truth to say. Grace, lady! give me comfort to possess

A hope, one day.

Seldom the music of her voice I hear Or wonder at the beauty of her eyes. It grieves me that I may not follow there Where at her feet my heart attentive lies. Oh, gentle Beauty without consciousness, Let me once feel a moment's hopefulness, If but one ray! Grace, lady! give me comfort to possess A hope, one day.

Certain there are who blame upon me throw

Because I will not tell whose love I seek; But truly, lady, none my thought shall know, None that is born, save you to whom I speak In cowardice and awe and doubtfulness, That you may happily with fearlessness

My heart essay. Grace, lady! give me comfort to possess A hope, one day.

Does Thibaut's verse sound simple? It is the simplicity of the thirteenth-century glass, - so refined and complicated that sensible people are mostly satisfied to feel, and not to understand. Any blunderer in verse, who will merely look at the rhymes of these three stanzas, will see that simplicity is about as much concerned there as it is with the windows of Chartres; the verses are as perfect as the colors, and the versification as elaborate. These stanzas might have been addressed to Queen Blanche; now see how Thibaut kept the same tone of courteous love in addressing the Queen of Heaven!

De grant travail et de petit esploit Voi ce siegle cargie et encombre Que tant somes plain de maleurte Ke nus ne pens a faire ce qu'il doit, Ains avons si le Deauble trouve Qu'a lui servir chascuns paine et essaie Et Diex ki ot pour nos ja cruel plaie Metons arrier et sa grant dignite; Molt est hardis qui pour mort ne s'esmaie.

With travail great, and little cargo fraught, See how our world is laboring in pain; So filled we are with love of evil gain That no one thinks of doing what he ought, But we all hustle in the Devil's train, And only in his service toil and pray; And God, who suffered for us agony, We set behind, and treat him with disdain; Hardy is he whom death does not dismay.

Diex que tout set et tout puet et tout voit

Nous auroit tost en entre-deus giete Se la Dame plaine de grant bonte Pardelez lui pour nos ne li prioit

Si tres douc mot plaisant et savoure Le grant courous dou grant Signour apaie; Molt par est fox ki autre amor essai K'en cestui n'a barat ne fausete

Ne es autres n'a ne merci ne manaie.

La souris quiert pour son cors garandir Contre l'yver la noif et le forment

Quant nous morrons ou nous puissions garir.

Nous ne cherchons fors k'infer le puant; Or esgardes come beste sauvage Pourvoit de loin encontre son domage Et nous n'avons ne sens ne hardement; Il est avis que plain somes de rage.

Li Deable a getey por nos ravir Quatre ameçons aeschies de torment;

Covoitise lance premierement

Et puis Orguel por sa grant rois emplir Et Luxure va le batel trainant

God who rules all, from whom we can hide nought.

Had quickly flung us back to nought again But that our gentle, gracious, Lady Queen Begged him to spare us, and our pardon wrought;

Striving with words of sweetness to restrain Our angry Lord, and his great wrath allay. Felon is he who shall her love betray Which is pure truth, and falsehood cannot feign,

While all the rest is lie and cheating play.

The feeble mouse, against the winter's cold, Garners the nuts and grain within his cell, Et nous chaitif nous n'alons rien querant While man goes groping, without sense to tell

Where to seek refuge against growing old.

We seek it in the smoking mouth of Hell. With the poor beast our impotence compare! See him protect his life with utmost care, While us nor wit nor courage can compel To save our souls, so foolish mad we are.

The devil doth in snares our life enfold: Four hooks has he with torments baited

And first with Greed he cast a mighty

And then, to fill his nets, has Pride enrolled, And Luxury steers the boat, and fills the sail,

Felonie les governe et les nage. Ensi peschant s'en viegnent au rivage

Dont Diex nous gart par son commandement En qui sans fons nous feismes homage.

A la Dame qui tous les biens avance T'en va, chançon s'el te vielt escouter Onques ne fu nus de millor chaunce. And Perfidy controls and sets the snare; Thus the poor fish are brought to land, and there

May God preserve us and the foe repel!

Homage to him who saves us from despair!

To Mary Queen, who passes all compare, Go, little song! to her your sorrows tell! Nor Heaven nor Earth holds happiness so rare.

XII

Nicolette and Marion

C'est d'Aucassins et de Nicolete.

Qui vauroit bons vers oir Del deport du viel caitif De deus biax enfans petis Nicolete et Aucassins Des grans paines qu'il soufri Et des proueces qu'il fist Por s'amie o le cler vis. Dox est li cans biax est li dis Et cortois et bien asis. Nus hom n'est si esbahis Tant dolans ni entrepris De grant mal amaladis Se il Poit ne soit garis Et de joie resbaudis Tant par est dou-ce.

This is of Aucassins and Nicolette.

Whom would a good ballad please
By the captive from o'er-seas,
A sweet song in children's praise,
Nicolette and Aucassins;
What he bore for her caress,
What he proved of his prowess
For his friend with the bright face?
The song has charm, the tale has grace,
And courtesy and good address.
No man is in such distress,
Such suffering or weariness,
Sick with ever such sickness,
But he shall, if he hear this,
Recover all his happiness,
So sweet it is!

THIS LITTLE thirteenth-century gem is called a Chante-fable, a story partly in prose, partly in verse to be sung according to musical notation accompanying the words in the single manuscript known, and published in fac-simile by Mr. F. W. Bourdillon at Oxford in 1896. Indeed, few poems, old or new, have in the last few years been more reprinted, translated, and discussed, than Aucassins, yet the discussion lacks interest to the idle tourist, and tells him little. Nothing is known of the author or his date. The second line alone offers a hint, but nothing more. Caitif means in the first place a captive, and secondly any unfortunate or wretched man. Critics have liked to think that the word means here a captive to the Saracens, and that the poet, like Cervantes three or four hundred years later, may have been a prisoner to the infidels. What the critics can do, we can do. If liberties can be taken with impunity by scholars, we can take the liberty of supposing that the poet was a prisoner in the crusade of Cœur-de-Lion and Philippe-Auguste; that he had recovered his liberty, with his master, in 1194; and that he passed the rest of his life singing to the old Queen Eleanor or to Richard, at Chinon, and to the lords of all the chateaux in Guienne, Poitiers, Anjou and Normandy, not to mention England. The living was a pleasant one, as the sunny atmosphere of the southern poetry proves.

Dox est li cans; biax est li dis, Et cortois et bien asis.

The poet-troubadour who composed and recited Aucassins could not have been unhappy, but this is the affair of his private life, and not of ours. What rather interests us is his poetic motive, "courteous" love, which gives the tale a place in the direct line between Christian of Troyes, Thibaut-le-Grand, and William of Lorris. Christian of Troves died in 1175; at least he wrote nothing of a later date, so far as is certainly known. Richard Cœur-de-Lion died in 1199, very soon after the death of his half-sister Mary of Champagne. Thibaut-le-Grand was born in 1201. William of Lorris, who concluded the line of great "courteous" poets, died in 1260 or thereabouts. For our purposes, Aucassins comes between Christian of Troyes and William of Lorris; the trouvère or jogléor, who sang, was a viel caitif when the Chartres glass was set up, and the Charlemagne window designed, about 1210 or perhaps a little later. When one is not a professor, one has not the right to make inept guesses, and, when one is not a critic, one should not risk confusing a difficult question by baseless assumptions; but even a summer tourist may without offence visit his churches in the order that suits him best; and, for our tour, Aucassins follows Christian and goes hand in hand with Blondel and the chatelain de Coucy, as the most exquisite expression of "courteous love." As one of Aucassins' German editors says in his introduction:-Love is the medium through which alone the hero surveys the world around him, and for which he contemns everything that the age prized: knightly honor; deeds of arms; father and mother; hell, and even heaven; but the mere promise by his father of a kiss from Nicolette inspires him to superhuman heroism; while the old poet sings and smiles aside to his audience as though he wished them to understand that Aucassins, a foolish boy, must not be judged quite seriously, but that, old as he was himself, he was just as foolish about Nicolette.

Aucassins was the son of the Count of Beaucaire. Nicolette

was a young girl whom the Viscount of Beaucaire had redeemed as a captive of the Saracens, and had brought up as a god-daughter in his family. Aucassins fell in love with Nicolette, and wanted to marry her. The action turned on marriage, for, to the Counts of Beaucaire, as to other Counts, not to speak of Kings, high alliance was not a matter of choice but of necessity, without which they could not defend their lives, let alone their counties; and, to make Aucassins' conduct absolutely treasonable, Beaucaire was at that time surrounded and besieged, and the Count, Aucassins' father, stood in dire need of his son's help. Aucassins refused to stir unless he could have Nicolette. What were honors to him if Nicolette were not to share them. "S'ele estait empereris de Colstentinoble u d'Alemaigne u roine de France u d'Engletere, si aroit il asses peu en li, tant est france et cortoise et de bon aire et entecie de toutes bones teces." To be empress of "Colstentinoble" would be none too good for her, so stamped is she with nobility and courtesy and high-breeding and all good qualities.

So the Count, after a long struggle, sent for his Viscount and threatened to have Nicolette burned alive, and the Viscount himself treated no better, if he did not put a stop to the affair; and the Viscount shut up Nicolette, and remonstrated with Aucassins:—"Marry a king's daughter, or a count's! leave Nicolette alone, or you will never see Paradise!" This at once gave Aucassins the excuse for a charming tirade against Paradise, for which, a century or two later, he would properly have been burned together with Nicolette:—

En paradis qu'ai je a faire? Je n'i quier entrer mais que j'aie Nicolete, ma tres douce amie, que j'aim tant. C'en paradis ne vont fors tex gens con je vous dirai. Il i vont ci viel prestre et cil vieil clop et cil manke, qui tote jour et tote nuit cropent devant ces autex et en ces vies cruutes, et cil a ces vies capes ereses et a ces vies tatereles vestues, qui sont nu et decauc et estrumele, qui moeurent de faim et d'esci et de froid et de mesaises. Icil vont en paradis; aveuc ciax n'ai jou que faire; mais en infer voil jou aler. Car en infer vont li bel clerc et li bel cevalier qui sont mort as tor-

In Paradise what have I to do? I do not care to go there unless I may have Nicolette, my very sweet friend, whom I love so much. For, to Paradise goes no one but such people as I will tell you of. There go old priests and old cripples and the maimed, who all day and all night crouch before altars and in old crypts, and are clothed with old worn-out capes and old tattered rags; who are naked and footbare and sore; who die of hunger and want and misery. These go to Paradise; with them I have nothing to do; but to Hell I am willing to go. For, to Hell go

nois et as rices gueres, et li bien sergant et li franc home. Aveuc ciax voil jou aler. Et si vont les beles dames cortoises que eles ont ii amis ou iii avec leurs barons. Et si va li ors et li agens et li vairs et li gris; et si i vont herpeor et jogleor et li roi del siecle. Avec ciax voil jou aler mais que j'aie Nicolere, ma tres douce amie, aveuc moi. the fine scholars and the fair knights who die in tournies and in glorious wars; and the good men-at-arms and the well-born. With them I will gladly go. And there go the fair courteous ladies whether they have two or three friends besides their lords. And the gold and silver go there, and the ermines and sables; and there go the harpers and jongleurs, and the kings of the world. With these will I go, if only I may have Nicolette, my very sweet friend, with me.

Three times, in these short extracts, the word "courteous" has already appeared. The story itself is promised as courteous; Nicolette is courteous; and the ladies who are not to go to Heaven are courteous. Aucassins is in the full tide of courtesy, and evidently a professional, or he never would have claimed a place for harpers and jongleurs with kings and chevaliers in the next world. The poets of courteous love showed as little interest in religion as the poets of the eleventh century had shown for it in their poems of war. Aucassins resembled Christian of Troyes in this, and both of them resembled Thibaut, while William of Lorris went beyond them all. The literature of the "siècle" was always unreligious, from the Chanson de Roland to the Tragedy of Hamlet; to be "papelard" was unworthy of a chevalier; the true knight of courtesy made nothing of defying the torments of Hell, as he defied the lance of a rival, the frowns of society, the threats of parents or the terrors of magic; the perfect, gentle, courteous lover thought of nothing but his love. Whether the object of his love were Nicolette of Beaucaire or Blanche of Castile, Mary of Champagne or Mary of Chartres, was a detail which did not affect the devotion of his worship.

So Nicolette, shut up in a vaulted chamber, leaned out at the marble window and sang, while Aucassins, when his father promised that he should have a kiss from Nicolette, went out to make fabulous slaughter of the enemy; and when his father broke the promise, shut himself up in his chamber, and also sang; and the action went on by scenes and interludes, until, one night, Nicolette let herself down from the window, by the help of sheets and towels, into the garden, and, with a natural dislike of wetting her skirts which has delighted every hearer or reader from that day to this, "prist se vesture a l'une main devant et a l'autre deriere si s'escorça por le rousee qu'ele vit grande sor l'erbe si s'en ala aval le gardin;" she raised her skirts with one hand in front and the other behind, for the dew which she saw heavy on the grass, and went off down the garden, to the tower where Aucassins was locked up, and sang to him through a crack in the masonry, and gave him a lock of her hair, and they talked till the friendly nightwatch came by and warned her by a sweetly-sung chant, that she had better escape. So she bade farewell to Aucassins, and went on to a breach in the city wall, and she looked through it down into the fasse which was very deep and very steep. So she sang to herself—

Peres rois de maeste Or ne sai quel part aler. Se je vois u gaut rame Ja me mengeront li le Li lions et li sengler Dont il i a a plente. Father, King of Majesty! Now I know not where to flee. If I seek the forest free Then the lions will eat me, Wolves and wild boars terribly, Of which plenty there there be.

The lions were a touch of poetic license, even for Beaucaire, but the wolves and wild boars were real enough; yet Nicolette feared even them less than she feared the Count, so she slid down what her audience well knew to be a most dangerous and difficult descent, and reached the bottom with many wounds in her hands and feet, "et li san en sali bien en xii lius;" so that blood was drawn in a dozen places; and then she climbed up the other side, and went off bravely into the depths of the forest; an uncanny thing to do by night, as you can still see.

Then followed a pastoral, which might be taken from the works of another poet of the same period, whose acquaintance no one can neglect to make—Adam de la Halle, a Picard, of Arras. Adam lived, it is true, fifty years later than the date imagined for Aucassins, but his shepherds and shepherdesses are not so much like, as identical with, those of the southern poet, and all have so singular an air of life that the conventional courteous knight fades out beside them. The poet, whether *bourgeois*, professional, noble, or clerical, never

much loved the peasant, and the peasant never much loved him, or anyone else. The peasant was a class by himself, and his trait, as a class, was suspicion of everybody and all things, whether material, social or divine. Naturally he detested his lord, whether temporal or spiritual, because the seigneur and the priest took his earnings, but he was never servile though a serf; he was far from civil; he was commonly gross. He was cruel, but not more so than his betters; and his morals were no worse. The object of oppression on all sides,—the invariable victim, whoever else might escape,—the French peasant, as a class, held his own-and more. In fact, he succeeded in plundering Church, Crown, Nobility and Bourgeoisie, and was the only class in French history that rose steadily in power and well-being, from the time of the crusades to the present day, whatever his occasional suffering may have been; and, in the thirteenth century, he was suffering. When Nicolette, on the morning after her escape, came upon a group of peasants in the forest, tending the Count's cattle, she had reason to be afraid of them, but instead they were afraid of her. They thought at first that she was a fairy. When they guessed the riddle, they kept the secret, though they risked punishment, and lost the chance of reward, by protecting her. Worse than this, they agreed, for a small present, to give a message to Aucassins if he should ride that way.

Aucassins was not very bright, but when he got out of prison after Nicolette's escape, he did ride out, at his friends' suggestion, and tried to learn what had become of her. Passing through the woods he came upon the same group of

shepherds and shepherdesses:-

Esmeres et Martinet Fruelins et Johannes Robecons et Aubries

who might have been living in the Forest of Arden, so like were they to the clowns of Shakespeare. They were singing of Nicolette and her present, and the cakes and knives and flute they would buy with it. Aucassins jumped to the bait they offered him; and they instantly began to play him as though he were a trout:—

'Bel enfant, dix vos i ait!'

'Dix vos benie!' fait cil qui fu plus enparles des autres.

'Bel enfant,' fait il, 'redites le cançon que vos disiez ore!'

'Nous n'i dirons,' fait cil qui plus fu enparles des autres. 'Dehait ore qui por vos i cantera, biax sire!'

'Bel enfant!' fait Aucassins, 'enne me connissies vos?'

'Oil! nos savions bien que vos estes Aucassins, nos damoisiax, mais nos ne somes mie a vos, ains somes au conte.'

'Bel enfant, si feres, je vos en pri!,

'Os, por le cuer be!' fait cil. 'Por quoi canteroie je por vos, s'il ne me seoit! Quant il n'a si rice home en cest pais saus le cors le conte Garin s'il trovait mes bues ne mes vaces ne mes brebis en ses pres n'en sen forment qu'il fust mie tant hardis por les ex a crever qu'il les en ossast cacier. Et por quoi canteroie je por vos s'il ne me seoit?'

'Se dix vos ait, bel enfant, si feres! et tenes x sous que j'ai ci en une borse!'

'Sire, les deniers prenderons nos, mais je ne vos canterai mie, car j'en ai jure. Mais je le vos conterai se vos voles.'

'De par diu!' fait Aucassins. 'Encore aim je mix conter que nient.'

'God bless you, fair child!' said Aucassins.
'God be with you!' replied the one who talked best.

'Fair child!' said he, 'repeat the song you were just singing.'

'We won't!' replied he who talked best among them. 'Bad luck to him who shall sing for you, good sir!'

'Fair child,' said Aucassins, 'do you know me?'

'Yes! we know very well that you are Aucassins, our young lord; but we are none of yours; we belong to the Count.'

'Fair child, indeed you'll do it, I pray you!'

Listen, for love of God!' said he. 'Why should I sing for you if it does not suit me? when there is no man so powerful in this country, except Count Garin, if he found my oxen or my cows or my sheep in his pasture or his close, would not rather risk losing his eyes than dare to turn them out! and why should I sing for you, if it does not suit me!'

'So God help you, good child, indeed you will do it! and take these ten sous that I have here in my purse!'

'Sire, the money we will take, but I'll not sing to you, for I've sworn it. But I will tell it you, if you like.'

'For God's sake!' said Aucassins; 'better telling than nothing!'

Ten sous was no small gift! twenty sous was the value of a strong ox. The poet put a high money-value on the force of love, but he set a higher value on it in courtesy. These boors were openly insolent to their young lord, trying to extort money from him, and threatening him with telling his father; but they were in their right, and Nicolette was in their power. At heart they meant Aucassins well, but they were rude and grasping, and the poet used them in order to show how love made the true lover courteous even to clowns. Aucassins' gentle courtesy is brought out by the boors' greed, as the colors in the window were brought out and given their value by a bit of blue or green. The poet, having got his little touch of color rightly placed, let the peasants go. 'Cil qui fu plus enparles des autres,'

having been given his way and his money, told Aucassins what he knew of Nicolette and her message; so Aucassins put spurs to his horse and cantered into the forest, singing:

Se diu plaist le pere fort Je vos reverai encore Suer, douce a-mie! So please God, great and strong, I will find you now ere long, Sister, sweet friend!

But the peasant had singular attraction for the poet. Whether the character gave him a chance for some clever mimicry, which was one of his strong points as a story-teller: or whether he wanted to treat his subjects, like the legendary windows, in pairs; or whether he felt that the forest-scene specially amused his audience, he immediately introduced a peasant of another class, much more strongly colored, or deeply shadowed. Everyone in the audience was, - and, for that matter, still would be, -familiar with the great forests, the home of half the fairy and nursery tales of Europe, still wild enough and extensive enough to hide in, although they have now comparatively few lions, and not many wolves or wild boars or serpents such as Nicolette feared. Everyone saw, without an effort, the young damoiseau riding out with his hound or hawk, looking for game; the lanes under the trees, through the wood, or the thick underbrush before lanes were made; the herdsmen watching their herds, and keeping a sharp look-out for wolves; the peasant seeking lost cattle; the black kiln-men burning charcoal; and in the depths of the rocks or swamps or thickets—the outlaw. Even now, forests like Rambouillet, or Fontainebleau or Compiegne are enormous and wild; one can see Aucassins breaking his way through thorns and branches in search of Nicolette, tearing his clothes and wounding himself "en xl lius u en xxx," until evening approached, and he began to weep for disappointment:-

Il esgarda devant lui enmi la voie si vit un vallet tel que je vos dirai. Grans estoit et mervellex et lais et hidex. Il avoit une grande hure plus noire qu'une carbouclee, et avoit plus de planne paume entre ii ex, et avoit unes grandes joes et un grandisme nez plat, et une grans narines lees et unes grosses levres plus rouges d'unes carbounees, et uns grans dens gaunes et lais As he looked before him along the way he saw a man such as I will tell you. Tall he was, and menacing, and ugly, and hideous. He had a great mane blacker than charcoal and had more than a full palmwidth between his two eyes, and had big cheeks, and a huge flat nose and great broad nostrils, and thick lips redder than raw beef, and large ugly yellow teeth, and et estoit caucies d'uns housiax et d'uns sollers de buef fretes de tille dusque deseure le genol et estoit afules d'une cape a ii envers si estoit apoiies sor une grande maçue. Aucassins s'enbati sor lui s'eut grand paor quant il le sorvit...

'Biax frere, dix ti ait!'

'Dix vos benie!' fait cil.

'Se dix t'ait, que fais tu ilec?'

'A vos que monte?' fait cil.

'Nient!' fait Aucassins; 'je nel vos demant se por bien non.'

'Mais pour quoi ploures vos?' fait cil, 'et faites si fait doel? Certes se j'estoie ausi rices hom que vos estes, tos li mons ne me feroit mie plorer.'

'Ba! me conissies vos!' fait Aucassins.

'Oie! je sai bien que vos estes Aucassins li fix le conte, et se vos me dites por quoi vos plores je vos dirai que je fac ici.' was shod with hose and leggings of raw hide laced with bark cord to above the knee, and was muffled in a cloak without lining, and was leaning on a great club. Aucassins came upon him suddenly, and had great fear when he saw him.

'Fair brother, good day!' said he.

'God bless you!' said the other.

'As God help you, what do you here?'
'What is that to you?' said the other.

'Nothing!' said Aucassins; 'I ask only from good-will.'

'But why are you crying!' said the other, 'and mourning so loud? Sure, if I were as great a man as you are, nothing on earth would make me cry.'

'Bah! you know me?' said Aucassins.

'Yes, I know very well that you are Aucassins, the count's son: and if you will tell me what you are crying for, I will tell you what I am doing here.'

Aucassins seemed to think this an equal bargain. All damoiseaux were not as courteous as Aucassins, nor all 'varlets' as rude as his peasants; we shall see how the young gentlemen of Picardy treated the peasantry for no offence at all; but Aucassins carried a softer, southern temper in a happier climate, and, with his invariable gentle courtesy took no offence at the familiarity with which the ploughman treated him. Yet he dared not tell the truth, so he invented, on the spur of the moment, an excuse;—He has lost he said, a beautiful white hound. The peasant hooted—

'Os!' fait cil; 'por le cuer que cil sires eut en sen ventre! que vos plorastes por un cien puant! Mal dehait ait qui ja mais vos prisera quant il n'a si rice home en ceste tere se vos peres l'en mandoit x u xv ux qu'il ne les envoyast trop volontiers et s'en esteroit trop lies. Mais je dois plorer et dol faire?'

'Et tu de quoi frere?'

'Sire, je le vos dirai! J'estoie liues a un rice vilain si caçoie se carue. iiii bues i avoit. Or a iii jors qu'il m'avint une grande malaventure que je perdi le mellor de mes bues Roget le mellor de me carue. Si le vois querant. Si ne mengai ne ne bue 'Listen!' said he; 'By the heart God had in his body! that you should cry for a stinking dog! Bad luck to him who ever prizes you! When there is no man in this land so great, if your father sent to him for ten or fifteen or twenty, but would fetch them very gladly, and be only too pleased. But I ought to cry and mourn.'

'And why you, brother?'

'Sir, I will tell you. I was hired out to a rich farmer to drive his plough. There were four oxen. Now three days ago I had a great misfortune, for I lost the best of my oxen, Roget, the best of my team. I am looking to find him. I've not eaten or iii jors a passes. Si n'os aler a le vile c'on me metroit en prison que je ne l'ai de quoi saure. De tot l'avoir du monde n'ai je plus vaillant que vos vees sor le cors de mi. Une lasse mere avoie; si n'avoit plus vaillant que une keutisele; si li a on sacie de desous le dos; si gist a pur l'estrain; si m'en poise asses plus que demi. Car avoirs va et vient; se j'ai or perdu je gaaignerai une autre fois; si sorrai mon buer quant je porrai, ne ja por çou n'en plorerai. Et vos plorastes por un cien de longaigne! Mal dehait ait qui mais vos prisera!'

'Certes tu es de bon confort, biax frere! que benois sois tu! Et que valoir tes bues!' 'Sire, xx sous m'en demande on, je n'en

puis mie abatre une seule maille.'

'Or, tien,' fait Aucassins, 'xx que j'ai ci en me borse; si sol ten buef!'

'Sire!' fait il, 'grans mercies! et dix vos laist trover ce que vos queres!' drunk these three days past. I daren't go to the town, for they would put me in prison, as I've nothing to pay with. In all the world I've not the worth of anything but what you see on my body. I've a poor old mother who owned nothing but a feather mattress, and they've dragged it from under her back, so she lies on the bare straw; and she troubles me more than myself. For riches come and go; if I lose today, I gain tomorrow; I will pay for my ox when I can, and will not cry for that. And you cry for a filthy dog! Bad luck to him who ever thinks well of you!

'Truly, you counsel well, good brother! God bless you! And what was your ox worth?'

'Sir, they ask me twenty sous for it. I cannot beat them down a single centime.'

'Here are twenty,' said Aucassins, 'that I have in my purse! Pay for your ox!'

'Sir!' said he; 'many thanks! and God grant you find what you seek!'

The little episode was thrown in without rhyme or reason to the rapid emotion of the love-story, as though the *jongleur* were showing his own cleverness and humor, at the expense of his hero, as *jongleurs* had a way of doing; but he took no such liberties with his heroine. While Aucassins tore through the thickets on horseback, crying aloud, Nicolette had built herself a little hut in the depths of the forest:—

Ele prist des flors de lis
Et de l'erbe du garris
Et de le foille autresi;
Une belle loge en fist,
Ainques tant gente ne vi.
Jure diu qui ne menti
Se par la vient Aucassins
Et il por l'amor de li
Ne si repose un petit
Ja ne sera ses amis
N'ele s'a-mie.

So she twined the lilies' flower,
Roofed with leafy branches o'er,
Made of it a lovely bower,
With the freshest grass for floor,
Such as never mortal saw.
By God's Verity, she swore,
Should Aucassins pass her door,
And not stop for love of her,
To repose a moment there,
He should be her love no more,
Nor she his dear!

So night came on, and Nicolette went to sleep, a little distance away from her hut. Aucassins at last came by, and dismounted, spraining his shoulder in doing it. Then he crept into the little hut, and lying on his back, looked up through the leaves to the moon, and sang:—

Estoilete, je te voi,
Que la lune trait a soi.
Nicolete est aveuc toi,
M'amiete o le blond poil.
Je quid que dix le veut avoir
Por la lumiere de soir
Que par li plus clere soit.
Vien, amie, je te proie!
Ou monter vauroie droit,
Que que fiust du recaoir.
Que fuisse lassus o toi
Ja te baiseroi estroit.
Se j'estoie fix a roi
S'afferies vos bien a moi
Suer douce amie!

I can see you, little star,
That the moon draws through the air.
Nicolette is where you are,
My own love with the blonde hair.
I think God must want her near
To shine down upon us here
That the evening be more clear.
Come down, dearest, to my prayer,
Or I climb up where you are!
Though I fell, I would not care.
If I once were with you there
I would kiss you closely, dear!
If a monarch's son I were
You should all my kingdom share,
Sweet friend, sister!

How Nicolette heard him sing, and came to him and rubbed his shoulder and dressed his wounds as though he were a child; and how in the morning they rode away together, like Tennyson's Sleeping Beauty,

> O'er the hills and far away Beyond their utmost purple rim, Beyond the night, beyond the day,

singing as they rode, the story goes on to tell or to sing in verse—

Aucassins, li biax, li blons, Li gentix, li amorous, Est issous del gaut parfont, Entre ses bras ses amors Devant lui sor son arçon. Les ex li baise et le front. Et le bouce et le menton. Elle l'a mis a raison. 'Aucassins, biax amis dox, 'En quel tere en irons nous?' 'Douce amie, que sai jou? 'Moi ne caut u nous aillons, En forest u en destor 'Mais que je soie aveuc vous.' Passent les vaus et les mons, Et les viles et les bors A la mer vinrent au jor, Si descendent u sablon Les le rivage.

Aucassins, the brave, the fair, Courteous knight and gentle lover, From the forest dense came forth; In his arms his love he bore On his saddle-bow before; Her eyes he kisses and her mouth, And her forehead and her chin. She brings him back to earth again: - 'Aucassins, my love, my own, 'To what country shall we turn?' -'Dearest angel, what say you? 'I care nothing where we go, 'In the forest or outside, 'While you on my saddle ride.' So they pass by hill and dale, And the city, and the town, Till they reach the morning pale, And on sea-sands set them down, Hard by the shore.

There we will leave them, for their further adventures have not much to do with our matter. Like all the Romans, or nearly all. Aucassins is singularly pure and refined. Apparently the ladies of courteous love frowned on coarseness and allowed no license. Their power must have been great, for the best Romans are as free from grossness as the Chanson de Roland itself, or the Church glass, or the illuminations in the manuscripts: and as long as the power of the Church ruled good society, this decency continued. As far as women were concerned, they seem always to have been more clean than the men, except when men painted them in colors which men liked best. Perhaps society was actually cleaner in the thirteenth century than in the sixteenth, as Saint Louis was more decent than Francis I, and as the bath was habitual in the twelfth century and exceptional at the renaissance. The rule held good for the bourgeoisie as well as among the dames cortoises. Christian and Thibaut, Aucassins and the Roman de la Rose, may have expressed only the tastes of high-born ladies, but other poems were avowedly bourgeois, and among the bourgeois poets none was better than Adam de la Halle. Adam wrote also for the Court, or at least for Robert of Artois, Saint Louis' nephew, whom he followed to Naples in 1284, but his poetry was as little aristocratic as poetry could well be, and most of it was cynically, -almost defiantly, -middleclass, as though the weavers of Arras were his only audience, and recognized him and the objects of his satire in every verse. The bitter personalities do not concern us, but, at Naples, to amuse Robert of Artois and his court, Adam composed the first of French comic operas, which had an immense success, and, as a pastoral poem, has it still. The Idyll of Arras was a singular contrast to the Idyll of Beaucaire, but the social value was the same in both: Robin and Marion were a pendant to Aucassins and Nicolette; Robin was almost a burlesque on Aucassins, while Marion was a northern, energetic, intelligent, pastoral Nicolette.

"Li Gieus de Robin et de Marion" had little or no plot. Adam strung together, on a thread of dialogue and by a group of suitable figures, a number of the favorite songs of his time, followed by the favorite games, and ending with a favorite dance, the *tresca*. The songs, the games and the

dances do not concern us, but the dialogue runs along prettily, with an air of Flemish realism, like a picture of Teniers, as unlike that of "courtoisie" as Teniers was to Guido Reni. Underneath it all a tone of satire made itself felt, goodnatured enough, but directed wholly against the men.

The scene opens on Marion tending her sheep, and singing the pretty air:—"Robin m'aime, Robin ma'a," after which enters a chevalier or esquire, on horseback, and sings:—"Je me repairoie du tournoiement." Then follows a dialogue between the chevalier and Marion, with no other object than to show off the charm of Marion against the masculine defects of the knight. Being, like most squires, somewhat slow of ideas in conversation with young women, the gentleman began by asking for sport for his falcon. Has she seen any duck down by the river?

Mais veis tu par chi devant Vers ceste riviere nul ane?

Ane, it seems, was the usual word for wild duck, the falcon's prey, and Marion knew it as well as he, but she chose to misunderstand him:—

C'est une bete qui recane; J'en vis ier iii sur che quemin, Tous quarchies aler au moulin. Est che chou que vous demandes?

"It is a beast that brays; I saw three yesterday on the road, all with loads going to the mill. Is that what you ask?" That is not what the squire has asked, and he is conscious that Marion knows it, but he tries again. If she has not seen a duck, perhaps she has seen a heron:—

Hairons, sire? par me foi, non! Je n'en vi nesun puis quareme Que j'en vi mengier chies dame Eme Me taiien qui sont ches brebis.

"Heron, sir! by my faith, no! I've not seen one since Lent

when I saw some eaten at my grandmother's—Dame Emma who owns these sheep." *Hairons*, it seems, meant also herring, and this wilful misunderstanding struck the chevalier as carrying jest too far:—

Par foi! or suis j'ou esbaubis! N'ainc mais je ne fui si gabes!

"On my word, I am silenced! never in my life was I so chaffed!" Marion herself seems to think her joke a little too evident, for she takes up the conversation in her turn, only to conclude that she likes Robin better than she does the knight; he is gayer, and when he plays his musette he starts the whole village dancing. At this, the squire makes a declaration of love with such energy as to spur his horse almost over her:

Aimi, sire! ostez vo cheval! A poi que il ne m'a blechie. Li Robin ne regiete mie Quand je voie apres se karue.

'Aimi!' is an exclamation of alarm, real or affected:—"Dear me, Sir! take your horse away! he almost hurt me! Robin's horse never rears when I go behind his plough!" Still the knight persists, and though Marion still tells him to go away, she asks his name, which he says is Aubert, and so gives her the catch-word for another song:—"Vos perdes vo paine, sire Aubert!" which ends the scene with a duo.

The second scene begins with a duo of Marion and Robin, followed by her giving a softened account of the chevalier's behavior, and then they lunch on bread and cheese and apples, and more songs follow, till she sends him to get Baldwin and Walter and Peronette and the pipers, for a dance. In his absence the chevalier returns and becomes very pressing in his attentions, which gives her occasion to sing:—

J'oi Robin flagoler Au flagol d'argent.

When Robin enters, the knight picks a quarrel with him for

not handling properly the falcon which he has caught in the hedge; and Robin gets a severe beating. The scene ends by the horseman carrying off Marion by force; but he soon gets tired of carrying her against her will, and drops her, and disappears once for all.

Certes voirement sui je beste Quant a ceste beste m'areste. Adieu, bergiere!

Bête the knight certainly was, and was meant to be, in order to give the necessary color to Marion's charms. Chevaliers were seldom intellectually brilliant in the mediæval Romans, and even the Chansons de Geste liked better to talk of their prowess than of their wit; but Adam de la Halle, who felt no great love for chevaliers, was not satisfied with ridiculing them in order to exalt Marion; his second act was devoted to

exalting Marion at the expense of her own boors.

The first act was given up to song; the second, to games and dances. The games prove not to be wholly a success; Marion is bored by them, and wants to dance. The dialogue shows Marion trying constantly to control her clowns and make them decent, as Blanche of Castile had been all her life trying to control her princes, and Mary of Chartres her kings. Robin is a rustic counterpart to Thibaut. He is tamed by his love of Marion, but he has just enough intelligence to think well of himself, and to get himself into trouble without knowing how to get out of it. Marion loves him much as she would her child; she makes only a little fun of him; defends him from the others; laughs at his jealousy; scolds him on occasions; flatters his dancing: sends him on errands, to bring the pipers or drive away the wolf; and what is most to our purpose, uses him to make the other peasants decent. Walter and Baldwin and Hugh are coarse, and their idea of wit is to shock the women or make Robin jealous. Love makes gentlemen even of boors, whether noble or villain, is the constant moral of mediæval story, and love turns Robin into a champion of decency. When, at last, Walter, playing the jongleur begins to repeat a particularly coarse fabliau, or story in verse, Robin stops him shortHo, Gautier, je n'en voeil plus! fi! Dites, seres vous tous jours teus! Vous estes un ors menestreus!

"Ho, Walter! I want no more of that: Shame! Say! are you going to be always like that! You're a dirty beggar!" A fight seems inevitable, but Marion turns it into a dance, and the whole party, led by the pipers, with Robin and Marion at the head of the band, leave the stage in the dance which is said to be still known in Italy as the tresca.

Marion is in her way as charming as Nicolette, but we are less interested in her charm than in her power. Always the woman appears as the practical guide; the one who keeps her head, even in love:—

Elle l'a mis a raison:
'Aucassins, biax amis dox,
'En quele tere en irons nous?'
'Douce amie, que sai jou?
'Moi ne caut ou nous aillons.'

The man never cared; he was always getting himself into crusades, or feuds, or love, or debt, and depended on the woman to get him out. The story was always of Charles VII and Jeanne d'Arc, or Agnes Sorel. The woman might be the good or the evil spirit, but she was always the stronger force. The twelfth and thirteenth centuries were a period when men were at their strongest; never before or since have they shown equal energy in such varied directions, or such intelligence in the direction of their energy; yet these marvels of history,—these Plantagenets; these scholastic philosophers; these architects of Rheims and Amiens; these Innocents, and Robin Hoods and Marco Polos; these crusaders, who planted their enormous fortresses all over the Levant; these monks who made the wastes and barrens yield harvests; -all, without apparent exception, bowed down before the woman.

Explain it who will! We are not particularly interested in the explanation; it is the art we have chased through this French forest, like Aucassins hunting for Nicolette; and the art leads always to the woman. Poetry, like the architecture and the decoration, harks back to the same standard of taste. The specimens of Christian of Troyes, Thibaut, Tristan, Aucassins and Adam de la Halle were mild admissions of feminine superiority compared with some that were more in vogue. If Thibaut painted his love-verses on the walls of his castle, he put there only what a more famous poet, who may have been his friend, set on the walls of his Chateau of Courteous Love, which, not being made with hands or with stone, but merely with verse, has not wholly perished. The Roman de la Rose is the end of true mediæval poetry and goes with the Sainte Chapelle in architecture, and three hundred years of more or less graceful imitation or variation on the same themes which followed. Our age calls it false taste, and no doubt our age is right; -every age is right by its own standards as long as its standards amuse it; -but after all, the Roman de la Rose charmed Chaucer,—it may well charm you. The charm may not be that of Mont Saint Michel or of Roland; it has not the grand manner of the eleventh century, or the jewelled brilliancy of the Chartres lancets, or the splendid self-assertion of the Roses: but even to this day it gives out a faint odor of Champagne and Touraine, of Provence and Cvprus. One hears Thibaut and sees Queen Blanche.

Of course, this odor of true sanctity belongs only to the Roman of William of Lorris, which dates from the death of Queen Blanche and of all good things, about 1250; a short allegory of Courteous Love in 4,670 lines. To modern taste, an allegory of 4,670 lines seems to be not so short as it might be; but the fourteenth century found five thousand verses totally inadequate to the subject, and, about 1300, Jean de Meung added eighteen thousand lines, the favorite reading of society for one or two hundred years, but beyond our horizon. The Roman of William of Lorris was complete in itself; it had shape; beginning, middle, and end; even a certain realism, action,—almost life!

The Rose is any feminine ideal of beauty, intelligence, purity or grace,—always culminating in the Virgin,—but the scene is the Court of Love, and the action is avowedly in a dream, without time or place. The poet's tone is very pure; a little subdued; at times sad; and the poem ends sadly; but all the figures that were positively hideous were shut out of the

Court, and painted on the outside walls: - Hatred: Felony: Covetousness: Envy: Poverty: Melancholy, and Old Age. Death did not appear. The passion for representing death in its horrors did not belong to the sunny atmosphere of the thirteenth century, and indeed jarred on French taste always, though the Church came to insist on it; but Old Age gave the poet a motive more artistic, foreshadowing Death, and quite sad enough to supply the necessary contrast. The poet who approached the walls of the chateau and saw, outside, all the unpleasant facts of life conspicuously posted up, as though to shut them out of doors, hastened to ask for entrance, and, when once admitted, found a court of ideals. Their names matter little. In the mind of William of Lorris, everyone would people his ideal world with whatever ideal figures pleased him, and the only personal value of William's figures is that they represent what he thought the thirteenthcentury ideals of a perfect society. Here is Courtesy, with a translation long thought to be by Chaucer:-

Apres se tenoit Cortoisie Oui moult estoit de tous prisie. Si n'ere orgueilleuse ne fole. C'est cele qui a la karole, La soe merci, m'apela, Ains que nule, quand je vins la. Et ne fut ne nice n'umbrage, Mais sages augues, sans outrage, De biaus respons et de biaus dis, Onc nus ne fu par li laidis, Ne ne porta nului rancune, Et fu clere comme la lune Est avers les autres estoiles Oui ne resemblent que chandoiles. Faitisse estoit et avenant; Je ne sai fame plus plaisant. Ele ert en toutes cors bien digne D'estre empereris ou roine.

And next that daunced Courtesve, That preised was of lowe and hye, For neither proude ne foole was she; She for to daunce called me, I pray God yeve hir right good grace, When I come first into the place. She was not nyce ne outrageous, But wys and ware and vertuous; Of faire speche and of faire answere; Was never wight mysseid of her, Ne she bar rancour to no wight. Clere browne she was, and thereto bright Of face, of body avenaunt. I wot no lady so pleasaunt. She were worthy forto bene An empresse or crowned quene.

You can read for yourselves the characters, and can follow the simple action which owes its slight interest only to the constant effort of the dreamer to attain his ideal,—the Rose,—and owes its charm chiefly to the constant disappointment and final defeat. An undertone of sadness runs through it, felt already in the picture of Time which foreshadows the end of Love—the Rose—and her Court, and with it the end of hope:—

Li tens qui s'en va nuit et jor, Sans repos prendre et sans sejor, Et qui de nous se part et emble Si celeement qu'il nous semble Ou'il s'arreste ades en un point, Et il ne s'i arreste point, Ains ne fine de trespasser, Oue nus ne puet neis penser Quex tens ce est qui est presens; S'el demandes as clers lisans. Ainçois que l'en l'eust pense Seroit il ja trois tens passe; Li tens qui ne puet sejourner, Ains vait tous jors sans retorner, Com l'iaue qui s'avale toute, N'il n'en retourne arriere goute: Li tens vers qui noient ne dure, Ne fer ne chose tant soit dure, Car il gaste tout et menjue; Li tens qui tote chose mue, Oui tout fait croistre et tout norist, Et qui tout use et tout porrist.

The tyme that passeth nyght and daye, And restelesse travayleth ave, And steleth from us so prively, That to us semeth so sykerly That it in one poynt dwelleth never, But gothe so fast, and passeth ave That there nys man that thynke may What tyme that now present is; Asketh at these clerkes this. For or men thynke it readily Thre tymes ben vpassed by. The tyme that may not sojourne But goth, and may never returne, As water that down renneth av. But never drope retourne may. There may no thing as time endure. Metall nor earthly creature: For alle thing it frette and shall. The tyme eke that chaungith all, And all doth waxe and fostered be. And alle thing distroieth he.

The note of sadness has begun, which the poets were to find so much more to their taste than the note of gladness. From the Roman de la Rose to the Ballade des Dames du Temps jadis was a short step for the middle-age giant Time,—a poor two hundred years. Then Villon woke up to ask what had become of the Roses:—

Ou est la tres sage Heloïs Pour qui fut chastie puis moyne, Pierre Esbaillart a Saint Denis? Pour son amour ot cest essoyne.

Et Jehanne la bonne Lorraine Qu' Englois brulerent a Rouan; Ou sont elles, Vierge Souvraine? Mais ou sont les neiges dantan? Where is the virtuous Héloïse, For whom suffered, then turned monk, Pierre Abélard at Saint Denis? For his love he bore that pain.

And Jeanne d'Arc, the good Lorraine, Whom the English burned at Rouen! Where are they, Virgin Queen! But where are the snows of spring!

Between the death of William of Lorris, and the advent of John of Meung, a short half-century (1250–1300), the Woman and the Rose became bankrupt. Satire took the place of wor-

ship. Man, with his usual monkey-like malice, took pleasure in pulling down what he had built up. The Frenchman had made what he called *fausse route*. William of Lorris was first to see it, and say it, with more sadness and less bitterness than Villon showed; he won immortality by telling how he, and the thirteenth century in him, had lost himself in pursuing his Rose, and how he had lost the Rose too, waking up at last to the dull memory of pain and sorrow and death, that "tout porrist." The world had still a long march to make from the Rose of Queen Blanche to the guillotine of Madame du Barry; but the *Roman de la Rose* made epoch. For the first time since Constantine proclaimed the reign of Christ, a thousand years, or so, before Philip the Fair dethroned him, the deepest expression of social feeling ended with the word: Despair.

XIII

Les Miracles de Notre Dame

Vergine Madre, figlia del tuo figlio, Umile ed alta piu che creatura, Termine fisso d'eterno consiglio, Tu sei colei che l'umana natura Nobilitasti si, che il suo fattore Non disdegno di farsi sua fattura.

La tua benignita non pur soccorre
A chi dimanda, ma molte fiate
Liberamente al dimandar precorre.
In te misericordia, in te pietate,
In te magnificenza, in te s'aduna
Quantunque in creatura e di bontate.

Vergine bella, che di sol vestita.
Coronata di stelle, al sommo sole
Piacesti si che'n te sua luce ascose;
Amor mi spinge a dir di te parole;
Ma non so 'ncominciar senza tu aita,
E di colui ch'amando in te si pose.
Invoco lei che ben sempre rispose
Chi la chiamo con fede.
Vergine, s'a mercede
Miseria estrema dell' umane cose
Giammai ti volse, al mio prego t'inchina!
Soccorri alla mia guerra,
Bench'i sia terra, e tu del ciel regina!

Dante composed one of these prayers; Petrarch the other. Chaucer translated Dante's prayer in "The Second Nonnes Tale." He who will may undertake to translate either;—not I! The Virgin, in whom is united whatever goodness is in created being, might possibly, in her infinite grace, forgive the sacrilege; but her power has limits, if not her grace, and the whole Trinity, with the Virgin to aid, had not the power to pardon him who should translate Dante and Petrarch. The prayers come in here, not merely for their beauty, although the Virgin knows how beautiful they are, whether man knows it or not; but chiefly to show the good faith, the depth of feeling, the intensity of conviction, with which society adored its ideal of human perfection.

The Virgin filled so enormous a space in the life and thought of the time that one stands now helpless before the mass of testimony to her direct action and constant presence in every moment and form of the illusion which men thought they thought their existence. The twelfth and thirteenth centuries believed in the supernatural, and might almost be said to have contracted a miracle-habit, as morbid as any other form of artificial stimulant; they stood, like children, in an attitude of gaping wonder before the miracle of miracles which they felt in their own consciousness; but one can see in this emotion, which is, after all, not exclusively infantile,

no special reason why they should have so passionately flung themselves at the feet of the Woman rather than of the Man. Dante wrote in 1300, after the height of this emotion had passed; and Petrarch wrote half a century later still; but so slowly did the vision fade, and so often did it revive, that to this day it remains the strongest symbol with which the Church can conjure.

Men were, after all, not wholly inconsequent; their attachment to Mary rested on an instinct of self-preservation. They knew their own peril. If there was to be a future life, Mary was their only hope. She alone represented Love. The Trinity were, or was, One, and could, by the nature of its essence, administer justice alone. Only childlike illusion could expect a personal favor from Christ. Turn the dogma as one would, to this it must logically come. Call the three Godheads by what names one liked, still they must remain one; must administer one justice; must admit only one law. In that law, no human weakness or error could exist; by its essence it was infinite, eternal, immutable. There was no crack and no cranny in the system, through which human frailty could hope for escape. One was forced from corner to corner by a remorseless logic

until one fell helpless at Mary's feet.

Without Mary, man had no hope except in Atheism, and for Atheism the world was not ready. Hemmed back on that side, men rushed like sheep to escape the butcher, and were driven to Mary; only too happy in finding protection and hope in a being who could understand the language they talked, and the excuses they had to offer. How passionately they worshipped Mary, the Cathedral of Chartres shows; and how this worship elevated the whole sex, all the literature and history of the time proclaim. If you need more proof, you can read more Petrarch; but still one cannot realise how actual Mary was, to the men and women of the middle-ages, and how she was present, as a matter of course, whether by way of miracle or as a habit of life, throughout their daily existence. The surest measure of her reality is the enormous money value they put on her assistance, and the art that was lavished on her gratification, but an almost equally certain sign is the casual allusion, the chance reference to her, which assumes her presence.

The earliest prose writer in the French language, who gave a picture of actual French life, was Joinville; and although he wrote after the death of Saint Louis and of William of Lorris and Adam de la Halle, in the full decadence of Philip the Fair, towards 1300, he had been a vassal of Thibaut and an intimate friend of Louis, and his memories went back to the France of Blanche's regency. Born in 1224, he must have seen in his youth the struggles of Thibaut against the enemies of Blanche, and in fact his memoirs contain Blanche's emphatic letter forbidding Thibaut to marry Yolande of Brittany. He knew Pierre de Dreux well, and when they were captured by the Saracens at Damietta, and thrown into the hold of a galley, "I had my feet right on the face of the count Pierre de Bretagne, whose feet, in turn, were by my face." Joinville is almost twelfth-century in feeling. He was neither feminine nor sceptical, but simple. He showed no concern for poetry, but he put up a glass window to the Virgin. His religion belonged to the Chanson de Roland. When Saint Louis, who had a pleasant sense of humor, put to him his favorite religious conundrums, Joinville affected not the least hypocrisy. "Would you rather be a leper, or commit a mortal sin?" asked the King. "I would rather commit thirty mortal sins than be a leper," answered Joinville. "Do you wash the feet of the poor on Holy Thursday?" asked the King. "God forbid!" replied Joinville; "never will I wash the feet of such creatures!" Saint Louis mildly corrected his, or rather Thibaut's seneschal, for these impieties, but he was no doubt used to them, for the soldier was never a churchman. If one asks Joinville what he thinks of the Virgin, he answers with the same frank-

Ung jour moi estant devant le roi lui demanday congie d'aller en pelerinage a nostre Dame de Tourtouze [Tortosa in Syria] qui estoit ung veage tres fort requis. Et y avoit grant quantite de pelerins par chacun jour pour ce que c'est le premier autel qui onques fust fait en l'onneur de la Mere de Dieu ainsi qu'on disoit lors. Et y faisoit nostre Dame de grans miracles a merveilles. Entre lesquelz elle en fist ung d'un pouvre homme qui estoit hors de son sens et demoniacle. Car il avoit le maling esperit dedans le corps. Et advint par ung jour qu'il fut amene a icelui autel de nostre Dame de Tourtouze. Et ainsi que ses amys qui l'avoient la amene prioient a nostre Dame qu'elle lui voulsist recouvrer sante et guerison le diable que la pouvre creature avoit ou corps

respondit:—'Nostre Dame n'est pas ici; elle est en Egipte pour aider au Roi de France et aux Chrestiens qui aujourdhui arrivent en la Terre sainte contre toute paiennie qui sont a cheval.' Et fut mis en escript le jour que le deable profera ces motz et fut apporte au legat qui estoit avecques le roi de France; lequel me dist depuis que a celui jour nous estion arrivez en la terre d'Egipte. Et suis bien certain que la bonne Dame Marie nous y eut bien besoin.

This happened in Syria, after the total failure of the crusade in Egypt. The ordinary man, even if he were a priest or a soldier, needed a miraculous faith to persuade him that Our Lady or any other divine power, had helped the crusades of Saint Louis. Few of the usual fictions on which society rested had ever required such defiance of facts; but, at least for a time, society held firm. The thirteenth century could not afford to admit a doubt. Society had staked its existence, in this world and the next, on the reality and power of the Virgin; it had invested in her care nearly its whole capital, spiritual, artistic, intellectual and economical, even to the bulk of its real and personal estate; and her overthrow would have been the most appalling disaster the western world had ever known. Without her, the Trinity itself could not stand; the Church must fall; the future world must dissolve. Not even the collapse of the Roman Empire compared with a calamity so serious; for that had created, not destroyed, a faith.

If sceptics there were, they kept silence. Men disputed and doubted about the Trinity, but about the Virgin the satirists Rutebeuf and Adam de la Halle wrote in the same spirit as Saint Bernard and Abélard, Adam de Saint-Victor and the pious monk Gaultier de Coincy. In the midst of violent disputes on other points of doctrine, the disputants united in devotion to Mary; and it was the single redeeming quality about them. The monarchs believed almost more implicitly than their subjects, and maintained the belief to the last. Doubtless the death of Queen Blanche marked the flood-tide at its height; but an authority so established as that of the Virgin, founded on instincts so deep, logic so rigorous, and, above all, on wealth so vast, declined slowly. Saint Louis died in 1270. Two hundred long and dismal years followed, in the midst of wars, decline of faith, dissolution of the old ties and interests, until, towards 1470, Louis XI succeeded in restoring some semblance of solidity to the State; and Louis XI divided

his time and his money impartially between the Virgin of Chartres and the Virgin of Paris. In that respect, one can see no difference between him and Saint Louis, nor much between Philippe de Commines and Joinville. After Louis XI. another fantastic century passed, filled with the foulest horrors of history-religious wars; assassinations; Saint Bartholomews; sieges of Chartres; Huguenot Leagues and sweeping destruction of religious monuments; Catholic Leagues and fanatical reprisals on friends and foes,—the actual dissolution of society in a mass of horrors compared with which even the Albigensian crusade was a local accident, all ending in the reign of the last Valois, Henry III, the weirdest, most fascinating, most repulsive, most pathetic and most pitiable of the whole picturesque series of French kings. If you look into the Journal of Pierre de l'Estoile, under date of Jan. 26, 1582, you can read the entry: - "The King and the Queen [Louise de Lorraine], separately, and each accompanied by a good troop [of companions] went on foot from Paris to Chartres on a pilgrimage [voyage] to Notre-Dame-de-dessous-Terre [Our Lady of the Crypt], where a neuvaine was celebrated at the last mass at which the King and Queen assisted, and offered a silver-gilt statue of Notre Dame which weighed a hundred marks [eight hundred ounces], with the object of having lineage which might succeed to the throne." In the dead of winter, in robes of penitents, over the roughest roads, on foot, the King and Queen, then seven years married, walked fifty miles to Chartres to supplicate the Virgin for children, and back again; and this they did year after year until Jacques Clément put an end to it with his dagger, in 1589, although the Virgin never chose to perform that miracle; but, instead, allowed the House of Valois to die out and sat on her throne in patience while the House of Bourbon was anointed in their place. The only French King ever crowned in the presence of Our Lady of Chartres was Henry IV, -a heretic.

The year 1589 which was so decisive for Henry IV in France, marked in England the rise of Shakespeare as a sort of stage-monarch. While in France, the Virgin still held such power that kings and queens asked her for favors, almost as instinctively as they had done five hundred years before, in England Shakespeare set all human nature and all human his-

tory on the stage, with hardly an allusion to the Virgin's name, unless as an oath. The exceptions are worth noting as a matter of curious Shakespearian criticism, for they are but two, and both are lines in the First Part of Henry VI, spoken by the Maid of Orleans:—

Christ's mother helps me, else I were too weak!

Whether the First Part of Henry VI was written by Shakespeare at all has been a doubt much discussed, and too deep for tourists; but that this line was written by a Roman Catholic is the more likely because no such religious thought recurs in all the rest of Shakespeare's works, dramatic or lyric, unless it is implied in Gaunt's allusion to "the world's ransom, blessed Mary's son." Thus, while three hundred years caused in England the disappearance of the great divinity on whom the twelfth and thirteenth centuries had lavished all their hopes, and during these three centuries every earthly throne had been repeatedly shaken or shattered, the Church had been broken in halves, faith had been lost, and philosophies overthrown, the Virgin still remained and remains the most intensely and the most widely and the most personally felt, of all characters, divine or human or imaginary, that ever existed among men. Nothing has even remotely taken her place. The only possible exception is the Buddha, Sakya Muni, but to the western mind, a figure like the Buddha stood much further away than the Virgin. That of the Christ even to Saint Bernard stood not so near as that of his mother. Abélard expressed the fact in its logical necessity even more strongly than Saint Bernard did:-

Te requirunt vota fidelium, Ad te corda suspirant omnium, Tu spes nostra post Deum unica, Advocata nobis es posita. Ad judicis matrem confugiunt, Qui judicis iram effugiunt, Quae praecari pro eis cogitur, Quae pro reis mater efficitur.

"After the Trinity, you are our *only* hope;" spes nostra unica; "you are placed there as our advocate; all of us who fear the wrath of the judge, fly to the judge's mother, who is logically compelled to sue for us, and stands in the place of a mother to the guilty." Abélard's logic was always ruthless, and the

"cogitur" is a stronger word than one would like to use now, with a priest in hearing. We need not insist on it; but what one must insist on, is the good-faith of the whole people,—kings, queens, princes of all sorts, philosophers, poets, soldiers, artists, as well as of the commoners like ourselves, and the poor,—for the good-faith of the priests is not important to the understanding, since any class which is sufficiently interested in believing, will always believe. In order to feel gothic architecture in the twelfth and thirteenth centuries, one must feel first and last, around and above and beneath it, the good-faith of the public, excepting only Jews and atheists, permeating every portion of it with the conviction of an immediate alternative between heaven and hell, with Mary as the only Court in Equity capable of over-ruling strict law.

The Virgin was a real person, whose tastes, wishes, instincts, passions, were intimately known. Enough of the Virgin's literature survives to show her character, and the course of her daily life. We know more about her habits and thoughts than about those of earthly queens. The Miracles de la Vierge make a large part, and not the poorest part, of the enormous literature of these two centuries, although the works of Albertus Magnus fill twenty-one folio volumes and those of Thomas Aquinas fill more, while the Chansons de Geste and the Romans, published or unpublished, are a special branch of literature with libraries to themselves. The collection of the Virgin's miracles put in verse by Gaultier de Coincy, monk, prior and poet, between 1214 and 1233,—the precise moment of the Chartres sculpture and glass,—contains thirty thousand lines. Another great collection, narrating especially the miracles of the Virgin of Chartres, was made by a priest of Chartres Cathedral about 1240. Separate series, or single tales, have appeared and are appearing constantly, but no general collection has ever been made, although the whole poetic literature of the Virgin could be printed in the space of two or three volumes of scholastic philosophy, and if the Church had cared half as truly for the Virgin as it has for Thomas Aquinas, every miracle might have been collected and published a score of times. The miracles themselves, indeed, are not very numerous. In Gaultier de Coincy's collection they number only about fifty. The Chartres collection

relates chiefly to the horrible outbreak of what was called leprosy—the *mal ardent*,—which ravaged the north of France during the crusades, and added intensity to the feelings which brought all society to the Virgin's feet. Recent scholars are cataloguing and classifying the miracles, as far as they survive, and have reduced the number within very moderate limits. As poetry Gaultier de Coincy's are the best.

Of Gaultier de Coincy and his poetry, Gaston Paris has

something to say which is worth quoting:-

It is the most curious, and often the most singular monument of the infantile piety of the middle-ages. Devotion to Mary is presented in it as a kind of infallible guarantee not only against every sort of evil, but also against the most legitimate consequences of sin and even of crime. In these stories which have revolted the most rational piety, as well as the philosophy of modern times, one must still admit a gentle and penetrating charm; a naïveté; a tenderness and a simplicity of heart, which touch, while they raise a smile. There, for instance, one sees a sick monk cured by the milk that Our Lady herself comes to invite him to draw from her 'douce mamelle'; a robber who is in the habit of recommending himself to the Virgin whenever he is going to 'embler,' is held up by her white hands for three days on the gibbet where he is hung, until the miracle becomes evident, and procures his pardon; an ignorant monk who knows only his Ave Maria, and is despised on that account, when dead reveals his sanctity by five roses which come out of his mouth in honor of the five letters of the name Maria; a nun who has quitted her convent to lead a life of sin, returns after long years, and finds that the Holy Virgin, to whom, in spite of all, she has never ceased to offer every day her prayer, has, during all this time, filled her place as sacristine, so that no one has perceived her absence.

Gaston Paris inclined to apologize to his "bons bourgeois de Paris" for reintroducing to them a character so doubtful as the Virgin Mary, but, for our studies, the professor's elementary morality is eloquent. Clearly, M. Paris, the highest academic authority in the world, thought that the Virgin could hardly, in his time, say the year 1900, be received into good society in the Latin Quarter. Our own English ancestors, known as Puritans, held the same opinion, and excluded her from their society some four hundred years earlier, for the same reasons which affected M. Gaston Paris. These reasons were just, and showed the respectability of the citizens who held them. In no well-regulated community, under a proper system of police, could the Virgin feel at home, and the same

thing may be said of most other saints as well as sinners. Her conduct was at times undignified, as M. Paris complained. She condescended to do domestic service, in order to help her friends, and she would use her needle, if she were in the mood, for the same object. The Golden Legend relates that:—

A certain priest, who celebrated every day a mass in honor of the Holy Virgin, was brought up before Saint Thomas of Canterbury who suspended him from his charge, judging him to be short-witted and irresponsible. Now Saint Thomas had occasion to mend his hair-cloth shirt, and while waiting for an opportunity to do so, had hidden it under his bed; so the Virgin appeared to the priest and said to him:—'Go find the archbishop and tell him that she, for love of whom you celebrated masses, has herself mended his shirt for him which is under his bed; and tell him that she sends you to him that he may take off the interdict he has imposed on you.' And Saint Thomas found that his shirt had in fact been mended. He relieved the priest, begging him to keep the secret of his wearing a hair-shirt.

Mary did some exceedingly unconventional things, and among them the darning Thomas A'Becket's hair-shirt, and the supporting a robber on the gibbet, were not the most singular, yet they seem not to have shocked Queen Blanche or Saint Francis or Saint Thomas Aguinas so much as they shocked M. Gaston Paris and M. Prudhomme. You have still to visit the Cathedral at Le Mans for the sake of its twelfthcentury glass, and there, in the lower panel of the beautiful, and very early, window of Saint Protais, you will see the fulllength figure of a man, lying in bed, under a handsome blanket, watching, with staring eyes, the Virgin, in a green tunic, wearing her royal crown, who is striking him on the head with a heavy hammer and with both hands. The miracle belongs to local history, and is amusing only to show how little the Virgin cared for criticism of her manners or acts. She was above criticism. She made manners. Her acts were laws. No one thought of criticising, in the style of a normal school, the will of such a Queen; but one might treat her with a degree of familiarity, under great provocation, which would startle easier critics than the French. Here is an instance:-

A widow had an only child whom she tenderly loved. On hearing that this son had been taken by the enemy chained, and put in prison, she burst into

tears, and addressing herself to the Virgin, to whom she was especially devoted, she asked her with obstinacy for the release of her son; but when she saw at last that her prayers remained unanswered, she went to the church where there was a sculptured image of Mary, and there, before the image, she said: - 'Holy Virgin, I have begged you to deliver my son, and you have not been willing to help an unhappy mother! I've implored your patronage for my son, and you have refused it! Very good! just as my son has been taken away from me, so I am going to take away yours, and keep him as a hostage!' Saving this, she approached, took the statue of the child on the Virgin's breast, carried it home, wrapped it in spotless linen, and locked it up in a box, happy to have such a hostage for her son's return. Now, the following night, the Virgin appeared to the young man, opened his prison doors, and said: - 'Tell your mother, my child, to return me my son now that I have returned hers!' The young man came home to his mother and told her of his miraculous deliverance; and she, overjoyed, hastened to go with the little Iesus to the Virgin, saying to her: - I thank you, heavenly lady, for restoring me my child, and in return I restore yours?'

For the exactness of this story in all its details, Bishop James of Voragio could not have vouched, nor did it greatly matter. What he could vouch for was the relation of intimacy and confidence between his people and the Queen of Heaven. The fact, conspicuous above all other historical certainties about religion, that the Virgin was by essence illogical, unreasonable and feminine, is the only fact of any ultimate value worth studying, and starts a number of questions that history has shown itself clearly afraid to touch. Protestant and Catholic differ little in that respect. No one has ventured to explain why the Virgin wielded exclusive power over poor and rich, sinners and saints, alike. Why were all the Protestant churches cold failures without her help? Why could not the Holy Ghost,—the spirit of Love and Grace,—equally answer their prayers? Why was the Son powerless? Why was Chartres Cathedral in the thirteenth century-like Lourdes todaythe expression of what is in substance a separate religion? Why did the gentle and gracious Virgin Mother so exasperate the Pilgrim Father? Why was the Woman struck out of the Church and ignored in the State? These questions are not antiquarian or trifling in historical value; they tug at the very heart-strings of all that makes whatever order is in the cosmos. If a Unity exists, in which and towards which all energies centre, it must explain and include Duality, Diversity, Infinity,—Sex!

Although certain to be contradicted by every pious churchman, a heretic must insist on thinking that the Mater Dolorosa was the logical Virgin of the Church, and that the Trinity would never have raised her from the foot of the Cross, had not the Virgin of Majesty been imposed by necessity and public unanimity, on a creed which was meant to be complete without her. The true feeling of the Church was best expressed by the Virgin herself in one of her attested miracles: - "A clerk, trusting more in the Mother than in the Son, never stopped repeating the angelic salutation for his only prayer. Once as he said again the Ave Maria, the Lord appeared to him, and said to him: - 'My Mother thanks you much for all the Salutations that you make her; but still you should not forget to salute me also. [Tamen et me salutare memento.]'" The Trinity feared absorption in her, but was compelled to accept, and even to invite her aid, because the Trinity was a Court of strict Law, and, as in the old Customary Law, no process of Equity could be introduced except by direct appeal to a higher power. She was imposed unanimously by all classes, because what man wanted most in the middle-ages was not merely law or equity but also and particularly favor. Strict justice, either on earth or in heaven, was the last thing that society cared to face. All men were sinners, and had, at least, the merit of feeling that, if they got their deserts, not one would escape worse than whipping. The instinct of individuality went down through all classes, from the Count at the top, to the jugleors and menestreus at the bottom. The individual rebelled against restraint; society wanted to do what it pleased; all disliked the laws which Church and State were trying to fasten on them. They longed for a power above law, -or above the contorted mass of ignorance and absurdity bearing the name of law, -but the power which they longed for was not human, for humanity they knew to be corrupt and incompetent from the day of Adam's creation to the day of the Last Judgment. They were all criminals; if not, they would have had no use for the Church and very little for the State; but they had at least the merit of their

faults; they knew what they were, and, like children, they yearned for protection, pardon and love. This was what the Trinity, though omnipotent, could not give. Whatever the heretic or mystic might try to persuade himself, God could not be Love. God was Justice, Order, Unity, Perfection; he could not be human and imperfect, nor could the Son or the Holy Ghost be other than the Father. The Mother alone was human, imperfect, and could love; she alone was Favor, Duality, Diversity. Under any conceivable form of religion, this duality must find embodiment somewhere, and the middle ages logically insisted that, as it could not be in the Trinity, either separately or together, it must be in the Mother. If the Trinity was in its essence Unity, the Mother alone could represent whatever was not Unity; whatever was irregular, exceptional, outlawed; and this was the whole human race. The saints alone were safe, after they were sainted. Everyone else was criminal, and men differed so little in degree of sin that, in Mary's eyes, all were subjects for her pity and help.

This general rule of favor, apart from law, or the reverse of law, was the mark of Mary's activity in human affairs. Take, for an example, an entire class of her miracles, applying to the discipline of the Church! A bishop ejected an ignorant and corrupt priest from his living, as all bishops constantly had to do. The priest had taken the precaution to make himself Mary's man; he had devoted himself to her service and her worship. Mary instantly interfered—just as Queen Eleanor or Queen Blanche would have done,—most unreasonably, and never was a poor bishop more roughly scolded by an orthodox queen! "Moult airieement," very airily or angrily, she said

to him (Bartsch, 1887, p. 363):-

Ce saches tu certainement Se tu li matinet bien main Ne rapeles mon chapelain A son servise et a s'enor, L'ame de toi a desenor Ains trente jors departira Et es dolors d'infer ira.

Now know you this for sure and true, Unless tomorrow this you do, —And do it very early too,— Restore my chaplain to his due, A much worse fate remains for you! Within a month your soul shall go To suffer in the flames below.

The story-teller,—himself a priest and Prior,—caught the lofty trick of manner which belonged to the great ladies of

the Court, and was inherited by them, even in England, down to the time of Queen Elizabeth, who treated her bishops also like domestic servants;—"matinet bien main!" To the public, as to us, the justice of the rebuke was nothing to the point; but that a friend should exist on earth or in heaven, who dared to browbeat a bishop, caused the keenest personal delight. The legends are clearer on this point than on any other. The people loved Mary because she trampled on conventions; not merely because she could do it, but because she liked to do what shocked every well-regulated authority. Her pity had no limit.

One of the Chartres miracles expresses the same motive in language almost plainer still. A good-for-nothing clerk, vicious, proud, vain, rude, and altogether worthless, but devoted to the Virgin, died, and with general approval his body was thrown into a ditch (*Ibid.*, 369):—

Mais cele ou sort tote pities Tote douceurs tote amisties Et qui les siens onques n'oublie Son pecheor n'oblia mie.

"Her sinner!" Mary would not have been a true Queen unless she had protected her own. The whole morality of the middle ages stood in the obligation of every master to protect his dependent. The herdsmen of Count Garin of Beaucaire were the superiors of their damoiseau Aucassins, while they felt sure of the Count. Mary was the highest of all the feudal ladies, and was the example for all in loyalty to her own, when she had to humiliate her own bishop of Chartres for the sake of a worthless brute. "Do you suppose it doesn't annoy me," she said, "to see my friend buried in a common ditch? Take him out at once! I command! tell the clergy it is my order, and that I will never forgive them unless tomorrow morning without delay, they bury my friend in the best place in the cemetery!":—

Cuidies vos donc qu'il ne m'enuit Quant vos l'aves si adosse Que mis l'aves en un fosse? Metes l'en fors je le comant! Di le clergie que je li mant! Ne me puet mi repaier Se le matin sans delayer A grant heneur n'est mis amis Ou plus beau leu de l'aitre mis.

Naturally, her order was instantly obeyed. In the feudal régime, disobedience to an order was treason, - or even hesitation to obey, -when the order was serious; very much as in a modern army, disobedience is not regarded as conceivable. Mary's wish was absolute law, on earth as in heaven. For her, other laws were not made. Intensely human, but always Queen, she upset, at her pleasure, the decisions of every court and the orders of every authority, human or divine; interfered directly in the ordeal; altered the processes of nature; abolished space; annihilated time. Like other Queens, she had many of the failings and prejudices of her humanity. In spite of her own origin, she disliked Jews, and rarely neglected a chance to maltreat them. She was not in the least a prude. To her, sin was simply humanity, and she seemed often on the point of defending her arbitrary acts of mercy, by frankly telling the Trinity that if the Creator meant to punish man, He should not have made him. The people, who always in their hearts protested against bearing the responsibility for the Creator's arbitrary creations, delighted to see her upset the law, and reverse the rulings of the Trinity. They idolised her for being strong, physically and in will, so that she feared nothing, and was as helpful to the knight in the mélée of battle as to the young mother in child-bed. The only character in which they seemed slow to recognize Mary was that of bourgeoise. The bourgeoisie courted her favor at great expense, but she seemed to be at home on the farm, rather than in the shop. She had very rudimentary knowledge indeed of the principles of political economy as we understand them, and her views on the subject of money-lending or banking were so feminine as to rouse in that powerful class a vindictive enmity which helped to overthrow her throne. On the other hand she showed a marked weakness for chivalry, and one of her prettiest, and most twelfth-century miracles, is that of the knight who heard mass while Mary took his place in the lists. It is much too charming to lose (Bartsch, 1895, p. 311):-

Un chevalier courtois et sages, Hardis et de grant vasselages, Nus mieudres en chevalerie, Moult amoit la vierge Marie. Pour son barnage demener Et son franc cors d'armes pener, Aloit a son tournoiement Garnis de son contentement. Au dieu plaisir ainsi avint Que quant le jour du tournoi vint Il se hastoit de chevauchier, Bien vousist estre en champ premier. D'une eglise qui pres estoit Oi les sains que l'on sonnoit Pour la sainte nuesse chanter. Le chevalier sans arrester S'en est ale droit a l'eglise Pour escouter le dieu servise. L'en chantoit tantost hautement Une messe devotement De la sainte Vierge Marie; Puis a on autre comencie. Le chevalier bien l'escouta, De bon cuer la dame pria, Et quant la messe fut fince La tierce fu recomenciee Tantost en ce meisme lieu. 'Sire, pour la sainte char dieu!' Ce li a dit son escuier, 'L'heure passe de tournoier, 'Et vous que demourez ici? Venez vous en, je vous en pri! Volez vous devenir hermite 'Ou papelart ou ypocrite? 'Alons en a nostre mestier!'

A knight both courteous and wise And brave and bold in enterprise. No better knight was ever seen, Greatly loved the Virgin Queen. Once, to contest the tourney's prize And keep his strength in exercise, He rode out to the listed field Armed at all points with lance and shield; But it pleased God that when the day Of tourney came, and on his way He pressed his charger's speed apace To reach, before his friends, the place, He saw a church hard by the road And heard the church-bells sounding loud To celebrate the holy mass. Without a thought the church to pass The knight drew rein, and entered there To seek the aid of God in prayer. High and clear they chanted then A solemn mass to Mary Queen;

Then afresh began again.
Lost in his prayers the good knight stayed;
With all his heart to Mary prayed;
And, when the second one was done,
Straightway the third mass was begun,
Right there upon the self-same place.
'Sire, for mercy of God's grace!'
Whispered his squire in his ear;
'The hour of tournament is near;
'Why do you want to linger here?
'Is it a hermit to become,
'Or hypocrite, or priest of Rome?
'Come on, at once! despatch your prayer!
'Let us be off to our affair!'

The accent of truth still lingers in this remonstrance of the squire, who must, from all time, have lost his temper on finding his chevalier addicted to "papelardie" when he should have been fighting; but the priest had the advantage of telling the story and pointing the moral. This advantage the priest neglected rarely, but in this case he used it with such refinement, and so much literary skill, that even the squire might have been patient. With the invariable gentle courtesy of the true knight, the chevalier replied only by soft words:—

'Amis!' ce dist li chevalier,
'Cil tournoie moult noblement
'Qui le servise dieu entent.'

In one of Milton's sonnets is a famous line which is commonly classed among the noblest verses of the English language:—

"They also serve, who only stand and wait."

Fine as it is, with the simplicity of the grand style, like the Chanson de Roland, the verse of Milton does not quite destroy the charm of thirteenth-century diction:—

'Friend!' said to him the chevalier,
'He tourneys very nobly too,
'Who only hears God's service through!'

No doubt the verses lack the singular power of the eleventh century; it is not worth while to pretend that any verse written in the thirteenth century wholly holds its own against Roland:—

'Sire cumpain! faites le vus de gred?
'Ja est ço Rollanz ki tant vos soelt amer!'

The courtesy of Roland has the serious solidity of the romanesque arch, and that of Lancelot and Aucassins has the grace of a legendary window; but one may love it, all the same; and one may even love the knight,—papelard though he were, as he turned back to the altar and remained in prayer until the last mass was ended.

Then they mounted and rode on towards the field, and of course you foresee what had happened. In itself the story is bald enough, but it is told with such skill that one never tires of it. As the chevalier and the squire approached the lists, they met the other knights returning, for the jousts were over; but, to the astonishment of the chevalier, he was greeted by all who passed him with shouts of applause for his marvellous triumph in the lists, where he had taken all the prizes and all the prisoners:—

Les chevaliers ont encontrez, Qui du tournois sont retournez, Qui du tout en tout est feru.

His friends, returning from the fight, On the way there met the knight, For the jousts were wholly run, S'en avoit tout le pris eu Le chevalier qui reperoit Des messes qu' oies avoit. Les autres qui s'en reperoient Le saluent et le conjoient Et distrent bien que onques mes Nul chevalier ne prist tel fes D'armes com il ot fet ce jour; A tousjours en avroit l'onnour. Moult en i ot qui se rendoient A lui prisonier, et disoient Nous somes vostre prisonier, 'Ne nous ne pourrions nier, 'Ne nous aiez par armes pris.' Lors ne fu plus cil esbahis, Car il a entendu tantost Que cele fu pour lui en l'ost Pour qui il fu en la chapelle.

And all the prizes had been won By the knight who had not stirred From the masses he had heard. All the knights, as they came by, Saluted him and gave him joy, And frankly said that never yet Had any knight performed such feat, Nor ever honor won so great As he had done in arms that day; While many of them stopped to say That they all his prisoners were: 'In truth, your prisoners we are: 'We cannot but admit it true: 'Taken we were in arms by you!' Then the truth dawned on him there, And all at once he saw the light, That She, by whom he stood in prayer -The Virgin, -stood by him in fight!

The moral of the tale belongs to the best feudal times. The knight at once recognized that he had become the liege-man of the Queen, and henceforth must render his service entirely to her. So he called his "barons," or tenants, together, and after telling them what had happened, took leave of them and the 'siècle':—

'Moult est ciest tournoiement biaux
'Ou ele a pour moi tournoie;
'Mes trop l'avroit mal emploie
'Se pour lui je ne tournoioie!
'Fox seroie se retournoie
'A la mondaine vanite.
'A dieu promet en verite
'Que james ne tournoierai
'Fors devant le juge verai
'Qui conoit le bon chevalier
'Et selonc le fet set jutgier.'

Lors prent congie piteusement, Et maint en plorent tenrement. D'euls se part, en une abaie Servi puis la vierge Marie. 'Glorious has the tourney been
'Where for me has fought the Queen;
'But a disgrace for me it were
'If I tourneyed not for her.
'Traitor to her should I be,
'Returned to worldly vanity.
'I promise truly, by God's grace,
'Never again the lists to see,
'Except before that Judge's face,
'Who knows the true knight from the base,
'And gives to each his final place.'

Then piteously he takes his leave While in tears his barons grieve. So he parts, and in an Abbey Serves henceforth the Virgin Mary.

Observe that in this case Mary exacted no service! Usually the legends are told, as in this instance, by priests, though they were told in the same spirit by laymen, as you can see in the poems of Rutebeuf, and they would not have been told

very differently by soldiers, if one may judge from Joinville; but commonly the Virgin herself prescribed the kind of service she wished. Especially to the young knight who had, of his own accord, chosen her for his liege, she showed herself as exacting as other great ladies showed themselves towards their Lancelots and Tristans. When she chose, she could even indulge in more or less coquetry, else she could never have appealed to the sympathies of the thirteenth-century knighterrant. One of her miracles told how she disciplined the young men who were too much in the habit of assuming her service in order to obtain selfish objects. A youthful chevalier, much given to tournaments and the other worldly diversions of the siècle, fell in love, after the rigorous obligation of his class, as you know from your Dulcinea del Toboso, with a lady who, as was also prescribed by the rules of courteous love, declined to listen to him. An Abbot of his acquaintance, sympathising with his distress, suggested to him the happy idea of appealing for help to the Queen of Heaven. He followed the advice, and for an entire year shut himself up, and prayed to Mary, in her chapel, that she would soften the heart of his beloved, and bring her to listen to his prayer. At the end of the twelve-month, fixed as a natural and sufficient proof of his earnestness in devotion, he felt himself entitled to indulge again in innocent worldly pleasures, and on the first morning after his release, he started out on horseback for a day's hunting. Probably thousands of young knights and squires were always doing more or less the same thing, and it was quite usual that, as they rode through the fields or forests, they should happen on a solitary chapel or shrine, as this knight did, and should stop long enough to kneel in it and renew his prayer to the Queen:-

La mere dieu qui maint chetif A retrait de chetivete Par sa grant debonnairte Par sa courtoise courtoisie Au las qui tant l'apele et prie Ignelement s'est demonstree, D'une coronne corronnee Plaine de pierres precieuses Si flamboianz si precieuses Pour pou li euil ne li esluisent. God's Mother who to many a wretch Has brought relief from wretchedness. By her infinite goodness, By her courteous courteousness, To her suppliant in distress Came from heaven quickly down; On her head she bore the crown, Full of precious stones and gems Darting splendor, flashing flames, Till the eye near lost its sight

Si netement ainsi reluisent Et resplendissent com la raie Qui en este au matin raie. Tant par a bel et cler le vis Que buer fu mez, ce li est vis, Qui s'i puest assez mirer. 'Cele qui te fait soupirer 'Et en si grant erreur t'a mis' Fait nostre dame, 'biau douz amis, 'Est ele plus bele que moi?' Li chevaliers a tel effroi De la clarte, ne sai que face: Ses mains giete devant sa face; Tel hide a et tel freeur Chaoir se laisse de freeur: Mais cele en qui pitie est toute Li dist: 'Amis, or n'aies doute! Je suis cele, n'en doute mie. 'Qui te doi faire avoir t'amie. 'Or prens garde que tu feras. 'Cele que tu miex ameras 'De nous ii auras a amie.'

In the keenness of the light, As the summer-morning's sun Blinds the eyes it shines upon. So beautiful and bright her face, Only to look on her is grace.

'She who has caused you thus to sigh, 'And has brought you to this end,' Said our Lady, - 'Tell me, friend, 'Is she handsomer than I?' Scared by her brilliancy, the knight Knows not what to do for fright; He clasps his hands before his face, And in his shame and his disgrace Falls prostrate on the ground with fear: But she with pity ever near Tells him: - 'Friend, be not afraid! 'Doubt not that I am she whose aid 'Shall surely bring your love to you: 'But take good care what you shall do! 'She you shall love most faithfully 'Of us two, shall your mistress be.'

One is at a loss to imagine what a young gentleman could do, in such a situation, except to obey, with the fewest words possible, the suggestion so gracefully intended. Queen's favors might be fatal gifts, but they were much more fatal to reject than to accept. Whatever might be the preferences of the knight, he had invited his own fate, and in consequence was fortunate to be allowed the option of dying and going to Heaven, or dying without going to Heaven. Mary was not always so gentle with young men who deserted or neglected her for an earthly rival; -the offence which irritated her most, and occasionally caused her to use language which hardly bears translation into modern English. Without meaning to assert that the Queen of Heaven was jealous as Queen Blanche herself, one must still admit that she was very severe on lovers who showed willingness to leave her service, and take service with any other lady. One of her admirers, educated for the priesthood but not yet in full orders, was obliged by reasons of family interest to quit his career in order to marry. An insult like this was more than Mary could endure, and she gave the young man a lesson he never forgot: -

Ireement li prent a dire La mere au roi de paradis: 'Di moi, di moi, tu que jadis 'M'amoies tant de tout ton coeur 'Pourquoi m'as tu jete puer! 'Di moi, di moi, ou est donc cele 'Qui plus de moi bone est et bele! . 'Pourquoi, pourquoi, las durfeus, 'Las engignez, las deceuz, 'Me lais pour une lasse fame, 'Qui suis du ciel Royne et Dame? 'Enne fais tu trop mauvais change 'Qui tu por une fame estrange 'Me laisses qui par amors t'amoie 'Et ja ou ciel t'apareilloie 'En mes chambres un riche lit 'Por couchier t'ame a grand delit? 'Trop par as faites grant merveilles 'S'autrement tost ne te conseilles 'Ou ciel serra tes lits deffais 'Et en la flamme d'enfer faiz!'

With anger flashing in her eyes Answers the Queen of Paradise: 'Tell me, tell me! you of old 'Loved me once with love untold; 'Why now throw me aside! 'Tell me, tell me! where a bride 'Kinder or fairer have you won! . . . 'Wherefore, wherefore, wretched one, 'Deceived, betrayed, misled, undone, 'Leave me for a creature mean, 'Me, who am of Heaven the Queen! 'Can you make a worse exchange, 'You that for a woman strange, 'Leave me who, with perfect love, 'Waiting you in heaven above, 'Had in my chamber richly dressed 'A bed of bliss your soul to rest? 'Terrible is your mistake! 'Unless you better council take, 'In Heaven your bed shall be unmade, 'And in the flames of Hell be spread.'

A mistress who loved in this manner was not to be gain-said. No earthly love had a chance of holding its own against this unfair combination of heaven and hell, and Mary was as unscrupulous as any other great lady in abusing all her advantages in order to save her souls. Frenchmen never found fault with abuses of power for what they thought a serious object. The more tyrannical Mary was, the more her adorers adored, and they wholly approved, both in love and in law, the rule that any man who changed his allegiance without permission, did so at his own peril. His life and property were forfeit. Mary showed him too much grace in giving him an option.

Even in anger Mary always remained a great lady, and in the ordinary relations of society her manners were exquisite, as they were, according to Joinville, in the court of Saint Louis, when tempers were not overwrought. The very brutality of the brutal compelled the courteous to exaggerate courtesy, and some of the royal family were as coarse as the king was delicate in manners. In heaven the manners were perfect, and almost as stately as those of Roland and Oliver. On one occasion Saint Peter found himself embarrassed by an affair which the public opinion of the Court of Heaven, although not by any means puritanic, thought more objectionable,—in fact, more frankly discreditable,—than an honest corrupt job

ought to be; and even his influence, though certainly considerable, wholly failed to carry it through the law-court. The case, as reported by Gaultier de Coincy, was this: - A very worthless creature of Saint Peter's, -a monk of Cologne, who had led a scandalous life, and "ne cremoit dieu, ordre ne roule," died, and in due course of law was tried, convicted, and dragged off by the devils to undergo his term of punishment. Saint Peter could not desert his sinner, though much ashamed of him, and accordingly made formal application to the Trinity for a pardon. The Trinity, somewhat severely, refused. Finding his own interest insufficient, Saint Peter tried to strengthen it by asking the Archangels to help him; but the case was too much for them also, and they declined. The brother Apostles were appealed to with the same result; and finally even the Saints, though they had so obvious interest in keeping friendly relations with Peter, found public opinion too strong to defy. The case was desperate. The Trinity were-or was-emphatic, and,-what was rare in the middle ages, - every member of the feudal hierarchy sustained its decision. Nothing more could be done in the regular way. Saint Peter was obliged to divest himself of authority, and place himself and his dignity in the hands of the Virgin. Accordingly he asked for an audience, and stated the case to Our Lady. With the utmost grace, she instantly responded: -

Pierre, Pierre,' dit Nostre Dame,
'En moult grand poine et por ceste ame
'De mon douz filz me fierai
'Tant que pour toi l'en prierai.'
La Mere Dieu lors s'est levee,
Devant son filz s'en est alee
Et ses virges toutes apres.
De lui si tint Pierre pres,
Quar sanz doutance bien savoit
Que sa besoigne faite avoit
Puisque cele l'avoit en prise
Ou forme humaine avoit prise.

Quant sa Mere vit li douz Sire Qui de son doit daigna escrire Qu'en honourant et pere et mere En contre lui a chere clere Se leva moult festivement Et si li dist moult doucement; Pierre, Pierre,' our Lady said,
'With all my heart Pll give you aid,
'And to my gentle son Pll sue
'Until I beg that soul for you.'
God's Mother then arose straight-way,
And sought her Son without delay;
All her virgins followed her,
And Saint Peter kept him near,
For he knew his task was done
And his prize already won,
Since it was hers, in whom began
The life of God in form of Man.

When our dear Lord, who deigned to write With his own hand that in his sight Those in his kingdom held most dear Father and mother honored here,—When he saw his mother's face He rose and said with gentle grace:

'Bien veigniez vous, ma douce mere,'
Comme douz filz, comme douz pere.
Doucement l'a par la main prise
Et doucement lez lui assise;
Lors li a dit:—'A douce chiere,
'Que veus ma douce mere chiere,
'Mes amies et mes sereurs?'

'Well are you come, my heart's desire!'
Like loving son, like gracious sire;
Took her hand gently in his own;
Gently placed her on his throne,
Wishing her graciously good cheer:—
'What brings my gentle mother here,
'My sister, and my dearest friend!'

One can see Queen Blanche going to beg—or command—a favor of her son, King Louis, and the stately dignity of their address; while Saint Peter and the Virgins remain in the antechamber; but, as for Saint Peter's lost soul, the request was a mere form, and the doors of Paradise were instantly opened to it, after such brief formalities as should tend to preserve the technical record of the law-court.

We tread here on very delicate ground. Gaultier de Coincy, being a priest and a Prior, could take liberties which we cannot, or ought not to take. The doctrines of the Church are too serious and too ancient to be wilfully misstated, and the doctrines of what is called Mariolatry were never even doctrines of the Church. Yet it is true that, in the hearts of Mary's servants, the Church and its doctrines were at the mercy of Mary's will. Gaultier de Coincy claimed that Mary exasperated the devils by exercising a wholly arbitrary and illegitimate power. Gaultier not merely admitted, but frankly asserted, that this was the fact:—

Font li deables: —'de cest plait,
'Mal por mal, assez miex nous plest
'Que nous aillons au jugement
'Li haut jugeur qui ne ment.
'C'au plait n'au jugement sa mere
'De droit jugier est trop avere;
'Mais dieu nous juge si adroit,
'Plainement nous lest notre droit.
'Sa mere juge en tel maniere
'Qu'elle nous met touz jors arriere
'Quant nous cuidons estre devant

'In this law-suit,' say the devils,
'Since it is a choice of evils,
'We had best appeal on high
'To the judge who does not lie.
'What is law to any other,
''Tis no use pleading with his mother;
'But God judges us so true
'That he leaves us all our due.
'His mother judges us so short
'That she throws us out of court
'When we ought to win our cause.

'En ciel et en terre est plus Dame 'Par un petit que Diex ne soit. 'Il l'aimme tant et tant la croit, 'N'est riens qu'elle face ne die 'Qu'il desveile ne contredie. 'Quant qu'elle veut li fait acroire, 'In heaven and earth she makes more laws
'By far, than God himself can do,
'He loves her so, and trusts her so,
'There's nothing she can do or say
'That he'll refuse, or say her nay.
'Whatever she may want is right,

'S'elle disoit la pie est noire
'Et l'eue trouble est toute clere:
'Si diroit il voir dit ma mere!'

'Though she say that black is white, 'And dirty water clear as snow:—
'My Mother says it, and it's so!'

If the Virgin took the feelings of the Trinity into consideration, or recognized its existence except as her Son, the case has not been reported, or, at all events, has been somewhat carefully kept out of sight by the Virgin's poets. The devils were emphatic in denouncing Mary for absorbing the whole Trinity. In one sharply disputed case in regard to a villain, or laborer, whose soul the Virgin claimed because he had learned the "Ave Maria," the devils became very angry indeed, and protested vehemently:—

Li lait maufe, li rechinie
Adonc ont ris et eschinie.
C'en font il: — 'Merveillans merveille!
'Por ce vilain plate oreille
'Aprent vo Dame a saluer,
'Se nous vorro trestous tuer
'Se regarder osons vers s'ame.
'De tout le monde vieut estre Dame!
'Ains nule dame ne fu tiez.
'Il est avis qu'ele soit Diex
'Ou qu'ele ait Diex en main bornie.

'Nul besoigne n'est fournie, 'Ne terrienne ne celestre.

'Que toute Dame ne veille estre.
'Il est avis que tout soit suen;
'Dieu ne deable n'i ont rien.'

The ugly demons laugh outright And grind their teeth with envious spite; Crying: - 'Marvel marvelous! Because that flat-eared ploughman there Learned to make your Dame a prayer, 'She would like to kill us all Just for looking towards his soul. 'All the world she wants to rule! 'No such Dame was ever seen! 'She thinks that she is God, I ween, 'Or holds him in her hollow hand. 'Not a judgment or command 'Or an order can be given 'Here on earth or there in heaven. 'That she does not want control. 'She thinks that she ordains the whole, 'And keeps it all for her own profit. 'God nor Devil share not of it.'

As regards Mary of Chartres, these charges seem to have been literally true, except so far as concerned the "laid maufé" Pierre de Dreux. Gaultier de Coincy saw no impropriety in accepting as sufficiently exact, the allegations of the devils against the Virgin's abuse of power. Down to the death of Queen Blanche, which is all that concerns us, the public saw no more impropriety in it than Gaultier did. The ugly, envious devils, notorious as students of the Latin Quarter, were perpetually making the same charges against Queen Blanche and her son, without disturbing her authority. No one could conceive that the Virgin held less influence in heaven than the

queen mother on earth. Nevertheless there were points in the royal policy and conduct of Mary which thoughtful men even then hesitated to approve. The Church itself never liked to be dragged too far under feminine influence, although the moment it discarded feminine influence it lost nearly everything of any value to it or to the world, except its philosophy. Mary's tastes were too popular; some of the uglier devils said they were too low; many ladies and gentlemen of the "siècle" thought them disreputable, though they dared not say so, or dared say so only by proxy, as in Aucassins. As usual, one must go to the devils for the exact truth, and in spite of their outcry, the devils admitted that they had no reason to complain of Mary's administration:—

Les beles dames de grant pris 'Qui traynant vont ver et gris, 'Roys, roynes, dus et contesses, 'En enfer vienent a granz presses; 'Mais ou ciel vont pres tout a fait 'Tort et boçu et contrefait.

'Ou ciel va toute la ringaille; 'Le grain avons et diex la paille.' 'All the great dames and ladies fair
'Who costly robes and ermine wear,
'Kings, queens and countesses and lords
'Come down to hell in endless hordes;
'While up to heaven go the lamed,
'The dwarfs, the humpbacks and the maimed;
'To heaven goes the whole riff-raff;

'We get the grain and God the chaff.'

True it was, although one should not say it jestingly, that the Virgin embarrassed the Trinity; and perhaps this was the reason, behind all the other excellent reasons, why men loved and adored her with a passion such as no other deity has ever inspired: and why we, although utter strangers to her, are not far from getting down on our knees and praying to her still. Mary concentrated in herself the whole rebellion of man against fate; the whole protest against divine law; the whole contempt for human law as its outcome; the whole unutterable fury of human nature beating itself against the walls of its prisonhouse, and suddenly seized by a hope that in the Virgin man had found a door of escape. She was above law; she took feminine pleasure in turning Hell into an ornament; she delighted in trampling on every social distinction in this world and the next. She knew that the universe was as unintelligible to her, on any theory of morals, as it was to her worshippers, and she felt, like them, no sure conviction that it was any more intelligible to the Creator of it. To her, every

suppliant was a universe in itself, to be judged apart, on his own merits, by his love for her,—by no means on his orthodoxy, or his conventional standing in the Church, or according to his correctness in defining the nature of the Trinity. The convulsive hold which Mary to this day maintains over human imagination,—as you can see at Lourdes,—was due much less to her power of saving soul or body than to her sympathy with people who suffered under law,—divine or human,—justly or unjustly, by accident or design, by decree of God or by guile of Devil. She cared not a straw for conventional morality, and she had no notion of letting her friends be punished, to the tenth or any other generation, for the sins of their ancestors or the peccadillos of Eve.

So Mary filled heaven with a sort of persons little to the taste of any respectable middle-class society, which has trouble enough in making this world decent and pay its bills, without having to continue the effort in another. Mary stood in a Church of her own, so independent that the Trinity might have perished without much affecting her position; but, on the other hand, the Trinity could look on and see her dethroned with almost a breath of relief. Aucassins and the devils of Gaultier de Coincy foresaw her danger. Mary's treatment of respectable and law-abiding people who had no favors to ask, and were reasonably confident of getting to heaven by the regular judgment, without expense, rankled so deeply that three hundred years later the puritan reformers were not satisfied with abolishing her, but sought to abolish the woman altogether as the cause of all evil in heaven and on earth. The puritans abandoned the New Testament and the Virgin in order to go back to the beginning, and renew the quarrel with Eve. This is the Church's affair, not ours, and the women are competent to settle it with Church or State, without help from outside; but honest tourists are seriously interested in putting the feeling back into the dead architecture where it belongs.

Mary was rarely harsh to any suppliant or servant, and she took no special interest in humiliating the rich or the learned or the wise. For them law was made; by them, law was administered, and with their doings Mary never arbitrarily interfered; but occasionally she could not resist the temptation

to intimate her opinion of the manner in which the Trinity allowed their—the regular—Church to be administered. She was a Queen, and never for an instant forgot it, but she took little thought about her divine rights, if she had any; and in fact Saint Bernard preferred her without them; while she was scandalised at the greed of officials in her son's Court. One day a rich usurer and a very poor old woman happened to be dying in the same town. Gaultier de Coincy did not sav. as an accurate historian should, that he was present, nor did he mention names or dates, although it was one of his longest and best stories. Mary never loved bankers, and had no reason for taking interest in this one, or for doing him injury; but it happened that the parish priest was summoned to both deathbeds at the same time, and neglected the old pauper in the hope of securing a bequest for his church from the banker. This was the sort of fault that most annoyed Mary in the Church of the Trinity, which, in her opinion, was not cared for as it should be, and she felt it her duty to intimate as much

Although the priest refused to come at the old woman's summons, his young clerk who seems to have acted as vicar though not in orders, took pity on her, and went alone with the sacrament to her hut, which was the poorest of poor hovels even for that age:—

Close de piex et de serciaus Comme une viez souz a porciaus. Roof of hoops, and wall of logs, Like a wretched stye for hogs.

There the beggar lay, already insensible or at the last gasp, on coarse thatch, on the ground, covered by an old hempen sack. The picture represented the extremest poverty of the thirteenth century; a hovel without even a feather-bed or bedstead, as Aucassins' ploughman described his mother's want; and the old woman alone, dying, as the clerk appeared at the opening:—

Li clers qui fu moult bien apris Le cors Nostre Seigneur a pris A l'ostel a la povre fame S'en vient touz seus mes n'i treuve ame. Si grant clarte y a veue Que grant peeur en a eue. The clerk, well in these duties taught, The body of our Savior brought Where she lay upon her bed Without a soul to give her aid. But such brightness there he saw As filled his mind with fear and awe. Ou povre lit a la vieillete
Qui couvers iert d'une nateite
Assises voit XII puceles
Si avenans et si tres beles
N'est nus tant penser i seust
Qui raconter le vout peust.
A coutee voist Nostre Dame
Sus le chevez la povre fame.
Qui por la mort sue et travaille.
La Mere Dieu d'une tovaille
Qui blanche est plus que fleur de lis
La grant sueur d'entor le vis
A ses blanches mains li essuie.

Covered with a mat of straw
The woman lay; but round and near
A dozen maidens sat, so fair
No mortal man could dream such light,
No mortal tongue describe the sight.
Then he saw that next the bed,
By the poor old woman's head,
As she gasped and strained for breath
In the agony of death,
Sat Our Lady,—bending low,
While, with napkin white as snow,
She dried the death-sweat on the brow.

The clerk, in terror, hesitated whether to turn and run away, but Our Lady beckoned him to the bed, while all rose and kneeled devoutly to the sacrament. Then she said to the trembling clerk:—

'Friend, be not afraid!
'But seat yourself, to give us aid,
'Beside these maidens, on the bed.'

And when the clerk had obeyed, she continued-

'Or tost, amis!' fait Nostre Dame,
'Confessies ceste bone fame
'Et puis apres tout sans freeur
'Recevra tost son sauveeur
'Qui char et sanc vout en moi prendre.'

'Come quickly, friend!' Our Lady says,
'This good old woman now confess
'And afterwards without distress
'She will at once receive her God
'Who deigned in me take flesh and blood.'

After the sacrament came a touch of realism that recalls the simple death-scenes that Walter Scott described in his grand twelfth-century manner. The old woman lingered pitiably in her agony:—

Lors dit une des demoiseles
A madame sainte Marie:
Encore, dame, n'istra mie
'Si com moi semble du cors l'ame.'
Bele fille,' fait Nostre Dame,
'Traveiller lais un peu le cors,
'Ainçois que l'ame en isse hors,
'Si que puree soit et nete
'Ainçois qu'en Paradis la mete.
'N'est or mestier qui soions plus,
'Ralon nous en ou ciel lassus,
'Quant tens en iert bien reviendrons
'En paradis l'ame emmerrons.'

A maiden said to Saint Marie,
'My lady, still it seems to me
'The soul will not the body fly.'
'Fair child!' Our lady made reply,
'Still let awhile the body fight
'Before the soul shall leave it quite.
'So that it pure may be, and cleansed
'When it to Paradise ascends.

'No longer need we here remain; 'We can go back to heaven again; 'We will return before she dies, 'And take the soul to paradise.'

The rest of the story concerned the usurer, whose deathbed was of a different character, but Mary's interest in deathbeds of that kind was small. The fate of the usurer mattered the less because she knew too well how easily the banker, in good credit, could arrange with the officials of the Trinity to open the doors of paradise for him. The administration of heaven was very like the administration of France; the Queen Mother saw many things of which she could not wholly approve; but her nature was pity, not justice, and she shut her eves to much that she could not change. Her miracles, therefore, were for the most part mere evidence of her pity for those who needed it most, and these were rarely the well-to-do people of the siècle, but more commonly the helpless. Every saint performed miracles, and these are standard, not peculiar to any one intermediator; and every saint protected his own friends; but beyond these exhibitions of power, which are more or less common to the whole hierarchy below the Trinity, Mary was the mother of pity and the only hope of despair. One might go on for a volume, studying the character of Mary and the changes that time made in it, from the earliest Byzantine legends down to the daily recorded miracles at Lourdes; no character in history has had so long or varied a development, and none so sympathetic; but the greatest poets long ago plundered that mine of rich motives, and have stolen what was most dramatic for popular use. The Virgin's most famous early miracle seems to have been that of the monk Theophilus, which was what one might call her salvation of Faust. Another Byzantine miracle was an original version of Shylock. Shakespeare and his fellow-dramatists plundered the Church legends as freely as their masters plundered the Church treasuries, yet left a mass of dramatic material untouched. Let us pray the Virgin that it may remain untouched, for, although a good miracle was in its day worth much money, -so much that the rival shrines stole each other's miracles without decency,—one does not care to see one's Virgin put to money-making for Jew theatre-managers. One's two hundred and fifty million arithmetical ancestors shrink.

For mere amusement, too, the miracle is worth reading of the little Jew child who ignorantly joined in the Christian communion, and was thrown into a furnace by his father in consequence, but when the furnace was opened, the Virgin appeared seated in the midst of the flames, with the little child unharmed in her lap. A better is that called the "Tombeor de Notre Dame," only recently printed; told by some unknown poet of the thirteenth century, and told as well as any of Gaultier de Coincy's. Indeed the "Tombeor de Notre Dame" has had more success in our time than it ever had in its own, as far as one knows, for it appeals to a quiet sense of humor that pleases modern French taste as much as it pleased the Virgin. One fears only to spoil it by translation, but if a translation be merely used as a glossary or foot-note, it need not do fatal harm.

The story is that of a tumbler—tombeor, street-acrobat,—who was disgusted with the world, as his class has had a reputation for becoming, and who was fortunate enough to obtain admission into the famous monastery of Clairvaux, where Saint Bernard may have formerly been blessed by the Virgin's presence. Ignorant at best, and especially ignorant of letters, music, and the offices of a religious society, he found himself unable to join in the services:—

Car n'ot vescu fors de tumer Et d'espringier et de baler. Treper, saillir, ice savoit; Ne d'autre rien il ne savoit; Car ne savoit autre leçon Ne 'pater noster' ne chançon Ne le 'credo' ne le salu Ne rien qui fust a son salu. For he had learned no other thing Than to tumble, dance and spring: Leaping and vaulting, that he knew, But nothing better could he do. He could not say his prayers by rote; Not 'pater noster'; not a note; Not 'ave Mary,' nor the creed; Nothing to help his soul in need.

Tormented by the sense of his uselessness to the society whose bread he eat without giving a return in service, and afraid of being expelled as a useless member, one day while the bells were calling to mass he hid in the crypt, and in despair began to soliloquize before the Virgin's altar, at the same spot, one hopes, where the Virgin had shown herself, or might have shown herself, in her infinite bounty, to Saint Bernard, a hundred years before:—

'Hai,' fait il, 'con suis trais! 'Or dira ja cascuns sa laisse 'Et jo suis çi i bues en laisse 'Ha!' said he, 'how I am ashamed!
'To sing his part goes now each priest,
'And I stand here, a tethered beast,

'Qui ne fas ci fors que broster 'Et viandes por nient gaster. 'Si ne dirai ne ne ferai? 'Par la mere deu, si ferai! Ja n'en serai ore repris; Jo ferai ce que j'ai apris; 'Si servirai de men mestier 'La mere deu en son mostier; 'Li autre servent de canter 'Et io servirai de tumer.' Sa cape oste, si se despoille, Deles l'autel met sa despoille, Mais por sa char que ne soit nue Une cotele a retenue Qui moult estait tenre et alise, Petit vaut miex d'une chemise, Si est en pur le cors remes. Il s'est bien chains et acesmes,

Sa cote çaint et bien s'atorne, Devers l'ymage se retorne Mout humblement et si l'esgarde: 'Dame,' fait il, 'en vostre garde 'Comant jo et mon cors et m'ame. 'Douce reine, douce dame, 'Ne despisies ce que jo sai 'Car jo me voil metre a l'asai 'De vos servir en bone foi 'Se dex m'ait sans nul desroi. To ne sai canter ne lire 'Mais certes jo vos voil eslire 'Tos mes biax gieus a esliçon. 'Or soie al fuer de taureçon 'Oui trepe et saut devant sa mere. 'Dame, qui n'estes mie amere 'A cels qui vos servent a droit, 'Quelsque jo soie, por vos soit!'

Lors li commence a faire saus Bas et petits et grans et haus Primes descur et puis desos, Puis se remet sor ses genols, Devers Pymage, et si l'encline: 'He!' fait il, 'tres douce reine, 'Par vo pitie, par vo francise, 'Ne despisies pas mon servise!' 'Who nothing do but browse and feed 'And waste the food that others need. 'Shall I say nothing, and stand still? 'No! by God's mother, but I will! 'She shall not think me here for naught; 'At least I'll do what I've been taught! 'At least I'll serve in my own way 'God's mother in her church today. 'The others serve to pray and sing; 'I will serve to leap and spring.' Then he strips him of his gown, Lays it on the altar down; But for himself he takes good care Not to show his body bare, But keeps a jacket, soft and thin, Almost a shirt, to tumble in. Clothed in this supple woof of maille His strength and health and form showed well

And when his belt is buckled fast, Towards the Virgin turns at last; Very humbly makes his prayer: 'Lady!' says he, 'to your care 'I commit my soul and frame. 'Gentle Virgin, gentle dame, 'Do not despise what I shall do, 'For I ask only to please you, 'To serve you like an honest man, 'So help me God, the best I can. 'I cannot chant, nor can I read, 'But I can show you here instead 'All my best tricks to make you laugh, 'And so shall be as though a calf 'Should leap and jump before its dam. 'Lady, who never yet could blame 'Those who serve you well and true, 'All that I am, I am for you.'

Then he begins to jump about,
High and low, and in and out,
Straining hard with might and main;
Then falling on his knees again
Before the image bows his face:
'By your pity! by your grace!'
Says he, 'Ha! my gentle queen,
'Do not despise my offering!'

In his earnestness he exerted himself until, at the end of his strength, he lay exhausted and unconscious on the altar steps.

Pleased with his own exhibition, and satisfied that the Virgin was equally pleased, he continued these devotions every day until at last his constant and singular absence from the regular services attracted the curiosity of a monk, who kept watch on him and reported his eccentric exercise to the Abbot.

The mediaeval monasteries seem to have been gently administered. Indeed this has been made the chief reproach on them, and the excuse for robbing them for the benefit of a more energetic crown and nobility who tolerated no beggars or idleness but their own; at least, it is safe to say that few well-regulated and economically administered modern charities would have the patience of the Abbot of Clairvaux, who, instead of calling up the weak-minded tombeor and sending him back to the world to earn a living by his profession, went with his informant to the crypt, to see for himself what the strange report meant. We have seen at Chartres what a crypt may be, and how easily one might hide in its shadows while mass is said at the altars. The Abbot and his informant hid themselves behind a column in the shadow, and watched the whole performance to its end when the exhausted tumbler dropped unconscious and drenched with perspiration on the steps of the altar, with the words:-

'Dame!' fait il, 'ne puis plus ore; 'Mais voire je reviendrai encore.'

'Lady!' says he, 'no more I can, 'But truly I'll come back again!'

You can imagine the dim crypt; the tumbler lying unconscious beneath the image of the Virgin; the Abbot peering out from the shadow of the column, and wondering what sort of discipline he could inflict for this unforeseen infraction of rule; when suddenly, before he could decide what next to do, the vault above the altar, of its own accord, opened:—

L'abes esgarde sans atendre Et vit de la volte descendre Une dame si gloriouse Ains nus ne vit si preciouse Ni si ricement conrece, N'onques tant bele ne fu nee. Ses vesteures sont bien chieres D'or et de precieuses pieres. Avec li estoient li angle The Abbot strains his eyes to see, And, from the vaulting, suddenly, A lady steps,—so glorious,—Beyond all thought so precious,—Her robes so rich, so nobly worn,—So rare the gems the robes adorn,—As never yet so fair was born.

Along with her the angels were, Archangels stood beside her there;

Del ciel amont, et li arcangle, Oui entor le menestrel vienent, Si le solacent et sostienent. Quant entor lui sont arengie S'ot tot son cuer asoagie. Dont s'aprestent de lui servir Por ce qu'ils volrent deservir La servise que fait la dame Oui tant est precieuse geme. Et la douce reine france Tenoit une touaille blance. S'en avente son menestrel Mout doucement devant l'autel. La france dame debonnaire Le col. le cors, et le viaire Li avente por refroidier; Bien s'entremet de lui aidier: La dame bien s'i abandone: Li bons hom garde ne s'en done, Car il ne voit, si ne set mie Ou'il ait si bele compaignie.

Round about the tumbler group To give him solace, bring him hope: And when round him in ranks they stood. His whole heart felt its strength renewed. So they haste to give him aid Because their wills are only made To serve the service of their Queen. Most precious gem the earth has seen. And the lady, gentle, true, Holds in her hand a towel new: Fans him with her hand divine Where he lies before the shrine. The kind lady, full of grace, Fans his neck, his breast, his face! Fans him herself to give him air! Labors, herself, to help him there!

The lady gives herself to it; The poor man takes no heed of it; For he knows not and cannot see That he has such fair company.

Beyond this we need not care to go. If you cannot feel the color and quality,—the union of naïveté and art,—the refinement,—the infinite delicacy and tenderness—of this little poem, then nothing will matter much to you; and if you can feel it, you can feel, without more assistance, the majesty of Chartres.

XIV

Abélard

Super cuncta, subter cuncta, Extra cuncta, intra cuncta, Intra cuncta nec inclusus, Extra cuncta nec exclusus, Super cuncta nec elatus, Subter cuncta nec substratus, Super totus, praesidendo, Subter totus, sustinendo, Extra totus, complectendo, Intra totus est, implendo.

ACCORDING TO HILDEBERT, Bishop of Le Mans and Arch-A bishop of Tours, these verses describe God. Hildebert was the first poet of his time, no small merit since he was contemporary with the Chanson de Roland and the first Crusade; he was also a strong man, since he was able, as Bishop of Le Mans, to gain great credit by maintaining himself against William the Norman and Fulk of Anjou; and finally he was a prelate of high authority. He lived between 1055 and 1133. Supposing his verses to have been written in middle life, towards the year 1100, they may be taken to represent the accepted doctrine of the Church at the time of the first Crusade. They were little more than a versified form of the Latin of Saint Gregory the Great who wrote five hundred years before: - "Ipse manet intra omnia, ipse extra omnia, ipse supra omnia, ipse infra omnia; et superior est per potentiam et inferior per sustentationem; exterior per magnitudinem et interior per subtilitatem; sursum regens, deorsum continens, extra circumdans, interius penetrans; nec alia parte superior, alia inferior, aut alia ex parte exterior atque ex alia manet interior, sed unus idemque totus ubique." According to Saint Gregory, in the sixth century, God was "one and the same and wholly everywhere;" "immanent within everything, without everything, above everything, below everything, sursum regens, deorsum continens;" while according to Archbishop Hildebert in the eleventh century: - "God is over all things,

under all things; outside all, inside all; within but not inclosed; without but not excluded; above but not raised up; below, but not depressed; wholly above, presiding; wholly beneath, sustaining; wholly without, embracing; wholly within, filling." Finally, according to Benedict Spinoza, another five hundred years later still;—"God is a being, absolutely infinite; that is to say, a substance made up of an infinity of attributes, each one of which expresses an eternal and infinite essence."

Spinoza was the great Pantheist, whose name is still a terror to the orthodox, and whose philosophy is, -very properly, -a horror to the Church; and yet Spinoza never wrote a line that, to the unguided student, sounds more Spinozist than the words of Saint Gregory and Archbishop Hildebert. If God is everywhere; wholly; presiding, sustaining, embracing and filling, sursum regens, deorsum continens, he is the only possible energy, and leaves no place for human will to act. A force which is "one and the same and wholly everywhere" is more Spinozist than Spinoza, and is likely to be mistaken for frank pantheism by the large majority of religious minds who must try to understand it without a theological course in a Jesuit College. In the year 1100 Jesuit Colleges did not exist, and even the great Dominican and Franciscan schools were far from sight in the future; but the School of Notre Dame at Paris existed, and taught the existence of God much as Archbishop Hildebert described it. The most successful lecturer was William of Champeaux, and to anyone who ever heard of William at all, the name instantly calls up the figure of Abélard, in flesh and blood, as he sang to Héloïse the songs which he says resounded through Europe. The twelfth century, with all its sparkle, would be dull without Abélard and Héloïse.

With infinite regret, Héloïse must be left out of the story, because she was not a philosopher or a poet or an artist, but only a Frenchwoman to the last millimetre of her shadow. Even though one may suspect that her famous letters to Abélard are, for the most part, by no means above scepticism, she was, by French standards, worth at least a dozen Abélards, if only because she called Saint Bernard a false apostle. Unfortunately, French standards, by which she must be judged in

our ignorance, take for granted that she philosophised only for the sake of Abélard, while Abélard taught philosophy to her not so much because he believed in philosophy or in her as because he believed in himself. To this day, Abélard remains a problem as perplexing as he must have been to Héloïse, and almost as fascinating. As the west Portal of Chartres is the door through which one must of necessity enter the gothic architecture of the thirteenth century, so Abélard is the Portal of approach to the gothic thought and philosophy within. Neither Art nor Thought has a modern equivalent; only Héloïse, like Isolde, unites the ages.

The first crusade seems, in perspective, to have filled the whole field of vision in France at the time; but, in fact, France seethed with other emotions, and while the crusaders set out to scale Heaven by force at Jerusalem, the monks, who remained at home, undertook to scale Heaven by prayer and by absorption of body and soul in God; the Cistercian Order was founded in 1098 and was joined in 1112 by young Bernard, born in 1090 at Fontaines-lès-Dijon, drawing with him or after him so many thousands of young men into the selfimmolation of the monastery as carried dismay into the hearts of half the women of France. At the same time, -that is, about 1098 or 1100, - Abélard came up to Paris from Brittany, with as much faith in logic as Bernard had in prayer or Godfrey of Bouillon in arms, and led an equal or even a greater number of combatants to the conquest of Heaven by force of pure reason. None showed doubt. Hundreds of thousands of young men wandered from their provinces, mostly to Palestine, largely to cloisters, but also in great numbers to Paris and the schools, while few ever returned.

Abélard had the advantage of being well-born; not so highly descended as Albertus Magnus and Thomas Aquinas who were to complete his work in the thirteenth century, but, like Bernard, a gentleman born and bred. He was the eldest son of Bérenger, sieur du Pallet, a chateau in Brittany, south of the Loire, on the edge of Poitou. His name was Pierre du Pallet, although, for some unknown reason, he called himself Pierre Abailard, or Abeillard, or Esbaillart, or Beylard; for the spelling was never fixed. He was born in 1079, and when, in 1096, the young men of his rank were rushing off to the first

crusade, Pierre, a boy of seventeen, threw himself with equal zeal into the study of Science, and, giving up his inheritance or birth-right, at last came to Paris to seize a position in the

schools. The year is supposed to have been 1100.

The Paris of Abélard's time was astonishingly old; so old that hardly a stone of it can be now pointed out. Even the oldest of the buildings still standing in that quarter, - Saint Julien-le-Pauvre, Saint Séverin, and the tower of the Lycée Henri IV.—are more modern; only the old Roman Thermæ, now part of the Musée de Cluny, within the walls, and the Abbey Tower of Saint Germain-des-Prés, outside, in the fields, were standing in the year 1100. Politically, Paris was a small provincial town before the reign of Louis le Gros (1108-1137) who cleared its gates of its nearest enemies; but, as a school, Paris was even then easily first. Students crowded into it by thousands, till the town is said to have contained more students than citizens. Modern Paris seems to have begun as a university town before it had a university. Students flocked to it from great distances, encouraged and supported by charity, and stimulated by privileges, until they took entire possession of what is still called the Latin Quarter from the barbarous Latin they chattered; and a town more riotous. drunken and vicious than it became, in the course of time, hardly existed even in the middle-ages. In 1100 when enthusiasm was fresh and faith in science was strong, the great mass of students came there to study, and, having no regular university organisation or buildings, they thronged the cloister of Notre Dame, -not our Notre Dame, which dates only from 1163, but the old romanesque Cathedral which stood on the same spot, - and there they listened, and retained what they could remember, for they were not encouraged to take notes even if they were rich enough to buy note-books, while manuscripts were far beyond their means. One valuable right the students seem to have had, -that of asking questions and even of disputing with the lecturer provided they followed the correct form of dialectics. The lecturer himself was licensed by the Bishop.

Five thousand students are supposed to have swarmed about the Cloister of Notre Dame, across the Petit Pont, and up the hill of Sainte Geneviève; three thousand are said to

have paid fees to Abélard in the days of his great vogue and they seem to have attached themselves to their favorite master as a champion to be upheld against the world. Jealousies ran high, and neither scholars nor masters shunned dispute. Indeed the only science they taught or knew was the art of dispute-dialectics. Rhetoric, Grammar and Dialectics were the regular branches of science, and bold students, who were not afraid of dabbling in forbidden fields, extended their studies to mathematics, - exercitium nefarium according to Abélard, which he professed to know nothing about but which he studied nevertheless. Abélard, whether pupil or master, never held his tongue if he could help it, for his fortune depended on using it well; but he never used it so well in Dialectics or Theology, as he did, towards the end of his life, in writing a bit of autobiography, so admirably told, so vivid, so vibrating with the curious intensity of his generation, that it needed only to have been written in "Romieu" to be the chief monument of early French prose, as the western Portal of Chartres is the chief monument of early French sculpture, and of about the same date. Unfortunately Abélard was a noble scholar, who necessarily wrote and talked Latin, even with Héloïse, and, although the Latin was mediaeval, it is not much the better on that account, because, in spite of its quaintness, the naïvetés of a young language,—the egotism, jealousies, suspicions, boastings and lamentations of a childlike time, -take a false air of outworn Rome and Byzantium, although, underneath, the spirit lives:-

I arrived at last in Paris where for a long time dialectics had specially flour-ished under William of Champeaux, rightly reckoned the first of my masters in that branch of study. I stayed some time in his school, but, though well received at first, I soon got to be an annoyance to him because I persisted in refuting certain ideas of his, and because, not being afraid to enter into argument against him, I sometimes got the better. This boldness, too, roused the wrath of those fellow-students who were classed higher, because I was the youngest and the last comer. This was the beginning of my series of misfortunes which still last; my renown every day increasing, envy was kindled against me in every direction.

This picture of the boy of twenty, harrassing the professor, day after day, in his own lecture-room before hundreds of

older students, paints Abélard to the life; but one may safely add a few touches that heighten the effect; as that William of Champeaux himself was barely thirty, and that Abélard throughout his career, made use of every social and personal advantage to gain a point, with little scruple either in manner or in sophistry. One may easily imagine the scene. Teachers are always much the same. Pupils and students differ only in degrees of docility. In 1100, both classes began by accepting the foundations of society, as they have to do still; only they then accepted laws of the Church and Aristotle, while now they accept laws of the Legislature and of Energy. In 1100 the students took for granted that with the help of Aristotle and syllogisms they could build out the Church intellectually, as the architects, with the help of the pointed arch, were soon to enlarge it architecturally. They never doubted the certainty of their method. To them words had fixed values, like numbers, and syllogisms were hewn stones that needed only to be set in place, in order to reach any height or support any weight. Every sentence was made to take the form of a syllogism. One must have been educated in a Jesuit or Dominican school in order to frame these syllogisms correctly, but merely by way of illustration one may timidly suggest how the phrases sounded in their simplest form. For example, Plato or other equally good authority defined Substance as that which stands underneath phenomena; the most universal of universals, the ultimate, the highest in order of generalisation. The ultimate essence or substance is indivisible; God is substance; God is indivisible. The divine substance is incapable of alteration or accident; all other substance is liable to alteration or accident; therefore the divine substance differs from all other substance. A substance is a universal, -as for example, Humanity, or the Human, is a universal and indivisible; the Man, Socrates for instance, is not a universal, but an individual; therefore the substance Humanity, being indivisible, must exist entire and undivided in Socrates.

The form of logic most fascinating to youthful minds, as well as to some minds that are only too acute, is the *reductio* ad absurdum; the forcing an opponent into an absurd alternative or admission; and the syllogism lent itself happily to this use. Socrates abused the weapon and Abélard was the

first French master of the art; but neither State nor Church likes to be reduced to an absurdity, and, on the whole, both Socrates and Abélard fared ill in the result. Even now, one had best be civil towards the idols of the forum. Abélard would find most of his old problems sensitive to his touch today. Time has settled few or none of the essential points of dispute. Science hesitates, more visibly than the Church ever did, to decide once for all whether Unity or Diversity is ultimate law; whether order or chaos is the governing rule of the Universe, if Universe there is; whether anything except phenomena exists. Even in matters more vital to society, one dares not speak too loud. Why, and for what, and to whom, is man a responsible agent? Every jury and judge, every lawyer and doctor, every legislator and clergyman has his own views, and the law constantly varies. Every nation may have a different system. One court may hang, and another may acquit for the same crime, on the same day; and Science only repeats what the Church said to Abélard, that where we know so little, we had better hold our tongues.

According to the latest authorities, the doctrine of Universals which convulsed the schools of the twelfth century has never received an adequate answer. What is a species? what is a genus or a family or an order? More or less convenient terms of classification, about which the twelfth century cared very little, while it cared deeply about the essence of classes! Science has become too complex to affirm the existence of universal truths, but it strives for nothing else, and disputes the problem, within its own limits, almost as earnestly as in the twelfth century, when the whole field of human and superhuman activity was shut between these barriers of Substance, Universals, and Particulars. Little has changed except the vocabulary and the method. The schools knew that their society hung for life on the demonstration that God, the ultimate Universal, was a reality, out of which all other universal truths or realities sprang. Truth was a real thing, outside of human experience. The schools of Paris talked and thought of nothing else. John of Salisbury, who attended Abélard's lectures about 1136, and became Bishop of Chartres in 1176, seems to have been more surprised than we need be, at the intensity of the emotion. "One never gets away from this

question," he said. "From whatever point a discussion starts, it is always led back and attached to that. It is the madness of Rufus about Naevia; 'He thinks of nothing else; talks of nothing else, and if Naevia did not exist Rufus would be dumb.'"

Abélard began it. After his first visit to Paris in 1100, he seems to have passed several years elsewhere, while Guillaume de Champeaux, in 1108, retired from the school in the cloister of Notre Dame, and, taking orders, established a class in a chapel near by, afterwards famous as the Abbaye-de-Saint-Victor. The Jardin des Plantes and the Gare d'Orléans now cover the ground where the Abbey stood, on the banks of the Seine outside the Latin Quarter, and not a trace is left of its site; but there William continued his course on dialectics, until suddenly Abélard reappeared among his scholars, and resumed his old attacks. This time Abélard could hardly call himself a student. He was thirty years old and long since had been himself a teacher; he had attended William's course on dialectics nearly ten years before, and was past master in the art; he had nothing to learn from William in theology, for neither William nor he were yet theologists by profession. If Abélard went back to school, it was certainly not to learn; but indeed he himself made little or no pretence of it, and told with childlike candor not only why he went, but also how brilliantly he succeeded in his object:-

I returned to study rhetoric in his school. Among other controversial battles, I succeeded, by the most irrefutable argument, in making him change, or rather ruin his doctrine of universals. His doctrine consisted in affirming the perfect identity of the essence in every individual of the same species, so that according to him there was no difference in the essence but only in the infinite variety of accidents. He then came to amend his doctrine so as to affirm, not the identity any longer, but the absence of distinction—the want of difference—in the essence. And as this question of universals had always been one of the most important questions of dialectics,—so important that Porphyry touching on it in his Preliminaries did not dare to take the responsibility of cutting the knot, but said: 'It is a very grave point,'—Champeaux who was obliged to modify his idea and then renounce it, saw his course fall into such discredit that they hardly let him make his dialectical lectures, as though dialectics consisted entirely in the question of universals.

Why was this point so "very grave?" Not because it was

mere dialectics! The only part of the story that seems grave today is the part that Abélard left out; the part which Saint Bernard, thirty years later put in, on behalf of William. We should be more credulous than twelfth-century monks, if we believed, on Abélard's word in 1135, that in 1110 he had driven out of the schools the most accomplished dialectician of the age by an objection so familiar that no other dialectician was ever silenced by it,—whatever may have been the case with theologians,—and so obvious that it could not have troubled a scholar of fifteen. William stated a settled doctrine as old as Plato; Abélard interposed an objection as old as Aristotle. Probably Plato and Aristotle had received the question and answer from philosophers ten thousand years older than themselves. Certainly the whole of philosophy has always been involved in the dispute.

The subject is as amusing as a comedy; so amusing that ten minutes may be well given to playing the scene between William and Abélard, not as it happened, but in a form nearer our ignorance, with liberty to invent arguments for William, and analogies,—which are figures intended to serve as fatal weapons if they succeed, and as innocent toys if they fail,—such as he never imagined; while Abélard can respond with his true rejoinder, fatal in a different sense. For the chief analogy, the notes of music would serve, or the colors of the solar spectrum, or an energy, such as gravity;—but the best is geometrical, because Euclid was as scholastic as William of Champeaux himself, and his axioms are even more familiar to the school-boy of the twentieth, than to the school-man of the twelfth century.

In these scholastic tournaments the two champions started from opposite points:—one, from the ultimate substance, God,—the Universal, the Ideal, the Type;—the other from the Individual, Socrates, the Concrete, the observed Fact of experience, the object of sensual perception. The first champion,—William in this instance,—assumed that the Universal was a real thing; and for that reason he was called a Realist. His opponent,—Abélard,—held that the Universal was only nominally real; and on that account he was called a Nominalist. Truth, Virtue, Humanity, exist as units and realities, said William. Truth, replied Abélard, is only the sum of all pos-

sible facts that are true, as Humanity is the sum of all actual human beings. The Ideal bed is a Form, made by God; said Plato. The Ideal bed is a name, imagined by ourselves; said Aristotle. "I start from the Universe," said William. "I start from the Atom," said Abélard; and, once having started, they necessarily came into collision at some point between the two.

William of Champeaux, lecturing on dialectics or logic, comes to the question of Universals, which he says, are substances. Starting from the highest substance, God, all Being descends through created substances by stages, until it reaches the substance Animality, from which it descends to the substance Humanity: and Humanity being, like other essences or substances, indivisible, passes wholly into each individual, becoming Socrates, Plato and Aristotle, much as the divine substance exists wholly and undivided in each member of the Trinity.

Here Abélard interrupts. The divine substance, he says, operates by laws of its own, and cannot be used for comparison. In treating of human substance, one is bound by human limitations. If the whole of Humanity is in Socrates, it is wholly absorbed by Socrates, and cannot be at the same time in Plato, or elsewhere. Following his favorite reductio ad absurdum, Abélard turns the idea round, and infers from it that, since Socrates carries all Humanity in him, he carries Plato too; and both must be in the same place, though Socrates is at Athens and Plato in Rome.

The objection is familiar to William, who replies by another commonplace:—

"Mr. Abélard, might I, without offence, ask you a simple matter? Can you give me Euclid's definition of a point?"

"If I remember right, it is: 'illud cujus nulla pars est'; that which has no parts."

"Has it existence?"

"Only in our minds."

"Not, then, in God?"

"All necessary truths exist first in God. If the point is a necessary truth, it exists first there."

"Then might I ask you for Euclid's definition of the line?"

"The line is that which has only extension; 'Linea vocatur illa quae solam longitudinem habet.'"

"Can you conceive an infinite straight line?"

"Only as a line which has no end, like the point extended."

"Supposing we imagine a straight line, like opposite rays of the sun proceeding in opposite directions to infinity,—is it real?"

"It has no reality except in the mind that conceives it."

"Supposing we divide that line which has no reality into two parts at its origin in the sun or star, shall we get two infinities? or shall we say, two halves of the infinite?"

"We conceive of each as partaking the quality of infinity."

"Now, let us cut out the diameter of the sun; or rather—since this is what our successors in the school will do,—let us take a line of our earth's longitude which is equally unreal, and measure a degree of this thing which does not exist, and then divide it into equal parts which we will use as a measure or metre. This metre, which is still nothing, as I understand you, is infinitely divisible into points? and the point itself is infinitely small? Therefore we have the finite partaking the nature of the infinite?"

"Undoubtedly!"

"One step more, Mr. Abélard, if I do not weary you! Let me take three of these metres which do not exist, and place them so that the ends of one shall touch the ends of the others. May I ask what is that figure?"

"I presume you mean it to be a triangle."
"Precisely! and what sort of a triangle?"

"An equilateral triangle, the sides of which measure one metre each."

"Now let me take three more of these metres which do not exist, and construct another triangle which does not exist;—are these two triangles or one triangle?"

"They are most certainly one,—a single concept of the only possible equilateral triangle measuring one metre on each face."

"You told us a moment ago, that a Universal could not exist wholly and exclusively in two individuals at once. Does not the Universal by definition,— the equilateral triangle mea-

suring one metre on each face,—does it not exist wholly, in its integrity of essence, in each of the two triangles we have conceived?"

"It does, -as a conception."

"I thank you! Now, although I fear wearying you, perhaps you will consent to let me add matter to mind. I have here on my desk an object not uncommon in nature, which I will ask you to describe."

"It appears to be a crystal."

"May I ask its shape?"

"I should call it a regular octahedron."

"That is, two pyramids, set base to base? making eight plane surfaces, each a perfect equilateral triangle?"

"Concedo triangula. I grant the triangles."

"Do you know, perchance, what is this material which seems to give substantial existence to these eight triangles?"

"I do not."

"Nor I! nor does it matter, unless you conceive it to be the work of man?"

"I do not claim it as man's work."

"Whose then?"

"We believe all actual creation of matter, united with form, to be the work of God."

"Surely not the substance of God himself? Perhaps you mean that this form,—this octahedron—is a divine concept."

"I understand such to be the doctrine of the Church."

"Then it seems that God uses this concept habitually to create this very common crystal. One question more, and only one, if you will permit me to come to the point. Does the matter,—the material,—of which this crystal is made, affect in any way the form,—the nature, the soul,—of the Universal Equilateral Triangle as you see it bounding these eight plane surfaces?"

"That I do not know, and do not think essential to decide. As far as these triangles are individual, they are made so by the will of God, and not by the substance you call Triangle. The Universal,—the abstract Right Angle, or any other abstract form,—is only an idea, a Concept, to which Reality, Individuality, or what we might call Energy is wanting. The only true Energy, except man's free will, is God."

"Very good, Mr. Abélard! we can now reach our issue. You affirm that, just as the line does not exist in space, although the eve sees little else in space, so the Triangle does not exist in this crystal, although the crystal shows eight of them, each perfect. You are aware that on this line which does not exist. and its combination in this triangle which does not exist, rests the whole fabric of mathematics with all its necessary truths. In other words, you know that in this line, though it does not exist, is bound up the truth of the only branch of human knowledge which claims absolute certainty for human processes. You admit that this line and triangle, which are mere figments of our human imagination, not only exist independent of us in the crystal, but are, as we suppose, habitually and invariably used by God himself to give form to the matter contained within the planes of the crystal. Yet to this line and triangle you deny reality. To mathematical truth, you deny compulsive force. You hold that an equilateral triangle may, to you and all other human individuals, be a right-angled triangle if you choose to imagine it so. Allow me to say, without assuming any claim to superior knowledge, that to me your logic results in a different conclusion. If you are compelled, at one point or another of the chain of Being, to deny existence to a substance, surely it should be to the last and feeblest. I see nothing to hinder you from denying your own existence, which is, in fact, impossible to demonstrate. Certainly you are free, in logic, to argue that Socrates and Plato are mere names,—that men and matter are phantoms and dreams. No one ever has proved, or ever can prove the contrary. Infallibly, a great philosophical school will some day be founded on that assumption. I venture even to recommend it to your acute and sceptical mind; but I cannot conceive how, by any process of reasoning, sensual or supersensual, you can reach the conclusion that the single form of truth which instantly and inexorably compels our submission to its lawsis nothing."

Thus far, all was familiar ground; certainly at least as familiar as the *Pons Asinorum*; and neither of the two champions had need to feel ruffled in temper by the discussion. The real struggle began only at this point; for until this point was reached, both positions were about equally tenable. Abélard

had hitherto rested quietly on the defensive, but William's last thrust obliged him to strike in his turn, and he drew himself up for what, five hundred years later, was called the coup

de Jarnac: -

"I do not deny," he begins; "on the contrary, I affirm that the Universal, whether we call it Humanity or Equilateral Triangle, has a sort of reality as a concept; that it is something; even a substance, if you insist upon it. Undoubtedly the sum of all individual men results in the concept of Humanity. What I deny is that the concept results in the individual. You have correctly stated the essence of the point and the line as sources of our concept of the infinite; what I deny is that they are divisions of the infinite. Universals cannot be divided; what is capable of division cannot be a Universal. I admit the force of your analogy in the case of the crystal; but I am obliged to point out to you that, if you insist on this analogy, you will bring yourself and me into flagrant contradiction with the fixed foundations of the Church. If the energy of the triangle gives form to the crystal, and the energy of the line gives reality to the triangle, and the energy of the infinite gives substance to the line, all energy at last becomes identical with the ultimate substance, God himself. Socrates becomes God in small; Judas is identical with both; Humanity is of the divine essence, and exists, wholly and undivided, in each of us. The Equilateral triangle we call Humanity exists, therefore, entire, identical, in you and me, as a subdivision of the infinite line, space, energy, or substance, which is God. I need not remind you that this is Pantheism, and that if God is the only energy, human free-will merges in God's free-will; the Church ceases to have a reason for existence; man cannot be held responsible for his own acts, either to the Church or to the State; and finally, though very unwillingly, I must, in regard for my own safety, bring the subject to the attention of the Archbishop, which, as you know better than I, will lead to your seclusion, or worse."

Whether Abélard used these precise words is nothing to the point. The words he left on record were equivalent to these. As translated by M. de Rémusat from a manuscript entitled: "Glossulae magistri Petri Baelardi super Porphyrium," the

phrase runs:—"A grave heresy is at the end of this doctrine; for, according to it, the divine substance which is recognised as admitting of no form, is necessarily identical with every substance in particular and with all substance in general." Even had he not stated the heresy so bluntly, his objection necessarily pushed William in face of it. Realism, when pressed, always led to Pantheism. William of Champeaux and Bishop or Archbishop Hildebert were personal friends, and Hildebert's divine substance left no more room for human free-will than Abélard saw in the geometric analogy imagined for William. Throughout the history of the Church for fifteen hundred years, whenever this theological point has been pressed against churchmen it has reduced them to evasion or to apology. Admittedly, the weak point of Realism was its fatally pantheistic term.

Of course, William consulted his friends in the Church, probably Archbishop Hildebert among the rest, before deciding whether to maintain or to abandon his ground, and the result showed that he was guided by their advice. Realism was the Roman arch,—the only possible foundation for any Church, because it assumed Unity, and any other scheme was compelled to prove it, for a starting-point. Let us see, for a moment, what became of the dialogue, when pushed into theology, in order to reach some of the reasons which reduced William to tacit abandonment of a doctrine he could never have surrendered unless under compulsion. That he was angry is sure, for Abélard, by thus thrusting theology into dialectics, had struck him a foul blow; and William knew

"Ah!" he would have rejoined:—"You are quick, M. du Pallet, to turn what I offered as an analogy, into an argument of heresy against my person. You are at liberty to take that course if you choose, though I give you fair warning that it will lead you far. But now I must ask you still another question. This Concept that you talk about,—this image in the mind of Man, of God, of Matter; for I know not where to seek it,—whether is it a reality or not?"

"I hold it as, in a manner, real."

"I want a categorical answer: - Yes or No!"

"Distinguo! I must qualify."

Abélard well: -

"I will have no qualifications. A substance either is, or not. Choose!"

To this challenge Abélard had the choice of answering Yes, or of answering No, or of refusing to answer at all. He seems to have done the last; but we suppose him to have accepted the wager of battle, and to answer:-

"Yes, then!"

"Good!" William rejoins; -- "Now let us see how your Pantheism differs from mine. My Triangle exists as a Reality, or what science will call an Energy, outside my mind, in God, and is impressed on my mind as it is on a mirror, like the triangle on the crystal, its energy giving form. Your Triangle you say is also an energy, but an essence of my mind itself; you thrust it into the mind as an integral part of the mirror; identically the same Concept, Energy or necessary truth which is inherent in God. Whatever subterfuge you may resort to, sooner or later you have got to agree that your mind is identical with God's nature as far as that concept is concerned. Your Pantheism goes further than mine. As a doctrine of the Real Presence peculiar to yourself, I can commend it to the Archbishop together with your delation of me."

Supposing that Abélard took the opposite course, and

answered: -

"No! my concept is a mere sign." "A sign of what, in God's name!"

"A sound! a word! a symbol! an echo only of my ignorance."

"Nothing, then! So Truth and Virtue and Charity do not exist at all. You suppose yourself to exist, but you have no means of knowing God; therefore to you God does not exist except as an echo of your ignorance; and, what concerns you most, the Church does not exist except as your concept of certain individuals, whom you cannot regard as a unity, and who suppose themselves to believe in a Trinity which exists only as a sound, or a symbol. I will not repeat your words, M. du Pallet, outside this cloister, because the consequences to you would certainly be fatal; but it is only too clear that you are a materialist, and as such your fate must be decided by a Church Council, unless you prefer the stake by judgment of a secular Court."

In truth, pure Nominalism—if, indeed, anyone ever maintained it, - afforded no cover whatever. Nor did Abélard's Concept help the matter, although for want of a better refuge, the Church was often driven into it. Conceptualism was a device, like the false wooden roof, to cover and conceal an inherent weakness of construction. Unity either is, or is not. If soldiers, no matter in what number, can never make an army, and worshippers though in millions, do not make a Church, and all humanity united would not necessarily constitute a State, equally little can their concepts, individual or united, constitute the one or the other. Army, Church and State, each is an organic whole, complex beyond all possible addition of units, and not a Concept at all, but rather an animal that thinks, creates, devours and destroys. The attempt to bridge the chasm between multiplicity and unity is the oldest problem of philosophy, religion and science, but the flimsiest bridge of all is the human Concept, unless somewhere, within or beyond it, an energy not individual is hidden; and in that case the old question instantly reappears: - What is that Energy?

Abélard would have done well to leave William alone, but Abélard was an adventurer and William was a churchman. To win a victory over a churchman is not very difficult for an adventurer, and is always a tempting amusement, because the ambition of churchmen to shine in worldly contests is disciplined and checked by the broader interests of the Church: but the victory is usually sterile, and rarely harms the churchman. The Church cares for its own. Probably the Bishops advised William not to insist on his doctrine, although every Bishop may have held the same view. William allowed himself to be silenced without a judgment, and in that respect stands almost, if not quite, alone among schoolmen. The students divined that he had sold himself to the Church, and consequently deserted him. Very soon he received his reward in the shape of the highest dignity open to private ambition—a Bishopric. As Bishop of Chalons-sur-Marne he made for himself a great reputation, which does not concern us, although it deeply concerned the unfortunate Abélard, for it happened, either by chance or design, that within a year or two after William established himself at Chalons, young Bernard of Citeaux chose a neighboring diocese in which to establish a branch of the Cistercian Order, and Bishop William took so keen an interest in the success of Bernard as almost to claim equal credit for it. Clairvaux was, in a manner, William's creation although not in his diocese, and yet, if there was a priest in all France who fervently despised the schools, it was young Bernard. William of Champeaux, the chief of schoolmen, could never have gained Bernard's affections. Bishop William of Chalons must have drifted far from dialectics into mysticism in order to win the support of Clairvaux, and train up a new army of allies who were to mark Abélard for an easy prev.

Meanwhile Abélard pursued his course of triumph in the schools, and in due time turned from dialectics to theology, as every ambitious teacher could hardly fail to do. His affair with Héloïse and their marriage seem to have occupied his time in 1117 or 1118, for they both retired into religious orders in 1119, and he resumed his lectures in 1120. With his passion for rule, he was fatally certain to attempt ruling the Church as he ruled the Schools; and, as it was always enough for him that any point should be tender in order that he should press upon it, he instantly and instinctively seized on the most sensitive nerve of the church system to wrench it into his service.

He became a sort of Apostle of the Holy Ghost.

That the Trinity is a mystery was a law of theology so absolute as in a degree to hide the law of philosophy that the Trinity was meant as the solution of a greater mystery still. In truth, as a matter of philosophy, the Trinity was intended to explain the eternal and primary problem of the process by which Unity could produce Diversity. Starting from Unity alone, philosophers found themselves unable to stir hand or foot until they could account for Duality. To the common, ignorant peasant, no such trouble occurred, for he knew the Trinity in its simpler form as the first condition of life, like Time and Space and Force. No human being was so stupid as not to understand that the Father, Mother and Child made a Trinity, returning into each other, and although every father, every mother and every child, from the dawn of man's intelligence, had asked why, and had never received an answer more intelligible to them than to philosophers, they never

showed difficulty in accepting that Trinity as a fact. They might even, in their beneficent blindness, ask the Church why that Trinity, which had satisfied the Egyptians for five or ten thousand years, was not good enough for churchmen. They themselves were doing their utmost, though unconsciously, to identify the Holy Ghost with the Mother, while philosophy insisted on excluding the human symbol precisely because it was human and led back to an infinite series. Philosophy required three units to start from; it posed the Equilateral Triangle, not the straight line, as the foundation of its deometry. The first straight line, infinite in extension, must be assumed, and its reflexion engendered the second, but whence came the third? Under protest, philosophy was compelled to accept the symbol of Father and Son as a matter of faith, but, if the relation of Father and Son were accepted for the two units which reflected each other, what relation expressed the Holy Ghost? In philosophy, the product of two units was not a third unit, but Diversity, Multiplicity, Infinity. The subject was for that reason, better handled by the Arabs, whose reasoning worked back on the Christian theologists and made the point more delicate still. Common people like women and children and ourselves could never understand the Trinity; naturally, intelligent people understood it still less, but for them it did not matter; they did not need to understand it provided their neighbors would leave it alone.

The mass of mankind wanted something nearer to them than either the Father or the Son; they wanted the Mother, and the Church tried in what seems to women and children and ourselves rather a feeble way, to give the Holy Ghost, as far as possible, the Mother's attributes,—Love, Charity, Grace; but in spite of conscientious effort and unswerving faith the Holy Ghost remained to the mass of Frenchmen somewhat apart, feared rather than loved. The sin against the Holy Ghost was a haunting spectre, for no one knew what else it was.

Naturally the Church, and especially its official theologists, took an instinctive attitude of defence whenever a question on this subject was asked, and were thrown into a flutter of irritation whenever an answer was suggested. No man likes to have his intelligence or good faith questioned, especially if

he has doubts about it himself. The distinguishing essence of the Holy Ghost, as a theological substance, was its mystery. That this mystery should be touched at all was annoying to everyone who knew the dangers that lurked behind the veil, but that it should be freely handled before audiences of laymen by persons of doubtful character was impossible. Such license must end in discrediting the whole Trinity under pre-

tence of making it intelligible.

Precisely this license was what Abélard took, and on it he chose to insist. He said nothing heretical; he treated the Holy Ghost with almost exaggerated respect as though other churchmen did not quite appreciate its merits; but he would not let it alone, and the Church dreaded every moment lest, with his enormous influence in the schools, he should raise a new storm by his notorious indiscretion. Yet so long as he merely lectured, he was not molested; only when he began to publish his theology did the Church interfere. Then a Council held at Soissons in 1121 abruptly condemned his book in block, without reading it, without specifying its errors and without hearing his defense; obliged him to throw the manuscript into the fire with his own hands, and finally shut him up in a monastery.

He had invited the jurisdiction by taking orders, but even the Church was shocked by the summary nature of the judgment, which seems to have been quite irregular. In fact, the Church has never known what it was that the Council condemned. The latest great work on the Trinity by the Jesuit Father de Régnon suggests that Abélard's fault was in applying to the Trinity his theory of Concepts. "Yes!" he says:— "the mystery is explained; the key of conceptualism has opened the tabernacle, and Saint Bernard was right in saying that, thanks to Abélard, everyone can penetrate it and contemplate it at his ease; 'even the graceless, even the uncircumcised.' Yes! the Trinity is explained, but after the manner of the Sabellians. For, to identify the persons in the terms of human concepts is, in the same stroke, to destroy their 'sub-

sistances propres."

Although the Savior seems to have felt no compunctions about identifying the persons of the Trinity in the terms of human concepts, it is clear that tourists and heretics had best

leave the Church to deal with its "subsistances propres," and with its own members, in its own way. In sum, the Church preferred to stand firm on the Roman arch, and the architects seem now inclined to think it was right; that scholastic science and the pointed arch proved to be failures. In the twelfth century the world may have been rough but it was not stupid. The Council of Soissons was held while the architects and sculptors were building the west porch of Chartres and the Aquilon at Mont Saint Michel, Averroës was born at Cordova in 1126; Omar Khayam died at Naishapur in 1123. Poetry and metaphysics owned the world, and their guarrel with theology was a private, family dispute. Very soon the tide turned decisively in Abélard's favor. Suger, a political prelate, became minister of the King, and in March, 1122, Abbot of Saint Denis. In both capacities he took the part of Abélard, released him from restraint, and even restored to him the liberty of instruction, at least beyond the jurisdiction of the Bishop of Paris. Abélard then took a line of conduct singularly parallel with that of Bernard. Quitting civilised life he turned wholly to religion. "When the agreement," he said, "had been executed by both parties to it, in presence of the King and his ministers, I next retired within the territory of Troyes, upon a desert spot which I knew, and on a piece of ground given me by certain persons, I built, with the consent of the bishop of the diocese, a sort of oratory of reeds and thatch, which I placed under the invocation of the Holy Trinity . . . Founded at first in the name of the Holy Trinity, then placed under its invocation, it was called Paraclet in memory of my having come there as a fugitive and in my despair having found some repose in the consolations of divine grace. This denomination was received by many with great astonishment, and some attacked it with violence under pretext that it was not permitted to consecrate a church specially to the Holy Ghost any more than to God the Father, but that, according to ancient usage, it must be dedicated either to the Son alone or to the Trinity."

The spot is still called Paraclet, near Nogent-sur-Seine, in the parish of Quincey about half-way between Fontainebleau and Troyes. The name Paraclet as applied to the Holy Ghost meant the Consoler, the Comforter, the Spirit of Love and Grace: as applied to the Oratory by Abélard it meant a renewal of his challenge to theologists, a separation of the Persons in the Trinity, a vulgarisation of the mystery; and, as his story frankly says, it was so received by many. The spot was not so remote but that his scholars could follow him and he invited them to do so. They came in great numbers and he lectured to them. "In body I was hidden in this spot; but my renown overran the whole world and filled it with my word." Undoubtedly Abélard taught theology, and, in defiance of the Council that had condemned him, attempted to define the persons of the Trinity. For this purpose he had fallen on a spot only fifty or sixty miles from Clairvaux where Bernard was inspiring a contrary spirit of religion; he placed himself on the direct line between Clairvaux and its source at Citeaux near Dijon; indeed, if he had sought for a spot as central as possible to the active movement of the church and the time, he could have hit on none more convenient and conspicuous unless it were the city of Troves itself, the capital of Champagne, some thirty miles away. The proof that he meant to be aggressive is furnished by his own account of the consequences. Two rivals, he says, one of whom seems to have been Bernard of Clairvaux, took the field against him, "and succeeded in exciting the hostility of certain ecclesiastical and secular authorities, by charging monstrous things not only against my faith but also against my manner of life to such a point as to detach from me some of my principal friends; even those who preserved some affection for me dared no longer display it, for fear. God is my witness that I never heard of the union of an ecclesiastical assembly without thinking that its object was my condemnation." The Church had good reason, for Abélard's conduct defied discipline; but far from showing harshness, the Church this time showed a true spirit of conciliation most creditable to Bernard. Deeply as the Cistercians disliked and distrusted Abélard they did not violently suppress him but tacitly consented to let the authorities buy his silence with Church patronage.

The transaction passed through Suger's hands and offered an ordinary example of political customs as old as history. An Abbey in Brittany became vacant; at a hint from the Duke Conan, which may well be supposed to have been suggested from Paris, the monks chose Abélard as their new Abbot, and sent some of their number to Suger to request permission for Abélard, who was a monk of Saint Denis, to become Abbot of Saint Gildas-de-Rhuys near Vannes in Brittany. Suger probably intimated to Abélard with a certain degree of authority, that he had better accept. Abélard "struck with terror, and as it were under the menace of a thunderbolt," accepted. Of course the dignity was in effect banishment and worse and was so understood on all sides. The Abbaye de Saint Gildasde-Rhuys, though less isolated than Mont Saint Michel, was not an agreeable winter residence. Though situated in Abélard's native province of Brittany, only sixty or eighty miles from his birthplace, it was for him a prison with the ocean around it and a singularly wild people to deal with; but he could have endured his lot with contentment, had not discipline or fear or pledge compelled him to hold his tongue. From 1125 when he was sent to Brittany until 1135 when he reappeared in Paris, he never opened his mouth to lecture. "Never, as God is my witness,-never would I have acquiesced in such an offer, had it not been to escape, no matter how, from the vexations with which I was incessantly overwhelmed."

A great career in the Church was thus opened for him against his will, and if he did not die an Archbishop it was not wholly the fault of the Church. Already he was a great prelate, the equal in rank of the Abbé Suger himself, of Saint Denis; of Peter the Venerable of Cluny; of Bernard of Clairvaux. He was in a manner a peer of the realm. Almost immediately he felt the advantages of the change. Barely two years passed when, in 1127, the Abbé Suger, in reforming his subordinate Abbey of Argenteuil, was obliged to disturb Héloïse, then a sister in that congregation. Abélard was warned of the necessity that his wife should be protected, and with the assistance of everyone concerned, he was allowed to establish his wife at the Paraclet as head of a religious sisterhood. "I returned there; I invited Héloïse to come there with the nuns of her community; and when they arrived, I made them the entire donation of the Oratory and its dependences. . . . The bishops cherished her as their daughter; the abbots as their sister; the laymen as their mother." This was merely the beginning of her favor and of his. For ten years they were

both of them petted children of the Church.

The formal establishment of Héloïse at the Paraclet took place in 1129. In February, 1130, on the death of the Pope at Rome, a schism broke out, and the cardinals elected two Popes, one of whom took the name of Innocent II and appealed for support to France. Suger saw a great political opportunity and used it. The heads of the French Church agreed in supporting Innocent, and the King summoned a Church Council at Etampes to declare its adhesion. The Council met in the late summer; Bernard of Clairvaux took the lead; Peter the Venerable, Suger of Saint Denis, and the Abbot of Saint Gildas-de-Rhuvs supported him; Innocent himself took refuge at Cluny in October, and on January 20, 1131, he stopped at the Benedictine Abbey of Morigny. The Chronicle of the Monastery, recording the Abbots present on this occasion: the Abbot of Morigny itself; of Feversham; of Saint Lucien of Beauvais, and so forth, added especially: - "Bernard of Clairvaux who was then the most famous pulpit orator in France; and Peter Abélard, Abbot of Saint Gildas, also a monk and the most eminent master of the schools to which the scholars of almost all the Latin races flowed."

Innocent needed popular support; Bernard and Abélard were the two leaders of popular opinion in France. To attach them, Innocent could refuse nothing. Probably Abélard remained with Innocent but in any case Innocent gave him, at Auxerre, in the following November, a diploma, granting to Héloïse, prioress of the Oratory of the Holy Trinity, all rights of property over whatever she might possess, against all assailants; which proves Abélard's favor. At this time he seems to have taken great interest in the new sisterhood. "I made them more frequent visits," he said, "in order to work for their benefit." He worked so earnestly for their benefit that he scandalized the neighborhood and had to argue at unnecessary length his innocence of evil. He went so far as to express a wish to take refuge among them and to abandon his Abbey in Brittany. He professed to stand in terror of his monks; he excommunicated them; they paid no attention to him; he appealed to the Pope, his friend, and Innocent sent a

special legate to enforce their submission "in presence of the Count and the Bishops."

Even since that, they would not keep quiet. And quite recently since the expulsion of those of whom I have spoken, when I returned to the Abbey, abandoning myself to the rest of the brothers who inspired me with less distrust, I found them even worse than the others. It was no longer a question of poison; it was the dagger that they now sharpened against my breast. I had great difficulty in escaping from them under the guidance of one of the neighboring lords. Similar perils menace me still and every day I see the sword raised over my head. Even at table I can hardly breathe. . . . This is the torture that I endure every moment of the day; I, a poor monk, raised to the prelacy, becoming more miserable in becoming more great, that by my example the ambitious may learn to curb their greed.

With this, the Story of Calamity ends. The allusions to Innocent II seem to prove that it was written not earlier than 1132; the confession of constant and abject personal fear suggests that it was written under the shock caused by the atrocious murder of the Prior of Saint Victor by the nephews of the arch-deacon of Paris who had also been subjected to reforms. This murder was committed a few miles outside of the walls of Paris, on August 20, 1133. The Story of Calamity is evidently a long plea for release from the restraints imposed on its author by his position in the prelacy and the tacit, or possibly the express, contract he had made, or to which he had submitted, in 1125. This plea was obviously written in order to serve one of two purposes:-either to be placed before the authorities whose consent alone could relieve Abélard from his restraints; - or to justify him in throwing off the load of the Church, and resuming the profession of schoolman. Supposing the second explanation, the date of the paper would be more or less closely fixed by John of Salisbury who coming to Paris as a student, in 1136, found Abélard lecturing on the Mont Sainte Geneviève; that is to say, not under the license of the Bishop of Paris or his Chancellor but independently, in a private school of his own, outside the walls. "I attached myself to the Palatine Peripatician who then presided on the hill of Sainte Geneviève, the doctor illustrious, admired by all. There, at his feet, I received the first elements

of the dialectic art, and according to the measure of my poor understanding I received with all the avidity of my soul every-

thing that came from his mouth."

This explanation is hardly reasonable, for no prelate who was not also a temporal lord would have dared throw off his official duties without permission from his superiors. In Abélard's case the only superior to whom he could apply, as Abbot of Saint Gildas in Brittany, was probably the Pope himself. In the year 1135 the moment was exceedingly favorable for asking privileges. Innocent, driven from Rome a second time, had summoned a Council at Pisa for May 30 to help him. Louis le Gros and his minister Suger gave at first no support to this Council, and were overruled by Bernard of Clairvaux who in a manner drove them into giving the French clergy permission to attend. The principal Archbishops, a number of Bishops, and sixteen Abbots went to Pisa in May, 1135, and some one of them certainly asked Innocent for favors on behalf of Abélard, which the Pope granted.

The proof is a papal bull, dated in 1136, in favor of Héloïse, giving her the rank and title of Abbess, accompanied by another giving to the Oratory of the Holy Trinity the rank and name of Monastery of the Paraclet, a novelty in Church tradition so extraordinary or so shocking that it still astounds churchmen. With this excessive mark of favor Innocent could have felt little difficulty in giving Abélard the permission to absent himself from his Abbey, and with this permission in his hands Abélard might have lectured on dialetics to John of Salisbury in the summer or autumn of 1136. He did not, as far

as known, resume lectures on theology.

Such success might have turned heads much better balanced than that of Abélard. With the support of the Pope and at least one of the most prominent Cardinals, and with relations at Court with the ministers of Louis le Gros, Abélard seemed to himself as strong as Bernard of Clairvaux, and a more popular champion of reform. The year 1137 which has marked a date for so many great points in our travels, marked also the moment of Abélard's greatest vogue. The victory of Aristotle and the pointed arch seemed assured when Suger effected the marriage of the young prince Louis to the heiress Eleanor of Guienne. The exact moment was stamped on the

façade of his exquisite creation, the Abbey church of Saint Denis, finished in 1140 and still in part erect. From Saint Denis to Saint Sulpice was but a step. Louis le Grand seems to stand close in succession to Louis le Gros.

Fortunately for tourists, the world, restless though it might be, could not hurry, and Abélard was to know of the pointed arch very little except its restlessness. Just at the apex of his triumph, August 1, 1137, Louis le Gros died. Six months afterwards the anti-pope also died, the schism ended, and Innocent II needed Abélard's help no more. Bernard of Clairvaux became Pope and King at once. Both Innocent and Louis le Jeune were in a manner his personal creations. The King's brother Henry, next in succession, actually became a monk at Clairvaux not long afterwards. Even the architecture told the same story, for at Saint Denis, though the arch might simulate a point, the old romanesque lines still assert as firmly as ever their spiritual control. The *flèche* that gave the façade a new spirit, was not added until 1215, which marks Abélard's error in terms of time.

Once arrived at power Bernard made short work of all that tried to resist him. During 1139 he seems to have been too busy or too ill to take up the affair of Abélard, but in March, 1140, the attack was opened in a formal letter from William of Saint Thierry who was Bernard's closest friend, bringing charges against Abélard before Bernard and the Bishop of Chartres. The charges were simple enough:—

Pierre Abélard seized the moment when all the masters of ecclesiastical doctrine have disappeared from the scene of the world, to conquer a place apart, for himself, in the schools, and to create there an exclusive domination. He treats Holy Scripture as though it were dialectics. It is a matter with him of personal invention and annual novelties. He is the censor and not the disciple of the faith; the corrector and not the imitator of the authorised masters.

In substance, this is all. The need of action was even simpler. Abélard's novelties were becoming a danger; they affected not only the Schools but also even the Curia at Rome. Bernard must act because there was no one else to act:—"this man fears you; he dreads you! if you shut your eyes, whom will he fear? . . . The evil has become too public to allow a

correction limited to amicable discipline and secret warning." In fact, Abélard's works were flying about Europe in every direction, and every year produced a novelty. One can still read them in M. Cousin's collected edition; among others, a volume on Ethics:- "Ethica, seu Scito teipsum;" on Theology in general, an Epitome: a "Dialogus inter Philosophum, Judaeum et Christianum;" and what was perhaps the most alarming of all, an abstract of quotations from standard authorities, on the principle of the parallel column, showing the fatal contradictions of the authorised masters, and entitled:-"Sic et Non!" Not one of these works but dealt with sacred matters in a spirit implying that the Essence of God was better understood by Pierre du Pallet than by the whole array of Bishops and Prelates in Europe! Had Bernard been fortunate enough to light upon the Story of Calamity, which must also have been in existence, he would have found there Abélard's own childlike avowal that he taught Theology because his scholars "said that they did not want mere words; that one can believe only what one understands; and that it is ridiculous to preach to others what one understands no better than they do." Bernard himself never charged Abélard with any presumption equal to this. Bernard said only that "he sees nothing as an enigma, nothing as in a mirror, but looks on everything face to face." If this had been all even Bernard could scarcely have complained. For several thousand years mankind has stared Infinity in the face without pretending to be the wiser; the pretention of Abélard was that, by his dialectic method, he could explain the Infinite, while all other theologists talked mere words; and by way of proving that he had got to the bottom of the matter, he laid down the ultimate law of the Universe as his starting-point: - "All that God does," he said, "he wills necessarily and does it necessarily; for his goodness is such that it pushes him necessarily to do all the good he can, and the best he can, and the quickest he can. . . . Therefore it is of necessity that God willed and made the world." Pure logic admitted no contingency; it was bound to be necessitarian or ceased to be logical; but the result, as Bernard understood it, was that Abélard's world, being the best and only possible, need trouble itself no more about God, or Church, or man.

Strange as the paradox seems, Saint Bernard and Lord Bacon, though looking at the world from opposite stand-points, agreed in this: - that the scholastic method was false and mischievous, and that the longer it was followed, the greater was its mischief. Bernard thought that because dialectics led wrong, therefore Faith led right. He saw no alternative, and perhaps in fact there was none. If he had lived a century later he would have said to Thomas Aguinas what he said to a schoolman of his own day: - "If you had once tasted true food,"-if you knew what true religion is, -- "how quick you would leave those Jew makers of books (literatoribus judaeis) to gnaw their crusts by themselves!" Locke or Hume might perhaps still have resented a little the "literator judaeus," but Faraday or Clerk-Maxwell would have expressed the same opinion with only the change of a word: - "If the twelfth century had once tasted true science, how quick they would have dropped Avicenna and Averroës!" Science admits that Bernard's disbelief in scholasticism was well-founded, whatever it may think of his reasons. The only point that remains is personal: - Which is the more sympathetic, Bernard or Abélard?

The Church feels no doubt, but is a bad witness. Bernard is not a character to be taken or rejected in a lump. He was many-sided, and even towards Abélard he showed more than one surface. He wanted no unnecessary scandals in the Church; he had too many that were not of his seeking. He seems to have gone through the forms of friendly negotiation with Abélard although he could have required nothing less than Abélard's submission and return to Brittany and silence; terms which Abélard thought worse than death. On Abélard's refusal, Bernard began his attack. We know, from the Story of Calamity, what Bernard's party could not have certainly known then,—the abject terror into which the very thought of a Council had for twenty years thrown Abélard whenever he was threatened with it; and in 1140 he saw it to be inevitable. He preferred to face it with dignity, and requested to be heard at a Council to meet at Sens in June. One cannot admit that he felt the shadow of a hope to escape. At the utmost he could have dreamed of nothing more than a hearing. Bernard's friends, who had a lively fear of his dialectics,

took care to shut the door on even this hope. The Council was carefully packed and overawed. The King was present; Archbishops, Bishops, Abbots, and other prelates by the score; Bernard acted in person as the prosecuting attorney; the public outside were stimulated to threaten violence. Abélard had less chance of a judicial hearing than he had at Soissons twenty years before. He acted with a proper sense of their dignity and his own by simply appearing and entering an appeal to Rome. The Council paid no attention to the appeal but passed to an immediate condemnation. His friends said that it was done after dinner; that when the volume of Abélard's Theology was produced and the clerk began to read it aloud, after the first few sentences the Bishops ceased attention, talked, joked, laughed, stamped their feet, got angry, and at last went to sleep. They were waked only to growl 'Damnamus-namus,' and so made an end. The story may be true, for all prelates, even in the twelfth century, were not Bernards of Clairvaux or Peters of Cluny; all drank wine, and all were probably sleepy after dinner; while Abélard's writings are, for the most part, exceedingly hard reading. The clergy knew quite well what they were doing; the judgment was certain long in advance, and the Council was called only to register it. Political trials were usually mere forms.

The appeal to Rome seems to have been taken seriously by Bernard, which is surprising unless the character of Innocent II inspired his friends with doubts unknown to us. Innocent owed everything to Bernard while Abélard owed everything to Innocent. The Pope was not in a position to alienate the French Church or the French king. To anyone who knows only what is now to be known, Bernard seems to have been sure of the Curia, yet he wrote in a tone of excitement as though he feared Abélard's influence there even more than at home. He became abusive; Abélard was a crawling viper, -a coluber tortuosus—who had come out of his hole,—egressus est de caverna sua, - and after the manner of a hydra. - in similitudinem hydrae, - after having one head cut off at Soissons, had thrown out seven more. He was a monk without rule; a prelate without responsibility; an abbot without discipline; "disputing with boys; conversing with women." The charges in themselves seem to be literally true and would not in some later centuries have been thought very serious; neither faith nor morals were impugned. On the other hand, Abélard never affected or aspired to be a Saint, while Bernard always affected to judge the acts and motives of his fellow-creatures from a stand-point of more than worldly charity. Bernard had no right to Abélard's vices; he claimed to be judged by a higher standard; but his temper was none of the best, and his pride was something of the worst; which gave to Peter the Venerable occasion for turning on him sharply with a rebuke that cut to the bone:—"You perform all the difficult religious duties," wrote Peter to the Saint who wrought miracles; "you fast; you watch; you suffer; but you will not endure the easy ones,—you do not love (non vis

levia ferre, ut diligas)."

This was the end of Abélard. Of course the Pope confirmed the judgment, and even hurried to do so in order that he might not be obliged to give Abélard a hearing. The judgment was not severe, as judgments went; indeed it amounted to little more than an order to keep silence, and as it happened, was never carried into effect. Abélard, at best a nervous invalid, started for Rome but stopped at Cluny, perhaps the most agreeable stopping place in Europe. Personally he seems to have been a favorite of Abbot Peter the Venerable whose love for Bernard was not much stronger than Abélard's or Suger's. Bernard was an excessively sharp critic and spared worldliness, or what he thought lack of spirituality, in no prelate whatever; Clairvaux existed for nothing else, politically, than as a rebuke to them all, and Bernard's enmity was their bond of union. Under the protection of Peter the Venerable, the most amiable figure of the twelfth century, and in the most agreeable residence in Europe, Abélard remained unmolested at Cluny, occupied, as is believed, in writing or revising his Treatises, in defiance of the Council. He died there two years later, April 21, 1142, in full communion, still nominal Abbot of Saint Gildas, and so distinguished a prelate that Peter the Venerable thought himself obliged to write a charming letter to Héloïse at the Paraclet not far away, condoling with her on the loss of a husband who was the Socrates, the Aristotle, the Plato, of France and the west; who, if among logicians he had rivals, had no master; who was the prince of study, learned, eloquent, subtle, penetrating; who overcame everything by the force of reason, and was never so great as when he passed to true philosophy, that of Christ.

All this was in Latin verses, and seems sufficiently strong, considering that Abélard's philosophy had been so recently and so emphatically condemned by the entire Church, including Peter the Venerable himself. The twelfth century had this singular charm of liberty in practice, just as its architecture knew no mathematical formula of precision; but Peter's letter to Héloïse went further still, and rang with absolute passion:—

Thus, dear and venerable sister in God, he to whom you are united, after your tie in the flesh, by the better and stronger bond of the divine love; he, with whom, and under whom, you have served the Lord, the Lord now takes, in your place, like another you, and warms in His bosom; and, for the day of His coming, when shall sound the voice of the archangel and the trumpet of God descending from Heaven, He keeps him to restore him to you by His Grace.

XV

The Mystics

THE SCHOOLMEN of the twelfth century thought they could reach God by reason; the Council of Sens, guided by Saint Bernard, replied that the effort was futile and likely to be mischievous. The Council made little pretence of knowing or caring what method Abélard followed; they condemned any effort at all on that line; and no sooner had Bernard silenced the Abbot of Saint Gildas for innovation. than he turned about and silenced the Bishop of Poitiers for conservatism. Neither in the twelfth nor in any other century could three men have understood alike the meaning of Gilbert de la Porée, who seems to one high authority unworthy of notice, and to another, worthy of an elaborate but quite unintelligible commentary. Where M. Rousselet and M. Hauréau judge so differently of a voluminous writer, the Council at Reims which censured Bishop Gilbert in 1148 can hardly have been clear in mind. One dare hasard no more than a guess at Gilbert's offence, but the guess is tolerably safe that he, like Abélard, insisted on discussing and analysing the Trinity. Gilbert seems to have been a rigid Realist, and he reduced to a correct syllogism the idea of the ultimate substance—God. To make Theology a system capable of scholastic definition he had to suppose, behind the active deity, a passive abstraction or Absolute Substance without attributes; and then the Attributes, - Justice, Mercy, and the rest, -fell into rank as secondary substances. "Formam dei divinitatem appellant." Bernard answered him by insisting with his usual fiery conviction that the Church should lay down the law, once for all, and inscribe it with iron and diamond, that Divinity—Divine Wisdom—is God. In philosophy and science the question seems to be still open. Whether anything ultimate exists, - whether Substance is more than a complex of elements,—whether the "Thing in itself" is a reality or a name, is a question that Faraday and Clerk-Maxwell seem to answer as Bernard did, while Haeckel answers it as Gilbert did; but in Theology even a heretic wonders how a doubt

was possible. The Absolute Substance behind the attributes

seems to be pure Spinoza.

This supposes that the heretic understands what Gilbert or Haeckel meant, which is certainly a mistake; but it is possible that he may see in part what Bernard meant and this is enough if it is all. Abélard's Necessitarianism and Gilbert's Spinozism, if Bernard understood them right, were equally impossible Theology, and the Church could by no evasion escape the necessity of condemning both. Unfortunately, Bernard could not put his foot down so roughly on the Schools without putting it on Aristotle as well; and, for at least sixty years after the Council of Reims, Aristotle was either tacitly or expressly prohibited. One cannot stop to explain why Aristotle himself would have been first to forbid the teaching of what was called by his name in the middle ages; but you are bound to remember that this period between 1140 and 1200 was that of transition architecture and art. One must go to Noyon, Soissons and Laon to study the Church that trampled on the Schools; one must recall how the peasants of Normandy and the Chartrain were crusading for the Virgin in 1145, and building her flèches at Chartres and Saint Pierre-sur-Dives while Bernard was condemning Gilbert at Reims in 1148; we must go to the poets to see what they all meant by it; but the sum is an emotion—clear and strong as love and much clearer than logic, - whose charm lies in its unstable balance. The Transition is the equilibrium between the Love of God, -which is Faith, and the Logic of God, -which is Reason; between the round arch and the pointed. One may not be sure which pleases most, but one need not be harsh towards people who think that the moment of balance is exquisite. The last and highest moment is seen at Chartres where, in 1200, the charm depends on the constant doubt whether emotion or science is uppermost. At Amiens, doubt ceases; emotion is trained in school; Thomas Aquinas reigns.

Bernard of Clairvaux and Thomas of Aquino were both artists,—very great artists, if the Church pleases,—and one need not decide which was the greater; but between them is a region of pure emotion,—of poetry and art,—which is more interesting than either. In every age man has been apt to dream uneasily, rolling from side to side, beating against

imaginary bars, unless tired out he has sunk into indifference or scepticism. Religious minds prefer scepticism. The true saint is a profound sceptic; a total disbeliever in human reason, who has more than once joined hands on this ground with some who were at best sinners. Bernard was a total disbeliever in scholasticism; so was Voltaire. Bernard brought the society of his time to share his scepticism but could give the society no other intellectual amusement to relieve its restlessness. His crusade failed; his ascetic enthusiasm faded; God came no nearer. If there was in all France, between 1140 and 1200, a more typical Englishman of the future Church of England type than John of Salisbury, he has left no trace; and John wrote a description of his time which makes a picturesque contrast with the picture painted by Abélard, his old master, of the century at its beginning. John weighed Abélard and the Schools against Bernard and the Cloister, and coolly concluded that the way to truth led rather through Citeaux, which brought him to Chartres as Bishop in 1176, and to a mild scepticism in faith. "I prefer to doubt," he said, "rather than rashly define what is hidden." The battle with the Schools had then resulted only in creating three kinds of sceptics:—the disbelievers in human reason; the passive agnostics; and the sceptics proper who would have been atheists had they dared. The first class was represented by the School of Saint Victor; the second by John of Salisbury himself; the third, by a class of schoolmen whom he called Cornificii, as though they made a practice of inventing horns of dilemma on which to fix their opponents; as, for example, they asked whether a pig which was led to market, was led by the man or the cord. One asks instantly: - What cord? whether Grace, for instance, or Free Will?

Bishop John used the science he had learned in the School only to reach the conclusion that, if philosophy were a science at all, its best practical use was to teach Charity,—love. Even the early, superficial debates of the schools in 1100–1150, had so exhausted the subject that the most intelligent men saw how little was to be gained by pursuing further those lines of thought. The twelfth century had already reached the point where the seventeenth century stood when Descartes renewed the attempt to give a solid, philosophical basis for deism by

his celebrated: - Cogito, ergo sum. Although that ultimate fact seemed new to Europe when Descartes revived it as the starting-point of his demonstration, it was as old and familiar as Saint Augustine to the twelfth century, and as little conclusive as any other assumption of the Ego or the Non-ego. The schools argued, according to their tastes, from Unity to Multiplicity or from Multiplicity to Unity; but what they wanted was to connect the two. They tried Realism and found that it led to Pantheism. They tried Nominalism and found that it ended in Materialism. They attempted a compromise in Conceptualism which begged the whole question. Then they lay down, exhausted. In the seventeenth century the same violent struggle broke out again, and wrung from Pascal the famous outcry of despair in which the French language rose, perhaps for the last time, to the grand style of the twelfth century. To the twelfth century it belongs; to a century of faith and simplicity; not to the mathematical certainties of Descartes and Leibnitz and Newton, or to the mathematical abstractions of Spinoza. Descartes had proclaimed his famous conceptual proof of God: "I am conscious of myself, and must exist; I am conscious of God, and he must exist." Pascal wearily replied that it was not God he doubted, but logic. He was tortured by the impossibility of rejecting man's reason by reason; unconsciously sceptical, he forced himself to disbelieve in himself rather than admit a doubt of God. Man had tried to prove God, and had failed: - "The metaphysical proofs of God are so remote (éloignées) from the reasoning of men, and so contradictory (impliquées, far-fetched,) that they make little impression; and even if they served to convince some people, it would only be during the instant that they see the demonstration; an hour afterwards they fear to have deceived themselves." Moreover this kind of proof could lead only to a speculative knowledge, and to know God only in that way was not to know him at all. The only way to reach God was to deny the value of reason, and to deny reason was scep-

En voyant l'aveuglement et la misère de l'homme et ces contrariétés étonnantes qui se découvrent dans sa nature; et When I see the blindness and misery of man and the astonishing contradictions revealed in his nature; and observe

regardant tout l'univers muet, et l'homme sans lumière, abandonné à lui-même et comme égaré dans ce recoin de l'univers, sans savoir qui l'y a mis, ce qu'il y est venu faire, ce qu'il deviendra en mourant; j'entre en effroi comme un homme qu'on aurait porté endormi dans une ile déserte et effroyable, et qui s'éveillerait sans connaître où il est et sans avoir aucun moyen d'en sortir. Et sur cela j'admire comment on n'entre pas en désespoir d'un si misérable état. Je vois d'autres personnes auprès de moi de semblable nature, et je leur demande s'ils sont mieux instruits que moi, et ils me disent que non. Et sur cela, ces misérables égarés, ayant regardé autour d'eux, et ayant vu quelques objets plaisants, s'y sont dounés et s'y sont attachés. Pour moi je n'ai pu m'y arrêter ni me reposer dans la société de ces personnes, en tout semblables à moi, misérables comme moi, impuissants comme moi. Je vois qu'ils ne m'aideraient pas à mourir; je mourrai seul; il faut donc faire comme si j'étais seul: or, si j'étais seul, je ne bâtirais pas des maisons; je ne m'embarrasserais point dans des occupations tumultuaires; je ne chercherais l'estime de personne, mais je tâcherais seulement à découvrir la vérité.

Ainsi, considérant combien il y a d'apparence qu'il y a autre chose que ce que je vois, j'ai recherché si ce Dieu dont tout le monde parle n'aurait pas laissé quelques marques de lui. Je regarde de toutes parts et ne vois partout qu' obscurité. La nature ne m'offre rien que ne soit matière de doute et d'inquiétude. Si je n'y voyais rien qui marquât une divinité, je me déterminerais à n'en rien croire. Si je voyais partout les marques d'un Créateur, je me reposerais en paix dans la foi. Mais voyant trop pour nier, et trop peu pour m'assurer, je suis dans un état à plaindre, et où j'ai souhaité cent fois que si un Dieu soutient la nature, elle le marquât sans équivoque; et que si les marques qu' elle en donne sont trompeuses, elle les supprimât tout à fait; qu'elle dit tout ou rien, afin que je visse quel parti je dois suivre.

the whole universe mute, and man without light, abandoned to himself, as though lost in this corner of the universe, without knowing who put him here, or what he has come here to do, or what will become of him in dying; I feel fear like a man who has been carried when asleep into a desert and fearful island, and has waked without knowing where he is and without having means of rescue. And thereupon I wonder how man escapes despair at so miserable an estate. I see others about me, like myself, and I ask them if they are better informed than I, and they tell me no. And then these wretched wanderers, after looking about them and seeing some pleasant object, have given themselves up and attached themselves to it. As for me, I cannot stop there, or rest in the company of these persons, wholly like myself, miserable like me, impotent like me. I see that they would not help me to die; I shall die alone; I must then act as though alone; but if I were alone I should not build houses; I should not fret myself with bustling occupations; I should seek the esteem of no one, but I should try only to discover the truth.

So, considering how much appearance there is that something exists other than what I see, I have sought whether this God of whom everyone talks may not have left some marks of himself. I search everywhere, and see only obscurity everywhere. Nature offers me nothing but matter of possible doubt and disquiet. If I saw there nothing to mark a divinity, I should make up my mind to believe nothing of it. If I saw everywhere the marks of a Creator, I should rest in peace in faith. But seeing too much to deny, and too little to affirm, I am in a pitiable state, where I have an hundred times wished that, if a God supports nature, she would show it without equivocation; and that, if the marks she gives are deceptive, she would suppress them wholly; that she say all or nothing, that I may see my path.

This is the true Prometheus lyric, but when put back in its place it refuses to rest at Port Royal which has a right to nothing but precision; it has but one real home—the Abbaye-de-Saint-Victor. The mind that recoils from itself can only commit a sort of ecstatic suicide; it must absorb itself in God; and in the bankruptcy of twelfth-century science the western Christian seemed actually on the point of attainment; he, like Pascal, touched God behind the veil of scepticism.

The schools had already proved one or two points which need never have been discussed again. In essence, religion was love; in no case was it logic. Reason can reach nothing except through the senses; God, by essence, cannot be reached through the senses; if he is to be known at all, he must be known by contact of spirit with spirit, essence with essence; directly; by emotion; by ecstasy; by absorption of our existence in his; by substitution of his spirit for ours. The world had no need to wait five hundred years longer in order to hear this same result reaffirmed by Pascal. Saint Francis of Assisi had affirmed it loudly enough, even if the voice of Saint Bernard had been less powerful than it was. The Virgin had asserted it in tones more gentle, but anyone may still see how convincing, who stops a moment to feel the emotion that lifted her wonderful Chartres spire up to God. The Virgin, indeed, made all easy, for it was little enough she cared for reason or logic. She cared for her baby, a simple matter, which any woman could do and understand. That, and the grace of God, had made her Queen of Heaven. The Trinity had its source in her, - totius Trinitatis nobile Triclinium, and she was Maternity. She was also poetry and art. In the bankruptcy of Reason, she alone was real.

So Guillaume de Champeaux, half a century dead, came to life again in another of his creations. His own Abbey of Saint Victor, where Abélard had carried on imaginary disputes with him, became the dominant school. As far as concerns its logic we had best pass it by. The Victorians needed logic only to drive away logicians, which was hardly necessary after Bernard had shut up the schools. As for its mysticism, all training is much alike in idea, whether one follows the six degrees of contemplation taught by Richard of Saint Victor, or the

eightfold noble way taught by Gautama Buddha. The theology of the school was still less important, for the Victorians contented themselves with orthodoxy only in the sense of caring as little for dogma as for dialectics; their thoughts were fixed on higher emotions. Not Richard the teacher, but Adam the poet, represents the school to us, and when Adam dealt with dogma he frankly admitted his ignorance and hinted his indifference; he was, as always, conscientious; but he was not always, or often, as cold. His statement of the Trinity is a marvel; but two verses of it are enough:—

Digne loqui de personis
Vim transcendit rationis,
Excedit ingenia.
Quid sit gigni, quid processus,
Me nescire sum professus,
Sed fide non dubia.

Qui sic credit, non festinet, Et a via non declinet Insolenter regia. Servet fidem, formet mores, Nec attendat ad errores Quos damnat Ecclesia. Of the Trinity to reason
Leads to license or to treason
Punishment deserving.
What is birth and what procession
Is not mine to make profession,
Save with faith unswerving.

Thus professing, thus believing, Never insolently leaving The highway of our faith, Duty weighing, law obeying, Never shall we wander straying Where heresy is death.

Such a school took natural refuge in the Holy Ghost and the Virgin,—Grace and Love,—but the Holy Ghost, as usual, profited by it much less than the Virgin. Comparatively little of Adam's poetry is expressly given to the Saint Esprit, and too large a part of this has a certain flavor of dogma:—

Qui procedis ab utroque Genitore Genitoque Pariter, Paraclite!

Amor Patris Filiique Par amborum et utrique Compar et consimilis! The Holy Ghost is of the Father and of the Son; neither made nor created nor begotten, but proceeding.

The whole three Persons are co-eternal together; and co-equal.

This sounds like a mere versification of the Creed, yet when Adam ceased to be dogmatic and broke into true prayer, his verse added a lofty beauty even to the Holy Ghost; a beauty too serious for modern rhyme:—

Oh, juvamen oppressorum,
Oh, solamen miserorum,
Pauperum refugium,
Da contemptum terrenorum!
Ad amorem supernorum
Trahe desiderium!

Consolator et fundator, Habitator et amator, Cordium humilium, Pelle mala, terge sordes, Et discordes fac concordes, Et affer præsidium! Oh, helper of the heavy-laden,
Oh, solace of the miserable,
Of the poor, the refuge,
Give contempt of earthly pleasures!
To the love of heavenly treasures
Lift our hearts' desire!

Consolation and foundation,
Dearest friend and habitation
Of the lowly-hearted,
Dispel our evil, cleanse our foulness,
And our discords turn to concord,
And bring us succor!

Adam's scholasticism was the most sympathetic form of mediæval philosophy. Even in prose, the greatest writers have not often succeeded in stating simply and clearly the fact that Infinity can make itself finite or that Space can make itself bounds or that Eternity can generate time. In verse, Adam did it as easily as though he were writing any other miracle,—as Gaultier de Coincy told the Virgin's,—and anyone who thinks that the task was as easy as it seems, has only to try it and see whether he can render into a modern tongue any single word which shall retain the whole value of the word which Adam has chosen;—

Ne periret homo reus Redemptorem misit Deus, Pater unigenitum; Visitavit quos amavit Nosque vitae revocavit Gratia non meritum.

Infinitus et Immensus,
Quem non capit ullus sensus
Nec locorum spatia,
Ex eterno temporalis,
Ex immenso fit localis,
Ut restauret omnia.

To death condemned by awful sentence, God recalled us to repentance, Sending his only Son; Whom he loved he came to cherish; Whom his justice doomed to perish, By grace to life he won.

Infinity, Immensity,
Whom no human eye can see
Or human thought contain,
Made of Infinity a space,
Made of Immensity a place,
To win us Life again.

The English verses, compared with the Latin, are poor enough, with the canting jingle of a cheap religion and a thin philosophy, but by contrast and comparison they give higher value to the Latin. One feels the dignity and religious quality

of Adam's chants the better for trying to give them an equivalent. One would not care to hasard such experiments on poetry of the highest class like that of Dante and Petrarch, but Adam was conventional both in verse and thought, and aimed at obtaining his effects from the skilful use of the Latin sonorities for the purposes of the chant. With dogma and metaphysics he dealt boldly and even baldly as he was required to do, and successfully as far as concerned the ear or the voice; but poetry was hardly made for dogma; even the Trinity was better expressed mathematically than by rhythm. With the stronger emotions, such as terror, Adam was still conventional and showed that he thought of the chant more than of the feeling and exaggerated the sound beyond the value of the sense. He could never have written the Dies Irae. He described the shipwreck of the soul in magnificent sounds without rousing an emotion of fear; the raging waves and winds that swept his bark past the abysses and up to the sky were as conventional as the sirens, the dragons, the dogs and the pirates that lay in wait. The mast nodded as usual; the sails were rent; the sailors ceased work; all the machinery was classical; only the prayer to the Virgin saved the poetry from sinking like the ship; and yet, when chanted, the effect was much too fine to bear translation: -

> Ave, Virgo singularis, Mater nostri Salutaris, Quae vocaris Stella Maris, Stella non erratica; Nos in hujus vitae mari Non permitte naufragari, Sed pro nobis Salutari Tuo semper supplica!

Saevit mare, fremunt venti, Fluctus surgunt turbulenti; Navis currit, sed currenti Tot occurrunt obvia! Hic sirenes voluptatis, Draco, canes cum piratis, Mortem pene desperatis Haec intentant omnia. Post abyssos, nunc ad cœlum Furens unda fert phaselum; Nutat malus, fluit velum, Nautae cessat opera; Contabescit in his malis Homo noster animalis; Tu nos, Mater spiritalis, Pereuntes libera!

Finer still is the famous stanza sung at Easter, in which Christ rises, the lion of Juda, in the crash of the burst gates of death, at the roar of the father lion:—

Sic de Juda, leo fortis, Fractis portis dirae mortis, Die surgens tertia, Rugiente voce patris Ad supernae sinum matris Tot revexit spolia.

For terror or ferocity or images of pain, the art of the twelfth century had no use except to give a higher value to their images of love. The figures on the west Portal of Chartres are alive with the spirit of Adam's poetry, but it is the spirit of the Virgin. Like Saint Bernard, Adam lavished his affections on Mary, and even more than Saint Bernard he could claim to be her poet-laureate. Bernard was not himself author of the hymn "Stella Maris" which brought him the honor of the Virgin's personal recognition, but Adam was author of a dozen hymns in which her perfections were told with equal fervor, and which were sung at her festivals. Among these was the famous:—

Salve, Mater Pietatis, Et totius Trinitatis Nobile Triclinium!

a compliment so refined and yet so excessive that the Venerable Thomas Cantimpratensis who died a century later, about 1280, related in his "Apiarium" that when "venerabilis Adam" wrote down these lines, Mary herself appeared to him and bent her head in recognition. Although the manuscripts do not expressly mention this miracle, they do contain, at that

stanza, a curious note expressing an opinion apparently authorized by the Prior, that, if the Virgin had seen fit to recognize the salutation of the Venerable Adam in this manner, she would have done only what he merited: "ab ea resalutari et regratiari meruit."

Adam's poems are still on the shelves of most Parisian bookshops, as common as Aucassins and better known than much poetry of our own time; for the mediæval Latin rhymes have a delightful sonority and simplicity that keep them popular because they were not made to be read but to be sung. One does not forget their swing:—

Infinitus et Immensus;

or:-

Oh, juvamen oppressorum;

or:-

Consolatrix miserorum Suscitatrix mortuorum,

The organ rolls through them as solemnly as ever it did in the Abbey Church; but in mediæval art so much more depends on the mass than on the measure, - on the dignity than on the detail,—that equivalents are impossible. Even Walter Scott was content to translate only three verses of the Dies Irae. At best, Viollet-le-Duc could reproduce only a sort of modern Gothic; a more or less effaced or affected echo of a lost emotion which the world never felt but once and never could feel again. Adam composed a number of hymns to the Virgin, and, in them all, the feeling counts for more, by far, than the sense. Supposing we choose the simplest and try to give it a modern version aiming to show, by comparison, the difference of sound; one can perhaps manage to recover a little of the simplicity, but give it the grand style one cannot; or, at least, if anyone has ever done both, it is Walter Scott, and merely by placing side by side the Dies Irae and his translation of it, one can see at a glance where he was obliged to sacrifice simplicity only to obtain sound:-

Dies irae, dies illa, Solvet seclum in favilla, Teste David cum Sibylla.

That day of wrath, that dreadful day, When heaven and earth shall pass away, What power shall be the sinner's stay? How shall he meet that dreadful day? Quantus tremor est futurus, Quando judex est venturus, Cuncta stricte discussurus!

Tuba mirum spargens sonum Per sepulchra regionum, Coget omnes ante thronum. When shrivelling like a parched scroll The flaming heavens together roll; When louder yet and yet more dread Swells the high trump that wakes the dead.

As translation the last line is artificial.

The Dies Irae does not belong in spirit, to the twelfth century; it is sombre and gloomy like the Last Judgments on the thirteenth century portals; it does not love. Adam loved. His verses express the Virgin; they are graceful, tender, fervent, and they hold the same dignity which cannot be translated:—

In hac valle lacrimarum Nihil dulce, nihil carum, Suspecta sunt omnia; Quid hic nobis erit tutum, Cum nec ipsa vel virtutum Tuta sit victoria!

Caro nobis adversatur, Mundus carni suffragatur In nostram perniciem; Hostis instat, nos infestans, Nunc se palam manifestans, Nunc occultans rabiem.

Et peccamus et punimur, Et diversis irretimur Laqueis venantium. O Maria, mater Dei, Tu, post Deum, summa spei, Tu dulce refugium;

Tot et tantis irretiti, Non valemus his reniti Ne vi nec industria; Consolatrix miserorum, Suscitatrix mortuorum, Mortis rompe retia! In this valley full of tears,
Nothing softens, nothing cheers,
All is suspected lure;
What safety can we hope for, here,
When even virtue faints for fear
Her victory be not sure!

Within, the flesh a traitor is,
Without, the world encompasses,
A deadly wound to bring.
The foe is greedy for our spoils,
Now clasping us within his coils,
Or hiding now his sting.

We sin, and penalty must pay,
And we are caught, like beasts of prey,
Within the hunter's snares.
Nearest to God! oh Mary Mother!
Hope can reach us from none other,
Sweet refuge from our cares;

We have no strength to struggle longer, For our bonds are more and stronger Than our hearts can bear! You who rest the heavy-laden, You who lead lost souls to Heaven, Burst the hunter's snare!

The art of this poetry of love and hope which marked the mystics, lay of course in the background of shadows which marked the cloister. "Inter vania nihil vanius est homine." Man is an imperceptible atom always trying to become one with God. If ever modern science achieves a definition of En-

ergy, possibly it may borrow the figure:—Energy is the inherent effort of every multiplicity to become unity. Adam's poetry was an expression of the effort to reach absorption through love, not through fear, but to do this thoroughly he had to make real to himself his own nothingness; most of all, to annihilate pride, for the loftiest soul can comprehend that an atom—say, of hydrogen,—which is proud of its personality, will never merge in a molecule of water. The familiar verse: "Oh, why should the spirit of mortal be proud?" echoes Adam's epitaph to this day:—

Haeres peccati, natura filius irae, Exiliique reus nascitur omnis homo. Unde superbit homo, cujus conceptio culpa, Nasci poena, labor vita, necesse mori? Heir of sin, by nature son of wrath,
Condemned to exile, every man is born.
Whence is man's pride, whose conception
fault,
Birth pain, life labor, and whose death is

Four concluding lines, not by him, express him even better:—

Hic ego qui jaceo, miser et miserabilis Adam, Unam pro summo munere posco precem. Peccavi, fateor; veniam peto; parce fatenti; Parce, pater: fratres, parcite; parce, Deus!

One does not conceive that Adam insisted so passionately on his sins because he thought them—or himself—important before the Infinite. Chemistry does not consider an atom of oxygen as in itself important, yet if it wishes to get a volume of pure gas it must separate the elements. The human soul was an atom that could unite with God only as a simple element. The French mystics showed in their mysticism the same French reasonableness; the sense of measure, of logic, of science; the allegiance to form; the transparency of thought, which the French mind has always shown on its surface like a shell of nacre. The mystics were in substance rather more logical than the schoolmen and much more artistic in their correctness of line and scale. At bottom, French saints were not extravagant. One can imagine a Byzantine asserting that no French saint was ever quite saintly. Their aims and ideals were very high, but not beyond reaching and not unreasonable. Drag the French mind as far from line and logic as space

permits, the instant it is freed it springs back to the classic and tries to look consequent.

This paradox, that the French mystics were never mystical. runs through all our travels, so obstinately recurring in architecture, sculpture, legend, philosophy, religion and poetry. that it becomes tiresome; and yet it is an idea that, in spite of Matthew Arnold and many other great critics, never has got lodgment in the English or German mind, and probably never will. Everyone who loves travel will hope that it never may. If you are driven to notice it as the most distinctive mark of French art, it is not at all for the purpose of arguing a doubtful law but only in order to widen the amusement of travel. We set out to travel from Mont Saint Michel to Chartres, and no further; there we stop; but we may still look across the boundary to Assisi for a specimen of Italian Gothic architecture, a scheme of color decoration, or still better for a mystic to compare with the Bernadines and Victorians, Everyone who knows anything of religion knows that the ideal mystic Saint of western Europe was Francis of Assisi, and that Francis, though he loved France, was as far as possible from being French; though not in the least French, he was still the finest flower from the French mediæval garden; and though the French mystics could never have understood him, he was what the French mystics would have liked to be or would have thought they liked to be as long as they knew him to be not one of themselves. As an Italian or as a Spaniard, Francis was in harmony with his world; as a Frenchman he would have been out of place even at Clairvaux and still more among his own Cordeliers at the doors of the Sorbonne.

Francis was born in 1186, at the instant when French art was culminating, or about to culminate, in the new cathedrals of Laon and Chartres, on the ruins of scholastic religion and in the full summer of the Courts of Love. He died in 1226, just as Queen Blanche became Regent of France and when the Cathedral of Beauvais was planned. His life precisely covered the most perfect moment of art and feeling in the thousand years of pure and confident Christianity. To an emotional nature like his, life was still a phantasm or "concept" of crusade against real or imaginary enemies of God,

with the Chanson de Roland for a sort of Evangel, and a feminine ideal for a passion. He chose for his mistress "domina nostra paupertas," and the rules of his Order of Knighthood were as visionary as those of Saint Bernard were practical. "Isti sunt fratres mei milites tabulae rotundae, qui latitant in desertis;" his Knights of the Round Table hid themselves for their training in deserts of poverty, simplicity, humility, innocence of self, absorption in nature, in the silence of God, and, above all, in love and joy incarnate, whose only influence was example. Poverty of body in itself mattered nothing; what Francis wanted was poverty of pride, and the external robe or the bare feet were outward and necessary forms of protection against its outward display. Against riches or against all external and visible vanity, rules and laws could be easily enforced if it were worth while, although the purest humility would be reached only by those who were indifferent and unconscious of their external dress; but against spiritual pride the soul is defenceless, and of all its forms the subtlest and the meanest is pride of intellect. If "nostra domina paupertas" had a mortal enemy, it was not the pride beneath a scarlet robe but that in a schoolmaster's ferule, and of all schoolmasters the vainest and most pretentious was the scholastic philosopher. Satan was logic. Lord Bacon held much the same opinion. "I reject the syllogism," was the starting-point of his teaching as it was the essence of Saint Francis, and the reasons of both men were the same though their action was opposite. "Let men please themselves as they will in admiring and almost adoring the human mind, this is certain: - that, as an uneven mirror distorts the rays of objects according to its own figure and section, so the mind . . . cannot be trusted . . ." Bacon's first object was the same as that of Francis, to humiliate and if possible destroy the pride of human reason; both of them knew that this was their most difficult task, and Francis, who was charity incarnate, lost his self-control whenever he spoke of the schools, and became almost bitter, as though in constant terror of a poison or a cancer. "Praeodorabat etiam tempora non longe ventura in quibus jam praesciebat scientiam inflativam debere esse occasionem ruinae." He foresaw the time not far off when puffedup science would be the ruin of his "domina paupertas." His

struggle with this form of human pride was desperate and tragical in its instant failure. He could not make even his novices understand what he meant. The most impossible task of the mind is to reject in practice the reflex action of itself, as Bacon pointed out, and only the highest training has sometimes partially succeeded in doing it. The schools—ancient, mediæval or modern—have almost equally failed, but even the simple rustics who tried to follow Francis could not see why the rule of poverty should extend to the use of a psalter. Over and over again he explained, vehemently and dramatically as only an Italian or a Spaniard could, and still they failed to catch a notion of what he meant:—

Quum ergo venisset beatus Franciscus ad locum ubi erat ille novitius, dixit ille novitius: - 'Pater, mihi esset magna consolatio habere psalterium, sed licet generalis illud mihi concesserit, tamen vellem ipsum habere, pater, de conscientia tua.' Cui beatus Franciscus respondit: - 'Carolus imperator, Rolandus et Oliverus et omnes palatini et robusti viri qui potentes fuerunt in proelio, prosequendo infideles cum multa sudore et labore usque ad mortem, habuerunt de illis victoriam memorialiter, et ad ultimum ipsi sancti martyres sunt mortui pro fide Christi in certamine. Nunc autem multi sunt qui sola narratione eorum quae illi fecerunt volunt recipere honorem et humanam laudem. Ita et inter nos sunt multi qui solum recitando et praedicando opera quae sancti fecerunt volunt recipere honorem et laudem;' . . . 'postquam habueris psalterium, concupisces et volueris habere breviarium; et postquam habueris breviarium, sedebis in cathedra tanquam magnus prelatus et dices fratri tuo:-Apporta mihi breviarium!'

Haec autem dicens beatus Franciscus cum magno fervore spiritus accepit de cinere et posuit super caput suum, et ducendo manum super caput suum in circuitu sicut ille qui lavat caput, dicebat:—'Ego breviarium!', et sic reiteravit multoties ducendo manum per caput. Et stupefactus et verecundatus est frater ille. . . . Elapsis autem pluribus

So when Saint Francis happened to come to the place where the novice was, the novice said: - 'Father, it would be a great comfort to me to have a psalter, but though my general should grant it, still I would rather have it, father, with your knowledge too.' Saint Francis answered: - 'The Emperor Charlemagne, Roland and Oliver and all the palatines and strong men who were potent in battle, pursuing the infidels with much toil and sweat even to death, triumphed over them memorably [without writing it?], and at last these holy martyrs died in the contest for the faith of Christ. But now there are many who, merely by telling of what those men did, want to receive honor and human praise. So too among us are many who, merely by reciting and preaching the works which the saints have done, want to receive honor and praise;' . . 'After you have got the psalter, you

will covet and want a breviary; and after getting the breviary you will sit on your throne like a bishop, and will say to your brother:—Bring me the breviary!

While saying this, Saint Francis with great vehemence took up a handful of ashes and spread it over his head; and moving his hand about his head in a circle as though washing it, said:—'I, breviary!' I, breviary!', and so kept on, repeatedly moving his hand about his head; and stupefied and ashamed was that novice. . . . But several months afterwards

mensibus quum esset beatus Franciscus apud locum sanctae Mariae de Portiuncula, juxta cellam post domum in via, praedictus frater iterum locutus est ei de psalterio. Cui beatus Franciscus dixit:-Vade et facias de hoc sicut dicet tibi minister tuus!' Ouo audito, frater ille coepit redire per viam unde venerat. Beatus autem Franciscus remanens in via coepit considerare illud quod dixerat illi fratri, et statim clamavit post eum. dicens: - 'Expecta me, frater! expecta!' Et ivit usque ad eum et ait illi:- 'Revertere mecum, frater, et ostende mihi locum ubi dixi tibi quod faceres de psalterio sicut diceret minister tuus.' Quum ergo pervenissent ad locum, beatus Franciscus genuflexit coram fratre illo, et dixit:-'Mea culpa, frater! mea culpa! quia quicunque vult esse frater Minor non debet habere nisi tunicam, sicut regula sibi concedit, et cordam et femoralia et qui manifesta necessitate coguntur calciamenta.

when Saint Francis happened to be near Sta Maria de Portiuncula, by the cell behind the house on the road, the same brother again spoke to him about the psalter. Saint Francis replied: - 'Go and do about it as your director says.' On this the brother turned back, but Saint Francis, standing in the road, began to reflect on what he had said, and suddenly called after him: - 'Wait for me, brother! wait!': and going after him, said: - 'Return with me, brother, and show me the place where I told you to do as your director should say, about the psalter.' When they had come back to it, Saint Francis bent before the brother, and said: - 'Mea culpa, brother, mea culpa! because whoever wishes to be a Minorite must have nothing but a tunic, as the rule permits, and the cord, and the loin-cloth, and what covering is manifestly necessary for the limbs.'

So vivid a picture of an actual mediaeval saint stands out upon this simple background as is hardly to be found elsewhere in all the records of centuries, but if the brother himself did not understand it and was so shamed and stupefied by Francis's vehemence, the world could understand it no better; the Order itself was ashamed of Saint Francis because they understood him too well. They hastened to suppress this teaching against science although it was the life of Francis's doctrine. He taught that the science of the schools led to perdition because it was puffed up with emptiness and pride. Humility, simplicity, poverty, were alone true science. They alone led to Heaven. Before the tribunal of Christ, the schoolmen would be condemned, "and, with their dark logic (opinionibus tenebrosis) shall be plunged into outer darkness with the spirits of the darkness." They were devilish, and would perish with the devils.

One sees instantly that neither Francis of Assisi nor Bacon of Verulam could have hoped for peace with the Schools; twelfth-century ecstasy felt the futility of mere rhetoric quite as keenly as seventeenth-century scepticism was to feel it; and yet when Francis died in 1226 at Assisi, Thomas was just

being born at Aquino some two hundred kilometers to the southward. True scholasticism had not begun. Four hundred years seem long for the human mind to stand still-or go backward; the more because the human mind was never better satisfied with itself than when thus absorbed in its mirror: but with that chapter we have nothing to do. The pleasantest way to treat it was that of Saint Francis; half-serious, halfjesting; as though, after all, in the thought of infinity, four hundred years were at most only a serio-comic interlude. At Assisi, once, when a theologian attacked Fra Egidio by the usual formal arraignment in syllogisms, the brother waited until the conclusions were laid down, and then, taking out a flute from the folds of his robe, he played his answer in rustic melodies. The soul of Saint Francis was a rustic melody and the simplest that ever reached so high an expression. Compared with it, Theocritus and Virgil are as modern as Tennyson and ourselves.

All this shows only what Saint Francis was not; to understand what he was and how he goes with Saint Bernard and Saint Victor through the religious idyll of transition architecture, one must wander about Assisi with the Floretum or Fioretti in one's hand;—the legends which are the Gospel of Francis as the Evangels are the Gospel of Christ who was reincarnated in Assisi. We have given a deal of time to showing our own sceptical natures how simple the architects and decorators of Chartres were in their notions of the Virgin and her wants; but French simple-mindedness was already complex compared with Italian. The Virgin was human; Francis was elementary nature itself, like sun and air; he was Greek in his joy of life:—

... Recessit inde et venit inter Cannarium et Mevanium. Et respexit quasdam arbores juxta viam in quibus residebat tanta multitudo avium diversarum quod nunquam in partibus illis visa similis multitudo. In campo insuper juxta praedictas arbores etiam multitudiom maxima residebat. Quam multitudinem sanctus Franciscus respiciens et admirans, facto super eum Spiritu Dei, dixit sociis:—Vobis hic me in via exspectantibus, ibo et praedicabo sororibus nostris

He departed thence and came between Cannara and Bevagna; and near the road he saw some trees on which perched so great a number of birds as never in those parts had been seen the like. Also in the field beyond, near these same trees, a very great multitude rested on the ground. This multitude, Saint Francis seeing with wonder, the spirit of God descending on him he said to his companions:—'Wait for me on the road, while I go and preach to our sisters the little aviculis.' Et intravit in campum ad aves quae residebant in terra. Et statim quum praedicare incepit omnes aves in arboribus residentes descenderunt ad eum et simul cum aliis de campo immobiles permanserunt, quum tamen ipse inter eas iret plurimas tunica contingendo. Et nulla earum penitus movebatur, sicut recitavit frater Jacobus de Massa, sanctus homo, qui omnia supradicta habuit ab ore fratris Massei, qui fuit unus de iis qui tunc erant socii sancti patris.

Quibus avibus sanctus Franciscus ait:- 'Multum tenemini Deo, sorores meae aves, et debetis eum semper et ubique laudare propter liberum quem ubique habetis volatum, propter vestitum duplicatum et triplicatum, propter habitum pictum et ornatum, propter victum sine vestro labore paratum, propter cantum a Creatore vobis intimatum, propter numerum ex Dei benedictione multiplicatum, propter semen vestrum a Deo in arca reservatum, propter elementum aeris vobis deputatum. Vos non seminatis neque metitis, et Deus vos pascit; et dedit vobis flumina et fontes ad potandum, montes et colles, saxa et ibices ad refugium, et arbores altas ad nidificandum; et quum nec filare nec texere sciatis, praebet tam vobis quam vestris filiis necessarium indumentum. Unde multum diligit vos Creator qui tot beneficia contulit. Quapropter cavete, sorores meae aviculae, ni sitis ingratae sed semper laudare Deum studete.'

birds.' And he went into the field where the birds were on the ground. And as soon as he began to preach, all the birds in the trees came down to him and with those in the field stood quite still, even when he went among them touching many with his robe. Not one of them moved, as brother James of Massa related, a saintly man who had the whole story from the mouth of brother Masseo who was one of those then with the sainted father.

To these birds, Saint Francis said:-'Much are you bound to God, birds my sisters, and everywhere and always must you praise him, for the free flight you everywhere have; for the double and triple covering; for the painted and decorated robe; for the food prepared without your labor; for the song taught you by the Creator; for your number multiplied by God's blessing; for your seed preserved by God in the ark; for the element of air allotted to you. You neither sow nor reap, and God feeds you; and has given you rivers and springs to drink at, mountains and hills, rocks and wild goats for refuge, and high trees for nesting; and though you know neither how to spin nor to weave, he gives both you and your children all the garments you need. Whence much must the Creator love you, who confers so many blessings. Therefore take care, my small bird sisters, never to be ungrateful, but always strive to praise God.'

Fra Ugolino, or whoever wrote from the dictation of Brother James of Massa, after the tradition of Brother Masseo of Marignano, reported Saint Francis's sermon in absolute good faith as Saint Francis probably made it and as the birds possibly received it. All were God's creatures, brothers and sisters, and God alone knew or knows whether or how far they understand each other; but Saint Francis, in any case, understood them and believed that they were in sympathy with him. As far as the birds or wolves were concerned it was no great matter, but Francis did not stop with vertebrates or even with organic forms. "Nor was it surprising," said the

Speculum, "if fire and other creatures sometimes revered and obeyed him; for, as we who were with him very frequently saw, he held them in such affection and so much delighted in them, and his soul was moved by such pity and compassion for them, that he would not see them roughly handled, and talked with them with such evident delight as if they were rational beings:"—

Nam quadam vice, quum sederet juxta ignem, ipso nesciente, ignis invasit pannos ejus de lino, sive brachas, juxta genu, quumque sentiret calorem ejus nolebat ipsum extinguere. Socius autem ejus videns comburi pannos ejus cucurrit ad eum volens extinguere ignem; ipse vero prohibuit ei, dicens:- Noli, frater, carissime, noli male facere igni!' Et sic nullo modo voluit quod extingueret ipsum. Ille vero festinanter ivit ad fratrem qui erat guardianus ipsius, et duxit eum ad beatum Franciscum, et statim contra voluntatem beati Francisci, extinxit ignem. Unde quacunque necessitate urgente nunquam voluit extinguere ignem vel lampadem vel candelam, tantum pietate movebatur ad ipsum. Nolebat etiam quod frater projiceret ignem vel lignum fumigantem de loco ad locum sicut solet fieri, sed volebat ut plane poneret ipsum in terra ob reverentiam illius cujus est creatura.

For once when he was sitting by the fire, a spark, without his knowing it, caught his linen drawers and set them burning near the knee, and when he felt the heat he would not extinguish it; but his companion, seeing his clothes on fire, ran to put it out, and he forbade it, saving: -'Don't, my dearest brother, don't hurt the fire!' So he utterly refused to let him put it out, and the brother hurried off to get his guardian, and brought him to Saint Francis, and together they put out the fire at once against Saint Francis's will. So, no matter what the necessity, he would never put out fire or a lamp or candle, so strong was his feeling for it; he would not even let a brother throw fire or a smoking log from place to place, as is usual, but wanted it placed gently (piano) on the ground, out of respect for him whose creature it is.

The modern tourist, having with difficulty satisfied himself that Saint Francis acted thus in good faith, immediately exclaims that he was a heretic and should have been burned; but, in truth, the immense popular charm of Saint Francis, as of the Virgin, was precisely his heresies. Both were illogical and heretical by essence;—in strict discipline, in the days of the Holy Office, a hundred years later, both would have been burned by the Church, as Jeanne d'Arc was, with infinitely less reason, in 1431. The charm of the twelfth-century Church was that it knew how to be illogical—no great moral authority ever knew it better—when God himself became illogical. It cared no more than Saint Francis or Lord Bacon, for the syllogism. Nothing in twelfth-century art is so fine as the air and gesture of sympathetic majesty with which the Church

drew aside to let the Virgin and Saint Francis pass and take the lead—for a time. Both were human ideals too intensely realised to be resisted merely because they were illogical. The Church bowed and was silent.

This does not concern us. What the Church thought or thinks is its own affair, and what it chooses to call orthodox is orthodox. We have been trying only to understand what the Virgin and Saint Francis thought, which is matter of fact, not of faith. Saint Francis was even more outspoken than the Virgin. She calmly set herself above dogma, and, with feminine indifference to authority, overruled it. He, having asserted in the strongest terms the principle of obedience, paid no further attention to dogma, but, without the least reticence, insisted on practices and ideas that no Church could possibly permit or avow. Towards the end of his life, his physician cauterised his face for some neuralgic pain:—

Et posito ferro in igne pro coctura fienda, beatus Franciscus volens confortare spiritum suum ne pavesceret, sic locutus est ad ignem:—'Frater mi, ignis, nobilis et utilis inter alias creaturas, esto mihi curialis in hac hora quia olim te dilexi et diligam amore illius qui creavit te. Deprecor etiam creatorem nostrum qui nos creavit ut ita tuum calorem temperet ut ipsum sustinere valeam.' Et oratione finita signavit ignem signo crucis.

When the iron was put on the fire for making the cautery, Saint Francis, wishing to encourage himself against fear, spoke thus to the fire:—'My brother, fire, noblest and usefullest of creatures, be gentle to me now, because I have loved and will love you with the love of him who created you. Our Creator, too, who created us both, I implore so to temper your heat that I may have strength to bear it.' And having spoken, he signed the fire with the cross.

With him, this was not merely a symbol. Children and saints can believe two contrary things at the same time, but Saint Francis had also a complete faith of his own which satisfied him wholly. All nature was God's creature. The sun and fire, air and water, were neither more nor less brothers and sisters than sparrows, wolves and bandits. Even "daemones sunt castalli Domini nostri;" the devils are wardens of our Lord. If Saint Francis made any exception from his universal law of brotherhood it was that of the schoolmen, but it was never expressed. Even in his passionate outbreak, in the presence of Saint Dominic, at the great Chapter of his Order at Sta Maria de Portiuncula in 1218, he did not go quite to the length of denying the brotherhood of schoolmen although he

placed them far below the devils, and yet every word of this address seems to sob with the anguish of his despair at the power of the school anti-Christ:—

Ouum beatus Franciscus esset in capitulo generali apud Sanctam Mariam de Portiuncula . . . et fuerunt ibi quinque millia fratres, quamplures fratres sapientes et scientiati iverunt ad dominum Ostiensem qui erat ibidem, et dixerunt ei:-'Domine, volumus ut suadetis fratri Francisco quod sequatur consilium fratrum sapientium et permittat se interdum duci ab eis.' Et allegabant regulam sancti Benedicti, Augustini et Bernardi qui docent sic et sic vivere ordinate. Quae omnia quum retulisset cardinalis beato Francisco per modum admonitionis, beatus Franciscus, nihil sibi respondens, cepit ipsum per manum et duxit eum ad fratres congregatos in capitulo, et sic locutus est fratribus in fervore et virtute Spiritus sancti:-

'Fratres mei, fratres mei, Dominus vocavit me per viam simplicitatis et humilitatis, et hanc viam ostendit mihi in veritate pro me et pro illis qui volunt mihi credere et imitari. Et ideo volo quod non nominetis mihi aliquam regulam neque sancti Benedicti neque sancti Augustini neque sancti Bernardi, neque aliquam viam et formam vivendi praeter illam quae mihi a Domino est ostensa misericorditer et donata. Et dixit mihi Dominus quod volebat me esse unum pauperem et stultum idiotam [magnum fatuum] in hoc mundo et noluit nos ducere per viam aliam quam per istam scientiam. Sed per vestram scientiam et sapientiam Deus vos confundet et ego confido in castallis Domini [idest daemonibus] quod per ipsos puniet vos Deus et adhuc redibitis ad vestrum statum cum vituperio vestro velitis nolitis.'

When Saint Francis was at the General Chapter held at Sta Maria de Portiuncula ... and five thousand brothers were present, a number of them who were schoolmen went to Cardinal Hugolino who was there, and said to him: - 'My lord, we want you to persuade brother Francis to follow the council of the learned brothers, and sometimes let himself be guided by them.' And they suggested the Rule of Saint Benedict, or Augustine or Bernard who require their congregations to live so and so, by regulation. When the Cardinal had repeated all this to Saint Francis by way of counsel, Saint Francis, making no answer, took him by the hand and led him to the brothers assembled in Chapter, and in the fervor and virtue of the Holy Ghost, spoke thus to the brothers:-

'My brothers, my brothers, God has called me by the way of simplicity and humility, and has shown me in verity this path for me and those who want to believe and follow me; so I want you to talk of no Rule to me, neither Saint Benedict nor Saint Augustine nor Saint Bernard. nor any way or form of Life whatever except that which God has mercifully pointed out and granted to me. And God said that he wanted me to be a pauper [poverello] and an idiot-a great fool,in this world, and would not lead us by any other path of science than this. But by your science and syllogisms God will confound you, and I trust in God's warders, the devils, that through them God shall punish you, and you will yet come back to your proper station with shame, whether you will or no.'

The narration continues: 'Tunc cardinalis obstupuit valde et nihil respondit. Et omnes fratres plurimum timuerunt.'

One feels that the reporter has not exaggerated a word; on the contrary, he softened the scandal, because in his time the Cardinal had gained his point, and Francis was dead. One can hear Francis beginning with some restraint, and gradually carried away by passion till he lost control of himself and his language: - "God told me, with his own words, that he meant me to be a beggar and a great fool, and would not have us on any other terms; and as for your science, I trust in God's devils who will beat you out of it, as you deserve.' And the Cardinal was utterly dumfoundered and answered nothing: and all the brothers were scared to death." The Cardinal Hugolino was a great schoolman, and Dominic was then founding the famous Order in which the greatest of all doctors, Albertus Magnus, was about to begin his studies. One can imagine that the Cardinal "obstupuit valde," and that Dominic felt shaken in his scheme of school-instruction. For a single instant, in the flash of Francis's passion, the whole mass of five thousand monks in a state of semi-ecstasy recoiled before the impassable gulf that opened between them and the Church.

No one was to blame—no one ever is to blame—because God wanted contradictory things, and man tried to carry out, as he saw them. God's trusts. The schoolmen saw their duty in one direction; Francis saw his in another; and, apparently, when both lines had been carried, after such fashion as might be, to their utmost results, and five hundred years had been devoted to the effort, society declared both to be failures. Perhaps both may some day be revived, for the two paths seem to be the only roads that can exist, if man starts by taking for granted that there is an object to be reached at the end of his journey. The Church embracing all mankind, had no choice but to march with caution, seeking God by every possible means of intellect and study. Francis acting only for himself, could throw caution aside and trust implicitly in God, like the children who went on crusade. The two poles of social and political philosophy seem necessarily to be organisation or anarchy; man's intellect or the forces of nature. Francis saw God in Nature, if he did not see Nature in God; as the builders of Chartres saw the Virgin in their apse. Francis held the simplest and most childlike form of Pantheism. He carried to its last point the mystical Union with God, and its necessary consequence of contempt and hatred for human intellectual processes. Even Saint Bernard would have thought his ideas wanting in that *mesure* which the French mind so much prizes. At the same time we had best try, as innocently as may be, to realise that no final judgment has yet been pronounced, either by the Church or by Society or by Science, on either or any of these points; and until mankind finally settles to a certainty where it means to go, or whether it means to go anywhere,—what its object is, or whether it has an object,—Saint Francis may still prove to have been its ultimate expression. In that case, his famous Chant,—the *Cantico del Sole*,—will be the last word of religion, as it was probably its first. Here it is—too sincere for translation:—

CANTICO DEL SOLE

. . . Laudato sie, misignore, con tucte le tue creature spetialmente messor lo frate sole lo quale iorno et allumini noi per loi et ellu e bellu e radiante cum grande splendore de te, altissimo, porta significatione.

Laudato si, misignore, per sora luna e le stelle in celu lai formate clarite et pretiose et belle.

Laudato si, misignore, per frate vento et per aere et nubilo et sereno et onne tempo per lo quale a le tue creature dai sustentamento.

Laudato si, misignore, per sor aqua la quale e multo utile et humile et pretiosa et casta.

Laudato si, misignore, per frate focu per lo quale enallumini la nocte ed ello e bello et jocondo et robustoso et forte.

Laudato si, misignore, per sora nostra matre terra la quale ne sustenta et governa et produce diversi fructi con coloriti flori et herba.

Laudato si, misignore, per sora nostra morte corporale de la quale nullu homo vivente po skappare guai acquelli ke morrano ne le peccata mortali. . . .

The verses, if verses they are, have little or nothing in common with the art of Saint Bernard or Adam of Saint Victor.

Whatever art they have, granting that they have any, seems to go back to the cave-dwellers and the age of stone. Compared with the naïveté of the Cantico del Sole, the Chanson de Roland or the Iliad is a triumph of perfect technique. The value is not in the verse. The Chant of the Sun is another Pons Seclorum,—or perhaps rather a Pons Sanctorum,—over which only children and saints can pass. It is almost a paraphrase of the sermon to the birds. "Thank you, mi signore, for messor brother sun, in especial, who is your own symbol; and for sister moon and the stars; and for brother wind and air and sky; and for sister water; and for brother fire; and for mother earth!" We are all yours, mi signore! We are your children; your household; your feudal family! but we never heard of a Church. We are all varying forms of the same ultimate energy; shifting symbols of the same absolute unity; but our only unity, beneath you, is nature not law! We thank you for no human institutions, even for those established in your name; but, with all our hearts we thank you for "sister our mother Earth and its fruits and colored flowers!"

Francis loved them all,—the brothers and sisters,—as intensely as a child loves the taste and smell of a peach, and as simply; but behind them remained one sister whom no one loved, and for whom, in his first verses, Francis had rendered no thanks. Only on his deathbed he added the lines of gratitude for "our sister death," the long-sought, neverfound sister of the schoolmen, who solved all philosophy and merged Multiplicity in Unity. The solution was at least simple; one must decide for oneself, according to one's personal standards, whether or not it is more sympathetic than that with which we have got lastly to grapple in the works of Saint Thomas Aquinas.

XVI

Saint Thomas Aquinas

TONG BEFORE Saint Francis's death in 1226 the French mys-Lics had exhausted their energies and the siècle had taken new heart. Society could not remain forever balancing between thought and act. A few gifted natures could absorb themselves in the absolute, but the rest lived for the day, and needed shelter and safety. So the Church bent again to its task, and bade the Spaniard Dominic arm new levies with the best weapons of science, and flaunt the name of Aristotle on the Church banners along with that of Saint Augustine. The year 1215, which happened to be the date of Magna Charta and other easily fixed events, like the birth of Saint Louis, may serve to mark the triumph of the schools. The pointed arch reveled at Reims and the gothic architects reached perfection at Amiens just as Francis died at Assisi and Thomas was born at Aquino. The Franciscan Order itself was swept with the stream that Francis tried to dam, and the great Franciscan schoolman, Alexander Hales, in 1222, four years before the death of Francis, joined the order and began lecturing as though Francis himself had lived only to teach scholastic philosophy.

The rival Dominican champion, Albertus Magnus, began his career a little later, in 1228. Born of the noble Swabian family of Bollstadt, in 1193, he drifted, like other schoolmen, to Paris, and the Rue Maître Albert, opposite Notre Dame, still records his fame as a teacher there. Thence he passed to a school established by the Order at Cologne, where he was lecturing with great authority in 1243 when the General Superior of the Order brought up from Italy a young man of

the highest promise to be trained as his assistant.

Thomas, the new pupil, was born under the shadow of Monte Cassino in 1226 or 1227. His father, the Count of Aquino, claimed descent from the imperial line of Swabia; his mother, from the Norman princes of Sicily; so that in him the two most energetic strains in Europe met. His social rank was royal, and the Order set the highest value on it. He took

the vows in 1243, and went north at once to help Albertus at Cologne. In 1245 the Order sent Albertus back to Paris, and Thomas with him. There he remained till 1248 when he was ordered to Cologne as assistant-lecturer, and only four years afterwards, at twenty-five years old, he was made full professor at Paris. His industry and activity never rested till his death in 1274, not yet fifty years old, when he bequeathed to the Church a mass of manuscript that tourists will never know enough to estimate except by weight. His complete works, repeatedly printed, fill between twenty and thirty quarto volumes. For so famous a doctor, this is almost meagre. Unfortunately his greatest work, the Summa Theo-

logiae, is unfinished—like Beauvais Cathedral.

Perhaps Thomas's success was partly due to his memory which is said to have been phenomenal; for, in an age when Cyclopaedias were unknown, a cyclopaedic memory must have counted for half the battle in these scholastic disputes where authority could be met only by authority; but, in this case, memory was supported by mind. Outwardly Thomas was heavy and slow in manner, if it is true that his companions called him "the big dumb ox of Sicily;" and in fashionable or court circles he did not enjoy reputation for acute sense of humor. Saint Louis' household offers a picture not wholly clerical, least of all among the king's brothers and sons, and perhaps the dinner-table was not much more used then than now, to abrupt interjections of theology into the talk about hunting and hounds; but however it happened, Thomas one day surprised the company by solemnly announcing: - "I have a decisive argument against the Manicheans!" No wit or humor could be more to the point,between two Saints that were to be, -than a decisive argument against enemies of Christ, and one greatly regrets that the rest of the conversation was not reported, unless indeed it is somewhere in the twenty-eight quarto volumes; but it probably lacked humor for courtiers.

The twenty-eight quarto volumes must be closed books for us. None but Dominicans have a right to interpret them. No Franciscan,—or even Jesuit,—understands Saint Thomas exactly or explains him with authority. For summer tourists to handle these intricate problems in a theological spirit would

be altogether absurd; but, for us, these great theologians were also architects who undertook to build a Church Intellectual, corresponding bit by bit to the Church Administrative, both expressing—and expressed by—the Church Architectural. Alexander Hales, Albert the Great, Thomas Aguinas, Duns Scotus, and the rest, were artists; and if Saint Thomas happens to stand at their head as type, it is not because we choose him, or understand him better than his rivals, but because his Order chose him rather than his master Albert, to impose as authority on the Church; and because Pope John XXII canonised him on the ground that his decisions were miracles; and because the council of Trent placed his Summa among the sacred books on their table; and because Innocent VI said that his doctrine alone was sure; and finally because Leo XIII very lately made a point of declaring that, on the wings of Saint Thomas's genius, human reason has reached

the most sublime height it can probably ever attain.

Although the Franciscans, and, later, the Jesuits, have not always shown as much admiration as the Dominicans for the genius of Saint Thomas, and the mystics have never shown any admiration whatever for the philosophy of the schools, the authority of Leo XIII is final, at least on one point and the only one that concerns us. Saint Thomas is still alive and overshadows as many schools as he ever did; at all events as many as the Church maintains. He has outlived Descartes and Leibnitz and a dozen other schools of philosophy more or less serious in their day. He has mostly outlived Hume, Voltaire and the militant sceptics. His method is typical and classic; his sentences, when interpreted by the Church, seem, even to an untrained mind, intelligible and consistent; his Church Intellectual remains practically unchanged, and, like the Cathedral of Beauvais, erect although the storms of six or seven centuries have prostrated, over and over again, every other social or political or juristic shelter. Compared with it, all modern systems are complex and chaotic, crowded with self-contradictions, anomalies, impracticable functions and out-worn inheritances; but beyond all their practical shortcomings is their fragmentary character. An economic civilisation troubles itself about the universe much as a hive of honey-bees troubles about the ocean, only as a region to be

avoided. The hive of Saint Thomas sheltered God and Man, Mind and Matter, the Universe and the Atom, the One and the Multiple, within the walls of a harmonious home.

Theologians, like architects, were supposed to receive their Church complete in all its lines; they were modern judges who interpreted the law but never invented it. Saint Thomas merely selected between disputed opinions, but he allowed himself to wander very far afield indeed in search of opinions to dispute. The field embraced all that existed, or might have existed, or could never exist. The immense structure rested on Aristotle and Saint Augustine at the last, but as a work of art it stood alone, like Reims or Amiens Cathedrals, as though it had no antecedents. Then, although, like Reims, its style was never meant to suit modern housekeeping and is ill-seen by the Ecole des Beaux Arts, it reveals itself in its great mass and intelligence as a work of extraordinary genius; a system as admirably proportioned as any Cathedral and as complete; a success not universal either in art or science.

Saint Thomas's architecture, like any other work of art, is best studied by itself as though he created it outright; otherwise a tourist would never get beyond its threshhold. Beginning with the foundation which is God and God's active presence in his Church, Thomas next built God into the walls and towers of his Church, in the Trinity and its creation of Mind and Matter in Time and Space; then finally he filled the Church by uniting Mind and Matter in man, or man's soul, giving to Humanity a Free Will that rose, like the flèche, to heaven. The Foundation,—the Structure,—the Congregation, - are enough for students of art; his ideas of law, ethics and politics; his vocabulary, his syllogisms, his arrangement, are, like the drawings of Villard de Honnecourt's sketchbook, curious but not vital. After the eleventh-century romanesque Church of Saint Michael came the twelfth-century transition Church of the Virgin, and all merged and ended at last in the thirteenth-century gothic Cathedral of the Trinity. One wants to see the end.

The Foundation of the Christian Church should be,—as the simple deist might suppose,—always the same, but Saint Thomas knew better. His foundation was Norman not French; it spoke the practical architect who knew the mathe-

matics of his art, and who saw that the foundation laid by Saint Bernard, Saint Victor, Saint Francis, the whole mystical, semi-mystical, Cartesian, Spinozan foundation, past or future, could not bear the weight of the structure to be put on it. Thomas began by sweeping the ground clear of them. God must be a concrete thing, not a human thought. God must be proved by the senses like any other concrete thing; "nihil est in intellectu quin prius fuerit in sensu;" even if Aristotle had not affirmed the law, Thomas would have discovered it. He admitted at once that God could not be taken for granted.

The admission, as every boy-student of the Latin Quarter knew, was exceedingly bold and dangerous. The greatest logicians commonly shrank from proving Unity by Multiplicity. Thomas was one of the greatest logicians that ever lived: the question had always been at the bottom of theology; he deliberately challenged what everyone knew to be an extreme peril. If his foundation failed, his Church fell. Many critics have thought that he saw dangers four hundred years ahead. The time came, about 1650-1700, when Descartes, deserting Saint Thomas, started afresh with the idea of God as a concept, and at once found himself charged with a deity that contained the universe; nor did the Cartesians, -until Spinoza made it clear-seem able or willing to see that the Church could not accept this deity because the Church required a God who caused the universe. The two deities destroyed each other. One was passive; the other active. Thomas warned Descartes of a logical quicksand which must necessarily swallow up any Church, and which Spinoza explored to the bottom. Thomas said truly that every true cause must be proved as a cause, not merely as a sequence; otherwise they must end in a universal energy or substance without causality,—a Source.

Whatever God might be to others, to his Church he could not be a Sequence or a Source. That point had been admitted by William of Champeaux, and made the division between Christians and infidels. On the other hand, if God must be proved as a true cause in order to warrant the Church or the State in requiring men to worship him as Creator, the student became the more curious,—if a churchman, the more anxious,—to be assured that Thomas succeeded in his proof, especially since he did not satisfy Descartes and still less Pascal.

That the mystics should be dissatisfied was natural enough since they were committed to the contrary view, but that Descartes should desert was a serious blow which threw the French Church into consternation from which it never quite recovered.

"I see motion." said Thomas: - "I infer a motor!" This reasoning, which may be fifty thousand years old, is as strong as ever it was; stronger than some more modern inferences of science: but the average mechanic stated it differently. "I see motion," he admitted: - "I infer energy. I see motion everywhere; I infer energy everywhere." Saint Thomas barred this door to materialism by adding:—"I see motion; I cannot infer an infinite series of motors: I can only infer somewhere at the end of the series, an intelligent, fixed motor." The average modern mechanic might not dissent but would certainly hesitate-"No doubt!" he might say: "We can conduct our works as well on that as on any other theory. or as we could on no theory at all; but, if you offer it as proof, we can only say that we have not yet reduced all motion to one source or all energies to one law, much less to one act of creation, although we have tried our best." The result of some centuries of experiment tended to raise rather than silence doubt, although, even in his own day, Thomas would have been scandalized beyond the resources of his Latin had Saint Bonaventure met him at Saint Louis' dinnertable and complimented him in the King's hearing on having proved, beyond all Franciscan cavils, that the Church Intellectual had necessarily but one first cause and creator, -himself

The Church Intellectual, like the Church Architectural, implied not one architect but myriads, and not one fixed, intelligent architect at the end of the series but a vanishing vista without a beginning at any definite moment; and if Thomas pressed his argument, the twentieth-century mechanic who should attend his conférences at the Sorbonne would be apt to say so. "What is the use of trying to argue me into it? Your inference may be sound logic but is not proof. Actually we know less about it than you did. All we know is the thing we handle, and we cannot handle your fixed, intelligent prime motor. To your old ideas of Form we have added what we

call Force, and we are rather further than ever from reducing the complex to unity. In fact, if you are aiming to convince me, I will tell you flatly that I know only the multiple, and have no use for unity at all."

In the thirteenth century men did not depend so much as now on actual experiment, but the Nominalist said in effect the same thing. Unity to him was a pure Concept, and anyone who thought it real would believe that a triangle was alive and could walk on its legs. Without proving unity, philosophers saw no way to prove God. They could only fall back on an attempt to prove that the concept of unity proved itself, and this phantasm drove the Cartesians to drop Thomas's argument and assert that "the mere fact of having within us the idea of a thing more perfect than ourselves, proves the real existence of that thing." Four hundred years earlier Saint Thomas had replied in advance that Descartes wanted to prove altogether too much, and Spinoza showed mathematically that Saint Thomas had been in the right. The finest religious mind of the time-Pascal-admitted it and gave up the struggle, like the mystics of Saint Victor.

Thus some of the greatest priests and professors of the Church, including Duns Scotus himself, seemed not wholly satisfied that Thomas's proof was complete, but most of them admitted that it was the safest among possible foundations, and that it showed, as architecture, the Norman temper of courage and caution. The Norman was ready to run great risks but he would rather grasp too little than too much; he narrowed the spacing of his piers rather than spread them too wide for safe vaulting. Between Norman blood and Breton blood was a singular gap, as Renan and every other Breton has delighted to point out. Both Abélard and Descartes were Breton. The Breton seized more than he could hold; the Norman took less than he would have liked.

God, then, is proved. What the schools called Form, what science calls Energy, and what the intermediate period called the evidence of Design, made the foundation of Saint Thomas's cathedral. God is an intelligent, fixed Prime Motor,—not a concept, or proved by concepts;—a concrete fact, proved by the senses of sight and touch. On that foundation Thomas

built. The walls and vaults of his church were more complex than the foundation; especially the towers were troublesome. Dogma, the vital purpose of the church, required support. The most weighty dogma, the central tower of the Norman cathedral, was the Trinity, and between the Breton solution which was too heavy, and the French solution which was too light, the Norman Thomas found a way. Remembering how vehemently the French church, under Saint Bernard, had protected the Trinity from all interference whatever, one turns anxiously to see what Thomas said about it; and unless one misunderstands him—as is very likely indeed to be the case, since no one may even profess to understand the Trinity,— Thomas treated it as simply as he could. "God, being conscious of himself, thinks himself; his thought is himself, his own reflection in the Verb,—the so-called Son." "Est in Deo intelligente seipsum Verbum Dei quasi Deus intellectus." The idea was not new, and as ideas went it was hardly a mystery; but the next step was naif: - God as a double consciousness, loves himself, and realizes himself in the Holy Ghost. The third side of the triangle is Love or Grace.

Many theologians have found fault with this treatment of the subject, which seemed open to every objection that had been made to Abélard, Gilbert de la Porée, or a thousand other logicians. They commonly asked why Thomas stopped the Deity's self-realisations at Love, or inside the Triangle, since these realisations were real, not symbolic, and the square was at least as real as any other combination of line. Thomas replied that Knowledge and Will,—the Verb and the Holy Ghost,—were alone essential. The reply did not suit everyone, even among doctors, but since Saint Thomas rested on this simple assertion, it is no concern of ours to argue the theology. Only as art, one can afford to say that the form is more architectural than religious; it would surely have been suspicious to Saint Bernard. Mystery there was none, and logic little. The concept of the Holy Ghost was childlike; for a pupil of Aristotle it was inadmissible, since it led to nothing and helped no step towards the universe.

Admitting, if necessary, the criticism, Thomas need not admit the blame, if blame there were. Every theologian was

obliged to stop the pursuit of logic by force, before it dragged him into paganism and pantheism. Theology begins with the Universal—God—who must be a reality, not a symbol; but it is forced to limit the process of God's realisations somewhere, or the priest soon becomes a worshipper of God in sticks and stones. Theologists had commonly chosen, from time immemorial, to stop at the Trinity; within the Triangle they were wholly Realist; but they could not admit that God went on to realise himself in the square and circle, or that the third member of the Trinity contained Multiplicity, because the Trinity was a restless weight on the church piers, which, like the central tower, constantly tended to fall, and needed to be lightened. Thomas gave it the lightest form possible, and there fixed it.

Then came his great tour-de-force, the vaulting of his broad nave, and, if ignorance is allowed an opinion, even a lost soul may admire the grand simplicity of Thomas's scheme. He swept away the horizontal lines altogether, leaving them barely as a part of decoration. The whole weight of his arches fell as in the latest Gothic, where the eye sees nothing to break the sheer spring of the nervures, from the rosette on the keystone a hundred feet above, down to the church-floor. In Thomas's creation nothing intervened between God and his world; secondary causes become ornaments; only two forces, God and Man, stood in the church.

The chapter of Creation is so serious, and Thomas's creation, like every other, is open to so much debate, that no student can allow another to explain it; and certainly no man whatever, either saint or sceptic, can ever yet have understood Creation aright unless divinely inspired; but whatever Thomas's theory was as he meant it, he seems to be understood as holding that every created individual,—animal, vegetable, or mineral,—was a special, divine act. Whatever has form is created, and whatever is created takes form directly from the will of God, which is also his act. The intermediate Universals,—the secondary causes,—vanish as causes; they are, at most, sequences or relations; all merge in one universal act of will; instantaneous, infinite, eternal.

Saint Thomas saw God, much as Milton saw him, resplendent in—

That glorious form, that light unsufferable, And that far-beaming blaze of Majesty, Wherewith he wont, at Heaven's high council-table, To sit the midst of Trinal Unity;

except that, in Thomas's thought, the council-table was a work-table, because God did not take counsel; he was an act. The Trinity was an infinite possibility of will; nothing within but—

The baby image of the giant mass Of things to come at large.

Neither Time nor Space, neither Matter nor Mind, not even Force existed, nor could any intelligence conceive how, even though they should exist, they could be united in the lowest association. A crystal was as miraculous as Socrates. Only abstract Force, or what the schoolmen called Form, existed undeveloped from eternity, like the abstract line in mathematics.

Fifty or a hundred years before Saint Thomas settled the church dogma, a monk of Citeaux or some other Abbey, a certain Alain of Lille, had written a Latin poem, as abstruse an allegory as the best, which had the merit of painting the scene of man's creation as far as concerned the mechanical process much as Thomas seems to have seen it. M. Hauréau has printed an extract (I, 352). Alain conceded to the weakness of human thought, that God was working in time and space, or rather on his throne in heaven, when Nature, proposing to create a new and improved man, sent Reason and Prudence up to ask him for a Soul to fit the new body. Having passed through various adventures and much scholastic instruction, the messenger Prudence arrived, after having dropped her dangerous friend Reason by the way. The request was respectfully presented to God, and favorably received. God promised the soul, and at once sent his servant Noys-Thought, - to the store-house of Ideas, to choose it:-

Ipse Deus rem prosequitur, producit in actum

Quod pepigit. Vocat ergo Noym quæ præparet illi God himself pursues the task, and sets in act

What he promised. So he calls Noys to seek

Numinis exemplar, humanæ mentis Idæam,

Ad cujus formam formetur spiritus omni Munere virtutum dives, qui, nube caducæ

Tunc Noys ad regis præceptum singula

Vestigans exempla, novam perquirit Idæam.

Inter tot species, speciem vix invenit illam

Quam petit; offertur tandem quæsita

Hanc formam Noys ipsa Deo præsentat ut

Formet ad exemplar animam. Tunc ille sigillum

Sumit, ad ipsius formæ vestigia formam Dans anima, vultum qualem deposcit Idæa Imprimit exemplo; totas usurpat imago

Exemplaris opes, loquiturque figura sigillum.

A copy of his will, Idea of the human mind,

To whose form the spirit should be shaped, Rich in every virtue, which, veiled in garb Carnis obumbratus veletur corporis umbra. Of frail flesh, is to be hidden in a shade of

> Then Noys, at the king's order, turning one by one

Each sample, seeks the new Idea.

Among so many images she hardly finds

Which she seeks; at last the sought one appears.

This form Noys herself brings to God for

To form a soul to its pattern. He takes the

And gives form to the soul after the model Of the form itself, stamping on the sample The figure such as the Idea requires. The

Covers the whole field, and the impression expresses the stamp.

The translation is probably full of mistakes; indeed one is permitted to doubt whether Alain himself accurately understood the process; but in substance he meant that God contained a store-house of ideas, and stamped each creation with one of these Forms. The poets used a variety of figures to help out their logic, but that of the potter and his pot was one of the most common. Omar Khayam was using it at the same time with Alain of Lille, but with a difference: for his pot seems to have been Matter alone, and his Soul was the Wine it received from God; while Alain's soul seems to have been the Form and not the contents of the pot.

The figure matters little. In any case God's act was the union of Mind with Matter by the same act or will which created both. No intermediate cause or condition intervened; no secondary influence had anything whatever to do with the result. Time had nothing to do with it. Every individual that has existed or shall exist was created by the same instantaneous act, for all time. "When the question regards the universal agent who produces beings and time, we cannot consider him as acting now and before, according to the

succession of time." God emanated time, force, matter, mind, as he might emanate gravitation, not as a part of his substance but as an energy of his will, and maintains them in their activity by the same act, not by a new one. Every individual is a part of the direct act; not a secondary outcome. The soul has no father or mother. Of all errors one of the most serious is to suppose that the soul descends by generation. "Having life and action of its own, it subsists without the body . . . ; it must therefore be produced directly, and since it is not a material substance it cannot be produced by way of generation; it must necessarily be created by God. Consequently to suppose that the intelligence [or intelligent soul] is the effect of generation is to suppose that it is not a pure and simple substance, but corruptible like the body. It is therefore heresy to say that this soul is transmitted by generation." What is true of the Soul should be true of all other Form, since no Form is a material substance. The utmost possible relation between any two individuals is that God may have used the same stamp or mould for a series of creations, and especially for the less spiritual: - "God is the first model for all things. One may also say that, among his creatures some serve as types or models for others because there are some which are made in the image of others;" but generation means sequence, not cause. The only true cause is God. Creation is his sole act, in which no second cause can share. "Creation is more perfect and loftier than generation, because it aims at producing the whole substance of the being though it starts from absolute nothing."

Thomas Aquinas, when he pleased, was singularly lucid, and on this point he was particularly positive. The architect insisted on the controlling idea of his structure. The Church was God, and its lines excluded interference. God and the Church embraced all the converging lines of the universe, and the universe showed none but lines that converged. Between God and Man, nothing whatever intervened. The individual was a compound of Form or Soul, and Matter; but both were always created together, by the same act, out of nothing. "Simpliciter fatendum est animas simul cum corporibus creari et infundi." It must be distinctly understood that souls were not created before bodies, but that they were created at the

same time as the bodies they animate. Nothing whatever preceded this union of two substances which did not exist:—
"Creatio est productio alicujus rei secundum suam totam substantiam, nullo praesupposito, quod sit vel increatum vel ab aliquo creatum." Language can go no further in exclusion of every possible preceding, secondary or subsequent cause, "Productio universalis entis a Deo non est motus nec mutatio, sed est quaedam simplex emanatio." The whole universe is, so

to speak, a simple emanation from God.

The famous junction, then, is made! that celebrated fusion of the Universal with the Individual, of Unity with Multiplicity, of God and Nature, which had broken the neck of every philosophy ever invented; which had ruined William of Champeaux and was to ruin Descartes; this evolution of the Finite from the Infinite was accomplished. The supreme triumph was as easily effected by Thomas Aquinas as it was to be again effected, four hundred years later, by Spinoza. He had merely to assert the fact:—"It is so! it cannot be otherwise!" "For the thousandth and hundred-thousandth time;—what is the use of discussing this Prime Motor, this Spinozan Substance, any longer? We know it is there!" that—as Professor Haeckel very justly repeats for the millionth time,—is enough.

One point, however, remained undetermined. The Prime Motor and his action stood fixed, and no one wished to disturb him; but this was not the point that had disturbed William of Champeaux. Abélard's question still remained to be answered. How did Socrates differ from Plato-Judas from John-Thomas Aguinas from Professor Haeckel? Were they, in fact, two, or one? What made an individual? What was God's centimetre measure? The abstract Form or Soul which existed as a possibility in God, from all time, -was it One or Many? To the Church, this issue overshadowed all else, for, if humanity was one and not multiple, the Church, which dealt only with individuals, was lost. To the schools, also, the issue was vital, for, if the Soul or Form was already multiple from the first, Unity was lost; the ultimate Substance and Prime Motor itself became multiple; the whole issue was reopened.

To the consternation of the Church, and even of his own

Order, Thomas, following closely his masters, Albert and Aristotle, asserted that the Soul was measured by Matter. "Division occurs in substances in ratio of quantity, as Aristotle says in his Physics. And so dimensional quantity is a principle of individuation." The Soul is a fluid absorbed by matter in proportion to the absorptive power of the matter. The Soul is an energy existing in matter proportionately to the dimensional quantity of the matter. The Soul is a wine, greater or less in quantity according to the size of the cup. In our report of the great debate of 1110, between Champeaux and Abélard, we have seen William persistently tempting Abélard to fall into this admission that Matter made the man, -that the Universal Equilateral Triangle became an individual if it were shaped in metal,—the matter giving it reality which mere Form could not give; and Abélard evading the issue as though his life depended on it. In fact, had Abélard dared to follow Aristotle into what looked like an admission that Socrates and Plato were identical as Form and differed only in weight, his life might have been the forfeit. How Saint Thomas escaped is a question closely connected with the same inquiry about Saint Francis of Assisi. A Church which embraced, with equal sympathy, and within a hundred years, the Virgin, Saint Bernard, William of Champeaux and the school of Saint Victor, Peter the Venerable, Saint Francis of Assisi, Saint Dominic, Saint Thomas Aguinas and Saint Bonaventure, was more liberal than any modern state can afford to be. Radical contradictions the State may perhaps tolerate, though hardly, but never embrace or profess. Such elasticity long ago vanished from human thought.

Yet only Dominicans believe that the Church adopted this law of individualisation, or even assented to it. If M. Jourdain is right, Thomas was quickly obliged to give it another form:—that, though all souls belonged to the same species, they differed in their aptitudes for uniting with particular bodies. "This soul is commensurate with this body, and not with that other one." The idea is double; for either the souls individualised themselves, and Thomas abandoned his doctrine of their instantaneous creation, with the bodies, out of nothing; or God individualised them in the act of creation and Matter had nothing to do with it. The difficulty is no

concern of ours, but the great scholars who took upon themselves to explain it, made it worse, until at last one gathers only that Saint Thomas held one of three views: - Either the Soul of Humanity was individualised by God, or it individualised itself, or it was divided by ratio of quantity, that is, by Matter. This amounts to saying that one knows nothing about it, which we knew before and may admit with calmness; but Thomas Aquinas was not so happily placed, between the Church and the Schools. Humanity had a Form common to itself, which made it what it was. By some means this Form was associated with Matter; in fact, Matter was only known as associated with Form. If then, God, by an instantaneous act, created Matter and gave it Form according to the dimensions of the Matter, innocent ignorance might infer that there was, in the act of God, one world-soul and one world-matter, which he united in different proportions to make men and things. Such a doctrine was fatal to the Church. No greater heresy could be charged against the worst Arab or Jew, and Thomas was so well aware of his danger that he recoiled from it with a vehemence not at all in keeping with his supposed phlegm. With feverish eagerness to get clear of such companions, he denied and denounced, in all companies, in season and out of season, the idea that intellect was one and the same for all men, differing only with the quantity of matter it accompanied. He challenged the adherent of such a doctrine to battle; "let him take the pen if he dares!" No one dared, seeing that even Jews enjoyed a share of common sense and had seen some of their friends burn at the stake not very long before for such opinions, not even openly maintained; while uneducated people, who are perhaps incapable of receiving intellect at all, but for whose instruction and salvation the great work of Saint Thomas and his scholars must chiefly exist, cannot do battle because they cannot understand Thomas's doctrine of Matter and Form which to them seems frank Pantheism.

So it appeared to Duns Scotus also, if one may assert in the Doctor Subtilis any opinion without qualification. Duns began his career only about 1300, after Thomas's death, and stands therefore beyond our horizon; but he is still the pride of the Franciscan Order and stands second in authority to the great Dominican alone. In denying Thomas's doctrine that matter individualises mind, Duns laid himself open to the worse charge of investing matter with a certain embryonic, independent, shadowy soul of its own. Scot's system, compared with that of Thomas, tended towards liberty. Scot held that the excess of power in Thomas's prime motor neutralised the power of his secondary causes, so that these appeared altogether superfluous. This is a point that ought to be left to the Church to decide, but there can be no harm in quoting on the other hand the authority of some of Scot's critics within the Church, who have thought that his doctrine tended to deify matter, and to keep open the road to Spinoza. Narrow and dangerous was the border line always between Pantheism and Materialism, and the chief interest of the

Schools was in finding fault with each other's paths.

The opinions in themselves need not disturb us, although the question is as open to dispute as ever it was and perhaps as much disputed; but the turn of Thomas's mind is worth study. A century or two later, his passion to be reasonable, scientific, architectural, would have brought him within range of the Inquisition. Francis of Assisi was not more archaic and cave-dweller than Thomas of Aguino was modern and scientific. In his effort to be logical he forced his Deity to be as logical as himself, which hardly suited omnipotence. He hewed the Church dogmas into shape as though they were rough stones. About no dogma could mankind feel interest more acute than about that of immortality, which seemed to be the single point vitally necessary for any Church to prove and define as clearly as light itself. Thomas trimmed down the soul to half its legitimate claims as an immortal being by insisting that God created it from nothing in the same act or will by which he created the body and united the two in time and space. The soul existed as Form for the body, and had no previous existence. Logic seemed to require that when the body died and dissolved, after the union which had lasted, at most, only an instant or two of eternity, the soul, which fitted that body and no other, should dissolve with it. In that case the Church dissolved too, since it had no reason for existence except the soul. Thomas met the difficulty by suggesting that the body's form might take permanence from the Matter to

which it gave form. That Matter should individualise Mind was itself a violent wrench of logic, but that it should also give permanence—the one quality it did not possess,—to this individual Mind, seemed to many learned doctors a scandal. Perhaps Thomas meant to leave the responsibility on the Church, where it belonged as a matter not of logic but of revealed truth. At all events, this treatment of Mind and Matter brought him into trouble which few modern logicians would suspect.

The human soul having become a person by contact with matter, and having gained eternal personality by the momentary union, was finished, and remains to this day for practical purposes unchanged; but the Angels and Devils, a world of realities then more real than man, were never united with Matter, and therefore could not be persons. Thomas admitted and insisted that the Angels, being immaterial,—neither clothed in Matter, nor stamped on it, nor mixed with it,—were Universals; that is, each was a species in himself, a class, or perhaps what would be now called an Energy, with no

other individuality than he gave himself.

The idea seems to modern science reasonable enough. Science has to deal, for example, with scores of chemical energies which it knows little about except that they always seem to be constant to the same conditions; but everyone knows that in the particular relation of Mind to Matter the battle is as furious as ever. The Soul has always refused to live in peace with the Body. The Angels, too, were always in rebellion. They insisted on personality, and the Devils even more obstinately than the Angels. The dispute was—and is—far from trifling. Mind would rather ignore Matter altogether. In the thirteenth century Mind did indeed admit that matter was something, - which it quite refuses to admit in the twentieth,—but treated it as a nuisance to be abated. To the pure in spirit one argued in vain that spirit must compromise; that nature compromised; that God compromised; that man himself was nothing but a somewhat clumsy compromise. No argument served. Mind insisted on absolute despotism. Schoolmen as well as mystics would not believe that Matter was what it seemed, - if indeed it existed; - unsubstantial, shifty, shadowy; changing with incredible swiftness into dust, gas, flame; vanishing in mysterious lines of force into space beyond hope of recovery; whirled about in eternity and infinity by that Mind, Form, Energy or Thought which guides and rules and tyrannises and is, the Universe. The Church wanted to be pure Spirit; she regarded matter with antipathy as something foul, to be held at arms'-length lest it should stain and corrupt the Soul; the most she would willingly admit was that Mind and Matter might travel side by side, like a double-headed comet, on parallel lines that never met, with a pre-established harmony that existed only in the Prime Motor.

Thomas and his master Albert were almost alone in imposing on the Church the compromise so necessary for its equilibrium. The balance of Matter against Mind was the same necessity in the Church Intellectual as the balance of thrusts in the arch of the gothic cathedral. Nowhere did Thomas show his architectural obstinacy quite so plainly as in thus taking Matter under his protection. Nothing would induce him to compromise with the Angels. He insisted on keeping Man wholly apart, as a complex of energies in which Matter shared equally with Mind. The Church must rest firmly on both. The Angels differed from other beings below them precisely because they were immaterial and impersonal. Such rigid logic outraged the spiritual Church. Perhaps Thomas's sudden death in 1274 alone saved him from the fate of Abélard, but it did not save his doctrine. Two years afterwards, in 1276, the French and English churches combined to condemn it. Etienne Tempier, bishop of Paris, presided over the French synod; Robert Kilwardeby, of the Dominican Order. Archbishop of Canterbury, presided over the Council at Oxford. The synods were composed of schoolmen as well as churchmen, and seem to have been the result of a serious struggle for power between the Dominican and Franciscan Orders. Apparently the Church compromised between them by condemning the errors of both. Some of these errors, springing from Alexander Hales and his Franciscan schools, were in effect the foundation of another Church. Some were expressly charged against Brother Thomas. "Contra fratrem Thomam" the Councils forbade teaching that - "quia intelligentiae non habent materiam, Deus non potest plures ejusdem speciei facere; et quod materia non est in angelis;" further, the Councils struck at the vital centre of Thomas's system,—"quod Deus non potest individua multiplicare sub una specie sine materia;" and again in its broadest form,—"quod formae non accipiunt divisionem nisi secundam materiam." These condemnations made a great stir. Old Albertus Magnus, who was the real victim of attack, fought for himself and for Thomas. After a long and earnest effort, the Thomists rooted out opposition in the Order, and carried their campaign to Rome. After fifty years of struggle, by use of every method known in Church politics, the Dominican Order, in 1323, caused John XXII to canonize Thomas and in effect affirm his doctrine.

The story shows how modern, how heterodox, how material, how altogether new and revolutionary the system of Saint Thomas seemed at first even in the Schools; but that was the affair of the Church and a matter of pure theology. We study only his art. Step by step, stone by stone, we see him build his church-building like a stone mason, "with the care that the twelfth-century architects put into" their work, as Viollet-le-Duc saw some similar architect at Rouen, building the tower of St. Romain: - "He has thrown over his work the grace and finesse, the study of detail, the sobriety in projections, the perfect harmony," which belongs to his school, and yet he was rigidly structural and Norman. The Foundation showed it; the Elevation, which is God, developed it; the Vaulting, with its balance of thrusts in Mind and Matter proved it; but he had still the hardest task in art, to model Man.

The Cathedral, then, is built, and God is built into it, but, thus far, God is there alone, filling it all, and maintains the equilibrium by balancing created Matter separately against created Mind. The proportions of the building are superb; nothing so lofty, so large in treatment, so true in scale, so eloquent of Multiplicity in Unity, has ever been conceived elsewhere; but it was the virtue or the fault of superb structures like Bourges and Amiens and the Church Universal that they seemed to need Man more than man needed them; they were made for crowds, for thousands and tens of thousands of human beings; for the whole human race, on its knees,

hungry for pardon and love. Chartres needed no crowd, for it was meant as a palace of the Virgin, and the Virgin filled it wholly; but the Trinity made their Church for no other purpose than to accommodate man, and made man for no other purpose than to fill their Church; if man failed to fill it, the Church and the Trinity seemed equally failures. Empty, Bourges and Beauvais are cold; hardly as religious as a way-side cross; and yet, even empty, they are perhaps more religious than when filled with cattle and machines. Saint Thomas needed to fill his church with real men, and although he had created his own God for that special purpose, the task was, as every boy knew by heart, the most difficult that om-

nipotence had dealt with.

God, as Descartes justly said, we know! but what is Man? The schools answered: - Man is a rational animal! So was apparently a dog, or a bee, or a beaver, none of which seemed to need churches. Modern science, with infinite effort, has discovered and announced that man is a bewildering complex of energies, which helps little to explain his relations with the ultimate Substance or Energy or Prime Motor whose existence both Science and Schoolmen admit; which Science studies in laboratories and Religion worships in churches. The Man whom God created to fill his Church, must be an energy independent of God; otherwise God filled his own Church with his own energy. Thus far, the God of Saint Thomas was alone in his Church. The beings he had created out of nothing, -Omar's pipkins of clay and shape-stood against the walls, waiting to receive the wine of life, a life of their own. Of that life, energy, will or wine-whatever the poets or professors called it, -God was the only cause, as he was also the immediate cause, and support. Thomas was emphatic on that point. God is the cause of energy as the sun is the cause of color:—"prout sol dicitur causa manifestationis coloris." He not only gives forms to his pipkins, or energies to his agents, but he also maintains those forms in being:-"dat formas creaturis agentibus et eas tenet in esse." He acts directly, not through secondary causes, on everything and evervone:- "Deus in omnibus intime operatur." If, for an instant, God's action, which is also his will, were to stop, the universe would not merely fall to pieces but would vanish,

and must then be created anew from nothing:—"Quia non habet radicem in aere, statim cessat lumen, cessante actione solis. Sic autem se habet omnis creatura ad Deum sicut aer ad solem illuminantem." God radiates energy as the sun radiates light, and "the whole fabric of nature would return to nothing," if that radiation ceased even for an instant. Everything is created by one instantaneous, eternal, universal act of will, and by the same act is maintained in being.

Where, then,—in what mysterious cave outside of creation—could Man, and his free-will, and his private world of responsibilities and duties, lie hidden? Unless Man was a free agent in a world of his own beyond constraint, the Church was a fraud, and it helped little to add that the State was another. If God was the sole and immediate cause and support of everything in his creation, God was also the cause of its defects, and could not,—being Justice and Goodness in essence,—hold Man responsible for his own omissions. Still less could the State or Church do it in his name.

Whatever truth lies in the charge that the schools discussed futile questions by faulty methods, one cannot decently deny that in this case the question was practical and the method vital. Theist or atheist, monist or anarchist must all admit that society and science are equally interested with theology in deciding whether the Universe is one or many, a harmony or a discord. The Church and State asserted that it was a harmony, and that they were its representatives. They say so still. Their claim led to singular but unavoidable conclusions, with which society has struggled for seven hundred years, and is still struggling.

Freedom could not exist in nature, or even in God, after the single, unalterable act or will which created. The only possible free will was that of God before the act. Abélard with his rigid logic averred that God had no freedom; being himself whatever is most perfect, he produced necessarily the most perfect possible world. Nothing seemed more logical, but if God acted necessarily, his world must also be of necessity the only possible product of his act, and the Church became an impertinence, since man proved only fatuity by attempting to interfere. Thomas dared not disturb the foundations of the Church, and therefore began by laying down

the law that God—previous to his act—could choose, and had chosen, whatever scheme of creation he pleased, and that the harmony of the actual scheme proved his perfections. Thus he saved God's free-will.

This philosophical apse would have closed the lines and finished the plan of his church-choir had the universe not shown some divergences or discords needing to be explained. The student of the Latin Quarter was then harder to convince than now that God was infinite Love and his world a perfect harmony, when perfect love and harmony showed them even in the Latin Quarter, and still more in revealed Truth, a picture of suffering, sorrow and death; plague, pestilence and famine; inundations, droughts and frosts; catastrophes worldwide and accidents in corners; cruelty, perversity, stupidity, uncertainty, insanity; virtue begetting vice; vice working for good; happiness without sense, selfishness without gain, misery without cause, and horrors undefined. The students in public dared not ask, as Voltaire did, "avec son hideux sourire," whether the Lisbon earthquake was the final proof of God's infinite goodness, but in private they used the argumentum ad personam divinam freely enough, and when the Church told them that Evil did not exist, the ribalds laughed.

Saint Augustine certainly tempted Satan when he fastened the Church to this doctrine that Evil is only the privation of Good, an amissio boni; and that Good alone exists. The point was infinitely troublesome. Good was Order, Law, Unity. Evil was Disorder, Anarchy, Multiplicity. Which was Truth? The Church had committed itself to the dogma that Order and Unity were the ultimate Truth, and that the anarchist should be burned. She could do nothing else, and society supported her, -still supports her, -yet the Church, who was wiser than the State, had always seen that Saint Augustine dealt with only half the question. She knew that Evil might be an excess of Good as well as absence of it; that Good leads to Evil. Evil to Good; and that, as Pascal says, "three degrees of polar elevation upset all jurisprudence; a meridian decides truth; fundamental laws change; rights have epochs. Pleasing Justice! bounded by a river or a mountain! truths on this side the Pyrenees! errors beyond!" Thomas conceded that God himself, with the best intentions, might be the source of Evil, and pleaded only that his action might in the end work benefits. He could offer no proof of it, but he could assume as probable a plan of good which became the more perfect for the very reason that it allowed great liberty in detail.

One hardly feels Saint Thomas here in all his force. He offers suggestion rather than proof; - apology, the weaker because of obvious effort to apologise, rather than defence, for infinite Goodness, Justice and Power; scoffers might add that he invented a new proof ab defectu, or argument for proving the perfection of a machine by the number of its imperfections; but at all events society has never done better by way of proving its right to enforce morals, or unity of opinion. Unless it asserts law, it can only assert force. Rigid theology went much further. In God's providence, man was as nothing. With a proper sense of duty, every solar system should be content to suffer, if thereby the efficiency of the Milky Way were improved. Such theology shocked Saint Thomas, who never wholly abandoned man in order to exalt God. He persistently brought God and man together, and if he erred, the Church rightly pardons him because he erred on the human side. Whenever the path lay through the valley of despair he called God to his aid, as though he felt the moral obligation of the creator to help his creation.

At best the vision of God, sitting forever at his work-table, willing the existence of mankind exactly as it is, while conscious that, among these myriad arbitrary creations of his will, hardly one in a million could escape temporary misery or eternal damnation, was not the best possible background for a Church, as the Virgin and the Savior frankly admitted by taking the foreground; but the Church was not responsible for it. Mankind could not admit an anarchical, -a dual or a multiple-universe. The world was there, staring them in the face, with all its chaotic conditions, and society insisted on its Unity in self-defence. Society still insists on treating it as Unity though no longer affecting logic. Society insists on its free will, although free will has never been explained to the satisfaction of any but those who much wish to be satisfied, and although the words in any common sense implied not unity but duality in creation. The Church had nothing to do with inventing this riddle,—the oldest that fretted mankind.

Apart from all theological interferences, -Fall of Adam or Fault of Eve, Atonement, Justification or Redemption, -either the Universe was One, or it was two, or it was many: either Energy was one, seen only in powers of itself, or it was several; either God was Harmony or he was discord. With practical unanimity, mankind rejected the dual or multiple scheme; it insisted on Unity. Thomas took the question as it was given him. The Unity was full of defects; he did not deny them; but he claimed that they might be incidents, and that the admitted Unity might even prove their beneficence. Granting this enormous concession, he still needed a means of bringing into the system one element which vehemently refused to be brought:-that is, Man himself, who insisted that the Universe was a unit, but that he was a universe; that Energy was one, but that he was another energy; that God was omnipotent but that man was free. The contradiction had always existed, exists still, and always must exist, unless man either admits that he is a machine, or agrees that anarchy and chaos are the habit of nature, and law and order its accident. The agreement may become possible, but it was not possible in the thirteenth century nor is it now. Saint Thomas's settlement could not be a simple one or final, except for practical use, but it served, and it holds good still.

No one ever seriously affirmed the literal freedom of will. Absolute liberty is absence of restraint; responsibility is restraint; therefore the ideally free individual is responsible only to himself. This principle is the philosophical foundation of anarchism, and, for anything that science has yet proved, may be the philosophical foundation of the Universe; but it is fatal to all society and is especially hostile to the State. Perhaps the Church of the thirteenth century might have found a way to use even this principle for a good purpose; certainly, the influence of Saint Bernard was sufficiently unsocial and that of Saint Francis was sufficiently unselfish to conciliate even anarchists of the militant class; but Saint Thomas was working for the Church and the State, not for the salvation of souls, and his chief object was to repress anarchy. The theory of absolute free-will never entered his mind, more than the theory of material free-will would enter the mind of an architect. The Church gave him no warrant for discussing the subject

in such a sense. In fact, the Church never admitted free-will, or used the word when it could be avoided. In Latin, the term used was *liberum arbitrium*,—free choice,—and in French to this day it remains in strictness *libre arbitre* still. From Saint Augustine downwards the Church was never so unscientific as to admit of liberty beyond the faculty of choosing between paths, some leading through the Church and some not, but all leading to the next world; as a criminal might be allowed the liberty of choosing between the guillotine and the gallows, without infringing on the supremacy of the Judge.

Thomas started from that point, already far from theoretic freedom. "We are masters of our acts," he began, "in the sense that we can choose such and such a thing; now, we have not to choose our end, but the means that relate to it, as Aristotle says." Unfortunately even this trenchant amputation of man's free energies would not accord with fact or with logic. Experience proved that man's power of choice in action was very far from absolute, and logic seemed to require that every choice should have some predetermining cause which decided the will to act. Science affirmed that choice was not free, -could not be free, -without abandoning the unity of force and the foundation of law. Society insisted that its choice must be left free, whatever became of science or unity. Saint Thomas was required to illustrate the theory of liberum arbitrium by choosing a path through these difficulties, where path there was obviously none.

Thomas's method of treating this problem was sure to be as scientific as the vaulting of a Gothic arch. Indeed, one follows it most easily by translating his school-vocabulary into modern technical terms. With very slight straining of equiva-

lents, Thomas might now be written thus:-

By the term God, is meant a Prime Motor which supplies all energy to the universe, and acts directly on man as well as on all other creatures, moving him as a mechanical motor might do; but man, being specially provided with an organism more complex than the organisms of other creatures, enjoys an exceptional capacity for reflex action,—a power of reflexion,—which enables him within certain limits to choose between paths; and this singular capacity is called free choice

or free-will. Of course, the reflexion is not choice, and though a man's mind reflected as perfectly as the facets of a lighthouse lantern, it would never reach a choice without an energy which impels it to act.

Now let us read Saint Thomas:-

Some kind of an agent is required to determine one's choice; that agent is Reflexion. Man reflects, then, in order to learn what choice to make between the two acts which offer themselves. But reflexion is, in its turn, a faculty of doing opposite things, for we can reflect or not reflect; and we are no further forward than before. One cannot carry back this process infinitely, for in that case one would never decide. The fixed point is not in man, since we meet in him, as a being apart by himself, only the alternative faculties; we must therefore recur to the intervention of an exterior agent who shall impress on our will a movement capable of putting an end to its hesitations:—That exterior agent is nothing else than God!

The scheme seems to differ little, and unwillingly, from a system of dynamics as modern as the dynamo. Even in the Prime Motor, from the moment of action, freedom of will vanished. Creation was not successive: it was one instantaneous thought and act, identical with the will, and was complete and unchangeable from end to end, including time as one of its functions. Thomas was as clear as possible on that point: - "Supposing God wills anything in effect, he cannot will not to will it, because his will cannot change." He wills that some things shall be contingent and others necessary, but he wills in the same act that the contingency shall be necessary. "They are contingent because God has willed them to be so, and with this object has subjected them to causes which are so." In the same way he wills that his creation shall develop itself in time and space and sequence, but he creates these conditions as well as the events. He creates the whole, in one act, complete, unchangeable, and it is then unfolded like a rolling panorama, with its predetermined contingencies.

Man's free choice—liberum arbitrium—falls easily into place as a predetermined contingency. God is the First Cause, and acts in all Secondary Causes directly; but while he acts mechanically on the rest of creation,—as far as is known,—he acts freely at one point, and this free action remains free as far as it extends on that line. Man's freedom derives from this

source, but it is simply apparent, as far as he is a cause; it is a reflex action determined by a new agency of the First Cause.

However abstruse these ideas may once have sounded, they are far from seeming difficult in comparison with modern theories of energy. Indeed, measured by that standard, the only striking feature of Saint Thomas's motor is its simplicity. Thomas's Prime Motor was very powerful, and its lines of energy were infinite. Among these infinite lines, a certain group ran to the human race, and, as long as the conduction was perfect, each man acted mechanically. In cases where the current, for any reason, was for a moment checked, -that is to say, produced the effect of hesitation or reflexion in the mind,—the current accumulated until it acquired power to leap the obstacle. As Saint Thomas expressed it, the Prime Motor, who was nothing else than God, intervened to decide the channel of the current. The only difference between Man and a Vegetable was the Reflex Action of the complicated mirror which was called Mind, and the mark of Mind was reflective absorption or choice. The apparent freedom was an illusion arising from the extreme delicacy of the machine, but the motive power was in fact the same—that of God.

This exclusion of what men commonly called freedom was carried still further in the process of explaining dogma. Supposing the conduction to be insufficient for a given purpose; a purpose which shall require perfect conduction? Under ordinary circumstances, in ninety-nine cases out of a hundred, the conductor will be burned out, so to speak; condemned, and thrown away. This is the case with most human beings. Yet there are cases where the conductor is capable of receiving an increase of energy from the Prime Motor, which enables it to attain the object aimed at. In dogma, this store of reserved energy is technically called Grace. In the strict, theological sense of the word as it is used by Saint Thomas, the exact, literal meaning of Grace is "a motion which the Prime Motor, as a supernatural cause, produces in the soul, perfecting freewill." It is a reserved energy, which comes to aid and reinforce the normal energy of the battery.

To religious minds, this scientific inversion of solemn truths seems, and is, sacrilege; but Thomas's numerous critics in the Church have always brought precisely this charge

against his doctrine, and are doing so still. They insist that he has reduced God to a mechanism and Man to a passive conductor of force. He has left, they say, nothing but God in the universe. The terrible word which annihilates all other philosophical systems against which it is hurled, has been hurled freely against his for six hundred years and more, without visibly affecting the Church; and yet its propriety seems, to the vulgar, beyond reasonable cavil. To Father de Régnon, of the extremely learned and intelligent Society of Jesus, the difference between Pantheism and Thomism reduces itself to this:- "Pantheism, starting from the notion of an Infinite Substance which is the plenitude of Being, concludes that there can exist no other beings than the Being; no other Realities than the Absolute Reality. Thomism, starting from the efficacy of the First Cause, tends to reduce more and more the efficacy of second causes, and to replace it by a passivity which receives without producing, which is determined without determining." To students of architecture, who know equally little about Pantheism and about Thomism, -or indeed, for that matter, about architecture too, -the quality that rouses most surprise in Thomism is its astonishingly scientific method. The Franciscans and the Jesuits call it Pantheism, but science too is Pantheism, or has till very recently been wholly pantheistic. Avowedly science has aimed at nothing but the reduction of multiplicity to unity, and has excommunicated, as though it were itself a Church, anyone who doubted or disputed its object, its method, or its results. The effort is as evident and quite as laborious in modern science, starting as it does from multiplicity, as in Thomas Aquinas who started from unity, and it is necessarily less successful, for its true aims as far as it is Science and not disguised Religion, were equally attained by reaching infinite complexity; but the assertion or assumption of ultimate unity has characterised the Law of Energy as emphatically as it has characterised the definition of God in Theology. If it is a reproach to Saint Thomas, it is equally a reproach to Clerk-Maxwell. In truth it is what men most admire in both—the power of broad and lofty generalisation.

Under any conceivable system the process of getting God and Man under the same roof,—of bringing two indepen-

dent energies under the same control,-required a painful effort, as science has much cause to know. No doubt, many good Christians and some heretics have been shocked at the tour de force by which they felt themselves suddenly seized, bound hand and foot, attached to each other, and dragged into the Church, without consent or consultation. To religious mystics, whose scepticism concerned chiefly themselves and their own existence, Saint Thomas's Man seemed hardly worth herding, at so much expense and trouble, into a Church where he was not eager to go. True religion felt the nearness of God without caring to see the mechanism. Mystics like Saint Bernard, Saint Francis, Saint Bonaventure or Pascal had a right to make this objection, since they got into the Church, so to speak, by breaking through the windows; but society at large accepted and retains Saint Thomas's Man much as Saint Thomas delivered him to the government; a two-sided being, free or unfree, responsible or irresponsible, an energy or a victim of energy, moved by choice or moved by compulsion, as the interests of society seemed for the moment to need. Certainly Saint Thomas lavished no excess of liberty on the Man he created, but still he was more generous than the State has ever been. Saint Thomas asked little from Man, and gave much; even as much freedom of will as the State gave or now gives; he added immortality hereafter and eternal happiness under reasonable restraints; his God watched over man's temporal welfare far more anxiously than the State has ever done, and assigned him space in the Church which he never can have in the galleries of Parliament or Congress; more than all this, Saint Thomas and his God placed Man in the centre of the universe, and made the sun and the stars for his uses. No statute law ever did as much for Man, and no social reform ever will try to do it; yet Man bitterly complained that he had not his rights, and even in the Church is still complaining, because Saint Thomas set a limit, more or less vague, to what the man was obstinate in calling his freedom of will.

Thus Saint Thomas completed his work, keeping his converging lines clear and pure throughout, and bringing them together, unbroken, in the curves that gave unity to his plan. His sense of scale and proportion was that of the great archi-

tects of his age. One might go on studying it for a life-time. He showed no more hesitation in keeping his Deity in scale, than in adjusting Man to it. Strange as it sounds, although Man thought himself hardly treated in respect to freedom, vet, if freedom meant superiority, Man was in action much the superior of God, whose freedom suffered, from Saint Thomas, under restraints that Man never would have tolerated. Saint Thomas did not allow God even an undetermined will; he was pure Act, and as such he could not change. Man alone was allowed, in act, to change direction. What was more curious still, Man might absolutely prove his freedom by refusing to move at all; if he did not like his life he could stop it, and habitually did so, or acquiesced in its being done for him: while God could not commit suicide or even cease for a single instant his continuous action. If Man had the singular fancy of making himself absurd,—a taste confined to himself but attested by evidence exceedingly strong,—he could be as absurd as he liked; but God could not be absurd. Saint Thomas did not allow the Deity the right to contradict himself, which is one of Man's chief pleasures. While Man enjoyed what was, for his purposes, an unlimited freedom to be wicked, - a privilege which, as both Church and State bitterly complained and still complain, he has outrageously abused, -God was Goodness and could be nothing else. While Man moved about his relatively spacious prison with a certain degree of ease, God, being everywhere, could not move. In one respect, at least, Man's freedom seemed to be not relative but absolute, for his thought was an energy paying no regard to space or time or order or object or sense; but God's thought was his act and will at once; speaking correctly, God could not think; he is. Saint Thomas would not, or could not, admit that God was Necessity, as Abélard seems to have held, but he refused to tolerate the idea of a divine maniac, free from moral obligation to himself. The atmosphere of Saint Louis surrounds the God of Saint Thomas, and its pure ether shuts out the corruption and pollution to come, - the Valois and Bourbons, the Occams and Hobbes's, the Tudors and the Medicis, of an enlightened Europe.

The theology turns always into art at the last, and ends in aspiration. The spire justifies the church. In Saint Thomas's

Church, man's free-will was the aspiration to God, and he treated it as the architects of Chartres and Laon had treated their famous flèches. The square foundation-tower, the expression of God's power in act,—his Creation,—rose to the level of the church façade as a part of the normal unity of God's energy; and then, suddenly, without show of effort, without break, without logical violence, became a many-sided, voluntary, vanishing human soul, and neither Villard de Honnecourt nor Duns Scotus could distinguish where God's power ends, and Man's free will begins. All they saw was the soul vanishing into the skies. How it was done, one does not care to ask; in a result so exquisite, one has not the heart to find fault with "adresse."

About Saint Thomas's theology we need not greatly disturb ourselves; it can matter now not much, whether he put more Pantheism than the law allowed, or more Materialism than Duns Scotus approved,—or less of either—into his universe. since the Church is still on the spot, responsible for its own doctrines; but his architecture is another matter. So scientific and structural a method was never an accident or the property of a single mind even with Aristotle to prompt it. Neither his Church nor the architect's Church was a sketch, but a completely studied structure. Every relation of parts, every disturbance of equilibrium, every detail of construction was treated with infinite labor, as the result of two hundred years of experiment and discussion among thousands of men whose minds and whose instincts were acute, and who discussed little else. Science and art were one. Thomas Aguinas would probably have built a better Cathedral at Beauvais than the actual architect who planned it; but it is quite likely that the architect might have saved Thomas some of his errors, as pointed out by the Councils of 1276. Both were great artists; perhaps in their professions, the greatest that ever lived; and both must have been great students beyond their practice. Both were subject to constant criticism from men and bodies of men whose minds were as acute and whose learning was as great as their own. If the Archbishop of Canterbury and the Bishop of Paris condemned Thomas, the Bernardines had, for near two hundred years, condemned Beauvais in advance. Both the Summa Theologiae and Beauvais Cathedral were excessively modern, scientific, and technical, marking the extreme points reached by Europe on the lines of scholastic science. This is all we need to know. If we like, we can go on to study, inch by inch, the slow decline of the art. The essence of it.—the despotic central idea—was that of organic unity both in the thought and the building. From that time, the universe has steadily become more complex and less reducible to a central control. With as much obstinacy as though it were human, it has insisted on expanding its parts; with as much elusiveness as though it were feminine, it has evaded the attempt to impose on it a single will. Modern science, like modern art, tends, in practice, to drop the dogma of organic unity. Some of the mediaeval habit of mind survives, but even that is said to be vielding before the daily evidence of increasing and extending complexity. The fault, then, was not in man, if he no longer looked at science or art as an organic whole or as the expression of unity. Unity turned itself into complexity, multiplicity, variety, and even contradiction. All experience, human and divine, assured man in the thirteenth century that the lines of the universe converged. How was he to know that these lines ran in every conceivable and inconceivable direction, and that at least half of them seemed to diverge from any imaginable centre of unity! Dimly conscious that his Trinity required in logic a fourth dimension, how was the schoolman to supply it, when even the mathematician of today can only infer its necessity? Naturally man tended to lose his sense of scale and relation. A straight line, or a combination of straight lines, may have still a sort of artistic unity, but what can be done in art with a series of negative symbols? Even if the negative were continuous, the artist might express at least a negation; but supposing that Omar's kinetic analogy of the ball and the players turned out to be a scientific formula! supposing that the highest scientific authority, in order to obtain any unity at all, had to resort to the middle-ages for an imaginary demon to sort his atoms! how could art deal with such problems, and what wonder that art lost unity with philosophy and science! Art had to be confused in order to express confusion; but perhaps it was truest, so.

Some future summer, when you are older, and when I have left, like Omar, only the empty glass of my scholasticism for

you to turn down, you can amuse yourselves by going on with the story after the death of Saint Louis, Saint Thomas and William of Lorris, and after the failure of Beauvais. The pathetic interest of the drama deepens with every new expression, but at least you can learn from it that your parents in the nineteenth century were not to blame for losing the sense of unity in art. As early as the fourteenth century, signs of unsteadiness appeared, and, before the eighteenth century, unity became only a reminiscence. The old habit of centralizing a strain at one point, and then dividing and subdividing it, and distributing it on visible lines of support to a visible foundation, disappeared in architecture soon after 1500, but lingered in theology two centuries longer, and even, in very old-fashioned communities, far down to our own time; but its values were forgotten, and it survived chiefly as a stock jest against the clergy. The passage between the two epochs is as beautiful as the Slave of Michael Angelo; but, to feel its beauty, you should see it from above, as it came from its radiant source. Truth, indeed, may not exist; science avers it to be only a relation; but what men took for truth stares one everywhere in the eye and begs for sympathy. The architects of the twelfth and thirteenth centuries took the Church and the Universe for truths, and tried to express them in a structure which should be final. Knowing by an enormous experience precisely where the strains were to come, they enlarged their scale to the utmost point of material endurance, lightening the load and distributing the burden until the gutters and gargoyles that seem mere ornament, and the grotesques that seem rude absurdities, all do work either for the arch or for the eye; and every inch of material, up and down, from crypt to vault, from Man to God, from the Universe to the Atom, had its task, giving support where support was needed. or weight where concentration was felt, but always with the condition of showing conspicuously to the eye the great lines which led to unity and the curves which controlled divergence; so that, from the cross on the flèche and the key-stone of the vault, down through the ribbed nervures, the columns, the windows, to the foundation of the flying buttresses far beyond the walls, one idea controlled every line; and this is true of Saint Thomas's Church as it is of Amiens Cathedral.

The method was the same for both, and the result was an art marked by singular unity, which endured and served its purpose until man changed his attitude towards the universe. The trouble was not in the art or the method or the structure, but in the universe itself which presented different aspects as man moved. Granted a Church, Saint Thomas's Church was the most expressive that man has made, and the great gothic

Cathedrals were its most complete expression.

Perhaps the best proof of it is their apparent instability. Of all the elaborate symbolism which has been suggested for the gothic Cathedral, the most vital and most perfect may be that the slender nervure, the springing motion of the broken arch, the leap downwards of the flying buttress,—the visible effort to throw off a visible strain,—never let us forget that Faith alone supports it, and that, if Faith fails, Heaven is lost. The equilibrium is visibly delicate beyond the line of safety; danger lurks in every stone. The peril of the heavy tower, of the restless vault, of the vagrant buttress; the uncertainty of logic, the inequalities of the syllogism, the irregularities of the mental mirror, -all these haunting nightmares of the Church are expressed as strongly by the gothic Cathedral as though it had been the cry of human suffering, and as no emotion had ever been expressed before or is likely to find expression again. The delight of its aspirations is flung up to the sky. The pathos of its self-distrust and anguish of doubt, is buried in the earth as its last secret. You can read out of it whatever else pleases your youth and confidence; to me, this is all.

The rest of the second of the

Notes

For an explanation of all architectural terms the reader is referred to the Glossary of Architectural Terms on page 377. Note that Adams frequently translates or paraphrases foreign phrases or passages employed in his text shortly before or shortly after the particular quoted passage. I have provided translations only for those foreign usages which Adams does not himself translate in his text or those for which the location of his translation or paraphrase might not be obvious to a reader.

Page 6, line 8: "chaussée"—causeway.

Page 7, chapter title: The title of the chapter translates as "Saint Michael of the Perilous Sea."

Page 8, lines 1–8: Adams alludes to section IX of William Wordsworth's "Ode: Intimations of Immortality from Recollections of Early Childhood," which runs in part:

"O joy! that in our embers
Is something that doth live,
That nature yet remembers
What was so fugitive!

Hence in a season of calm weather Though inland far we be, Our souls have sight of that immortal sea Which brought us hither, Can in a moment travel thither, And see the children sport along the shore, And hear the mighty waters rolling evermore."

Page 8, line 12: "Constantinus pagus"—Adams reminds us that Cotentin was once within a district (pagus) in the empire of Constantine.

Page 8, line 35: "After the scole of Stratford atte bowe"—Adams uses a line from Chaucer's comical description of his affected Prioress, who spoke French with an English accent (French learned in the Stratford-Nunnery), to make the point that French, in however bastardized a form, was still spoken and esteemed as the language of polite conversation as late as Chaucer's era (1400).

Page II, line 9: "pons sectorum"—"the bridge of the ages." As my introduction suggests, the concept of making (and crossing) im-

aginative "bridges" is central to Adams' project.

Page 18, line 1: "Roman"—the generic name for any medieval metrical tale in the French vernacular, as this one is.

Page 18, line 16: "vers romieus"—the verses of the tale. See line 13 of the epigraph to this chapter.

Page 19, line 6: "précieuse"—a reference to Molière's play les Précieuses ridicules, a comic satire of the practice—by women, mainly—in the seventeenth-century court of speaking in elaborate or metaphorical language to describe anything that was deemed crude or common.

Page 20, lines 32-39: "Whanne that April..."—the opening lines of Geoffrey Chaucer's Canterbury Tales, roughly translated as follows: "When April's sweet showers have watered the dry March ground... Then people long to begin pilgrimages, and religious votaries to travel to foreign lands... And, in particular, from every corner of England, pilgrims make their way to the shrine at Canterbury, to give thanks to the martyr [they prayed to] who helped them when they were ill."

Page 25, lines 29-30: "Otreiez mei . . "—translated by Adams above as:

"Grant to me as mine of right
The first blow struck in the fight."

Page 25, line 35: "lo l'otrei!"—I grant it!

Page 26, line 18: "a grant enor"—in great honor.

Page 28, line 9: "doulcement et suef"—gently and softly.
Page 29, line 4: "Ferut vus ai. . . "—translated by Adams above as:

Page 29, line 4: "Ferut vus as..."—translated by Adams above as: "Strike you I did. I pray you pardon me."

Page 29, line 7: "Ja est to . . ."—translated by Adams above as: "You know 'tis Roland who has so loved you."

Page 30, line 24: "seigneur"-lord.

Page 30, lines 30-33: "Jo Ven cunquis . . . "—Roland is near death, and is addressing his sword Durendal:

"With it I conquered Anjou and Britanny
And with it I conquered Poitou and Maine
With it I conquered noble Normandy
And with it I conquered Provence and Aquitaine."

Page 33, lines 22-24: "Whereat he inly raged..."—Adams quotes the description of Cain's slaying of Abel from Milton's *Paradise Lost*, Book XI, lines 444-46.

Page 33, lines 33-34: "Guaris de mei..."—translated by Adams

above as:

"Save my soul from all the perils For the sins that in my life I did!" NOTES 363

Page 35, chapter title: "The Merveille"—as Adams explains on page 40, the name for the north face of the Mount. Literally, "the marvel "

Page 41, line 6: "Viollet-le-Duc"—Eugene Emmanuel Viollet-le-Duc (1814-1879), a French architect, professional restorer of cathedrals and other medieval buildings, and writer on architecture, whose views Adams quotes or paraphrases at many points in his argument.

Page 46, line 40: "Belle Chaise"—a former entrance to the abbey.

Page 51, line 36: "Notre Dame"—literally, "Our Lady," the honorific title for the Virgin.

Page 54, lines 13-14: "C'est là, du reste ..."—"It is, in any case, a charming building."

Page 54, line 26: "Arlette"—the mother of William the Bastard.

Page 56, line 3: "chef-d'œuvre"-masterpiece.

Page 56, line 12: "mesquin"—pedestrian, or lacking in imagination. Page 56, line 27: "genre ennuyeux"-a phrase used by Voltaire in his

L'Enfant Prodique to indicate a tedious style of speech.

Page 57. line o: "Douane"—a custom-house at the border between sovereign states. Adams suggests that we are leaving one architectural realm and entering another.

Page 58, line 40: "oeil-de-boeufs," "oculi"-literally "a bull's eye" (French), "eyes" (Latin), a description of the appearance of the highly decorated round windows of a cathedral.

Page 62, line 4: "the Beauce"—the name of the ancient district of France within which Chartres was located.

Page 64, line 36: "droiture"-rightness, correctness (contrasted with "adresse"—manner, style, approach).

Page 65, line 29: "pitrines"—glass display cases.

Page 67, line 21: "Diane de Poitiers," 1499-1566, was the duchess of Valentinois and mistress of Henry II of France. She was a legendary beauty, whose actual physical charms were subsequently disputed by many nineteenth-century historians.

Page 68, line 9: "Queen Eleanor of Guienne"-see Chapter XI, es-

pecially pages 198-200.

Page 69, line 29: "restaurer"—an architectural restorer (a deliberately anachronistic use of this word).

Page 72, line 3: "Basilissa"—the honorific name of the reigning Byzantine empress.

Page 75, line 4: "Eginetan marbles"—sculpture of pre-Phidian type discovered in 1811 in Aegina. Adams uses them as a metaphor for the source of all subsequent art within a particular tradition.

Page 87, lines 26-34: "the eternal child of Wordsworth . . . "-another allusion to Wordsworth's poetry. The lines quoted at the bottom of the page are from section VIII of his "Ode: Intimations of Immortality from Recollections of Early Childhood."

Page 90, line 27: "Ave Maris Stella"—a common Latin prayer to Mary. which begins with the words "Hail, Star of the Ocean."

Page 90, lines 27-28: "Monstra te esse Matrem"—"Show me that you are the Mother [of God]."

Page 92, line 6: "milliards"—a thousand millions, a billion.

Page 95, line 2: "Templum Trinitatis"—"the temple of the trinity."

Page 95, line 3: "totius Trinitatis . . . "-"the grand dining room [i.e., the nurturer] of the whole trinity."

Page 95, line 21: "Mariolatry"—the idolization or worship of Mary. Page 98, line 14: "Ane qui vielle"—"the donkey who fiddles."

Page 100, lines 16-17: "Hujus sacrae ... "—"these holy institutional rites were begun at Chartres cathedral."

Page 100, lines 19-21: "Postremo per totam . . . "-"Finally, through nearly all Normandy, far and wide, it throve, especially taking hold in all of the places devoted to Mary, the mother of mercy."

Page 113, line 37: "cele qui la rose ... "-"She who is the rose of roses."

Page 113, line 39: "Super rosam rosida"-"More rosy than the rose" (a Latin pun involving dew and roses that has no literal English equivalent).

Page 123, lines 25-26: "Truie qui . . . Ane qui"—"The sow who spins, and the donkey who fiddles." Adams means that the effect would be felt by the very gargoyles in the stone as well as by the most brutish intellect contemplating them.

Page 128, line 37: "Noli Me Tangere"—literally "Touch me not." Christ speaks these words to Mary Magdalene after his resurrection

(cf. John 20:17).

Page 142, line 31: "Comes Teobaldus . . . "-"Friend (Count) Theobald gives . . . for prayers on behalf of his friend (Count) Perche." (Involving a Latin pun on "Count" and "friend.")

Page 142, line 35: "pagus perticensis"—the ancient district ruled by the Count of Perche.

Page 143, lines 9-10: "Mes compaignons . . . "-translated by Adams at the bottom of page 209 as:

> "Companions whom I loved, and still do love, Geoffroi du Perche and Ansel de Caïeux."

Page 143, lines 37-38: "Je nel di ..."—translated by Adams at the top of page 210 as:

> "I say not this of Chartres' dame, Mother of Louis!"

NOTES 365

Page 146, lines 2-3: "the English Barons sent hostages to Louis"a group of rebellious barons, attempting to overthrow King John, proposed making Louis king of England. After accepting and receiving hostages as proof of fidelity Louis invaded England with a group of his own counts. The two passages Adams includes tell first of the taking of hostages and the gathering of Louis's forces.

and then of the final rout of Louis's forces in England.

Page 146, lines 3-9: "et mes sires . . . "-"and my lord Louis had them [the hostages] well guarded, in all honor . . . and he assembled those great by their affection, and by their wealth, and by their lineage (birth). And with him were the Count of Perche, and the Count of Montfort, and the Count of Chartres, and the Count of Monblar, and my lord Enjorrans de Coucy, and many another great lord that I won't mention."

Page 146, lines 14-20: "Et li cuens . . . "—"And the Count of Perche was in the front line, and ran against the doors; and the forces therein came out and attacked them; and there were arrows and lances; and dead and fallen horses, and foot soldiers dead and dving. And the Count of Perche was killed by a villain who lifted the mask of his head-piece and struck him with a knife; and the front line was dismayed by the death of the Count. And when my lord Louis knew of it, he felt the greatest sorrow he had ever felt, for he was his nearest friend and kin."

Page 146, line 34: "le Jeune ou le Lépreux"-"the Young or the Leper." Page 150, lines 3-4: "de quibus . . . "-"with which to make a soldier riding on horseback."

Page 150, lines 18-19: "de camera Regis"—"of the King's council."

Page 162, line 14: "winding his olifant"—blowing his horn.

Page 163, line 15: "Clemens vitrearius . . . "-"Clement the glassmaker of Chartres."

Page 186, lines 13-14: "the heaven that lies about us . . . "-another allusion to Wordsworth's "Ode: Intimations of Immortality from Recollections of Early Childhood." Adams combines in one phrase references to lines 66 and 197 of the poem.

Page 188, line 40: "Fabliaux"—a short metrical tale for and about the lower classes. Such a tale is usually comic, coarse, and cynical,

especially about the morals and conduct of women.

Page 189, line 10: "tradites"-forms traditions.

Page 190, lines 7-8: "My liege lady! ... "-"My lord and lady! most of all, said he, women want sovereignty [i.e., to rule their husbands]." Quoted from Chaucer's Wife of Bath's Tale, where the irony is that a man is forced to say this at the compulsion of a woman who is exacting rule over him at this very moment.

Page 193, lines 16-18: "Li Beaudrains ... "-

"Baldwin moved his Virgin (Queen) to save his pawn, And the other his Dauphin (Bishop) in order to take The Virgin or the pawn, or to make them retreat."

Page 193, line 19: "The aufin or dauphin" is the eldest son of the king and the heir apparent to the throne; "the Fou" is the fool or knave. Page 195, lines 9-15: "For well I wote . . . "—

"For I well know that Christ personally said That in Israel as big as it is, He found no greater faith Than a woman's, and this is no lie. And as for men, notice, such cruelty They do all the time, judge whoever will, The most honest is still quite fallible."

Note that Adams twists the meaning of "brotell" to his purposes.

Page 198, line 12: "bête"-foolish, silly, stupid.

Page 200, line 10: Legend had it that Eleanor of Aquitaine murdered "Fair Rosamund," Henry's mistress, by poisoning her. The event (or alleged event) generated a vast body of medieval romance literature.

Page 201, line 39: "Christian of Troyes"—otherwise known as Chrétien de Troyes (fl. 1170), the greatest of medieval French poets and the author of a series of poetic treatments of Arthurian legend and many other romances.

Page 203, line 3: "Eructavit"—the first word of the Latin text of Psalm 45 (King James Version): "My heart is inditing a good

matter."

Page 205, lines 11-20: "Et li vaslet . . . "-

"And the squires prepared
The beds and fruits for bedtime
And these were very dear,
Dates, figs, and nutmegs,
Cloves and pomegranates,
And jams at the end,
And Alexandria gingerbread.
After this they drank of many drinks,
Spice wine without honey or pepper,
And old berry wine and clear juice."

Page 206, line 12: "Aucassins"—Here and subsequently, Adams will refer to the figure modern writers name "Aucassin" with this spelling of his name.

NOTES 367

Page 208, lines 25-34: "Puisque ma dame ..."

"Since my lady of Champagne
Wishes me to undertake a romance

It is said, and I bear witness
That she is the lady who surpasses
All living ladies
Just as the smoke passes the winds
That blow in May or in April

I will say that as many as a jewel
Is worth of straws and fishes
As many queens is the Countess worth."

Page 210, lines 11-12: "mi ome et mi . . ."—translated in lines 7-8 of the preceding passage, on page 209.

Page 212, lines 27-28: "Maintes paroles . . ."—

"As many [offensive] things were said of her As of Tristan and Isolde."

Page 213, line 26: "Gaston Paris"—an influential French scholar who lived from 1839 to 1903 and was an editor of many medieval texts.

Page 218, lines 3—4: "Dox est li cans . . . "—

"Sweet is the song; fair is the telling, And courtly and well told."

Page 218, lines 17-18: "trouvère"—troubadour; "jogléor"—minstrel; "viel caitif"—old soul or old beggar. Adams is indicating the end of an era.

Page 220, line 25: "papelard"—hypocritical.

Page 222, lines 30-32: "Esmeres et Martinet ..."—the names of shepherds.

Page 224, line 30: "en xl lius . . . "—"in 30 or 40 places."

Page 228, lines 16-20: The "bourgeoisie" here means the burghers, the prosperous lower classes or shopkeepers. "Dames courtoises" are high-born ladies. In this context, the distinction may be understood as that between the common man and the nobles of the court. That is to say, Adam de la Halle wrote songs, poems, and plays for the common man as well as for the court.

Page 228, line 36: "Li Gieus de Robin . . . "—The Play of Robin and Marion (a play in verse and song by Adam de la Halle). "Gieus" can mean both a game and a dramatic play, hence it is a pun here.

Page 229, line 7: "Robin m'aime . . . "—"Robin loves me; Robin has [won] me."

Page 229, lines 8-9: "Je me repairoie . . . "—"I'm returning from the tournament."

Page 229, line 18: "Ane" in old French may mean either ass or fowl, and the game depends on taking the one meaning instead of the other. (In the following passage there is a similar pun on "Hairons," which means either herrings or herons.)

Page 230, lines 23-24: "Vos perdes vo paine ..."—"You're wasting your time, Sir Aubert."

Page 230, lines 32-33: Poi Robin flagoler ... "-

"I hear Robin piping On his silver pipe."

Page 231, lines 6-8: "Certes voirement . . . "-

"I am really a fool To tarry for this wench. Farewell, shepherdess!"

Page 232, lines 14-18: "Elle l'a mis . . . "-

"She asked [literally: spoke sense to] him: 'Aucassins, my fair sweet friend, Where will we go?' 'Sweet friend, how do I know? It matters little to me where we go.'"

Page 233, line 24: "William of Lorris"—Otherwise known as Guillaume de Lorris, he wrote, around 1235, the first part (about 4600 lines) of the Roman de la Rose (The Romance of the Rose), which was continued and completed with an additional 18,000 lines by Jean de Meung around 1280.

Page 234, lines 19-34: "Yeve"—give; "nyce"—precious or fussy; "ware"—considerate; "wight"—man; "wot"—knew.

Page 235, lines 3-23: "restelesse travayleth aye"—that proceeds without ever stopping; "prively"—slyly; "sykerly"—sure; "nys"—is not; "clerkes"—scholars, learned men; "or"—before; "sojourne"—stay; "frette"—consumes; "distroieth he"—he destroys.

Page 235, lines 30-38: Ballade des Dames du temps jadis, from which these lines are taken, was written by François Villon around 1460 and is best known for its refrain, "where are the snows of yester-year?" ("Mais ou sont les neiges dantan?"), a reference to the effects of time on beauty, fame, and human emotions.

Page 236, line 3: "fausse route"—"taken a wrong turn," "gone the wrong way."

Page 236, lines 8-9: "tout porrist"—"everything rots, fades, dies."
Page 237, chapter title: The title of the chapter translates as "Our Lady's Miracles."

Page 237, left-column epigraph: "Vergine Madre . . . "-

"Virgin and Mother, daughter of your Son, humble and elevated more than any creature, fixed goal of the Eternal Counsel,

You are the one who so ennobled human nature, that its Maker did not disdain to become its creature. . . .

Your goodness not only assists those who ask, but oftentimes it freely anticipates the request.

In you is mercy, in you is pity, in you is magnificence, in you gathers whatever goodness that is in any creature."

—from Dante Alighieri, *The Divine Comedy, Paradiso*, Canto XXXIII, lines 1-6 and 16-21.

Page 237, right-column epigraph: "Vergine bella . . . "-

"Beautiful Virgin who, clothed with the sun, crowned with the stars, you so pleased the highest Sun that in you He hid His light, love thrusts me to say a few words to you, but I do not know how or where to begin without your help and His, who due to His love became incarnate in you.

I appeal to her who has always rightly answered whoever has implored her with faith.

Virgin, if the extreme misery of human things ever touched your mercy bow to my prayer, give aid to my war, although I am made of earth, and you are queen of Heaven."

—from Francesco Petrarch, Rerum vulgarium fragmenta, fragment CCCLXVI, lines 1–13.

Page 237, lines 2-3: "Chaucer translated Dante's prayer"—See the Prologue to The Second Nun's Tale, lines 36-77.

Page 239, line 31-page 240, line 6: "Ung jour ..."—"One day when I was before the King I asked him leave to go on pilgrimage to Our Lady of Tortosa, which was a strongly recommended journey. And there were many pilgrims each day, for it is the first shrine that was ever dedicated to the Mother of God, as they said then. And Our Lady performed great and marvellous miracles there. Among others she made one for a poor man who was out of his mind and maniacal, for he had the fiendish spirit in his body. And it happened one day that he was brought to the shrine of Our Lady of Tortosa. And while his friends who had brought him there were praying to Our Lady to restore his health, the devil that the poor creature had in his body responded: 'Our Lady is not here; she is in Egypt helping the King of France and the Christians who are arriving today in the Holy Land against all the heathens that ride.' And this was put down in writing the day that the devil spoke these words and was taken to the legate who was with the King of France: and he told me later that on that very day we had arrived in the land of Egypt. And I am certain that the Good Lady Mary took good care of us."

Page 241, line 20: "neuvaine"—a novena, an act of devotion.

Page 241, lines 28-29: "Jacques Clément"—the assassin of Henry III of France.

Page 242, line 5: "the Maid of Orleans"—Joan of Arc.

Page 243, lines 19-20: "Miracles de la Vierge"—Miracles of the Virgin.

Page 247, line 4: "Mater Dolorosa"—Mother of Sorrow, Sorrowful Mother.

Page 247, line 27: "escape worse than whipping"—an allusion to Shakespeare's *Hamlet*, II, ii, 530. Hamlet is speaking to Polonius: "Use everyman after his desert and who will scape whipping?"

Page 249, lines 17-20: "Mais cele ou sort ... "-

"But She in whom resides all pity, All kindness, all love And who never forgets her own Did not forget her sinner."

Page 249, line 25: "damoiseau"—a young nobleman, a page aspiring to be knighted.

Page 251, lines 45-47: "'Amis?' ce dist ..."—translated on page 252, lines 8-10.

Page 252, line 4: "They also serve . . ."—the final line of Milton's Sonnet XIX ("When I consider how my light is spent").

Page 252, lines 15-16: "Sire cumpain!..."—translated on page 28, lines 28-29.

NOTES 371

Page 253, line 24: "siècle"—"siècle" is used here in its root meaning of "the secular world."

Page 254, line 14: "Dulcinea del Toboso"—the lady to whom Don Quixote devoted his service as a knight-errant. Adams invokes Cervantes' hero slyly to remind a reader how radically attitudes towards courtly love had changed by the early seventeenth century, the time of Don Quixote.

Page 257, lines 5-6: "ne cremoit dieu . . . "-"feared neither God,

order, nor rule."

Page 259, line 32: "laid maufe"—"ugly devil," a reference to the first line of the preceding quotation.

Page 269, epigraph to the chapter:

"Above all things, beneath all things,
Outside of all things, within all things,
Within, but not included,
Outside, but not excluded,
Above, but not elevated,
Beneath, but not below,
Wholly above, presiding,
Wholly below, sustaining,
Wholly outside, embracing,
Wholly within, full-filling."

Page 269, lines 14–20: "Ipse manet intra omnia..."—"He Himself is in all. He Himself is outside all. He is above all. He is below all. He is superior through His power, and inferior through His sustenance, outside by virtue of His magnitude, inside by virtue of His permeating fineness. Ruling above, containing below, enclosing without, penetrating within, superior in some parts, inferior in others, exterior in some, interior in others, but one and the same and complete everywhere."

Page 269, lines 23-24: "sursum regens ... "—"ruling above, con-

taining below."

Page 273, line 9: "exercitium nefarium"—evil exercise.

Page 273, line 17: "Romieu"—in the verse form of a Romance.

Page 281, line 37: "Pons Asinorum"—"the asses' bridge," originally the name humorously given to the Fifth Proposition of the First Book of Euclid, owing to the difficulty that beginners or dull-witted pupils find in "getting over" it. More generally, any critical test of their faculties imposed upon the ignorant or inexperienced.

Page 282, lines 3-4: "coup de Jarnac"—an unexpected and decisive stroke, from that with which the Baron de Jarnac overcame his

rival in a famous duel before Henry II in 1547.

Page 298, line 16: "Damnamus—namus"—"We convict." Adams comically imagines the judges too sleepy and lazy even to pronounce the whole word as they chime in on each other's words.

Page 301, lines 25-26: "Formam dei . . . "—"They named the form of God divinity."

Page 309, line 24-page 310, line 8: "Ave, Virgo . . . "-

"Hail, unique virgin,
Mother of our salvation,
Who are called the Star of the Sea,
A fixed star.
In the sea of this life,
Save us from ship-wreck,
And supplicate your savior on our behalf.

The sea rages, the winds roar,
The waves rise turbulent,
The ship rushes,
And encounters many travails.
Sirens, pleasures, serpents,
Dogs and pirates threaten us
With death and make us almost desperate.

Beyond the abyss, now towards heaven A furious wave drives our vessel. The mast shivers, the soul goes slack, The sailor ceases his work, The living man wastes away. You, holy Mother, free us Who are perishing."

Page 310, lines 12-17: "Sic de Juda . . . "-

"Thus from Juda, a great lion, Shattering dread death's doors, On the third day is risen, With the roar of his father, Nursing at the bosom of his mother, He restores all of our lost riches."

Page 310, lines 30-32: "Salve, Mater Pietatis . . . "-

"Hail, Mother of Piety, Noble nourisher Of the whole Trinity." Page 311, line 12: "Infinitus et Immensus"—translated on page 308, line 30.

Page 311, line 13: "Oh, juvamen oppressorum"—translated on page 308, line 1.

Page 311, line 14: "Consolatrix miserorum"—translated on page 312, line 34.

Page 312, line 39: "Inter vania ... "-

"Among all vain things, Nothing is vainer than man."

Page 313, lines 19-22: "Hic ego qui jaceo . . . "-

"I who here lie so low
Wretched and pitiful Adam
Can only offer a prayer as my highest gift.
I have sinned, I confess.
I beg for forgiveness. Spare me.
Spare me father, brothers, God!"

Page 313, line 32: "nacre"—mother-of-pearl.
Page 315, lines 2-3: "domina nostra paupertas"—Our Lady Poverty.
Page 315, lines 5-6: "Isti sunt fratres..."—

"These are my brother knights of the round table, hiding in the desert."

Page 322, lines 44-45: "Tunc cardinalis..."—translated on page 323, lines 7-9.
Page 324, line 2: "mesure"—propriety, decorum, balance.

Page 324, lines 13-34: "Cantico Del Sole"-

The Song of the Sun

"Praised be, my Lord, with all Your creatures, especially master brother sun, who gives us daylight, and You through him give us light, and he is beautiful and radiant with great splendor; of You, most High, he brings meaning.

Praised be, my Lord, for sister moon and the stars, in Heaven you created them bright and precious and beautiful. Praised be, my Lord, for brother wind and for the air and for all weather: cloudy and clear, through which to all Your creatures You give sustenance.

Praised be, my Lord, for sister water, who is most useful and humble and precious and pure.

Praised be, my Lord, for brother fire through whom You enlighten the night and he is beautiful and joyous and vigorous and strong.

Praised be, my Lord, for our sister mother earth, who sustains us and takes care of us, and bears many fruits with colored flowers and grass.

Praised be, my Lord, for our sister bodily death from whom no living person will ever escape.

Woe to all who will die in the state of mortal sin..."

—from San Francesco d'Assisi, The Canticle of Creatures, lines 4-21 and 26-28.

Page 325, line 6: "Pons Sanctorum"—bridge of the spirits.

Page 330, lines 7-8: "nihil est in intellectu"..."—"nothing is in our minds but what was first in our senses" (from Aristotle's Metaphysics).

Page 331, line 35: "conférences"—lectures. Page 333, lines 15-16: "Est in Deo . . . "—

> "There is in God, thinking Himself, The Word of God, as it were Himself intellectualized."

Page 335, lines 1-4: "That glorious form ..."—quoted from Milton's "On the Morn of Christ's Nativity," lines 8-11. These lines refer to Christ's residence with God in heaven. Christ is the "he" in the third line.

Page 335, lines 9-10: "The baby image...—Adams slightly misquotes Nestor's line in Shakespeare's Troilus and Cressida, I, iii, 345:

"The baby figure of the giant mass Of things to come at large."

Page 343, lines 38-39: "Contra fratrem . . ."—against (or in response to) Brother Thomas.

Page 343, line 39-page 344, line 6: "quia intelligentiae . . ."—"Because the acts of the intellect do not have material form, God cannot make more than one of the same species; and because God cannot multiply individual members of one species without matter, and matter is not in angels . . . because forms can not receive division except as secondary matter."

Page 345, line 27: "Omar's pipkins of clay . . . "—A reference to The Rubáiyát of Omar Khayyám, of which Edward Fitzgerald translated

NOTES 375

seventy-five quatrains in 1859. The metaphor of man as a clay vessel runs throughout the poem, but especially in stanza 53 of Fitzgerald's translation.

Page 347, lines 18-19: "avec son hideux sourire"-"with his horrid

grin," a phrase from Voltaire's Candide.

Page 347, lines 20–21: "argumentum ad personam divinam"—literally "an argument based on the personhood of God," more generally an argument that treats God's attributes analogically as comparable to man's.

Page 347, line 25: "amissio boni"—the absence of good.

Page 348, line 9: "ab defectu"—literally "from its defects or limita-

Page 357, lines 31-33: "Omar's kinetic analogy..."—another reference to Fitzgerald's *The Rubdiyât of Omar Khayyâm*. In stanzas 45, 46, and 50 of Fitzgerald's translation, man is imagined as a ball in a game. Stanza 50 reads:

"The Ball no Question makes of Ayes and Noes, But Right or Left as strikes the Player goes; And He that tossed thee down into the Field, He knows about it all—He knows—He knows!"

Adams takes this and imaginatively transforms the balls into molecules in a gas in accordance with the thermodynamic theory of random molecular movement. The *Rubáiyát* generally expressed a sense of human frailty and weakness and a fatalistic attitude of resignation that theoretically appealed to Adams, even as he personally and stylistically reacted against it in his life and work.

Page 357, line 35: "an imaginary demon to sort his atoms"—a reference to James Clerk Maxwell's famous thought experiment involving a "sorting demon" who could take the random kinetic energies in nature and organize them into a humanly valuable and orderly result. Adams despairs of the possibility of there being a "sorting demon" to order and arrange the chaos and confusion in our lives and experiences. Ultimately, entropy—the loss of order, the decay of organization, and the triumph of confusion—is the central recognition of his science of man. There can be no "sorting demon" except in our lives, which are all the more exhilaratingly lived in the face of the randomness, mess, and flux of earthly existence, as we make our attempts at order.

Page 358, line 17: "the Slave of Michael Angelo"—a reference to any one of the unfinished slave sculptures of Michelangelo, four slaves in all, now on view in Florence, commissioned for the tomb of

376 NOTES

Pope Julius. In their state of incompletion and as "seen from above." they appear to be imprisoned not only by the fetters marked on their arms and chests, but by the very blocks of stone that surround them and in which they are still partially embedded. Along with many other nineteenth-century romantic critics, Adams imagines them to be pushing out of and attempting to break loose from the medium in which they are half submerged. They symbolize the human will to freedom and independence, the artistic imagination wresting order and beauty out of chaos or entropy through an exertion of imagination and power. They exist forever in a state of transition as an allegory for the condition of the human soul as Adams imagines it to exist in Mont Saint Michel and Chartres-in an unstable dynamism, half submerged in the inchoate formlessness of the rough stone block, half thrusting upward, out of it, into a realm of transcendental beauty and freedom, as sublime sculptural figures.

An additional reason for Adams to invoke the name of Michelangelo at this point in his argument is to work one final triumphant change on the name and identity with which his book began-the Angel Michael atop Mont Saint Michel. Michelangelo represents the greatest creativity and power attainable by a human aspiring upward under the downward protection and care of the Angel Michael. It is by holding in one thought both the divine ideals represented by the Angel Michael and the worldly realities embodied in the life and work of Michelangelo that we are enabled to see the slave sculptures from above and below at the same time. Along with Adams, we can cherish their embeddedness in the impure world of men and matter, even as we simultaneously appreciate their aspiration to escape into a purer realm of imaginative transcendence and spirituality. That is the double vision of Adams' entire work and the invigorating double consciousness structures like Mont Saint Michel and Chartres induce in us, according to him. It is a double vision profoundly related to that of Emerson in his late essays, or that of James in his final novels.

Glossary of Architectural Terms

ABBATIAL BUILDINGS-structures of or pertaining to an abbey.

AMBULATORY—the aisle around an apse or circular structure.

ARCADE—a row of arches on columns.

ARC-DOUBLEAUX—a massive arch that runs across a vault, supporting or reinforcing it.

ARC-FORMERET-a heavy wall arch or arch rib that supports a vault

along its edge.

APSE—a semicircular space at the end of an axis of a church, intended to house an altar, and along the walls of which chapels may be arranged.

ATTIC—the story immediately above the cornice of a structure.

CHARTERHOUSE—the room in a monastery in which its public business was transacted.

CHEMIN DE RONDE—a walkway behind a rampart on which guards

or lookouts might be stationed.

CHOIR—the area of a church or cathedral located between the nave and the sanctuary, closed to the laity, accessible only to the clergy, their assistants, and the members of the choir.

CLERESTORY—the upper part of the nave; the story of a cathedral or

church with windows above the roofs of the aisles.

CLOCHER—a bell tower or belfry.

CROISÉE—the space in a structure where the nave intersects the tran-

FENESTRATION—the arrangement and decoration of the windows in

FLÈCHE—a spire built on top of a tower, extending above the line of the roof and usually octagonal in plan.

FLYING BUTTRESS—a structure of masonry beyond the walls of a structure carrying the lateral thrust of a roof or vault into an external

pier.

GOTHIC ARCHITECTURE—a style originating in the twelfth century and based on Romanesque forms. It is characterized by walls with a maximum amount of decorative fenestration, pointed arches, ribbed vaulting, and exterior flying buttresses.

GRISAILLE—a stained-glass window executed not in color but in var-

ious gravish tints.

GROIN—the ridge or curved line formed by the intersection of two contiguous vaults.

LANCET—a tall narrow window with a sharply pointed arch at its top. NAVE—the middle aisle of a church. The part of a church intended for the laity.

NERVURES—the ribs of a groined vault. (In his use of it, Adams puns on the word to mean "nerves" as well, which is its literal French translation, as if a cathedral were an architectural extension of the nervous systems of the individuals within it.)

PARVIS—an area in front of a large church, in some instances open, in others enclosed with walls and a roof.

PIGNON-a gable.

PORCH—the decorated structure surrounding and sheltering an entrance to a church or cathedral.

REFECTORY—a large hall in which meals are eaten by groups of people.

ROMANESQUE ARCHITECTURE—a style originating in the eleventh century based on Byzantine and Roman forms. It is characterized by massive, solid walls; round arches; and heavy vaulting.

ROSE WINDOW—a circular window filled with and bordered by complex ornamental stonework.

SANCTUARY—the area immediately surrounding the main altar.

TRANSEPT—the line of a cruciform church projecting at right angles to the main structure.

TRICLINIUM—a refectory (as Adams uses it, a term applied to the Virgin).

TRIFORIUM—a story running along the wall, above the arches of the nave and choir, but below the clerestory.

TRUMEAU—the central, columnar support of a doorway or portal.

TYMPANUM—the semicircular space often containing a sculptural pro-

gram above the lintel of a doorway.

VAULT—an arched structure of masonry forming the ceiling or roof of a structure.

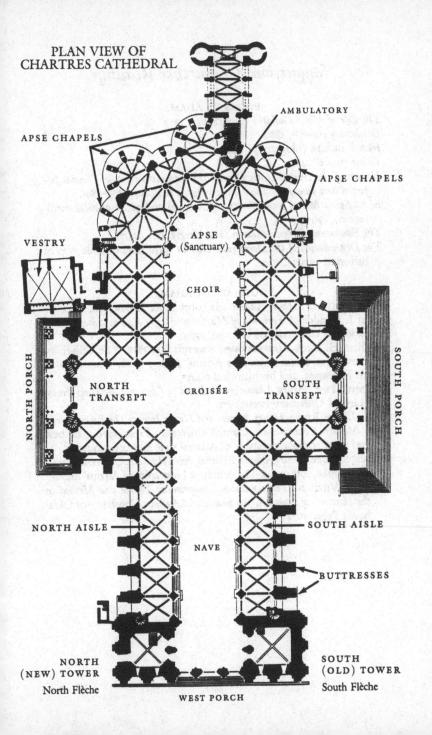

Suggestions for Further Reading

BOOKS BY ADAMS:

The Life of Albert Gallatin (biography), 1879.

Democracy (novel), 1880.

John Randolph (biography), 1882.

Esther (novel), 1884.

History of the United States During the Administrations of Thomas Jefferson and James Madison (nine-volume history), 1889–1891.

Mont Saint Michel and Chartres (historical and philosophical meditation), 1905.

The Education of Henry Adams (autobiography), 1907.

The Degradation of the Democratic Dogma (posthumous collection of historical essays), 1919.

BOOKS ABOUT ADAMS:

R. P. Blackmur. Henry Adams. Harcourt Brace Jovanovich, 1980. John J. Conder. A Formula of His Own: Henry Adams' Literary Ex-

periment. University of Chicago, 1970.

William H. Jordy. Henry Adams: Scientific Historian. Yale University Press, 1952. Concentrates on Adams' History of the United States, his Education, and his historical essays.

Robert Mane. Henry Adams on the Road to Chartres. Belknap Press/

Harvard University Press, 1971.

John Carlos Rowe. Henry Adams and Henry James: The Emergence of a Modern Consciousness. Cornell University Press, 1976. The best and most stimulating study of Adams' style and consciousness.

Ernest Samuels. Henry Adams. Belknap Press/Harvard University Press. 3 vol., 1948, 1958, 1964. The definitive biography of Adams' life.

Richard Vitzhum. The American Compromise: Theme and Method in the Histories of Bancroft, Parkman, and Adams. University of Oklahoma Press, 1974.

Index

Aaron, window at Chartres, 176	Albertus Magnus, Doctor universalis,
Abbatial buildings, 40	271, 326, 327
Abbaye-aux-Dames and Abbaye-aux-	his liber de laudibus, 91, 137
Hommes at Caen, 11, 12, 54, 189	his collected works, 243
de Citeaux, 41, 44, 90	Albi, cathedral at, 106
de Clairvaux, 38, 41, 44, 90, 265	Alda, in the Chanson de Roland, 26, 32,
de Cluny, 41, 44	36
de Saint Gildas-de-Rhuys, 291, 299	Alexander II, Pope, 9
de Saint Leu d'Esserent, 59, 64, 112,	Alexander Hales, 326
201-202	Alexandrine gingerbread, 205
de Saint Victor, 276, 306	Alfonso of Portugal, 80
de Saint Denis (See Saint Denis)	Alix, duchess of Brittany, married to
Abbot, rank and duties of, 40–41	Pierre de Dreux, 83, 86, 172
Abélard, Pierre du Pallet, 38, 133, 134,	Alix de Champagne, queen of Louis VII
	of France, (1160-1206), 144, 145,
165, 235, 303	200
his hymns to the Virgin, 91, 240	Alix de France, married to Count Thi-
his love-songs, 207–208	baut of Chartres, 144, 145, 191,
his statement of the Virgin's rank in	
theology, 242	Alix de France, affianced to Richard
his origin and career, 271-300	Cœur-de-Lion, 200
his Historia Calamitatum, 273-93	Alix of Savoy, queen of Louis VI of
his gloss on Porphyry, 282	
his condemnation in 1121, 288	France, 73, 77, 191
his condemnation in 1140, 295-99	Almogenes (See Hermogenes) Amaury de Montfort, at Chartres, 148
his death, 299	
(See Héloïse, Peter the Venerable,	Amboise, chateau of, 44
Saint Bernard, William of Cham-	Arniens cathedral (Notre Dame), 48, 51,
peaux, Suger, John of Salisbury)	70, 87, 88, 182, 302, 326, 329,
Abraham and Isaac, in the north Porch	344
of Chartres Cathedral, 82, 113, 174	Beau Christ of, 7
Abydos, 97	statuary of, 77, 79, 97
Acquitaine (See Guienne)	height of vault, 107
Adam, Mystery Play, 194	rose window of, III
Adam de Saint Victor, 91, 113, 307	apse of, 120
his hymns to the Virgin, 93-94, 309-	Thierry, bishop of, 100
312	Ane qui vielle, 98, 123
to the Trinity, 307	Angels, hierarchy of, window at Chartres,
to the Holy Ghost, 307	172, 175
on scholasticism, 308	not individual but species, 342-44
miracle of, 310-11	Angers, hall of bishop's palace, 39
epitaph of, 313	chateau of, 44
Adam de la Halle, 221, 228, 239, 240	cathedral of, (St. Maurice), 112;
his play of Robin and Marion, 228-	glass of, 131
232	Angevin school, 106
Agnes Sorel, 232	Anjou, county of, in the Chanson de
Alain of Lille, 335-36	Roland, 30

Anjou (cont.) Geoffroy Plantagenet of, 191, 199 Henry of, king of England, 198; marries Eleanor of Guienne, 200 Anne (See Saint Anne) Anne, duchess of Brittany, queen of France, (1476-1514), 89 Antioch, 199 Apocalypse, figures of, 71, 177 Apses and choirs, 15, 51, 97, 114-22 Aquilon, the, at Mt. St. Michel, 36, 37, Aquino, the birth-place of St. Thomas, 156, 318, 326 Arab philosophy, 166, 287, 340 Arcs boutants (See Buttressing) Arcs doubleaux and arcs formerets, 37 Argentueil, abbey of, 291 Aristotle, at Chartres, 72, 91 his attraction to French thought, 135, 166, 167, 274, 278, 330, 339 bridled, 193 his authority in the schools, 277, 294, adopted by the Church, 326, 329, 330, 333, 339, 350 Arles, architectural school of, 61; sculptures, 69 Arlette, mother of William the Bastard, Armancourt. "Notes héraldiques et généalogiques, 1908," 148, 149 Arnold, Matthew, 314 Arques, chateau of, 44 Arts, the seven liberal, 72, 91 Assisi (See Francis), 17 church at, 106 country of, 314 Assumption of the Virgin, 77 Aucassins et Nicolete, 150, 206, 217-28, 260, 261, 262 Aufin, dauphin, fou, in chess, 193 Augustine (see Saint Augustine)

Autun, cathedral of, (St. Lazare), 69-70

Auvergne, architectural school of, 61,

cathedral of (St. Etienne), glass at, 139,

docher de Saint Germain, 50, 65

115

Auxerre, 91, 292

Ave Maria, 244, 259, 265

Averroës, 134, 289, 297 Avicenna, 135, 297 Avignon, 211 Avranches, 8, 39 Bacon, Lord Verulam, 297; rejected the syllogism, 315-16, 317 Bakers' window at Chartres, 163, 172 Baronius, his Ecclesiastical Annals, 157 Barry, Madame du, 14, 236 Bath, the, in the middle ages, 228 Battle Abbey, roll of, 24 Battle-cries, 37, 91 Bayeux, cathedral of (Notre Dame), 88 its towers, 12, 53, 56, 64 tapestry of Queen Matilda, 22, 23 eleventh century architecture, 10, 35 Béarn, 91 Beaucaire (See Aucassins) Beauce, plain of, 62, 131 Beaugency, on the Loire, 199 Beaumont, in Normandy, 16 in Le Perche, 150 Beauvais, cathedral of (Saint Pierre), 14, 96, 106, 182, 314, 327, 328, 345, 356, 358 apse of, 119 church of St. Etienne, rose of, 112 Abbey of Saint Lucien, 202 architects of cathedral, 53, 356 Beaux Arts, Ecole des, 38, 105, 106, Belle Verrière, window at Chartres, 140, 141, 142, 153, 172 Benedictines, 9, 17, 322 Benoist, Norman chronicle of, 21, 25 Benoit-sur-Loire, church of, 11 Berchères l'Evêque, quarry of, 101, 112, Bérenger, sieur du Pallet, father of Abélard, 271 Bernard (See Saint Bernard), abbot of Clairvaux, (1090-1153), 17, 36, 38, 51, 103, 123, 153, 155, 191, 198, 201, 265, 301, 302, 303 his crusade, 100 his hymns and sermons, 90, 91, 93, 240, 310 his origin, 271 establishes Clairvaux, 90, 286, 290

Stella Maris, 36, 90, 94, 310

his controversy with Abélard, 277his political authority, 191, 292-99 described by Heloïse, 270 described by Peter the Venerable, his controversy with Gilbert de la Porée, 301 his rules, 322 Berou, Robert de, his window, 147 Bestiaries, 98 Bibliothèque Nationale, 65, 124 Blanche of Castile (1187-1252), queen of Louis VIII, mother of Saint Louis, 76, 77, 79, 80, 86, 113, 137, 148, 190, 195, 258, 259 her influence at Chartres, 113, 137, 158, 172, 183 her quarrel with the students, 166, 259 her Rose window at Chartres, 174-176 genealogical table of, 191 her relations with Thibaut of Champagne, 148, 179, 211-16, 239 her marriage to Louis VIII, 211 queen and regent, 211-13, 314 Blois, city of, 199 hall of chateau, 44 apartments of, 89 Blondel, 218 Blue, value of, 125-26, 130, 146-47 Bluebeard, 195 Bollstadt in Swabia, counts of, 326 Bonaventure, Saint, 331, 354 Boscherville, in Normandy, 55, 64 Bosham, port of Chichester, 22 Boulogne, Countess Mahaut, or Matilda, of, 79-81 Bourbon kings of France, (1589-1793), 89, 241 Bourdillon, F. W., 217 Bourges, cathedral of (Saint Etienne), 48, 87, 99, 107, 183 apse of, 119, 120 Last Judgment, at, 70 Monograph on, 124, 166 twelfth-century glass at, 131 thirteenth-century glass at, 158, 164-166 fifteenth- and sixteenth-century glass at, 182

Bourgogne, 91 Bramante, 66 Bridan, Charles Antoine, sculptor, (1767-1773), 147, 148 Brittany, province of, 10, 11, 30, 40, 165, 179 (See Abélard) Dukes and Duchesses of: Conan III, (1112-1148), 290 Alix (1203-1221), married in 1212 to Pierre of Dreux, 83, 86 death in 1221, 179 her son, John I, (1237-1286), her daughter Yolande, 148, 179, Pierre de Dreux (Mauclerc), duke (1212-1236), 83-86, 99, 113, 137, 174-81; on the seventh crusade in 1248, 239 Anne, queen of France, (1488-1514), 89 Buddha, Sakya Muni, 242, 307 Bullant, Jean, 66 Bulteau, Abbé, his "Monographie de la Cathédrale de Chartres," 38, 72, 76, 81, 85, 86, 93, 107, 147 Burgundy, architectural school of, 61 Butchers' windows at Chartres, &cc., 164, Buttressing, 105-106 Byzantium, 13, 35, 70, 74, 89 Virgin of, 89, 93 influence of, on glass, 128-29

Caen in Normandy, II, 16, 53
towers of, 50, 53
Caheu, or Caieu, Ansel de, 143, 209
Cairo, 129, 131, 134
Calixtus II, his supposed decree of II22
declaring the Pseudo-Turpin authentic, 159
Calvados, 9
Cantico del sole, 324
Carpenters and Coopers, their window
at Chartres, 163
Carteret in Normandy, 10
Castile (See Blanche and Ferdinand),
arms of, 155
Catherine of Medicis, queen of France,

Caumont, Arcis de, his "Histoire de l'Architecture Religieuse," 52 Cefalu, cathedral, 10 Cérisy-la-Forêt, 16 Cervantes (See Quijote) 217 Chalons-sur-Marne, glass at, 131 Champagne, county of, 201, 204 Counts of: Henry (†1180), 144, 191, 200 Henry (1150-1197), 210 Thibaut (†1201), 144, 191, 210 Thibaut-le-Grand (1201-1253), 144, 148, 191, 211, 212, 218, 220; affianced to Yolande of Brittany, 148, 179; his poems, 214-16 Countess Marie de France (†1198), 143, 144; her marriage to Henry of Champagne (1164) 200, 201; her influence on poetry, 202, 206, 207; object of Cœur-de-Lion's prison-song, 209-210; widowhood and death, 210 Champeaux, William of, 270; his disputes with Abélard, 273-286; patron of Saint Bernard, 285-86 Chanson de Roland, 10, 17, 21, 24-34, 38, 49, 159, 202; examples of the grand style, 28-29, 252; unreligious, 220; free from grossness, 228; evangel of Saint Francis, 315 Chansons de Geste, 21, 231, 243 Chardonnel, Geoffroi, 163 Charente, architecture of, 50, 61 Charlemagne, defeated at Roncesvalles (778), 10, 23 window at Chartres, 17, 160, 162, 168, 182, 206, 218 never sainted, 159 in the first lines of the Chanson, 26 in the last plaint of Roland, 30, 31, friend of Constantine VI, 35, 160 ideal of Saint Francis, 17, 316 Charles VII, King of France (1422-1461), 198, 232 Chartres, County of, 57, 61, 97 Counts of: Thibaut (†1197), 143, 144, 191,

199, 200

Louis (†1205), 144, 145, 191, 210 Thibaut VI (†1218), 142, 144, 172, 101 Countesses of: Alix de France, 143, 144, 191, 200, Isabel, 191 Bishops of, 147, 166, 168 (See Regnault de Mouçon. John of Salisbury) Chartres, Shrine of, 11, 118, 137-38 Virgin of, always the Virgin of Majesty, 70, 92-97, 138-41 her presence always felt, 99-102, 108-113, 121, 138, 141 Chartres Cathedral (Notre Dame) monograph on, 124 (See Bulteau) guide-book of, 171 (See Clerval, Abbé) meaning of, 87, 88, 92, 103, 105, 171-86, 306, 318 rebuilt in 1145, 100, 102 rebuilt, 1195-1220, 42, 142, 147-150 its solidity, 14, 101, 107 Architecture and statuary of: West Portal, 11, 36, 38, 63, 69-71, 90, 105, 108, 124, 133, 135, 139, 141, 192, 271, 273 southern tower and flèche, 15, 50-51, 53, 55, 62, 63, 65-67, 100, 108 northern tower and flèche, 63, 66, arcade of kings, 63 north Porch, 63, 76-80, 175 south Porch, 63, 76, 80-86 height of vault, 107 vaulting of choir and apse, 115-122 nave and transepts, 108, 120 western rose, 63, 65, 109, 112, 113, 135 northern rose, 112, 137 southern rose, 113, 137 fenestration of, 96, 110 buttresses of, 107 Glass of: rwelfth-century, 124-35 thirteenth-century, in western rose, 135-38

in the Rose de France, 137, 174-180 in the Rose de Dreux, 137, 174in the apse, 142, 151-60, 169 in the nave, 171 in the transepts, 172 in the clerestory, 172-76 above the high-altar, 181-86 fifteenth-century, Chapel of Vendome, 171 Chartres, church of Saint Pierre in lower town, glass of, 184 Châtelet at Mont Saint Michel, 46 Chatillon, Gaultier or Gaucher, 81 Chatillon, Jean de, 148 Chaucer, his Canterbury Pilgrimage, 20 his Wife of Bath, 190 his Legend of Good Women, 195 his translations, 234-37 Chess, game of, 193 Chinon, chateau of, 198, 217 Choirs and apses, 15, 51, 114-122, 142, Christ, at Amiens, 7 at Mont Saint Michel, 13 at Byzantium, 70 at Chartres, 70, 77, 82, 83, 99-100, 128, 154, 155, 174, 177 absorbed in the Mother, 92-94, in the Trinity, 90, 259, 288, 289 forgotten by Roland, 33 reincarnated at Assisi, 318 Christian of Troyes, 133, 201, 218 his Eric et Enide, 202 his Tristan, 202-208 his Lancelot, 202 his Perceval, 202-206 Church of the 11th century, 9, 269-70, of the 12th century, 70, 285-99, 320, 323-25 (See Abélard, St. Berof the 13th century, 70, 198, 212, 233, 321, 339, 353-57 (See Thomas Aquinas, Duns Scotus, Saint Francis)

secular tastes of, 13

Holy Ghost, 77, 94, 247, 287, 120-21 Citeaux, Abbey of, 41, 44, 90, 271, 286, 200 Clairet, a drink, 205 Clairvaux, Abbey of, founded by St. Bernard in 1115, 38, 41, 44, 90, 265, 290, 299, 314 Clemens vitrearius Carnutensis, 163 Clément, Jacques, 241 Clerk-Maxwell, James, 297, 353 Clermont-Ferrand (Puy-de-Dome), church of Notre Dame du Port, 11, 69, 115 cathedral (Notre Dame), 66, 163 Clerval, Abbé, his guide-book of Chartres, 171 Clochers (see Towers) Cloisters, at Mont Saint Michel, 45 Cluny, Abbey of, 41, 44, 292, 299 Cogito, ergo sum, 304 Cologne, Dominican school of, 134, 326 Comnenus, John, Basileus, 89, 93 Conan, Duke of Brittany, 290 Conceptualism, 279-80, 282-85, 288, 304, 332 Conches in Normandy, 149, 197 Conciergerie, Galerie St. Louis, 44 Constantine VI, emperor of the east, 35, Constantinople, 30, 89 (see Byzantium); French Emperors of, 149 Cordeliers at Paris, 314 Cornard, Robert, inventor of pointed shoes, 192 Cornificii, 303 Coronation of the Virgin, 77 Corroyer, Edouard. "Description de l'Abbaye du Mt. St. Michel (1887)," 8, 16, 17, 41, 43, 53 Cotentin, 8, 9 Coucy, Chateau of, 44 Battle-cry of, 91 Châtelain de, 218 Enguerrand de, 146, 180 Couesnon, river boundary of Normandy and Brittany, 23 Councils, Church, at Ephesus (95), 89 at Soissons (1121), condemns Abélard, 288, 298

its attitude towards the Virgin and the

Councils, Church (cont.)

at Etampes (1130), 292

at Pisa (1135), 294

at Sens (1140), condemns Abélard, 297-300, 301

at Reims (1148), condemns Gilbert de la Porée, 301

at Beaugency (1152), divorces Eleanor of Guienne, 199

at Paris (1276), condemns Thomas of Aquino, 343

at Oxford (1276), condemns Thomas of Aquino, 343

at Trent (1545-1563), 328 Court of Love, 201, 208, 233, 314 Courtenay, Pierre de, and Isabel, 149

Courteous Love, religion of, 201, 202 drama of, 213

poetry of, 202, 206, 213-36

Courtesy, figure of, in the Roman de la Rose, 234

Cousin, Victor, editor of Abélard's works, 296

Coutances, 8, 9, 12, 88

cathedral of (Notre Dame), apse, 51, flèches, 49-54; central tower, 52

Crusade, the first, (1096), 35, 69, 70, 90, 271

the second, (1147), 67, 100 the third, (1190), 217

the seventh, (1248), 83, 240

Crypt, of Chartres, 7, 14, 37, 108, 142, 267

examples of, 37 Gros Piliers, 16, 37

Curriers' window at Chartres, 172

Damietta, 150, 239

Daniel saved from the lions, 32; in Chartres window, 177

Dante, 90, 101, 102, 206, 213, 574; his prayer to the Virgin, 237

David, King, at Chartres, 82, 176 Delacroix, Eugene, 132

Descartes, René, 303-304, 328, 330, 338, 345

Dialectics, science of, 273

Diane de Poitiers, 67 Dies Irae, 309, 311, 312

Domfront in Normandy, 39

Dominic (Domingo de Guzman), Saint (1170-1221), 166, 321-22, 323, 326

Dominican Schools, 323, 326, 327, 343 Don Quijote, 203, 254

Drapers' window at Chartres, 164, 172 Dreux, county of, (see Pierre Mauclerc)

Duns Scotus, doctor subtilis, 328, 340,

Durand, Paul, on Chartres glass, 124, 128, 130

Durazzo, 149

Durendal, Roland's sword, 29-31, 161

Edward the Confessor, King of England, 22

Egidio, Franciscan monk, 318 Egypt, Joinville in, 239-40

Eleanor of Guienne, Queen of France and England (1122-1202), 39, 68,

75, 143, 144, 188, 201, 217, 294 genealogical tables of, 144, 191

story of her life, 190, 198-201, 211 her death, 145, 211

Elizabeth, Queen of England, 191, 249 Energy, equivalent to scholastic Form,

England, Norman conquest of, 8, 9, 14,

her share in mediæval literature, 134 her civil war in 1215-1216, 145-46

Enlart, Camille, "Manuel d'Architecture Religieuse," 37, 61

Eracle, poem by Walter of Arras, 202

Eric et Enide, poem by Christian of

Troyes, 202

Eructavit, translation of psalm, 203
Etampes, (Seine-et-Oise), its church of
Notre Dame, 65, 112

Euclid, 72, 277, 278

Eustace, Saint, window of, at Chartres, 163

Eve, 187, 191, 261

her dialogue with Satan, 194 Evesham, battle of, 148 Evil, an Amissio Boni, 347

Evreux in Normandy, 197

Ezekiel, in Chartres window, 177

Fabliaux, 188, 231
Fair Rosamund, 200

Falaise, tower of, 15, 54, 55 Faraday, Michael, 297, 301 Fenestration, at the Merveille, 43 at Paris, Mantes and Chartres, 57 at Mantes, 58 at Chartres, 96, 110, 118 Fenioux on the Charente, flèche of, 50 Ferdinand of Castile (see St. Ferdinand) Ferragus, giant, 161 Feversham, abbot of, 292 Filetus (see Hermogenes) Fioretti or Floretum of St. Francis, 156, 318 Flaubert, Gustave, his Norman style, 56 Flèches, in Normandy, 12, 15, 50-56 at Coutances, 49-54 at Vendome, 50 at Auxerre, 50 at Fenioux, 50 in the Ile de France, 59 (See Chartres, Laon, Towers, etc.) Fontevrault, Abbey of, 44, 211 Form, scholastic term meaning that which gives being to matter, the equivalent of Energy, 301 France (see Ile de France), battle-cry of, Francis I, King of France, (1515-1547), 66, 228 Francis of Assisi, Saint, 17, 156, 201 his birth, 314; his death, 314, 325 his hostility to the Schools, 314-25 his sermon to the birds, 46, 318-19 his pantheism, 319-25 his Cantico del Sole, 324 Franciscan Schools, 270, 326, 327, 328 Free Will, liberum arbitrium, 270, 282, 303, 349-50, 352 Freeman, Edward A., his History of the Norman Conquest, 22, 189 Fulbert, canon of Notre Dame de Paris, 38

Gaillard, chateau of, 44 Ganelon, the traitor, 26 Garreau, L., his "État social de la France au temps des Croisades," 187-88

Furriers' window at Chartres, 160, 163,

Fulk of Anjou, 209

164

387 Gascony, 68 (See Guienne) Gassicourt, church below Mantes, 56 Gaucher, or Gaultier, de Bar-sur-Seine, Gaucher, or Gaultier, de Chatillon, 81 Gaultier de Coincy, his "Miracles de la Vierge," 244, 257, 262, 308 Geoffroy d'Anjou, 191, 199 Geoffroy Gaimer, chronicles of, 25 Geoffroy III, Comte du Perche, 143, Gesu, church of, at Rome, 37 Gilbert de la Porée, bishop of Poitiers, Gildas (see Saint Gildas-de-Rhuys) Glass (see Windows) God, definitions of: by Saint Gregory the Great, 269 by Bishop Hildebert of Le Mans, by Spinoza, 270 by Saint Thomas Aquinas, 351-53 the ultimate substance, or universe, 274, 275, 277 proofs of his existence, 304 as conceived by Saint Francis, 323 Godfrey of Bouillon, 271 Godwin, Earl of Wessex, 22 Golden Legend (Legenda Aurea), 85, 156, 245-46 Good Samaritan window at Chartres, 157, 167, 171 Gothic architecture: its beginning and end, 15, 36-37, 47, 58, 187, 190, 289 its singularity, 87, 133 its vaults and buttresses, 105-106 its apses, 113-22 (See Mont Saint Michel, Chartres, Romanesque, Transition, etc.) Graal, Conte du, 202-206 Grace, doctrine of, 303, 352 Greece, its influence on France, 133 its coins, 186 its architecture, 35, 37, 74

its share in twelfth-century glass, 128its share in scholastic philosophy, 339 (See Aristotle, Albertus Magnus, Thomas Aquinas, etc.)

Gregory the Great, Pope and Saint (204–268), his definition of God, 269
Greville, in Normandy, 10
Grisaille, windows described by Violet-le-Duc, 151
at Chartres, 154–55, 156–58, 168
Gros Piliers, crypt at Mont Saint Michel, 16, 37
Gueldres, battle-cry of, 91
Guesclin, battle-cry of, 91
Guienne (Acquitaine), Duchy of, 30 (See Eleanor of Guienne)
Guillaume (see William)
Guy of Amiens, Latin poem of, 25
Gyrth, brother of Harold, killed at Hastings, 27

Haeckel, Prof. Ernest, 301, 302, 338 Haimon, Abbot of St. Pierre-sur-Dives, 100

Hainault, province of Flanders, 91, 197 Hales, Alexander, Doctor doctorum, 326, 328

Halls in mediæval architecture, 41-45,

Harold the Saxon, earl of Wessex, II, 22; his visit to Normandy, 22, 23, 26–27; at Mont Saint Michel, 23, 26; his death, 27

Hastings, battle at, 22, 23, 24, 27 Hauréau, B., "Philosophie Scolastique," 301, 335

Hauteville, near Coutances, 10 Havise, countess of Evreux, 197 Helena, empress, 73

Héloïse, wife of Abélard, 38, 207, 208, 235, 270, 271, 286

established at the Paraclet, 292
made Abbess of the Paraclet, 294
letter of condolence from Peter the
Venerable, 200

Henry of Anjou, King Henry II of England, 18, 39, 144

marries Eleanor of Guienne, 198–200 Henry III, king of England (1216– 1272), 148

Henry of France, monk at Clairvaux,

Henry II, king of France (1547-1559),

Henry III, king of France (1574–1589), his pilgrimages to Chartres, 241 Henry IV, king of France (1589–1610),

Heraclius, emperor, 80

Hermogenes, or Almogenes, magician, in Saint James window at Chartres, 158-59

Herod, in Chartres windows, 131, 159 Hildebert, Abbot of Mont Saint Michel, 9, 11, 12, 16

Hildebert, bishop of Le Mans and archbishop of Tours (1055-1133), his definition of God, 269, 283

Hobbes, Thomas, 355
Holy Ghost, 95, 99
in Chartres glass, 140, 174
mystery of, 286–88
in Adam de Saint Victor, 307
Paraclet, 289, 294
Homer, 29

Hugo, archbishop of Rouen, letter on the rebuilding of Chartres, 100 Hugolino of Ostia, cardinal, 322, 323 Hume, David, 297 Hurepel (see Philip Hurepel) Huysmans, J. K., "The Cathedral," 75, 81–82

Ile de France, province between the Seine, Marne and Oise, 30, 57-61, 117 Iliad, 325

Illiers, Raoul de, his window at Chartres,

Individualisation, principle of, 280, 338-342

Ingres, 132
Innocent II, Pope (1130–1143), favors
Abélard, 292–94
condemns Abélard, 298–99

Innocent VI, Pope (1352-1362), 328
Isaac et Abraham, in the north Porch of
Chartres cathedral, 82, 113

Isabel de Chartres, 191
Isabel de Conches, in Normandy, 197
Isabel de France (see Saint Isabel)
Isaiah in Chartres window, 177

Isaiah, in Chartres window, 177 Iseult, or Isolde, 52, 206, 207, 208, 213, 271 Issoire, church of, 115

Ivanhoe, 204

Jacobus de Massa, 319 Jacques de Voragine (Giacomo di Varaggio) bishop, his "Legenda Aurea," 156, 246 James the Major, St. Iago di Compos-

tella, window at Chartres, 157-158

Jarnac, coup de, 282 Jean de Meung, 233, 235

Jeanne d'Arc, 198, 232, 235, 320

Jeanne de Dammartin, her window at

Chartres, 147-48 Jehanne, La belle, conte, 195-97 Jeremiah, in Chartres window, 177 Jerusalem, Henry of Champagne, king

Jesuits, Societas Jesu, 270, 288, 327, 353

Joachim, Saint, 78, 156 John, Saint (see Saint John, the Evangelist)

John XXII, Pope, 328

John, king of England, (1199-1216), 142, 143, 146, 211

John I, duke of Brittany, 179

John of Gaunt, in Shakespeare's Richard II, 242

John of Salisbury, bishop of Chartres, (1176), 275, 293, 294, 303

Joinville, Jean sire de, his chronicle, 213; his education, 188; his religion, 239-40; his account of Queen Blanche, 177, 190, 195; of court manners, 256

Jongleur, joculator, 21-26, 218, 226,

Jordan, abbot (see Mont Saint Michel) Jourdain, Charles, "La Philosophie de Saint Thomas d'Aquin," 339

Justinian, emperor, (557), rebuilds the church of Sancta Sofia, 170

Kilwardeby, Robert, archbishop of Canterbury, 343

Labarte, Jules, "Histoire des Arts Industriels au Moyen Age," 104 "La belle Jehanne," thirteenth-century

novel, 195-97

Lacroix, Paul, "Le Moyen Age et la Renaissance," 104

Lady Chapels, 92 La Marche, count of, 179 Lancelot, by Christian of Troyes, 202, 203, 206

Laon, cathedral of (Notre Dame), 57, 98, 112, 302, 314 towers and flèches of, 48, 65, 66 oxen of, 98 apse of, 114, 119, 120, 121

western rose-window of, 111, 112 Last Judgments, 70, 84, 312 in western Rose at Chartres, 138

Lasteyrie, Ferdinand de, "Histoire de la Peinture sur Verre," 124 Latin Quarter of Paris, 165, 207, 259,

Lazarus (see Saint Lazare) Legenda Aurea, by Jacques de Voragine (See Golden Legend) Leibnitz, Gottfried Wilhelm, 304 Le Mans, Cathedral of (Saint Julien),

61, 69 apse of, 120 glass of, 131, 162

window of Saint Protais, 245 bishop Hildebert of, 269 Leo XIII, on Thomas Aquinas, 328 Leonardo da Vinci, 66

Lescine, Nicolas, 163 Lescot, Pierre, 44, 66 Lessay church in Normandy, 15, 52 Lincoln, battle of, (1217), 146 Lisbon earthquake, 347

Littré, his dictionary, 14 Loches, chateau of, 89

Locke, John, 297 Lohengrin, 76, 98

Loire, architectural school of, 48, 61 Louis VI (le Gros), king of France, (1081-1137), 73, 83, 149, 191 (genealogical table), 268, 292, 294

his death, 295

his queen, Alix de Savoie, 73, 77, 191 Louis VII (le Jeune), king of France, (1120-1180), marries Eleanor of Guienne, 72, 191 (genealogical tables), 207

divorced, 198, 200

marries Alix de Champagne, 144 (genealogical table), 200

Marc, king, in the Roman of Tristan, Louis VII (cont.) his monastic tastes, 205 206, 212 at the Council of Sens to condemn Margaret of Provence, queen of Louis Abélard, 298 IX, Joinville's story of, 190, 195 Louis VIII (the Lion), king of France, Marion et Robin, play of, 228-32 (1187-1226), 77, 79, 83, 143, 144, Marly, Bouchard de, 150 Marseilles, 196 145, 150, 172 marries Blanche of Castile, 211 Masseo of Marignano, 319 Mathematics, exercitium nefarium, 71, is invited to England by the barons, 145, 146 dies in 1226, 212 Matilda of Flanders, duchess of Nor-Louis IX (Saint), king of France, (1215mandy and queen of England, 1270), 44, 77, 79, 82, 144 (gene-(†1183), 17, 25, 191 alogical table), 145, 148, 150, 166, her marriages, 189 172, 188, 212, 239, 240, 241, 258 Matter, its importance in theology, 280, his crusade of 1248, 83, 149, 239, 329, 336-44 Matthew Paris, 148 240 Melchisedec window at Chartres, 176 in glass at Chartres, 148 in awe of his mother, 190 Menestrel de Reims, 145-46 his sense of humor, 239 Menestreus, menestrier, 20, 232, 247 Merveille, the (See Mont Saint Michel) his relations with Thomas Aquinas, Michael, Archangel, patron saint of Louis XI, king of France, (1469), cre-France, 7, 191 ates Order of Saint Michael, 7, 42 his day, October 16, 10, 19 builds Loches, 89 his power, 7, 11 restores civil order, 240 his architecture, 13, 42-44, 329 Louis XIV, style of, 14, 44, 137, 208 pilgrimages to shrine of, 19-21 Louis XV, style of, 14 Order of Chevaliers of, 7, 42 Louis d'Orleans, builder of Pierrefonds, in the Chanson de Roland, 34 at Chartres, 84, 129, 140, 153 Louise de Lorraine, queen of Henry III Michael Angelo, 66, 67, 182, 358 of France, 241 Michelet, Jules, history of France, 177 Lourdes, Notre Dame de, 78, 103, 246, Milky Way, 348; in window at Chartres, 261, 264 Louvre, hall of Pierre Lescot, 44 Milton, John, 33, 252, 334 Minorites (see Francis of Assisi) Macbeth, Lady, 197 Miracles, of the lances, 161 Magdalen (see Saint Mary pécheresse) of the Virgin (see Virgin) Magna Charta, 145, 326 Moissac, Abbey of, (Tarn-et-Garonne), Mahaut (Mathilde) de Boulogne, 79, 80 11, 54, 69 Mahaut (Mathilde) de Champagne, 143, Molière, 19 Molinier, Emile, "Histoire Générale des Maine, province of (see Le Mans) Arts Appliqués, (1896)," 104 Mal ardent, leprosy, 244 Money-changers and bankers, window Mâle, Em., "L'Art religieux en France at Chartres, 172

Manicheans, 327 cathedral of, 10, 114 Mantes (Seine-et-Oise), death-place of Mont Saint Michel in periculo maris, 7, King William the Norman, 27, 57 its church of Notre Dame, 56-61, 110, Abbey Church of, 8, 10-16, 329 202

au XIIIe Siècle," 98, 124, 160

triumphal columns, 8, 22

Monreale, mosaics of, 171

tower lost, 15, 52 choir, 15 crypt, 16, 37 pilgrimage to, 19-21, 73 relation to the Chanson de Roland. 17, 26, 33-34 Refectory of the 11th century, 16-17, 25, 39 Buildings of the 12th century: Aquilon, 36, 37, 42, 70 Promenoir, 36, 37-38, 70 Buildings of the 13th century: Merveille, 16, 40-47, 88, 106 Refectory and Hall, 41-45, 46 Charter-house, 45 Cloisters, 41, 45 Belle Chaise entrance, 46 Châtelet of 14th century, 46 Mont Saint Michel, abbots of: Hildebert II (1017-1023), fourth abbot, 9, 11, 12, 15, 16 Ralph de Beaumont (1048-1060). eighth abbot, 16, 26 Ranulph du Mont (1060-1085), ninth abbot, 17 Roger II (1106-1123), eleventh abbot, 35, 38, 39, 70 Robert de Torigny (1154-1186), fifteenth abbot, 12, 18, 19, 39, 46 Jordan (1191-1212), seventeenth abbot, 40, 41 Pierre Le Roy (1386-1410), twentyninth abbot, 46 Mont Saint Michel, Roman du, by William of St. Pair, 18-22, 39 Montargis, chateau de, 44 Monte Cassino, 11, 326 Montespan, Mme de, 14 Montfort l'Amaury, 148 Montfort, Simon and Amaury, 148 Montjoie, battle-cry of France, 27, 91 Moret, a drink, 205 Morigny, abbey of, 292 Moucon, Reynault de, Bishop of Chartres, 147 Murano, church at, 114 Murillo, painting of St. Bernard, 90 Mystics, French and Italian, 98, 313-325, 331, 354

Naïf, natif, 14, 16, 32, 33

Naples, Norman conquest of, 10 Nebuchadnezzar, in Chartres window. Necessitarianism of Abélard, 295-96, Nervures, rib-vaulting, 37, 358 New Alliance, the dependence of the new dispensation on the old, windows at Chartres, &cc., 157, 159, 163, 167, 171, 177 Newton, Sir Isaac, 304 New York, towers of, 56 Nicholas (see Saint Nicholas) Nicolette (see Aucassins) Nimbus, 73 Nippur, 155 Noah, window at Chartres, 171 Nominalism, 277, 332 results in materialism, 285, 304 Normandy, character and influence of, 8-16, 51-52, 55, 197, 201 conquered by Roland, 30 architecture of, 12, 15, 35, 55-56 flèches of, 49-56 conquered by Philip Augustus (1203), outbreak of devotion to the Virgin, 12, 100, 102 women of, 8 Notre Dame (see Virgin) Notre Dame de la belle Verrière, window at Chartres, 140, 141, 142 Novon, cathedral of (Notre Dame), 39, 57, 63, 88, 110, 201, 302 transepts of, 114 Novs, Thought, 335-36

Odo, brother of William the Conqueror, 26, 31
Oliphant, 29, 31, 162
Oliver and Roland at Roncesvalles, 23, 27–29, 256, 316
Omar Khayam, 289, 336, 357
Orderic, monk of St. Evroul, his history of Normandy, 192, 197, 207
Ottin, L., "Le Vitrail," 124
Ouistreham in Normandy, 15, 54

Palermo, 10 Pallet in Brittany, 271 Pantheism, 270, 282, 284, 304, 323, 325, 334, 353 Paraclet, Holy Ghost, the Consoler, 280 Abélard's foundation near Nogent-sur-Seine, 200, 200 erected into a priory for Héloïse, 292 papal bull of 1136 in its favor, 294 Paradise, 138, 210, 223 Paris, 48: in the time of Abélard, 272 churches of, 60 schools of, 270-76 cathedral of (Notre Dame), 57, 77, 99, 104, 110, 272 its windows, 57, 59, III its apse, 61, 115, 120, 121 its sculptures, 69, 97, 98 Paris, Gaston, his history of mediaval French literature, 194 on Christian of Troves, 202, 207 on Thibaut of Champagne, 213 on Gaultier de Coincy, 244 Parsifal, 98, 202-205 Partenopeus of Blois, 195 Parvis, small square in front of large church, II, 63 Pascal, Blaise, 123, 330, 332, 354 his Pensées, 304-306, 347 Pascal III, antipope, canonises Charlemagne, 159 Pastry-cooks' window at Chartres, 172 Peasant, character of the French, 222, Perceval, Parsifal, Conte du Graal, by Christian of Troyes, 202-205 Perche, Comte du, 143-47; his window at Chartres, 146-47 (See Geoffroi) Percherain, 143 Percy, in Normandy, 10 Peter (see Saint) Peter the Venerable, abbot of Cluny, 68, 291, 292, 298; his opinion of St. Bernard, 299; of Abélard, 299-300 Petrarch, prayer to the Virgin, 237, 309 his religion of women, 201, 206, 213 Philip Augustus, king of France (1180-

1223), 77, 83, 113, 145, 147, 149,

Philip Hurepel, son of Philip Augustus,

79-81, 83, 149, 172, 180

163, 210, 217

Philip the Hardy, king of France (1270-1284), 63, 77 Philip the Fair, king of France (1285-1314), 86, 236, 230 Philippe de Commines, 241 Phocas, emperor, 80 Pierpont in Normandy, 10 Pierre (see Saint Peter) Pierre de Courtenay, 140 Pierre le Vénérable (see Peter) Pierre de Dreux, Mauclerc, his porch at Chartres, 83-86, 99, 123 his rose-window, 113, 137, 172, 174his figure in glass, 180 his rebellion, 80, 174, 176, 213, 259 prisoner at Damietta, 239 Pierre du Pallet (see Abélard) Pierre de l'Estoile, journal of, 241 Pierrefonds, chateau of, 44 Pilgrimages, 19-22 Pisa. 202 Placidas (see Saint Eustace) Plato, 274, 277 Poissy, Abbey of, 44 abbey-church of, so Poitiers, 63, 199 church of Notre Dame la Grande, 44 cathedral of (St. Pierre), 63 twelfth-century glass at, 131 bishop of, 301, 302 Raymond, count of, 17 Poitou, 30 Ponthieu, county of, 22 Count of, 147 La Comtesse de, conte, 195, 197 Porches and Portals, 69-86 Porphyry, his Preliminaries, 276, 282 Port Royal, 306 Prison-song of Richard Cœur-de-Lion, 200-210 Prodigal Son, 75-76, 165-66 windows at Chartres, &cc., 157, 164-168, 172 Provence, 30 Provins, in Champagne, 213 Pythagoras, 72 Queen of Sheba, 76, 82

Quijote, Don, 201, 203

Rafael Sanzio, 66 Ralph de Beaumont, eighth abbot of Mont St. Michel (1048-1060), 16, Ralph, seigneur de Conches, 197 Ranulph du Mont, ninth abbot of Mont St. Michel (1060-1085), 17, 34 Raoul de Cambray, Roman, 202 Ravenna, 114, 124, 172 Raymond of Poitiers, 17 Realism, 165, 277, 301 results in pantheism, 282-84, 356 Régnon, Th. de, S. J. "Etudes sur la Sainte Trinité," 288, 353 Reims, cathedral of (Notre Dame), 51, 77, 79, 87, 88, 182, 212, 326, 329 sculpture at, 81, 97 height of vault, 107 rose-windows, III twelfth-century glass, 131 Rémusat, Charles de, his work on Abélard. 282 Renaissance, the, 87 Renan, Ernest, 332 "Averroès et l'Averroïsme," 134 Revnault, or Renaud, de Moucon, bishop of Chartres, his window, 147, 160 Rhine, architectural school of, 61 Richard, Cœur-de-Lion, king of England, (1189-1199), 143, 144, 191, 205, 209, 218 his poetry, 18, 143, 209-210 his education, 188, 189 affianced to Alix de France, 200 his death, 210, 218 Richard I, sans-Peur, duke of Normandy (943-996), 9 Richard II of Normandy (996-1026), Richard de Saint Victor, 306 Robert of Artois, 228 Robert Guiscard, (1015-1085), 10 Robert de Beaumont, at Chartres, 150 Robert of Torigny, fifteenth abbot of Mont St. Michel (1154-1186), 12, 18, 19, 39, 46 Robin et Marion, play of, 228-32 Robin Hood, 205, 232

Roger of Sicily, twelfth son of Tancred

de Hauteville (1031-1101), 10

Roger II, king of Sicily, (1101-1154), Roger II. eleventh abbot of Mont Saint Michel (1106-1123), 35, 38-39 Roger of Wendover, 145, 146 Rohault de Fleury, his "Iconographie de la Sainte Vierge," 73, 89, 93 Roland, prefect of the Breton marches, killed at Roncesvalles, (778), 10, 26-32 Chanson de, 17, 24-34, 36, 220, 252, his relics, 29-30 at Chartres, 17, 159-60 ideal hero of St. Francis, 315, 316 Roman, du Mont St. Michel, 18-22 de Rou, 22 Partenopeus de Blois, 195 de la Charette, 202, 208 de la Rose, 224, 233-36 Romanesque architecture of the 11th century, 11-16 Rome, church of Il Gesu, 37; St. Peter's, jealousy of, 93, 119 Roncesvalles, 10, 23, 32, 127 Rose motive in windows, 210 Rose-windows, at Mantes, 57, 58, 210, at Amiens, 211 at Paris, 57, 211 at Beauvais, 212 at Laon, 211 at Etampes, 212 (see Chartres) Rotrou, comte du Perche, 144 Rouen, hall at, 44 cathedral of (Notre Dame), 55, 88, 163 abbey of Jumièges, 55 Rousselot, Xavier, "Etudes sur la Philosophie," 301 Runnimede, 145 Rutebeuf, satirist, 240, 253

Saint Anne (mother of the Virgin), at Chartres, 78, 81, 176, 181; her daughters, 156 Apollinaris, window at Chartres, 172 Augustine, bishop of Hippo, 155, 174, 304, 322, 326, 329, 347, 350 Saint Anne (cont.) Germain-des-Prés, abbey church of, at Bartholomew, massacre of, 241 Paris, 59, 60, 272 Basil, blood of, so Gervais, docher at Falaise, 54; Gervais Benedict, 24 et Protais (martyrs), window to, at Le Mans, 245 Benoit-sur-Loire, abbey-church of, II Bernard, abbot of Clairvaux, 17, 36, Gildas-de-Rhuys, abbey in Brittany, 38, 51, 67, 68, 90, 103, 153, 165, 291, 292, 299; elects Abé-155, 165, 265, 301-303, 306; lard as abbot, 291; treatment of hymns to the Virgin, 90, 93, 240, Abélard, 292 242, 310; theologist, 123, 301, Gregory the Great, 269 330; politician, 191, 192 (See Hilary of Poitiers, 174 Abélard, Gilbert de la Porée, Isabel of France, 81, 160 Bernard) James the Major (Santiago of Com-Bonaventure, General of the Francispostella), 156; his window at can Order, 331, 339 Chartres, 157-59, 161 Christopher, 52 James the Minor, 156 Denis, hair of, 30 Joachim, 78, 156 seigneur of Roland, 30 John the Evangelist, 84, 156; his winabbey-church of, 37, 44, 161, 235, dow at Chartres, 171; in the Rose de Dreux, 177 glass of Abbé Suger, 124, 129, 130, Joseph, 72, 156, 167 139, 192 (see Suger) Jude, 156, 157 battle-cry of France, 37, 91 Julien-le-pauvre, church of, in Paris, Dominic (see Dominic) Etienne, window at Chartres, 162, 168 Lawrence, window at Chartres, 172 rose in church, at Beauvais, 112 (See Lazare, 32; cathedral at Autun, 70 Abbaye-aux-Hommes, Leu d'Esserent (Oise), abbey church Bourges, and Sens) of, 59, 112, 201-202; flèche of, Eustace, window of, at Chartres, 163, Louis (See Louis IX) Ferdinand of Castile and Leon, 147, Lubin, window of, at Chartres, 171, in glass at Chartres, 181; his ge-Lucien, abbey of Beauvais, 202 nealogy, 191 Luke, in Chartres window, 177 Francis of Assisi, 17, 90, 306 his prodigal son, 75, 166 his sermon to the birds, 46, 318-19 Mark, church of, at Venice, 11, 114 his birth, 314 in Chartres window, 177 his Knights of the Round Table, Martin of Tours, windows at Chartres, 163, 174 his hatred of schools and scholars, Martin-des-Champs, church of, in 318, 322-23 Paris, 60; its apse, 115 his Fioretti, 156, 318 Mary (See Virgin) his pantheism, 318-25 Mary the Gypsey, (pécheresse), her his Cantico del Sole, 324 window at Chartres, 167, 174 his death, 314, 325 Mary Magdalen (pécheresse), her Gabriel, archangel, 32, 72, 78, 129, window at Chartres, 167, 171 Matthew, in Chartres window, 177 140 Geneviève, hill of, 272 Maurice, cathedral of Angers, 112, 131 George, statue at Chartres, 85 Michael (See Michael)

Nicholas, 84; his windows at Chartres,

171, 174

window at Chartres, 174

Germain at Auxerre, docher, 65

Pair, in Normandy, 18, 19 Paul, 105, 178; window at Chartres. 144. 166 Peter, his attitude to the Virgin, 155; tooth of, 30; statue, 75; window at Chartres, 154, 156, 174 church of, sur Dives, flèche at, 54, 100, 302 church of, at Rome, 106 Piat, chapel of, at Chartres, 112, 163, Pierre (See Saint Peter), or Protais, window of, at Le Mans, 245 Romain, docher of, at Rouen, 55-56 Sernin, church of, at Toulouse, 11 Séverin, church of, at Paris, 272 Simeon, 72 Simon and St. Jude, 155, 156 Sofia, church of, at Constantinople, 107, 114, 170, 181 Stephen (See Etienne) Sulpice, church of, at Paris, 37, 107,

Sylvestre and Melchiades, window of, at Chartres, 147, 162, 163, 168 Theodore, statue of, at Chartres, 85

Thierry, abbey of, 295 Thomas, apostle and martyr, his win-

dow at Chartres, 162-63, 168 Thomas a' Becket, martyr, 20; window at Chartres, 167, 168; his hairshirt, 245

Thomas Aquinas, doctor angelicus, 91, 103, 271; his works, 243; his birth and career, 326-27; at court of St. Louis, 327; his authority in the Church, 327-28; his Church as architecture, 302, 329-59

Victor, cloister and school of, in Paris, 276, 303-312, 330 (See Adam de St. Victor); murder of Prior in 1133, 293

Sainte Chapelle, at Paris, 147, 150, 233
Sancerre, 91
San Vitale, church of, at Ravenna, 114
Sapphires, in glass, 130
Satan (See Adam)
Scheherazade, 195
Schools of romanesque architecture, 62
Schools and scholastic teaching, at Paris,

165, 167, 271-92, 317, 327, 346 at Cologne, 326 Scott, Walter, 204, 263

his translation of the Dies Irae, 311-

Secqueville in Normandy, flèche of, 55,

Senlis, cathedral of (Notre Dame), 60, 65, 201

Sens, cathedral of (Saint Etienne), its sculptures, 69

its glass, 164, 165, 171

council at, in 1140, condemns Abélard, 297, 299, 301

Shakespeare, 109, 220, 222; Much Ado, 195; Lady Macbeth, 197; Henry VI, 242

Sheba, queen of, at Chartres, 181 Shoemakers' window at Chartres, 163 "Sic et Non," work by Abélard, 296 Sicily, Norman conquest of, 10

temples of, 35

churches of, at Palermo, Monreale, Cefalu, 170-71

Counts and Dukes of:

Roger I, (1037-1101), 10 Roger II, (1097-1154), king of, 10 William II, (1166-1187), 10

Socrates, the scholastic individual, 274, 278, 281, 282, 335, 338

Soissons, cathedral of, (Saint Gervais et Saint Protais), 39, 57, 114, 120,

architects of, 53

council of (1121), condemns Abélard, 288, 298

Solomon window at Chartres, 176 Sorbonne, school of theology in Paris, founded in 1253, 331

Spinoza, Benedict, his definition of God, 270, 302, 304, 330, 338

Statuary, a mark of the Virgin's churches,

Stratford atte Bowe, 8

Stella Maris, 310

Substance, sub-stans, that which stands behind or under the phenomenon, das Ding an sich; 274, 278, 301

Suger, abbot of Saint Denis, (1122-1152), 37, 68, 289

rebuilds the Abbey of Saint Denis, 295

Suger (cont.) his glass, 124, 129, 130, 137, 139 his political influence, 191, 198, 290, Syllogisms, 135, 274 rejected by Bacon, 297, 320 Synagogue, symbol in art, 99, 166, 178 Taillefer, Incisor-ferri, Duke William's jongleur, 23-29, 34, 36 Tailors' window at Chartres, 158 Tancred of Hauteville, 10 Tanners' windows at Chartres and Bourges, 163, 165 Tempier, Etienne, bishop of Paris, 343 Tennyson, Alfred, 227, 318; his Merlin, Thaon, church in Normandy, 15, 54 Theocritus, 318 Theophilus, miracle of, 264 Thibaut, Count of Champagne, (†1201), 144, 191, 210 le Grand, count of Champagne, (1201-1253), 144 (genealogical table), 191 (genealogical table), 210, 211, 218, 233 the friend of Queen Blanche, 179, 180, 210, 211-13 affianced to Yolande of Brittany, 179, 230 his poems, 214-16 Count of Chartres (†1197), 144 (genealogical table), 191 (genealogical table), 199, 200 VI of Chartres (†1218) le Jeune, ou le Lepreux, 144, 145, 146, 172, 191 (genealogical table) Thomas Aquinas, doctor angelicus, saint, 58, 91, 103, 297 his birth, 156, 271, 317-18, 326 his death, 343 his training and character, 326-27 at court of Louis IX, 327 Trajan, 163 his works, 243, 327 his church as architecture, 328 92, 302 its Norman foundation, 329 his demonstration of God, 331 his definition of the Trinity, 333 his doctrine of Creation, 334-38

his doctrine of free-will and Grace, 346-47 Thomas of Le Perche, count, 144 (genealogical table); killed at Lincoln, 146; his window at Chartres, 143, Thomas Cantimpratensis, canon of the Abbey of Cantimpré, 310 Time, in the Roman de la Rose, 234 in theology, 335 Tombeor de Notre Dame, 265-68 Torcello, 114, 184 Torigny, Abbot Robert of, 12 Tortosa in Syria, miracle at, 239-40 Toulouse, 210, 211; church of St. Sernin, 11, 115 Tours, cathedral of (St. Gatian): glass in, 158, 183 men of, give window at Chartres, 172 Towers, clochers and flèches: in Normandy, 12, 15, 50-54 at Bayeux, 12, 53 at Boscherville, 55 at Caen, 50, 53 at Cérisy-la-Forêt, 15-52 at Coutances, 48-54 at Falaise, 54, 55 at Jumièges, 55 at Lessay, 52 at Rouen, 55, 56 at St. Pierre-sur-Dives, 54-55, 302 at Secqueville, 55 at Thaon, 54 at Vaucelles, ss in the Ile de France, 48, 50, 55, at St. Leu d'Esserent, 59 at Senlis, 60 at St. Denis, 59, 295 in the Chartrain (See Chartres) at Fenioux, 50 in New York, 56 Transition, the French, 36, 37, 38, 58, Tree of Jesse window at Chartres, 124-Trent, Council of, 328 Tresca, 13th century dance, 228, 232

Triangle, mystic, 99, 279-82, 284-85,

333-34

his doctrine of Individualisation, 338-

Trianon, 137 Triclinium, 95, 310 Trinity, the, at Mt. St. Michel, 13 in the Chanson de Roland, 32 at Chartres, 78, 99 overshadowed by the Virgin, 90, 95, 99, 138-140 mystery of, 170, 174, 278, 284 defined by Thomas Aquinas, 333 immutable in law, 238, 247-48 dependent on the Virgin, 240, 247, 250, 259 in essence Unity, 248 its philosophical value, 286-89, 301 in Egypt, 170, 287 in the verses of Adam de Saint Victor, in the Church fabric, 329, 334 Tristan and Isolde, 52, 76, 202, 206-Trouvères, poetry of, 134 Troyes, 201, 202, 208, 213, 289, 290 Truie qui file, 123 Trumcau, 84, 86 Turpin, archbishop of Reims, 27, 161; his death at Roncesvalles, 29; his Chronicle, 159 Tutbury Abbey, 100

Ugolino, Cardinal (Pope Gregory IX), 322, 323 Ugolino, Franciscan monk, 319 Unity (see Trinity), 285-87, 304, 329-349 Universals, doctrine of, 275-82, 342

Valois kings of France (1328–1589), 82
Vaucelles, central tower of church at
Caen, 54, 55; suburb of Caen, 189
Vaulting, 105–106, 115–22, 334, 344
Vendome, flèche, of, 53, 63
twelfth-century glass at, 131
chapel of, at Chartres, 141, 171
Venice, San Marco, 11
Verlaine, 18
Versailles, Salle des Glaces, 44; queen's
apartments, 89
Vexin, French county, 10
Vezelay, abbey of, 11, 44, 69; apse of,
115–16, 202
Villard de Honnecourt, thirteenth-

century architect, his notes on Chartres and Laon, 65-66, 112, 329 Villon, his Ballade des Dames, 235 Viollet-le-Duc, Dictionary of French Architecture, 41, 45, 112; of Mobilier, 104 remarks on Coutances, 49, 52 on Thaon, 54 on Rouen, 55, 344 on Mantes, 56-59 on Vendome, 64 on the old tower at Chartres, 63-66 at Clermont, 66-67 on the Chartres porches, 76, 78-79 on the Chartres structure, 107 on the Chartres fenestration, 110-11, on apses, 116-22 on glass, 124-28; on grisaille, 151, Virgin, of Chartres: of the crypt, 7, 241 of the Belle Verrière, 140 of the Pillar, 140 of France and of Dreux, 175-81 always the Virgin of Majesty, 71-78, 81-86, 104-105, 129, 141 coronation of, 77 court of, 81, 173-86 authority of, 245, 247, 250, 255-56, 258, 259, 260, 345 character and tastes of, 17, 88, 93-94, 166-67, 173-74, 193, 200, 237-59 illogical by essence, 247-61, 320 Virgin, Miracles of, 68, 100, 171, 237-248, 250-59 at Tortosa, 239-40 at Chartres, 243 for Saint Thomas of Canterbury, 245 at Le Mans, 245 for her Son, 247 against Church discipline, 248-50 for chevaliers, 251-56 against the decisions of the Trinity, 250, 257 for her Tombeor, 265-68 for Adam de Saint Victor, 310-11 Virgin, of Majesty: at Byzantium, 89 in the western Portal of Chartres, 71-78, 139

Virgin, of Majesty (cont.) on the Porches at Chartres, 81-86. in twelfth-century glass, 129, 139 in thirteenth-century glass, 140-41, in fifteenth-century glass, 141, 171 Virgin, of Theology, 72, 82, 99, 247 as understood by Saint Bernard, 90, 02. 101 by Abélard, 242 by Albertus Magnus, 91 by Adam de Saint Victor, 93-94, 310the religion of love, 306 Virgin, of twelfth- and thirteenthcentury society: battle-cries of, 37, 91 in the game of chess, 193 palaces of, 88; their money-cost, 92, 05-06 poetry of (See Abélard, Saint Bernard, Gaultier de Coincy, Adam de Saint Victor, Rutebeuf) symbol of, the rose, 109, 112 her family connection, 156 her presence assumed, 99-102, 108-109, 114, 117, 138, 173-86, 238-40 Voltaire, 18, 104, 303, 347

Wace, his Roman de Rou, 21-23, 201 his account of the battle of Hastings, 23-24, 25 Wagner, Richard, his Tristan, 207
Water-carriers' window at Chartres, 171, 172
Westlake's "History of Design," 124
William the Conqueror, duke of Nor-

William, the Conqueror, duke of Normandy, 8, 9, 13, 16, 17, 19, 22, 34, 189, 191, 269; his conquest of England, 8, 9, 14, 23, 26; his death at Mantes, 56

William Rufus, king of England, Duke of Normandy, 192

William II, king of Sicily (1166–1189),

William of Champeaux, bishop of Chalons, 270, 273-86, 306, 330, 338-339

William of Lorris, his Roman de la Rose, 218, 220, 233, 234, 235, 239

William of Malmesbury, 24
William of St. Pair, his Roman du Mt.
St. Michel, 18-22, 39, 45, 201

William of St. Thierry, abbot, his charges against Abélard, 295

Windows, French books on, 124; glass at Chartres, 123 of twelfth-century, 124-35 of thirteenth-century, 133-169 of fifteenth and sixteenth centuries.

Women of the twelfth and thirteenth

women of the twelfth and thirteenth centuries, 75, 79–81, 97, 187–216 Wordsworth, 7, 87

Yolande of Brittany, 148, 179, 239